Painting in
Cinquecento Venice:
Titian, Veronese, Tintoretto

Painting in Cinquecento Venice:
Titian, Veronese, Tintoretto

DAVID ROSAND

NEW HAVEN AND LONDON

YALE UNIVERSITY PRESS

ND
621
.V5
R67
1982

For my parents

Published with the assistance of the F. B. Adams, Jr. Publication Fund.

Designed by Nancy Ovedovitz
and set in Palatino type.

Printed in the United States of America by
The Murray Printing Company, Westford, Mass.

Library of Congress Cataloging in Publication Data

Rosand, David.
 Painting in cinquecento Venice: Titian, Veronese, Tintoretto

 Bibliography: p.
 Includes index.
 1. Painting, Italian—Italy—Venice. 2. Painting, Renaissance—Italy—Venice. 3. Titian, ca. 1488–1576. 4. Veronese, 1528–1588. 5. Tintoretto, 1512–1594. I. Title.
ND621.V5R67 759.5′31 81-4530
ISBN 0-300-02626-9 AACR2
 10 9 8 7 6 5 4 3 2 1

Contents

Illustrations

Preface

This book is about painting in sixteenth-century Venice; it explores the subject by focusing on certain aspects of the art of the masters who dominated and shaped the traditions of Venetian painting in the cinquecento: Titian, Veronese, and Tintoretto. Concerned essentially with monumental public imagery, altarpieces and murals, each of the chapters interprets a painting or group of paintings within the several determining contexts of conventions and institutions—artistic, social, historical—of Renaissance Venice, especially as these are manifest in the patterns of patronage that occasioned the pictures and in the specific locations for which they were intended. Created in and for Venice, these paintings can be best understood by being viewed *in situ*; when considered in that special setting, they appear as part of the unique, highly structured, splendid world that was Renaissance Venice.

Such contextualism necessarily reinforces our awareness of the position of these images in history, of the distance separating us from the moments and circumstances of their creation. Part of our task in attempting to understand them involves historical reconstruction, a reimaging of those dimensions of experience that surrounded a picture and that both constituted and resonated its fullest significance.

And yet, no matter how aware we must be of the historical distance between us and the Venetian cinquecento—or any time and place not our own—the images themselves do speak directly to us across that temporal divide. Although grounded in the practices and assumptions of the past, their affective structures retain a certain eloquence in the face of time, a validity that transcends historical limitation—that which makes a work of art different from (and greater than) mere historical data.

These two aspects of our approach, historical and critical, are explicitly reflected in the introductory chapter. The first three parts attempt to set Venetian painting into the special matrix of its place and time, to define the conditions that distinguish Venice from other major centers of artistic production in the Renaissance. The final and longest section seeks to set out certain principles of picture-making and picture-reading that are central to the method of the following chapters; for these studies assume that those basic principles of pictorial composition which both defined and realized the expressive aims and potential of Renaissance painting continue to retain their expressive function and impact.

Essential to this approach, therefore, is the assumption that analysis properly proceeds from experience, that our own response to pictures can be a generally reliable guide to rediscovering pictorial intention. The fundamental question posed is: how does a picture work? On this level our central concern is with the affective mechanisms of painting, the ways in which an image functions—imitating and persuading, signifying and communicating—and the ways in which we read it. The image, in turn, directly offers us ways of comprehending it, through qualities inherent in its structure—in painting, the fundamental dialectic between frame and field, actual surface and fictive space. Defining the particular mode or modes of its own existence, each work invites us to participate in its illusion and, at the same time, to ask questions of and about it; and each affords the controls by which to determine the relevance of those queries. Guided by whatever historical and cultural data circumscribed its origins and subsequent life, my method, then, has been to follow in so far as possible the suggestions of the painting itself, hoping thereby to restore to it some of its original eloquence—as well as, perhaps, some flavor of its special dialect.

These studies have developed over the course of many years. The first sections of the introductory chapter draw upon materials first explored in my dissertation, "Palma Giovane and Venetian Mannerism" (Columbia University, 1965), revised and published in part as "The Crisis of the Venetian Renaissance Tradition" in *L'Arte* (11–12 [1970]: 5–53), and further developed in a series of lectures, "L'Artista a Venezia nel '500: Aspetti di una storia sociale dell'arte," delivered at the Università Internazionale dell'Arte, Venice, in 1972. Chapters 2, 3, and 4 revise and expand material originally published in the pages of *The Art Bulletin*. Chapter 5 was first presented in part as a public lecture at Yale University in 1978 and again, in slightly different form, at the J. Paul Getty Museum in 1979. Representing the fruits of an enterprise that can only be described as long-term and cumulative, these studies have developed in two very specific locales, Venice and Columbia University, which have been the complementary sites of my own development.

My involvement with both the material and the method of this book began at Columbia, and I am keenly and affectionately aware of my profound debt to four distinguished teachers: Howard McP. Davis, Julius S. Held, Meyer Schapiro, and the late Rudolf Wittkower. These men taught me to look and to see. And, immediately after my teachers, it is appropriate that I express my appreciation of my own students at Columbia, who have, in effect, assumed the responsibility of continuing my education.

That responsibility has also been shared, in different ways, by two very special colleagues. Michelangelo Muraro first introduced me to the fuller context of art in Venice; his personal friendship—warm, enlightening, generous—has added the fullest satisfaction to my living and work-

ing in Venice. My debt to Leo Steinberg is perhaps less tangible but no less strongly felt; beyond the challenge of his own publications and lectures, our discussions about art, history, and criticism have meant much to me.

To the late Millard Meiss I dedicated an earlier version of the section "Titian's Light as Form and Symbol," and I now rededicate those pages to the memory of a scholar who regarded iconography as "responsive to form and symbolic of deeper intrinsic meanings."

It is with an appropriate sense of obligation but also with a very definite sense of satisfaction that I acknowledge the importance to me of two scholars I never had the good fortune to meet: Hans Tietze and Erica Tietze-Conrat. To *venezianisti* their names quite naturally evoke a more heroic age of scholarship; their pioneering work, which opened paths and raised questions that still remain to be properly explored, first taught me important lessons in method and about Venice.

In Venice itself I have accumulated many debts over the years, to Francesco Valcanover and Terisio Pignatti, in particular, and to the directors and staffs of the several institutions that have hosted my studies: the Fondazione Giorgio Cini, the Biblioteca Nazionale Marciana, the Biblioteca Correr, the Archivio di Stato, the Soprintendenza alle Gallerie.

My studies have been generously supported at various times by grants from the National Endowment for the Humanities, the John Simon Guggenheim Memorial Foundation, the American Council of Learned Societies, the American Philosophical Society, the Fulbright-Hays Commission, and the Council for Research in the Humanities of Columbia University.

My greatest support has always come from Eric, Jonathan, and Ellen.

1 Introduction

The Conditions of Painting
in Renaissance Venice

*Augustissima Venetorum urbs quae una hodie libertatis ac pacis, et iustitiae domus est,
unum bonorum refugium, unus portus, quem bene vivere cupientium tyrannicis undi-
que, ac bellicis tempestatibus quassae rates petant, urbs auri dives, sed ditior fama, potens
opibus, sed virtute potentior, solidis fundata marmoribus, sed solidiore etiam fun-
damento civilis concordiae stabilita, salsis cincta fluctibus, sed salsioribus tuta consiliis.*
 —Petrarch, *Epistolae seniles,* IV.3*

1. THE HISTORICAL SITUATION OF ART IN VENICE

Venice is different—from Florence or Rome, or any other city. Its uniqueness, arising from its lagoon foundation and its special relation to the sea (fig. 1), is manifest in every aspect of its history and culture. Surviving as an independent city-state for a thousand years, Venice at the height of its power, by the close of the fifteenth century, ruled an empire extending from the Aegean well into Lombardy. *La Serenissima,* the most serene republic, remained enviably free from internal strife during its long history and could boast of its successful resistance to foreign conquest—until Napoleon's armies "liberated" it from its own weighty past and forced it to enter a more modern age. Out of the facts and fictions of its history the republic wove that fabric of propaganda that would be known as the "myth of Venice": the image of the ideally formed state, miraculously uniting in its exemplary self the best of all governmental types—monarchy, oligarchy, and democracy—and in-stitutionalizing this harmonic structure in a constitution that would inspire other European nations for centuries. A republic governed by an order of self-designated nobles representing a minute percentage of the total population and ostensibly led by a doge normally of venerable age, Venice came to stand for the very idea of the state, the ideal abstraction concretely embodied and functioning on earth.[1]

Declaring its own immutability, it remained secure in its lagoon for-tress and in the righteousness of its institutions, the guaranteed and absolute rule of law that made Venice the paragon of justice in the eyes of

*Most august city of Venice, today the only abode of liberty, peace, and justice, the one refuge of the good and haven for those who, battered on all sides by the storms of tyranny and war, seek to live in tranquility: city rich in gold but richer in fame, mighty in resources but mightier in virtue, built on solid marble but based on the more solid foundations of civic concord, surrounded by salty waters but more secure through her saltier councils.

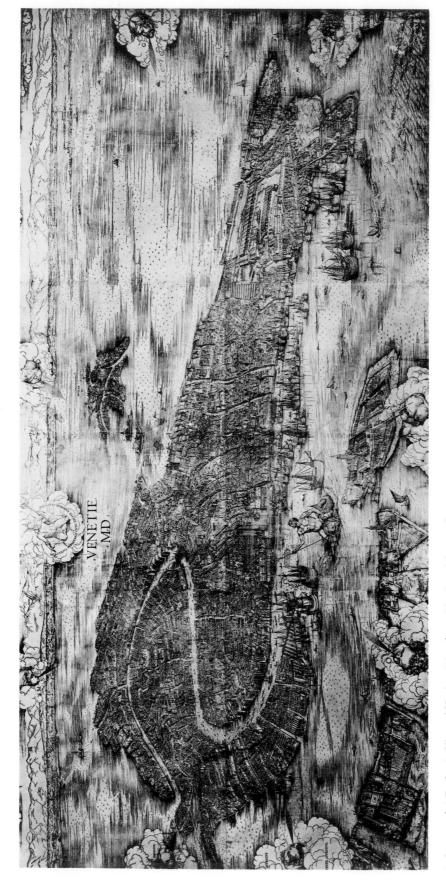

1. Jacopo de' Barbari, *View of Venice*. Woodcut. Venice, Museo Correr

the world—including Shakespeare's agonizing Antonio, the Venetian merchant who knows

> The duke cannot deny the course of law;
> For the commodity that strangers have
> With us in Venice, if it be denied,
> Will much impeach the justice of the state;
> Since that the trade and profit of the city
> Consisteth of all nations.

[*The Merchant of Venice,* III.iii]

The fundamental conservatism of Venice, the respect for the *ordene antiquo,* was a condition of its stability and longevity. It also serves to define an important dimension of the context of art in Venice, for painting, like all other activities, had to operate according to the wisdom of the laws that kept the complex organism of the state in balanced harmony. In the history of no other school of Renaissance or post-Renaissance painting does the concept of tradition carry such practical significance.

We can appreciate some of the distinctive quality of the Venetian situation by comparing it briefly with the more volatile historical patterns of late medieval and early Renaissance Florence—a city as proud of its republican heritage, yet apparently committed to subverting its own stability and civic identity by its willful and contentious individualism. Thanks to the influential writings of Giorgio Vasari, the history of art in Florence has become the great paradigm of modern art historiography: the grand scheme of progress (in painting) from Cimabue and Giotto through Masaccio to Leonardo and Michelangelo has served as the model for our vision of the artistic past. The corollary of this phenomenon—indeed, since Vasari—has been the difficulty of accommodating developments in Venice to the master plan, for the patterns of artistic production in Venice are different, as is the position of the artist.

The Florentine historical vision is in every way a heroic one: the history of art is propelled by the bold, innovative gestures of individuals, usually in public and historically self-conscious competition—as in that of 1401 for the new Baptistery doors, with Brunelleschi and Ghiberti the fateful finalists.[2] Both Florentine patrons and Florentine artists seemed to agree that, rough as it was, their intensely competitive world guaranteed to inspire the very best results, the highest performance. This goading challenge to perform was, according to Vasari, what Donatello so missed during his long sojourn in Padua and what led to his decision to return to Florence: praise came too easily in Padua and encouraged a laxity of application and inventive energy, whereas the sharp criticism to which one was continually exposed in Florence spurred the artist to further study and "consequently to greater glory."[3]

Most eloquent testimony to the different mentalities reigning in Venice and Florence is offered by the decorations of their respective council halls. When, during the last great flowering of their republic, the Florentines sought an appropriate model for such a monumental public room,

they turned naturally to the Sala del Maggior Consiglio (fig. 2) in the Ducal Palace (fig. 3), the political showpiece of the Venetian republic.[4] But the Florentine approach to such a state commission confirms those values of competition that had informed the earlier history of art in the Tuscan center, for the new Sala del Gran Consiglio of the Palazzo della Signoria would have been—had its intended decorations been realized—a tribute to the Florentine republic and, at the same time, to the genius of its greatest artists. Vasari's narration of the events, admittedly colored by native pride, remains revealing in its tone as well as detail. The Florentines, according to his account, desired of Leonardo da Vinci, their most renowned artist, a work that would be "notable and grand," one that by its "genius, grace, and good judgment" would reflect upon them both honor and ornament. Led by Piero Soderini, *gonfaloniere di giustizia,* the Florentines in 1503 offered the painter a wall of the recently completed room on which to create a monumental pictorial affirmation of their republic's greatness. While Leonardo was working on the *Battle of Anghiari,* Soderini, recognizing the extraordinary talent of another son of Florence, assigned another part of the room to the younger Michelangelo: the Sala del Gran Consiglio was thereby transformed into an arena of artistic competition between the two giants, with all Florence as audience and judge.[5] As it had a century earlier, with respect to the Baptistery doors, Florence again seemed to assume that competition would bring out the best in its artists.

The contrast with Venice could not be more indicative. Whereas the Florentine painters emerge as genuine protagonists in a patriotic drama (and may even have played some role in the selection of their subjects), their Venetian counterparts appear as faithful servants of the state. The pictorial iconography of the Ducal Palace was established by long tradition, its specific subjects determined by historical precedent and by the duly defined needs of political propaganda. Following Guariento's *Paradise* of 1365, which put Venice under the special protection of the Virgin, Queen of Heaven, the main theme of the decorative cycle in the Sala del Maggior Consiglio was the emergence of Venice as the third great power of Europe, along with the pope and the Holy Roman emperor. Dating from the twelfth century, the story of Doge Sebastiano Ziani's mediation between Pope Alexander III and Emperor Frederick Barbarossa served as the basis of the republic's subsequent political self-image, the foundation of the evolving myth of Venice.[6]

Once established on the walls of the Sala del Maggior Consiglio, by the early fifteenth century, this iconography was as immutable as Venice itself. The major problem facing the government became that of conservation. Ruined by the ecological conditions of the lagoon site, humid and saline, in which fresco could hardly set properly, and occasionally destroyed by fire (as in 1574 and 1577), the paintings in the Ducal Palace remained in a continuing state of repair or restoration. "Restoration," however, might mean total replacement; and yet the new paintings

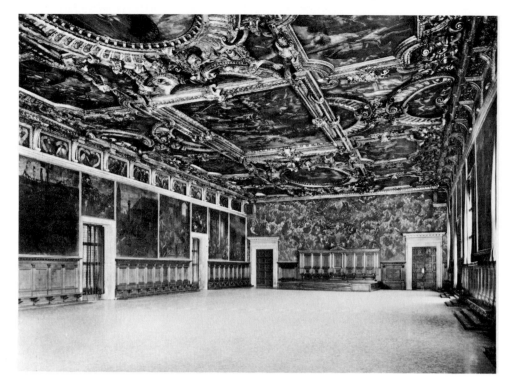

2. Venice, Ducal Palace. Sala del Maggior Consiglio

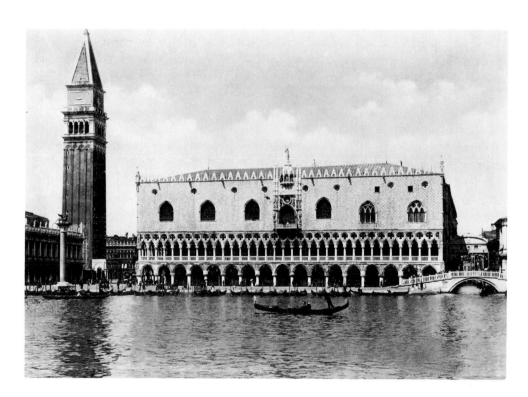

3. Venice, Ducal Palace

generally preserved not only the subjects of the old, which were sanctified by historical tradition and political necessity, but also frequently the larger characteristics of the lost composition. Pictorial style might change, but content and its compositional carrier could not.[7] Upon such decorative cycles depended the self-presentation of the *Serenissima*, and their maintenance as well as creation naturally remained serious concerns of the state.[8] When in the course of the sixteenth century new subjects were added, expanding the Ur-cycle of the events of 1177, committees of patricians, sometimes aided by special advisors, were charged with the grave responsibility of enlarging or renewing Venice's public image of itself. That a painter should have been allowed to contribute to the essential iconography is difficult to imagine—no matter how much initial thematic programs might come to be modified in the course of practical execution.[9]

As early as 1409 the frescoes initiated by Guariento and continued by other masters were already in poor condition; in that year and again in 1411 funds were voted for necessary repairs.[10] In 1422 an annual sum of 100 ducats was assigned to the general maintenance of the paintings, and, *pro honore nostri dominij et civitatis nostre*, a master painter was retained for the work.[11] Gentile Bellini assumed this position in 1474, and when, five years later, he was sent on diplomatic mission to the sultan, his brother Giovanni was appointed to replace him.[12] In fact, by the end of the fifteenth century the Bellini seem to have gained something like family control over the Sala del Maggior Consiglio.[13] But it was hardly possible in Venice to transform that room into a gallery dedicated to the work of a single artist or even to a single workshop. The idea of a "monument" to such individualism, particularly in the Ducal Palace, the seat of distributive justice, was anathema to the Venetian state— whether on the level of doges or of painters. For the sake of the internal stability of the republic, it was best to avoid such a monopoly by a single *bottega* and to assure a more equitable distribution of economic opportunity, especially state patronage. Thus, when in 1488 Alvise Vivarini complainingly petitioned the Signoria to be allowed to participate in the decoration of the Sala, "just as the two Bellini brothers are working at present," he was immediately awarded a commission.[14]

By 1494 nine painters are listed at work on the decorations of the Sala del Maggior Consiglio, seven masters, including Giovanni Bellini, and two assistants.[15] The nominal head of the group was Gentile Bellini, the painter officially charged with maintaining the murals; in return for this responsibility he had been granted a broker's patent (*sansaria*) at the Fondaco dei Tedeschi, which guaranteed a certain annual income.[16] The other painters drew a salary from the *Provveditori al Sal*. These officials, however, concerned over delays in the completion of the work, ordered the *protomaestro* Bartolommeo Bon, architect in charge of the Ducal Palace, to go to the Sala each day to take the roll and to dock the salary of any painter who was absent.[17]

Such, then, was the official respect for artistic genius in Venice. The painters in the Ducal Palace were considered merely employees of the state, and, if we may judge by the precautions taken by the *Provveditori al Sal*, not always completely reliable. Not in Venice could the glorification of the state be identified with the glory of the artist—at least not until Titian acquired his international fame. Rather, a sanctified legal structure, responsible governmental institutions, and a clearly defined sociopolitical hierarchy combined to assure stability and order, the predictability of routine, and the preservation of custom, and, in turn, to discourage potentially disruptive competition—and, perhaps the corollary of this conservatism, to discourage innovation as well.

The highly structured character of the Venetian experience extended beyond the immediate situations of state patronage, however, to comprehend and govern every aspect of the artist's professional life, from training to production, from his beginnings as *garzone* to his maturity as full *maestro*, from the functioning of his workshop to the organization of his representative guild. One of the aims of our studies will be to define, in fact, just how artistic exploration and invention proceeded within the apparently constraining context of such official conservatism, to observe artists of differing temperaments such as Titian, Veronese, and Tintoretto manipulating and representing the substance of this Venetian experience, transforming it into remarkable pictorial creations.

2. THE SOCIAL SITUATION OF THE ARTIST

One phenomenon that must strike any student of the history of Venetian art is the persistence of a peculiar institution, one too easily dismissed as a vestigial medievalism: the family workshop. If the history of Florentine art, especially as it has been codified for us by Vasari, is the story of creative individuals, the history of art in Venice must appear somewhat less heroic; it is rather an institutional history. Artistic production in Venice tended to be a more communal enterprise. With some conspicuous exceptions, like Giorgione, painters in Venice generally appear as members of families, working together in large workshops that often continued over generations. Indeed, this phenomenon is one of the most distinctive characteristics of the history of Venetian painting over the course of more than four centuries: the list of relevant names runs from Paolo da Venezia in the fourteenth century, through those of the Vivarini, Bellini, Vecellio, Robusti, Caliari, and Da Ponte in the fifteenth and sixteenth, to Tiepolo and Guardi in the final years of the republic and into the nineteenth century. [18]

The resulting problems of connoisseurship are obvious and continue to frustrate the art historian trying to distinguish the hand of Titian from that of Girolamo da Tiziano or Orazio Vecellio, or the hand of Paolo Veronese from that of his brother Benedetto or his son Carletto Caliari. [19] In a workshop all concerned cooperated in the production of paintings that were clearly marked by a characteristic style established by the master. A young apprentice learned by copying and then participating in

the work of the master; his own artistic personality had first to submit to that of the master and then, if it was itself strong enough, it might slowly begin to assert its own independent character. This pattern, of course, applies to workshop training and production in general throughout the later Middle Ages and Renaissance; it is hardly exclusive to Venice. What is typically Venetian, however, is the longevity of the family dimension, which is itself both a product and a function of the traditions of institutional conservatism in Venice.

Poeta nascitur, non fit: that ancient aphorism epitomized a theme frequently voiced in the artistic literature of the Renaissance, which declared that the artist (at least one worthy of the name) is born as such, that talent or genius is, as we would say, genetic.[20] Still, however much the traditions of the family workshop may have depended upon or even reinforced such genetic transmission of talent, the institution itself was founded upon a very different notion: namely, that an art like painting is essentially a craft, the practical knowledge of which can be taught to anyone with a minimum of aptitude. It was natural for a father to pass on to his son not only the basic knowledge of his own *mestiere* but, if possible, the practical means of production as well, that is, the *bottega* with all its working material. And we must bear in mind the kind of capital investment that a fully equipped workshop represented and the degree to which it comprised the accumulated experience and wisdom of the trade. The very practical function of drawings, for example—as records of inventions and useful motifs, solutions to standard compositional problems that could continue to serve as the basis for the production of new works—explains their prominence in the testaments of artists, as the precious and most useful parts of their legacy to their professional heirs. In this way we well understand the special value of Jacopo Bellini's albums of drawings, handed down by his widow in 1471 to Gentile, and at his death in 1507 passing to Giovanni.[21] It is indeed in the testaments of artists that we can often follow the mechanics, so to speak, of the continuity of the workshop tradition.

Another, later example offers perhaps the most impressive documentation of the strength and momentum of that tradition. The Tintoretto workshop lasted over three generations: founded by Jacopo, the son of a dyer, it was inherited by his sons Domenico and Marco, who, in turn, were succeeded by their apprentice and brother-in-law, the German-born Sebastian Casser. The situation is explicitly, and rather poignantly, described by the great master's daughter, Ottavia Robusti, in her final testament of 1645:

> I find myself bound in matrimony to Misier Sebastian Casser, . . . painter of the family establishment, and this by order and command of my brothers Domenico and Marco, who, before they died, made me promise that if the said Sebastian proved to be an able painter I should take him for my husband; in this way, by virtue of his talent, the Tintoretto name would be maintained.[22]

Sebastian did eventually prove himself as a painter, especially in portraiture, and, after some hesitation, Ottavia married him. Whatever may have been her personal sacrifice, she was clearly constrained not only by her brothers but by Venetian tradition as well to think first of the professional continuity of the *casa*, of the name of Tintoretto.

Such continuity may appear quite natural, even inevitable in the context of Venetian history, but underlying the phenomenon of the family workshop, helping to explain as well as to sustain it, is another institution, the *Arte dei Depentori*, the Venetian painters' guild. By his membership in the guild the Venetian painter found his officially sanctioned place in the great socioeconomic hierarchy of Venice. The *capitolari*, or statutes (*mariegola* is the Venetian term), of the *Arte dei Depentori* date from 1271, making it probably the oldest painters' guild in Italy.[23] It differed from the others, however, especially in its particular relationship to the state. Unlike the guilds in many other communes—the case of Florence being perhaps the best known—those in Venice never exercised actual power of government; nor could they participate in a government that was, we must remember, exclusively patrician.[24] Rather, as in the Byzantine world, they were under the direct control of the state, to which they owed the privileges and powers they enjoyed in their respective fields.[25] A special office of the Venetian government, the *Giustizia Vecchia*, was established in 1173; its three magistrates were charged with supervising the activities of the *arti*.[26] The *capitolari* of the guilds, while covering the regulation of the particular trades, represented in fact an extension of the laws of the republic in that the statutes opened with certain standard articles declaring the duties of the members to the state. In affirming the *capitolari* of his guild, each master swore allegiance to the state.[27] In this light we can more fully appreciate the wording of Gentile Bellini's appointment as official painter in the Ducal Palace, the senate's nomination of "maistro Zintil venetian nostro fedelissimo."

Through the system of guilds and confraternities the patrician Venetian state could directly organize and control various segments of its disenfranchised population. Through his guild the artisan or tradesman found his place in the structure of Venetian society, the arena in which he could exercise public responsibility and earn honor according to his estate; and through his guild he paid his own obligations to the republic, since each guild owed the government certain taxes and services, in return, as it were, for the guarantee of its privileges.[28] In moments of crisis the state could make special financial claims upon the guilds as well as conscript members for military service. Thus, on 15 June 1310, the masters of the *Arte dei Depentori* joined the brothers of the Scuola Grande di Santa Maria della Carità to fight for the doge, Pietro Gradenigo, against the rebellious forces of Bajamonte Tiepolo.[29] Such loyalty in effect confirmed the state's guarantee of the privileges and prerogatives enjoyed by the guild.

The statutes of the Venetian *Arte dei Depentori*, like the regulations of

guilds elsewhere, also established the pattern and practice of an artist's career: from apprenticeship as *garzone* to inscription as *maestro dell'arte,* with the right to open a shop, employ assistants, and make and sell art objects. The guild maintained professional standards and controlled, as an extension of the state, the working conditions and schedules of the shops; it saw to the religious and moral life of its members as well as to their economic and social needs. It assured a broad distribution of available work by limiting the number of apprentices and assistants permitted the head of each shop.[30] The number of novices entering the trade was also limited, varying with circumstances—such restrictions being suspended, for example, for a period of three years following a major plague to allow the replenishing of the crafts in Venice.[31]

Central to the protective function of the guilds was the principle of *arte chiusa;* this early model of the modern union shop, which forbade anyone not inscribed in the guild to practice his art, to make or sell articles in Venice, was the primary means of protecting Venetian artisans against foreign competition. The 1436 revision of the *mariegola* of the *Arte dei Depentori* forcefully reinvoked this law—but, as so often in the history of Venetian legislation, the periodic reaffirmation of a regulation seems evidence of the frequency of transgression.[32] Although the archival history of the Venetian painters' guild has been only partially preserved for the Renaissance period, we can nonetheless reconstruct one particular case involving a rather famous *forestiero.* During his second trip to Venice Albrecht Dürer described his tribulations with the local artistic community, whose members, he observed, did not hesitate to steal his inventions even as they criticized his work and forced him to pay the price of a foreigner trying to practice his art in the city of St. Mark. "The painters here, let me tell you, are very unfriendly to me," Dürer complains to Pirckheimer in a letter of 2 April 1506. "They have summoned me three times before the magistrates [sc. the *Giustizieri Vecchi*] and I have had to pay four florins to their school."[33]

Within the larger contexts of Venetian society and history the position and function of the *Arte dei Depentori* assume their special relevance, defining mechanisms of artistic production, commerce, and tradition. Perhaps still more revealing, however, are the internal organization and operations of the guild. They cast a fascinating light upon the somewhat ambivalent status and self-image of the Venetian artist, especially within the developing cultural assumptions of the Renaissance.

The painters of Venice, like those elsewhere, were organized with other craftsmen. In the sixteenth century the masters of the *Arte dei Depentori* were listed under eight headings: figure painters, gilders, textile designers and embroiderers, leatherworkers, makers of playing cards, mask makers, sign painters, and illuminators.[34] The guild thus comprised *depentori* of the most varied kinds; from at least the early sixteenth century those in the first column, the painters who are our concern, were distinguished by the designation of *figurer.*[35] When in

1573 Paolo Veronese was called before the Inquisition, he identified himself and his work in strict accord with the legal distinctions of the *arte:* "Io depingo et fazzo delle figure"—that is, I am a painter inscribed in the first column of the guild.[36]

Purely a descriptive label, the denomination *figurer* conferred no special status or privilege on our painters; within the organization of the guild they were merely one among several specialties, and the *mariegola* guaranteed an equitable distribution of authority and responsibility among the several *colonelli*. And yet, given the rising social and intellectual aspirations of Renaissance artists in general, it seems almost inevitable that the artisan democracy of the *arte* should have been subject to internal tension, that Venetian figure painters should have sought to assert their supremacy in some way over the other *depentori*. That the challenge should have been sounded by Cima da Conegliano may surprise us, but in 1511 this brilliant conservative painter evidently attempted to weight the membership of the *banca*, the governing board of the guild, upsetting its representational balance by having two *depentori de figure*. Objections were obviously raised by *compagni* of the other columns, and Cima was reprimanded by the *Giustizieri Vecchi*. In a predictably Venetian response, the magistrates sternly upheld *el modo et ordene antiquo*—always the key to the unruffled stability of the *Serenissima*.[37]

Although unsuccessful, Cima's move attests to a certain disaffection within the ranks of the *Arte dei Depentori*. The "new" Renaissance ideals of art and of the artist, born in Florence a century earlier, had indeed taken hold even in Venice. By 1435 they had been clearly and pointedly articulated in Leon Battista Alberti's book *Della pittura:* painting had been defined as a liberal not a mechanical art, and the painter recognized as no mere artisan working with his hands but rather a man of intellectual and social standing, "uomo buono e dotto in buone lettere."[38] Such ideals may well have inspired the Venetian *figureri,* but of what relevance were they to a *coffaner, cortiner, dorador,* or the other *depentori* of the *arte?* Legally joined with such mechanicals, the painters of Venice were inevitably frustrated in their aspiration to be recognized as modern artists.

Indeed, until the end of the seventeenth century the figure painters of Venice would remain *compagni* of the other *depentori*. And, although the records are disappointingly incomplete, it is clear that even the most famous masters of the cinquecento fulfilled their obligations to the guild and served as officers in various capacities. Apparently the only exception was Giovanni Bellini, who, as official painter in charge of the Ducal Palace decorations, was exempted in 1483 from all responsibilities to the guild.[39] His successors in that position, however, seem not to have enjoyed such an extraordinary privilege—not even Titian, who was an active member of the guild at least until 1531. In that year he was elected along with Lorenzo Lotto and Bonifazio de' Pitati to the *Comessaria di Vincenzo Catena,* a board of twelve executors charged with the distribu-

tion of a charitable fund left to the *Arte dei Depentori* by Catena.[40]

Catena's testament specifically documents the guild's function as a confraternity concerned with the social well-being of its brothers and their families. A sum of 200 ducats was left by this master, half of which was to be distributed to needy members of the guild; the other 100 ducats were to be used to marry the daughters of five poor brothers by supplying them with dowries of 20 ducats each. Such acts of charity—especially the establishment of dowries—were frequent and normal within the larger social structure, and the various *scuole* served to organize and channel distribution.[41] That Catena himself was fully aware of the example of the other confraternities is clear from another item in his will. After having taken care of his own family, he stipulates that the remainder of his legacy should go to the guild, to be used to acquire real estate so that the painters might have a proper meetinghouse. And it was indeed thanks to Catena's generosity and professional concern that the *Arte dei Depentori* was able to establish its own center near Santa Sofia in 1532.[42]

A still more interesting commentary on the social world of the Venetian painters is offered by the rather unusual testament of Lorenzo Lotto, one of the trustees of the Catena bequest. The seventh article of the will Lotto had drawn up in 1546 asked the guild to select his heirs and, in effect, to see to the continuity of his workshop. He asked his colleagues to find two worthy young painters who would know how to benefit from the professional materials he was leaving behind; he then asked that two girls be chosen from the hospital of SS. Giovanni e Paolo—"of quiet nature, healthy in mind and body, capable of running a household" —and that these be dowered and married to the two forementioned painters. By this idiosyncratic complicated extension of normal charitable practice, the very idiosyncratic Lotto intended to set up two young artists in their careers and, by extending his benefaction to two poor girls, he would have seen also to their domestic comfort and well-being.[43] However unusual the particulars of the case, they nonetheless reflect the values of the world we have been exploring, the communal world of the *depentori* with its network of economic concerns and social responsibilities.

We may gain some idea of the larger dimensions of that world and of the tensions inherent in it by returning to another of the *comessari* of the Catena fund, Titian himself. A specific measure of the socioeconomic distance separating the poles of the Venetian painters' world is afforded by a comparison of the dowry provided each of the five *donzelle* by Catena's will (20 ducats) with that accompanying Titian's daughter in marriage in 1555 (1,400 ducats).[44] The distance had already opened to an unbridgeable gap within a year of Titian's service on the *Comessaria di Vincenzo Catena:* in 1532 the Holy Roman Emperor Charles V appointed Titian court painter and ennobled him as Count Palatine and Knight of the Golden Spur.[45] Whether or not the "New Apelles"[46] continued to associate in any official capacity with his *compagni* in the *Arte dei Depentori*

we really do not know, but the example of his extraordinary international success hardly encouraged the other *figureri* to remain content with the position assigned them in the legally determined hierarchy of the Venetian system.

If the case of Titian cannot be taken as typical in any sense, the triumphal events of his career are indeed revealing of the more general situation. In his earliest documentary appearance, in 1511—in connection with the frescoes in the Scuola del Santo in Padua—the young artist signed himself "Tician depentor," that is, *maestro* in the *Arte dei Depentori*.[47] Two years later, however, in his petition to the Signoria, he was sounding a new note. He declared that from childhood on he had dedicated himself to learning the art of painting "not so much out of desire for profit as to seek the acquisition of some small fame. . . ." The words seem almost a paraphrase of Alberti. Continuing, then, to offer his services to the state, as had Alvise Vivarini in 1488, Titian expressed his desire, "as a most faithful subject" of Venice, "to leave behind some record [of my work] in this glorious city." He volunteered to apply all his talent to the execution in the Sala del Maggior Consiglio of "that battle picture on the wall toward the piazzetta," a task evidently so challenging that "so far no one has been willing to undertake it."[48] In his petition, so arrogant in tone, the young painter boldly announced his presence on the Venetian scene. We are even tempted to imagine that, having heard about the famous competition between Leonardo and Michelangelo in the *sala grande* of the Palazzo della Signoria, Titian had indeed learned from the Florentine example.

And the brash tactics worked: Titian got the job (fig. 4)—despite some momentary setbacks inspired, it would seem, by doubts about this assault upon *el modo et ordene antiquo*—as well as the promise of the next *sansaria* at the Fondaco dei Tedeschi.[49] The trajectory of Titian's public career, moving from appointment as Giovanni Bellini's successor in the Ducal Palace to appointment as imperial court painter and knighthood, can also be gauged in another, rather more semantic way. In the earliest documents—for example, the receipts of 1511 for the Paduan frescoes or those of 1519–26 for the *Madonna di Ca' Pesaro*[50]—the artist generally signs himself "Ticiano depentore." Later, his international reputation fully established and publicly celebrated by supporting rhetoric, he signs himself in his letters to various courts of Italy and Europe "Titiano Vecellio pittore."[51] The distinction between the two denominations, *depentore* and *pittore*, is a revealing one.

In 1679, moving finally to separate themselves from the *Arte dei Depentori*, the *figureri* complained in their petition to the senate of being united "with other mechanical arts of the city, with whom most of the figure painters refuse to associate." Objecting to being held *confratelli* with gilders, textile designers, leatherworkers, house painters, and so on, they asked permission to dissociate themselves from such a low and motley union and to establish a new representative organization, "sotto

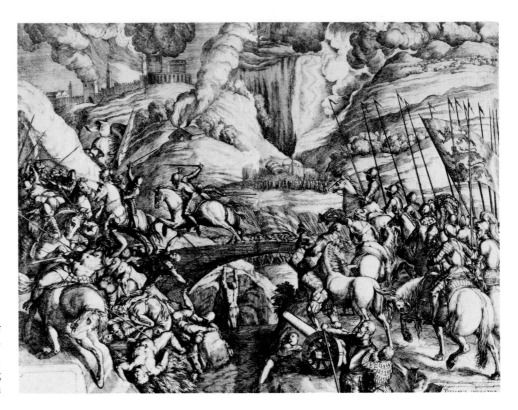

4. After Titian, *Battle of Spoleto*. Engraving by Giulio Fontana. Vienna, Graphische Sammlung Albertina

il nome di accademia dei pittori.''[52] Their plea was heard with some sympathy, and in 1682 a *Collegio dei Pittori* came into existence by senatorial decree. The *mariegola* of the new institution, proudly recording "the separation of the *Pittori* from the *Depentori*," welcomes its foundation as a recognition of painting as a liberal art, "separate and distinct from the mechanical arts."[53] Painters no longer had to bear that stigmatizing title; henceforth they were to be *pittori*.

But they were not yet to be academicians; the senate had decreed a *Collegio*, not an *Accademia dei Pittori* as requested. The new institution was in fact merely another guild, still under the jurisdiction of the *Giustizia Vecchia*, and its *capitolari* were essentially identical to those of the *Arte dei Depentori*.[54] The foundations of Venetian stability, the institutional structuring of Venetian society, its organization and control through a representational system involving *scuole* and *arti*, in sum, *el modo et ordene antiquo* —all this was not to be upset so readily by the vanity of socially ambitious painters.[55]

A Venetian *Accademia di Pittura e Scultura* was not established until 1754.[56] Only after nearly every major city in Italy and most in Europe boasted an academy of fine arts did Venice move to keep up with the times, and nearly two centuries after the creation of the first such academy in Florence.[57]

The foundation in 1563 of the Florentine *Accademia delle Arti del Disegno*, the inspiration of Giorgio Vasari, represented the institutional realization of those values and ideals first formulated in early quattrocento Florence. The new artist of the emerging Renaissance sought to acquire fame rather than wealth by his work and claimed his art to be liberal rather than mechanical, intellectual rather than material. He felt increasingly out of place within the traditional medieval guild system, which united him with an assortment of artisans and merchants. Contact with humanists and especially the model of Ficino's Platonic academy helped to articulate the new organizational goal of the artists' intellectual and social aspirations: an academy of art.

The academy conceived by Vasari brought together "i più eccellenti pittori, scultori ed architettori" under the special protection of the grand duke, Cosimo de' Medici.[58] Assembling the various arts within a single organization was one of Vasari's most significant contributions to the struggle against the old guild system, for the arts—the "fine arts"—were no longer divided by their material differences but were now united by their common intellectual bond: *disegno* —"padre delle tre arti nostre Architettura, Scultura e Pittura."[59] That concept, central to Vasari's whole aesthetic, provided the principle for unifying and elevating the visual arts and for liberating the artist; by ducal decree, in 1571 Florentine academicians were officially exempted from their various guild obligations.[60]

But in seeking a basic unity among the arts Vasari was able to draw as well upon local practical tradition. Florentine artists from Giotto to Michelangelo had moved with relative ease among the visual arts, working at times in painting, in sculpture, and in architecture. Such creative adaptability was, in effect, illegal in Venice, for it would have involved a violation of the protected precincts of the different *arti*. Venetian masters were exclusively painters, *depentori*, and rarely practiced sculpture or architecture, although they may have occasionally contributed designs for projects such as altars or reliquaries.[61] In Venice we find nothing to compare with the multiple activities of a workshop like Verrocchio's in Florence. In fact, we find instead the *depentori* and the *intaiadori*, the carvers, squabbling before the *Giustizieri Vecchi* over who may actually carve the frames and model the relief of an *ancona* and who may paint or gild them.[62] Considering the practical barriers maintained by the guild system, it was thus neither relevant nor appropriate in Venice to seek a union of the three *arti del disegno*.

The separation of painting from architecture in Venetian practice could only prove an obstacle to its recognition as a liberal art. Architecture, with a foundation in mathematics and classical textual pedigree provided by Vitruvius, had prepared the way for the emancipation of painting in quattrocento Florence. Alberti had clearly and deliberately grounded the art of painting in geometry, the basis of the modern system of pictorial perspective.[63] And the values of commensurability, of precise

3. VENETIAN AESTHETIC AND THE *DISEGNO-COLORITO* CONTROVERSY

definition, that were so crucial to the new perspective would continue to find expression, however modified, in the cinquecento in the notion of *disegno*—especially as it was articulated by Vasari.

In the pages of his *Vite* Vasari firmly established the practical and theoretical importance of drawing, defined as the progenitor and foundation of the three arts of painting, sculpture, and architecture. On the broadest historical scale, *disegno* provides the measure of progress in the arts from their rebirth with Giotto to the overwhelming teleological achievement of Michelangelo.[64] More specifically, drawing is viewed as the key to the entire imaginative process, the medium of the painter's very thought as well as of its concrete expression. From the initial conception of the idea through its formal statement in sketches to its final execution in a finished cartoon, the entire creative procedure is defined by Vasari essentially in terms of *disegno*.[65] Behind this aesthetic, and providing its experiential base, lies the great tradition of Tuscan fresco painting, which, from the middle of the fifteenth century, had developed the cartoon as a means of dissociating the preparation and execution of mural compositions.[66] Vasari, in effect, was codifying practice and lending it the rhetorical support of theory; but he was also articulating aesthetic values shared by his contemporaries and predecessors in Florence and Rome.

According to this aesthetic, at least in its more dogmatic formulations, the quality of its drawing provides the critical measure of a painting, and the significant criteria of formal judgment for a critic like Vasari are basically graphic and plastic values: line and shading, form and proportion. The painter's primary problem is the representation of the human figure in contour and modeling, and to that task color can contribute only superficially to the basic design. Indeed, Vasari defines painting— somewhat reductively, perhaps—as "a plane the surface of which is covered by fields of colors . . . , which by virtue of a good drawing [or, design: *buon disegno*] of circumscribed lines define the figure."[67] Venetian painting of the cinquecento obviously failed to conform to such critical presuppositions, and Vasari was constantly frustrated in his attempts to deal with the alternative of Venice's painterly aesthetic.

The development of Venetian painting in the cinquecento was predicated on and represents the convergence of two specific technical factors: the oil medium and the canvas support.

We have already noted the deterioration of the original frescoes in the Ducal Palace, which necessitated restoration by 1409 and which led eventually to the official appointment of a master painter-conservator. At the core of the problem was the Venetian climate, the humidity and salinity of the lagoon setting; in that ambience it was difficult for plaster to set properly, and colors therefore adhered poorly to the walls.[68] As successive efforts at restoration evidently failed, an alternative solution was adopted: the great celebratory cycle in the Sala del Maggior Consiglio, begun by Guariento and worked on by masters such as Gentile da Fabriano and Pisanello, was, from 1474 on, gradually replaced by a series

of paintings on canvas.[69] And this became the favored support in Venetian painting, in the other rooms of the palace and in pictorial cycles of the various *scuole.* In noting the usefulness of canvas for large-scale decorative projects, Vasari quite naturally cites as his prime example the Ducal Palace in Venice.[70]

The use of the canvas support became a necessary premise for the Venetian transformation of the traditional oil medium, for the establishment, in fact, of an entirely new kind of painting. Developed earlier in the Netherlands, the oil medium assumed a special importance in Venice in the last quarter of the fifteenth century. Whether or not Antonello da Messina actually first introduced Flemish technique to Venice in 1475, from about that date both he and Giovanni Bellini were exploiting its possibilities.[71] The light that is so impressively suffused throughout Bellini's compositions—whether in the Byzantine glow of sacred architecture (pl.1, fig. 19) or in the symbolically weighted illumination that transposes his natural landscapes to a spiritual key (fig. 5)—depends upon the exploitation of this medium. Applying colors in glazes, darker tones over a lighter ground, the painter was able to create a light that seemingly emanates from the very depths of the picture itself; light could assume an existence independent of the objects illuminated. "With these

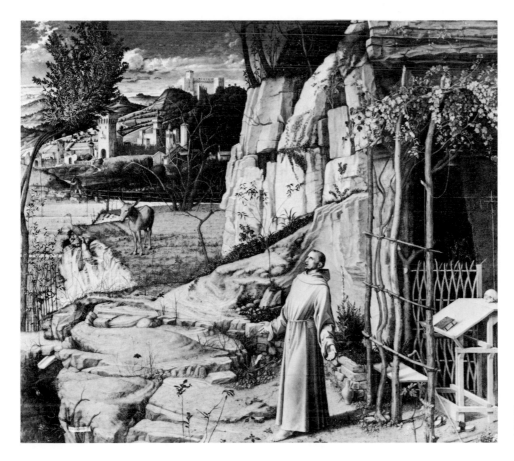

5. Giovanni Bellini, *St. Francis in Ecstasy.* New York, The Frick Collection

techniques," as Millard Meiss has written, ". . . the diffusion of light could become a major pictorial theme."[72]

By the opening years of the sixteenth century, however, new alternatives to this technique of panel painting had become available as the canvas support came increasingly to substitute not only for fresco in mural decoration but also for panel in the newly developing category of cabinet pictures for private patrons. Led by Giorgione (fig. 6), a younger generation opened a new range of expressive possibilities through the exploration of different aspects of the oil medium itself, especially its fatty substance, and the more deliberate exploitation of the rough texture of the canvas surface.

Developing the potential opacity, rather than the transparency, of the medium, the new technique involved a reversal of priorities and sequence in execution. Instead of constructing layers of transparent pigment, the effect of which depended ultimately upon the white gesso ground, the new practice worked up from a dark base. The canvas was prepared with a brown ground, a middle tone over which lights and darks were applied; and light now meant opaque white, which became the thickest part of the painting (fig. 7). Transparent glazes, no longer an element of the essential structure of the painting, were reserved for final modifications of hue and tone.

What truly distinguishes Giorgione's tonalism from that of predecessors like Giovanni Bellini—or, beyond Venice, Leonardo da Vinci[73]—is his development of the actual texture of paint, the physical substance of

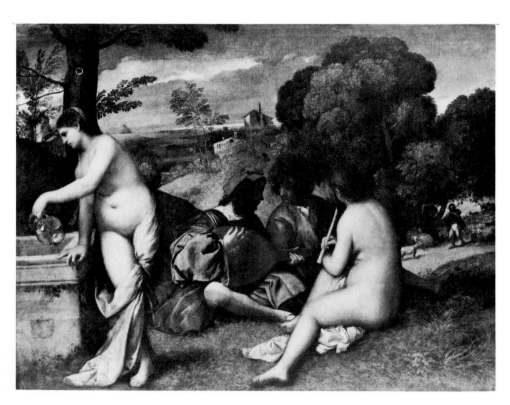

6. Giorgione, *Concert Champêtre*. Paris, Musée du Louvre

the medium articulated in its reciprocal relation to the canvas ground. In Giorgione's pictures figures and objects not only emerge from surrounding shadow, sharing a common and palpable atmosphere, they also begin to share a communality of fabric, a surface of increasingly independent touches and open brushwork. Paint stroked over the woven support left a broken, interrupted mark, lending a new vibrancy to the surface itself.[74] Already in the final years of the fifteenth century, Carpaccio had thinned the gesso priming applied to the canvas, thereby revealing more of the texture of the cloth (fig. 8); and in the cinquecento the use of a heavy, coarse canvas of twilled or herringbone pattern would become common in Venice.[75]

Furthermore, as Vasari himself has recorded for us (and as modern X-rays have confirmed), Giorgione worked directly on the canvas, brushing in his forms without preliminary drawings; he is said (by Vasari) to have maintained that "painting only with the colors themselves, without any preparatory studies drawn on paper, was the true

7. Giorgione, *Concert Champêtre* (detail)

8. Vittore Carpaccio, *Reception of the English Ambassadors* (detail). Venice, Gallerie dell'Accademia

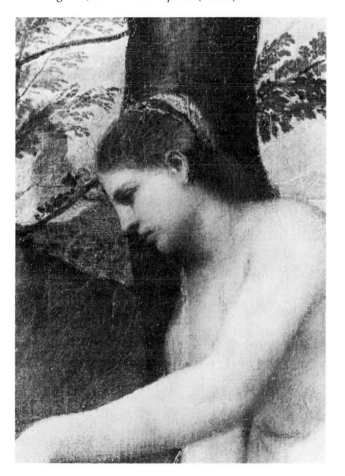

and best way of working and *il vero disegno*."[76] Giorgione's reputation had forced Vasari to acknowledge him among the founders of the modern era, right after—but still at some distance from—Leonardo.[77] But the Venetian painter's revolution, no matter how appreciated historically, could only appear to the Tuscan biographer as founded on a fundamental error, and his paraphrase of Giorgione's tenet regarding "il vero disegno" serves to launch his own critical counterattack, allowing him to reiterate the basic truth according to his own aesthetic gospel. Drawing on paper, he declared, is not only essential for the proper preparation of paintings, it is also an exercise by which the artist develops new ideas; drawing fixes in his mind all the forms of nature so that he does not always have to depend on having the model before his eyes or—and here Vasari returns to the object of his sermon—"to hide under the alluring beauty of colors his inability to draw, as the Venetian painters have done for many years." He cites Giorgione, Palma Vecchio, Pordenone, "and others who never saw Rome or other works of the highest perfection."[78]

Disegno, then, becomes the central issue in the great aesthetic debate of the cinquecento, which would establish a basic tenet of international academic doctrine for the next two centuries at least: namely, that the Venetian artists of the Renaissance were pure painters, working solely with color, and had in fact neglected the art of drawing; the corollary of this proposition was that drawing had been practiced and perfected by central Italian artists. Students were advised to look to Venice for their coloring and to Rome and Florence for drawing. The doctrine is summarized in the eleventh discourse of Sir Joshua Reynolds:

> The Venetian and Flemish schools, which owe much of their fame to colouring, have enriched the cabinets of the collectors of drawings with very few examples. Those of Titian, Paul Veronese, Tintoret, and the Bassans, are in general slight and underdetermined. Their sketches on paper are as rude as their pictures are excellent in regard to harmony of colouring.[79]

Vasari, however, despite his polemical stance, was a fine enough critic to recognize the very positive achievement of Venetian painting, at least in the art of Titian—although even his description of Giorgione's contribution reveals a definite appreciation of its extraordinary novelty. Vasari saw that the full potential of this manner of painting directly on the canvas was most eloquently realized in the late style of Titian, and to that *pittura di macchia* he responded with genuine sympathy. He described with great sensitivity that manner in which colors are applied in broken marks and large patches, leaving a rough surface of crude paint:

> It is quite true that his method in these later works is rather different from that of his youth: his early paintings are executed with a certain fineness and incredible diligence and can be viewed both from close up and from afar; these recent works, on the other hand, are dashed off in bold strokes, broadly applied in great patches in such a manner that they cannot be looked at closely but from a distance appear perfect. And this method has been the reason that many, wishing to imitate Titian and so demonstrate their own ability, have

produced only clumsy pictures. This happens because they think that such paintings are done without effort, but such is not the case and they delude themselves; for Titian's pictures are often repainted, gone over and retouched repeatedly, so that the work involved is evident. Carried out in this way, the method is judicious, beautiful, and magnificent, because the pictures seem to come alive and are executed with great skill, hiding the effort that went into them.[80]

Notwithstanding his own conception of *buon disegno* and its theoretical and practical importance, Vasari succumbed to the mimetic power of a technique that, according to one witness, used "brushes as big as a broom" for the blocking in of figures or the artist's fingers for final touches.[81] In such a process clearly there is no place for careful consideration of contours, whose linear precision would only be subverted by the texture of the fabric or by the disintegrating effect of assertive brushwork (fig. 9).[82]

A Venetian painting could be constructed right on the canvas, the ideas developed and modified during the actual painting process. In the new technique of painting in oils, paint was applied not in delicate glazes but opaque, and its thick substance could be scraped off or painted over with no difficulty. The Venetian masters, beginning with Giorgione and particularly Titian, were constantly altering and adjusting their compositions in the course of executing them; the changes might affect details only or an entire design.[83] Both style and technique rendered the cartoon, that grand monument of central Italian *disegno*,[84] irrelevant to painting in Venice and called into question the very necessity of the systematic graphic preparation of a painted composition. To Vasari and other critics of central Italian persuasion the whole Venetian procedure must have seemed arbitrary, irresponsible, and, in the case of Tintoretto, an absolute affront to art. If Titian alone among the Venetians, in part because of his international stature, stood beyond the reach of such carping, Tintoretto generally drew the heaviest fire from non-Venetian critics; his free and active manner frustrated and, in their estimate, even mocked accepted distinctions between *finito* and *abbozzato* in painting (fig. 10).[85]

Failing to inform their compositions with a firm and controlled structure based on the solid principles of *disegno*, the Venetians seemed to have divorced painting from drawing, treating them as two separate and technically unrelated creative acts. The casual reading of Vasari can indeed lead to the once common assumption that the Venetian painters drew rarely and that when they did their graphic efforts bore little relation to the production of paintings.[86] Drawing in Venice has frequently been viewed as a supposedly autonomous activity, and the spontaneity of Venetian drawings has been ascribed to their lack of function.[87] However, as the Tietzes insisted, an approach to this material is needed that not only allows a function to drawing in Venice but recognizes the primary consideration of that function: the organic role of

9. Titian, *Pietà* (detail). Venice, Gallerie dell'Accademia

10. Jacopo Tintoretto, *Carrying of the Body of St. Mark* (detail). Venice, Gallerie dell'Accademia

drawing in the creation of paintings and its relation to patterns of workshop production.[88]

The style of Venetian draftsmanship—"in general slight and underdetermined," in Reynolds's characterization—can be comprehended only in the context of the practices and techniques of Venetian painting. That style, with its open calligraphy, was in fact a graphic equivalent to the *pittura di macchia.* The pen stroke or chalk mark is suggestive rather than definitive; the general preference for black chalk and charcoal is analogous to the use of oil and canvas, and these friable graphic media offer similar pictorial possibilities in the dissolution of form.[89] The general contrast with the closed contours of central Italian drawing is evident, whether one compares the drawings of Carpaccio and Botticelli or those of Titian (fig. 11) and Michelangelo (fig. 12). This stylistic distinction between the two schools naturally further reflects the different approaches to painting, the differing roles of drawing in the preparation of a fresco and an oil painting, of a painting on a smooth plaster or gesso ground and one on the coarser texture of canvas. The physical dependence of painting on drawing, as epitomized in the nature and function

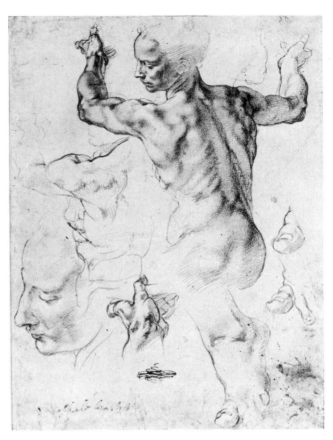

11. Titian, *Study for the Archangel Gabriel.*
Florence, Gabinetto Disegni e Stampe degli
Uffizi

12. Michelangelo, *Studies for the Libyan Sibyl.* New York,
Metropolitan Museum of Art

of the cartoon, was an important determinant of graphic style in Florence
and Rome. In Venice drawing remained ancillary to painting, a constant
aid rather than an absolute guide.

Without *disegno* and deprived of the benefits of Roman culture in
general, the Venetian painters could never hope to attain perfection in
their art, since, according to Vasari, they lacked the means of freeing
themselves from slavish dependence on nature and were forced to con-
ceal under the superficial charm of coloring their ineptitude at drawing.
Not even Titian, "il più bello e maggiore imitatore della natura nelle cose
de' colori," could fully overcome the handicaps of Venetian training.[90]
Without *disegno* he could never raise his art above the mere reproduction
of natural appearances to imitation in a higher, Aristotelian sense, en-
nobling nature by representing its ideal aspects, by imposing style upon
its raw material.[91]

The way to the attainment of such a *maniera* was clearly indicated by
Vasari and others: beyond the study of nature and the works of the best
modern masters, the young artist should copy the sculpture of the
ancients, in which a selection of the purest elements of nature had

already been made.[92] By drawing from classical statuary and reliefs, the artist concentrated on the ideal. This program was identical to the one prescribed for the mastery of *disegno,* and in this context the latter concept, signifying much more than drawing in a strictly technical sense, assumed the most far-reaching aesthetic implications in later Renaissance art theory. *Disegno* was the key to the mastery of composition, of proportion and anatomy, the very foundations of Renaissance painting.[93] The Venetians' evident failure to recognize this was, for their critics, an aesthetic heresy tantamount to lack of faith.[94]

Venetian partisans naturally contributed their share to this aesthetic debate. In their writings the central Italian values are understandably reversed, color taking precedence over line. But the Venetian apologists never developed a rational or systematic theory of art comparable to the grand aesthetic statement of Vasari. *Colorito,* unlike *disegno,* did not provide a conceptual base for theoretical elaboration. "The things pertaining to coloring are infinite," wrote Paolo Pino in 1548, indicating the dilemma, "and it is impossible to explain them with words."[95] The most effective critical language in Venice was not objectively analytical but rather looser, poetic and evocative, a literary correlative to the style of Venetian painting. One thinks above all of Pietro Aretino's prose and especially of the famous *ekphrasis* in which he describes a natural scene, a view of the Grand Canal, in purely painterly terms, deriving his vocabulary as well as his vision from Titian's palette.[96]

Other Venetian critics did, however, attempt an intellectually more orthodox presentation, beginning with the standard tripartite division of painting into drawing, color, and composition.[97] But if Vasari stressed the reigning superiority of *disegno* over the other two categories, the Venetians tended to regard it rather as one, limited aspect of a larger pictorial experience. They dwelt upon the incompleteness of drawing as a mimetic medium and defined *disegno* in such a way that it became merely a subheading of color.[98] The conservative Pino, for example, argues that since color and shading are indispensable to pictorial imitation of nature and since any preliminary design must necessarily be covered over with colors, a carefully delineated drawing is hardly necessary.[99]

Lodovico Dolce's *Dialogo della pittura* of 1557, a response to the first edition of Vasari's *Vite* and an apologia for Titian, is more sophisticated than Pino's dialogue.[100] Following the traditional trinitarian definition of painting (*invenzione, disegno, colorito*), Dolce too cites the mimetic obligation of the art. Since contours are abstractions and do not exist in nature, which is perceived as color and tone, successful imitation in painting must therefore be based on color not line.[101] The true test of an artist's skill is not in the drawing of the figure but in rendering human flesh and the other substances of nature.[102] Whereas many painters excel in *disegno* and *invenzione,* Titian alone claims the glory of perfect *colorito,* and because of this singular mastery the Venetian is, in the art of painting, "divino e senza pari."[103]

Perhaps the most complete and sensitive formulation of the Venetian aesthetic is that by Marco Boschini, the seventeenth-century artist, poet, and critic, spiritual heir to the Venetian Renaissance. Despite its baroque ornamentation—or perhaps even because of it and the use of dialect —Boschini's language affords the most appropriate literary expression of the pictorial tradition of Venice, made all the more persuasive by the passionate partisanship of the critic.[104] In its fundamentals his theoretical position varies little from that of his predecessors. *Disegno, colorito,* and *invenzione* form the "vero trino di perfezione" of painting.[105] Drawing is even accepted initially as the basis of the art, the fundamental structure, but it is considered only a skeleton over which must lie the real substance of painting. Furthermore, Boschini too rejects any definition of drawing as mere delineation. Once again, the aim of painting is imitation, and this cannot be achieved without chiaroscuro and, ultimately, color. Without coloring, he concludes paradoxically, drawing remains imperfect: "Sì che, senza il Colorito, non resta perfezionato il Dissegno."[106]

It is important to note that the Venetians do not use the term *colore* but rather *colorito* or *colorire,* not the noun but a form of the verb. They are not concerned with color per se. Pino and Dolce agree that the quality of *colorito* does not reside in the physical properties of the colors themselves, which are beautiful even in their boxes, but in the manner in which these colors are applied: *colorito* is an active, constructive concept.[107] Although their primary consideration is the imitation of nature, the duplication of its tones and hues on the canvas, both authors demand a certain manual dexterity in the application of the pigments, a "prontezza e sicurtà di mano."[108] In theory as in practice, Venetian coloring is inseparable from Venetian brushwork; the effect of the color depends on the touch of the painter's brush. This critical relationship between medium and implement is not fully explored by either Pino or Dolce, although it remains implicit in their discussions of coloring. Boschini, however, looking back upon the achievements of the cinquecento, was able to articulate the matter with greater understanding and precision. His notion of *colorito* directly involves the *pratica* itself, and the concept assumes a certain vitality in his analysis of its components. These include: impasto, which, he says, is the foundation; the rough sketch ("la macchia"), which is style ("maniera"); the blending of colors, which is softness; the working of colors, to distinguish the individual parts; the highlighting and deepening of tones, which is modeling; the bold stroke ("il colpo sprezzante"), which is freedom of coloring; muting or scumbling to create greater tonal unity. From these and other similar techniques derives "il Colorito alla Veneziana"—which is nothing less than the very act of painting.[109]

In his paean to the brush stroke, glaze, and scumble, Boschini is hardly concerned with the beauty of individual colors. If they are to serve the mimetic ends of painting, colors can no more retain their intrinsic purity than can a contour its physical integrity. Color and contour do indeed

operate in that way in Florentine painting: the colors of Pontormo, Rosso, or Bronzino, for example, appear purer, more intense and highly saturated, more striking and deliberately studied than anything to be seen in sixteenth-century Venetian painting; but these colors, as the Venetians might say, come straight from the box, seem hardly affected by the brushes by which they are applied.[110] Florentine color, for all its aesthetic impact or expressive power, still serves to enhance delineated formal distinctions; *colore* rather than *colorito,* ever respectful of the boundaries of its field and participating in the affective precision of the contour, it is indeed basically in the service of *disegno.*[111]

Il colorito alla veneziana is distinguished by what we might term a more fundamentally constructive use of color, in which individual touches form the primary components of pictorial structure. *Colorito* is in fact an additive process, the building up of the picture from the dark prepared ground of the canvas to the final modifying glazes; it is the technique of painting in oils first demonstrated by Giorgione. This appreciation of the manual application of paint runs through Venetian criticism. "Swiftness of hand," Pino declares, "is a very important thing in creating figures, and a painter can hardly work well without a sure and steady hand."[112] The idea is further developed by Dolce, who demands of the painter "una certa convenevole sprezzatura," especially with respect to coloring. Approaching a *maniera* aesthetic, he proclaims "facility" the "principal measure of excellence in any art, and the most difficult to achieve: art is the hiding of art."[113] In his appreciation of Titian's late manner, Vasari himself had recognized that in Venice *pratica* and *sprezzatura* were to be sought in the brushwork of the master painter who could create the semblance of a figure in just a few *colpi sprezzanti.*[114] Even bearing in mind the Venetian translation of Tuscan terminology and transposition of central Italian values, one can appreciate the irony in Boschini's conferring upon Tintoretto, Vasari's *bête noire,* in recognition of his *colorito,* the title of "Monarca nel Dissegno."[115]

4. FORMAL PRINCIPLES: RENAISSANCE CONVENTIONS/ VENETIAN CONTEXT

Epitomizing the differences between the two major traditions of Italian painting in the cinquecento, the *disegno-colorito* controversy reflected more than a conflict of stylistic or technical alternatives; it revealed fundamental differences of value, of expression or poetic system. The suggestive quality of Venetian *colorito,* its openness and tendency toward the allusive and the implicit, its refusal to yield to objective control and its insistence on subjective participation—all this challenged and distracted critics in search of clarity and commensurability, precision of style and formal closure. Such observers, Vasari in particular, were further frustrated by what they perceived as a corollary casualness of content in Venetian art: not only did Giorgione refuse to abide by the rules of proper style and procedure, he ignored the dictates of iconographic decorum as well. Lack of formal clarity evidently led to confusion of content and even iconographic illegibility: witness Vasari's problem in

interpreting the façade decorations on the Fondaco dei Tedeschi or the difficulties faced by modern students in attempting to decipher meaning in a painting like the *Tempesta* (fig. 13).[116] On every level, then, Giorgione's art seems calculated to frustrate. And when the modern scholar acknowledges the possibility of deliberate vagueness in that art, assuming that indeterminacy of form implies indeterminacy of content, he is, in effect, prolonging the critical tradition of Vasari: both would conclude that Giorgione's paintings signify in some idiosyncratic way, different from the conventions of pictorial expression in Italian Renaissance art.[117]

For all his technical innovation, however, and his new pictorial poetic, Giorgione was building on just those expressive conventions; his art, we may assert, shared and was inspired by those mimetic assumptions and aims that guided the development of Renaissance painting in general.

13. Giorgione, *La Tempesta.* Venice, Gallerie dell'Accademia

Indeed, it is against this background of commonly held principles that we can better measure the particular qualities and achievements of Venetian painting; by recalling the affective goals of Italian Renaissance art we can better comprehend the deeper functions of *il colorito alla veneziana*.

Mimetic Assumptions For the first and clearest enunciation of this common background, we must return to Alberti's remarkable little treatise on painting, of 1435, in which he set down fundamental tenets of the new Renaissance art that had been developed by his Florentine friends in the first quarter of the fifteenth century. There he codified the system of mathematical perspective that was the core of the new pictorial structure and, with great eloquence, recognized and articulated the expressive ends of this art, toward which perspective construction was a means.[118] Satisfying the modern need for rational process, for predictability and commensurability, this mathematically based spatial illusion also answered to the requirements of mimetic conviction.

The picture plane, technically definable as the intersection of the pyramid of vision, assumed a complexity of function and reference that weighted it as a field of special significance. The new system permitted the full articulation of a situation that was, almost by definition, an inherent property of that plane: the paradox of its simultaneous opacity and transparency—a surface on which lines are drawn and colors applied, yet also a plane through which we look as through a window onto a fictive world.[119] It is precisely this ambivalence that so charges the plane with expressive potential, the tension of this conflict between illusion and reality that engages the observer in the game of participation—that is, interpretation.

The new perspective postulated a correlation between the viewing eye, the apex of the visual pyramid, and the vanishing point, infinitely deep within the nominal space of the picture yet accessible as the focus of the orthogonals on the surface schema.[120] But it was at the limits of the field, the bounding frame defining the edges of the picture plane, that the two worlds came into most direct contact. There, ambiguity became a particularly refined instrument in the hands of the painter. Ostensibly proclaiming the isolation of illusion from reality, the frame itself—according to all the rules, a part of reality—effectively mediated between these realms.

From the other side of the frame, within the picture's fictive space, Alberti's recommended interlocutor, directly addressing the observer, invites us to cross the threshold and enter his world. Beyond that spatial politeness, however, by physiognomic indication of the proper mode, he also instructs us in the decorum of response. Figure and space share a common rhetorical function; both participate in the mechanics of involvement, facilitating entrance into the picture, getting us beyond the transparent barrier of the front plane. Suspending disbelief, we confront

the drama itself, respond to those actions of the body that reveal the movements of the soul: "we weep with the weeping, laugh with the laughing, and grieve with the grieving."[121]

In the quieter realm of the altarpiece, where the dramatic passions of the narrative *istoria* yield to the decorum of pious respect, the controlled spatial consistency of perspective construction made the heavenly court accessible to the worshipful observer with a new and persuasive logic. Madonna and Child, the focus of the receding orthogonals, await our presence. The way is clearly marked; beyond the frame a higher order of being invites our participation—a promise, ultimately, of salvation. Before such religious images, structured on the geometry of illusion, the complex act of interpretation implicates both reason and faith, aesthetics and piety.

Interpretation, moreover, becomes a commentary on experience, the temporal experience of our involvement with and in the picture. Our journey through those fictive courts takes place in a time that is as ambivalently real, for the duration of involvement, as the space in which it unfolds.

And time itself is enfolded in the very structure of the image, whether the linear narrative of an *istoria*, with its sequence of moments present, past, and future, or the more centralized hierarchy of temporal values offered by the *sacra conversazione*, its saints gathered around the still center of the infant deity, a cosmic time, *sub specie aeternitatis*.

Space and time become the essential coordinates of the dimensions of pictorial experience. Each offers its own fiction, a convincing illusion made all the more significant by a range of references and allusions, implicit as well as explicit.

Frame and Field: Iconic Space

Two well-known Florentine pictures can serve as examples. Masaccio's *Trinity* (ca. 1425–27?), the first great monument in this pictorial tradition, already explores all these possibilities (fig. 14). The artist designed his perspective system so that the vanishing point is located on the central vertical axis at a height corresponding generally to the eye level of an observer, or worshipper, in Santa Maria Novella; thus, apparently opening into the barrel-vaulted chapel enshrining the Trinity, the wall of the church is the intersection of the pyramid of vision, Alberti's transparent plane. But even as the painted architectural frame decorates and thereby identifies itself with the actual wall of Santa Maria Novella, it is compromised, as it were, by its own ambivalence. Masaccio has placed the two kneeling donor figures in front of the framing pilasters; evidently on this, our side of the picture plane, they exist not in the holy space behind the wall but in our world. Like us, they, too, pray before the vision of the Trinity. Their prayer, in turn, is mediated by the intercessory figures of the Virgin and St. John, whose presence further complicates the temporal structure of the image by referring the eternal aspect of the central icon back to the historical moment of the Crucifixion on Golgotha. At the

level of the wall, then, a number of realities meet, and by their interaction lead us into the mystery of the consecrated space.[122]

The frescoed mural, in which painted image and surrounding wall actually share a common surface, offers the richest potential for this kind of structural complexity. In panel painting, however, the image field physically terminates, cut off and bounded by the physically distinct frame; and it is, of course, the frame itself that establishes the context for spatial layering. Domenico Veneziano's *St. Lucy Altarpiece* (ca. 1445) defines and manipulates these possibilities with calculated precision (fig. 15). At the upper edge of the field the spandrels, graphically accentuated by their inlaid pattern, align themselves with the frame; and this attachment identifies them with the surface of the picture plane. The painted architecture thereby defines the barrier between the world of the spectator and that of the image. But this is true only at the upper frame, for, following the supports of that architecture to their bases, we discover that these columns are grounded well back in the fictive space, behind the figures comprising the *sacra conversazione*. As the Baptist, playing his role as preacher, fulfills the interlocutory function recommended by Alberti, these saints interpose themselves between the architecture—which we had tentatively associated with the picture's own surface—and the observer. The plane has apparently fallen away, yielded to a new illusion. Within a narrower set of constraints, the pictorial surface has become as complicated and ambivalent a field as the frescoed wall of Masaccio's *Trinity*; and in both cases the dynamics of that complication, a shifting between functioning states of opacity and transparency, challenge us to respond with a corresponding agility and awareness.

By the middle of the quattrocento the pictorial language first formulated in Florence had become available throughout much of Italy. In Venice, the new principles of perspective construction served as the basis for an *aggiornamento* of style in the works of leading masters like Antonio Vivarini, who in 1446, along with his elusive associate, Giovanni d'Alemagna, signed the *sacra conversazione* for the Scuola Grande di Santa Maria della Carità (fig. 16). The enthroned Virgin and Child and attendant Doctors of the Church are assembled in a courtyard whose continuous space imposes a unity on the separate fields of the triptych. Absent, however, is the rigorous play with the picture plane that characterizes Domenico Veneziano's altarpiece.[123]

Venetian painting had traditionally assigned a special value to the picture plane, but as the bearer of its own significant visual richness: gold ground, applied ornament, modeled relief. Such a plane did not readily sacrifice its reality to the theoretical suppositions of intersected pyramids of vision; rather, even with the controlled illusions of perspective design, it insisted upon an essential substantiality, a tangible opacity.

The basic principles underlying a Florentine composition like Masaccio's *Trinity* were fully comprehended in Venice and northern

14. Masaccio, *The Trinity*. Florence, Santa
Maria Novella

15. Domenico Veneziano, *St. Lucy Altarpiece*. Florence,
Galleric degli Uffizi

Italy. But that comprehension evidently was initially limited to draw-
ings, that is, to an activity of deliberate theoretical speculation (figs. 17,
18).[124] Not until later in the century would these principles begin to
inform monumental painting; when they did, however, the result was
the transformation of the very concept of the altarpiece in Venice.

That transformation occurred sometime around 1475, and the two
major protagonists in the development were Giovanni Bellini and An-
tonello da Messina. In the former's altarpiece in SS. Giovanni e Paolo
(destroyed in the nineteenth century) and the latter's in San Cassiano
(preserved only in fragments)—both *sacre conversazioni* of vertical format
with the Madonna enthroned—the principles of Masaccio's *Trinity*
(possibly mediated by Piero della Francesca) became fully established in
Venice.[125] With the loss of these works, Giovanni Bellini's *San Giobbe
Altarpiece*, slightly later in date and probably of the following decade, now
serves as the earliest preserved example of the new mode of monumental
Venetian altarpiece (pl. 1, fig. 19).[126]

Set above altars along the side walls of churches, Bellini's panels were
enclosed by richly ornamented architectural frames. The order of this
architecture was continued in the internal setting of the image itself.
Here, too, then, the wall of the church opens onto a chapel space, the

16. Antonio Vivarini and Giovanni d'Alemagna, *Madonna and Child with Sts. Jerome and Gregory, Ambrose and Augustine*. Venice, Gallerie dell'Accademia

repeated architectural decoration reinforcing the spatial continuities implicit in the perspective construction.[127] The horizon is low in the field, easing the observer's visual access to the sacred precinct, while monumentalizing the enthroned Madonna. In the *San Giobbe Altarpiece* St. Francis, standing at the left frame, looks out to us with a gesture that simultaneously displays his stigmata and beckons us into the realm of the holy.

Bellini's fictive apse, however, despite its analogous principles of construction, is fundamentally different in tone from the architectural units of his Florentine predecessors. The clarity of Tuscan perspective and the logic of architectural structure are here transformed by a mood that is quintessentially Venetian: evocatively Byzantine, it recreates the deep chiaroscuro experience of the church of San Marco itself (fig. 20). The richly veined marbled paneling behind the Virgin's throne is modeled explicitly on the revetment of the ducal chapel of Venice, but it is the gold mosaics of the semidome, glowing above the lower darkness and

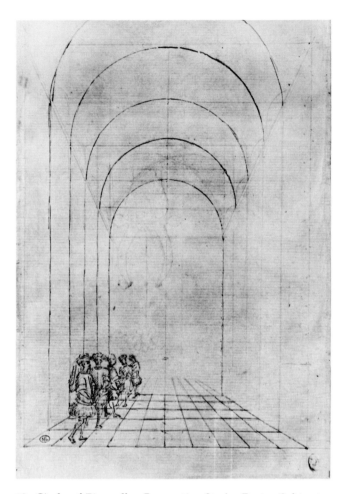

17. Jacopo Bellini, *St. John the Baptist Preaching*. Paris, Cabinet des Dessins, Musée du Louvre

18. Circle of Pisanello. *Perspective Study*. Paris, Cabinet des Dessins, Musée du Louvre

gathering into itself the golden bosses in the coffers of the barrel vault, that most completely set the tone of Bellini's altarpiece. Even more consistently than the perspective, this tonal depth invites us into a new world, promising to take us beyond the commensurability of mere architecture to a higher level of transcendence. To the rational structures of Florentine perspective the Venetian master has added a further dimension of experience, an invitation that is all the more compelling for being beyond the reach of reason.

Bellini's great altarpieces—for San Giobbe, in the sacristy of the Frari, and in San Zaccaria—establish their hieratic solemnity about the governing armature of the central vertical axis. Controlling our approach to the image, this focused centrality guides us directly to its iconic core: the enthroned Virgin and Child, the object of our devotion, set before us with ceremonial precision, *in maestà*. Within the vertical format of this tradition, however, other possibilities of pictorial and narrative content were explored, especially in the early years of the cinquecento. Upon the

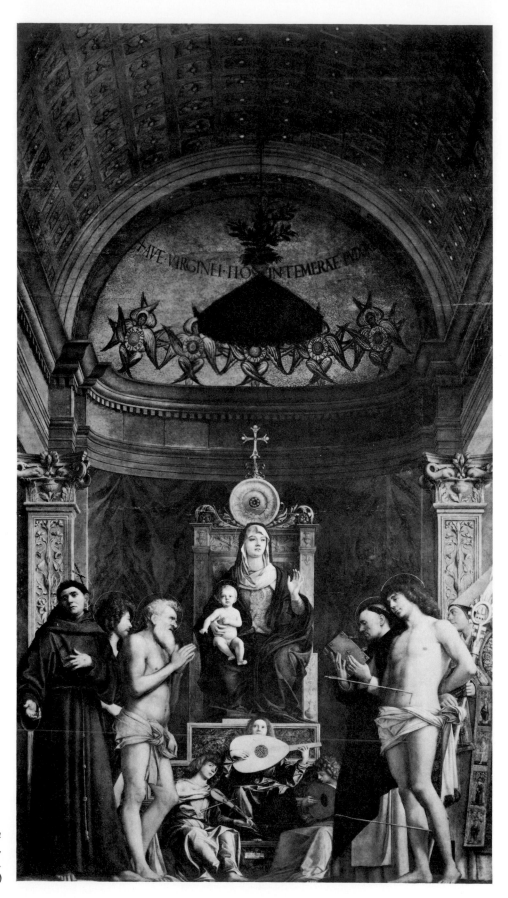

19. Giovanni Bellini, *San Giobbe Altarpiece*. Venice, Gallerie dell'Accademia. (See also colorplate 1.)

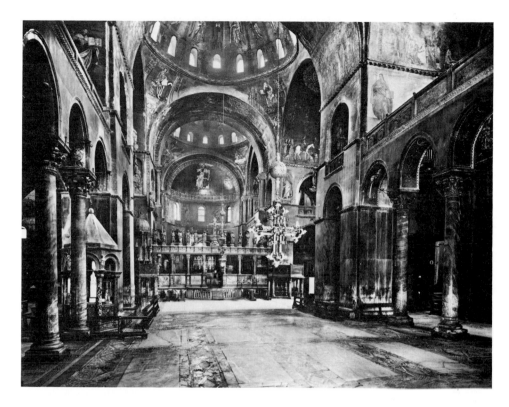

20. Venice, San Marco. Interior

structural assumptions of the arched opening and perspective continuum and the privileged position of the center axis of the field, artists began to elaborate new patterns of mimetic involvement.

In Cima da Conegliano's *Incredulity of St. Thomas* (ca. 1505), for a prime example, the courtly schema of the *sacra conversazione*—attendants flanking a central figure—shifts into a lateral motion (fig. 21). Christ, the focal protagonist of this altarpiece, is still on center, ostensibly accompanied by St. Thomas and St. Magnus. But, turning off axis to his right, the resurrected Christ relates exclusively to the doubting Thomas, guiding the probing finger into the open wound—a directed movement reflected with special eloquence in the diagonally cast shadow above. St. Magnus, isolated from the dialogue, becomes a spectator to this dramatic proving. The three figures stand within an open architecture, an arched baldachin that distinguishes this sanctified setting from the natural realm of the background landscape.

This distinction is further refined in Marco Basaiti's altarpiece from San Giobbe, the *Agony in the Garden*, dated 1510 or, possibly, 1516 (fig. 22).[128] Here, however, it is the landscape that assumes the higher value as sacred space, the setting for Christ's prayer. Although structurally analogous to Cima's altarpiece, Basaiti's architecture interposes itself between the observer and the scene in Gethsemane; functioning as frame in a fully three-dimensional sense, it at once serves as aperture onto that landscape and as mediating space in front of it. Its intermediary

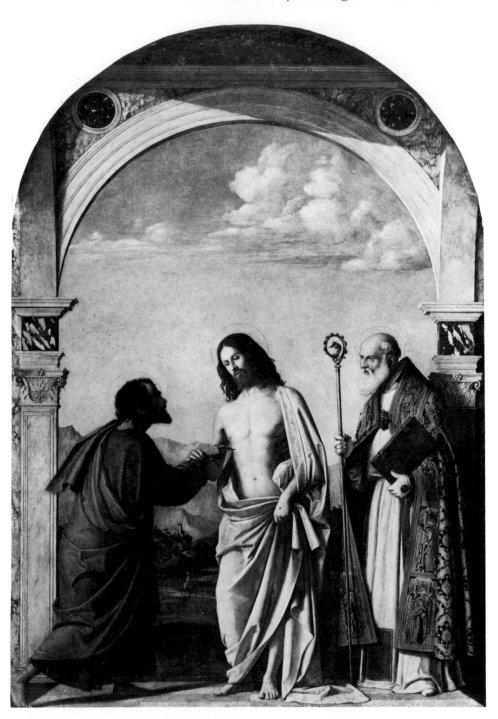

21. Cima da Conegliano,
Incredulity of St. Thomas.
Venice, Gallerie
dell'Accademia

status is further defined by the presence of the attendant saints, who,
like the architecture itself, participate in the pictorial illusion even as they
stratify the space of that illusion into a hierarchy of differentiated levels.

Crystallizing this entire situation about itself is the lamp hanging in
space, precisely on axis, above the kneeling Jesus. A piece of church
furniture, it belongs, of course, to the world of the worshipper, and yet
its fragile luminosity relates immediately to the glowing ambience of

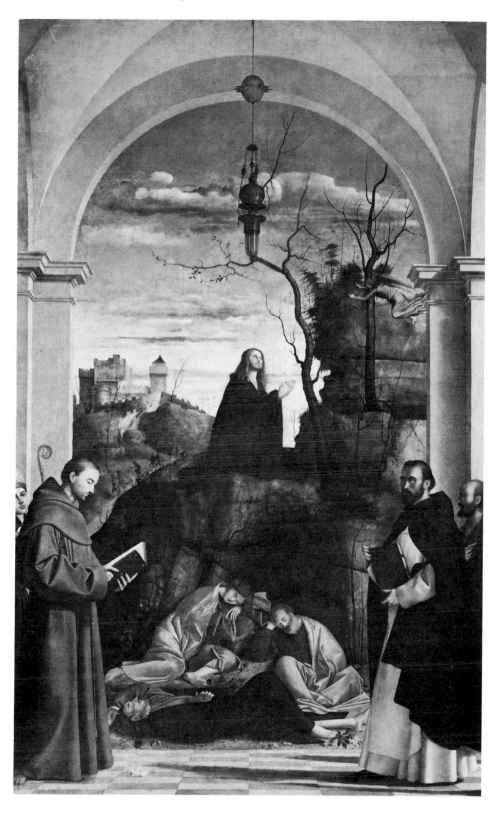

22. Marco Basaiti, *Agony in the Garden.* Venice, Gallerie dell'Accademia

Christz's world.[129] More radically even than the foreground saints, the hanging lamp, then, shifts between levels of reality, the paradox of its

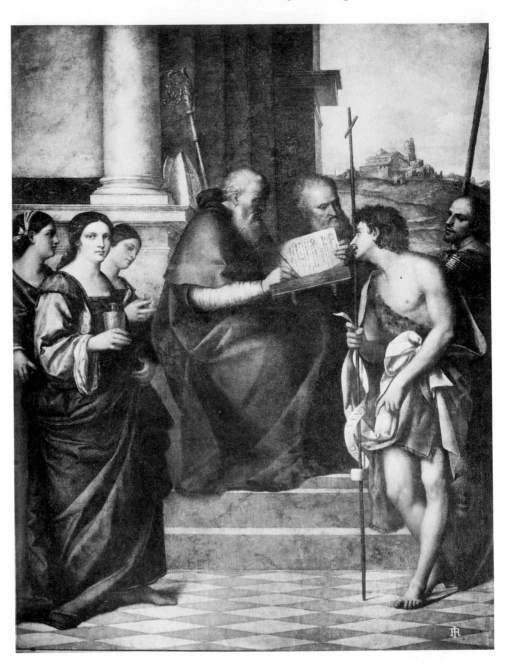

23. Sebastiano del Piombo, *San Giovanni Crisostomo Altarpiece*. Venice, San Giovanni Crisostomo

own situation leading the viewer from the space of the church of San Giobbe, beyond the fictive architecture, to the drama of Christ's final hours.

One further example may serve to return us to some basic principles: the main altarpiece for the church of San Giovanni Crisostomo (fig. 23), a painting possibly initiated by Giorgione but certainly completed by Sebastiano del Piombo (ca. 1509–10).[130] Built about the figure of the eloquent St. John Chrysostom, the image is, in effect, a *sacra conversazione* without Madonna and Child. And the absence of these central holy figures seems to have inspired a less hierarchically determined composition, a more democratic distribution of position within the field. The

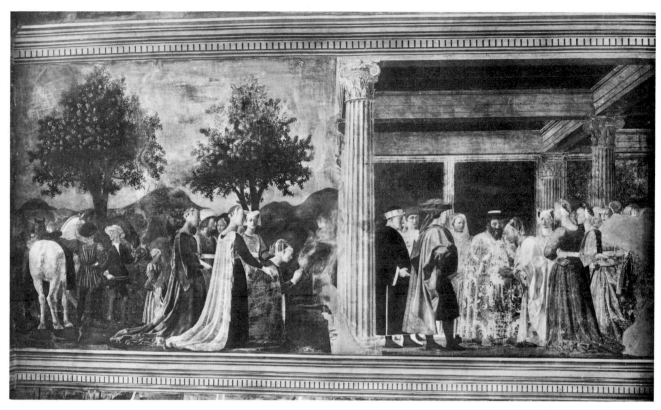

24. Piero della Francesca, *The Queen of Sheba before Solomon.* Arezzo, San Francesco

field itself is significantly less vertical, and the absolute value of the axis, already muted by the profile view of the writing saint, has been further undermined by the asymmetrical massing of the architecture. Indeed, the relative informality of the whole configuration suggests a set of values rather different from those governing Bellini's sacred precincts. Architecture here does not aim to create a higher, yet accessible, spiritual realm; instead, its tectonic coordinates seem designed to serve as a standard against which to measure the contrapposto of the figures. Iconic space, with its essential focus, yields to a more discursive space, one that risks perhaps becoming anecdotal in its distributive display of figural invention.

If the altarpiece in its purest form represents what we might call an iconic spatial mode—vertical, frontal, and centralized—a different spatial construct, determined instead by the horizontal, afforded an alternative mode for narrative painting. Still manipulating the dynamics of frame/ field and plane/space relationships, the long rectangular format of this mode engages the viewer in different patterns of legibility and involvement. Narrative continuity and pictorial integrity depend upon the primacy of organization across the plane. Not particularly invited to penetrate the recesses of background space, the eye is rather held to the surface; the act of interpretation takes place not by a progressive entry into fictive depth but by a process of lateral scansion, as it were, a reading

Frame and Field: Narrative Space

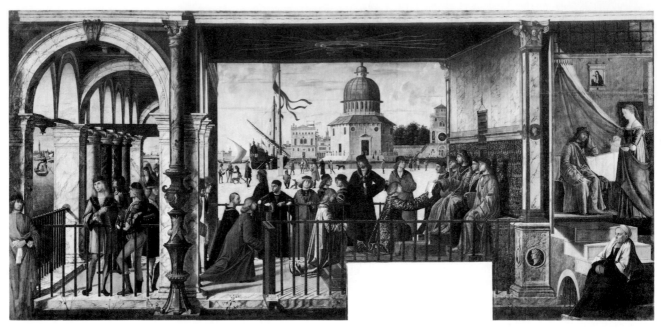

25. Vittore Carpaccio, *Reception of the English Ambassadors*. Venice, Gallerie dell'Accademia

across the plane—and that generally from left to right. [131] In various ways this processional principle governs the affect of the great quattrocento monuments of this tradition: Piero della Francesca's cycle of the *Legend of the True Cross* in San Francesco at Arezzo, Domenico Ghirlandaio's *Life of the Virgin* in the choir of Santa Maria Novella in Florence, and, in Venice, the preserved *teleri* by the Bellini and Carpaccio from the *scuole grandi* and *piccole*.

A composition like Piero's *Queen of Sheba before Solomon* (fig. 24) defines the essential tenets of this narrative mode—with, however, a structural eloquence and controlled articulation that transcend the type itself. Bisecting the long rectangle of his field, Piero treats the resultant squares—each representing a distinct moment in the chronological progress of the subject—quite differently. The left side is in motion; among the figures the profile dominates, and the flow of the courtly trains and undulating horizon confirms the processional impulse toward the right. Moving beyond the center axis (actually the locus of the vanishing point and further marked by the columns of the atrium), space becomes now deeper; a full perspective construction houses the centralized arrangement of the reception about the nearly frontal figure of the king, a configuration relatively static in its centripetal structure.

In the broadest terms, then, Piero's fresco counters lateral movement and stabilized centrality, the one leading up to and culminating in the other. Formally and iconographically, this sequence of procession and arrival is manifestly legible; following such a sequence involves us in an unfolding narrative, which we read, from the left, as an experience in time. These are the fundamental elements of the narrative compositional mode: directional impulse across the plane and resolution in an opposite

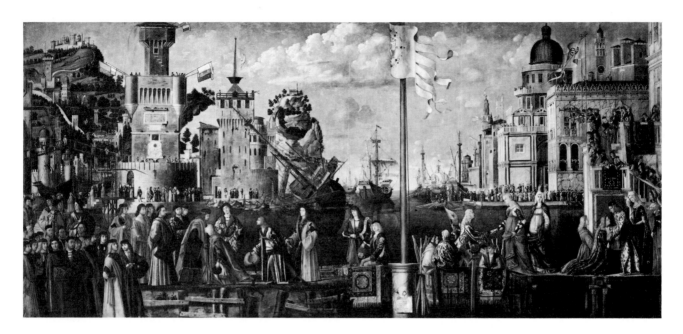

26. Vittore Carpaccio, *The Leavetaking of St. Ursula and the Prince.* Venice, Gallerie dell'Accademia

response, a counterthrust just strong enough to receive, absorb, and, finally, ground that initial propulsion.

Without the mathematical rigor of Piero's design and in a more discursive and anecdotal fashion, these same principles determine the great tableaux of Carpaccio's cycle from the Scuola di Sant'Orsola. In the *Reception of the English Ambassadors* (fig. 25), which opens the story, we also follow a procession across the surface, a proportionally longer field divided into three areas, to its moment of resolution in the presentation of the petition in the center scene, and then to the consequent action in a kind of pictorial epilogue, the private conference at the extreme right. Here, too, differentiation of architectural space distinguishes moments in a temporal sequence: entry, reception, consultation.

The action occurs on an elevated platform, and a railing separates us from that action—except where, with almost arch self-consciousness, a gate swings open (and, implicitly, into our space) to allow us direct access. Carpaccio's chatty realism contrasts with the aloofness of Piero's formal precision. If the Venetian painter is intent upon telling the tale, he is also concerned that we follow it closely, that we have ways of engaging the narrative with conviction. He wants us to believe. Toward this end he charges the pictorial surface with special responsibilities, playing upon the ambiguities of the plane in ways that seem almost naïve in comparison to the assured calculations of Piero's solution.[132] Within the architectural continuity of setting in the St. Ursula canvas, the architrave parallels the upper frame of the picture; arch and pilaster therefore press against and apparently identify with the actual surface, a situation deliberately confounded by the standing officer of the Scuola di Sant'Orsola, the ornate column, and, at the right—before a spatially compromising

flight of steps that seems to bridge the worlds on either side of the plane—Ursula's old nurse.

The fenced-in arcaded loggia at the left represents, in effect, a prologue to the narrative, a direct address to the audience still outside the fiction of the story. Ostensibly continuous with the subsequent spatial structure, it is distinguished from it by architectural detail as well as by its general stasis. These lounging portrait figures, led by the robed official, root the inception of the mimetic action in late quattrocento reality and provide the most immediate access to it for the contemporary spectator.[133]

In the following tableaux of the St. Ursula cycle Carpaccio consistently manipulates this narrative compositional mode. Running the story across the surface from left to right, he breaks the long field to the right of center, thereby dividing the original format into two constituent fields: one oriented along the horizontal and establishing the initial narrative impulse; the other, either square or vertical, climaxing that momentum. Often, as in the *Leavetaking* (fig. 26) and in the *Martyrdom and Funeral of St. Ursula* (fig. 27), that break signals a temporal distinction as well; scansion of the continuous landscape setting thus implicates a movement through successive moments in narrative time.

The principles informing narrative tableau compositions like Carpaccio's are most effectively articulated within the context of another pictorial genre: the votive picture, in which a kneeling donor is presented to the Virgin and Child (fig. 28). Depicted in profile, the praying donor is here the figure in action, moving (spiritually if not actually physically) toward the object of his devotion. The enthroned Madonna, on the other hand, generally appears frontal, if not quite *in maestà*;[134] even as she or the child acknowledges his presence, her body is primarily addressed to the plane and, therefore, to the outside observer. In terms of figural representation, this profile/frontal contrast epitomizes within a particularly charged image type the alternatives of narrative movement and iconic stasis, transience and permanence.[135]

Carpaccio's *teleri*, however, like those of his Venetian contemporaries, were conceived and executed not as individual pictures but as parts of larger decorative cycles. The story of St. Ursula unfolded, from canvas to canvas, across the walls of the main room of the confraternity, culminating at the altar, with its image of the saint's apotheosis.[136] Narrative continuity depended very much upon reading the entire sequence. Even as each individual picture resolved its internal forces—recounting its particular episode(s) of the legend and effecting a visually satisfying compositional closure—the directional impulse, therefore, had to be maintained across the boundaries of the frame, flowing from canvas to canvas (cf. fig. 29).

Crucial to this enterprise was the integrity of the picture plane and, by extension, the mural surface itself. The tableau composition disposes its figures along a narrow foreground strip running parallel to and just behind the plane. Although deep space lies beyond, the chief protagonists and choral attendants ignore it, adhering rather strictly to the

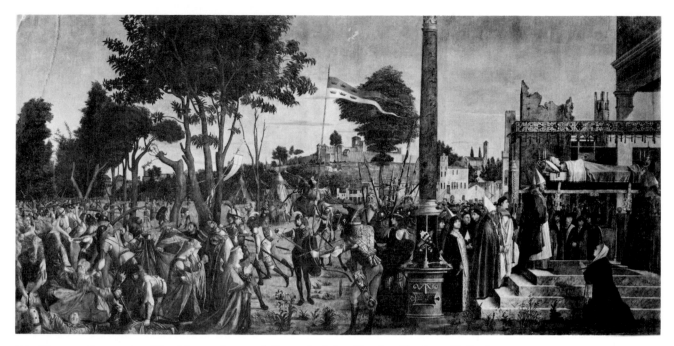

27. Vittore Carpaccio, *The Martyrdom and Funeral of St. Ursula*. Venice, Gallerie dell'Accademia

foreground stage; and even the diminutive figures populating that distance are arranged parallel to the picture plane. Background space functions as backdrop; as suggestive as the painted *fondali* of the theater, it is as functionally, or dramatically, inaccessible. Our attention is held essentially at the level of the picture plane by the procession of dramatic encounters; and that processional momentum keeps us moving past the frame to the next episode.

In developing new techniques of painting in oil on canvas, Giorgione had adapted Bellini's luminous aesthetic to new expressive, and basically secular, purposes; his tonalism created and explored a new poetry of shadow. Like the *sfumato* world of Leonardo's painting, the pictorial realm defined by the young Venetian exploited the suggestive and the implied. And such a world of thick tonal ambience, of shadows clinging to form and denying contour, offering visual information only partially described, makes certain demands upon the beholder. He must participate in the satisfactory completion of the full representation, must himself supply a dimension of experience that is only hinted at by the image. Directly engaging the spectator in this way, making definite demands upon him, such tonal imagery is fundamentally subjective. Inviting us to enter in the fullest sense, to live among its suggestive shadows, offering a poetry that is evocative and romantic, it promises a privacy of experience that, despite its generally secular iconography, approaches the devotional. A new kind of patronage, individual and personal, supported the development of this aesthetic, which found its typical format in the cabinet picture, a painting of modest size intended for private delectation (figs. 6, 13).

Tonal Structure

28. Pietro Lombardo,
*Votive relief of Doge Leonardo
Loredan.* Venice, Ducal
Palace

Like Bellini's tonal manipulation, Giorgione's reaches out directly to draw us in, but now with less support from the scaffolding of perspective constructions. Even on the monumental scale of mural decoration—the frescoes on the Fondaco dei Tedeschi—deep spaces, articulated by bold foreshortening, were shaped by a kind of brilliant tonalism, higher in key than the umber shadows of Giorgione's smaller canvases.[137] It is difficult, however, to imagine the affect of such tonal structures working in the different context of the narrative tableau. This kind of tonalism puts into question the manifest integrity of the picture plane that is axiomatic to the narrative mode of the late quattrocento.

If, on the one hand, Giorgione's art, in its maturest development, seems unsuited to the processional iconography of the *scuole*, it was, on the other, able to conceive and realize narrative possibilities that were beyond the range of Carpaccio or the Bellini. The situation is best documented in the pictorial cycle decorating the *albergo* of the Scuola di San Marco. There, amidst the wall-affirming murals of the Bellini studio and school and of Paris Bordone's ceremonial *Consignment of the Ring* (fig. 73), one canvas stands out as an example of tonal painting on a monumental scale: the problematic *Burrasca* (fig. 30).[138] Although it hardly ignores the picture surface, this composition—of Sts. Mark,

29. Venice, Scuola di San Giorgio degli Schiavoni. *Sala terrena*

George, and Nicholas calming a storm and saving Venice from a demon-driven ship—clearly depends for its dramatic impact upon a deeper tonal involvement. The central confrontation of the legend takes place in the middleground, and the energies of the foreground figures are directed back toward that space. The main unifying element is not the common reference to the plane but rather the tonal ambience that binds figures and vessels in a containing turbulent atmosphere. As on the more intimate scale of Giorgione's *Tempesta* (fig. 13), so here the painting presents an image of activated space; it addresses us with immediacy, and our acceptance of its invitation precipitates us into the depths of a strange world. Reading is not a process of lateral scansion across the plane, of following an unfolding narrative line; instead, we are compelled to cross the threshold, to enter and immerse ourselves in a literally more profound fiction.

Obviously this tonal mode functions somewhat idiosyncratically within the context of a decorative mural cycle. To control the spatial recess of a single canvas is quite different from controlling a sequence of such images across a vast wall surface. That challenge, however, was met

30. Jacopo Palma il Vecchio and Paris Bordone, *La Burrasca*. Venice, Biblioteca dell'Ospedale Civile

by the last great master of the Venetian cinquecento, Tintoretto, in the rooms of the Scuola di San Marco and, above all, the Scuola di San Rocco. There, he organized and controlled such cycles, and his main instrument in the realization of this achievement was just that dynamic tonalism first formulated by Giorgione at the beginning of the sixteenth century.

2

Titian and the Challenge of the Altarpiece

The transformation of the Venetian altarpiece in the opening years of the cinquecento found its most innovative protagonist in the young Titian. Committing himself at the very outset of his public career to the development of new, more dynamic modes of design, Titian continued to explore the expressive possibilities inherent in the monumental *pala*, in the affective potential of its iconography and of the contexts of its functioning—the conventions of devotional practice and the controlling conditions of architectural site. In a series of altarpieces—from his earliest, *St. Mark with Sts. Cosmas and Damian, Roch and Sebastian* (fig. 31), to the *Martyrdom of St. Peter Martyr* (fig. 32), completed in 1530—Titian responded to the challenges of the genre and, adding new dimensions of vital experience to it, transformed the notion of religious vision.

His knowing mastery of the aesthetic conventions we have discussed, of the pictorial mechanics of the earlier Renaissance tradition and their role in the devotional experience, is nowhere more clearly documented than in his woodcut design of *St. Roch* (fig. 33). Published in the early 1520s as a broadside to raise funds for the Scuola di San Rocco and essentially popular in its appeal, the composition is conceived as an altarpiece.[1] The central panel depicts the pilgrim St. Roch himself, and the surrounding architectural frame comprises scenes from his life. On the predella below is an alms box and a model of a child's head, an ex voto commemorating one of the medical miracles of the saint, who was traditionally invoked against the plague. A votive tablet propped against the altar represents with almost naïve simplicity the intervention of the saint in response to the prayer of a sick believer. At the very end of his career, as we shall see, Titian would include a similar pious panel in the *Pietà* he intended for the altar above his own tomb (fig. 52).

The woodcut offers not only an important document of popular piety in Renaissance Venice but also a revealing comment on the nature of the altarpiece, its function in daily life, and its status as visionary image. In the main panel St. Roch turns toward an angel, who at once greets him and points heavenward, indicating a vision above, an apparition of Christ carrying the cross. This vision is significantly contained within a cloud overlapping the frame and thus is not part of the fictive world of the altar painting itself but rather of the worshipper's own space, reality

31. Titian, *St. Mark with Sts. Cosmas and Damian, Roch and Sebastian*. Venice, Santa Maria della Salute

on this, our side of the frame. The vision itself deliberately recalls an early picture by Titian, then in the church of San Rocco and now in the Scuola (fig. 34), that had acquired a reputation as a miracle-working image and, according to several sources, had attracted enormous sums in alms.[2]

Titian's woodcut, then, participates fully in the religious life of early cinquecento Venice; the image itself becomes a highly self-conscious

32. After Titian, *The Martyrdom of St. Peter Martyr*. Engraving by Martino Rota. New York, Metropolitan Museum of Art

intersection of art and life, its several parts figuring those basic dimensions of piety: faith, hope, and charity. As we watch vision and reality mingle and dissolve, as it were, the barrier of the picture plane, we become increasingly aware not of the artifice of aesthetic construct but rather of the personal drama of affliction and salvation, less aware of the art than of the life of the picture. In purchasing this woodcut, and making his donation to the building of the Scuola di San Rocco, the sixteenth-century Venetian performed not an aesthetic choice but an *opera pia;* tacked up on the wall or door, Titian's *St. Roch* may have contributed some special delight to the décor of a modest dwelling, but more importantly it offered the perpetual promise of divine aid in time of need.

Even as it so clearly articulates the basic axioms of Renaissance picture-making, this popular print, an altarpiece in miniature, reminds us that in the context of religious imagery the laws of art were in the service of God. We must bear this in mind as we return to examine Titian's transformation of the monumental altarpiece.

The process begins in the *St. Mark* altarpiece that Titian painted for the church of Santo Spirito in Isola about 1508/09.[3] In this panel he modified the traditional composition of the *sacra conversazione* by dissociating the figural and the architectural axes. The saints, grouped around the en-

33. After Titian, *St. Roch.* Woodcut. London, British Museum

throned Mark, and the perspective of the pavement are centrally fo-
cused, but the architecture of the setting has been shifted to the extreme
right of the field—thereby opening the heavenly backdrop.

Probably contemporaneous with or even preceding the design of the
San Giovanni Crisostomo altarpiece (fig. 23), Titian's *St. Mark* may
appear in comparison somewhat less radical in its asymmetry. And yet it
is precisely because the iconographic core of the image adheres to the
central axis that the architectural shift assumes its particular function and

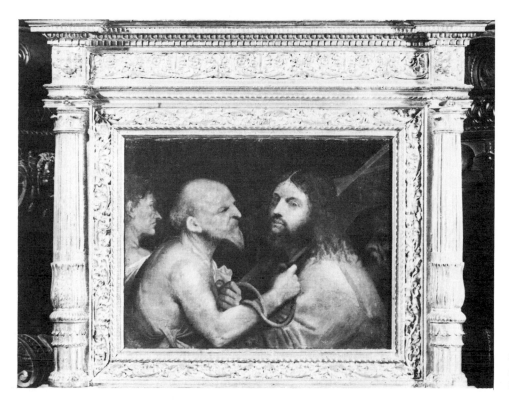

34. Titian, *Christ Carrying the Cross*. Venice, Scuola Grande di San Rocco

value; the tension here is actually greater than in Sebastiano's (or Giorgione's) composition, where, as we have suggested, iconic focus is rather diffused by a more discursive lateral distribution over a wider field. Titian's control over the elements of pictorial structure manifests from the beginning an exactness and purpose that will grow in response to the increasingly monumental challenges of his next altarpiece commissions.

Three great altarpieces span what is generally acknowledged to be the most energetic period of Titian's development, the years between 1516 and 1530: the *Assunta* (ca. 1516–18), the *Madonna di Ca' Pesaro* (1519–26), both in Santa Maria Gloriosa dei Frari, and the *Martyrdom of St. Peter Martyr* (1526–30), painted for the church of SS. Giovanni e Paolo.[4] The last of these was destroyed by fire in 1867, but the first two are still *in situ*. The *Assunta* was removed from the high altar of the Frari to the galleries of the Accademia in 1817 and was returned to its original location only after the First World War; except for restorations, the *Pesaro Madonna* has never left its position on the altar of the Pesaro family. During the decade of 1516–26, then, the Frari was the most significant scene of activity for Titian as a painter of religious images; its continued importance to the master is further attested by the arrangements he made to be buried there beneath the altar of the Crucifixion, for which he was to have provided as an altarpiece his late canvas of the *Pietà*.

In the long course of his career Titian surely came to be quite familiar

**1. IN THE FRARI, I:
THE *ASSUNTA***

with that Gothic basilica, to know its vast spaces, traffic patterns, and visual axes. Considering his altarpieces in the context of their architectural setting—in three dimensions, so to speak—becomes essential to any analysis of the painter's achievement; it affords new modes of approach to some of the critical problems surrounding these pictures, thereby adding a further dimension to our idea of Titian's creative imagination.

The inscription on the high altar of the Frari informs us that it was erected in 1516 at the charge of Fra Germano da Casale, prior of the Franciscan monastery.[5] An unusual entry in the diaries of Marino Sanuto, rare for its explicit reference to a work of art, records the unveiling of Titian's picture two years later, on 19 May 1518.[6] On that day Titian established a classical High Renaissance art in Venice, for in its dramatic gestures, its breadth of form, and its symbolically geometric structure, the *Assunta* (pl. 2, fig. 35) epitomizes a style more commonly defined with reference to the art of Raphael. Critics since the sixteenth century have indeed marveled that Titian could have created a work of such monumentality before he made the pilgrimage to Rome.[7] Venetian painting to that date offers nothing in the way of precedent and very little, even in the juvenilia of Titian himself, that can be said to anticipate the grandeur of the *Assunta*. The composition actually depicts the Coronation as well as the Assumption of the Virgin, and in interpreting the subject dramatically, Titian created a heroic figure type new to Venice. Abandoning the modest naturalism of his predecessors (cf. fig. 36), he conceived the celestial realm as a truly supernatural phenomenon: the golden circle of heaven in the *Assunta*, like that of Raphael's *Disputa*, glows with a radiance beyond nature. In the art of Giovanni Bellini celestial light found expression through empirically comprehensible phenomena, manifesting itself as a purer distillation of natural light or as the reflection of golden mosaics (fig. 19). Titian, however, depicted a divine radiance existing entirely on its own terms, a visual reality essentially different from that of this world. In this he realized, again like Raphael, new possibilities of expression and ideality.[8]

The accounts in the art literature of the sixteenth and seventeenth centuries concerning the reception of the *Assunta* confirm its extraordinary impact; and, granting the suspicious status of biographical anecdote as art-historical source material, the reports of Dolce and Ridolfi nevertheless ring true. "Surely in this panel are to be found the grandeur and awesomeness of Michelangelo, the charm and grace of Raphael, and the coloring of nature itself," writes Lodovico Dolce with enthusiastic admiration.[9] Then, in a passage echoing Vasari in its historicism, he describes the shocked incredulity of the initial audience: "For all that, the oafish painters and the foolish masses, who until then had seen nothing but the dead and cold works of Giovanni Bellini, of Gentile, and of Vivarino . . . , which were without movement and modeling, grossly defamed that picture. Then, as envy cooled and the truth slowly dawned on them, people began to marvel at the new style established in Venice by Titian. . . ."[10]

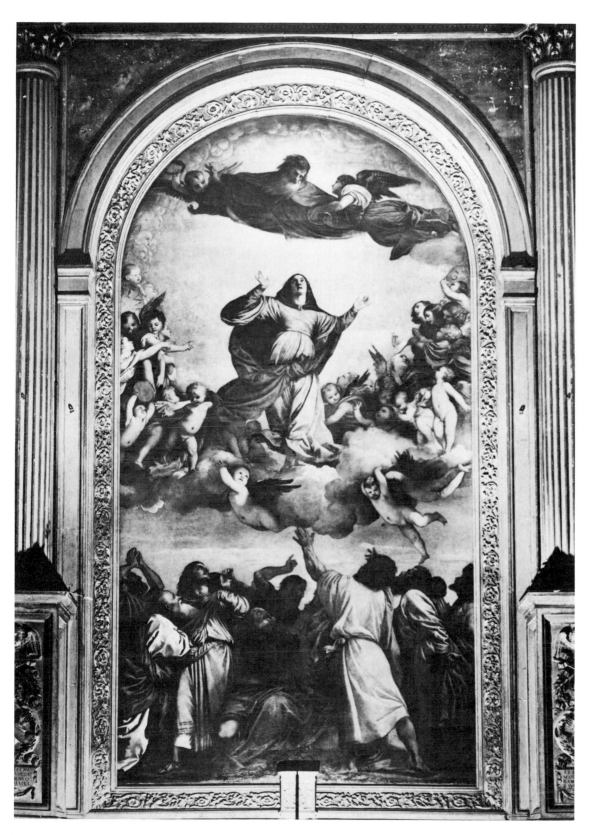

35. Titian, *Assunta*. Venice, Santa Maria Gloriosa dei Frari. (See also colorplate 2.)

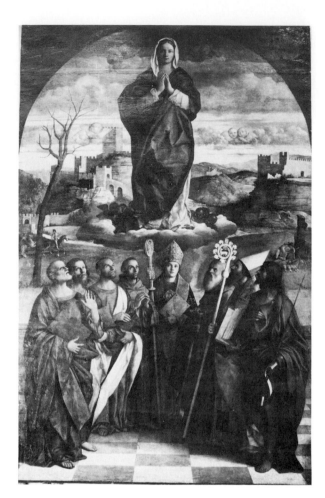

36. Giovanni Bellini and Workshop, *Immaculate Conception*. Murano, San Pietro Martire

Writing nearly a century after Dolce and without any overt reference to his account, Carlo Ridolfi offers a further commentary on the reception of the picture as well as some interesting details concerning its execution. Titian, he records, worked on the panel in the convent of the Frari itself, "so that he was disturbed by the frequent visits of the monks and especially by Fra Germano, guardian of the work, who complained that the Apostles were much too large; trying desperately to correct their ignorance, Titian sought to explain to them that the figures had to be proportioned to the vast space in which they were to be viewed, and that when seen from that distance they would appear in proper scale."[11] Now, while it is of course impossible to verify the particulars of Ridolfi's narrative, Fra Germano's protest would seem to corroborate the general tenor of Dolce's account and is certainly understandable in view of the picture's innovative qualities.[12] More significantly, Titian's supposed response, acknowledging the extraordinary scale of the figures, related directly to the very nature of the commission and the peculiarities of its architectural setting.

The church of Santa Maria dei Frari, completed in the early quattrocento, is a broad Gothic basilica on a Latin cross plan oriented to the

southwest (fig. 37).[13] In the apse the sixteenth-century high altar rises to the height of the arcade (fig. 38), and this juxtaposition of High Renaissance altar and Gothic setting must have posed a particular kind of challenge.[14] The stylistic conflict is partly reconciled by certain architectural adjustments; the altar, for example, fills the width of two bays and its cornice is aligned with the string course above the arcade. Within Titian's painting the golden circle of heavenly radiance containing the Virgin, God the Father, and the celestial choir corresponds to the upper zone of the arcade windows; the rectangular block of apostles below reaches to the height of the bottom zone of windows.

But a more difficult visual problem was posed by the glowing, dappled backdrop of windows and tracery against which the altarpiece was to be seen.[15] The breadth and simplicity of Titian's design and colors in the *Assunta* are calculated to establish a dominant contrast to the more delicate detail of the surrounding apse. Seen now with the aid of artificial light, the painting does indeed emerge triumphant from its busy environment, but it was evidently not always so effective. Vasari, for example, reports that the *Assunta* was hard to see; he blames this, however, on the fact that it was painted on canvas (it is, of course, actually on panel) and on its supposedly poor state of preservation.[16] While his reporting may be inaccurate in some rather fundamental details, Vasari's perception of the picture was apparently shared by later observers, for in 1650 permission was granted to open two large lunette windows above the ducal tombs on the presbytery walls in order to obtain better illumination for the painting.[17]

The bold geometry of Titian's composition was conceived with respect to other conditions of the site as well. In Ridolfi's biography the artist defends the enormous size of the figures by citing the space in which they must operate and the distance from which they are to be seen, and here too the details of the literary account seem to be verified by the work itself and its site. First of all, the dimensions of the panel, which is over twenty-two feet high (6.90 x 3.60 m.), do indeed require figures of a proportionally monumental scale. Secondly, the size of the altar is commensurate with the spaciousness of the Frari itself. Approaching the high altar along the nave of the church, one's vision is focused upon it from a distance through the open arch of a choir screen (fig. 39 and C in fig. 37). Constructed in 1475, this screen was one of the given factors of the site, and its arched aperture provided a scenographic frame for the *Assunta*.[18] Although the choir screen was a preexistent architectural unit, it was not just passively accepted by the designer of the altar. He actually utilized it, repeating, with some modification, the ornament of the screen in his own design; specifically, the gilded arabesque motif of the quattrocento arch is taken up in the arched frame of the altarpiece, thereby establishing a direct visual relationship between the two monuments.

The sculptural decoration of the reredos, understandably neglected in discussions of the Frari altarpiece, deserves some comment, for its iconography is in fact related to that of Titian's painting. Crowning the

37. Venice, Santa Maria
Gloriosa dei Frari. Plan
(after Paoletti)

triumphal arch of the architectural frame (cf. fig. 38) stands the figure of
the resurrected Christ, flanked by the primary saints of the church,
Francis and Anthony of Padua. In the center of the bottom cornice of the
frame itself is a small relief of the dead Christ attended by two angels.
Thus the theme of Mary's ascent from her tomb to heaven is com-
plemented by that of Christ's own Resurrection. The triumph over

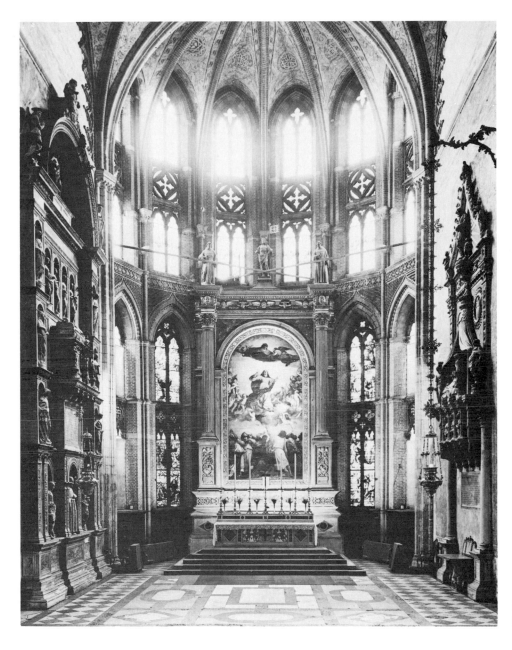

38. Venice, Santa Maria
Gloriosa dei Frari. Apse

death, explicitly articulated by details like the Victory figures in the
spandrels and implicit in the sacrificial bucrania in the entablature, is the
guiding idea behind the altar; like many of the preceding monuments in
the Frari, the high altar is based precisely on the concept of the triumphal
arch.[19]

The design of the Frari altar has been plausibly ascribed to Lorenzo
Bregno,[20] but one particular factor could not possibly have been the
decision of an early cinquecento stonecarver in Venice: the conception of
an altar painting on such a monumental scale. That daringly imaginative
choice must have been made by the painter himself, who, after all, bore
the final public responsibility for its effective realization. Indeed, it
seems evident that the very conception of the altar itself was an act of the

highest pictorial and, we might say, theatrical imagination, and the *Assunta* is so beautifully attuned to the various architectural considerations of the site that one feels compelled to attribute the basic idea of the entire monument to a single mind. Lorenzo Bregno may indeed have carved and gilded the stone, but very likely he was following the directions of Titian.[21]

2. IN THE FRARI, II: THE *PESARO MADONNA*

Titian's awareness of architectural settings and of the attendant problems of vision is still further revealed in his second Frari altarpiece, the *Madonna di Ca' Pesaro* (pl. 3, fig. 40), which graces the altar of the Immaculate Conception (D in fig. 37). On 3 January 1518 the altar was conceded to Jacopo Pesaro as the Pesaro family chapel in perpetuity; at the same time he was granted permission to erect his own funerary monument on the wall just to the right of the altar (fig. 41).[22] On April 28 of the following year Titian acknowledged the first payment for the altarpiece.[23] Payments continued until 27 May 1526, and the painting was in place by December 8, in time for the celebration of the Feast of the Immaculate Conception.[24]

The most striking feature of Titian's *Pesaro Madonna*, always cited in discussions of the picture's place in his oeuvre and its significance in the development of Renaissance painting, is the asymmetry of its composition, setting the Virgin and Child off center. With this bold and innovative design Titian liberated the conventional *sacra conversazione* from its obedience to iconic axiality and thereby further extended the range of potential movement and interaction within the realm of the altarpiece.

In theological essence, the *Pesaro Madonna* belongs to the same category of picture as Piero della Francesca's *Montefeltro Altarpiece* or Mantegna's *Madonna della Vittoria* (fig. 42), that is, the *sacra conversazione* with kneeling donor.[25] The situation informing this kind of image, the presentation of the worshipper to the divine object of his devotion, assumes a somewhat different pattern in another category of image to which we have alluded, the votive picture, in which compositional asymmetry traditionally played a role. The altarpiece, conceived *in maestà*, establishes a direct visual confrontation with the observer. The votive picture, on the other hand, most often in a horizontal format, presents rather a dominant profile view—as in Titian's earlier picture of Jacopo Pesaro presented to St. Peter by Pope Alexander VI (fig. 43).[26] Implicit in the structure of the votive picture, as we have already observed, is an equilibrium between narrative movement and iconic stasis, and these same poles determine the dynamics of the *Pesaro Madonna*. With its six portraits, this composition is indeed an altarpiece *cum* votive picture.[27]

The prominence accorded the members of the family assures them a significant role in the working of the composition as a cult image. Aligned parallel to the picture plane, they are seen essentially in profile, except for the illuminated face of the youngest Pesaro; turning to the observer, his face appealingly radiant, he effects the only direct psychological contact between painted world and reality.[28] The holy

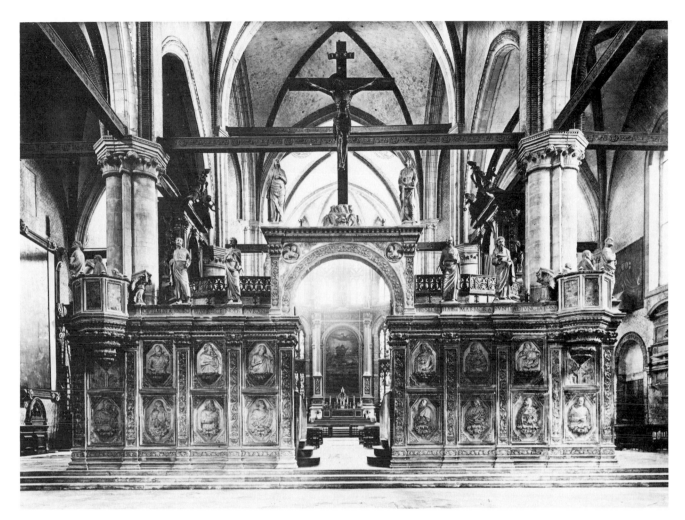

39. Venice, Santa Maria Gloriosa dei Frari. Choir screen

figures and saints are concerned exclusively with the adoring Pesaro, and it is through this patrician family that the outsider eventually gains access to the Virgin and Child.

Along the nave of the Frari there are no actual side chapels, enclosed independent spaces (fig. 44). The *Pesaro Madonna*, above an altar against the wall, is visible to an observer as he moves down the nave of the basilica toward the choir. And it is precisely this approach, previously considered by Titian in his conception of the *Assunta* on the high altar, that the composition of the Pesaro altarpiece recognizes. One's first encounter with the painting is from an angle (fig. 45), and the design itself is constructed to accommodate this oblique view. The vanishing point of the perspective construction lies beyond the frame of the picture to the left, indicating an ideal vantage point to the left rather than directly in front of the picture.[29]

Because of its site, then, the *Pesaro Madonna* must function both as a wall painting, continually visible from a variety of angles as one passes down the nave, and as an altarpiece, to be approached frontally on a

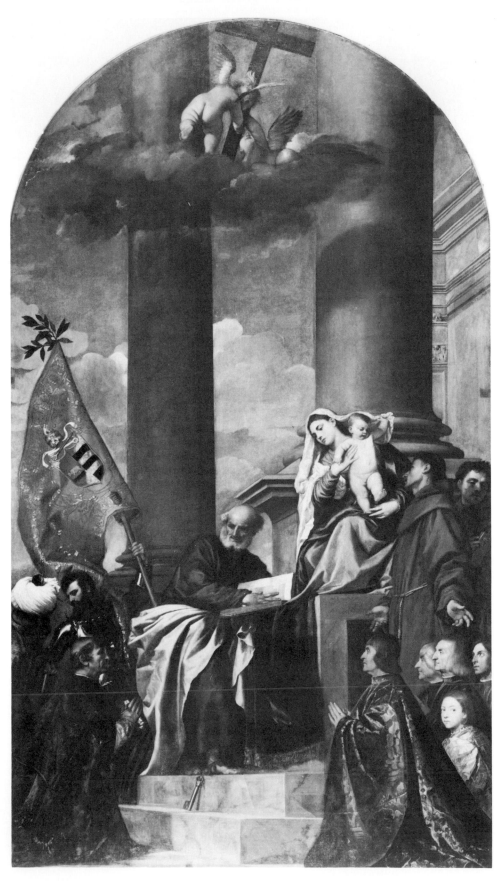

40. Titian, *Madonna di Ca' Pesaro* (after restoration, 1978). Venice, Santa Maria Gloriosa dei Frari. (See also colorplate 3.)

41. Venice, Santa Maria
Gloriosa dei Frari. Tomb
of Jacopo Pesaro

central axis when one worships at the Pesaro altar. As a wall painting, the
asymmetry and obliquity of Titian's composition render it accessible
from the left; the orientation of the steps to the Virgin's throne, rein-
forced by further architectural elements in Titian's first ideas for the
painting, invites entrance from the side. The holy figures naturally
follow this general arrangement. But the narrative sequence within the
picture functions with respect to a frontal approach, the viewer facing
the altar directly. The grouping of the Pesaro family—Jacopo Pesaro on
the left, the others on the right—subtly modifies the obliquity of the
spatial structure; the balance of the two groups creates a certain centrality
within the asymmetry of the design. Their profiled parallelism at first
establishes a barrier at the level of the picture plane—the surface tension
of which is broken only by the boy's face—but this simple tableau
parallelism is only apparent. The situation is significantly complicated by
the isolation of Jacopo Pesaro, whose location farther back in space than
his relatives leaves open an area of pavement, a space which affords the
first step into the painting from the oblique approach. Before the altar,
however, our own immediate involvement in the painting follows a
different direction, from right to left. Beginning with our encounter with

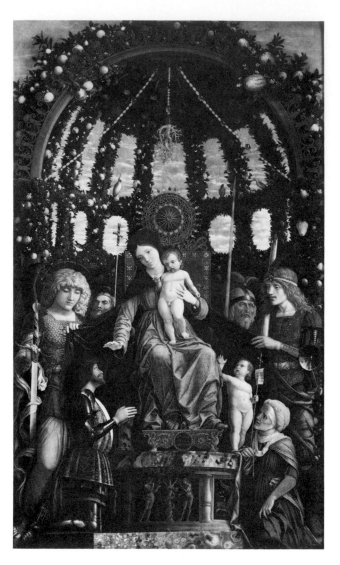

42. Andrea Mantegna,
Madonna della Vittoria.
Paris, Musée du Louvre

the youngest Pesaro, we look to the left with his elders to the leader of the
clan. Jacopo Pesaro, in turn, faces to the right, presented to the Virgin by
his special patron, St. Peter; this is the main dramatic action in the
painting, complemented on the right by the gesture of St. Francis, who
presents the rest of the family to the Christ Child. St. Peter occupies the
pivotal position in the design as the only figure on center; looking down
and to the left while moving toward the Virgin at the right, he is the only
one of the sainted figures completely open to the viewer. Out of this
large-scale contrapposto of action, gesture, and glance emerges a self-
contained dramatic situation which resolves the two different axial
imperatives in a synthesizing composition of extraordinary balance—
acknowledging all the while the validity of both.[30]

In the restricted space of an enclosed chapel an altarpiece is generally
perpendicular to the main axis of approach, and the movement of the
observer is controlled to some extent by the confines of the actual ar-
chitecture. The Pesaro altar, however, is actually parallel to the initial
line of approach, the longitudinal axis of the Frari itself, and, as we have

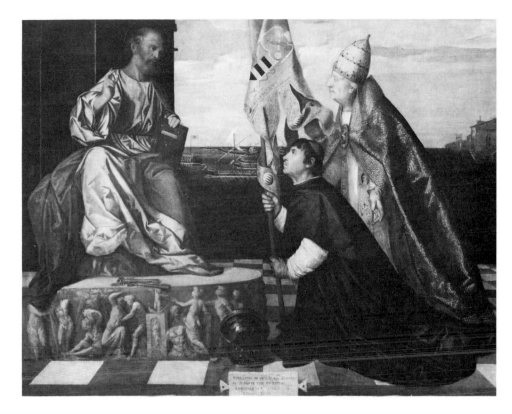

43. Titian, *Jacopo Pesaro Presented to St. Peter by Pope Alexander VI*. Antwerp, Koninklijk Museum voor Schone Kunsten

observed, the viewer enjoys a certain latitude of unrestricted movement. The dynamics of Titian's composition, then, are not a deliberate assault upon aesthetic and theological tradition but represent rather a response to the challenge of a particular site. His aim was to establish a rapport between the depicted space of the painting and that of the church, to affirm a spatial continuity under rather special, open circumstances.

The problem was evidently a difficult one, forcing Titian to test his ideas *in situ*. Not surprisingly, no drawings for this project have survived as testimony to the preparatory process, but the painting itself, like so many canvases by the Venetian master, actually reveals something of its own evolution.[31] Even this monumental altarpiece underwent the kind of radical modification in process that we tend to associate with Titian's later work, and the major problem clearly involved the architectural setting.

In 1877 August Wolf first observed that behind the columns of the *Pesaro Madonna* could be discerned the traces of a barrel vault springing from the wall at the right—which now supports nothing but blue sky.[32] More recently, X-ray investigation of the picture has brought to light still other architectural solutions tried and then abandoned by Titian as he struggled to create a setting that would satisfy his own sense of architectural as well as theological decorum.[33] Actively seeking and testing alternative solutions to the staging of the *Pesaro Madonna*, he pushed beyond the conventions of the traditional *sacra conversazione* to establish new models of sacred space. The determining context for this search, however, was defined by the initial decision to shift the Madonna and

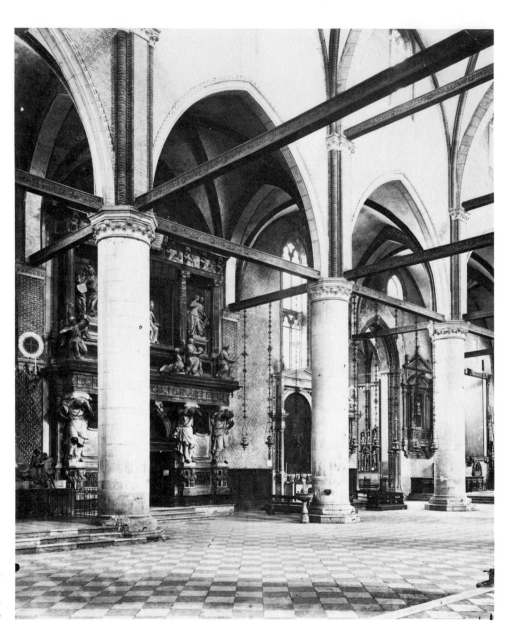

44. Venice, Santa Maria
Gloriosa dei Frari. Nave,
view toward the Pesaro
family altar

Child off the central axis to the right, a decision prompted, as we have
suggested, by Titian's own experience of the site, the space of the Frari
itself.

It has been possible to establish a relatively full reconstruction of one of
the master's first ideas (fig. 46), the vaulted setting first noticed by
Wolf—a segment of which was barely visible through the overpaint
between the wings of the angels. In this composition the *sacra
conversazione* takes place beneath a majestic vault that rises from the wall
behind the Virgin, not unlike the structure of the Treviso *Annunciation*
(fig. 47), which Titian had recently completed. In style and decorative
detail the setting is an extension of that of the surrounding architecture of
the altar. The wall to the right and the base of the Virgin's throne are of

45. Venice, Santa Maria Gloriosa dei Frari. The Pesaro family altar

Lombardesque design; their marble revetment, red Verona set in white, matches and continues the encrusted manner of the altar frame and of the neighboring tomb of Jacopo Pesaro.[34] Titian's composition, then, would have effected a union of real and fictive space by relating the actual architecture of the altar and the painted architecture of the picture. Hardly a radical innovation in itself, it continued, with significant modification, that earlier tradition deriving ultimately from Masaccio and best known in Venice in the altarpieces of Giovanni Bellini.[35] The earlier paintings, in which the depicted space of the altarpiece is conceived as a continuation of the chapel itself, maintain a fairly strict symmetry both in architectural setting and in the central placement of the holy figures, an iconic symmetry that generally followed the main axis of the chapel; more importantly, this symmetrical structure established a direct confrontation with the viewer, acknowledging and affirming an avenue of approach perpendicular to the picture plane.

The first modern scholar to work out this hypothetical reconstruction of the *Pesaro Madonna*'s early state and to suggest the terms in which Titian's altarpiece should be considered was Staale Sinding-Larsen. Stressing the importance of the votive component in the *Pesaro Madonna*, with its narrative emphasis upon the experience of the donor and his family, and viewing it as a radical rupture of the traditional relationship between worshipper and image, Sinding-Larsen interpreted the asym-

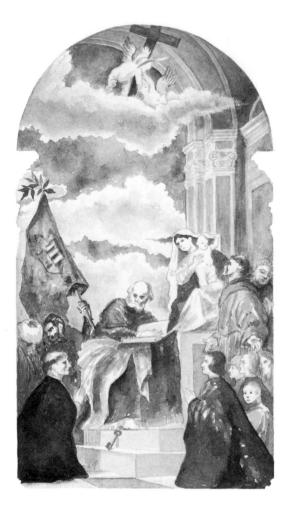

46. Reconstruction of an
early state of Titian's
Madonna di Ca' Pesaro

metry of the vaulted architecture as a reinforcement of the dramatic
autonomy of the picture, a further denial of access to the observer. He
writes,

> in the representations [in altarpieces] where a donor or a particular saint is
> presented to the enthroned Madonna, "modern" artists found an occasion to
> create a story which both by virtue of its self-containedness and by its drama-
> tic or momentary character emphasized the participation of the person pre-
> sented. When in Titian's *Pesaro Madonna* even the vault architecture was
> reoriented so as to disconnect the depicted room from the room of the church,
> this was the final step in transforming the altar-image into a window through
> which the events of another world could be seen.[36]

I would propose that Titian had designed this vaulted setting for pre-
cisely the opposite purpose, namely, to assure the apparent spatial
continuity between the two realms and to guarantee constant access, as it
were, to the fictive, holy space. Recognizing the mobility of the viewing
eye and its initial, oblique contact with the picture, Titian thought, in
effect, to open a transept in the side wall of the Frari.[37]

 This solution evidently failed to satisfy the artist, possibly because it so
abruptly and literally opened the wall of the church, and he continued to
explore other possibilities. The recent X-rays suggest that he tested a

design involving a backdrop of horizontal entablature of some form supported by two columns. Abandoning that idea—which may have seemed too insistent upon the frontal address of the picture—he returned to the focus upon the throne at the right: a great curtain was swept dramatically across the upper part of the field and dropped as a cloth of honor behind the Virgin. This, too, apparently failed to satisfy. Continuing his architectural explorations within the canvas, Titian began developing the concept of the two massive columns. In their first redaction they were crowned logically by great capitals. Finally, he extended those giant shafts beyond the frame so that their culmination was, implicitly, in heaven.[38]

Although set obliquely—and thereby softening, so to speak, the axial shift from the Frari nave to the picture's space—the columns represent more than an extension of Titian's thoughts on spatial continuity; this ultimate solution stands, in fact, as a truly radical revision of those ideas. Where his earliest composition had extended both the style and scale of the altar architecture into the painted scene, these columns seem deliberately to negate that rapport. Escalating to a level of incommensurability, they establish a new order, beyond the reach of the modest proportions of the Lombard surround. Their size has invited comparison with the great Gothic piers of the Frari itself, but that relationship is not sustained by stylistic affinity; although the very plastic presence of the columns, punctuating and defining the space about them, may recall the situation of those piers within the church (fig. 44), they proclaim a quite different architectural order. Instead of smoothly bridging the realms on either side of the picture plane, Titian evidently now sought disjuncture. Beyond measure, in effect, the two columns declare a new order of proportion for a heavenly architecture—even as they eclipse the remnants of the modest, polychromed Lombard style of the background wall and throne base, vestigial reminders of the architecture of the Pesaro altar and of Titian's earlier design.

The aggressive intrusion of the columns has been found disturbing at times, and eighteenth-century repaint, "correcting" Titian's perspective, may have exaggerated their anomalous position.[39] Crowe and Cavalcaselle, for example, had some reservations regarding the aesthetic propriety of the columns; although they resolved their doubts by a critical leap of faith, their response registers the impact of the proportional conflict:

> Far away from those humble conceptions of place which mark the saintly pictures of earlier times, the Pesari kneel in the portico of a temple, the pillars of which soar to the sky in proportions hitherto unseen. The Virgin's throne is raised to a platform, to which access is obtained by two high steps, and still the plinths upon which the pillars rest are as high as the Virgin's form and the die of the stone on which she sits, and the human shape is but a pigmy in those colossal surroundings. We might fancy that such a massive edifice on so large a scale would needs crush the figures and spoil them of their grandeur; but whoever should fancy this would misjudge Titian, who knew how to temper all this vastness and fetter the eye to the parts upon which it is

required to be fettered, on the group of the Virgin and her noble band of adorers.[40]

Against the coloristic activity of the polychrome architecture the columns do indeed appear quite incongruous in their monolithic gravity and colossal size. Moreover, they themselves have no evident function. Disappearing beyond the upper limits of the frame, they support nothing, nor do they give any indication of a natural termination. Seemingly a last, almost desperate gesture on Titian's part as he struggled with the composition, they dominate the field; their very prominence declares them to be invested with some special significance.

The traditions of theological literature offer a symbolic language capable of charging images with meaning, of turning description into interpretation. In the *Pesaro Madonna* the architecture, with its jarring juxtapositions, participates in, even as it stages, the devotional drama of the figures. Just as Jacopo Pesaro's prayer, mediated by St. Peter, is directed to the Virgin, so the path to the Madonna and Child is articulated by the steps of her throne. She is indeed the stairway to heaven, *scala coelestis:* "Mary is the heavenly ladder by which God descends to earth, so that through her, men who merit it ascend to heaven."[41] She is also the gate of heaven, *porta coeli,* and the two columns have been read, quite appropriately, as architectural signs of this epithet.[42] Literally rising to heaven, they lead us up to the descending cloud bearing the angels who hold the cross, symbol and means of salvation.

We assume that Titian must have determined the figural composition of the *Pesaro Madonna* at an early stage in its development and that the figure grouping served as an essential standard by which he judged the adequacy of the architectural housing.[43] On a basic level, as we have seen, the figures define the spatial structure and sequence of the design. Indeed, the off-center position of the Madonna and Child remains as the strongest declaration of the original notion and function of the composition as a wall picture—and, at the same time, sets up the diagonal relation across the surface between donor and deity. The figures play the crucial role in mediating the polarities of altarpiece and votive picture—ultimately, of humanizing the incommensurable scale of the heavenly architecture. Individually and collectively, their contrapposto and their dialogue guide us through the rich circuit of relationships. And our response to that complex—to the pivotal role of St. Peter, to the distributed attention under the shared veil at the apex of the group, to the quiet pleading of St. Francis (his gesture simultaneously revealing the signs of Christ's compassion for him and extending that to the Pesaro family), to the firm dedication of the victorious head of the clan[44]—engages us in that fictive world as surely as the perspective construction was intended to.[45]

On two levels, then, Titian's *Pesaro Madonna* transforms the traditional *sacra conversazione:* the spatial dynamics of its architectural asymmetry and the narrative impulse of its figural construct. Freed from the controls of iconic centrality—a liberation inspired, we must remember, by the

conditions of site—the altarpiece discovers a new rhetorical flexibility and, in its very functionalism, a new subtlety of affect.

The *Assunta* and the *Madonna di Ca' Pesaro* attest to the extraordinary range and precision of Titian's imagination, particularly as it responded to the challenge of fitting an image to a given site. Adapting his designs to the Gothic style and monumental scale of the Frari and to its patterns of traffic and illumination, the master found in each of those conditions not a limitation or restraint on invention but, rather, an inspiration. Each provocation led to innovation.

3. TITIAN'S LIGHT AS FORM AND SYMBOL

In addition to such challenges of architecture, however, he found as well within his own medium, within oil painting, another kind of challenge; and his response here yielded an increasing technical control over an essential expressive and formal constituent of his art: light. Already in the *Assunta* this control had enabled him to overcome the problems posed by the dappled light of the Gothic apse and stained glass of the Frari; and the achievement of that great panel reminds us of the traditions within which Titian was operating, the traditions of luminosity in Christian imagery and, more particularly, of its technical realization in the modern development of oil painting. Beyond the generation of Giovanni Bellini, we inevitably look back to the earlier fifteenth century, in the Netherlands: the art of Jan van Eyck raises issues of the interrelation of form and content, of technique and symbol, that are of immediate relevance to the interpretation of Titian's altarpieces.

Van Eyck had explored the suggestive world of religious symbolism and poetic metaphor but, simultaneously and as part of the same creative impulse, he explored and expanded the limits, affective and structural, of his own art of painting.[46] Indeed, in the art of Jan van Eyck the worlds are mutually dependent. The visual realization of the imagery of light occurred within the technical context of the development of the oil medium, a development that not only made possible the new pictorial iconography but that in turn surely received inspiration from the demands that iconography made upon the painter's imagination. The iconography of light became a function of the oil medium, and it is not surprising that the later development of oil painting continued to inspire painters to investigate the expressive potential of light—and of its inevitable corollary, shadow.

In the art of Titian, distant but definite heir to the Eyckian heritage as well as to the more immediate models of Giovanni Bellini and Giorgione, light assumes a particularly full and supple role. Titian expanded still further its significative range, increasing both its dramatic and symbolic weight and, as it were, elevating light to a monumental scale consonant with the powerful affect of his High Renaissance figures. As early as the *St. Mark* altarpiece (fig. 31), executed for Santo Spirito in Isola before 1510,[47] he began to investigate the potential of affective illumination. The shadow cast across the head of the patron saint of Venice gives concrete expression to a situation otherwise only symbolized by the assembled

saints in this modified *sacra conversazione*. The iconography makes it nearly certain that the altarpiece was commissioned in response to a plague: Cosmas and Damian, Roch and Sebastian are traditionally invoked during such a crisis, but the gloom falling over Mark dramatically suggests the specific situation, the ominous terror of the disaster befalling his own city, Venice. Although the architectural unit massed asymmetrically to the right of the composition is the apparent effective cause of that shadow, it hardly explains the reasons behind Titian's invention of the motif. Such explanation is afforded only by a reading of the image, recognizing the expressive function of the deliberate absence of light. Through such means Titian began his dynamic transformation of the traditionally stable structure of *pala* design and initiated as well his long concern with the emotional impact of light and dark. The romantic shadows falling suggestively over the eyes of Giorgione's young pastoral heroes offered Titian a fundamental expressive theme that he developed and to which he assigned a more active dramatic role: the shadow cast across the face became a sign of tragedy in his art—from the *St. Mark* altarpiece and the fresco of the *Jealous Husband* of 1511 through the Louvre *Entombment* of ca. 1525 to the later *poesie* of *Danaë* and the *Rape of Europa* and the Prado *Fall of Man*.[48]

Such drama, however affectively human in its pathos, depends in essence on shadow rather than light. For Titian, as for his predecessors, light itself evoked direct association with the divine, and in this traditional context it serves explicitly to distinguish the realms of earth and heaven in the *Assunta*. Above the solid rectangular block of apostles and the background of natural blue sky, Titian set the ascending Virgin Mary and the receiving figure of God the Father in a heavenly circle of gold, a supernatural chromatic field of divine geometric perfection. Like Raphael in the *Disputa* but even more so, Titian gives palpable reality to the ancient metaphor of the golden dome of heaven. We can more fully appreciate Titian's achievement by comparing it with a masterpiece of the preceding generation, Giovanni Bellini's *San Giobbe Altarpiece* (fig. 19). Bellini, too, had explored the visual potential of the concept, but his realization, the glowing mosaic niche (to which Titian would revert knowingly in his very late *Pietà*), is, so to speak, a literal transcription of the metaphor: the golden dome remains precisely that, the architectural symbol of heaven.[49]

The traditions of quattrocento realism and its so-called disguised symbolism[50] were never overtly rejected by sixteenth-century artists like Titian. Rather, that heritage, including both its conceptual structures as well as perceptual concerns, provided a basic pictorial language and visual poetics that continued to inform with deep meaning the increasingly dramatic naturalism of Venetian painting.[51] Light, in both its form-defining and symbolic functions, remained central to this experience, never losing its character as the carrier of divine significance that was its special role in the history of Christian art. And to this continuing tradition—which runs from the golden mosaics of Byzantium through the windows of the Gothic cathedrals and the subtle pictorial explora-

tions of the early Netherlandish masters to the profound radiance of Rembrandt—Titian contributed, literally, a new dimension.[52]

With remarkable and controlled imaginative energy, he extended his investigations into the expressibility of divine light. The *Annunciation* (fig. 47), possibly painted by 1519, for the Malchiostro Chapel in the Duomo of Treviso, finds its meaning within the peculiar spatial and luminous context of that chapel (fig. 48).[53] The iconography of the altarpiece is based on a traditional Marian epithet, the symbolic cloud: as Christ himself was the *Sol splendidissimus,* so his mother was likened to a cloud containing that brilliance; his birth was the emergence of the new sun from that covering. In the Treviso *Annunciation* the metaphor comes to life as "the light of the world" streams from behind the clouds to enter its new, temporary chamber, the tabernacle from which its divinity, incarnate, will shine forth.[54]

The Malchiostro Chapel was decorated with frescoes by Pordenone, and as Juergen Schulz has observed, "the apparition in the dome was shown moving towards Titian's altarpiece of the *Annunciation* and supplied the figure of God the Father that was lacking in the painting itself."[55] Within his own composition, however, Titian had already established the divine presence: accompanied by the angel Gabriel below, it manifests itself in the heavenly light emerging from the clouds. And yet the prominent shadow cast across the pavement cannot be caused by that light; its source must be off to the right and, by implication, on our side of the picture plane. It is hardly coincidental that this corresponds exactly to the only sources of illumination in the chapel, two windows in front of and to the right of the altar: one in the wall of the chapel, the other an oculus above the cornice (fig. 48). By the very structure of his design, Titian created a deliberate distinction between the two levels of light and by this clear contrast articulated the very quality of divine illumination. In the Malchiostro Chapel, then, he not only took into account the particular characteristics of the site but, organizing them with reference to his painting, gave them a new unity and significance.[56]

As in the Frari, Titian exploited the scenographic potential of the site. Indeed, throughout his career the painter would be concerned with what may be called structural decorum, that is, the proper adaptation of a picture to its architectural setting.[57] And in the experience of making such adjustments Titian discovered new expressive resources, which retain their original eloquence, of course, only when a painting can be viewed *in situ.*

At this point we can isolate still another challenge that evoked from Titian responses of great inventiveness: the challenge of the word. The traditions of Christian iconography depended heavily upon the verbal articulation, at once descriptive and interpretive, of the image—most often functioning as metaphor. Just how literally Titian could work with a given text can be judged with reference to his *Martyrdom of St. Lawrence* (fig. 49), completed about 1557 but begun nearly a decade earlier. In this nocturne, light itself becomes the true protagonist, and the entire composition assumes a complicated Manichean structure as light competes

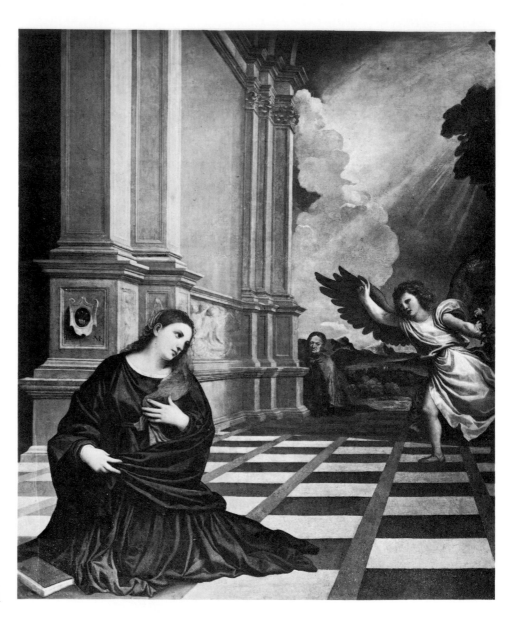

47. Titian, *Annunciation*.
Treviso, Cathedral

not only with darkness but with its own various manifestations as well. Vasari's enthusiastic description recognizes the peculiar moral dynamics of the picture, especially the triumph of heavenly light: "a flash, coming from heaven and cleaving the clouds, that vanquishes the light of the fire and that of the torches."[58] And Vasari's response to the painting aptly corresponds to the letter and spirit of Titian's literary source, the account of the martyrdom in the *Golden Legend:* "In that same night Lawrence was again brought before Decius. . . . Then every sort of torture was prepared for him, and Decius said to him: 'Sacrifice to the gods, or thou shalt pass the night in torments!' And Lawrence answered: 'My night hath no darkness: all things shine with light!' "[59] If Titian's *St. Lawrence* thus represents a remarkably faithful rendition of the text, we are forced to acknowledge the imaginative daring of such literalism. Again much like

48. Treviso, Cathedral. Malchiostro Chapel

Van Eyck, Titian read the text carefully and with purpose, and efforts to explain his nocturnal vision primarily with reference to the influence of earlier images such as Raphael's *Deliverance of St. Peter* hardly do justice to the master's powers of imagination.[60]

The *Annunciation* he painted for San Salvatore about 1560–65 (fig. 50) offers a further document of Titian's pictorial translation of textual sources. The particularly powerful explosion of heavenly light in this altarpiece may assume a special significance in the context of the words actually inscribed on the step below the Virgin: "IGNIS ARDENS ET NON COMBVRENS." Mary, who conceived and bore the child while retaining her virginity, is the burning bush that was not consumed (Exodus 3:2), and Titian's painting, in the violent incandescence of the holy presence, seems to exploit the energy implicit in the text. In deli-

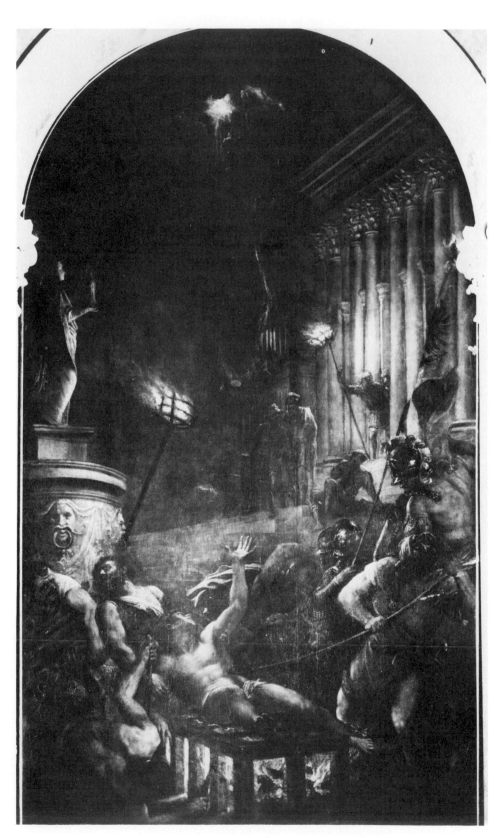

49. Titian, *The Martyrdom
of St. Lawrence*. Venice,
Church of the Gesuiti

cately fragile contrast to that heavenly eruption is the crystal vase with flowers poignantly set above the inscription, an image that more than any other recalls the pictorial iconography of Early Netherlandish painting.[61] Instead of the traditional lilies, however, Titian's vase contains a heavier plant whose petals seem to burst into flame. It is difficult to read with absolute precision the details of this motif, but that the effect was intended to represent the burning bush itself is made quite clear in Cornelis Cort's graphic translation of the picture (fig. 51), which was engraved under the master's close personal supervision.[62] Taming the wild energy of Titian's bold brushwork, the skilled burin reduces its suggestively ambiguous *macchie* to prosaic clarity: the plant, now a little tree, blooms literally into fiery flower.[63]

Through the perfection of the oil medium and techniques of glazing the early fifteenth-century masters were able to realize the expressive possibilities inherent in the imagery of theological literature, reversing the process, as it were, and transforming poetic metaphor back into a visible reality. Titian too found in his medium and in his knowing application of it—*il colorito alla veneziana*—a vehicle for such realization. And no more than in the case of Jan van Eyck's inventions can one assume that any theological advisor had a guiding hand in the conception of such imagery. Only the artists themselves could have recognized the pictorial potential of a text, and only through their close and imaginative reading could the word become paint.

The third altarpiece Titian designed for the Frari was never installed. Intended to stand above the altar where the master was to be buried, the *Pietà* (pl. 4, fig. 52) remained in his studio, unfinished, when he died on 27 August 1576.[64] The artist had made arrangements for a tomb at the Altare del Crocefisso in the Frari (F in fig. 37), in return for which he agreed to paint the altarpiece. The project seems to have been abandoned, however, possibly because the monks hesitated to tamper with that particularly venerated altar, the site of a miraculous Crucifix. For all this Ridolfi is our main source of information.[65] The earlier account of the so-called Anonimo del Tizianello makes no mention of the *Pietà* but notes that Titian was buried in the Frari against his own final wishes, which were that his body be interred in the Vecellio family chapel in Pieve di Cadore.[66] Whatever the painter's last request may have been, his earlier negotiations with the monks at the Frari were evidently widely known. Following his death, despite the fact that the plague was then raging in Venice, the revered master was given a public funeral, by special dispensation of the state, and was buried at the altar for which he had designed the *Pietà*.[67]

The elaborate obsequies planned by the painters of Venice on the model of the honors accorded Michelangelo by the Florentine *Accademia delle Arti del Disegno* were never realized,[68] and no public monument or even inscription is recorded until the eighteenth century. The mausoleum for Titian designed by Canova in 1794–95 was constructed

4. THE LAST ALTARPIECE

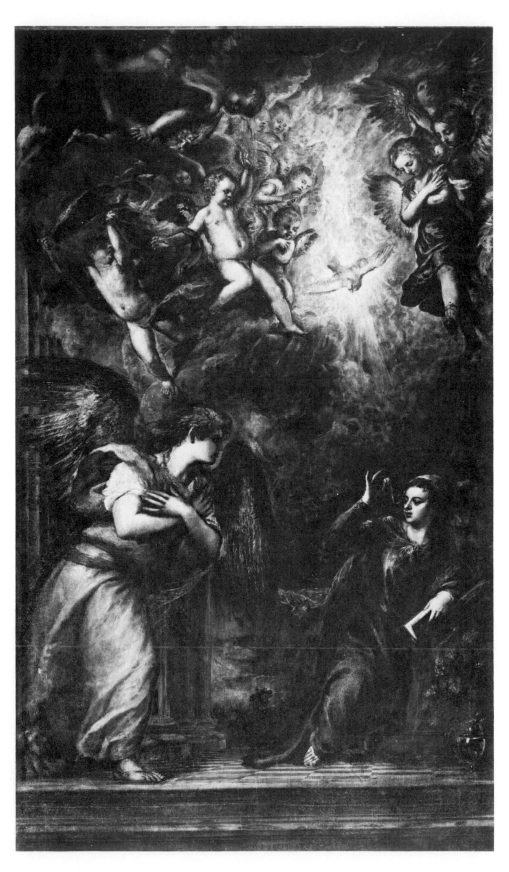

50. Titian, *Annunciation*.
Venice, San Salvatore

51. After Titian, *Annunciation.* Engraving by Cornelis Cort (detail). Washington, National Gallery of Art

only after the sculptor's death by his own followers, on the opposite side of the Frari, as a tribute to Canova himself.[69] Only in the last years of the eighteenth century was an epitaph inscribed on the pavement near the altar of the Crucifixion: "QUI GIACE IL GRAN TIZIANO DE'VECELLI/EMULATOR DE'ZEUSI E DEGLI APELLI."[70] Finally, in the mid-nineteenth century, the Cappella del Crocefisso was transformed by the present monument to Titian.[71]

The unfinished canvas of the *Pietà* was somehow acquired after Titian's death by Jacopo Palma il Giovane, who brought it to completion and added the inscription at the bottom: "QVOD TITIANVS INCHOATVM RELIQVIT/PALMA REVERENTER ABSOLVIT/DEOQ. DICAVIT OPVS."[72] This fact has often been cited as confirmation of Palma's close relationship to the aged Titian, but this in itself is something of a myth perpetuated by Palma himself and given wider circulation by Marco Boschini.[73] Although opinions have differed on the extent of Palma's participation in the execution, his hand is unmistakably evident in the rendering of the flying angel (fig. 53)—the only figure specifically mentioned in any of the older sources as being definitely by Palma.[74] Compared to the texture of the rugged but always intelligently structured brushwork of the old Titian, the rendering of Palma's angel appears hard; its contours are neatly drawn and its surface is smooth, owing to the unbroken transitions between light and dark and the shin-

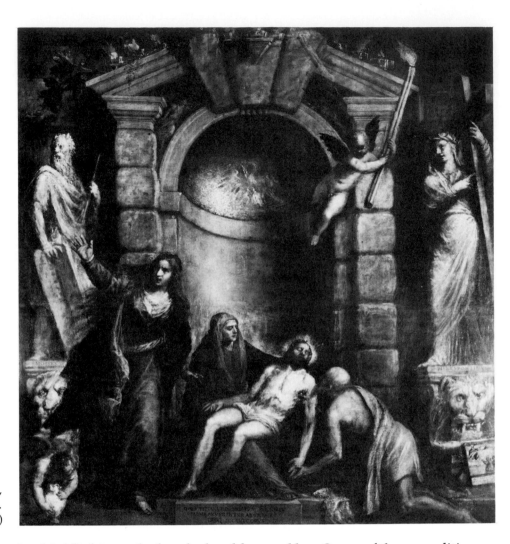

52. Titian, *Pietà*. Venice,
Gallerie dell'Accademia.
(See also colorplate 4.)

ing highlights on the head, shoulder, and leg. Some of these qualities are
shared by the statue of the Hellespontine Sibyl (fig. 54), whose physiog-
nomic features, moreover, recall those of figures in Palma's own work,
further suggesting that she too may have been modeled by the younger
artist's brush. The contrast between the relatively smooth chiaroscuro
modulations of the Sibyl and the powerfully suggestive manner of Moses
(fig. 55) seems to speak of more than just a difference between feminine
and masculine modes and may indeed summarize the stylistic polarity
present in the *Pietà*.

The question naturally arises, then, as to just how finished the canvas
was at the time of Titian's death. We know that the master worked on
paintings over long periods of time, keeping them in a continuous state
of execution, attacking them repeatedly, each time changing some part
or even the whole of the composition.[75] We may therefore assume that
when the *Pietà* came to Palma the entire composition was more or less
fully indicated. From the examples of other *abbozzi* by Titian we know
that such unfinished pictures, awaiting completion at a future date, were
often elaborately, if freely, painted and that the principal figures, at any

53. Titian, *Pietà* (detail)

rate, were completely established.[76] It is very likely that the *Pietà* was in such condition when Palma assumed the responsibility for its completion. The main group could hardly have been very different from its present appearance, and Palma's primary task was probably to fill in the details of the surrounding areas, which were, no doubt, more roughly painted. It is especially in the upper zones—the angel, the sibyl, and the architecture—that Palma's hand seems most clearly in evidence, smoothing over the personal texture and touch of Titian's brush.[77]

Obviously an artist like Palma faced an impossible challenge in attempting to follow the example of the old master's style, and in this he

54. Titian, *Pietà* (detail)

was confronted with the dilemma of all young painters seeking inspira-
tion at this particular source. Titian's later manner was not suitable to
workshop production; the culmination of a long lifetime devoted to
painting, it was not easily passed on to disciples.[78] If we may judge from
the stylistic dichotomy in the *Pietà*, Palma apparently recognized the
spiritual distance separating him from Titian, and, taking him at his
word, we may believe that he "reverently completed" the canvas, mod-
estly finishing the secondary areas while barely touching the last brush
strokes of the master.

Standing before the painting in the Accademia, one feels only the

55. Titian, *Pietà* (detail)

pictorial power and eloquence of Titian himself. The *Pietà* has justly been acclaimed as his own very personal artistic testament. An image climaxing and summarizing a venerable career, its art-historical recollections, so to speak, are indeed formidable. Most frequently cited are the transformation of a lamenting Venus from an ancient Adonis sarcophagus into a distraught Magdalen, and the response to the challenge of Michelangelo in the statues and in the central group of the Virgin and Christ.[79] Granting the significance of this dialogue with antiquity and with Michelangelo, we must recognize an even greater richness in Titian's language here. Toward the end of his life, as attested by other

works as well, he looked back over most of the sixteenth century to his own origins. If the late, also unfinished *Nymph and Shepherd* in Vienna is a reprise of an earlier Giorgionesque motif,[80] then the *Pietà* must be considered ultimately a homage by the aged Titian to the first genius of the Venetian Renaissance, Giovanni Bellini. Sanctified by the illumination of the niche's golden mosaics, the painting recalls Bellini's altarpieces for San Giobbe (fig. 19), the Frari sacristy, and San Zaccaria. For all its spiritual dynamism, Titian's *Pietà* may be said to relate more intimately to those *sacre conversazioni,* with their muted piety, than to any other altarpieces of the cinquecento. Despite differences of style and technique, both painters were deeply concerned with the pictorial realization of divine light. Whereas in the *Assunta* Titian had created a supernatural heavenly illumination, in the painting he intended for his own tomb he returned to a more humble mode, to the naturalistic metaphor of his great predecessor. And in this both artists in turn drew upon the moving experience of the glowing Byzantine domes of San Marco (fig. 20).

The self-consciousness revealed by this wealth of artistic reference seems quite proper in the context of a painter's final testament. It is frequently suggested that the kneeling figure of St. Jerome is a self-portrait, and despite the problems inherent in this sort of identification, its particular appropriateness here is impossible to deny;[81] like Michelangelo in the Florentine *Deposition,* Titian would approach his Savior directly. This pious old man is alternatively called Joseph of Arimathea, but the penitent's garb is hardly suitable to that follower of Christ. Moreover, such an identification assumes a historical specificity in the painting, but Titian's picture does not narrate an actual event following the Crucifixion; it is not a Deposition, a Lamentation, or an Entombment—historical situations in which the presence of Joseph of Arimathea (or Nicodemus) might be expected. The Pietà, by its very nature, does not deal with a particular event but represents rather an eternal moment, a theological epitome in which fundamental truths are manifested in an affective but ideal image. The beauty of the visual concept resides precisely in its synthesis of human pathos and liturgical symbolism.[82] In Titian's *Pietà* the saint kneels in veneration before the body of Christ with a humble piety that reminds us of his relation to a series of penitent St. Jeromes in Titian's oeuvre.[83] A further personal touch and the most poignant conceit in the composition is the small votive picture in the lower right corner; propped up against the Vecellio family arms, it depicts two figures, usually recognized as Titian and his son Orazio, in prayer before a vision of the very Pietà before which St. Jerome kneels—a signature, for all its personal pathos, as unobtrusively self-conscious as any of El Greco's.[84]

With its art-historical, personal, and internal references, Titian's *Pietà* assumes an extraordinary richness, for all this conceit contributes to its complex profundity. The composition seems to pick up and, once and for all, to silence the polemics of sixteenth-century art criticism. It might well be considered the last word in the *disegno-colorito* controversy, for the

Titian-Michelangelo conflict is here, in a certain sense, resolved. In Erwin Panofsky's words, "A lifelong rivalry, compounded of mutual respect as well as opposition, ended in a tribute paid by the survivor to his defunct antagonist—and doing honor to both."[85]

On another, related level, the painting can be read as a monumental *paragone* of the visual arts, uniting architecture, sculpture, and painting in a single image—naturally, under the reigning auspices of painting. Like Jan van Eyck, Titian demonstrated in his painting his own mastery of the other arts, and, also like Jan, he spoke their languages with great eloquence.[86] Every detail in the picture contributes to the total harmony of the image, fully confirming Fritz Saxl's recognition of Titian as "one of the greatest Christian humanists."[87] The statues of both seers, the Old Testament prophet and the pagan sibyl, are founded upon the bases of Divine Wisdom, symbolized by the lions.[88] Significantly, Moses holds both the tablets of the Law and a rod, the instrument with which he struck water from the rock, prefiguring the sacrificial blood of Christ. Thus, both he and the Hellespontine Sibyl, who holds a cross and wears a crown of thorns, prophesy the Crucifixion. The self-sacrifice of the pelican in the mosaic niche further symbolizes the sacrificial death below, while the Victory figures carved in relief in the spandrels trumpet the ultimate triumph over death.[89]

But the motif that most fully establishes the sacramental solemnity of the image is the rusticated monument crowning the Pietà; its grave presence proclaims the sacredness of the site.[90] With its broken pediment and massive keystone, this intriguing form protectively contains the luminous mosaic within its rough outdoor framework; its ponderous stability sets off the flickering of the half-dome and tapers as well as the volatile agitation of the Magdalen.[91]

In the balance between the symmetry of the centralized architecture and the narrative thrust of the figures lies an important key to the intended functioning of Titian's composition. Acknowledging the care with which he adapted his earlier Frari altarpieces to their respective sites, one can only assume that Titian gave similar consideration to the *Pietà*. The Cappella del Crocefisso for which it was designed, the second altar on the right in the Frari (F in fig. 37), is (or was) fully visible from an angle just a few paces from the entrance to the nave. Thus, like the *Pesaro Madonna,* diagonally opposite, the *Pietà* would have had to operate as both wall painting and altarpiece, and Titian's solution here is intimately related to that at the Pesaro altar. The liturgical centrality of the altarpiece derives from the symmetry of the architecture; that monumental niche containing the divine radiance and crowned by eternal lights is indeed a shrine before which the worshipper is to kneel in veneration.

Against the frontal symmetry of the setting, the figures in the painting form a compositional unit mounting along a diagonal to the left, from the humble St. Jerome to the outstretched arms of the Magdalen and ultimately including the powerful figure of Moses. The scalene triangle of this figural group bears a certain resemblance to the composition of the *Pesaro Madonna,* but here flowing in the opposite direction. The direc-

tional quality of this movement to the left is further reinforced by—indeed, one might rather say, is primarily stated by—the glances of the protagonists. The Magdalen and the two statues look out of the picture toward the left; her contrapposto most dramatically underscores this visual thrust. Access into the painting is initiated by the adoring figure of St. Jerome; the view of his back and the lost profile of his sharply featured face emphasize his entrance into the sanctified space. The aged Virgin Mary, displaying the sacrificed body of her son, turns to the right, toward the approaching Jerome. While the worshipper before the altar would have had a clear view of the body of Christ, the orientation of this central group is not primarily toward him. We are thus confronted with a dramatic-theological situation very much like that of the *Pesaro Madonna*, and I suggest that Titian's *Pietà* design responds to the same kind of challenges that inspired the earlier altarpiece.

The orientation of the figures is conditioned by the initially oblique view and approach of the observer. Within the internal context of the composition itself the orientation is toward St. Jerome—a relationship that further encourages interpretation of this figure as a self-portrait. The movement of the Magdalen's step and body, as opposed to her gesture and glance, is directed toward the approaching observer, and even the light, falling from the right, accentuates those surfaces meeting such an approach. The movement is from right to left, that is, toward the high altar of the Frari. Once again, the nave axis of the basilica is a major factor in the design.[92] Titian's use of an asymmetrical compositional format, in the *Pietà* as in the *Pesaro Madonna*, thus makes extraordinary sense with respect to the conditions and functioning of the site. Operating initially as wall paintings, both pictures respect the orientation of the space in which they were to be seen.[93]

Viewed in the context of its intended setting, Titian's *Pietà*, like his other Frari altarpieces, does indeed confirm that spatial aspect of his imagination, his awareness of the challenges and opportunities of a particular site. Remarkable in this instance, however, is the combination of architectural awareness with the open impasto of the master's late style, of such precision in planning with such looseness of execution. So completely do we accept the mimetic invitation of the surface of the *Pietà* that we hardly think of the structure behind it; yet even in this, his last altarpiece, so complex in its genesis and never quite brought to completion, Titian conceived his composition with the same circumspect intelligence that had shaped his first great altarpieces more than half a century earlier.

3

Titian's Presentation of the Virgin in the Temple and the Scuola della Carità

"In its primary aspect, a great picture has no more definite message for us than an accidental play of sunlight and shadow for a few moments on the wall or floor. . . ." Walter Pater's declaration of aesthetic autonomy in his essay of 1877, "The School of Giorgione,"[1] cites as its culminating example Titian's *Presentation of the Virgin in the Temple* (pl. 5, fig. 56). The sensibilities of the nineteenth century were in open sympathy with the sensuous delights of Venetian *colorito;* art, in Pater's words, is "always striving to be independent of the mere intelligence, to become a matter of pure perception." Such attitudes have shaped the modern appreciation of Venetian painting, for essentially we have continued to assume with Pater its "subordination of mere subject to pictorial design." This dissociation of "form" and "content," a barrier to our understanding of art in general and the art of the past in particular, has especially hampered our evaluation of Titian, and no work by that master has suffered as much in this process as the *Presentation of the Virgin.*

Nearly twenty-five feet in length, this canvas was painted between 1534 and 1538 for the site it still occupies, the entrance wall of the *sala dell'albergo* of the Scuola Grande di Santa Maria della Carità—since 1807 part of the galleries of the Accademia di Belle Arti of Venice (figs. 57 and 58).[2] Modern critics have usually recognized it as Titian's masterpiece of the 1530s, but the same critics (particularly Theodor Hetzer and Hans Tietze) have tended to regard that decade as a *détente* in Titian's creative life, a relaxation of inventive energies[3]—a decade, as Erwin Panofsky more recently summarized it, "dominated by a spirit of quiet observation and impassive order."[4] Following the remarkably powerful works of the preceding years of his career, years of supposed *Sturm und Drang,* Titian is said to have retired for a less heroic period of calm reflection devoted to the meditated refinement of his earlier stylistic achievements and to a certain indulgence of his own predilection toward naturalism.

Adduced as primary evidence of this slackening of inventiveness, the *Presentation of the Virgin* is recognized especially for the demonstrably conservative quality of its compositional scheme—which had in fact led the seventeenth-century biographer Carlo Ridolfi to list it among Titian's

56. Titian, *Presentation of the Virgin in the Temple.* Venice, Gallerie dell'Accademia. (See also colorplate 5.)

earliest works[5]—and for the carefully observed realism of its details. Indeed, admiration for the picture's naturalism and above all for its array of portraits has characterized critical response since the sixteenth century.[6] Following Ridolfi's identification (mistaken, as we shall see) of the two leading contemporary figures in the picture, writers have been investigating this portrait gallery in search of further identities; and, not unexpectedly, they have found names for the faces, including those of Pietro Bembo, Pietro Aretino, Titian himself, and his daughter Lavinia.[7]

This fascination eventually lent a peculiar, if not perverse, sanction to the nineteenth and twentieth centuries' appreciation of the picture's formal qualities and the resultant neglect of its iconography. "The real subject," observed Jacob Burckhardt in 1855, "is nearly overlaid by the crowd of accessory motives, which are indeed represented with astonishing freshness and beauty."[8] The old egg-seller in front of the stairs (fig. 80) has inspired more comment than any other single figure in the composition. Critics have been almost unanimous in acclaiming her coarse-textured reality,[9] and modern historians especially have rarely failed to trace her lineage back to earlier *vecchie* in the work of Carpaccio (fig. 67) and Cima da Conegliano (fig. 66). In his encyclopedia of Christian iconography Louis Réau cites her specifically to illustrate the progressive undermining of the basic theme of holy consecration in Renaissance depictions of the Presentation by the addition of nonsignificant, purely pictorial details.[10]

Even when modified by a stronger sense of the picture's compositional structure, recognition of its naturalism remains an essential ingredient of critical opinion.[11] The *Presentation of the Virgin*, like other paintings by Titian of the 1530s, appears somehow to be truly the sum of its parts.

Plate 1. Giovanni Bellini, *San Giobbe Altarpiece*. Venice, Gallerie dell'Accademia

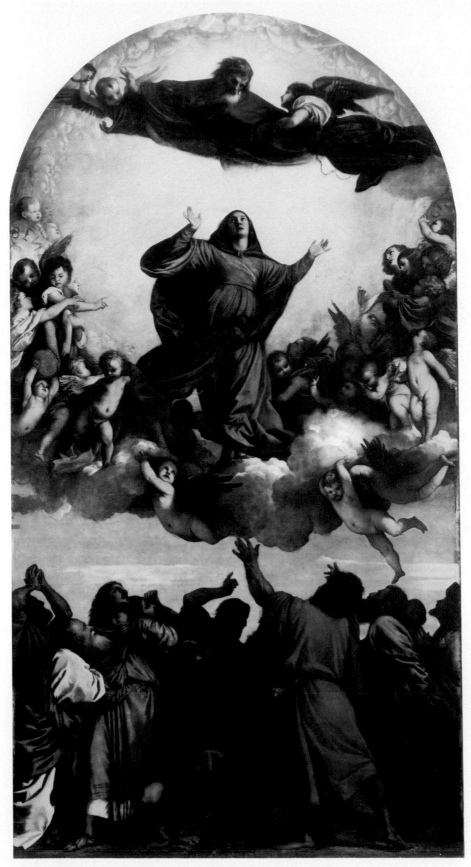

Plate 2. Titian, *Assunta*. Venice, Santa Maria Gloriosa dei Frari

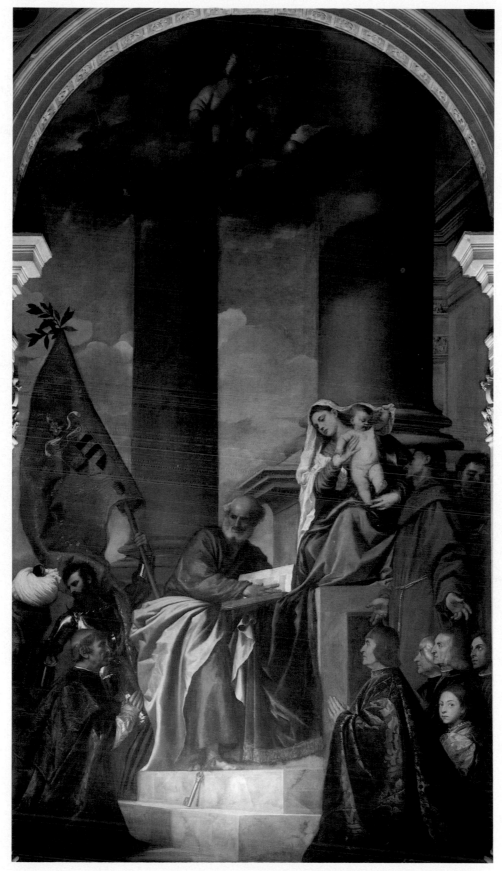

Plate 3. Titian, *Madonna di Ca' Pesaro* (after restoration, 1978). Venice, Santa Maria Gloriosa dei Frari

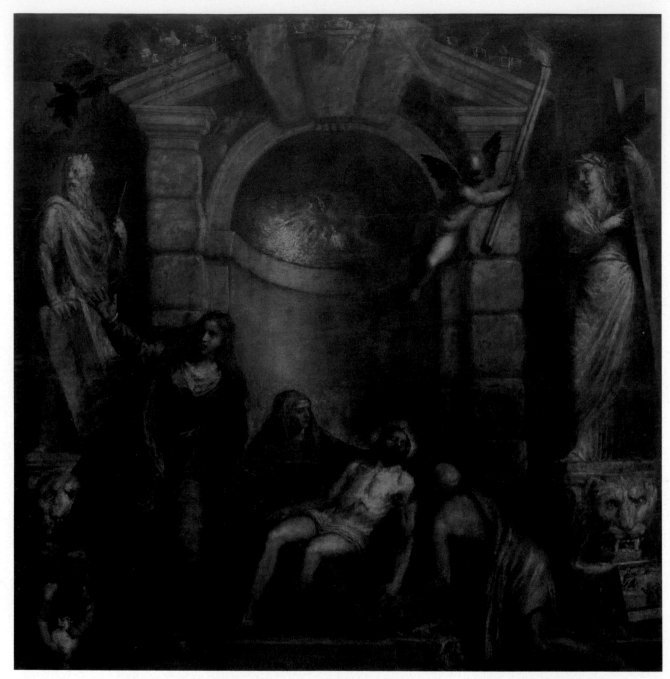

Plate 4. Titian, *Pietà*. Venice, Gallerie dell'Accademia

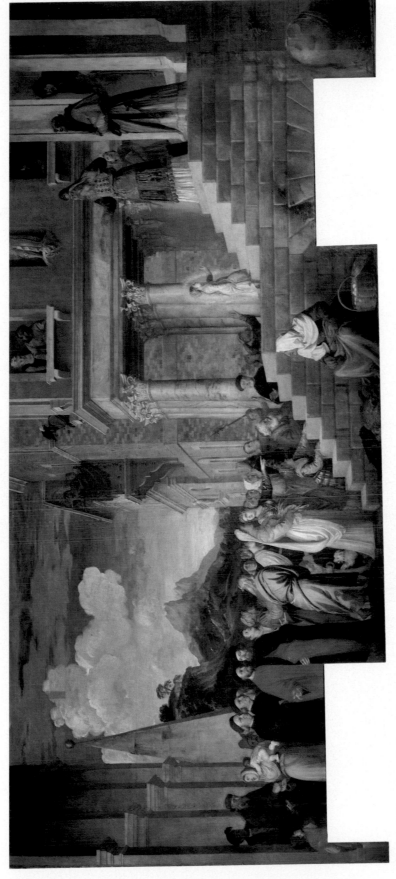

Plate 5. Titian, *Presentation of the Virgin in the Temple* (after restoration. 1980). Venice, Gallerie dell'Accademia

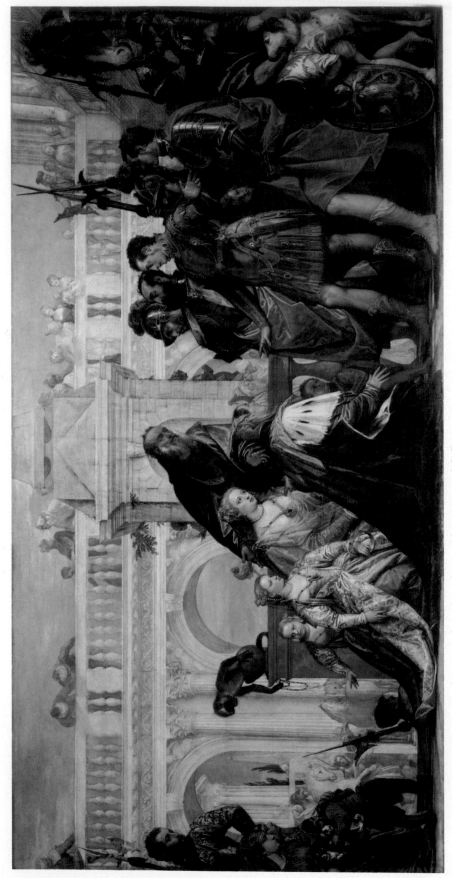

Plate 6. Paolo Veronese, *The Family of Darius before Alexander*. London, National Gallery

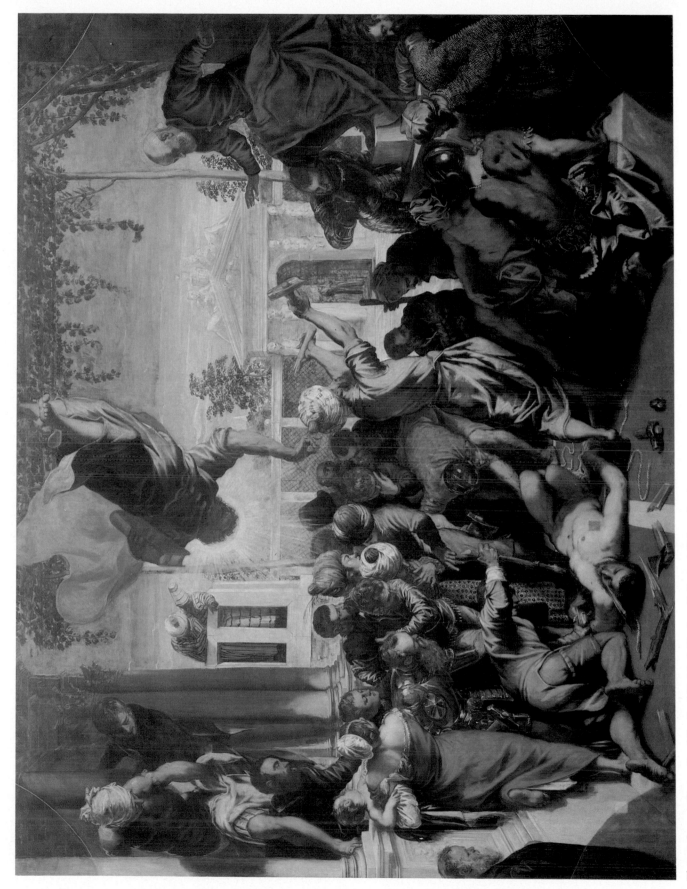

Plate 7. Jacopo Tintoretto, *Miracle of St. Mark*. Venice, Gallerie dell' Accademia

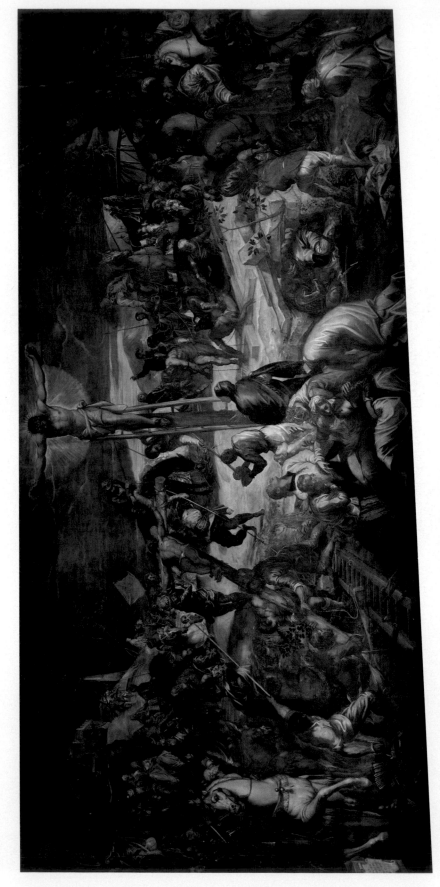

Plate 8. Jacopo Tintoretto, *Crucifixion*. Venice, Scuola Grande di San Rocco

57. Venice, Accademia di Belle Arti

Finding Paul Frankl's concept of "additive" an apt characterization of Titian's work of this period, Panofsky (who, of course, did not discount iconography) writes that "the huge surface is . . . organized by verticals and horizontals and . . . such details as the horrid egg woman sitting in front of the stairs or the onlookers enframed by windows strike the beholder as selfcontained genre pictures while the dignitaries approaching from the left form a detachable, isocephalous group portrait."[12]

Hetzer's perceptive and influential analysis emphasized the function of color as the great unifying element in the composition.[13] No longer bound to the objects depicted but applied in free, grand strokes, colors assume a certain independence; by their complex modulations and interwoven distribution across the canvas they provide a fundamental

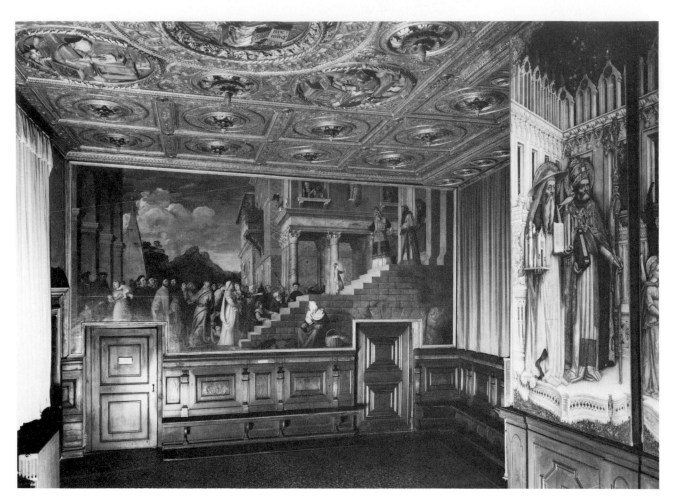

58. Venice, ex-Scuola Grande di Santa Maria della Carità (now Gallerie dell'Accademia). *Sala dell'albergo*

large-scale unity. Although this structural approach affords an important antidote to the traditional anecdotal fascination with the *Presentation*'s links to actuality, Hetzer's exclusive concern with style also has the effect of fragmenting comprehension. His analysis, not unlike earlier appreciations, ultimately shares Pater's assumption that "mere subject" is subordinate to "pictorial design."

In the following pages we propose to take a new look at Titian's painting, to consider it on its own terms, the details of the composition as well as its broader contexts: the nature of the patronage that caused it to be made and, hence, the social function of the picture; the position of the image within the history of its type; the relationship of the painting to its physical site and to the conditions under which it was to be seen. These, in addition to the questions of subject and of the artist's own development, define some of the essential dimensions of the picture's existence; they determine and in turn are revealed by the painting's form.

Founded in 1260, the Scuola di Santa Maria della Carità was the oldest and wealthiest of the Venetian *scuole grandi,* the lay brotherhoods devoted to acts of piety and charity, whose origins, as *scuole dei battuti,* go back to the flagellant movement of the mid-thirteenth century.[14] These confraternities, along with similar, smaller *scuole*—guilds and associations of national groups within Venice that also catered to the spiritual as well as economic and social needs of their members—constituted one of the most fundamental means of organizing the nonpatrician population of the city. Through the confraternities the citizens of Venice participated in the republic's political and social life, membership in such institutions defining their role and position within the fabric of society. The civic function of the confraternities, which will offer a key to interpreting aspects of Titian's *Presentation of the Virgin,* involved various services to the state—from supplying men for the militia and galleys to caring for the sick and indigent. Charity, however, was the primary concern of the *scuole* and particularly of the Scuola di Santa Maria della Carità, whose *mariegola,* or statutes, affirmed this principle: "Our fraternity originated from the greatest love and affection for our fellowman and is named after the glorious and honored name of the major theological virtue, charity, in which is the faith of God."[15] Acts of charity provided an ideal means toward the salvation of the souls of the brothers.

The contribution of the *scuole* to the public pageantry of Renaissance Venice is most immediately documented for us by Gentile Bellini's well-known painting of the *Procession in Piazza San Marco* (fig. 59), part of the cycle originally decorating the walls of the Scuola di San Giovanni Evangelista.[16] In the course of the fifteenth and sixteenth centuries the *scuole grandi* became as renowned for their architectural magnificence and internal embellishment as for their charitable activities: "How necessary and appropriate to mortal men is the adornment of the tabernacle of omnipotent God and of the most glorious protectress, mother of Charity, Our Holy Lady Mary, cannot be expressed with words."[17] Following this typical preamble, the Scuola della Carità records its decision of 6 March 1538 to continue the decoration of its *albergo* after the completion of Titian's picture.

The architectural structure of most of the *scuole grandi* followed a basic layout: the main rooms were the large *sala del capitolo* or *delle riunioni* and the smaller *sala dell'albergo* (fig. 58).[18] The former, as the names imply, was intended for meetings and functions including the entire chapter or brotherhood. The smaller room was the business or nerve center where the governing board of the *scuola,* the *banca,* plus the additional officers of the *giunta* (*zonta* in the Venetian dialect), met, and where the important documents and other valuables, such as relics, were preserved; there all decisions were made and there charity was disbursed.[19] Both rooms normally contained altars.

The Scuola della Carità erected its *casa grande* on land acquired from and adjacent to the church and monastery of Santa Maria della Carità in 1343. The *sala dell'albergo* was originally constructed in 1384 and ex-

1. SITE: THE SCUOLA DELLA CARITÀ

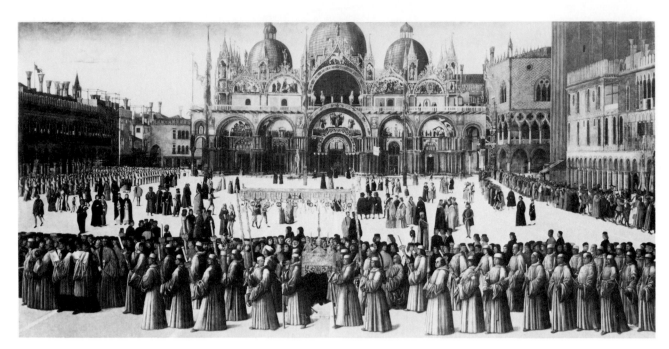

59. Gentile Bellini, *Procession in Piazza San Marco.* Venice, Gallerie dell'Accademia

panded to its present irregular form in 1442–44, situated rather casually between the *casa grande* of the Scuola and the contiguous church, above the entrance to the *cortile* shared by the confraternity and the monastery (fig. 60). In 1491 the construction of an attic, the *cancelleria* above the *albergo,* completed the basic fabric of the Scuola.[20]

The *albergo*'s earliest extant pictorial decoration is the signed altarpiece by Antonio Vivarini and Giovanni d'Alemagna, dated 1446 (fig. 16).[21] The carved polychrome ceiling (fig. 61), installed in the later fifteenth century, was certainly reworked in some way following the construction of the *cancelleria.*[22]

Although it was evidently the desire of succeeding *guardiani e compagni* to continue the pictorial embellishment of the expanded *albergo,* not until 1504 was a further effort made.[23] The Scuola was then able to commit a sum of 170 ducats toward the decoration of the room. On 20 January 1504, the brothers recorded their intention to order a canvas for the entrance wall of the *albergo,* to go over the door: its subject was to be "in praise of Our Lady," depicting "how she was offered in the temple."[24] A competition was held and the commission awarded to a little-known painter, Pasqualino Veneto, whose design was judged "much better than the others that have been entered." We know nothing further about this competition, unfortunately, not even the names of the other contestants. Before he could carry out the work, however, Pasqualino died.[25]

For thirty years the project lay dormant, the money for it invested, and the entrance wall of the *albergo* evidently remained bare. Not until 29 August 1534 was the idea revived; on that day the decision was taken to commission "such painting and decoration as are required for the dig-

60. Venice, Scuola Grande di Santa
Maria della Carità. Plan of the *piano nobile:*
(A) *sala dell'albergo,* (B) *sala del capitolo,*
(C) *cortile,* (D) church, (E) monastery

nity of our *albergo* and as are to be seen in the other *alberghi* of the *scuole
grandi* of this most illustrious city."[26] It is fairly characteristic that the
Scuola della Carità was responding to the challenge of other *scuole,* for
the competition among the confraternities was indeed keen; in fact,
precisely in the final months of 1534 the Scuola di San Marco was
recording the completion of its own *albergo* decoration.[27] Although the
officers of the Carità determined to consult with "sufficient and famous
painters," there is no evidence that a new competition was actually held
in 1534. All we know is that by 6 March 1538 the documents refer to the
painting "already executed by the excellent master Titian,"[28] and this is
the only reference to the painter in the preserved documents. We may
surmise, nonetheless, that Titian was actually engaged in planning the
work by 2 February 1535, for an entry of that date is concerned with the
problem of illumination for the painting.[29]

We know that the Scuola della Carità kept Pasqualino's prize-winning
design of 1504, for which the deceased artist's brother was paid, and it
would be typical of Venetian conservatism if, even thirty years later,
Titian were required in some way to base his own composition on the
older model or at least to take it into consideration.[30] At any rate, his
Presentation of the Virgin does indeed recall a rather archaic type of
Venetian mural decoration, the narrative tableau; this type was the
essential compositional unit of the decorative cycles of the Venetian
scuole from the later quattrocento—preserved for us especially in the
teleri from the Scuola di San Giovanni Evangelista (fig. 59) and in
Carpaccio's from the small Scuola di Sant'Orsola (figs. 25–27).
 The use of canvas as a support for large-scale murals, an invention of
Venice, and most celebrated in the Ducal Palace, was a response to the

**2. PICTORIAL
TRADITION**

61. Venice, ex-Scuola Grande di Santa Maria della Carità (now Gallerie dell'Accademia). Ceiling of the *sala dell'albergo*

failure of fresco to withstand the damaging effects of the constant humidity of the Venetian climate.[31] Monumental history painting of the Venetian Renaissance developed in such a context and under such circumstances, and it is important to recall here the fundamental distinction between Venice and central Italy, where the great tradition was in painting *al fresco*. In Florence or Rome a painter decorating a room in fresco might design the articulating and enframing architectural detail as well as the pictorial compositions contained within, and all would be painted on a common surface of plaster; thus the artist could exercise control over the entire decorative scheme.[32] In Venice, however, the painter generally contributed to an already conceived wall space; his canvas was commissioned and executed only after the room was completed and, in most cases, already given its architectural ornament.[33] Bounded below by the high dado paneling and above by the cornice of the ornamented ceiling, the canvas received from the surrounding wooden architectural decoration an elaborate three-dimensional framework (fig. 58). The en-

tire impression is, needless to say, quite different in tone as well as
structure from mural decoration in fresco.[34]

The format of the pictorial fields, often long horizontals, no doubt
contributed significantly to the development of an aesthetic common to
most *teleri* painted for the Venetian *scuole*. The insistent narrative quality
of these compositions is perhaps their most distinctive feature, especially
important since the cycles usually did unfold stories in chronological
sequence. To maintain the continuity of narrative flow, the figures are
kept immediately behind and parallel to the picture plane; deep spatial
recesses may serve as backdrops, but such spaces are, as it were, func-
tionally ignored. The eye is held to the surface, and as it moves along
these individual processional friezes and then from canvas to canvas, the
resulting sequence establishes a decorative unity as well as a directional
impulse.[35]

The very nature of the theme of the Presentation of the Virgin, with its
pious procession, suited it particularly for this sort of depiction. Like so
many aspects of Venetian painting in the early Renaissance, the first
statement of a monumentally conceived *Presentation* is to be found in the
drawing albums of Jacopo Bellini (fig. 62). Here we already encounter,
albeit without the crowded pageantry, a tableau narrative unfolding
parallel to the picture plane, established by the elaborate architecture,
reading from left to right and culminating in the Virgin's ascent of the

62. Jacopo Bellini, *Presentation of the Virgin in the Temple.* London, British Museum

stairs.[36] A similar structure informs the Uffizi drawing generally attributed to Carpaccio (fig. 64)[37] and, on a less monumental scale, the same artist's canvas painted about 1504 for the Scuola degli Albanesi (fig. 65).[38]

Another rendering of the subject, by Cima da Conegliano (fig. 66), although less insistently linear in its structure, is frequently cited as containing *in nuce* the fundamentals of Titian's composition—particularly the combination of landscape and architectural setting and the old woman with the basket of eggs at the foot of the temple stairs.[39] But, as we have already had occasion to note, the latter motif can be found in other tableau compositions, especially by Carpaccio (figs. 25, 67), and the double setting itself is also a common feature of Venetian *teleri* (cf. fig. 71).

Evidently there existed in Venice a traditional compositional solution to the subject of the Presentation of the Virgin, a solution inspired by the iconographic requirements of the procession culminating at the grand staircase as well as by the formal conventions of Venetian mural decoration, the tableau aesthetic. The situation is rather complex, however, and it is not easy to discern clearly the chronological priorities within the development. On the one hand, the pageantlike character of the Venetian Presentation of the Virgin may well derive ultimately from Byzantine models, in which the procession always played an important role.[40] (The more centralized and spatially involved compositions of the Tuscan tradition in the trecento—for example, Giotto's fresco in the Arena Chapel [fig. 68] or Taddeo Gaddi's influential design in Santa Croce [fig.

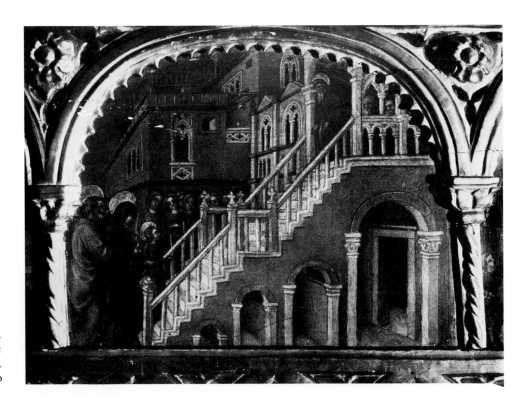

63. Jacopo Bellini,
*Presentation of the Virgin in
the Temple.* Brescia,
Sant'Alessandro

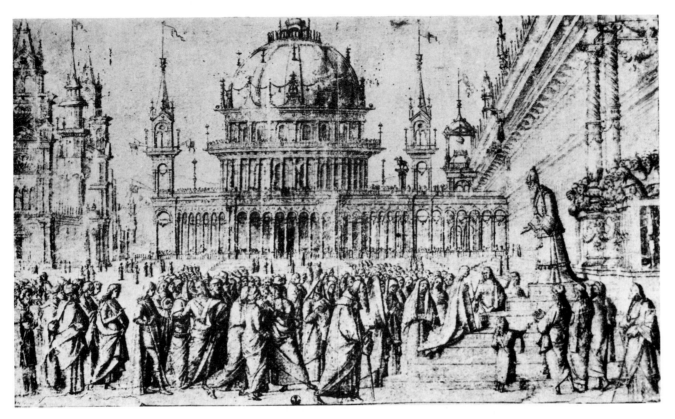

64. Vittore Carpaccio, *Presentation of the Virgin in the Temple.* Florence, Gabinetto Disegni e Stampe degli Uffizi

69]—offer a contrasting alternative.)[41] On the other hand, however, those same processional qualities inform nearly all monumental narrative painting in Venice.

To illustrate the complexity of the situation more precisely, we may consider the repoussoir motif of the old woman before the stairs, to whose significance we shall be returning further on. She seems to make her earliest Venetian appearance in Carpaccio's *Reception of the English Ambassadors* of about 1496 (fig. 67) and then reappears in depictions of the Presentation of the Virgin such as those by Cima and Titian; as we shall see, however, the *vecchia* does figure in the Presentation before Carpaccio, and, interestingly, within the Tuscan rather than Venetian tradition (fig. 70).[42]

Furthermore, the structural formulae of a painting like Carpaccio's *Ordination of the Deacons* from the Scuola di Santo Stefano (fig. 71) seem to derive directly from the compositional conventions elaborated in pictures of the Presentation; it is conceivable that this composition of 1511 may reflect the structures of the Presentation—including the typically located *vecchia*—precisely because its own iconography of dedication to the Church parallels that of the Virgin's Presentation in the Temple.[43] Perhaps more than any other of the *teleri* we have adduced, Carpaccio's Santo Stefano canvas seems to anticipate Titian's in the Scuola della Carità from a purely formal point of view. In Carpaccio's

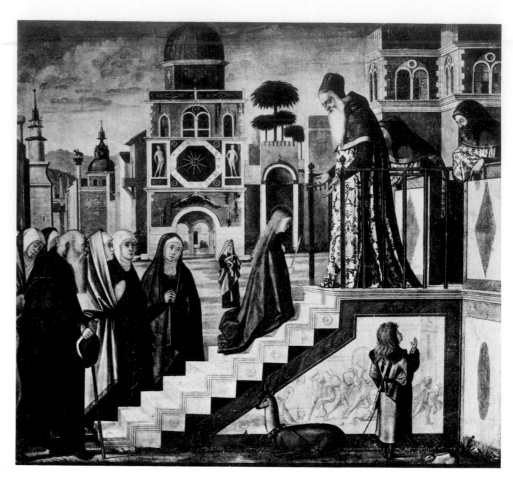

65. Vittore Carpaccio,
*Presentation of the Virgin in
the Temple.* Milan,
Pinacoteca di Brera

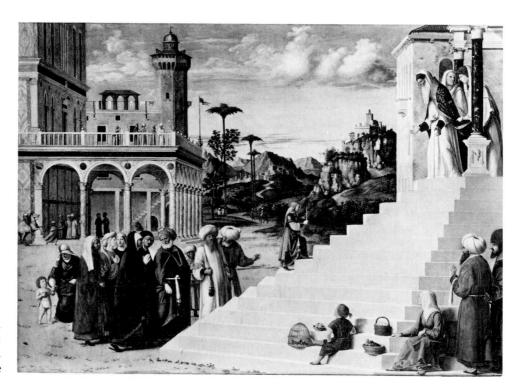

66. Cima da Conegliano,
*Presentation of the Virgin in
the Temple.* Dresden,
Gemäldegalerie

67. Vittore Carpaccio,
*Reception of the English
Ambassadors* (detail).
Venice, Gallerie
dell'Accademia

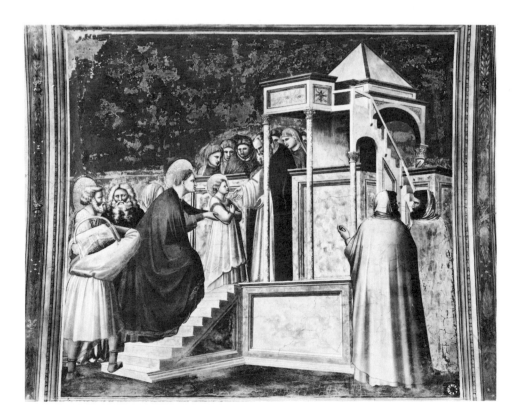

68. Giotto, *Presentation of
the Virgin in the Temple.*
Padua, Arena Chapel

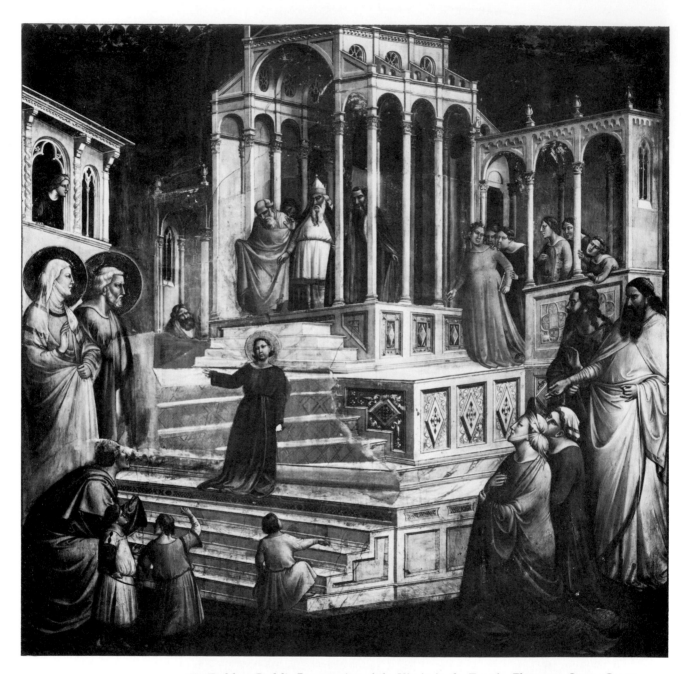

69. Taddeo Gaddi, *Presentation of the Virgin in the Temple.* Florence, Santa Croce

painting we are also confronted by the older master's attempt to deal with the new archaeology, trying to create a genuine antique *ambiente* by incorporating Roman monuments such as the Castel Sant'Angelo, the little temple, and the obelisk in the background. The combination of landscape and classicizing architecture is obviously relevant to Titian's painting.

Another comparison may further underscore the essential continuity of this Venetian tradition. Peruzzi's fresco in Santa Maria della Pace in Rome (fig. 72), closer in date to Titian's painting than any of the other

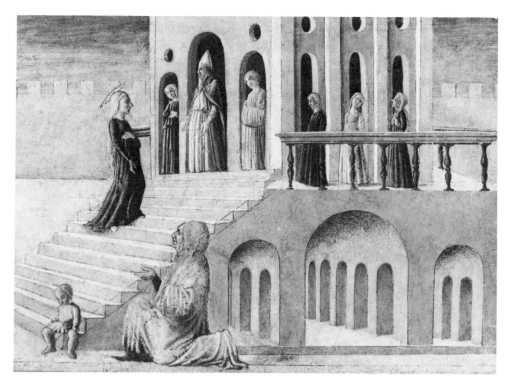

70. Anonymous Tuscan painter, *Presentation of the Virgin in the Temple*. Milan, Collection Saibene

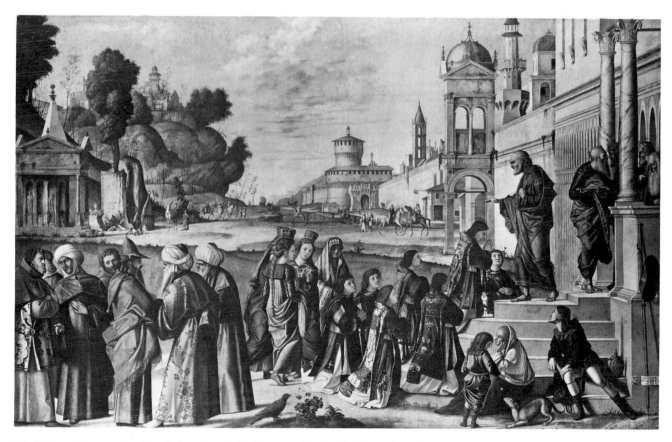

71. Vittore Carpaccio, *The Ordination of the Deacons*. Berlin-Dahlem, Staatliche Museen

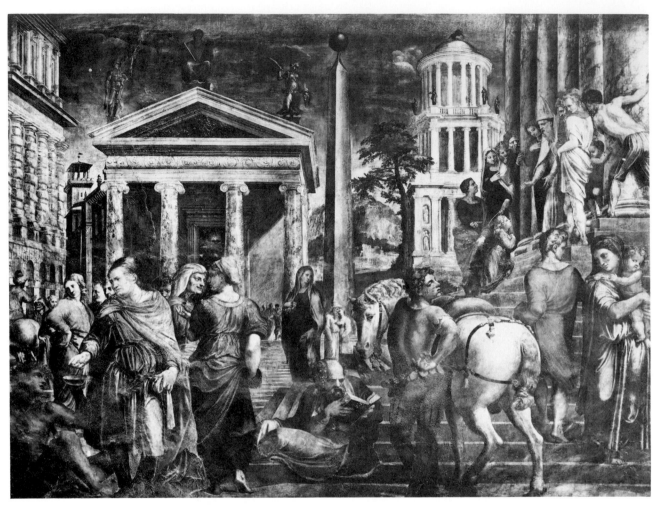

72. Baldassare Peruzzi, *Presentation of the Virgin in the Temple.* Rome, Santa Maria della Pace

examples thus far cited,[44] resembles it in a superficial way in that the action climaxes at the grand staircase to the right. But the Roman composition, located high on one wall of an octagonal space, is not allowed to follow a simple narrative line; the flow is interrupted by the prominent architectural monuments, especially the obelisk intersecting the design.[45] Moreover, the significant action occurs in the middle ground, behind a series of foreground figures, who, by their poses, create a number of independent sculptural units rather than a friezelike continuity. The entire spatial setting of Peruzzi's architectural re-creation of antiquity is a full, three-dimensional stage space with a deliberately marked gridwork pattern measuring the recession of the pavement.

Such perspective scenes had no functional place in the traditional Venetian tableau composition. That tradition itself, however, was modified in the course of the cinquecento, in particular by central Italian influences for which Peruzzi himself was in large measure responsible, through his follower, Sebastiano Serlio.[46] Paris Bordone's *Consignment of the Ring to the Doge* (fig. 73), painted for the *albergo* of the Scuola di San

Marco, of a somewhat different format from the *teleri* we have been discussing, represents an attempt to reconcile the traditional pageantry of the narrative procession with the newer forms of deep perspective space.[47] Here the horizon is set high in the field and the full effect of the orthogonal movement is maintained. With this canvas, probably, the decoration of the Scuola di San Marco's *albergo* was completed in 1534, and, as we have seen, just this completion may have encouraged the Scuola della Carità to see to its own, still unfinished *albergo;* thus Bordone's picture may well have presented itself to Titian as an immediate challenge.[48] Titian himself always worked well under the pressure of competition, and the appearance of a composition with such an elaborate architectural apparatus indeed may have inspired him to display his own powers in this field.

The subject of the Presentation of the Virgin was developed in the apocryphal Greek gospels, which elaborate upon the biographical data of the young Jesus and his Mother. The story was codified in the West in the thirteenth-century *Golden Legend,* compiled by Jacobus de Voragine:

3. THE PAINTING *IN SITU:* DIVINE WISDOM AND THE ICONOGRAPHY OF LIGHT

> When the Blessed Virgin was three years old, and was weaned from the breast, her parents brought her with gifts to the Temple of the Lord. Around the Temple there were fifteen steps, one for each of the fifteen gradual Psalms; for, since the Temple was built upon a hill, one could not go up to the altar of holocaust from without except by the steps. And the Virgin, being placed upon the lowest of these steps, mounted all of them without the help of anyone, as if she had already reached the fulness of her age.
>
> When they had made their offering, Joachim and Anna left the child with the other virgins in the Temple, and returned to their home. And Mary advanced in every virtue, and daily was visited by the angels, and enjoyed the vision of God. . . .[49]

This narration, more laconic than most of its sources, offers in summary the essentials of the legend. As we shall suggest, however, Titian drew upon other traditions as well, iconographical and liturgical.

Fortunately, his *Presentation of the Virgin* is *in situ,* for it is only in this context, viewed in the special physical circumstances of the *albergo* of the Scuola della Carità, that the picture begins to reveal its full significance. As he had carefully adapted his earlier monumental creations to their sites, and one thinks especially of the altarpieces,[50] so too in this canvas Titian continued to explore the possibilities of relating a painting to its architectural setting.

The L-shaped room itself is, as already noted, a rather awkward space, added over the entrance to the *cortile* of the monastery between the corner of the church and the *casa grande* of the confraternity (figs. 58, 60). Originally, the *albergo* had only a single door—the second door having been cut into the wall, and into Titian's painting, only in 1572.[51] Taking that given opening into account, Titian explicitly incorporated it into his composition: the masonry of the staircase wall is specifically fitted to the lintel of the doorway. The painted wall, filling a large part of the surface

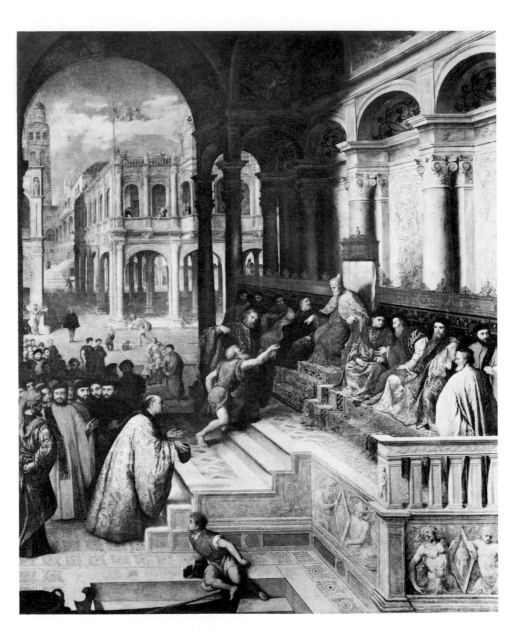

73. Paris Bordone,
*Consignment of the Ring to
the Doge.* Venice, Gallerie
dell' Accademia

and paralleling the picture plane, thereby articulates that plane by its identification with the actual wall of the *albergo,* at the same time setting up in the immediate foreground an ambiguous spatial situation for the old woman and the antique torso—to which we shall return. The entire composition further respects the integrity of the mural surface in a number of ways: the isocephalic procession, the parallel architectural planes, the de-emphasis and even masking of receding orthogonals.[52] The overall tectonic quality of the design, one of its most striking features, establishes a basic relationship between painting and architecture; defining the stable monumental backdrop, its coordinates measure the progress of the narrative flow and, ultimately, the very scale of the composition.

Over the altar on the short wall opposite Titian's picture was the *sacra conversazione* by Antonio Vivarini and Giovanni d'Alemagna (fig. 16). In a public lecture on Titian's *Presentation of the Virgin,* Leo Steinberg indicated the importance of the viewing axis established by the central ceiling beam and given special weight by the position of the quattrocento Madonna.[53] On this altar axis, which falls left of center in his own composition, Titian located the vanishing point of his perspective: the focus is within the node of draperies of old Joachim (fig. 74), who turns back, placing a comforting hand upon the shoulder of the adoring

74. Titian, *Presentation of the Virgin in the Temple* (detail)

Anna.[54] When the picture is seen from this point (as it nearly is in our fig. 58) the line of the ceiling beam extends uninterrupted along the cornice of the palace into the space of the picture, creating an extraordinary spatial continuity. Steinberg's reading of this structural situation makes it abundantly clear that Titian was not as casual in thinking about his architectural settings as is often assumed.[55]

We can continue the analysis of Titian's adaptation of his picture to the room for which it was created on another level by considering the elements of light and color. Titian's own words confirm our sense of the importance of lighting conditions in the conception of a work for a specific site. Twice, for example, when he was hoping to obtain large commissions from Philip II, the painter wrote to the king asking for the dimensions of the canvases and for the conditions of illumination of the room in which the work was to be displayed.[56] Such concern is indeed quite traditional in Renaissance painting, and it is worth noting in this regard that in the quattrocento triptych opposite Titian's *Presentation* the light falls from the right; Vivarini and d'Alemagna followed the standard practice of acknowledging the available source of natural light.[57]

The *albergo* of the Scuola della Carità receives its illumination from windows located on one wall, to the left of Titian's painting (fig. 58), and those windows were in fact renovated just when he was planning the composition. On 2 February 1535, it was decided to enlarge the external spiral staircase leading from the *albergo* to the *cancelleria,* the storage attic just above; the door to that staircase is in the wall directly adjacent to the left of the canvas. The document, cognizant of the lighting needs of the picture, concludes with the additional decision to "remake and adapt the windows of our *albergo* in order to give light to the painting that is going into said *albergo.*"[58] It seems highly probable that Titian himself was involved or consulted in these matters. At any rate, he has, not unexpectedly, utilized this natural illumination in his *Presentation of the Virgin.* Picked up immediately in the bright sky of the landscape, this is the light that models and articulates the figures in the procession.

The balancing of open landscape space against closed architectural forms in Titian's design varies yet another Venetian pictorial tradition: the asymmetrical composition, originally developed in a purer landscape context.[59] The complementary opposition of the two sides of the *Presentation,* however, although an apparently formal device, expands to provide a structure to the very meaning of the painting. Formally, the distinction between nature and architecture is reflected in the coloristic contrast between cool and warm tones—the dominant blues of sky and distant mountains on the left, and the browns and pinks of masonry on the right, the whole knit into an overall unity by a subtle and calculated interchange.[60]

A similar large distinction is stated even more emphatically by the contrast in illumination between the lighter landscape and the darker temple precinct. This contrast responds to the conditions of the room itself. Moving toward the right, away from the natural light of the

windows, the illumination in the painting gradually diminishes in intensity, as it actually does in the *albergo.* And against the relatively darker ground of the architecture of palace and temple a new light shines forth: the diminutive figure of the Virgin Mary (fig. 75).

Dressed in pale blue and surrounded by an aureole of golden rays of which she herself is the apparent source, Mary casts a new and more intense light on the risers of the steps before her; the brightness of her illumination is reflected in the gestures of the witness behind her and of the high priest above.[61] The blue and gold, a celestial combination traditionally reserved for the Virgin, epitomize the chromatic keynotes of the composition, and here too, as has often been observed, Titian harmonized picture and setting by adopting the preexistent color scheme of the fifteenth century ceiling.[62] The direct confrontation of Virgin and high priest, moreover, is reflected in their chromatic relationship: the essentially pure brilliance of her golden aureole and pale blue dress finds, as it were, a mere material approximation in the jeweled splendor of his costume.[63]

Even beyond the colors, however, the earlier ceiling decoration of the *albergo* provides a key to the meaning of Titian's painting. Elaborately carved, painted, and gilded, the ceiling features the figure of Christ Pantocrator in the central roundel surrounded by the four Evangelists (fig. 61). The deity, emitting golden rays, displays an open book with the inscription *Ego sum lux mundi* ("I am the light of the world"). From the Gospel of St. John (8:12), this text initiates the major theme of the picture, the diffusion of that divine light into the world.[64]

Through centuries of Christian art gold has signified the light of heaven, the glow of mosaics or applied gold leaf always symbolizing a higher, supernatural illumination.[65] In the course of the fifteenth century, the reflected light of actual gold began to be replaced in painting by the natural light of the real world, in which artists discovered a more convincing objective correlative for the divine presence. Since it depended on the painter's manipulation of his medium rather than on the actual physical properties of applied material, this new approach permitted, from the point of view of an early Renaissance aesthetic, a greater unity of pictorial expression.[66] In the High Renaissance, however, the painting of celestial light reassumed the qualities of a truly *un*natural phenomenon. In the revived gold leaf application of Raphael's *Disputa,* surest testimony to its iconic value, and in the oil paint of Titian's *Assunta,* as we have seen, supernatural light functions in contrast to the setting of an otherwise "natural" world.[67]

Rather remarkably, however, Titian surrounded the young Mary with a full mandorla of golden light, a motif, so far as I know, without precedent in depictions of her Presentation in the Temple. Usually crowned by a simple halo, she is frequently shown, as in Carpaccio's modest picture (fig. 65), holding a candle—an allusion to her symbolic role as the candlestick bearing the light that is Christ.[68] In a grander and more dramatic manner, Titian has established this theme of the *theotókos*

75. Titian, *Presentation of
the Virgin in the Temple*
(detail)

by the full mandorla, itself a venerable sign of theophany.[69]

The use of light as a metaphor for the Virgin belongs, of course, to a
very impressive liturgical and aesthetic tradition. In his classic essay on
the function of light as form and symbol Millard Meiss explored its
significance in works such as Jan van Eyck's Berlin *Madonna in the
Church,* in which the Virgin physically embodies the brilliance of divine
illumination.[70] The words inscribed on her tunic come from Van Eyck's
favorite text and supply an exegetical key to this and many other images:
''For she is more beautiful than the sun, and above all the order of the

stars; being compared with the light, she is found before it. For she is the brightness of eternal light, and the unspotted mirror of God's majesty."[71]

The text is a collation of passages from the apocryphal book of the Wisdom of Solomon (7:29, 26), and the original object of this hyperbole is Divine Wisdom. Her many virtues and attributes, elaborately described in this book as well as in the Book of Proverbs and the apocryphal Ecclesiasticus, were early transferred to the person of Mary, becoming a basic part of the liturgical celebration of the Virgin[72]—and eventually, in the fifteenth century, finding new visual expression at the hands of artists capable of fully realizing the potential of the imagery. It is important, once again, to underscore here the crucial role of the painter in this development, for his active participation was surely the critical factor, giving tangible form to literary metaphor.[73]

This imagery and these texts underlie Titian's composition as well, the essential meaning of which is epitomized in the contrast of lights: the Virgin does indeed rival and outshine the natural light entering through the windows of the room; she *is* the light beyond the light of nature, a radiance more brilliant than the sun. The application of luministic imagery to the Presentation of the Virgin was sanctioned especially by Byzantine iconographic traditions as well as by liturgical example.[74] The very particular conditions of the *albergo*, however, encouraged Titian to reconsider its pictorial potential with new imaginative energy; the single prominent source of illumination and the central text inscribed on the ceiling, *Ego sum lux mundi*, evidently combined to inspire a profound unity of form and content—a unity that convincingly attests to the painter's primary responsibility for the iconography itself.[75] Like Jan van Eyck, Titian found in the textual sources a wealth of imagery awaiting, as it were, visual expression. The Wisdom texts, the basis of this Marian celebration, afford then a means of reading Titian's *Presentation*, allowing us to determine the significance of many of its supposedly merely picturesque details within the controlling context of a unified thematic structure.

The major contrast between the two sides of the composition, landscape and architecture, implies a certain dialectic inherent in the design itself and suggests that these forms carry further and specific meanings. The two great mountain peaks, like the perspective focus of the construction, are deliberately related to the figures of Anna and Joachim (fig. 76)—who are otherwise nearly lost in the crowd.[76] Always admired, these twin mountains have generally been viewed from a naturalistic bias, recognized only as magnificently depicted recollections of the Dolomites around Titian's native Cadore.[77] Given their distinct formal prominence, however, one might expect them to carry a consonantly weighted significance, especially since they are related to the Virgin in rather precise ways: also elevated above the crowd, their distant color modifies the blue of her dress. The inspiration behind this comparative juxtaposition, and hence a key to its meaning, is offered by the same Wisdom texts

4. ICONOGRAPHY EXPANDED: THE SYMBOLIC LANDSCAPE

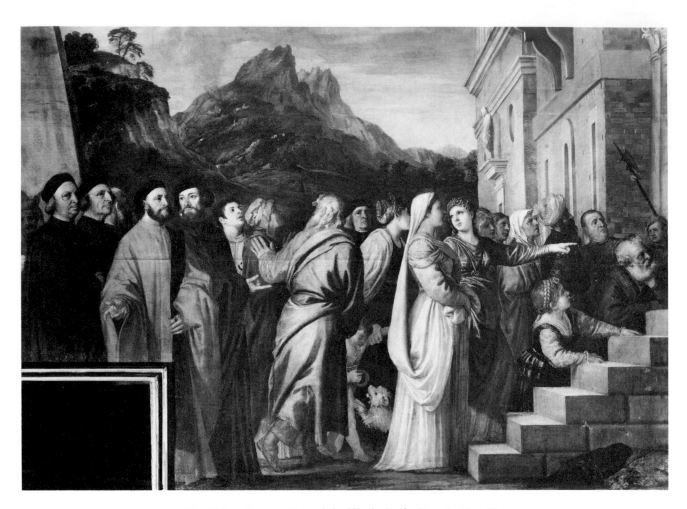

76. Titian, *Presentation of the Virgin in the Temple* (detail)

we have been considering. In Proverbs (8:22–25) Divine Wisdom de-
clares: "The Lord possessed me in the beginning of his ways, before he
made anything from the beginning. I was set up from eternity, and of old
before the earth was made. . . . The mountains with their huge bulk had
not as yet been established: before the hills I was brought forth"
("Dominus possedit me in initio viarum suarum, antequam quidquam
faceret a principio. Ab aeterno ordinata sum, et ex antiquis antequam
terra fieret. . . . Necdum montes gravi mole constiterant: ante colles ego
parturiebar"). Like the sunlight, then, the mountains in the *Presentation*
would appear to provide a natural standard against which to measure the
eternal brilliance of the Virgin[78]—the concept of *Maria aeterna* (fig. 77),
celebrated in her liturgy with words from Ecclesiasticus (24:14): "From
the beginning and before the ages was I created and never shall I cease to
be" ("Ab initio, et ante saeculum creata sum, et usque ad futurum
saeculum non definam").[79] These words are central to the doctrine of the
Immaculate Conception, which, after long theological debate, was fi-
nally accorded official sanction by the Franciscan Pope Sixtus IV in 1476

77. Giulio Clovio, *Creation* (from the Farnese Book of Hours). New York, Pierpont Morgan Library

and again in 1480. In 1496 the brothers of the Scuola della Carità decided to celebrate the feast annually.[80]

The idea of the eternity of the Virgin as Divine Wisdom is further expressed in Titian's painting by the elongated pyramid at the left.[81] Egyptologists of the Renaissance were familiar with the ancient association of the pyramid or obelisk with the sun and knew that through these forms "the Egyptians imitated the rays of the sun whom they themselves worshipped."[82] As an architectural symbol of radiance the pyramid stands as witness to the incarnation of Divine Wisdom in distant antiquity and hence to her eternity.[83]

Although the pyramid was a standard part of the archaeological stage sets of Renaissance painting (cf. fig. 108), it seems to have acquired this specific symbolic function in images of the Presentation of the Virgin. We are perhaps better accustomed to accepting such significance in the more obviously intellectual and antiquarian atmosphere of the Roman High Renaissance. And, indeed, the obelisk in Peruzzi's fresco (fig. 72), for which the crouching prophet in the foreground seems almost to provide a base, proclaims its significance by its central position in the design.

Contemporaneously, however, in a fresco dated 1525 in San Michele del Pozzo Bianco in Bergamo, Lorenzo Lotto, no stranger to the arcana of hieroglyphics, gave clearer articulation to the theme by silhouetting against the sky the forms of a pyramid and of the Virgin, here holding the traditional candle (fig. 78). Although Tintoretto's *Presentation of the Virgin* in the Madonna dell'Orto in Venice (fig. 79), finished by 1556, suggests his knowledge of Lotto's composition, his rendering of the Virgin leaves no doubt that he found a major inspiration in Titian's work. This young Mary advances with the same sure confidence, holding her dress in an identical way; her radiance, emanating as a nimbus around her head, is so closely juxtaposed to the pyramid as to epitomize the essential iconographic relationship.[84]

Titian's development of the iconography of light is thus hardly an isolated phenomenon in the cinquecento, but one may doubt that any other artist so fully explored the possibilities of the theme—or, indeed, was so peculiarly equipped by talent and imagination to do so. The *Presentation of the Virgin* in the Scuola della Carità is clearly, then, more than a well-organized miscellany of naturalistic vignettes governed by purely pictorial considerations. A basic unifying theme begins to emerge, and we can follow its visual resonance as it expands throughout the composition, touching nearly every detail.

Rising behind the pyramid is a great cumulus cloud, its luminous shape dominating the left side of the canvas.[85] Accepting the foregoing interpretation of the picture, one ought to expect this form, moving so majestically over the landscape, to assume a meaning beyond its obvious naturalistic function. And I would suggest that this meaning derives from the same Wisdom texts with which Titian was so evidently familiar. In Ecclesiasticus (24:5–7) Divine Wisdom herself boasts: "I came out of the mouth of the most High, the firstborn before all creatures: I made that in the heavens there should rise a light that never faileth, and as a cloud I covered all the earth: I dwelt in the highest places, and my throne is a pillar of cloud" ("Ego ex ore Altissimi prodivi, primogenita ante omnem creaturam: Ego feci in caelis ut oriretur lumen indeficiens, et sient nebula texi omnen terram: Ego in altissimi habitavi, et thronus meus in columna nubis"). In this form the divinity presides over Titian's landscape, becoming with the pyramid a monumental hieroglyph of the divine immanence,[86] while on the opposite side of the picture the Virgin's radiance speaks of its ultimate incarnation for the salvation of mankind.

Earlier in his art Titian had already given pictorial form to the symbolic cloud of a more traditional Marian epithet. As Christ himself was the *Sol splendidissimus,* so Mary was likened to a cloud containing that light; his birth was the emergence of the sun from that covering.[87] In the Treviso *Annunciation* (fig. 47), as we have seen, the metaphor comes to life as "the light of the world" streams from clouds to enter its new, temporary chamber, from which its divinity will newly shine forth—as in the Virgin of the *Presentation.*[88] But even earlier in his career, in the great woodcut of the *Submersion of Pharaoh's Army in the Red Sea,* published about 1515, Titian had rendered the *Shekinah* of the Old Testament, the Divine

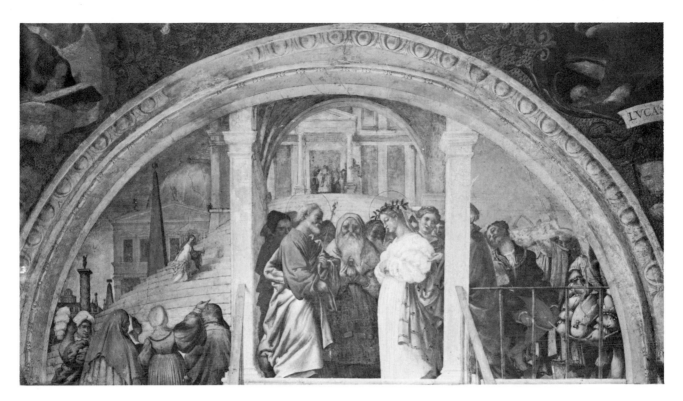

78. Lorenzo Lotto, *Presentation and Marriage of the Virgin.* Bergamo, San Michele del Pozzo Bianco

Manifestation: the magnificent cloud moving over the scene is just that "pillar of cloud" that had guided the Israelites and protected them against the Egyptians (Exodus 13:21, 14:19–20).[89]

Although it is hardly surprising that the greatest landscape painter of the cinquecento should have found such expressive eloquence in the forms of nature,[90] it ought to be just as evident that Titian was not merely an illustrator of received texts. A literary or theological advisor could have done little more than bring to the attention of the artist the texts that were readily accessible in Scripture or in liturgical adaptations. The essential imaginative impulse behind each of the iconographic passages we have considered thus far is always pictorial, the conceptual realization always visual.[91] And each of these details participates in and contributes to the harmonic structure unifying every level of the *Presentation of the Virgin.*

The working of Titian's imagination is perhaps nowhere more clearly in evidence than in the figure of the old egg woman (fig. 80). Seated in front of the rusticated wall of the temple stairs—a surface, as we have noted, identified with the picture plane itself—she is situated ambiguously in a spatial zone that belongs by implication to the world of the viewer; both she and her inanimate companion, the antique torso to the right of the door, are thereby deliberately excluded from the main space of the picture, explicitly separated from the divine radiance. Her profile,

5. DRAMATIS PERSONAE, I: SYNAGOGUE AND GRACE

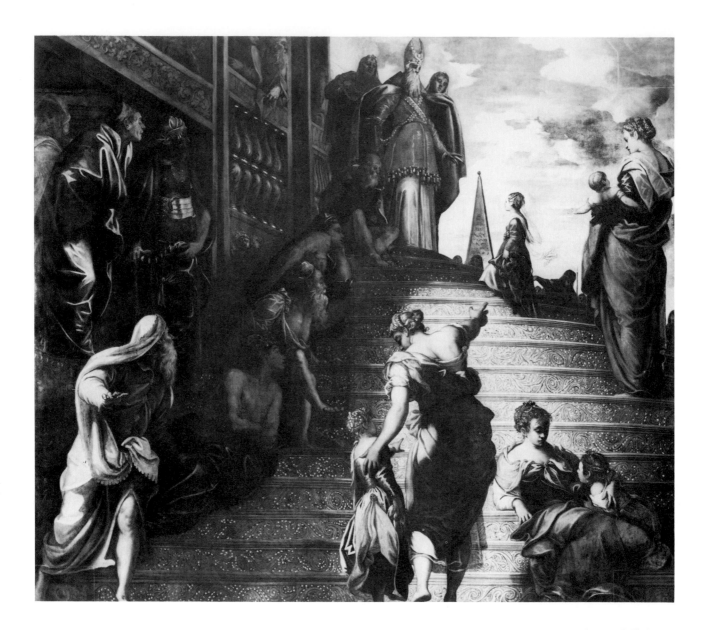

79. Jacopo Tintoretto, *Presentation of the Virgin in the Temple.* Venice, Madonna dell'Orto

turned to the left, opposes the basic narrative flow of the composition. Her close juxtaposition to the Virgin above underscores this opposition, which thereby operates hierarchically on a double set of coordinates— vertically as well as horizontally. The figure directly above the old woman, shielding his eyes, reacts in the most obvious way to the radiant Mary, thus emphasizing the egg-seller's lack of awareness. Such deliberate formal structuring surely has thematic implications.

Justly observing that "with a master of Titian's stature even obvious 'space-fillers' are rarely without significance," Panofsky saw in this figure—a favorite, we recall, of naturalist appreciation—a symbol of unconverted Judaism, and in the classical torso a sign of ancient paganism.[92] In so identifying Titian's old egg-seller, Panofsky adduced

80. Titian, *Presentation of the Virgin in the Temple* (detail)

as an influential example Dürer's woodcut of the *Presentation of the Virgin* (fig. 81), in which a group of Jewish merchants at the entrance to the temple sell the required offerings: lambs, small loaves of shewbread, and turtledoves. Panofsky's conclusion does a certain justice to Titian's figure, recognizing a significance in the peculiar qualities of the "Vecchia tutta ranichiatta e crespa": "in replacing the merchants—who, though bent on profit, sell things required for the cult—with an old hag selling nothing but eggs—entirely unrelated to even Jewish ritual—he produced the symbol of a mentality not only unenlightened but incapable of ever seeing the light: the spirit of those of whom the Evangelist (John 12:40) says that the Lord 'hath blinded their eyes and hardened their heart.' "[93]

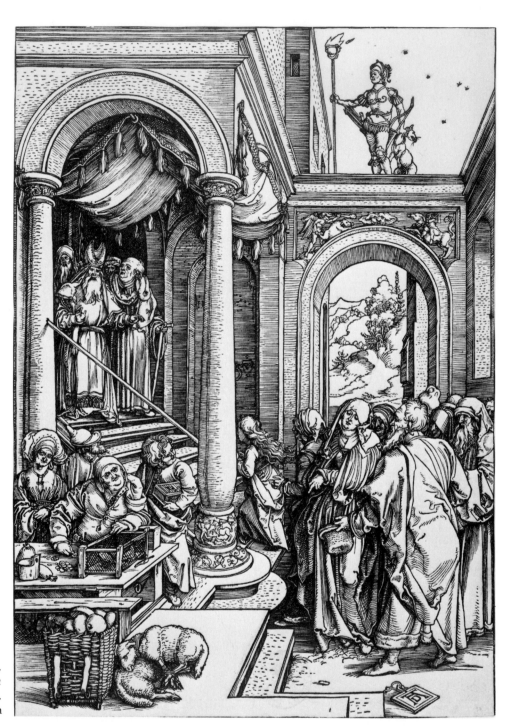

81. Albrecht Dürer,
*Presentation of the Virgin in
the Temple.* Woodcut.
London, British Museum

But this despised old creature sells more than eggs, for at her feet are a
chicken and a lamb. Now the fowl is indeed evidently unrelated to any
traditions of Old Testament sacrifice, even as they were interpreted in
the Renaissance, but eggs were already being sold at the steps of the
temple by Cima's old woman (fig. 66)[94]—who, interestingly, appears to

Panofsky as a "charming farmer's wife" as opposed to "the repulsive old egg woman" of Titian. Panofsky also overlooks the lamb, which is, of course, the classic sacrificial animal of the Old Testament and thus appears in Dürer's woodcut. Like Dürer, Titian placed at the foot of the temple stairs a lamb trussed for sacrifice, but his lamb is black, a color choice that may well intend a deliberate moral inversion.[95]

The right side of Titian's composition, then, contains *in nuce* the Christian tripartition of history into the eras *ante legem, sub lege,* and, foreshadowed by the triumphal ascent of Mary, *sub gratia*. Panofsky properly assumed that the same iconographical significance was carried by Titian's supposed visual source for the motif of the old woman, Cima's *Presentation of the Virgin*. And he further recognized the same tripartite structure on a large scale in Ghirlandaio's fresco in Santa Maria Novella (fig. 82): "Two Jews arrayed in rich oriental garb, and a nude figure, seated on the steps in a classicizing posture. . . , which seems to invoke the spirit of paganism. . . ."[96]

One may go even further, however, for this kind of historical, or theological, juxtaposition was in fact a standard part of the iconography

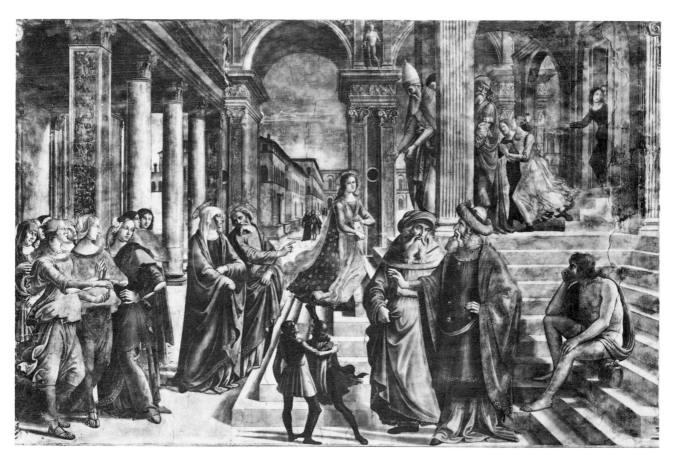

82. Domenico Ghirlandaio, *Presentation of the Virgin in the Temple.* Florence, Santa Maria Novella

of the Presentation of the Virgin. Two Jews, witnessing and responding to the momentous event from which they are explicitly separated, usually at the lower right of the composition, appear in Giotto's treatment of the subject (fig. 68) and again in Taddeo Gaddi's fresco (fig. 69) and subsequently in those designs inspired by it.[97] Two such figures accompany the old woman in Cima's picture—two more respond negatively to the event on the far side of the stairs—and a single old man, with possibly the same significance, is isolated at the extreme right of Carpaccio's drawing (fig. 64).

There is, however, a variant iconography, the same significance being carried by a different type of figure: a female personification. In the Florentine predella panel cited earlier (fig. 70) the representation of the Old Testament may already have been assumed by an old woman kneeling—in opposition, as it were—before the steps to the temple, and, as Meiss has suggested, this same image may reflect aspects of a more monumental tradition.[98] In Venice, in Giambono's mosaic design in the Mascoli Chapel of San Marco, the opposing figure, clearly excluded from the architecture of the action, is a woman holding two turtledoves, standard offerings in the Jewish temple (fig. 83). Instead of representatives of the Jews as such, we have here, then, a personification of Synagogue. And it is to this tradition that Titian's old egg-seller, as the unreconstructed Synagogue, belongs. Indeed, gold medallions or buttons adorning her drab garments appear as dim reflections of (or visual allusions to) the rich vestments of the high priest of the temple, and the gold lines of her shawl seem to invest it with some ritual significance.[99]

The feast of the Presentation of the Virgin in the Temple, celebrated on November 21 and long a part of the Byzantine liturgical calendar, was introduced to the West only in the late fourteenth century through the efforts of Philippe de Mézières. From Cyprus, where he served as chancellor, Mézières brought a version adapted to Latin usage to Pope Gregory XI at Avignon; there, on 21 November 1372, it was given its first official celebration, a central part of which was a *rapraesentatio figurata*, a sacred drama.[100] It is hardly insignificant for our purposes that, according to Mézières himself, this feast was celebrated for the first time in the West in Venice several years before its official acceptance.

Indeed, it was precisely in the world of the Venetian *scuole* that the feast was first introduced, possibly as early as 1369. In that year Mézières donated to the Scuola di San Giovanni Evangelista its most precious relic, a piece of the True Cross, and it is very likely to that brotherhood that he refers when he writes of performing the *rapraesentatio* in Venice "sometimes in communion with those of that city devoted to the Virgin."[101] Recently published documents indicate that the *confratelli* of San Giovanni Evangelista marched in procession at the annual celebration of the feast of the Presentation of the Virgin in the Temple, which seems to have found its natural locus in the church of Santa Maria Gloriosa dei Frari.[102]

The iconography of Mézières's dramatic representation is ultimately related to that of Byzantine cycles of the early life of Mary,[103] and some of

83. Michele Giambono, *Presentation of the Virgin in the Temple.* Mosaic. Venice, San Marco

its features may still retain a certain role in Titian's painting. In addition to Mary, Joachim, and Anna, the dramatis personae included the virgins following Mary, a host of angels, the archangels Gabriel, Raphael, and Michael, Lucifer, *Ecclesia,* and *Synagoga.* It is, of course, the last of these figures who interests us most at the moment. She is described as an old woman dressed in tattered black garments. In her right hand she holds, inverted, the Tablets of the Law; in her left is the broken Roman vexillum, a red banner emblazoned with the gold letters S.P.Q.R. [104] Thus *Synagoga* herself stands for the entire historical era *ante gratiam,* both Jewish and pagan. In the narrative, Mary's ascent of the steps to the altar is accompanied by lauds sung by the angels; then Anna, Joachim, and *Ecclesia* in turn offer their praises. *Synagoga,* however, breaks into tearful lamentation, whereupon Gabriel and Raphael, indignant at her interruption of the ceremony, seize and thrust her from the platform; dropping

her banner and tablets, she is expelled from the church amid derisive laughter.

The identification of Judaism and ancient paganism would appear to have been even more traditional than Panofsky himself assumed, and the precedent of Dürer's woodcut now seems less crucial.[105] Titian's pairing of the old woman with the torso is in its own way as clear as the tablets and vexillum of *Synagoga* in Mézières's *Festum*. Although it is not possible to document any subsequent performances of the *rapraesentatio* in Venice, we do know that such sacred dramas were performed there at least well into the seventeenth century;[106] and since the feast of the Presentation of the Virgin assumed a permanent place in the Venetian calendar, it is not inconceivable that such a *sacra rappresentazione* was indeed produced there during the Renaissance.[107] But one need not press this point. The iconographies of religious drama and religious painting are as closely linked as the forms of the two arts themselves, and it is perhaps enough to indicate the continuities of these traditions to underscore, with Panofsky, the significance of Titian's "space-fillers."

6. DRAMATIS PERSONAE, II: WITNESSES AND BROTHERS

Continuing with our reading of Titian's painting, we can now expect to find meaning in the other figures in this great procession. In approaching this large and varied cast of characters, however, we must bear in mind that they fulfill diverse functions within different contexts. For example, the picture is replete with portraits of Titian's contemporaries, brothers of the Scuola della Carità, whose relation to the central theme will require special consideration. The other witnesses to the spectacle, leaning out of windows and over the balcony, are a fairly traditional feature of Renaissance dramatic painting, reflecting the response of the actual audience on this side of the canvas; as observers themselves, outside the action, they are likely free of iconographic responsibility. But both these groups of personages, recognizable members of the Scuola and anonymous spectators, expand the dimensions of the total experience; through their pictorial participation they extend the historical subject into the present.[108]

A different kind of historical expansion may be observed among the figures of the witnesses below, those who bear immediate witness to Mary's ascent to the temple rather than to the general pageant of which they themselves form a part. Within the crowd behind the steps, Titian has placed a turbaned Turk and a Vitellius-inspired Roman with a baton (fig. 84)—possibly recalling a group similarly located behind the stairs in Raphael's tapestry cartoon of *St. Paul Preaching in Athens*. It is conceivable that they represent the generations of mankind, the nations of men, East and West, alluding to the diffusion of Divine Wisdom *per nationes:* "And being but one, she can do all things: and remaining in herself the same, she reneweth all things, and through nations conveyeth herself into holy souls, she maketh the friends of God and prophets" ("Et cum sit una, omnia potest: et in se permanens omnia innovat, et per nationes in animas sanctas se transfert amicos Dei et prophetas constituit"). These

84. Titian, *Presentation of the Virgin in the Temple* (detail)

words from the Wisdom of Solomon (7:27) occur within the very passages of immaculist imagery that ultimately lie behind Titian's iconography of light, and it is not unlikely that he knew and realized them. The inspiring revelation of Divine Wisdom incarnate in the Virgin is, as we have already noted, dramatized in the gesture of the figure immediately behind her. His proximity to the source of radiance justifies his physical response, but those more distant can hardly be less moved.

The beautiful young woman at the foot of the stairs (fig. 85), so often carelessly identified as Anna, acquires by her prominence within the composition a rather distinctive significance. Although one might consider her in relation to the train of maidens that traditionally follows Mary in Byzantine iconography,[109] care has obviously been taken to distinguish her from the rest of the procession. Dressed in gold and white, stately yet modest, seen in pure profile, she seems to reflect in her larger person the figure of the Virgin herself, and this connection is made explicit by the indication of her companion.[110]

85. Titian, *Presentation of the Virgin in the Temple* (detail)

At the top of the stairs stands the second priest, receiving special focus by the upturned glance of the young acolyte (fig. 86); he too is in profile, but facing left. These two figures, the beautiful maid and the virile priest, bracketing the radiant Mary and the ancient high priest, are isolated as a couple within the composition, formally responding to one another across the distance of the staircase. On the basis of this particular relationship Leo Steinberg has suggested that the modest young woman, who wears a sort of bridal veil, is Mary's older cousin, Elizabeth, and the priest is Zacharias, her future husband. [111] (The same relationship seems

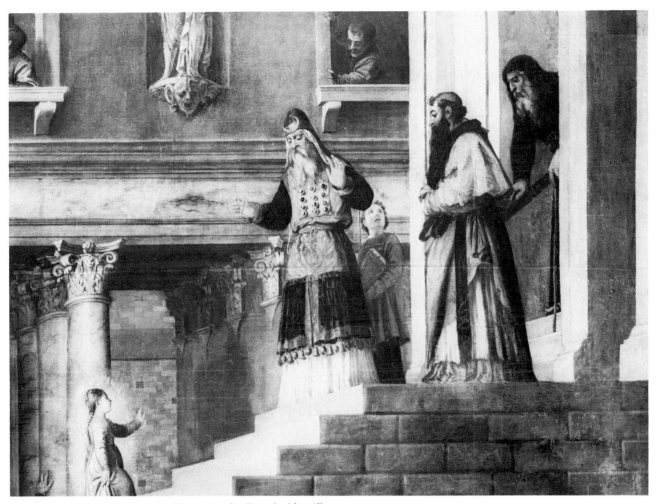

86. Titian, *Presentation of the Virgin in the Temple* (detail)

to exist in Giambono's mosaic [fig. 83], where, within a deliberately restricted cast, each character assumes added weight: the woman accompanying the Virgin's parents would be Elizabeth and the observing priest at the right Zacharias.) Such an interpretation is particularly plausible in the context of the site, for on the ceiling of the *albergo* (fig. 61) the roundel with St. Luke, which is nearest the priests in the painting, displays the following text from his Gospel (1:5): "There was in the days of Herod, the King of Judea, a certain priest named Zacharias."[112] Here too, then, Titian may have taken a cue from the conditions of the site, and by including in the *Presentation of the Virgin* the parents of John the Baptist, the first prophet of the new era, he expanded still further its historical resonance.

The distribution of alms at the extreme left of the canvas (fig. 87) has often been cited as a particularly appropriate motif for the Scuola della Carità. The distribution of charity was a primary function of the *scuole grandi,* and the *albergo* was in fact the center of this activity.[113] It is thus indeed significant that only through this act of charity do the members of

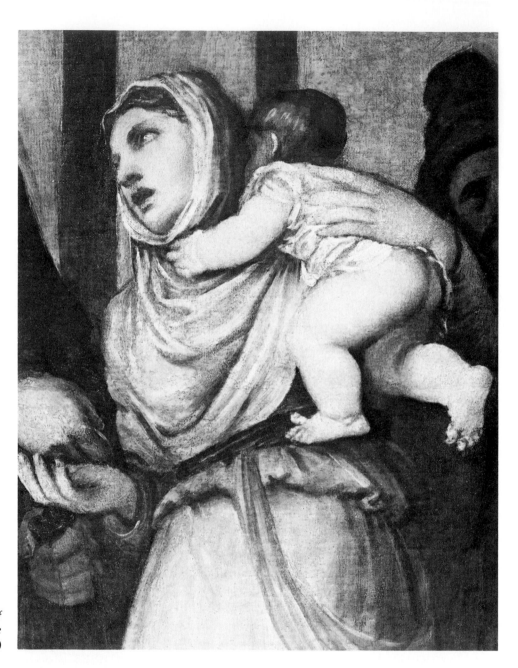

87. Titian, *Presentation of the Virgin in the Temple* (detail)

the Scuola actually participate directly in the narrative as more than witnesses. The beggar herself, assuming the typical importunate gesture of a mendicant, acquires a certain individuality through her costume; this has been described as a "long, girt Doric chiton," and by such clear classical allusion Titian implicitly elevates her, or rather the entire action, to the status of a personification, or enactment, of *Caritas*—and, as we shall see, *Caritas* of a very special kind.[114]

The charity motif in Titian's painting is, however, of more than parochial relevance, for *Caritas*, the epithet of the holy patroness of this confraternity, was frequently associated with the iconography of her

Presentation in the Temple. Beggars were a traditional sight at the entrance to the temple (for example, Acts 3:1–11), and it is therefore conceivable that the nude at the right of Ghirlandaio's fresco (fig. 82), rather than evoking "the spirit of paganism," as Panofsky suggested, and, despite his "classicizing posture," is such a pauper.[115] Almsgiving is the dominant act at the left of Peruzzi's composition (fig. 72), balanced at the extreme right by a maternal *Caritas* figure; here it is possible to suggest an identity for the charitable figure at the left, who is probably none other than Joachim—with Anna directly behind him. Such an identification is supported by a small Florentine engraving of the later quattrocento (fig. 88), which offers a concise summary of the most essential iconographic features of theme as we have been discussing them: the charity of Joachim and, witnessing Mary's reception, two Jews.[116]

The figures in Titian's pageant, then, operate on several levels of significance, and one of the most impressive qualities of the *Presentation* is the manner in which he has organized them into the grand procession following the progress of the Virgin. Whereas the procession was, as we have observed, a standard feature of Venetian tableau compositions—which accounts for the apparently retardataire character so frequently noted by critics in Titian's canvas—the master has given it a new complexity as well as monumentality.[117] The greater energies of his figures, in comparison with those of his quattrocento predecessors, require a consonant degree of control. And this control depends upon the rhythmic articulation of the calculated movement from left to right; figures turning or looking back, and thereby creating closed units within the open framework of the procession, serve to punctuate and check this inevitable flow—a function then assumed with greater precision by the architectural units on the right.

Among the most distinctive stabilizing elements in the procession are the celebrated portraits, admired by critics ever since Vasari singled them out for his only comment on the painting.[118] Inclusion of such portraits was itself a tradition in Venetian narrative painting, in the *teleri* of the *scuole* and in the Ducal Palace. Ridolfi was the first to offer names for the two most prominent contemporary witnesses in Titian's *Presentation* (fig. 89). He recognized them as Andrea de' Franceschi, grand chancellor of Venice and a friend of the painter, and Lazzaro Crasso; and these identifications, soon repeated by Boschini, have always been accepted.[119] But Ridolfi was probably wrong. The red-robed figure in the *Presentation* bears little resemblance to portraits generally recognized as representing Andrea de' Franceschi (fig. 90).[120] And the younger man to the right can hardly be the same Lazzaro Crasso who was exercising important official duties as early as 1496.[121]

Indeed, there is little reason to expect the presence of the grand chancellor in a picture decorating the *albergo* of the Scuola della Carità. This powerful official of the state was not, so far as we know, a member of the Scuola, and the normal practice, naturally, was to portray officers of the confraternity itself in such compositions.[122] The eight obvious

88. Anonymous Florentine engraver, *Presentation of the Virgin in the Temple* (detail of an engraving). New York, Metropolitan Museum of Art

portraits in Titian's picture must surely represent the chief officers of the Carità—the *guardiano grande*, the *vicario*, the *guardian da mattin*—and other members of the *banca*. [123] That the two main personages are in fact the *guardiano grande* and the *vicario* is confirmed by Francesco Sansovino's description of their official dress: "The *Guardiano Grande* along with the *Vicario* on the most solemn festival of Corpus Christi are dressed the one in crimson robes with ducal sleeves and the other in robes of deep blue-violet, as representatives of the state: and, following ancient tradition, the *Guardiano* is honored with the title of *Magnifico*."[124]

In 1534, when the decision to commission the painting was taken (and when the commission was, in all probability, awarded to Titian) the *guardiano grande* was Nicolò dalla Torre. The term of office, however, was limited to one year, and since we do not know precisely when in the period 1534–38 Titian actually executed the work we can hardly be certain of this particular identification. [125]

7. JUSTICE, CHARITY, AND THE WISDOM OF STATE

Given the iconographic richness of the dramatis personae and the symbolic roles of the pyramid and landscape, it is not likely that the architecture in Titian's *Presentation of the Virgin* is as casual as most critics have assumed. [126] Whatever the forms themselves may owe to the example of Serlio or other central Italian models, we can no longer accept the view that Titian was merely interested in creating a fashionable scenic back-

89. Titian, *Presentation of the Virgin in the Temple* (detail)

drop. The architecture, after all, serves as the setting for the most sacred part of the composition, and it is inconceivable that Titian did not give it as much imaginative attention and thought as the other elements.

On the most obvious level, his primary task was to re-create the Temple of Solomon, of which the essential feature for the subject of the Virgin's Presentation was the great staircase. Here too, however, Titian was not content simply to recapitulate the standard iconography handed down by pictorial tradition. Ignoring the traditional prescription of a flight of fifteen steps, he designed a staircase of only thirteen, broken significantly to establish a ratio of 8:5; the Virgin, then, stands at a point

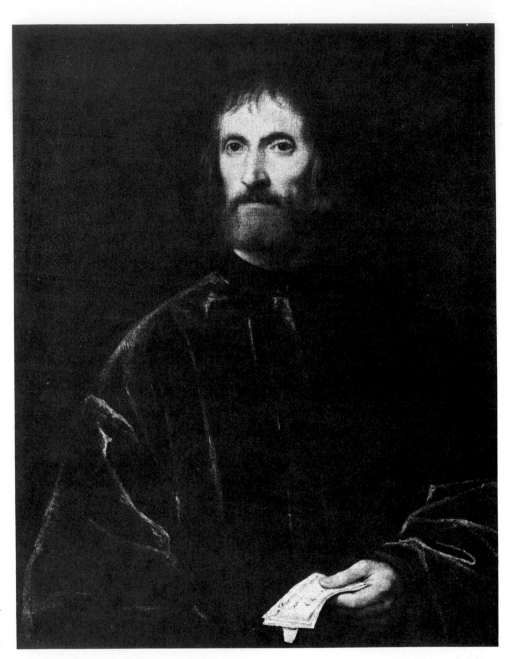

90. Titian, *Portrait of Andrea de' Franceschi*. Detroit Institute of Arts

defining the golden section.[127] Titian sought to create a temple that would appropriately reflect the perfection of divinely inspired proportions according to the standards of the Renaissance, and he naturally turned to the example of classical antiquity, specifically, to Vitruvius. Among the discoveries of human wisdom described in the preface to the ninth book *De architectura* is the Pythagorean triangle—whose discoverer, Vitruvius explains, was convinced that he had been inspired by the Muses. The Roman architectural author recommends that the proportions of this triangle be used as a guide in the construction of staircases, and Titian apparently followed this advice: each of the two flights

of the stairway in the *Presentation* is based on that 3-4-5 ratio.[128] The deliberate planimetric articulation of the drafted masonry, regardless of any possible relation to Serlio or to contemporary architectural models, thus assumes a critical function in underscoring the commensurability and proportionality of this structure.

But Titian did not entirely neglect the scriptural sources. The temple formed part of a still greater building complex that included as well the Palace of Solomon, a structure distinguished by its *porticum columnarum* (III Kings 7:6).[129] Just such a porch of columns provides the immediate backdrop for the Virgin in Titian's painting, and I think there can be little doubt that it is more than a simple scenographic device. Its bay rhythm corresponding to that of the ceiling beams of the *albergo* and articulating the culmination of the procession, this colonnade is a further constituent in the reconstruction of the Solomonic complex.

More difficult to read is the statue cut off by the frame in the niche above the portico (fig. 86), evidently inspired by the figure of an archaistic *kore*.[130] There is indeed venerable iconographic sanction for placing such statuary on or near the temple in depictions of the Presentation, a tradition continued by Ghirlandaio (fig. 82) and Dürer (fig. 81).[131] But perhaps more interesting than these Renaissance examples for our purposes is the martial figure on the pediment of Solomon's Temple in the Early Christian mosaics of Santa Maria Maggiore in Rome, which has been interpreted as Divine Wisdom herself.[132] It is possible that Titian's sculpture, which makes undoubted stylistic allusion to classical antiquity and displays a Medusa-like mask on its console, may refer to the Graeco-Roman personification of Wisdom, Minerva. Although such an interpretation would not be out of place in the iconographic context we have been defining, especially since Minerva was also recognized as a type for the Virgin,[133] it can be offered only tentatively.

Seen through the colonnades of the portico, the rich diaper pattern of pink and white masonry introduces another dimension of architectural allusion. Often appreciated for the way in which it offers a monumental tectonic correlative to the broken touches of Titian's painterly brushwork, this polychrome wall is clearly intended to evoke the Ducal Palace in Venice, the upper walls of which are characterized by just such a polychrome masonry pattern (fig. 91). By this means the architecture extends from scriptural antiquity to the Venetian present, in much the same way that the portraits expand the temporal dimensions of the dramatis personae.

The significance of this architectural presence can be defined with a certain iconographic precision, however, for the Palace of the Doges, a palace of justice (*ad jus reddendum*), was itself deliberately associated with the Palace of Solomon. The major iconographic theme of the Ducal Palace is justice, and from at least the early quattrocento that theme was visually epitomized in the identification of the city with that virtue: the traditional personification of *Justitia* became the figure of *Venecia* (fig. 92).[134] The heritage of the wisdom of Solomon, practically manifested in his role as judge, was claimed by the *Serenissima* —and so a representa-

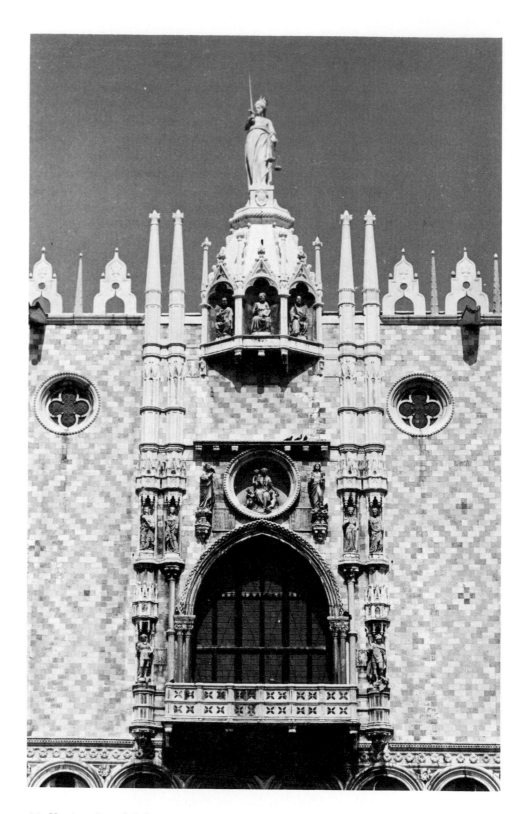

91. Venice, Ducal Palace. *Finestrone*

tion of the *Judgment of Solomon* graces the corner of the palace nearest its main entrance, the Porta della Carta (fig. 93).[135] In the Venetian dominion, Divine Wisdom finds expression through the state.

Furthermore, the second virtue claimed as a special attribute of the state, and traditionally complementing *Justitia,* was *Caritas.* [136] The model inspiring Titian's charity figure (fig. 87) was identified by Cornelius Vermeule as "the Italia or personified Alimenta from a sestertius of Trajan or the *Anaglypha Traiani* in the Roman Forum, even to her long, girt Doric chiton."[137] This figure, illustrated here from Sebastiano Erizzo's publication on ancient numismatics (fig. 94), was well known to the Renaissance, and its significance bears directly on a major theme in Titian's painting. The inscription on the coin stands for *Alimenta Italiae* and commemorates the *institutio alimentaria* of Trajan, his command to feed the children of Italy at public expense: the image thus symbolizes the charity of the state.[138] Although Titian's adaptation of it (which might have been clearer had not the later door so truncated the figure) involved substituting the babe in arms for the cornucopia, transforming it into a purer *Caritas,* the figure, read together with the generosity of the brothers of the Scuola, maintains her original meaning: the symbol of the liberality of the Roman emperor has been translated to celebrate the charity of the Christian republic.[139]

To a Venetian public of the sixteenth century the presence of the Ducal Palace in the architectural complex of Titian's *Presentation of the Virgin* would have made perfect and immediate sense, an iconographic extension of state propaganda similar to the extension of patrician government through the *scuole.* And to these considerations we might add the traditional identification of the city with the Virgin herself: the founding of Venice was celebrated on March 25, the day of the Annunciation.[140]

The government of Venice was an oligarchy from which were excluded all the nonpatrician elements of the population. Yet the *Serenissima* had earned its title by maintaining internal equilibrium and concord as well as independence from foreign domination, and this required offering compensations to the disenfranchised segments of society. Institutions such as the guilds and confraternities afforded the means by which the average Venetian citizen found his place within the structure of the state, for they were, in effect, extensions of that structure.[141] With regard to the *scuole,* Francesco Sansovino is quite explicit in his apology for Venice. His comments on the confraternities, from which we have already quoted, continue: "These also represent a certain type of civil government, in which, as if in a republic of their own, the citizens enjoy rank and honor according to their merits and qualities."[142] The *scuole* reflected in plebeian microcosm the larger order of the patrician state, and their wealth and splendor were in turn an adornment of that state as well as of religion (cf. fig. 59).[143] Through the *scuole* the brothers participated in the functioning of the larger order and especially, as Brian Pullan has demonstrated, through the distribution of charities.[144] The officers of the Scuola della Carità quite appropriately balance the Ducal Palace in Titian's *Presentation of the Virgin.*

92. Venice, Ducal Palace.
Personification of Venice

This, then, is the world reflected in the painting, a world in which religion and state, under the aegis of justice and charity, are brought together for the temporal and spiritual well-being of its citizens. It is the world of Venice, which in all its subtle complexities as a Christian republic may have found its most perfect pictorial expression in Titian's canvas.

8. STYLE AND SIGNIFICANCE: SOME CONCLUDING REMARKS

The number of elements contributing to the meaning of the *Presentation of the Virgin* is impressive, but even more so is the degree to which they participate synthetically in the overall unity of the composition. For all their conceptual variety and diversity of reference, they contribute to the definition of a single structure, a structure qualified by two crucial characteristics: its wholeness and its essentially pictorial foundation. Paradoxically, the first of these points is attested by traditional criticism of the painting, which found it a relatively simple, not to say superficial, composition, an image undisturbed by heuristic problems—"a matter of

93. Venice, Ducal Palace.
Judgment of Solomon

pure perception." One might say, in light of this view, that the picture
had successfully hidden its content behind its painted façade.

Our interpretation, however, has not sought to substitute an icono-
graphical approach for formal analysis. The whole of the image's struc-
ture is comprehended only when form and content are recognized no
longer as antitheses in some absolute dialectic. [145] Isolated from the forms
and colors of Titian's *Presentation* and considered separately as an icono-
graphic program, our interpretation might well seem improbable, an
overly complicated set of instructions guaranteed to encumber even the

94. Coin of Trajan (from *Discorso di
M. Sebastiano Erizzo sopra le medaglie
de gli antichi,* 1568)

most fertile pictorial imagination. But we are not dealing with illustration or applied iconography. The genesis of this painting's meaning, in all its complexity of reference and significance, is rooted in Titian's active, indeed, enthusiastic, response to a set of specific conditions. His iconography, however it may have utilized program notes suggested by the usually anonymous "advisors" postulated by art historians, is, as we have insisted throughout our study, organically related to his art, to his genius as a painter—indeed, as the official painter of Venice.

Although dissolving the form-content antithesis, the wholeness of the *Presentation* nonetheless depends upon the second characteristic we identified: the pictorial base of the structure. Traditional formal analysis of the picture, incomplete as it may seem to us, is in fact confirmed by our reading, for the very possibility of this unity derives from the broadening and opening up of Titian's painterly style. The sheer size of the mural surface proved highly conducive to such a development; less object-bound and applied with new freedom, color creates a larger field effect in this work—a prelude to the still looser brushwork of Titian's late manner. This overall network of touches and accents, by which the design achieves its chromatic distribution, proves capable of containing within and as fully integral parts of its fabric the many elements revealed by our investigation. Moreover, Titian's respect for the picture plane, essential to the control of this monumental surface, literally provides the ground for such a unified construct and forms the network comprising the individual components and by which they acquire their interrelationships. An essential condition for this unity is, in short, Venetian *colorito* itself, which thereby begins to assume a function beyond the manual mode of paint application, the *pittura di macchia,* and moves to the very core of the total creative experience.[146]

If the *Presentation of the Virgin* is not the simply retardataire composition some critics suggest, it is certainly a major monument in what may be considered the extended life of an older Venetian pictorial tradition.

At a time when modish central Italian scenographic perspective models were rendering the Venetian tableau composition aesthetically obsolete, Titian demonstrated, and on a grand scale, the still vital potential of the native tradition. [147] In fact, the stylistic reference functions as a part of the meaning of the picture; evoking as it does an unmistakable sense of history and tradition, it celebrates the continuity and stability of the *Serenissima* and, of course, its institutions such as the *scuole grandi*.

The Scuola di Santa Maria della Carità was founded in 1260 on the feast of St. Leonard, November 6, at the church of San Leonardo in the *sestiere* of Cannaregio in Venice; from its inception, however, it was associated with the monastery of the Carità in Dorsoduro. Indeed, the growing affluence of the Scuola and the monastery's financial need account in large measure for the pattern of the confraternity's expansion. From the beginning the Scuola had arranged for burial of its members in the church of Santa Maria della Carità, [148] and in 1287 the brothers obtained permission to construct a second fraternal funerary monument ("un'arca sivè sepoltura di pietre rosse da Verona"). [149] The confraternity occupied a variety of rooms on the premises of the monastery before it finally erected its own permanent headquarters on land acquired 7 January 1343 (Document 1). [150] According to the commemorative inscription, the new *casa grande* was initiated 12 April 1343 and completed by the following January. [151]

On 3 July 1384 the Scuola agreed to pay 100 ducats for the restoration and repair of walls and foundations of the monastery, the ruinous state of which threatened the collapse of the church's bell tower. In return, the monks granted permission to the Scuola to build an *albergo* above the portal to the *cortile* shared by the two institutions (figs. 60, 95) and extending from the wall of the Scuola to the façade of the church (Document 2). [152] Construction was completed by 21 December 1384, when the monks formally approved the new structure as conforming to the stipulations of the contract (Document 3). By 26 November 1411 the brothers had negotiated permission to enlarge the *albergo* (Document 4), although no action seems to have been taken at that time. [153] The project was carried out later, however, following renegotiations in 1442 (Document 5), and payments recorded in 1443–44 indicate that the work was accomplished in the following year. [154]

With the construction of a *cancelleria*, the storage attic above the *albergo*, in 1491 (Document 6) the essential fabric of the Scuola was completed by the end of the fifteenth century (fig. 96). From the first part of the sixteenth century on, however, the building was subject to a series of extensive restorations and renovations—culminating after 1807 with the conversion of the whole complex of Scuola, church, and monastery of the Carità to its new function as seat of the Accademia di Belle Arti. [155]

Despite this nearly total overhaul of the Scuola, it is still possible to gain some idea of its earlier state, basing such tentative reconstruction on the testimony of descriptions and references in the documents and on

95. Venice, ex-Scuola Grande di Santa Maria della Carità (now Gallerie dell'Accademia). *Cortile*

certain archaeological and pictorial evidence, as well as comparative consideration of other Venetian buildings. The documents regarding the sixteenth-century restorations confirm that there were two entrances to the Scuola della Carità, both of which were in need of repair in 1547 (Document 9). On the north side, facing the *campo santo* on the Grand Canal was the portal, still preserved (fig. 97), leading to the *cortile* shared with the monastery; its appearance in the fifteenth century is known to us, albeit rather imperfectly, through an anonymous painting representing the meeting in 1177 of Doge Sebastiano Ziani and Pope Alexander III in the Campo della Carità (fig. 98).[156] As the agreement of 1442 makes quite explicit (Document 5), this entrance served the Scuola particularly for processional occasions.[157]

On 15 May 1566 it was decided to renovate this entire façade (Document 12), to restore the portal and gild the sculptural decoration, the

96. Venice, ex-Scuola Grande di Santa Maria della Carità (now Gallerie dell'Accademia).
Exterior of the *sala dell'albergo*

image of the Madonna and the emblem of the Scuola (fig. 99).[158] This
decision followed that taken on December 16 of the preceding year to
renew the other entrance, that "sopra il rio," and the staircase and
balconies (Document 11). This part of the fabric, which disappeared
totally in the nineteenth-century transformations of the building and the
surrounding topography, can be somewhat reconstructed with the
further aid of orthographic plans published in the seventeenth and
eighteenth centuries. On its western side the Scuola was bounded by
the Rio della Carità (cf. Document 1), a small canal running into the
Grand Canal—subsequently filled in and hence now a *rio terrà*; the
entrance there, "la porta grande" of Document 9, was presumably ap-
proached by a bridge over the *rio.*[159]

It is not possible at this time to reconstruct the precise location of that
entrance, or to determine whether it led directly into the *sala terrena* or, as
seems more probable, into a *cortile* with outdoor staircase of a type

97. Venice, ex-Scuola
Grande di Santa Maria della
Carità (now Accademia di
Belle Arti). Portal

common to many Venetian structures.[160] This entrance complex,
however—including portal, stairs, and balconies—was the object of the
extensive restorations voted in 1565 (Document 11), restorations proudly
recorded in tablets inscribed in the following year.[161] During this work it
was discovered that the main façade of the Scuola was in a dangerous
state of disrepair, and the further repairs were voted (Document 12).

The main outlines of the Scuola's structure evidently remained until
the eighteenth century. The major restorations of 1756 and 1765 trans-
formed the façade on the *campo* according to the design of Giorgio
Massari and the interior of the *sala terrena* with the construction of
Bernardino Maccaruzzi's double staircase (fig. 57).[162] The present stair-

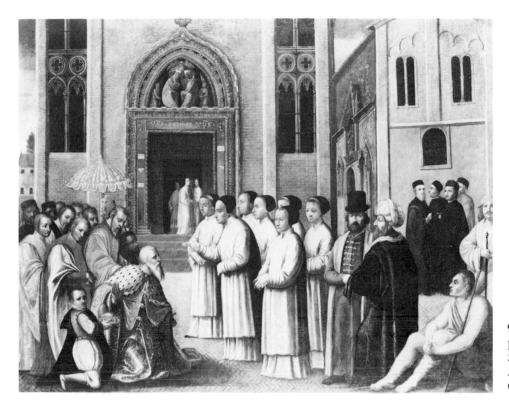

98. Anonymous Venetian painter, *The Meeting of Doge Sebastiano Ziani and Pope Alexander III.* Venice, Gallerie dell'Accademia

case, however, may have replaced a much older one at this end of the Scuola, as suggested by views of the façade before the eighteenth-century changes. In Canaletto's painting of about 1730 generally known as the *Stonemason's Yard,* for example, the overlapping arrangement of the windows on the façade (fig. 100) seems to imply the existence of a staircase on the internal wall. [163] Indeed, we note that the idea behind the Massari-Maccaruzzi projects may go back as far as 1553, when it was already proposed to construct "two staircases as well as a large portal on the *campo*" (Document 10). The proposal was rejected by the brotherhood, and we can only wonder whether some record of the original idea had been preserved in the Scuola—as had been Pasqualino's winning *modello* of 1504 for the *Presentation* (Document 16)—and played a role in the subsequent deliberations when the proposal was resuscitated. [164]

By the early eighteenth century, then, the façade on the *campo* had undergone a transformation in which both the style and the position of the original windows (as known to us in fig. 98) had been altered. But there is reason to believe that already toward 1600 it was subject to some alteration. In a painting by the heirs of Paolo Veronese in the Sala del Maggior Consiglio of the Ducal Palace (fig. 101), also representing the meeting of doge and pope, the façade structure anticipates that of Canaletto's view; the lower window extends beyond the floor level of the upper storey, suggesting the presence of an internal staircase landing. [165] However, no documents pertaining to such a construction have yet come to light.

99. Venice, ex-Scuola Grande di Santa Maria della Carità (now Accademia di Belle Arti). Portal (detail)

The *albergo* of the Scuola, as we have seen, was extended to its present irregular shape by 1444. With regard to our particular interest in the pictorial decoration of the room, we should call attention to the fact that it always had two windows: on 25 January 1444 "Ser Jachomo de Lazaro" received payment of 40 ducats "per 2 fenestre zanchade guarda sulla corte."[166]

100. Giovanni Antonio Canaletto, *The Stonemason's Yard* (detail). London, National Gallery

101. Heirs of Paolo
Veronese, *The Meeting of
Doge Sebastiano Ziani and
Pope Alexander III* (detail)
Venice, Ducal Palace

On 31 July 1491 it was decided to build a *cancelleria* above the *albergo* in
which to preserve the important written records and other valuables of
the Scuola, which hitherto had been kept, "without any order," in the
albergo itself (Document 6). Access to this attic was (and still is) by means
of a spiral staircase, which was evidently perilous enough to discourage
frequent use; hence another state of disorder led to the necessity of
redoing and enlarging the structure (Document 7). In the deliberations of
2 February 1535—approximately five months after the decision to renew
the project of the *Presentation of the Virgin*—it was further decided to
"remake and adapt the windows of our *albergo* in order to give light to the
painting that is going into said *albergo.*"

Finally, on 10 March 1572, the officers of the Scuola della Carità, citing
the great inconvenience caused by traffic flowing through a single nar-
row portal, voted to cut a second door, identical to the first, into the wall
of the *albergo*—and into Titian's canvas (Document 8).[167]

The Decoration Marcantonio Michiel's description of the pictures "In la scola della
of the *Albergo* Karita la qual scola è la piu anticha de scolae de Venezia" offers the fullest
available documentation of the early decorations. Although his inven-
tory is replete with tantalizing lacunae, he is rather circumstantial in
listing the two major pictorial decorations of the quattrocento *albergo:* the
triptych by Antonio Vivarini and Giovanni d'Alemagna (although
Michiel does not mention the latter) and a series of apostles by Jacobello
del Fiore, dated 13 February 1418, and located on the wall to the left—and

now lost.[168] We do not know what kind of altarpiece, if any, may have been replaced by the Vivarini-d'Alemagna image of 1446 (fig. 16), which was clearly the major commission following the recent enlargement of the *albergo*. The elaborately carved and painted ceiling (fig. 61), also presumably executed as part of the expansion program, acquired its present form—or, conceivably, was restored to its previous form—only after the building of the *cancelleria*, as the document of 1491 makes quite explicit (Document 6). And this may well confirm Lorenzetti's date of ca. 1496 for the ceiling, a date which has thus far been unsubstantiated.[169]

Only in 1504 was a move made to decorate the entrance wall of the *albergo* opposite the *sacra conversazione* (Document 13). The same document records the competition and the victory of Pasqualino Veneto, who, upon satisfactory completion of the work was to receive 170 ducats "for all his expenses." He in turn promised to use only "good and fine colors, to apply good cinnabar and fine ultramarine blue, the finest obtainable regardless of cost." On January 28 Pasqualino agreed to the terms and signed the contract (Document 14). By December 6, however, the painter had died, evidently having accomplished little on the project. The members of the confraternity reaffirmed their intention to apply the funds, on deposit in the bank of the Pisani, toward the new mural in the *albergo* and for no other purpose; the money itself was to be withdrawn and invested with the Monte Nuovo (Documents 15, 17). On 19 January 1505 Pasqualino's brother, Marin, appeared before the board, "asking some recompense for the design and the labor." To this request the officers responded, "only out of piety and charity," agreeing to pay the costs of the canvas and wood (Document 16).[170]

The project, as we know, was resumed in 1534 (Document 18) and the commission awarded to Titian, who finished the work by 6 March 1538 (Document 20).[171]

On that date, presumably shortly after Titian completed the canvas of the *Presentation*, the governors of the Scuola voted to continue the decoration of the *albergo* with a painting on the wall before which was displayed the reliquary cross donated to the confraternity by Cardinal Bessarione (Document 19).[172] The commission was given to Pordenone, that "most ingenious and prudent man." It would appear that on this occasion the Scuola held no competition, the brothers deciding instead to follow their Titian with a work by his most active and celebrated rival, for which they intended to pay 120 ducats.

Recalling the situation a year later, the documents give us a precious glimpse into the relations between artist and patrons (Document 20). Having accepted the task and inquiring about the subject, Pordenone was asked to paint an Assumption of the Virgin. The painter politely demurred, offering three objections to this selection: (1) the format of the space available (essentially a horizontal rectangle) was wrong for such a subject (of vertical ascent); (2) the Assumption was not the miracle in Mary's life that followed her Presentation in the Temple; and (3) the Scuola already possessed a picture of that theme in the *sala grande*. Pordenone recommended that instead he paint a Marriage of the Virgin,

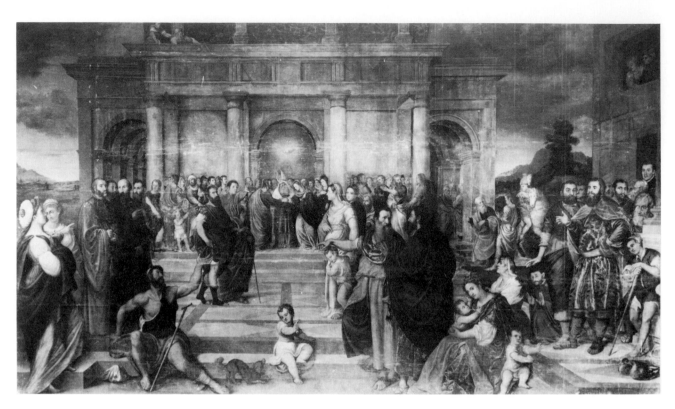

102. Gian Pietro Silvio, *Marriage of the Virgin.* Venice, Gallerie dell'Accademia (on deposit at Mason Vicentino)

a more appropriate subject since it "followed upon that other canvas and because the space was well suited to such a theme." While the iconographic issues involved are hardly profound, it is important to recognize the position of the Renaissance painter as a qualified expert in such matters of iconography and decorum; after all, this sort of problem was a constant concern of his professional activity. The brothers of the Carità, clearly impressed by their chosen artist, acknowledged the wisdom of his counsel and ordered a Marriage of the Virgin. The chalk drawing submitted to them by Pordenone can no longer be identified; but before getting any further than this preparatory design, the artist died, in Ferrara, on 14 January 1539.

In its search for a successor the Scuola this time did hold a competition, and entries were submitted by Paris Bordone, Bonifazio de' Pitati, Vettor Brunello, and Gian Pietro Silvio. On 6 March 1539 the commission was awarded to Silvio (Document 20). The painter agreed to complete the picture within one year but failed to satisfy that condition. Indeed, by 19 February 1540 he had scarcely begun work, and the officers of the confraternity, disappointed but still anxious to have a "finished work," voted an extension of another year (Document 21).

Silvio, who had already received an initial payment of 40 ducats on account, continued to procrastinate. Finally, on 11 November 1543, seeing that "until this time nothing has been done," the Scuola ap-

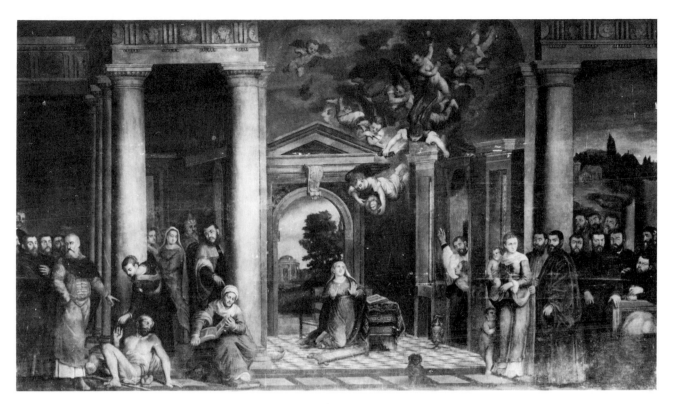

103. Girolamo Dente, *Annunciation.* Venice, Gallerie dell'Accademia (on deposit at Mason Vicentino)

pointed two of its members to press the issue, instructing them to take any legal action necessary to see that the commission was fulfilled as quickly as possible (Document 22).[173]

Eventually, Silvio did complete the work, and his painting of the *Marriage of the Virgin* is still preserved (fig. 102).[174] Its intended location in the *albergo,* clearly indicated in the documents, is confirmed by Boschini's rather brief description: "To the left, entering by the door toward the *campo,* two pictures from the school of Titian: but because they have been entirely repainted little remains of their authors."[175]

The second of these canvases, appropriately an *Annunciation* (fig. 103), is also preserved.[176] It is generally assumed that it too is by Silvio,[177] although we may doubt that the brothers would have entrusted him with another commission after their difficulty in obtaining delivery of the first. The *Annunciation,* however, is almost certainly the work executed between 1557 and 1561 by Girolamo Dente, known as Girolamo di Tiziano. On 5 August 1557 this painter, a favorite assistant in Titian's studio,[178] offered to replace "a very old picture, out of style with the others that are now to be seen in said *albergo*" (Document 23); this painting, like Silvio's, was on the wall to the left as one enters but nearer the altar or tribune wall (Documents 24, 16).[179] The Scuola responded to Girolamo's initiative, having nothing to lose, since if the work failed to please they need not accept it. But it did satisfy, and on March 12 of the

following year the artist was paid 100 ducats for the work in addition to the 10 he had already received toward the cost of colors; moreover, his application for membership in the Scuola was accepted as well (Document 25). Not until 7 June 1561, however, did Girolamo receive the final payment "for completion of the picture" (Document 26).

Although one can make certain observations concerning the stylistic differences between the *Marriage of the Virgin* and the *Annunciation*,[180] we must bear in mind the extensive damage and repainting suffered by both canvases. Boschini's comment on their condition is in fact supported by the documents of the Scuola: the inventory of 1679 declares that the pictures were damaged by a fire in the monastery and subsequently "retouched" by Domenico Tintoretto (Document 27).[181]

The *Marriage of the Virgin* and the *Annunciation*, continuing the Marian narrative after the *Presentation*, filled the two parts of the wall opposite the windows in the *albergo*; Silvio's picture was immediately adjacent to Titian's, and Girolamo's extended to the altar wall (Document 24). The three cinquecento canvases, the quattrocento triptych, and Jacobello del Fiore's lost apostles comprised the major pictorial decoration of the *albergo* of the Carità. The room contained in addition other, smaller pictures and objects—including the portrait of Cardinal Bessarione and the cross he donated, as well as a number of images variously described in the literature and inventories[182]—but after 1561 there were no further decorative campaigns. The brothers of the Scuola di Santa Maria della Carità seemed satisfied that their *albergo* did indeed, at last, reflect honor on their confraternity.

4

Theater and Structure in the Art of Paolo Veronese

We have always loved Paolo Veronese—for the chromatic brilliance of his palette, the splendor and sensibility of his brushwork, the aristocratic elegance of his figures, and the magnificence of his spectacle. He has offered us a banquet of the senses, and for centuries his name has meant joy in painting, untroubled delight. But of the great trio that dominated Venetian painting of the cinquecento, the master from Verona has proved least able to withstand the critical affection of later times. Despite modern appreciation of the unique pictorial qualities of his art, a certain dimension seems to be lacking. His painterly rhetoric, unlike that of Titian or Tintoretto, has somehow lost part of its eloquence; it seems not to permit expression of the profound, the human, or the sublime.[3] And so, responding with fin de siècle habits, we continue to appreciate it essentially on the level of aesthetic hedonism, and paradoxically to delight either in its naturalism, in the tactile display of its material substances, or in its more abstract qualities as pure paint, its dissociation of color from object. For a long time the label "decorative" seemed adequately to cover the contradictions and uneasiness of critical response. But that very label, suggesting the dominance of surface values, implies that Veronese's merits are essentially and merely superficial.[4] Scholars and critics, perhaps with some relief, have remained content not to ask too much of Veronese, apparently happy to accept him as a

"pure" painter really unconcerned with the intellectual challenges of meaning.[5]

Modern scholarship has been necessarily directed to the problems of connoisseurship and chronology, separating Veronese's work from that of his contemporaries and trying to find some sequential order in the accepted corpus.[6] But so long as we are preoccupied with this kind of order, which is admittedly difficult in his case, and so long as our idea of Veronese's style is founded upon superficial values alone, we are bound to miss a great deal in these brilliant pictures. Concern with chronology is not likely to lead us very far into the life of a picture. Fortunately, in dealing with questions of style and meaning, scholars are beginning to appreciate the complexity of Veronese's art and of his imaginative and intellectual faculties. The architectural settings that play such a crucial role in many of his most splendid compositions have naturally proven to be a rewarding field for investigation; in this area especially it has been possible to establish the painter's connection with architects like Sanmicheli, Sansovino, and Palladio and the culture they represent.[7]

The following pages attempt to explore the implications of certain of those connections, in particular the often recognized affinity between the styles of Veronese and Palladio. Starting from a comparative analysis of the painter's mode of dramatic composition and the architect's conception of theater space, they seek to define more precisely the pictorial structures of Veronese's art and to interpret their expressive significance.[8]

1. *THE FAMILY OF DARIUS* One of Veronese's most universally admired canvases can serve as an ideal base for our study: the *Family of Darius before Alexander* (pl. 6, fig. 104), probably dating from the late 1560s.[9] Singled out for special comment by Goethe, the picture portrays the women of the defeated Persian humbling themselves before the victor and his entourage of officers. The mother has mistaken the taller Hephaestion for Alexander, who, dressed in brilliant crimson, steps forward and with a gesture of imperial magnanimity allays the queen's embarrassment by turning the mistake into a tribute both to his general, who is also an Alexander, and, of course, to himself.[10] The meeting takes place on a narrow foreground stage contained by a balustrade and set on a level above that of the background space; the narrowness of the stage is emphasized by Veronese's typical choice of a low horizon, which reduces the amount of pavement visible. In this way the dominant forms and colors adhere closely to the surface.

The narrative unfolds across that surface in a great wave sweeping down from the left frame, which is reinforced by a columnar cluster of figures, crosses the brief gap before the balustrade, and then, following the complex path of draperies, gestures, and glances, mounts to the handsome head of the intercessor presenting the Persian ladies. This curve is met by the solid block of figures of the Greek warriors.[11] However, through the broad gesture of Alexander himself—as well as through the contrapposto of gently swaying figures and the tilt of heads

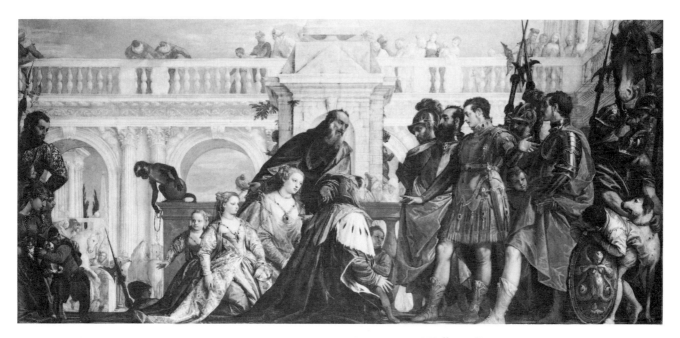

104. Paolo Veronese, *The Family of Darius before Alexander*. London, National Gallery. (See also colorplate 6.)

and halberds—the curve continues its course to the right, turning down, forward, and completely reversing itself finally in the curious page in white. (The sophistication of this compositional line, with its system of internal counterpoint, was fully appreciated by Rubens, whose *Queen Tomyris Receiving the Head of Cyrus* in the Boston Museum of Fine Arts is a baroque variation on it.)

This spectacle of grand gestures is set against a monumental architectural backdrop. The organic curve of the drama is plotted against the regular rhythm of tectonic coordinates, the increasingly rapid measures of arcade, colonnade, and balustrade. Furthermore, this relationship operates as well on a coloristic level. The intense hues of the costumes are set off, like jewels, against the relatively neutral light tones of the backdrop. Thus, spatial structure, dramatic action, and color reinforce the dissociation of foreground and background—and, in turn, depend upon that dissociation for their full effect.

At once the culmination and quintessence of Veronese's developed mural style,[12] the *Alexander* belongs in fact to the venerable Venetian tradition of tableau composition. The pictorial decorations of the Venetian *scuole* were composed of cycles of such narrative representations, and, as we have seen, the tradition can be traced back through the extant works of Carpaccio (figs. 25–27) and Gentile Bellini (fig. 59) to its earliest Renaissance formulation in designs conserved in the albums of Jacopo Bellini—and ultimately to the earliest murals in the Ducal Palace. In this type of mural design the narrative line flows parallel to and close behind the picture plane; the protagonists act on a narrow foreground stage, while the background, often composed of deep perspectives, remains

curiously detached, a separate backdrop for the foreground action.[13] This sort of pictorial structure—which, especially in sequential cycles, insistently maintains the integrity of the mural surface—lent itself particularly to ceremonial scenes of procession and reception. In the sixteenth century, aside from such conspicuous monuments as Titian's *Presentation of the Virgin in the Temple* (fig. 56), the type continued to be adopted primarily for votive pictures, in which private donors or officials of the state are presented to the appropriate holy figures, as well as for the archetypal votive subject, the Adoration of the Magi. The *Alexander* of Veronese can be read as a thematic variant of the votive type.[14]

In the later cinquecento, however, Veronese remained the only major master committed to the tableau as a still vital theme for pictorial development. Already before the middle of the century, vanguard taste in Venice had been turning to more ambitious perspective backgrounds, deep spaces capable of accommodating more complex dramatic action and of engaging the eye of the observer, leading him well into the illusion of the picture. An important measure of this development, as Cecil Gould has shown, was the increasing influence of Serlio's theatrical illustrations.[15] The artist who most consistently and adventurously explored the possibilities of the deep perspective vista was Tintoretto, and his *Carrying of the Body of St. Mark* of about 1562–66 (fig. 105) offers an instructive comparison with Veronese's *Alexander*.

Originally forming part of a mural cycle in the Scuola di San Marco,[16] Tintoretto's canvas emphatically abandons the tableau tradition and, like the other compositions in the series (for example, fig. 135), seems deliberately to avoid any parallels between the formal structure and the picture plane. Indeed, every effort seems to have been made to challenge the integrity of the plane; the great counterpoint of the orthogonals' rapid recession and the forward thrust of the straining figures is calculated to establish a primary narrative axis perpendicular to the picture plane. The integrity of the mural surface is preserved rather through the overall distribution of chiaroscuro values—as can still be seen in the great cycles of the Scuola di San Rocco. But here too an important distinction exists. The spatial conviction of Tintoretto's composition depends in addition upon the atmospheric unity of the pictorial space. Both the penetrating focus of the perspective and the tangible continuity of the atmosphere invite the eye to enter deep into the world of the picture. Tintoretto's tonalism, in this sense, represents a continuing development of that impulse initiated in Venetian painting by Giorgione in the first decade of the cinquecento.

The tableau tradition in Venice attained its fully developed maturity in the later quattrocento; the tableau composition itself thus represents a decidedly pre-Giorgione phase in Venetian painting. One could even argue that the tableau tradition and *giorgionismo* are in fact incompatible; at least historically they have remained separate.

In its chromatic clarity as well as in its planar structure, Veronese's *Alexander* (and, for that matter, much of his art) relates more directly to

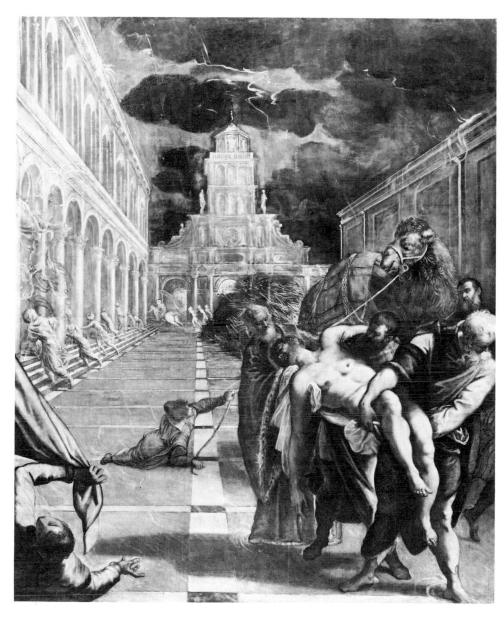

105. Jacopo Tintoretto,
*Carrying of the Body of St.
Mark.* Venice, Gallerie
dell'Accademia

Carpaccio than to any developments descending from Giorgione. The
eye is held essentially on the surface rather than being drawn beyond it
into the shadowy depths of space; spatial continuity between foreground
and background is frustrated by the low horizon, the break in pavement
levels, and the deliberate avoidance of pronounced orthogonals. Colors
refuse to sacrifice themselves to the dictates of optical naturalism and
insist instead upon their own basic purity; even the figures in the
Alexander, despite their physical proximity, discretely preserve through
position and posture their physical independence, relating to one
another through decorous gesture and glance.

The differences between Tintoretto's *Carrying of the Body of St. Mark*
and Veronese's *Family of Darius before Alexander* epitomize the stylistic

alternatives offered by these two rivals. More than matters of purely pictorial style are at issue here, however. Differences in compositional structure, spatial depth, figure distribution and interaction, tone and palette should be considered in the larger context of *mimesis*, the imitation of significant human action that is the central concern of narrative painting in the Renaissance tradition—*l'istoria*, in its simplest storytelling sense as well as in its more exalted humanistic implications. In appreciating the personal styles of Tintoretto and Veronese, in reading their paintings in the fullest sense, one is responding to alternative modes of dramatic presentation. Their choices with regard to perspective construction and space imply fundamental differences in their attitudes toward staging in a quite theatrical sense.

2. *UT PICTURA THEATRUM*

In talking about "stage space" in Renaissance painting, we rightly acknowledge the intimate relation between theater and painting in that period, a relation which is indeed most clearly documented by the traditions of perspective representation and the development of stock types of architectural settings—from the Berlin, Baltimore, and Urbino panels through the designs associated with Bramante, Raphael, and Peruzzi to the famous woodcuts published by Serlio in his second book on perspective in 1545.[17] The unified spatial setting of early Renaissance painting became an important ingredient in the evolution of the new humanist theater, at once inspiring and satisfying the demand for dramatic unity as it was expressed in sixteenth-century commentaries on Aristotle's *Poetics*.[18] The ideal setting of the High Renaissance was constructed on a centralized, single-point perspective scheme, a measured recession of modular pavement and articulated palace façades. Serlio's illustrations of the Vitruvian tragic and comic scenes codified once and for all the earlier researches and made them more readily available to a much wider audience, especially to painters in search of useful architectural models for backgrounds.

Serlio himself carried these ideas to Venice in 1527, and, even before their publication, the settings for the tragic and comic scenes were probably serving as convenient references for Venetian painters. The theatrical origin is clear in the backdrop of Paris Bordone's *Bathsheba* (fig. 106), and the background architecture of Tintoretto's *Washing of the Feet* (fig. 107) is a quite literal quotation of Serlio's *scena tragica* (fig. 108).[19] The basic space-defining formulae are the same for both painting and theater. The horizon is high, maintaining the visibility of the vanishing point and, more important, of the receding ground plane; in this way the means into the fictive space are manifest to the observer/audience. In Bordone's picture the back cloth effect is left undisguised, even awkwardly so; the figures are not related convincingly to the background space, which therefore remains passive. With greater imaginative energy, Tintoretto directs his figures more dynamically, and as they occupy more of the stage area they animate the space around them. By such means Tintoretto overcomes the feeling of the seam, as it were, of

106. Paris Bordone,
Bathsheba at the Bath.
Cologne, Wallraf-Richartz
Museum

the distinct separation between foreground stage and illusionistic
fondale—ultimately, as in the *Carrying of the Body of St. Mark*, achieving
the total spatial unity that was the desired effect of the theatrical setting,
with figures freely moving in and out of a spatial continuum.[20]

Now the identification of the Vitruvian stage and Renaissance per-
spective inventions, for all its historical significance, in fact represents a
misreading of the ancient Roman's text.[21] Vitruvius's quite laconic de-
scription of the three kinds of scenes (*De architectura* V.vi.9) refers to the
decoration of the three faces of the *periaktoi*, the rotating triangular
prisms of painted scenery at either side of the stage. The misunderstand-
ing of the nature and position of the *periaktoi* gave rise to some of the most
influential creations in Renaissance art and theater. Concentrating on
the scenic décor, which played a minor role in Vitruvius, dissociating it
from the rest of the theater, and magnifying it out of all proportion to its
original context, Renaissance artists initiated the development of the
modern stage. Moving the *scaenae frons* to the front of the stage, they
conceived the proscenium arch, which, by analogy to the picture frame,

107. Jacopo Tintoretto, *Washing of the Feet*. Madrid, Museo del Prado

108. Sebastiano Serlio,
Scena Tragica (from
Secondo libro di perspettiva,
1545)

delimits the view and provides an explicit separation of stage and auditorium (fig. 109).[22] The establishment of this absolute barrier made possible the complete illusion and hence autonomy of the stage world. Characters moving within this realm are clearly separated from the audience; behind the proscenium every care is taken to expand the dimensions of the scene, creating a fusion of the actual stage space and the painted illusion of the back cloth.

The action of Veronese's *Family of Darius before Alexander,* unfolding across the surface as a frieze, is obviously staged according to different conventions, but conventions perhaps even more professionally theatrical than those of Tintoretto's work and certainly closer to the Vitruvian theater—which was "emphatically an actor's theatre, not a scene-painter's theatre."[23] The alternative to the Peruzzi-Serlio convention involved the staging of dramatic productions before a purely architectural backdrop, rather than before or, by implication, within an illusionistic set. The use of a permanent structure, usually an arcade screen, as a theatrical backdrop was in fact a fairly common feature of the High Renaissance villa: in Peruzzi's own Farnesina the loggia of the Sala di Psiche served just such a function, as did the loggia built by Falconetto for Alvise Cornaro at Padua in 1524.[24]

More theatrical evidence of the practice of reciting plays before such screens is afforded by the well-known illustrations to the 1518 edition of Plautus (fig. 110), which take us directly into the ambience of the early humanist theater.[25] As in Veronese's *Alexander* the actors declaim their parts with rhetorical gestures on a shallow stage in front of an arcade. Scenic spectacle plays a decidedly small role here, the very nature of the multiple aperture surely discouraging ambitious displays of perspective art (although the landscape views of the painted back cloth may well have been inspired by the Vitruvian *periaktoi*).

The continuing vitality of this tradition in the later sixteenth century is attested by the pictorial record of the 1562 production of Giangiorgio Trissino's *Sofonisba,* staged at Vicenza in a theater designed by Palladio. As depicted in a monochrome fresco in the atrium of the Teatro Olimpico (fig. 111), the actors move not in an illusionistic space but against a fixed monumental background; the urban view through the central arch is now beyond any doubt to be read as one of the scenic *periaktoi*.

We have come, finally, to the greatest Renaissance interpreter of the Vitruvian theater. Not unexpectedly, it is with respect to the theater as conceived by Palladio that we can define more precisely some of the theatrical principles and conventions underlying the pictorial structures of Veronese's art. Palladio's sense of the theater was formed on the experience of his particularly close reading of Vitruvius and his careful investigation of the ruins of ancient theaters. The final fruits of his research are preserved in the permanent theater he designed for the Accademia Olimpica in Vicenza shortly before he died in 1580 (figs.

3. THE PALLADIAN THEATER

109. Bartolomeo Neroni,
Stage set for *Ortensio.*
Woodcut by Andrea
Andreani. London, Victoria
and Albert Museum

110. Illustration from
Plautus, *Comoediae,*
Venice, 1518

111. Vicenza, Teatro Olimpico. Fresco of 1562 production of *Sofonisba*

112–15). Despite certain changes effected after his death, the Teatro Olimpico basically follows Palladio's original design.[26]

Reversing the priorities of most of his Renaissance predecessors and contemporaries, Palladio, following Vitruvius, placed little emphasis on the scenic décor, concentrating instead on the total organization of the theater as an architectural whole. The basic problem involved the unification of two functionally distinct areas, auditorium and stage. Palladio's solution was to establish a clear continuity between the decorative scheme and proportions of the *scaenae frons* and the colonnade crowning the *cavea*. And the solution itself naturally followed Vitruvian specifications: namely, that a roofed colonnade should surround the rim of the *cavea* at the top row of seats and that the level of this colonnade should correspond to that of the stage building (*De architectura* V.vi.4). Palladio established a further link in this relationship, as the theme of alternating half-columns and niches with statues is picked up and, with some modulation, restated three times in the auditorium: flowing directly from *scaenae frons* to *cavea* at either side and repeated in the center on the main axis of the theater.

The perspective views seen through the portals of the *scaenae frons,* although probably designed and constructed by Scamozzi, follow Palladio's intention, being based upon his interpretation of the *periaktoi* of the ancient Roman theater.[27] The problem of the form and location of the *periaktoi* was thoroughly discussed in Daniele Barbaro's 1556 edition of Vitruvius and illustrated in Palladio's accompanying designs.[28] Their interpretation, however, was the outcome of a misreading of the Vitruvian text; instead of placing the *periaktoi* to the sides of the stage itself, in front of the *scaenae frons*, they put them immediately behind the aper-

112. Vicenza, Teatro
Olimpico

113. Vicenza, Teatro
Olimpico. *Scaenae frons*

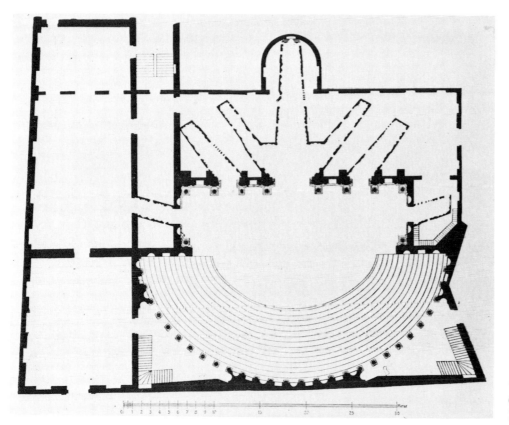

114. Vicenza, Teatro
Olimpico. Plan (from
Bertotti-Scamozzi)

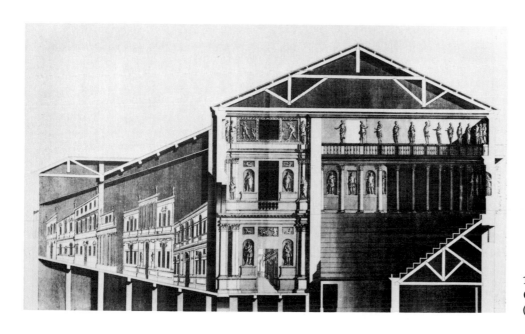

115. Vicenza, Teatro
Olimpico. Cross section
(from Bertotti-Scamozzi)

tures in the screen. That this decision, which was to have crucial consequences, was inspired by Renaissance pictorial conventions seems clear from Barbaro's subsequent observations on the subject in his treatise on perspective, published in 1568; there, after reviewing the function of the *periaktoi* and their location within the open arches, he declares that the views painted on the three *periaktoi* should follow a single perspective scheme, their orthogonals receding to a common vanishing point, so that together they form a unified architectural view—that is, approximate the single perspective backdrop of the Serlian model, which Barbaro, in fact, pirates for his illustrations.[29]

There are three distinct spatial zones in Palladio's theater: the auditorium, the stage in front of the *scaenae frons,* and the street scenes extending behind it (figs. 114, 115). Architecturally, the areas of stage and auditorium are unified. The perspectives, however, although constructed in deep relief, remain essentially pictorial spaces, dissociated from the structurally organic unity of the main body of the theater.[30] The spatial continuity from the stage platform to the scenic backdrop, so important to the Peruzzi-Serlio theatrical experience, is interrupted in the Teatro Olimpico by the monumental screen of the *scaenae frons*. The perspective views seen through the openings—the modern *periaktoi*— lie, in effect, beyond the space of the action.

Palladio's search for architectural unity on a large scale made the very concept of a proscenium arch—a separating element in violation of Vitruvian principles—inconceivable in his theater, where instead a permanent triumphal screen serves as background to the action.[31] Another fresco in the atrium of the Teatro Olimpico, depicting the 1585 inaugural production of *Edipo Tiranno* (fig. 116), illustrates quite clearly the proximity of performer to audience, who in fact seem to share a common space. Neither actor nor spectator is actually invited back into the perspective streets. Yet during the performance itself those vistas do indeed become an integral part of the spectacle—when the forestage and the perspectives are united by lighting effects, and this common illumination finally distinguishes the illusion of the drama from the reality of the audience.[32]

Palladio's theater design represents a minority approach in the late Renaissance. The more popular and influential alternative, continuing the Peruzzi-Serlio tradition, was based on the more rigorous single-point perspective construction; it was this pictorial approach that developed the notion of the proscenium arch as a barrier between stage and audience and laid the foundations for the baroque theater. Similarly, Veronese's sophisticated compositional principles were less important for the development of baroque painting than the more dynamic spatial involvement of Tintoretto's art.

4. VERONESE'S MAESTOSO TEATRO

Our sense of the stylistic affinities between Veronese and Palladio, a relationship noted so frequently yet so casually by critics, begins to assume greater clarity in light of their mutual interest in a specific mode of theatrical representation—a Vitruvian mode, one might say. But this

116. Vicenza, Teatro Olimpico. Fresco of 1585 production of *Edipo Tiranno*

comparison can be taken further, beyond questions of stage direction to fundamental issues of compositional principle. The deliberate ambiguity of overlapping and intersecting zones and shifting levels of reality, operating in an especially complex way for the duration of the drama in the Teatro Olimpico, represents a basic aspect of Palladio's aesthetic in general. In various ways it can be observed in the rich spatial compositions and scenographic effects of his church interiors and in the subtly intersecting planes and orders of his façade designs.[33] And just these elements of Palladio's aesthetic are paralleled in the spatial structures of Veronese's most ambitious and monumental compositions, his famous feasts.

In the greatest of these, the *Marriage at Cana* (fig. 117), the *Supper of Gregory the Great* (fig. 118), and the so-called *Feast in the House of Levi* (fig. 119), the banquet takes place in a vast architectural setting, projected frontally, *in maestà*—a "maestoso Teatro," as Ridolfi would call it.[34] These terms are perfectly appropriate, since Veronese's architecture corresponds in its particulars to the standard prescription for the *scena tragica*, the setting for noble action, comprised of "colonne, frontispicii, figure et altri ornamenti regali."[35] And yet Veronese's settings are not

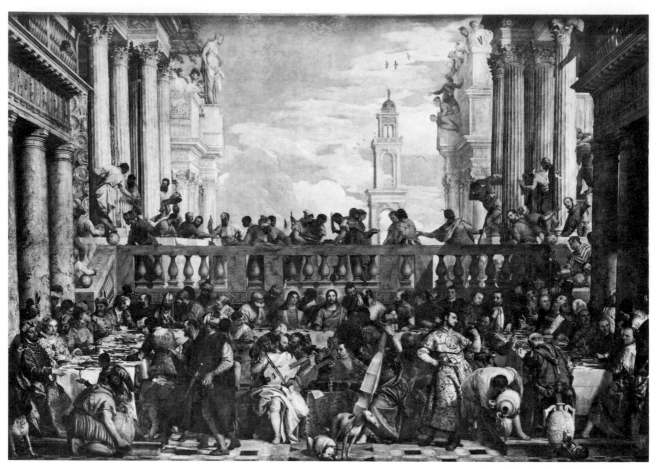

117. Paolo Veronese, *Marriage at Cana.* Paris, Musée du Louvre

the *fondali* of standard stage *vedute;* indeed, in every case he deliberately ignores or subverts the classic rules of perspective. In none of these symmetrical compositions do the receding orthogonals converge to a central vanishing point. Rather, Veronese seems almost to return to a primitive system of vanishing axes, each layer of the picture following a different order.[36] While the resulting compositional structure ultimately resolves all recessional elements into the overall surface design in a most unobtrusive manner, Veronese has not at all abandoned the traditional Renaissance concern with what we have called structural decorum, that is, the proper adaptation of a mural composition to the room for which it is conceived.[37] His solutions—not unlike the divergent axes of Palladio's scenic alleys—are undoubtedly inspired by the recognition of the contradictions inherent in creating a mathematically precise and "correct" spatial illusion over so vast a surface and for a large room allowing the beholder a variety of points of view. Under such circumstances to attempt to organize a fully convincing illusion on the basis of a single fixed vanishing point would be naïve indeed.[38]

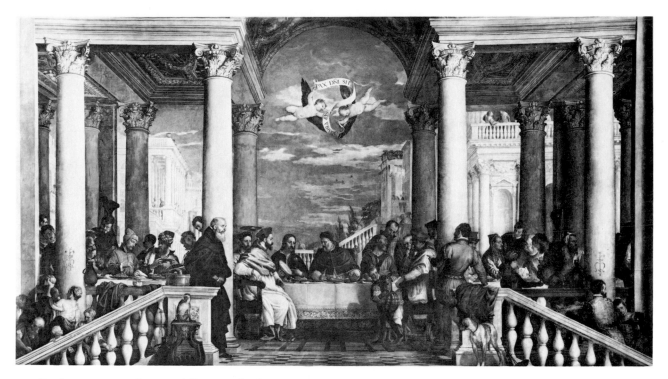

118. Paolo Veronese, *Supper of Gregory the Great*. Vicenza, Santuario di Monte Berico

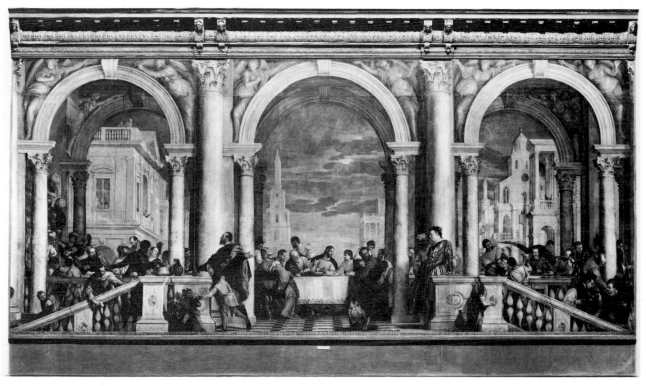

119. Paolo Veronese, *Last Supper* (retitled *Feast in the House of Levi*). Venice, Gallerie dell'Accademia

As in his tableau compositions, Veronese in his great feasts truncates the receding orthogonals. Thus the eye is discouraged from depending upon such purely linear continuities for a sense of spatial extension and instead accepts the shorter fragmented orthogonals as adequate hints, accepting on faith, as it were, the correctness of the construction.[39] In a similar fashion the expansive surfaces of these canvases can barely be comprehended in a single view. Rather, the eye moves over them, taking in portions, each of which presents its own visual logic and completeness; total comprehension of the design therefore becomes a temporal process as the sequence of connected fragments reveals the larger order of the full composition.

Reading tableau compositions like the *Family of Darius before Alexander* involves a similar temporal experience. The eye travels across the surface of the picture following the narrative sequence. In such a structure one may imagine how any deep perspective setting, focusing upon a single distant point in the background, would seriously disrupt or even destroy such surface scansion. Our Veronese-Tintoretto *paragone* was based on an analysis of perpendicular alternatives: either the eye moves across the picture plane (left-right) or it pushes beyond that plane (front-back). The panoramic sweep of Veronese's feast settings represents a complex adaptation—or escalation—of the tableau aesthetic to a still more spectacular level.

The tripartite structure of compositions like the *Supper of Gregory the Great* and the so-called *Feast in the House of Levi* offers an architectural means of isolating moments in the reading of the picture. And, particularly in the latter painting, one is impressed by the similarity to the *scaenae frons* of the Palladian theater with its multiple-focus arcade.[40] Indeed, with its more striking ambiguities, this feast displays a kind of structural dissociation very close to Palladio's. The triple arcade of the open loggia provides the basic organizing schema of the design.[41] In the upper portion of the composition the attached half-columns support the frame itself—which originally would have been the cornice of the refectory wall of the monastery of SS. Giovanni e Paolo—thereby articulating the actual surface of the canvas. In the lower zone, however, several additional layers of space overlap the architectural units. If the great arcade, related as it was to the surrounding architecture of the room, defines the level of the wall or picture plane, then the figures advancing before it exist, by implication, on our side of that plane, in the world of the viewer.[42] Thus, there are three different spatial strata to the picture: first, those figures, including the troublesome German soldiers and buffoon, in front of the loggia and belonging to the realm of the spectator; then, just on the other side of the front arches, beneath the vaulting of the loggia, and clearly within the world of the picture, Christ and his disciples at the table; and finally, viewed through and beyond the arcade is the panoramic backdrop of buildings and open sky—the *periaktoi,* so to speak. The architecture of each of these realms is constructed according to its own individual perspective system.

Thus far our analysis has dealt primarily with formal problems of pictorial organization, and, at this point, one may perhaps legitimately insist that these involve matters of decoration, the sort of thing for which Veronese has long been celebrated. How, after all, does this contradict the general assumption of this painter's supposed lack of interest in and even disregard for iconographic content? What, if any, is the significance of that spatial complexity? The answers to some of the questions are, I believe, offered by the artist himself in his only recorded commentary on his work, the transcript of his interrogation before the Inquisition.

The painting now titled the *Feast in the House of Levi* was originally conceived and executed as a *Last Supper* to replace a painting of that subject by Titian in the refectory of SS. Giovanni e Paolo which was destroyed by fire in 1571. On 20 April 1573, Veronese dated his completed canvas,[43] and on 18 July of the same year he was summoned before the Holy Tribunal to answer charges of indecorum in his large painting—most specifically of having depicted in a *Last Supper* "buffoons, drunkards, Germans, dwarfs and other such scurrilities."[44] The outcome of the hearing was that he was ordered to make, at his own expense and within a period of three months, appropriate corrections in the composition to remove the offenses. As is well known, the only change Veronese made was to add an inscription that retitled the painting: "FECIT. D. COVI. MAGNV LEVI—LVCAE CAP. V." Henceforth the painting was to be known as a *Feast in the House of Levi*, a less frequently depicted subject that called for the presence of "publicans and sinners" (Luke 5:30) and which presumably could also accommodate "other such scurrilities."

The part of Veronese's testimony that is most frequently quoted is his defense of poetic license for painters. Granted the twenty words he had requested in order to explain the presence in his painting of a servant with a bloody nose and of German halberdiers, he began, "We painters assume the same license as do poets and madmen. . . ." Although the rest of his response, which offers a basically naturalistic apology for these figures, may appear as something of a disappointment after the high promise of the opening assertion, there is still good reason to recognize the significance of that assertion on the part of a Venetian painter, especially in the light of its position as a traditional *topos* of ancient pedigree.[45] Much of Veronese's declaration may indeed be read as a defense of relative pictorial liberty—if not of total aesthetic autonomy, of "puri valori estetici."[46] Why the jester with a parrot? "For ornament, as is customary." Just who did he think was actually present at the Last Supper? Christ and his apostles, "but, if in a picture there is extra space, I enrich it with figures according to the subject." Did anyone commission him to paint Germans and buffoons? No. "But the commission was to decorate the picture as I saw fit; it seemed to me that it was large and capable of accommodating many figures."[47]

These quotations have always seemed to confirm the traditional image of Veronese as a purely decorative painter. There are, however, other

5. SPLENDOR AND SIGNIFICANCE

passages, hitherto ignored by commentators, that tell us more about the specific nature of Veronese's imagination. Twice, when asked why he painted those buffoons, drunkards, Germans, and dwarfs, he refers in reply to the spatial structure of the composition: "I did it because I assumed that these were outside of the place of the supper," and "While I may not have considered many things, I intended to cause no confusion, especially since those figures of buffoons are outside of the place where Our Lord is depicted."[48] Twice, then, Veronese himself makes the kind of spatial distinctions suggested by our analysis, isolating the middle level as a sort of sacred space, "dove è il Nostro Signore." While acknowledging the validity of Philipp Fehl's observation that "an interrogation by the Inquisition is not an occasion for the free exchange of views on the function of works of art," I do not think that the painter's own comments here can be dismissed or even devalued as simply naïve or as expediently disingenuous. They point, rather, to a positive significance in the compositional structure of his *Last Supper* (as we should now call it) that is surely worthy of the sophistication of the structure itself.

Moreover, a similar isolation of the sacred space is effected with respect to the surface design. Of the three great arches comprising the basic organization of the field, the middle one naturally enjoys a privileged position, and Veronese reinforces this hierarchy in a number of ways. The central arch (fig. 120) frames the group of Christ, St. Peter, and St. John, and, on the near side of the table, probably the host and Judas. It is the only arch open directly to the viewer, the others being closed by balustrades. The *periaktoi* vistas seen through the lateral arches display the "prospettive rarissime" for which Veronese was famous.[49] In the central arch, however, only two buildings continue this kind of backdrop at the margins; significantly, the space behind Christ and his two closest disciples is without architecture, a purely heavenly background. The related composition of the *Supper of Gregory the Great* (fig. 118) is based on the same structural pattern, a tripartite division, but here "Serlian" in form. Here too the architectural vista yields to pure sky in the center zone,[50] but now its heavenly status is more explicitly articulated by the presence of the two angels with the inscription, "Pax Domini sit semper vobiscum."[51]

The close relationship of the *Supper of Gregory the Great*, painted in 1572 for the Servite refectory at Monte Berico, just outside Vicenza, to the *Last Supper* of SS. Giovanni e Paolo has often been noted. The two works were executed in quick succession and the earlier picture is frequently viewed as in some ways a preparation for the still more monumental Venetian canvas. The similarities of the two compositions, however, can also be interpreted as revealing their parallel iconographies. One of the most prominent features shared by the two settings is the flanking double staircase, which Veronese himself calls "una scala morta." It defines a two-tiered structure, which in the case of the *Last Supper* would refer to the position of the "large upper room" in which the meal was

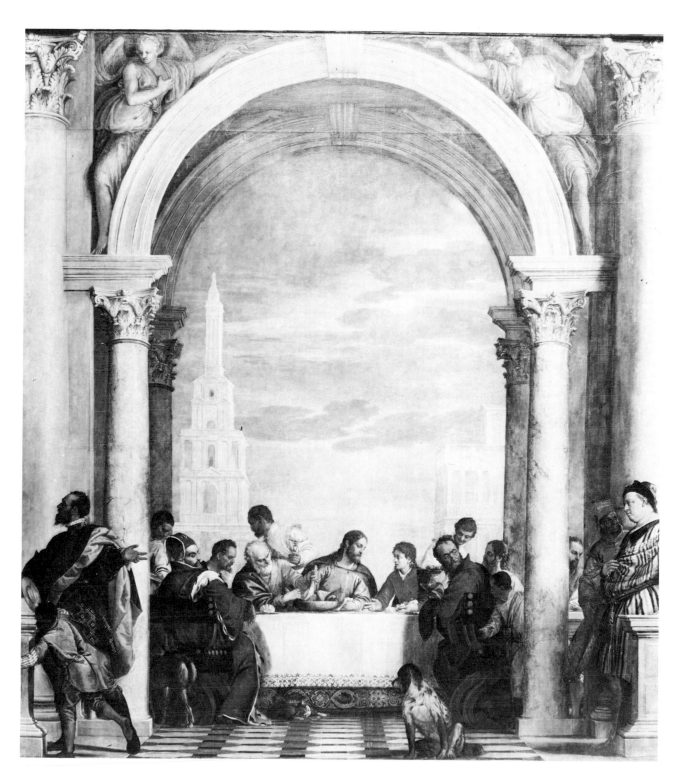

120. Paolo Veronese, *Last Supper* (detail)

served. Veronese's monumental loggia is indeed a quite appropriate rendering of the *caenaculum grande* (Mark 14:15) or *coenaculum magnum* (Luke 22:12) described in the Gospels.[52] When we recall that St. Gregory's supper was a reenactment of Christ's, the function of the stairs in the Monte Berico painting becomes clearer. In both pictures the central arch enframes a prominent *mensa* covered by an embroidered white cloth. That this is a reference to the altar table is made all the more plausible when the table is viewed in the context of the lateral stairs, for this sort of arrangement—the altar directly visible on a high platform but physically accessible only from the sides—is well known especially in Italian Romanesque churches. It is significant that this particular form is used in no other feasts by Veronese or his studio but is reserved exclusively for the *Last Supper* and its Gregorian imitation.[53]

If this reading is correct, then Veronese's compositions manifest a hierarchical structure based on what we might term iconic coordinates.[54] And this should lead us to expect a more profound set of meanings beneath the surface brilliance of a painting like the *Marriage at Cana* (fig. 117). Christ, iconically frontal and directly on the central axis, is the still center of a world in motion, the efficient cause of the miracle and hence of the responses of those figures, to the lower left and right, who are at this moment aware of the liquid transformation: "This beginning of miracles did Jesus in Cana of Galilee, and manifested forth his glory: and his disciples believed on him" (John 2:11).[55]

An expansive canvas like the *Marriage at Cana* must have provided an inviting field for that poetic license claimed by the painter before the Holy Tribunal. In distinguishing the various levels of operative hierarchies, however, one recognizes the obvious stress upon the central axis, which, it can be assumed, would not have been considered a marginal area by the artist.[56] Critics have occasionally been disturbed by Veronese's displacement of the bride and groom to the extreme left of the composition.[57] But this is the feast at which Jesus sanctified the sacrament of marriage. Here Christ himself, manifesting forth his glory, usurps the central place of honor thematically as well as visually: we are directly confronted then by the heavenly groom whose beloved bride is Mary, *sponsa Christi*. Read in this light, Veronese's placement of the miraculous transformation to the sides of the field and his depiction of a Christ rigidly on axis, *in maestà*, ought no longer to appear quite so iconographically arbitrary.[58]

The importance of the axis in the *Marriage at Cana* is still further developed in an extraordinarily subtle fashion, one that illuminates the sophistication of Veronese's imagination. In the foreground, at the base of the central coordinate is the famous quartet of Venetian painters, a direct link with the world of the sixteenth-century viewer.[59] At the top, immediately above Christ, a group of figures in the background is busy preparing the meat for the feast; the upraised cleaver serves as a culminating accent to the vertical axis. I think we are justified in expecting the musicians-Christ-butcher sequence to hold some significance central

to the entire image. A key to this meaning is offered by the hourglass on the table in the midst of the musicians. This object, totally without function in musical practice, is purely symbolic, making explicit the interpretation of music as measured time. The hourglass is an allusion to Christ's response to his mother: "mine hour is not yet come" (John 2:4).[60] The preparation of the lamb above, then, a prophecy of the sacrifice of that hour to come, assumes a positive symbolic meaning consonant with its visual prominence.

Time is indeed another coordinate in the complex structure of Veronese's art, functioning in two basic ways: as historical reference and as narrative sequence. One of his major means for establishing the parameters of historical reference is costume; variations in fashion are juxtaposed to create a series of temporal allusions ranging over wide stretches of geography as well as chronology—a more spectacular elaboration of traditional principles we have already observed in Titian's *Presentation of the Virgin.* Thus, within the sartorial splendor of the *Marriage at Cana*—whose referents extend from the sumptuous luxury of sixteenth-century Venice to extravagant outfits *alla turca*—the robes of Christ, Mary, and the accompanying disciples appear almost nondescript in their humble simplicity; the glory of Jesus and his mother shines forth rather in the divine radiance about their heads. In this way the costuming of characters reinforces the dramatic structure of the composition, which sets off the purity of heavenly glory against the material opulence of earthly wealth and, at the same time, brings into the present the past moment when Christ was with man on earth.[61]

6. TEMPORAL STRUCTURES

Few aspects of Veronese's art have at once so delighted and yet disturbed critics as much as the costumes of his figures. Given the generally prevailing assumption of the purely decorative quality of his aesthetic, they were hardly likely to inspire close scrutiny—except, perhaps, as possible clues to the chronology of Veronese's work. But the use of costume as an aid in dating is itself partly based on the sort of naturalist fallacy typified by Goethe's comment on the *Family of Darius before Alexander:* "Once it is understood that Veronese wanted to paint an episode of the sixteenth century, no one is going to criticize him for the costumes."[62] Of course Veronese was not painting a historical action simply as a slice of contemporary life; he has, however, taken the magnanimous gesture of Alexander and staged it for a contemporary audience. Dressing his dramatis personae with a magnificence that must surely have pressed the limits of Venetian sumptuary laws,[63] he mixes ancient Roman martial costume, modern European armor and dress, and exotic Afro-Asian types.

That the aesthetic underlying this variety is indeed theatrical can be verified by turning to contemporary treatises on theater production. Both Leone de' Sommi and Angelo Ingegneri called for splendor, richness, and diversity in costume, for clear, bright colors. "Speaking about costume," writes de' Sommi, ". . . I may say that I always aim, first of all,

121. Paolo Veronese,
Costume Studies. Paris,
École Nationale Supérieure
des Beaux-Arts

at dressing the actors as richly as possible, yet with proportionate varia-
tions, since sumptuous costumes (particularly in these times when show
is at a premium, and above all things we must consider time and place)
seem to me to add much to the fame and beauty of comedies and still
more so to that of tragedies."[64] To achieve this, designers drew upon
many sources, but they especially looked to ancient art and to the Near
East. For the costumes of the inaugural production of the Teatro Olim-
pico Giambattista Maganza followed the recommendations of Ingegneri,
the director, and mixed his styles—which prompted the objections of

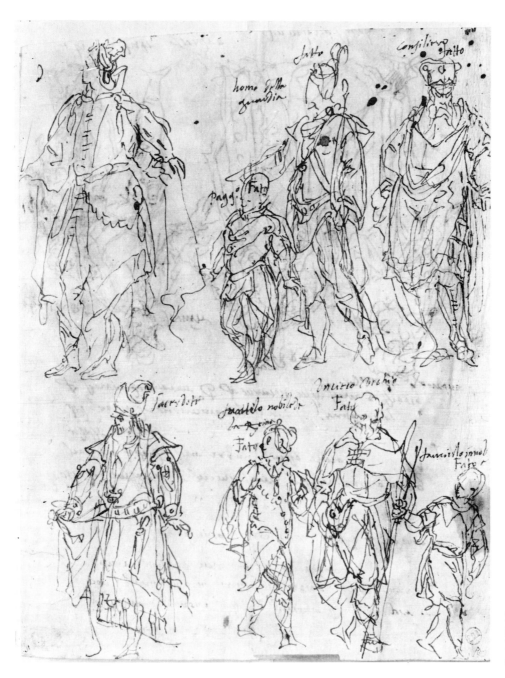

122. Paolo Veronese, *Costume Studies*. Paris, École Nationale Supérieure des Beaux-Arts

purists to the anachronous costuming of the Theban tyrant's soldiers as Turkish archers and to the resemblance of Tiresias to a biblical Aaron.[65]

That Veronese himself, like many of his colleagues (Titian and Tintoretto, Fasolo and Zelotti, for example), was actually involved with the theater can be deduced from the sheet of sketches in the École des Beaux-Arts in Paris (figs. 121, 122).[66] Both sides contain costume studies for a cast of characters typical of tragedy: queen, prince, counselor, priest, lady of the court, guards, servants, and a blind old man. Each

figure is labeled and, presumably as the design was more completely executed, then marked "fato."[67]

In the *Family of Darius before Alexander* the actors are quite specifically differentiated by costume. Within the commanding group of warriors Alexander is distinguished not only by the jeweled splendor and crimson color of his armor; his is the only armor here that makes direct reference to antique prototypes, particularly in the anatomically molded cuirass.[68] His officers wear armor plate of a more contemporary Renaissance stamp.[69] The female members of Darius's family are dressed in aristocratically sumptuous garments of fashionable sixteenth-century cut. At the extreme left frame the two female heads in profile are characterized as Near Eastern—one is tempted to say more precisely, Egyptian—not only by their costume but by their distinctive physiognomies as well. Thus Veronese's characters quite clearly establish by their dress some fundamental points of the story: the classical antiquity of the conqueror, the nobility of the women of Darius, and the exoticism of their "Persian" entourage.[70] The inclusion of modern fashions and, most probably, of specific portraits underscores what we might today call the contemporary relevance of the picture.[71]

There would seem to operate in Veronese's costumes and character types, then, a system of references as significant as the larger pictorial structures containing them, a system dependent upon certain extrapictorial conventions based on particular cultural experiences and references, operating in a manner analogous to the symbolic and iconographic functioning of architectural forms. We may recall here the architectural evocation of an elevated altar space in the *Supper of Gregory the Great* and the *Last Supper* from SS. Giovanni e Paolo. In that same category of references would be the triumphal aspect of the arch decorations in the latter painting. The prominence of the gilded winged victories in the spandrels lends them a special—although, it is important to note, by no means unusual—significance: further articulating the typological relationship of this great loggia to the triumphal arches of antiquity, they declare the ultimate triumph of the resurrected Christ over the death he anticipates at the Last Supper.

In only two other paintings by the master does such an arcade play an important role, the *Alexander* and the earlier fresco of *St. Sebastian before Diocletian* (fig. 123) on the upper wall of San Sebastiano in Venice.[72] These arcades are not quite comparable to the great screen of the *Last Supper*, for they do not dominate and control the composition in the same way but rather measure the pace of the narrative action unfolding before them. Yet in each the arcade may conceivably retain its triumphal reference: in the *St. Sebastian* announcing the ultimate victory of the Christian martyr and in the *Alexander* celebrating the military victory of the young conqueror.

Simply to compare the setting of the London picture to the atrium of a grand palace is to impose a misleading and restrictive naturalism upon Veronese's conception.[73] Despite parallels to actual constructions of

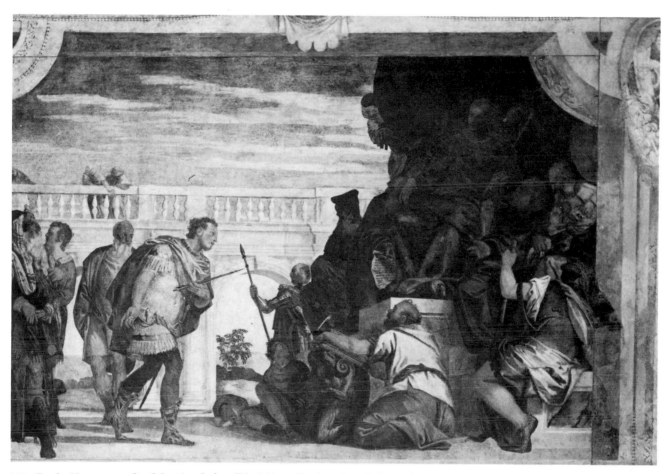

123. Paolo Veronese, *St. Sebastian before Diocletian*. Venice, San Sebastiano

Sanmicheli, Sansovino, or Palladio, the architecture of Veronese's historical pictures does not permit the possibility of reconstruction—any more than his historical costumes can be taken as sure guides to the whims of sixteenth-century Venetian fashion. It is not real architecture[74] but theatrical and, hence, symbolic. Its status with respect to the realities of the Renaissance urban ambience would be closer to that of the temporary structures erected for special festive, usually triumphal, occasions; those structures were intended precisely to transform the mundane world of contemporary reality into something extraordinary and symbolic, to celebrate timeless virtue.[75] Where analogies to the function of actual buildings seem to exist in Veronese's art they frequently allude to specifically ceremonial structures, such as Sansovino's Loggetta at the base of the campanile of San Marco. The central monument of the *Alexander* recalls, for all the obvious differences in style, the Arco Foscari in the Palazzo Ducale (fig. 124), one of the best known permanent triumphal monuments in Venice.[76] Crowning this form in Veronese's canvas, although truncated by the upper frame, is a great obelisk, symbol of ''vera gloria'' or ''gloria dei principi.''[77] The symbolism of the setting,

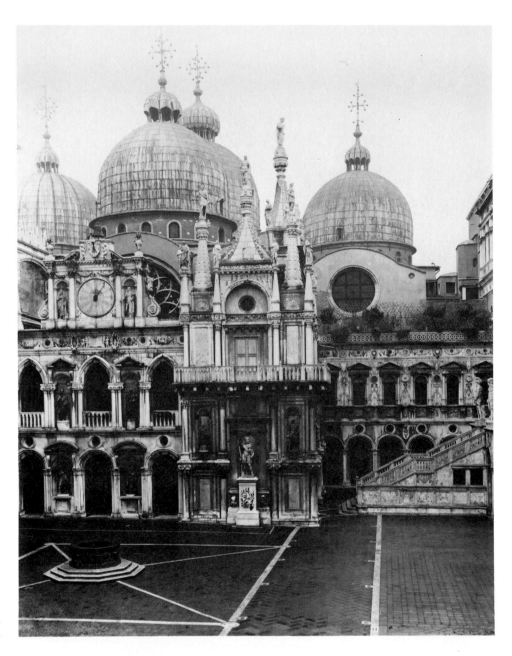

124. Venice, Ducal
Palace. Arco Foscari

then, gives permanent form to the fundamental theme of the composi-
tion, the glory of Alexander.

Veronese's articulate use of costume and his expressive distinction of
spaces, epitomized respectively in the *Marriage at Cana* and the *Last
Supper,* are two structural keys to the functioning of his art. The
significant division of the pictorial field in particular is a basic composi-
tional principle consistently informing his work. In the *Madonna of the
Cuccina Family* (fig. 125), for example, there exists a division similar in
a way to that of the *Last Supper* with its isolation of a picture-within-
a-picture. The paired polychrome columns mark the division in the

125. Paolo Veronese, *Madonna of the Cuccina Family.* Dresden, Gemäldegalerie

Dresden canvas, separating the family and the accompanying personifications of Faith, Hope, and Charity from the group of holy figures at the left.[78] While the continuity of sky and pavement guarantees the overall visual unity of the horizontal setting, the columns unequivocally establish the hierarchical distinction between the two realms. Portraiture, human and architectural, dominates the reality of the right-hand rectangle of the composition, the specificity of the individualized Cuccina being further localized by the prominent position of the façade of their recently completed palace.[79] The *sacra conversazione* enframed at the left contains none of these references to sixteenth-century Venice.

This sort of irregular division, in which a long rectangular field leads to and culminates at a more stable narrow zone, constitutes an important part of the Venetian tableau tradition and, as we observed, appears fully developed in Carpaccio's *Reception of the English Ambassadors* (fig. 25). The tripartite narrative structure of this first canvas in the St. Ursula cycle, we recall, begins with an introductory unit based in late quattrocento reality, leads into the first episode of the story, the reception of the ambassadors which dominates the central rectangle, and concludes with the conference of Ursula and her father.[80]

Just as he continued the tableau tradition into the later cinquecento, so too Veronese continued to develop the temporal multiplicity of the older tradition. The picture-within-a-picture, in addition to describing spatial hierarchies, became a means for distinguishing moments of time, as in the Louvre *Supper at Emmaus* (fig. 126). Although apparently a centralized composition with Christ just off axis, the picture's asymmetrical construction approximates that of traditional votive tableaux. Here the separation between two unequal fields is effected by a distinction be-

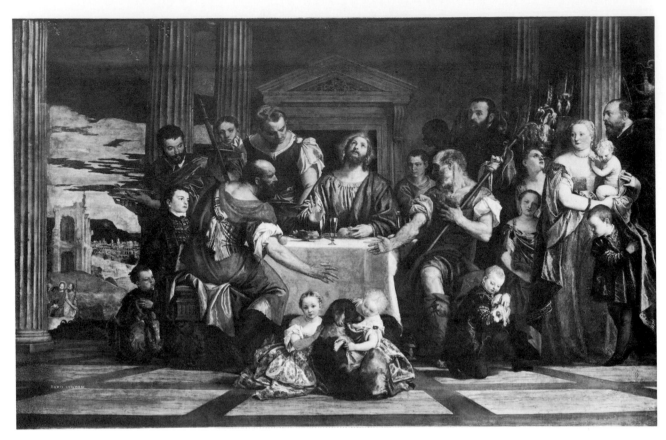

126. Paolo Veronese, *Supper at Emmaus.* Paris, Musée du Louvre

tween architecture and landscape, the contrasting settings containing two different moments in the narrative. The main scene, of course, is the actual supper with the disciples—highly complicated by the presence of the donor and his family, who reflect the unresponsiveness of the servant by their own evident detachment from the miraculous revelation; the archaeological landscape seen to the left, however, contains the preceding moment, the encounter of the two pilgrims with the still anonymous third.[81]

Veronese seems more frequently to have explored the possibilities of such complex temporal structures in full landscape settings, as in the Borghese *St. John the Baptist Preaching* (fig. 127) and in the magnificent late canvas, now in the Brera, depicting the *Baptism and Temptation of Christ* (fig. 128). In these compositions there is a clear juxtaposition of separate but related moments in time, rather a montage effect.[82] A smoother flow, however, governs the narrative of the *Rape of Europa* (fig. 129). Instead of suggestive juxtaposition, we find here a more linear, uninterrupted progress in time and space, following the story of the bull's calculated seduction of the maiden from foreground to middleground to background. Each layer of pictorial space thus represents a separate event, and the movement of the observer's eye deeper into the

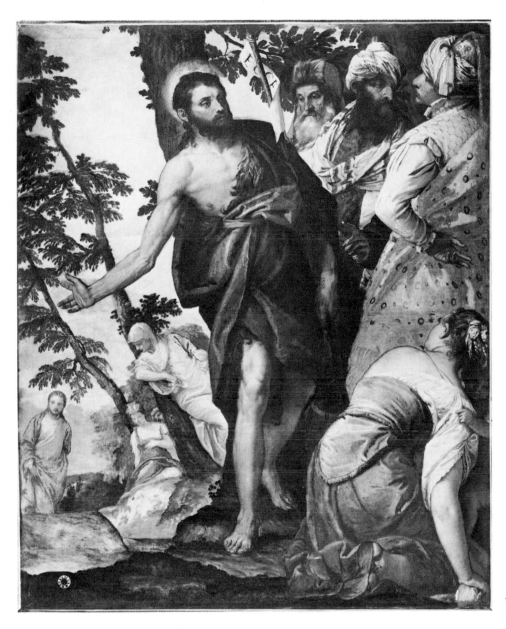

127. Paolo Veronese, *St. John the Baptist Preaching*. Rome, Galleria Borghese

fictive space corresponds in a quite literal way to a temporal sequence. In this spatial flow Veronese seems to have abandoned the kind of structures that we have been analyzing—but which continues to inform the asymmetrical surface design, at any rate, of the *Rape of Europa*—in favor of one rather closer to Tintoretto. The very notion of articulating moments, however, had already been developed by him as part of the structural principles organizing his earlier work. The narrative line of the *Rape of Europa* derives from and depends on Veronese's previous experiences in dramatic presentation.[83] Even when, in his late work, he approaches the tonalism of Tintoretto—or, more accurately, of Jacopo Bassano—and, in that respect, the heritage of *giorgionismo* with its

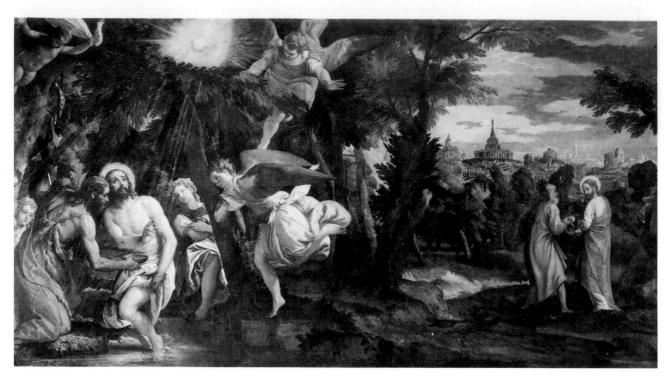

128. Paolo Veronese, *Baptism and Temptation of Christ.* Milan, Pinacoteca di Brera

thicker spatial ambience, he maintains those structural principles that had evolved in the Venetian tableau tradition and which were more concerned with narrative movement on a panoramic scale.

Veronese's is an art of grand gestures and demands, on one level, to be considered as theater. And the comparison offers an aesthetic parallel and convenient reference, a point from which to gain a new perspective on that art. But, for all their common concerns, painting and theater of course remain in the final analysis two different arts, each with its own problems and principles. They may share the frame as a common real element, but the field of painting, the flat picture plane, can serve in theater criticism only by analogy, as a metaphor. Analysis of Veronese's paintings has perforce to lead us from the fictive world of the stage back to the reality of the picture plane. Such a dialectic, recognizing the peculiar duality of the painted image, must be central to any pictorial analysis. Basing our initial observations on the mimetic narrative, or rhetorical, features of this art allowed us to return to Veronese's surfaces, those undisputed sources of delight, with new expectations.[84]

In these pages I have tried to suggest some ways of reading Veronese's compositions by following relationships inherent in the very structures of their design. Internal guides such as spatial coordinates and figure differentiation lead to interpretations that seem to me to have the merit of consistency and to reflect a unified but flexible and expanding vision, one capable of creating and controlling complex systems of internal and external references, of dealing in time as well as space. The interpreta-

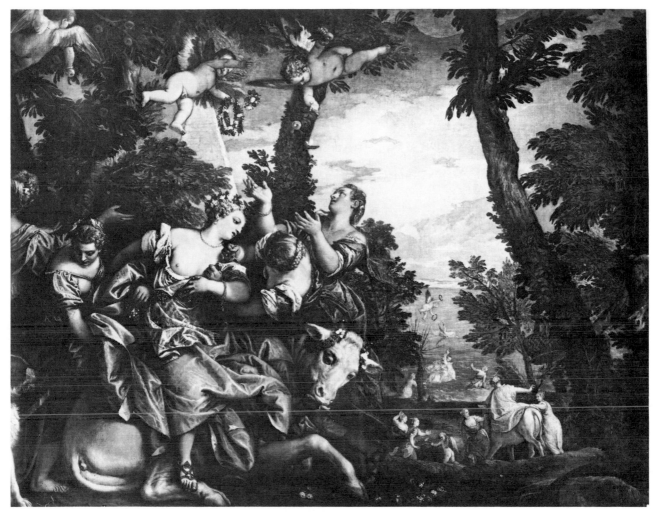

129. Paolo Veronese, *Rape of Europa*. Venice, Ducal Palace

tions themselves cannot pretend to be exhaustive or definitive—any more than literary criticism can pretend to finality. For the method itself, however, I would claim that it has the virtue of assuming positive meaning in Veronese's work on several levels, and in that way at least it acknowledges his creativity and imagination more fully than do our inherited approaches to the artist. That one cannot divorce form from content is a lesson we have generally learned with respect to the great masters of the central Italian Renaissance. We have yet to appreciate that the lesson is no less valid for the great Venetians; in regard to their work as well, for all its openly sensuous appeal, one can speak only of the content of form—and this especially for the dazzling productions of the painter crowned by Boschini the "Treasurer of Painting."

That Veronese and Palladio moved in a common aesthetic and intellectual circle is attested not only by the visual evidence of their work but also by their relationship to a common patron, Daniele Barbaro. And the writings of this remarkable patrician humanist, one-time Venetian am-

EXCURSUS: DANIELE BARBARO ON *SCAENOGRAPHIA*

bassador to England and patriarch elect of Aquileia, may actually shed some light on the scenographic contexts of Veronese's art.

Barbaro published his translation of and commentary on Vitruvius's ten books *De architectura* in 1556.[85] On that project he enjoyed the close collaboration of Palladio, and his acknowledgment of the architect's help includes specific mention of his work on the ancient Roman theater.[86] Their interpretation of the *periaktoi,* as we have seen, had important consequences for Palladio's own conception of the classical theater —and, by implication, for Veronese's mode of pictorial staging.

Several other passages in Vitruvius of immediate relevance to our concerns had further troubled Barbaro, those referring to *scaenographia.* Discussing the fundamental principles of architecture (I.ii.2), Vitruvius had asserted that arrangement or disposition (*dispositio*) finds expression in three forms: *orthographia* (ground plan), *ichnographia* (elevation), and *scaenographia* (perspective). His Venetian commentator, declaring the third term to be incommensurate with the first two and hence not properly a part of *dispositio,* substituted an alternative reading of the text: *sciagraphia,* which he rendered in Italian as "profilo." Barbaro thereby obtained a theoretical grouping of plan, elevation, and profile, or cross section, a trinity of commensurable graphic representations more in keeping with his own rigorous sense of *dispositio.*[87]

The pictorial concept of *scaenographia* Barbaro preferred to reserve for the perspective views of stage scenery. In his commentary on the three scenic modes he expanded upon the laconic description of Vitruvius and outlined his own plans for a full book on "la prospettiva pratica."[88] Oddly enough, Barbaro states that until now so far as he knows no one has treated the subject or published anything on it, and this despite the marvelous effects of perspective rendering acclaimed in the past. From this he concludes that one can "reasonably reprove our own age, which has produced excellent painters but few masters of perspective. I see the effects of perspective rendering being applauded while the effort necessary to such achievement is disdained; the effective work is admired but the study behind it is shunned. Everyone wants to have such beautiful things, but done by others; no one is willing to apply himself to the task."[89] To correct this situation Barbaro himself undertook the responsibility of teaching the art of perspective, and in 1568 he published his promised volume, *La pratica della perspettiva . . . opera molto utile a pittori, a scultori, & ad architetti.*[90]

The preface to this treatise recapitulates and expands the argument of Barbaro's Vitruvius commentary, now acknowledging, however, the work of his Renaissance predecessors. He cites the studies of Piero della Francesca "and others," which he describes as crude and without order, "possibly useful to idiots," and recognizes the "ingenious and subtle" investigations of Dürer and the less acute work of Serlio; Barbaro adds, however, that both stopped short at the very threshold of the subject. His attitude seems rather ironic, not to say ungrateful, since in different parts of his book he makes extensive use of the examples of all three, indeed, to

the point of outright plagiarism.[91] Finally, he returns to his criticism of contemporary painters, who, while "otherwise celebrated and famous, are content with a very simple practice, failing in their pictures to demonstrate an understanding of perspective worthy of much praise, and offering no real principles in their writings."[92] No names are mentioned.

In an earlier draft of his text, a manuscript preserved in the Marciana, Barbaro had been somewhat more specific, singling out for praise one living artist, Jacopo Sansovino, "famous not only as sculptor and architect, but a most subtle master of perspective."[93] Otherwise his taste appears strangely retardataire and, from the point of view of the mid-cinquecento, even somewhat naïve—although of special interest with regard to Veronese's own revival, as it were, of the older tableau tradition. For example, in the manuscript version of the chapter on the location of the vanishing point ("In qual parte del quadro si deve fermar il punto"), Barbaro, following Alberti, discusses the relation between the horizon line and the eye-level of the figures within the picture; he proceeds to consider the situations requiring radical displacement of the point, as in crowded compositions such as battles where the observer is ideally well above the ground plane and where a high horizon is neces-. sary for the sake of representational clarity. His illustrations, however, are not drawn from contemporary examples. Rather he praises Giovanni Bellini's now lost paintings in the Ducal Palace. It is perhaps even more interesting to find Barbaro celebrating the perspective structures of Carpaccio, "by common consent worthy of eternal fame."[94] For examples of the low positioning of the vanishing point dictated by exigencies of site, where a painting is situated high above the observer's eye-level, Barbaro understandably turns to Mantegna's Eremitani frescoes in Padua. And the same master's *Triumph of Caesar,* in addition to serving as an illustration for the placement of the vanishing point outside the field, inspires the Venetian humanist's warmest enthusiasm.[95]

Barbaro's admiration for these late quattrocento masters of a manner Vasari and Dolce had only recently stigmatized as crude, hard, and dry seems symptomatic of his general attitude; his preference, aesthetic as well as intellectual, is for clarity and commensurability. The order of his treatise, like that of Alberti's, proceeds from the linear rendering of *disegno,* founded on the principles of perspective, to the addition of light, shadow, and color to achieve a fuller illusion. But he actually has little to say about coloring, that part of painting which was so elusively complex and, as Paolo Pino wrote, "impossible to explain in words."[96] Like Alberti, Barbaro found it easier to confine his comments to questions of modeling and chiaroscuro. Indeed, his brief passages on color express an amateur's delight in the simplicity of watercolor effects, and he suggests the use of a light ground in order to bring out the fullness of the colors. In this he seems to be rejecting the practice, common in Venetian painting at least since Giorgione, of painting on a dark prepared ground. Barbaro's critical stance—by implication appreciative of Veronese, more Veneto than Venetian—is distinctly outside the Giorgione tradition; the

poetic evocation of rich tonalism evidently has little place in the Aristotelian world of his critical values.[97]

Not surprisingly, when he comes to consider the topic of human proportions Barbaro turns to the most comprehensive published source available, Dürer's *Vier Bücher von menschlicher Proportion*. And while criticizing the minute scale of the German's anthropometry, which he claims to temper by crossing it with the larger dimensions of the Vitruvian canon, Barbaro nonetheless reproduces many of the woodcuts from the *Vier Bücher*.[98]

Following the same pattern of research, so to speak, for his section on scenic design, Barbaro republishes, without the least acknowledgment, Serlio's famous illustrations of the tragic, comic, and satyric scenes.[99] As we have noted, Serlio's perspective designs do not fit comfortably into the Barbaro–Palladio interpretation of the Roman theater. But, like Vitruvius himself (VII.v.2), Barbaro extends the application of the scenic modes beyond the theater proper. While many of the painters he was presumably addressing were undoubtedly involved in stage design, Barbaro's instruction in perspective refers to the art of painting in general—as Serlio's woodcuts had exercised a most significant influence on painting. It is important to recognize the direction here, for the established Vitruvian categories of scenic décor became models for Renaissance art theory and criticism. Aside from the general analogies of mimetic aim and structure that we have traced, the movement from theater to art was, we might say, fundamentally literary and theoretical: in the ancient traditions of theatrical commentary painting found a useful critical vocabulary, categories of description as well as terms for articulating the expressive functions of space.[100]

The revival of interest in the scenographic art of antiquity, then, had an influence far beyond the limits of theater per se, and perhaps no finer monument of this may be adduced than Daniele Barbaro's own villa at Maser. In both his Vitruvius commentary and his treatise on perspective Barbaro, citing Pliny as well as Vitruvius, describes the marvelous effects of ancient scenographic painting: "not only landscapes, mountains, forests, and buildings all beautifully designed and executed, but also human figures and animals foreshortened and rendered correctly according to the rules of perspective."[101] Vitruvius had recorded the application of tragic, comic, and satyric scenic types to mural decoration in antiquity (VII.v.2). Veronese's frescoes in the Barbaro villa follow quite faithfully some of the descriptions of Vitruvius and Pliny.[102] If they betray no obvious debt to the scenic modes, we must again recall that the patron's own conception of *scaenographia* was not limited to a strictly theatrical context but intended perspective construction in its broadest application. It may be, therefore, that this decorative project, comprising "not only landscapes, mountains, forests . . . ," represents in fact the fullest realization of Barbaro's own ideas on ancient scenographic art and, further, testifies quite directly to Veronese's active involvement in this aspect of Renaissance humanism. Indeed, we are increasingly coming to recognize the painter's fundamental responsibility for the full

range of the villa's interior decorations—stucco designs as well as frescoes.[103]

The relationship between the painter and the architect at Maser, however, continues to bother students of both, but particularly of Palladio. "Although it is the most distinguished decorative scheme in any Palladian building," admits James Ackerman, "and is so ingeniously integrated into the architectural design as to suggest close collaboration, it is not referred to in the text of the *Quattro libri,* which normally lists the decorators. We have no way of knowing whether this omission indicates a disagreement between Palladio and his distinguished colleague, as some critics have suggested, or an oversight."[104] It is indeed usually agreed that however one chooses to read Palladio's silence Veronese's decorations in the Barbaro villa appear absolutely perfect, the appropriate figuration of the harmonic proportions of Palladio's design.[105] Those who would argue that Veronese's frescoes violate the principles of the architecture by opening those precisely located walls[106] seem to miss a crucial point: namely, that even if he had no direct role in the planning of those decorations, Palladio himself surely did not expect his walls to remain blank but rather to receive some sort of pictorial embellishment. That such embellishment should follow the descriptions of Pliny and, more relevantly, Vitruvius is to be expected in a Renaissance villa *all'antica;* any other solution might have been legitimately considered a breach of architectural decorum.[107] The question ought not to be phrased with exclusive reference to painter and architect, for one must ultimately refer back to the man responsible for the building, Daniele Barbaro himself.[108] And in that context especially Maser stands without internal contradictions as a perfectly harmonious achievement—and the triumph of the revived art of *scaenographia.*

Action and Piety in Tintoretto's Religious Pictures

1. *THE MIRACLE OF ST. MARK* Early in 1548 Tintoretto, not yet thirty, made his presence on the Venetian scene felt with the kind of public gesture, and resultant controversy, that would characterize his career to the end. At the center of the turmoil was his painting of the miraculous intervention of St. Mark (pl. 7, fig. 130). Commissioned by the Scuola Grande di San Marco as the first in the pictorial cycle decorating the *sala grande* of the confraternity, the unusually large canvas was intended for the wall opposite the altar.[1] It was evidently on view there by April of 1548, the date of Pietro Aretino's letter to the young painter in which the grand publicist, congratulating his own critical acumen in having earlier recognized the talent of Tintoretto, enthusiastically documents the public acclaim that confirmed his judgment.[2] Typical of Aretino's critical language, the letter celebrates the naturalism of the image, especially the lively effect of the foreshortened nude, and the overall impact of the composition. But the writer then proceeds to offer, and not for the first time, friendly counsel, advising the artist for the good of his future development and reputation to moderate his speed of execution.[3] Aretino was sounding what would become a standard caveat in the criticism of the cinquecento: if only this brash Venetian would slow down and bring his works to a proper state of finish, then, as Vasari put it, he might become one of Venice's greatest painters.[4]

We cannot automatically assume, however, that the troubled reception of Tintoretto's picture among the brothers of the Scuola di San Marco was related to such matters of style; internal politics are as likely to have been the source of discord, as they would again be in Tintoretto's relations with the Scuola di San Rocco. Ridolfi reports that the *confratelli* were divided over acceptance of the canvas, that Tintoretto, understandably offended, removed the picture from the *scuola* and took it home, but that eventually the factions were reconciled and the painting returned to the *sala grande*.[5]

The *Miracle of St. Mark* does indeed represent a moment of arrival in the art of Tintoretto. Summarizing all the forces present in his youthful work, of which it is the culmination, its still greater energies announce the course of his future development. If its architectural setting seems less ambitious and elaborate than the complex of spaces in the probably

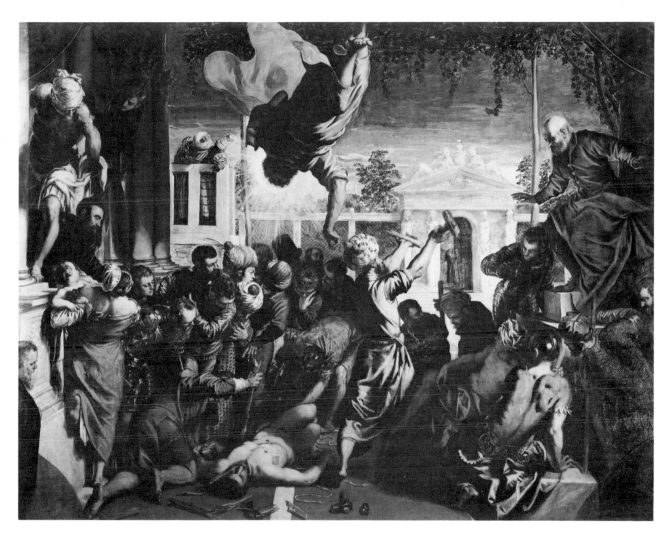

130. Jacopo Tintoretto, *Miracle of St. Mark.* Venice, Gallerie dell'Accademia. (See also colorplate 7.)

contemporaneous *Washing of the Feet* (fig. 107), it is nonetheless more unified in its clarity. In keeping with the subject, the figures themselves now assume the greater responsibility for dramatic spatial articulation. Tintoretto's early, if distant, study of the art of Michelangelo—the first clear results of which were manifest in single figures on the façade of Ca' Gussoni[6]—here achieves a fully fluent language of corporeal eloquence[7]—although the *Miracle of St. Mark,* too, features quotations from the Florentine's Medici *Crepuscolo* and from the Sistine *ignudi.*[8] More significant still is the synthesis of *disegno* and *colorito,* an aesthetic ideal proclaimed in these very years, that would serve as the foundation as well as the hallmark of the creations of Tintoretto's full maturity.[9]

The injunction of Aretino notwithstanding, the *Miracle of St. Mark* is in every way a deliberately constructed painting, thoroughly thought out in each detail of its execution. Despite the evident rapidity of that execution, the canvas is really quite fully covered; little of the toned ground is

functionally visible (as it is, for instance, in the later *Carrying of the Body of St. Mark* [fig. 105]), and the brush strokes themselves, in their energetic direction, play a decisive role in the definition of both form and action.

This deliberation is perhaps most evident initially in the colors and their distribution. Essentially cool and clear, they are surprisingly quite localized, contained within bounded areas of costume and drapery. Against the varied cerulean field of the background sky, descending from the olive-green of the foliage at the upper frame, the figure of the saint himself establishes what may be called the basic operational color notes of the composition: the crimson-mauve of his garment and the gold of his cloak. Distributed throughout the picture—most significantly muted in the costume of the officiating noble enthroned at the right and, at the left frame, shared by the foremost spectator perched upon a column base and the curious mother below—these form a central component of the picture's chromatic structure. Similarly, the olive-green is spread from the central figure holding up the broken hammer, and the azure blue of the sky is distributed below, modified in brilliance and saturation, in various figures from the kneeling torturer to the cap of the mailed onlooker at the left. Run through a full range of variations of hue, modified as they participate in the tonalism of the image's plastic structure, and, finally, set off by the brilliant passages of bravura painting in the reflective armor, such color relationships constitute a fundamental aspect of the picture's organization. Indeed, in its clarity and intelligence of chromatic construction, the *Miracle of St. Mark* is something of a demonstration piece—not so much a tour de force as, literally, a quite finished "masterpiece," the public announcement of a young painter's ambitious control of his art.

Commissioned to fill the space between two windows on the short wall of the *sala grande* of the Scuola di San Marco, Tintoretto's canvas received its primary illumination from the windows along the adjacent wall to its left (the observer's right).[10] And, following traditional Renaissance practice, the composition's internal lighting acknowledges this fact of the site, as the forms are illuminated from that side.[11] Within the scene, however, this natural light is eclipsed by the divine radiance of St. Mark's halo, which, touching none of the other forms or figures in the picture, finds its correspondence only in the illuminated body of the pious victim below—just as the saint's position in space is reflected in the latter's reverse foreshortening.

On a major scale, the great contrapuntal relationship between the two sharply angled figures establishes the central dramatic axis of the *Miracle of St. Mark*. If one can adduce as a much earlier example of a similarly foreshortened and inverted divine figure Uccello's fresco of the *Sacrifice of Noah* in the Chiostro Verde of Santa Maria Novella in Florence, the truly relevant comparison for this physical dialogue of salvation is, of course, Michelangelo's *Conversion of St. Paul* in the Cappella Paolina (fig. 131). In Tintoretto's canvas, as in Michelangelo's fresco, divine intervention in the world of man occurs with an insistent physicality, the savior intruding from heaven with precisely directed force. And yet, for all the

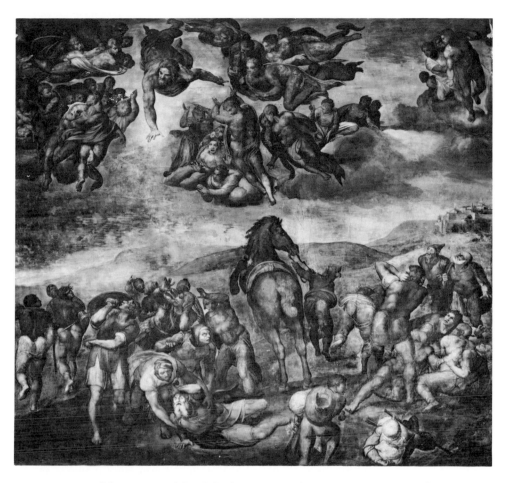

131. Michelangelo, *The Conversion of St. Paul.* Vatican, Cappella Paolina

apparent suddenness of St. Mark's miraculous apparition—of which no one in the picture is aware other than the faithful sufferer who has invoked his aid—the painting does not represent an instantaneous eruption. Rather, within the complex interactions of his composition, Tintoretto has created a narrative structure that unfolds in time; in order to read the image we must turn to the story it depicts.

The event represents one of the many miracles credited to St. Mark in the course of the Middle Ages, the apocryphal accretion to the basic hagiographic trilogy of *passio, translatio,* and *inventio.* This body of legends constitutes, in effect, the afterlife of the saint, the record of his continuing intervention on behalf of the faithful—"the miracles that God deigned to work through the intercession of St. Mark," in the words of a later hagiographer.[12] Tintoretto's painting recounts the story of a certain Provençal devotee of the saint, variously identified as a slave, a servant, or a castellan.[13] Ignoring his lord's prohibition, this faithful Christian made a pilgrimage to the church of San Marco in Venice; there, at the high altar, he pledged himself to God and to the saint, and in particular he dedicated all of his body to St. Mark. Upon his return he was condemned by his master, who ordered him tortured. In his fury the noble of Provence swore that not even St. Mark himself could save the disobedient servant, whose eyes he commanded to be put out with sharp

spikes. The servant replied that he had no fear, for he had commended his body and all its parts to his patron saint; and, in fact, the torturers were unable to blind him. Whereupon the lord ordered that his legs be cut off, again to no avail: the axes could not harm those limbs. Finally, in exasperation and to prevent the servant from calling upon St. Mark again, he ordered that his mouth be beaten with a heavy hammer. As this and still further torments failed, the noble and his executioners marveled and, acknowledging the miraculous protection of the saint, repented and went themselves upon a pilgrimage to Venice, where in the church of San Marco they confessed their sin and announced to all the miracle they had witnessed.[14]

The length of this narration, with its succession of attempted mutilations and accompanying mechanical detail, is of obvious relevance to an understanding of Tintoretto's conception, for out of this circumstantial material the painter constructed his own pictorial narrative. The full sequence of acts, upon which the story builds to its climax of repentance, unfolds in a manner complex in its anecdotal richness but absolutely clear in its discourse.

We may better evaluate these qualities of Tintoretto's work through a brief comparison with a slightly earlier representation of the same subject, one that has generally been recognized as an important model for the painter: Jacopo Sansovino's bronze relief on the left choir stall of San Marco, executed between 1541 and 1544 (fig. 132).[15] Actually, Sansovino's narration of the story extends over three panels; following the attempted martyrdom are depicted scenes of the *Apparition of St. Mark* (fig. 133) and the *Repentance of the Master* (fig. 134). With the greater discursive latitude permitted by the three fields, the first relief concentrates, then, on a single moment in the story; and within the greater physical density of his field—and medium—Sansovino condenses the subject to a single movement, a simultaneity of action that combines into a unified choreography the attempted tortures and the amazed response to the miracle. The impacting of figures reduces them to a choral group, their common mass articulated by the internal variations of gesture that differentiate them as individuals. Well above the crowd hovers the figure of the saint himself, the distant cause of the drama below.

On a purely dramatic level, then, this tragic economy distinguishes Sansovino's image from the particular pathos of Tintoretto's painting, a world more open and, ultimately, more human. In the painting, despite the fullness of the spectacle, victim and saint relate with that direct intimacy which isolates them from the rest. Instead of coordinating the several attempts of the torturers into a dense unity of action, Tintoretto maintains the relative independence, the separateness of the individual acts. Time manifests itself in a distinction of moments, and we, as readers of this surface, find ourselves participating in that temporal structure. From the fragments of broken tools upon the ground, to the evidently just broken hammer lifted high in wonder, to the torturers persisting in their vain endeavors, to, finally, the hammer held in readiness by the armored soldier to the left—an allusion to the attempt to

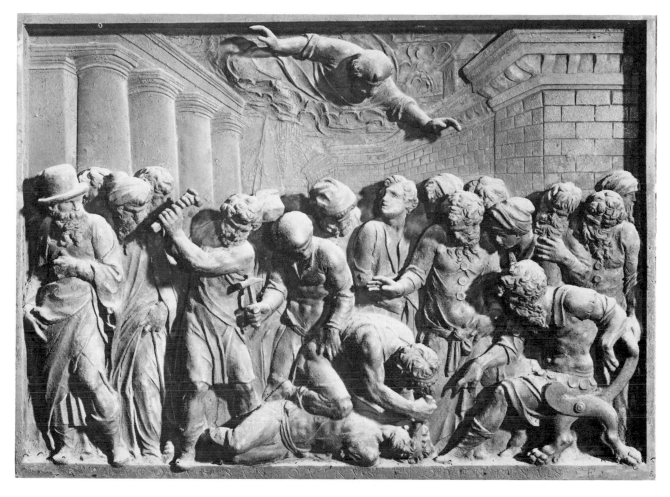

132. Jacopo Sansovino, *Miracle of St. Mark.* Venice, San Marco

silence the servant, an act still in the future—we are invited to move through and, in effect, to reconstruct the full sequence of the story. Tintoretto, apparently, will sacrifice no detail, no anecdote, to a decorum of classical unity. Within the context of this narrative multiplicity, then, the saint's foreshortened entry must appear, for all its energetic movement, rather like a permanent suspension. Indeed, Mark's healing hand, so triumphantly juxtaposed to the vanquished hammer, corresponds exactly with the vanishing point and thereby simultaneously generates and focuses the orthogonals of the underlying perspective construction. The very force of this conception, dramatically and structurally, thus activates the entire composition—"for in times of need saints do not fail in the protection of their devotees."[16]

Over the expansive field of his large canvas, Tintoretto distributes a group of participants and witnesses more varied than that of Sansovino's relief. Across the diagonally off-center axis of St. Mark and the prostrate servant, the painter threads a lateral movement from left to right, thereby establishing the basic coordinates, narrative as well as

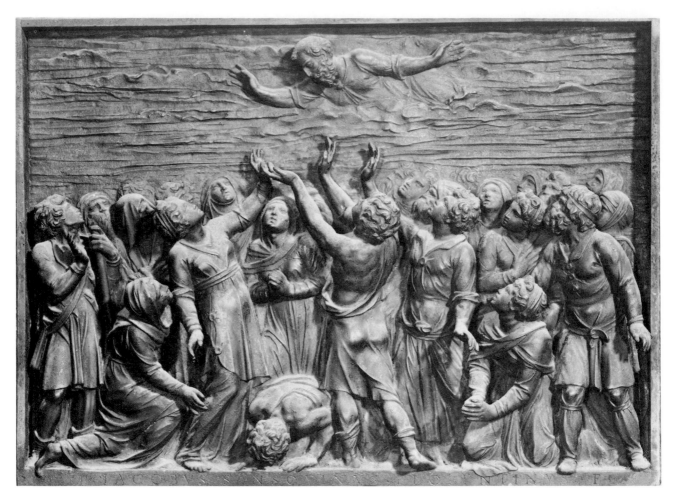

133. Jacopo Sansovino, *The Apparition of St. Mark.* Venice, San Marco

pictorial, of his design. In the private relationship of the central axis is contained not only the miraculous core of the story but also the pious devotion that is its end. The horizontal narrative, on the other hand, is more mundane, essentially responsive to the physical effects of that piety. More discursive in its variety, it traverses a sequence of levels of involvement: from spectators and torturers to the climactic figure of the enthroned nobleman. Propelled by gestures and glances, this lateral flow moves with deliberate rhythm, finding its first focus in the miraculously saved servant and then, its course continued by the prominent turbaned executioner holding up the broken hammer, continuing past the countering figures at the base of the throne, to the amazed noble. Recapitulating the internal counterpoint of this movement are the Michelangelesque figures in the lower right whose pictorial function it is to close the composition, to slow and reverse the momentum of the narrative flow: looking toward the center, their glances counter that movement, while their poses participate in that basic narrative impulse, backing away, as it were, to the right.

134. Jacopo Sansovino, *The Repentance of the Master*. Venice, San Marco

Although ostensibly within a clearly defined architectural setting, the space of the *Miracle of St. Mark* is defined more essentially by the figures. The dialectic of this relationship is epitomized at the painting's dramatic core, where the foreshortened body of the servant overlaps with calculated precision the white border of the pavement pattern. Like the surrounding pieces of spike, hatchet, and hammer, this receding orthogonal of the architectural perspective is reduced to a fragment by the figure. The body, in turn, imposes a new and more insistent, if only implicit, orthogonal direction, supported by the strategic placement of the broken tools; moving at a sharper angle from lower left to upper right—its visual momentum continued by the limbs and body of the crouching tormenter and then by the outstretched arms of his standing companion—its apparent goal is the conventional focus of the open arch behind.

Along this figural orthogonal, in fact, the functional space of the picture is defined. For this is indeed the path of entry most immediately accessible to the viewer. On either side of the spatial construct, at the very surface of the picture plane and cut off by the frame, onlookers

initiate, by glance and posture, the recession toward the dramatic center. But Tintoretto has carefully distinguished two levels, at least, of reality along these peripheries. On the right, with the exception of a possible portrait,[17] the warriors are participants in the historical action, that is, in the fiction of the picture's narrative. On the left, however, entry into the scene is initiated by a figure that is very clearly outside the immediate setting, a portrait that has generally been identified as Tommaso Rangone;[18] past the pedestal, the other spectators, closer to the drama, reinforce his role as outside observer. Thus, whereas the right side, dominated by the personage of the ruling master, comprises militant participants in the wrathful event, the left, and more open, side contains a chorus of innocent witnesses to the miracle.

The variety of this crowd has often been remarked by appreciative critics, beginning with Ridolfi.[19] In costume and type it runs a range from the exotic to the contemporary to the timeless: soldiers and merchants, Venetians, Turks and Moors, young and old, to the figure of the curious mother with her child, straining backward to get a better view—a significant motif in Tintoretto's art.[20] And, as we have observed with regard to Titian's *Presentation of the Virgin* and the spectacular displays of Veronese, this variety suggests a range of temporal and geographic reference. Here, too, the expanding resonance of the miracle sounds on a universal level: "Without doubt this miracle occasioned the greatest amazement through all the City, all of Italy, all the World."[21] The hierarchy of involvement—from direct participants to witnesses immediate and distant—extends the relevance of the painting into the realm of the spectator, the world of the brothers of the Scuola di San Marco in mid-sixteenth-century Venice.

Our reading of the composition, then, is determined by the corporeal indications of the painted figures. We respond to these bodies, empathize with their movements, and recognize in them different levels of response and degrees of involvement. Unlike Titian's, Tintoretto's is not, after all, an art of individualized pathos. We are not invited to share the emotions expressed in the shaded ambivalences of the human face; rather we are asked to sense a meaning actively represented through pose and gesture. And how little gratuitous rhetoric, purely formal or empty gesturing, there is in the figural action of his art. We are, instead, struck by the efficiency of Tintoretto's choreography: each figure participates with a certain functional precision in the dramatic structure; each response is exact on its own particular level. The tale is told with great energy, but always with a clarity requisite to public communication on this grand scale.

2. THE THEATER OF PIETY As the setting for significant human action, the architectural spaces of cinquecento painting inevitably assume a certain theatrical function. The conventions of painting and theater, as we have observed before, are inextricably bound together in the Renaissance; sharing basic structures on a phenomenological as well as formal level, both arts are concerned

with mimetic fiction, which involves spectacle and public, *palcoscenico* and *cavea*, actor and audience, miracle and witness. And both manipulate the ambiguities inherent in this fundamental binary situation, especially at their plane of intersection, to compound and complicate the dimensions of experience.

If Tintoretto's *Miracle of St. Mark* is less obvious than his *Washing of the Feet* (fig. 107) in its debt to the traditions of perspective stage design, it is nonetheless more compelling in its dramatic theatricality. The composition of the *Washing of the Feet* presents a more radical tension between perspective focus and thematic center—what Luigi Coletti has called Tintoretto's compositional "diopsia."[22] The *Miracle of St. Mark*, more concentrated in its spatial focus, establishes an essential proscenium aperture by reinforcement of the frame. The massed architecture at the left, the wall at the right, and the vine-covered trellis above create, with the pavement below, a stage that serves as the containing space of the action and, at the same time, as a foreground opening to the more brightly illuminated *fondale* of the background. But, as we have noted, space in the *Miracle of St. Mark* is essentially a function of the figures and does not depend upon architectural definition; revealed in fragments, the architecture serves rather as a stabilizing scaffold to support the figures.

Thus, at the left frame, where the architecture is in fact most massive, the more convincing articulation of that mediating unit depends instead on the dynamic interplay of the figures hanging from the columns. Their outward thrust at the very level of our entry into the fictive space of the picture creates that physical counterpoint that is so central to Tintoretto's art. But even beyond this active, internal function, these figures serve as sure signs of theater. By the end of the quattrocento, in illustrated frontispieces to the printed editions of ancient Roman comedies, the figure clinging to the column and straining for a better view of the action had become a standard feature of pictorial representations of theater.[23] In the spectacle of the *Miracle of St. Mark*, then, we are confronted with a full *sacra rappresentazione*, a religious theater, the aim of which, through the depiction of a miraculous intervention, is to confirm our faith.

If our involvement in this spectacle is effected primarily through figure-generated space, Tintoretto nonetheless hardly ignored the possibilities of scenic perspective. More aggressively than in the Serlian backdrop to the *Washing of the Feet*, he created deep centralized architectural recessions in his later paintings for the cycle in the Scuola di San Marco, the *Carrying of the Body of St. Mark* (fig. 105) and the *Finding of the Body* (fig. 135).[24] Within these zooming perspective vistas, space is again articulated by figural action; but now the actors, no longer so densely massed in the foreground, are more obedient to the dictates of the perspective, participating more directly in its orthogonal construction.

The chromatic range of these paintings, moreover, is less varied than in the earlier work. Further defined by the darker tonal ground, space is now articulated as well by the atmospheric effects of the divinely in-

135. Jacopo Tintoretto, *Finding of the Body of St. Mark.* Milan, Pinacoteca di Brera

spired storm in the *Carrying of the Body* and, in both canvases, by the
visible resonance of the marvelous perfume that, according to the
legends, emanated from the body of the saint.[25] The greater dynamics of
tone and chiaroscuro, allowing a new dramatic dimension to light as a
pictorial and narrative force, derive from Tintoretto's own development
of Venetian *colorito,* from the activity of his brush drawing light across
and through the darkness.

In preparing his compositions—especially, we may imagine, the more ambitious of them—Tintoretto followed a long studio tradition of using small models. Ridolfi's description of this practice, which is very likely well founded, is quite detailed: Tintoretto would make small models of wax or clay, dressing them in cloth as a way of studying drapery folds; he would also suspend such models from the ceiling in order to control the effects of foreshortening *dal sotto in sù*—as, very probably, in the case of St. Mark miraculously invading the world of Provence. Furthermore, the painter would construct small stage boxes of wood and cardboard into which he placed such figurines, and, using small lamps, he experimented with various lighting effects.[26] Conceived and developed in this manner, Tintoretto's paintings would have acquired an innate theatricality.[27]

Like many of his colleagues, Tintoretto himself was, in fact, actively engaged in the theater as a designer of costumes and sets for comedies performed by the *compagnie della calza*. His inventions, Ridolfi adds, were always extraordinary, marvelously unique and exciting wonder in the audience.[28] Nevertheless, although we must acknowledge the direct Serlian quotation in the *Washing of the Feet* and we might be inclined to recognize in some of the more exotic costumes of a picture like the *Miracle of St. Mark* reflections of those "bizzarri capricci" to which Ridolfi alludes, Tintoretto's paintings seem to relate to actual theatrical practice in only rather general ways, with regard especially to the mechanisms of audience involvement, as we have noted above. The deep perspectives of the *Carrying of the Body of St. Mark,* for example, do indeed distinguish his spatial conception from Veronese's grand *logge,* and the insistence of such a spatial invitation is quite different in its urgency from the calculated planar control of Veronese's theater of aristocratic humanism. It is precisely in this directness of assault that the full seriousness of Tintoretto's representations is felt—less as a sophisticated game of aesthetically distancing mediating planes than as an immediate confrontation with an event of the most palpable presence. For all the evident links with Serlian stage perspective, for all his own presumed awareness of the comedies of Ruzante and personal friendship with Andrea Calmo,[29] Tintoretto's theater is essentially religious.

Although the surviving visual documentation is meager, the richness of theatrical experience in cinquecento Venice is well established. In addition to such well-publicized events as the production in 1542 of Aretino's *Talanta* by the Compagni Sempiterni with sets by Vasari,[30] the diaries of Marino Sanuto fully attest to that richness, at least for the first third of the century, with a long list of spectacles of diverse sort: *feste, solennità, mascare, mumarie, commedie.*[31] In the great Corpus Christi processions the *scuole grandi* competed to produce the most elaborate floats, *tableaux vivants* bringing to actuality the same Christian iconography preserved for us in pictorial art—in works like Titian's early monumental woodcut of the *Triumph of Christ* or even, as we have suggested, in a tableau composition like the *Presentation of the Virgin.*[32]

Venice, like so many towns throughout medieval and Renaissance

136. Giovanni Antonio da Pordenone, *Nailing to the Cross.* Cremona, Duomo

Europe, also enjoyed a tradition of religious drama, *sacre rappresentazioni* that played out the great Christian narrative, including the lives of the saints. Although this tradition is rarely as well documented as it is for Florence, where a great number of the texts were published,[33] Sanuto again offers a precious, if tantalizingly incomplete, record of two such productions, both in 1515: one dedicated to the story of St. Alexis, performed in the monastery of San Salvatore, the other, representing the conversion of St. Hilarion by St. Anthony, given in the church of San Donato at Murano.[34]

The vitality of religious drama in northern Italy is better documented outside of Venice, and convincing analogies can be drawn between theater and painting on the mainland. The violent drama of a painter like Pordenone (fig. 136), aggressively breaking the barriers between spectacle and spectator, evokes not only the patterns of northern, specifically German, art but also the direct emotional identification with the suffering of Christ that characterized audience response to the Passion plays themselves.[35] Pordenone's brutal physiognomies, like the barely controlled physicality of his figures and the spaces they inhabit, assault us with a power to which we can respond only with matching revulsion; his

137. Jacopo Tintoretto, *Ecce Homo*. Venice, Scuola Grande di San Rocco

tortores, like those in late medieval drama, act with such violence that we, in turn, must of necessity feel with visceral conviction the torments of the Savior.[36]

If in Venice we have no documents of such violent productions of the Passion cycle—which elsewhere led to a corresponding violence on the part of the aroused audience, a reaction the Venetian government would certainly have sought to forefend[37]—the emotional identification with Christ's suffering was a goal of such imagery in all media. As a relevant Venetian example we might cite Pietro Aretino's own *Humanità di Christo* (first published in 1534), a novelistic elaboration of the life and Passion of Jesus. In his narrative Aretino quite naturally concentrates upon and develops the mimetic possibilities of the theme, and in this respect his text is indeed dramatic. The personality and physiognomy of Judas, for example, afford an exceptionally rich occasion for the expansion of the Gospel sources by imaginative invention, as the betrayer's own inner torment becomes visibly manifest in his face and in his gestures.[38] Later, as Christ is nailed to the cross, the reader sees his hands opened, each nail applied to the palm, the hammer rise and fall, and the iron point enter the flesh. All Heaven responds to the blow. Each wound, more-

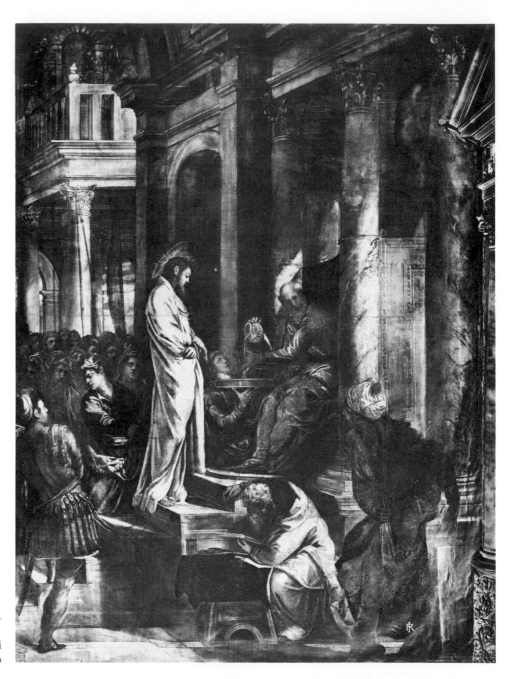

138. Jacopo Tintoretto,
Christ before Pilate.
Venice, Scuola Grande di
San Rocco

over, is felt by the Virgin as she watches—and, as we too attend, we are encouraged to feel those torments through and with her. And beyond this central action, the crowd roars its approval "as in the theater."[39]

Aretino's text, of course, is not a theatrical script. But in its mimetic aims, its physiognomic representation, and its wider world of responsive resonance, it is truly dramatic literature. And as its imagery is often inspired by the experience of painting—especially Titian's[40]—it may serve as a legitimate bridge between the worlds of theater and the visual arts, testifying to a common representational impulse. In turn,

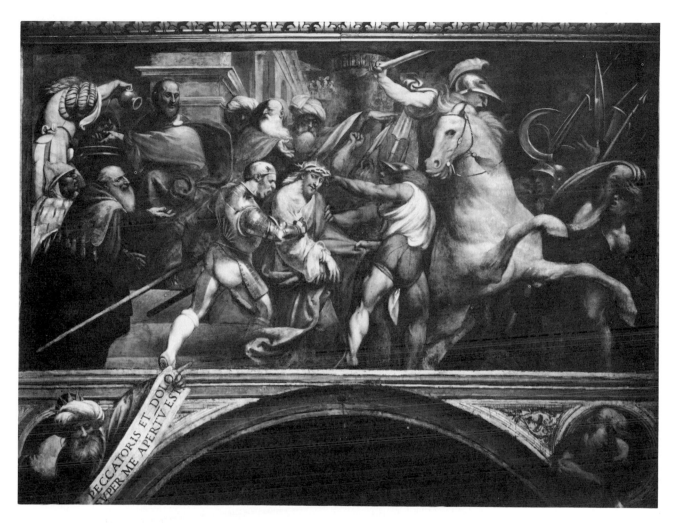

139. Giovanni Antonio da Pordenone, *Christ before Pilate*. Cremona, Duomo

Aretino's religious writings, with their expansive range of emotional tone and dramatic detail, may actually have served as sources of inspiration for painters: in his own *Presentation of the Virgin* (fig. 79) Tintoretto himself may have been following dramatic suggestions in the writer's *Vita di Maria Vergine*.[41]

By the end of the fifteenth century new iconographic emphases attest to a more general rapport between religious theater and art. Themes like the Nailing to the Cross and the Elevation of the Cross—which in the Corpus Christi plays afforded opportunities for a range of affect, from the comic to the cruel—elaborated the mechanisms of martyrdom, the physical means of torture in all their technical detail.[42] And by such circumstantial digression from the theological essence of the sacrifice they allowed the time for compassionate response and for meditation on the prolonged sufferings of the Son of man.

The later sixteenth century witnessed a revival of interest in the mechanisms of martyrdom.[43] Tintoretto's own representations of the

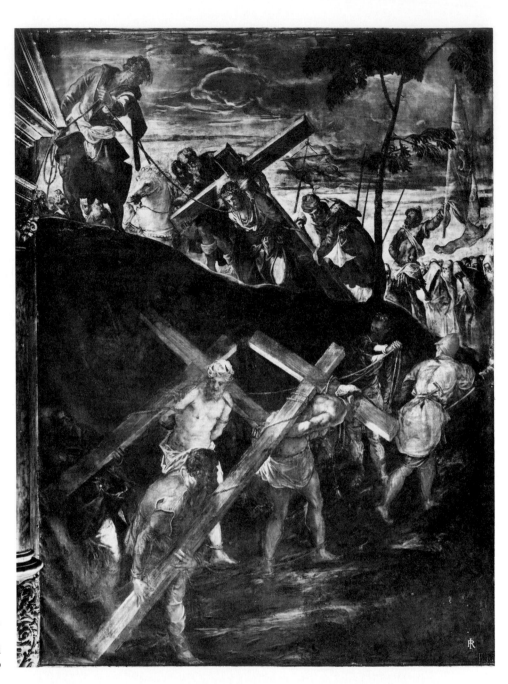

140. Jacopo Tintoretto,
Carrying of the Cross.
Venice, Scuola Grande di
San Rocco

Passion of Christ, however, notwithstanding their physical activity and
the stress upon the blood shed by the Redeemer (fig. 137),[44] do not share
the brutal violence of the earlier Passion plays or of Pordenone's im-
agery. His *Christ before Pilate* in the *albergo* of the Scuola di San Rocco (fig.
138), for example, reveals none of the aggressiveness of Pordenone's
Cremona fresco (fig. 139), and in the *Carrying of the Cross* (fig. 140), an
ironically triumphal procession, Christ bears his burden with calm resig-
nation and undisturbed dignity, aided by Simon of Cyrene and un-
molested by tormenters (fig. 141). In general, physiognomic expression

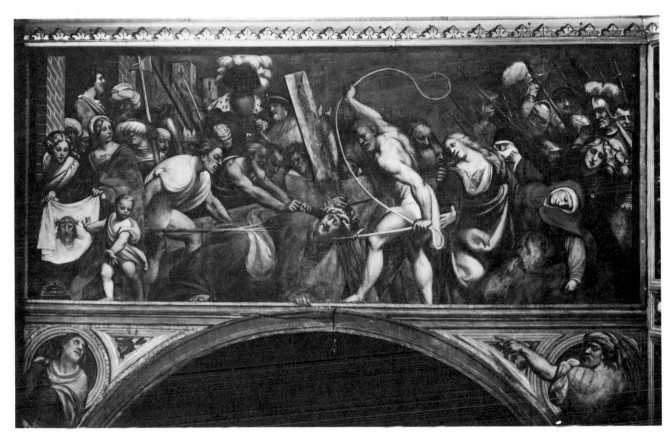

141. Giovanni Antonio da Pordenone, *Carrying of the Cross*. Cremona, Duomo

plays little role in Tintoretto's art, and the bestiality of Pordenone's *tortores* is entirely absent.[45] Even where the subject might have invited such treatment, Tintoretto avoids depicting Christ as "afflicted, bleeding, spat upon, with his skin torn, wounded, deformed, pale, and unsightly."[46]

We can more fully gauge the mood of Tintoretto's religious drama in what is undoubtedly his most impressive single work, the monumental *Crucifixion* executed in 1565 for the Scuola di San Rocco (pl. 8, fig. 142).[47] Stretching just over forty feet across the long wall *sopra la banca* of the *albergo* (fig. 143), the picture presents a panoramic spectacle containing a wealth of incident, all of it emanating from the central and controlling event, the Crucifixion of Jesus. Within the context of its site, a room only about half as deep as it is wide, a mural of this length must accommodate its design to certain problems of viewing and legibility, and such exigencies surely challenged the resourcefulness of Tintoretto's art. At the heart of his response is a calculated balance of dimensional scale, between sweeping breadth and focused detail, that controls our relationship to the picture on every level.

3. THE GREAT *CRUCIFIXION*

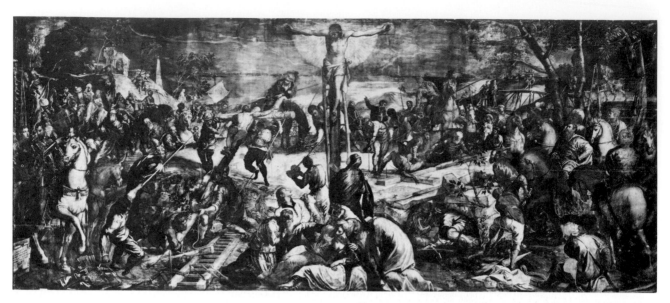

142. Jacopo Tintoretto, *Crucifixion*. Venice, Scuola Grande di San Rocco. (See also colorplate 8.)

Central to the expansive composition is the reach of Christ himself. Set above the earth against the turbulent sky, he is the source of a circular aureole of divine light. His outstretched arms upon the cross extend horizontally, parallel to and reinforcing the upper frame of the canvas; indeed, rather than being determined by this expansive field, his reach seems its very cause. Thus identified at its height with the frame and hence with the surface of the picture, the cross is actually implanted farther back in space, behind, yet apparently within, the mound of mourners at its base. And this ambiguity, as we shall see, provides a structural key to the functioning of the entire image.

Christ's radiance is reflected below, in the illuminated zone of the middle ground. Defined by divergent orthogonals receding from a center near the foot of the cross, the lighted plateau extends that central reach of the surface into space—its extension contained at either side by the surrounding crowd—with a centrifugal energy that charges the entire picture. This great counterpoint of spatial thrust is echoed in many smaller incidents but especially in the pulling and pushing of the cross of the good thief and, on a still smaller scale, in the stretching of the bad thief upon his.[48] Both on the ground and above, space is articulated by the tension of these actions, by taut ropes that thread their way between foreground and middle ground, by fragmented orthogonals of tools and cut wood and the foreshortened ladder. Although constantly aware of the overall design, we perceive its space in separate units, limited thrusts or isolated pockets of denser figure complexes. As in the more obviously measured architectural surfaces of Veronese's large canvases, so here, the very expansiveness precludes comprehension at a single glance: reading the image is of necessity a cumulative experience.

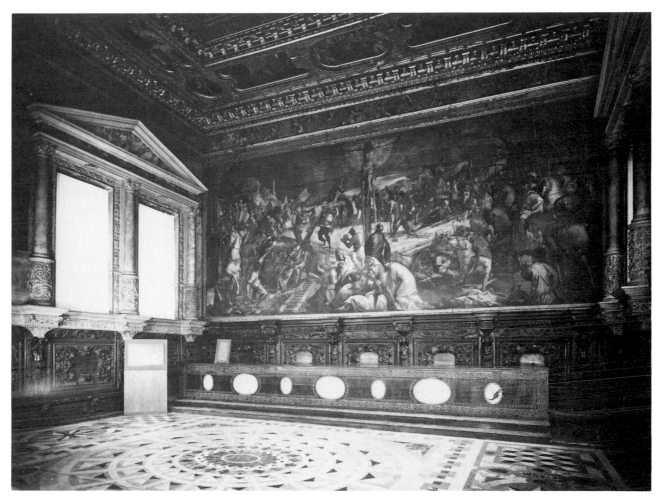

143. Venice, Scuola Grande di San Rocco. *Sala dell'albergo*

The narrative of this *Crucifixion,* then, is constructed of distinct incidents which, like the details of attempted torture in the *Miracle of St. Mark* but on a much grander scale, reduce temporal flow to a series of discrete moments. In the largest dimension, the different stages of the three crosses combine to represent the full sequence of elevation. Behind and to Christ's sinister side, the bad thief is tied to his cross, still on the ground, while in the foreground the hole is being dug to receive it. On the dexter side of Christ the cross bearing the good thief is actually being raised. And the completion of this physical progression of crosses, the third stage, is already accomplished on the central axis. Across this sequence the three protagonists who share the common fate relate to one another with theological and dramatic exactness: the thief who will mock Christ has, quite literally, already turned his back on him; the other, who will reprove his companion and acknowledge the Savior and whose place in paradise is promised by Jesus, looks up to him, whose respond-

ing glance completes the most moving and significant visual dialogue in the painting (Luke 23:39–43). "Today shalt thou be with me in paradise"—Christ's words to the thief, taken by the brothers of the Scuola di San Rocco as a sign of his mercy and of the efficacy of prayer, were in fact quoted in the opening of the *mariegola* of the confraternity.[49]

Christ himself, having announced his thirst, is about to suffer the vinegar-dipped sponge, while, huddled below as if in shame, the soldiers dice for his garment. In the backgound, prominently silhouetted beneath the arm of the cross, the centurion sits upon his grazing mule, still turned away from Christ, his lance, though ominously directed, still idle.[50] Christ's body, in fact, has not yet received that final wound in its side.

This complex of narrative episodes, then, creates a range of temporal reference and allusion—past, present, and future. Pictorial narration is effected by the reduction of temporal flow to its constituent events, exactly as pictorial organization is achieved by the distribution of relatively self-contained formal groupings across the field. On both levels—and to separate them in this way is a deliberate act of critical analysis that ought not to mask their organic unity—interpretation must attend to syntactical structure, and here the composition itself, as an ordered whole, affords its own internal guide to reading, that is, to affective involvement.

One of the major challenges facing the designer of a mural of these dimensions and of this subject is the reconciliation or balancing of axial emphasis. The decision to place Christ *in maestà*, frontally on center—the alternative being the asymmetrical pattern, with its more determined lateral thrust, that Tintoretto himself would adopt, in a different situational context, at San Cassiano—accorded special weight to the vertical axis of this long field, reinforcing inherent qualities of that axis as the focus of visual forces in the field. At the same time, the very length of the picture makes horizontal scansion a natural and even primary mode of perceiving such a field. Exploiting these potentially conflicting compositional axioms, Tintoretto designed a picture that has us engage both and find meaning precisely in that tension between the iconic and the narrative.

The significant ambivalence is most clearly articulated on the central axis, the iconic core of the image (fig. 144). Identifying with and defining the surface of the picture, the crucified Christ is appropriately located at once above the nominal space of the scene and within it, its very center. As we have observed—and in a basic way analogous to the spatial function of the arcade in Veronese's *Feast in the House of Levi*—the cross itself is actually planted well behind the picture plane, within that fictive space. Apparently supporting the cross and filling the ground before it, the group of pious mourners, the swooning Virgin at its core, effectively mediates our way to the Savior. Built upon the bottom edge of the picture, they are physically closest to and open to the observer; as we follow their sequence of gestures and glances upward their pathos engages us and suggests the pious mode of our response (fig. 145). To-

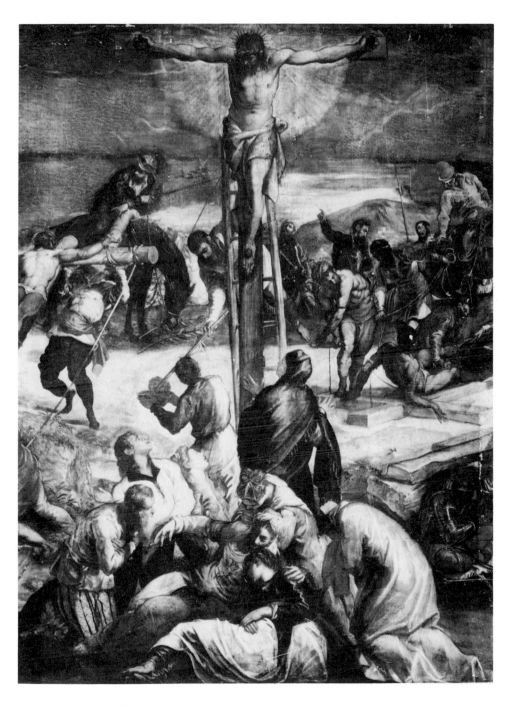

144. Jacopo Tintoretto,
Crucifixion (detail)

gether, Christ and the mourners establish a fully self-sufficient image, a
proper icon of devotion (cf. fig. 146).[51]

On the larger scale, across the surface vastness of the canvas,
Tintoretto's composition continues to acknowledge the motivating cen-
trality of this vertical axis, even as it develops the narrative momentum
from left to right inherent to such a long horizontal field. If the pathetic
group at the base of the cross reinforces the central focus, Christ's reach
initiates the lateral expansion that will comprehend a wider world. His

145. Venice, Scuola
Grande di San Rocco
Doorway to *sala dell'albergo*

divinity radiates against a background that darkens in accordance with
the Gospel accounts.[52] The "earthquake darkness," in fact, moves across
the sky from the left, the direction further articulated by a wind made
visible by the bending trees and unfurled vexillum. Around the central

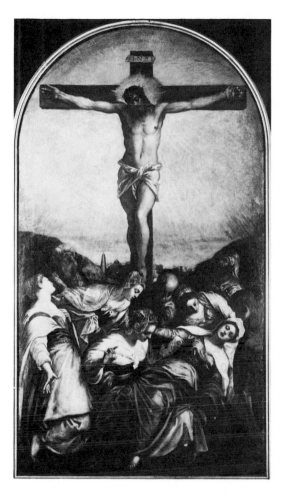

146. Jacopo Tintoretto, *Crucifixion.* Venice, Santa Maria del Rosario

event, yet significantly distanced from it, Tintoretto gathers the crowd of spectators in an open semicircle, apparently, but not actually, completed by the active participants in the foreground. And that great cycle, impelled by glance and gesture, moves in a clockwise direction, from left to right.

Entry into the space of the picture is effected at the lower corners to either side, but the major and more urgent penetration is made from the left. As in the *Miracle of St. Mark,* this is the more open side, more directly accessible; in every detail that side, Christ's dexter, is weighted with more positive significance. Here, in the background far from the cross, are the women who had followed Jesus from Galilee[53]—including a mother and child. Here, too, we find most of the portraits of the painter's contemporaries, brothers of the Scuola di San Rocco. Chief among them, we must assume, is the *guardian grande* Girolamo Rota, whose name figures prominently in the inscription, together with Tintoretto's signature, which so explicitly locates the picture in the world of sixteenth-century Venice.[54]

Anachronistically (at least from a strictly literal point of view) mixing historical witnesses to the great event and the *confratelli* of San Rocco,[55]

the encircling crowd of spectators remains open in the foreground. And in this way, spilling out into the world of the *albergo,* it requires for its completion the participation of the observer, thereby insisting on his active involvement. Standing directly before the iconic image of Christ on the cross, the viewer thus finds himself as well a participant in the larger spectacle, his devotional act implicated in the deliberate ambiguities of theological history. That single moment in time past, when God sacrificed His Son for mankind, resonates in the present. The drama of Tintoretto's *Crucifixion* realizes this eternal relevance with all the mimetic conviction of his pictorial art; his religious theater is, in the fullest sense, a *theatrum mundi.*

We are drawn into the *Crucifixion* by a range of phenomena: the chiaroscuro of its tonal structure and the meteorological turbulence of its setting, the openness of its spatial arena, the energies expended by the laboring figures, the palpable reality of recognizable portraits, the diversity of narrative incident, and, most centrally and significantly, by the pathos of the event itself.[56] Yet, despite the fullness of our engagement, a certain dimension is, finally, absent here: the physiognomic, with its extraordinary mimetic potential. As our brief comparison with Pordenone suggested, Tintoretto does not actually invite us to feel the vicious hostility of Christ's tormenters.[57] We are convinced, rather, by signs of the mechanics of torture and by the apparent efficiency of these workers performing their assigned tasks; they participate in the great redemptive scheme with none of that perverse pleasure and with no awareness of the significance of their labors.

There is, in other words, a fundamental anonymity among Tintoretto's dramatis personae (and not only in the chorus) that is essential to his control of this panoramic spectacle. Each character submits to the dictates of the larger drama. There is little room for rhetorical display, as actions and postures, no matter how extreme or forced, fulfill explicit dramatic functions. In a painting so dependent upon gesture for its eloquence, the range of such acts is in fact surprisingly limited; if they are not completely passive, hands either work, indicate, or respond in awe. Even among the most immediate protagonists, the mourners at the foot of the cross, emotional response remains muted, restricted to expressions of pious concern and, at most, gestures of *admiratio.*[58]

4. PRANDIUM CARITATIS One theme in particular afforded Tintoretto a more concentrated dramatic situation in which to explore and develop the possibilities of pious action: the Last Supper. The earliest of his many depictions of the subject, which span his entire career, is the canvas dated 1547 in the church of San Marcuola (fig. 147).[59] Unique in several respects, the composition presents the scene frontally, the *mensa* parallel to the picture plane and framed by two personifications, Faith and Charity.[60] Christ, with an ambivalent gesture between benediction and admonishment, announces the fateful betrayal; his eyes are downcast, but his face turns toward the figure seated to the left of center on the near side of the table:

Judas, whose pronated arm twists behind his back, concealing the purse of silver from his companions while revealing it to us.[61] Responding to the words of Jesus, the other apostles enact the dialogue of disbelief and profession of faith.

Their agitation is more violent in the canvas Tintoretto painted about a decade later for the Cappella del Santissimo Sacramento in San Trovaso (fig. 148).[62] Indeed, the entire setting of this *Last Supper* has been conceived with a heightened dynamism. No longer iconically frontal, the *mensa* is set at an angle to the picture plane, the receding orthogonals of its sides extended into the foreground by the overturned chair and the figure reaching out for the flask of wine—and their distant points of termination shifting abruptly back and upward along the staccato lights of the stairs at the left and through the standing apostle at the right, who leans toward Christ. The tense counterpoint of spatial thrusts, moving with and against the divergent two-point perspective of the controlling table—a condensation of the compositional principles informing the San Rocco *Crucifixion*—charges the entire picture with an instability that seems literally to extend at its nearest point into our space.[63]

This spatial aggressiveness has been one of the aspects of the San Trovaso *Last Supper* that has most embarrassed later critics, from Zanetti, who felt compelled to excuse it by acknowledging the license of genius,[64] to Ruskin:

> Its conception seems always to have been vulgar, and far below Tintoret's usual standard; there is singular baseness in the circumstance, that one of the near Apostles, while all the others are, as usual, intent upon Christ's words, "One of you shall betray me," is going to help himself to wine out of a bottle which stands behind him. In so doing he stoops towards the table, the flask being on the floor. If intended for the action of Judas at this moment, there is the painter's usual originality in the thought; but it seems to me rather done to obtain variation of posture, in bringing the red dress into strong contrast with the tablecloth.[65]

Ruskin, it need hardly be said, took Tintoretto quite seriously; his response is inspired by deep critical commitment and his comment reveals a real intuition. But it is not likely that the worshipful spectator is invited to enter this scene through the intercession of Judas. Indeed, in the darkness to the right the betrayer reveals himself by his own action, dipping his hand into a bowl: "He that dippeth his hand with me in the dish, the same shall betray me" (Matthew 26:23).[66]

What Ruskin termed "vulgar," however, an earlier observer might have recognized rather as "humble." This, at least, is the way Ridolfi viewed the picture when he described, quite straightforwardly and with no particular critical insight, the "humble chairs" and "devout gestures."[67] Humility and piety are indeed central to Tintoretto's conception.

Turning from the *Last Supper* in San Trovaso to the later rendition in San Polo (fig. 149), Ridolfi did nonetheless recognize the fundamental change in interpretation.[68] We here witness not the announcement of the

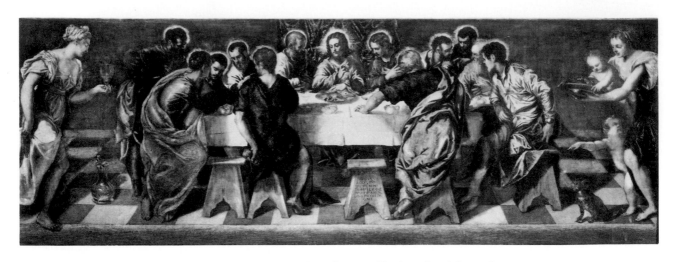

147. Jacopo Tintoretto, *Last Supper.* Venice, San Marcuola

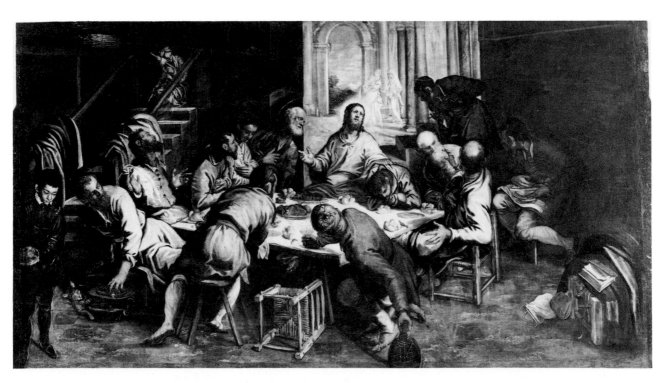

148. Jacopo Tintoretto, *Last Supper* (after restoration, 1979). Venice, San Trovaso

betrayal but the communion of the apostles, the ceremonial institution of the Eucharist: having blessed and broken the bread, Christ distributes it with a deliberately exaggerated gesture, his outreach a clear sign of the forthcoming sacrifice that will fulfill the prophecy of his words: "This is my body which is given for you" (Luke 22:19).[69] On the table, immediately before Christ, is the paschal lamb of the Old Testament that is soon to be replaced by the new dispensation.

As urgent in its instability as the San Trovaso composition, the San Polo *Last Supper* is also based on a two-point perspective system, defined here in the pattern of the precipitously tilted pavement. As motive force, Christ's action itself generates the full spatial structure. His thrust initiates the centrifugal burst of space, which extends beyond the containment of the central scene to more distant views at the sides; and his radiance (*Sol novus* and *splendidissimus*) at once ignites and outshines the natural rays of the background landscape. Finally, like the more stable design of the San Marcuola *Last Supper* (fig. 147), the composition is enframed by two figures: an anonymous servant, his back to us, at the left, and, at the right, the portrait of a donor, a privileged witness to the sacred event—and presumably a member of the Scuola del Santissimo, for whom the picture was painted.[70]

Developing patterns used in the San Trovaso picture, the figural mechanics of spatial involvement and extension here assume a greater precision of purpose. The thematic counterpoint sets the inward movement of the standing apostles receiving communion against the outward reach of those leaning away from the table offering food to two beggars, one of them a child seated near the foot of the donor. With remarkable —indeed, fundamental—clarity, the full meaning of the image manifests itself in these acts of charity: through the institution of the Holy Sacrament the benefit of Christ's sacrifice is made ever available to the faithful.[71]

With less drama and a more deliberately articulated hierarchy, the same conception informs the *Last Supper* in the *sala grande* of the Scuola di San Rocco (fig. 150), executed between 1579 and 1581. At the far end of the markedly foreshortened table—and this "bizzarra prospettiva," in Ridolfi's words,[72] leads directly and appropriately toward the altar in the *sala grande*—Christ administers communion, now with a gesture bespeaking a more controlled liturgical decorum.[73] Seated below the steps that elevate the setting of the *mensa*, and clearly belonging to a world beyond the historical moment of Christ's supper, two beggars patiently await that charity. Between them and the prominently displayed bread and bowl and pitcher, a dog noses his way back into the sacred space, a canine foil to the Eucharistic fare: "Ecce, panis angelorum . . . , non mittendus canibus."[74]

The world of Tintoretto's Last Suppers is poor indeed. Christ and his disciples dine not in the *coenaculum magnum* of the Gospels—so richly realized in Veronese's feast—but on the ground floor, "in una Sala terrena," as Ridolfi describes the scene in the Scuola di San Rocco.[75]

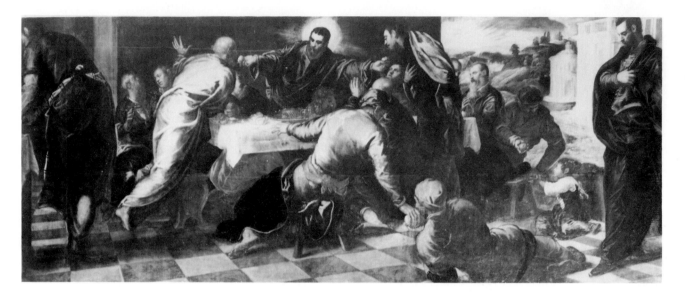

149. Jacopo Tintoretto, *Last Supper*. Venice, San Polo

Kneeling or seated upon simple stools or wicker chairs, Tintoretto's apostles, close in every way to the congregation, are poor and humble, their clothes homespun and patched. There is, then, a social aspect to the accessibility of Tintoretto's pictures; they appeal to a basic popular level of Christian imagination, and their invitation is more than an aesthetic formality.[76] If in the first of the painter's Last Suppers (fig. 147) Faith and Charity are present as personifications, these virtues subsequently abandon such abstraction to become instead principles in action, vital components of both the drama and our response.[77]

Unlike the festive meals painted by Veronese, Tintoretto's Last Suppers were not commissioned for the refectories of wealthy monasteries.[78] His paintings were intended rather for smaller chapels in Venetian churches, and his patrons came from more modest levels of society, members of small confraternities dedicated to the Holy Sacrament. The San Trovaso *Last Supper* was painted for the "compagnia di Nostro Signore;"[79] that in San Polo is located "sopra il Banco della scuola del Santissimo."[80] The inscription itself on the *Last Supper* in San Marcuola dates the picture to the term of a specific *guardiano* or *gastaldo, et conpagni,* of another Scuola del Santissimo Sacramento.[81] Like the *scuole grandi,* only on a significantly smaller scale, these devotional fraternities dedicated to the Sacrament constituted typical units in the pious fabric of Venetian society.

The degree to which the social values of that world are informing constituents of Tintoretto's conception may be further comprehended by viewing these pictures in the larger context of their commission or subsequent function. Two of these Last Suppers were paired with representations of the Washing of the Feet, in San Marcuola (fig. 107) and in San Trovaso (fig. 151)—both of which have been replaced by copies.[82] Christ's washing of the feet of the apostles was a deliberate act of

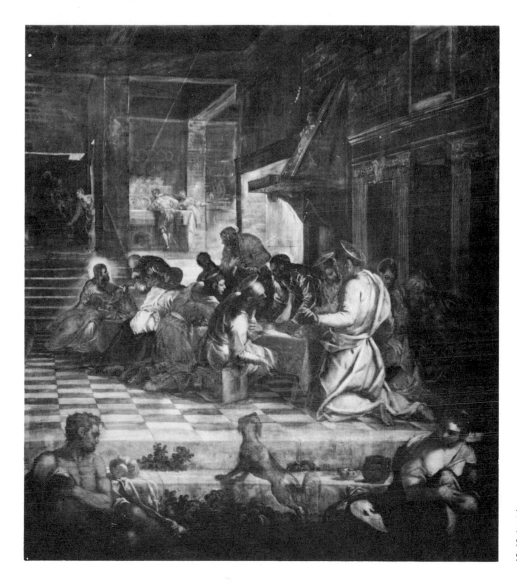

150. Jacopo Tintoretto, *Last Supper*. Venice, Scuola Grande di San Rocco

humility, intended as an example for them: "Know ye what I have done to you? Ye call me Master and Lord: and ye say well; for so I am. If I then, your Lord and Master, have washed your feet; ye also ought to wash one another's feet. For I have given you an example, that ye should do as I have done to you" (John 13:12–15). Tintoretto's *Washing of the Feet*, then, represents Christ's *mandatum*, that lesson in humility,[83] an explicit admonishment to a virtue that is, particularly at San Trovaso, a central motive in the pictorial conception of the *Last Supper*.

Ritualized into a ceremony of humility in which on Maundy Thursday the high and mighty lowered themselves before twelve paupers, in Venice the Washing of the Feet was naturally performed by the doge, personification of power in that Christian republic.[84] Even beyond its ritual significance as a reenactment of Christ's original gesture, however, the act itself was properly understood in its largest symbolic sense, as a gestural sign of humility. Thus, on 24 March 1524 Sanuto records in his

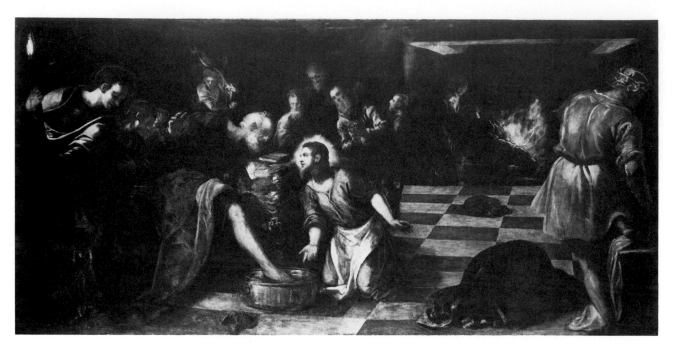

151. Jacopo Tintoretto, *Washing of the Feet.* London, National Gallery

diary the spectacle that took place at the Ospedale degl'Incurabili: twelve Venetian noblemen washed the feet of the poor syphilitics, and noble ladies did the same to the women suffering the incurable disease. Attracting a large crowd, the event inspired many with new devotion, "seeing these highest among men perform such a pious work."[85]

In a world that could perform such symbolic acts publicly and with such conviction, and that could respond to the affect of such acts with appropriate comprehension, paintings like Tintoretto's must surely have inspired the completest kind of response. We may imagine that those dimensions of meaning we now reconstruct with some effort were immediately and eloquently present to the sixteenth-century Venetian observer.

No other institution so fully exemplifies the world in and for which Tintoretto painted as do the *scuole grandi.* These great confraternities, governmental surrogates for the nonnoble population, bridged the hierarchies of Venetian society from rich to poor. From their magnificently decorated buildings, citizen-class rivals to the splendor of the Ducal Palace itself, the *scuole grandi* distributed large sums in charity. *Caritas,* as we have seen, was the reigning virtue in this world.[86] And, like the *humilitas* of the foot washing, this virtue, too, found expression in a range of public acts—from the distribution of alms and the awarding of dowries to the care of the sick and indigent and establishment of hospitals.

Most immediately relevant to our discussion, if not most proximate chronologically, is the early fourteenth-century tradition, recorded for the Scuola di San Giovanni Evangelista, of the *prandium caritatis.* Before this modest feast of the brotherhood, which took place on the fourth

Sunday in Lent, the *guardian grande et compagni* prepared a meal for a congregation of the poor, equal in number to the membership of the confraternity; then, at the conclusion of their own feast, the *confratelli* collected the remains and distributed them to other *poveri*. [87]

Such traditions and the attitudes they represent add a new dimension to what we might term the social relevance of Tintoretto's images of the Last Supper, and, most particularly, that in the Scuola di San Rocco (fig. 150). We may now prefer to stress the naturalism of Tintoretto's art, [88] as we consider the affective and mimetic functions of his deep spaces and the energies, human as well as pictorial, that spill out of the framing boundaries of his canvases—clear indication of the immediate relevance of Christ's institution of the Eucharist, of its extension into our world, of its perpetual resonance. The mimetic structures of painting give visible form to the mechanics of salvation.

At the center of this relationship, as we have seen, is the basic concept of charity, that "major theological virtue . . . in which is the faith of God," [89] implicating a social sense of sharing, a mutual responsibility both physical and spiritual. In Tintoretto's art this concept, initially embodied in the traditional personification of *Caritas*, as in the San Marcuola *Last Supper* (fig. 147) and other early compositions, [90] becomes increasingly humanized: the *Caritas* figure with her several children is transformed into a simpler mother-child couple—in the *Miracle of St. Mark*, for example, but even more tellingly in later paintings, in which the mother is shown nursing her infant, as in the *Baptism* in the Scuola di San Rocco (fig. 152). In compositions of the *Miracle of the Loaves and Fishes* (fig. 153) the maternal image is combined with that of the mendicant, and by this stress upon the charitable act underscores the full Eucharistic significance of the theme. [91]

Tintoretto's piety can be considered Counter-Reformatory only in the most general way, if at all, and to discuss it with specific reference to the decrees of the Council of Trent may be somewhat misleading. [92] It belongs, rather, in the larger context of pre-Tridentine Catholic reform, with its emphasis on the basic tenets of spiritual responsibility. It would seem more appropriate to talk about the fundamentalism of Tintoretto's Christian faith—or at least that faith that is figured in his paintings. In its dramatic simplicity and immediacy, its "corporale eloquenza," this art represents a pictorial *opera pia*, the social actions of a working Christian morality, but with a particularly Venetian quality. [93] The paintings we have been looking at do not offer an iconography for theologians—nothing as complex, for example, as the Eucharistic program of Tintoretto's *Israelites in the Desert* (fig. 154) and *Last Supper* (fig. 155) commissioned for the presbytery of the Benedictine church of San Giorgio Maggiore. [94] Tintoretto's own religious vision is neither mystical nor exclusively personal; rather, it is open and popular, common in the sense of shared conviction. The directness of his pictorial language guaranteed a basic legibility, even as the technical bravura of his developing style functioned to make the miraculous convincing in its visual presence. [95]

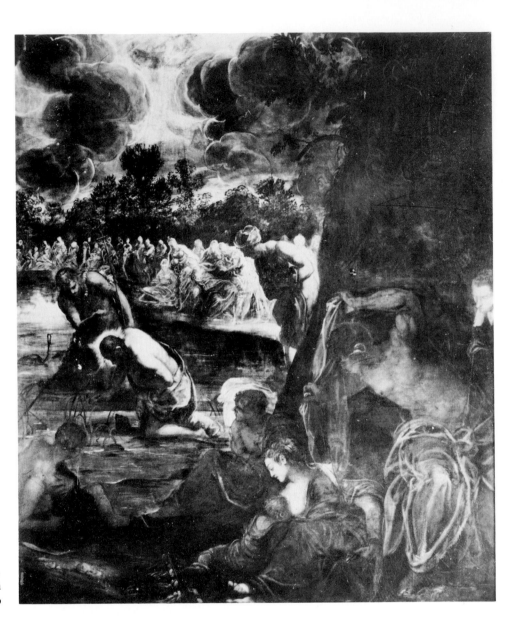

152. Jacopo Tintoretto,
Baptism. Venice, Scuola
Grande di San Rocco

5. TINTORETTO'S
VENEZIANITÀ

Tintoretto's personal control of the tenets of this faith is nowhere better documented than in the history of his decoration, over a span of more than two decades, of the Scuola di San Rocco. For all its richness of pictorial elaboration, the iconography of this vast cycle has always impressed observers with its functional clarity, and the artist's own basic responsibility for the program has been generally acknowledged. His offer, following the completion of the *albergo* cycle, to continue the decorations in the *sala grande,* beginning with the central panel of the ceiling, included precise suggestions regarding the subject of that painting: "una instoria da lui ditta a bocha over altra instoria. . . ."[96] Presumably, the *instoria* Tintoretto described to the *bancha et zonta,* and which he did indeed execute, was of the *Brazen Serpent.* And to that nucleus he

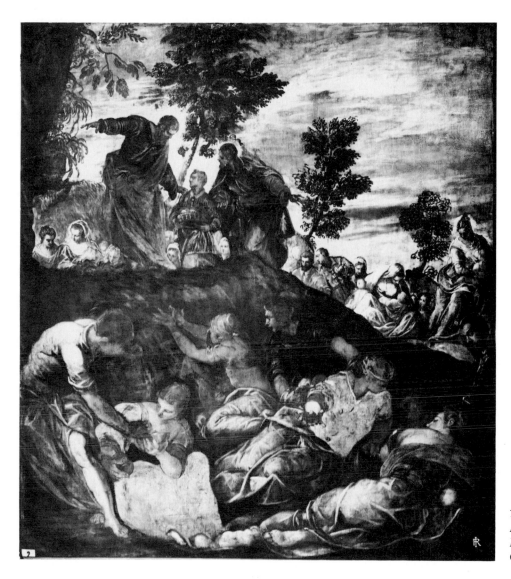

153. Jacopo Tintoretto, *Miracle of the Loaves and Fishes.* Venice, Scuola Grande di San Rocco

subsequently added two other large compositions on the ceiling: *Moses striking Water from the Rock* and, over the altar area, the *Fall of Manna.* In these three images of miraculous deliverance from pestilence, thirst, and hunger are depicted not only the Old Testament record of divine intervention and salvation, typologically figuring the sacrifice of Christ and the salvation of the spirit, but also the epitome of the charitable activities of the Scuola di San Rocco itself.[97]

Painting for his fellow Venetians, Tintoretto shared their practical piety and sense of communal obligation. Although his work would come to dominate the decorations of the Ducal Palace and he himself would succeed Titian as chief painter to the *Serenissima,*[98] he was clearly most at home in the world of the *scuole,* one of which he would transform into a monument to himself and his art. But even as he claimed for his own the ceilings and walls of the Scuola di San Rocco, of which he would become

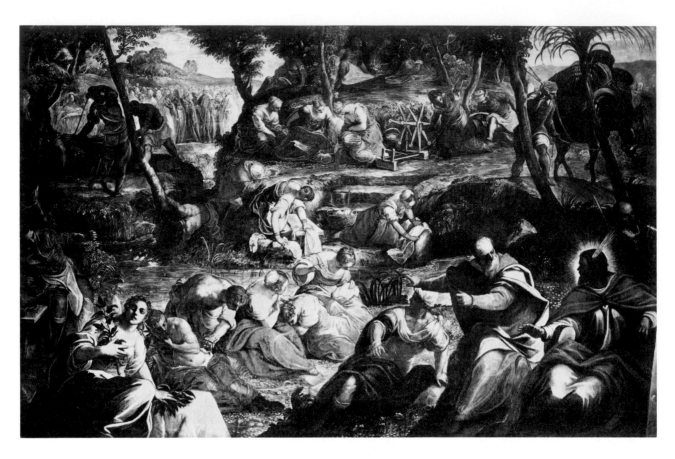

154. Jacopo Tintoretto, *Israelites in the Desert.* Venice, San Giorgio Maggiore

a member, we are persuaded by the sincerity of his profession of devotion expressed in his promise to complete the decorations. Wanting to demonstrate his great love for the confraternity and his devotion to its patron, in 1577 he dedicates the rest of his life to the service of St. Roch, pledging to deliver annually three paintings on the saint's feast day until the task is done:

> Hora volendo dimostrar l'amor grando ch'io porto à ditta venerando nostra scola per devocion ch'io ho nel glorioso messer san rocho da desiderio di veder essa scola finita, et adornata di pitture in tutte le parti fanno bisogno, son contento, et mi obligo deddicar el restante della mia vita al suo servicio promettendo di far oltra el soffittado preditto . . . tutt'altre pitture cosi nella scola, . . . et prometto dar ogni anno per la festa de messer san rocho tre quadri grandi posti suso⁹⁹

The act of painting thus becomes a gesture of piety.

 In every respect, Tintoretto's is the voice of the Venetian *scuole* and the society they represent. Titian too had served this same class of patrons, but never with that intimacy of identification: when he came to the Scuola della Carità in 1534 he had just been knighted by the Holy Roman Emperor Charles V, and his *Presentation of the Virgin in the Temple,* as attuned as it is to the *albergo* of the Carità and all that that room rep-

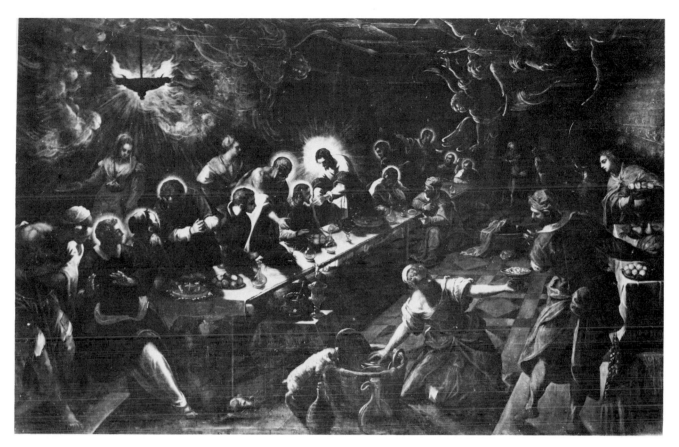

155. Jacopo Tintoretto, *Last Supper*. Venice, San Giorgio Maggiore

resented, reached out to mediate, in effect, between the world of the *scuola* and the higher noble realm of the governing *Signoria*. The most international of Venetian painters, Titian's ambitions were different, more grandiose, than Tintoretto's; he remained, in comparison, an outsider to the world of the confraternities, in which Tintoretto was so completely at home. Titian sought his glory in the courts of Europe as well as in Venice, while Tintoretto, the only one of the major painters of cinquecento Venice actually born there, dedicated himself with remarkable loyalty to his native city. His ambition, apparently, was to cover the walls of Venice with the creations of his brush. Working toward that end, he seems to have laid the foundations for the anecdotes, some better documented than others, concerning his professional ethics and unorthodox practices.[100]

Despite his origins, however, this most faithful son of Venice put the local traditions of painting to their severest test. Emerging as a master in his own right just when the Michelangelo-plus-Titian success formula was being publicized as the ideal reconciliation of the *disegno-colorito* debate, he did indeed study Michelangelo's art with greater imagination and independence than any of his Venetian contemporaries; and out of that experience he forged a new, dynamic figural language, transforming those sculptural models as he subjected them to the conditions of his

own pictorial logic. With respect to the indigenous tradition, Tintoretto's major assault was directed at the picture plane itself, the very surface that had served as a common value, respected by and thereby uniting generations of Venetian painters. That assault was effected in part by acute foreshortening—a weapon refined by the study of Michelangelesque models—but also by a willful rethinking of an aspect of the Venetian tradition itself: the tonalism of Giorgione.

Tintoretto, in this respect not unlike Titian, discovered new possibilities in the early cinquecento example. But if the aged Titian's profound exploration of the resources of the Venetian *pittura di macchia* represents a meditated development, Tintoretto's dramatic transposition of *giorgionismo* to a monumental scale seems a brasher gesture. Predicated on the earlier examples of Titian and Schiavone as well as Giorgione, Tintoretto's *colorito* is the final event in the Venetian pictorial tradition of the cinquecento. Essential to his extension of that tradition are two factors central to his own art: the independence of the brush stroke and the structuring function of light and dark.

Tintoretto's challenge to the axiomatic integrity of the picture plane, however, carried with it the potential reintegration of that surface by the imposition of new ordering values. Steeply foreshortened figures may seem to break the plane and lead us precipitously back into fictive pictorial space, but those very figures, as well as the spaces they penetrate, surrender some of their own physical continuity to a light that moves deliberately across them—for example, in the *Massacre of the Innocents* in the Scuola di San Rocco. The large patterns of light and dark that so often divide the field along a diagonal—as in so many canvases in the Scuola di San Rocco, beginning with the *Carrying of the Cross* (fig. 140)—establish the bases for a new order, one that seems to thwart the spatial logic of conventional perspective construction.[101] Charged with such tension, the picture plane assumes, after all, an even greater significance as the locus of conflicting pictorial energies.

Technically, that resolution depends upon the structuring function of the brush stroke, which, especially in Tintoretto's late painting, does indeed effect a union of *disegno* and *colorito*. Tintoretto's long stroke draws as it colors; carrying the pigment, it applies it with directed energy.[102] And when that pigment is essentially light applied to the dark ground, an entire atmosphere is established that transcends the expectations of mere naturalism; the imposition of a new painterly order yields a correspondingly new vision of the natural world transformed (figs. 156, 157). That even in these late visionary landscapes we follow the transforming process—that is, we attend with keen awareness to the manner of the brushwork—affords us a way of staying in touch with the fictive realm. The solidity and conviction of the stroke, the latter in part a function of its speed, assume the surrogate function of imitated natural material; in this triumph of Venetian *colorito* the reality of the paint persuades us to accept the reality of the vision.

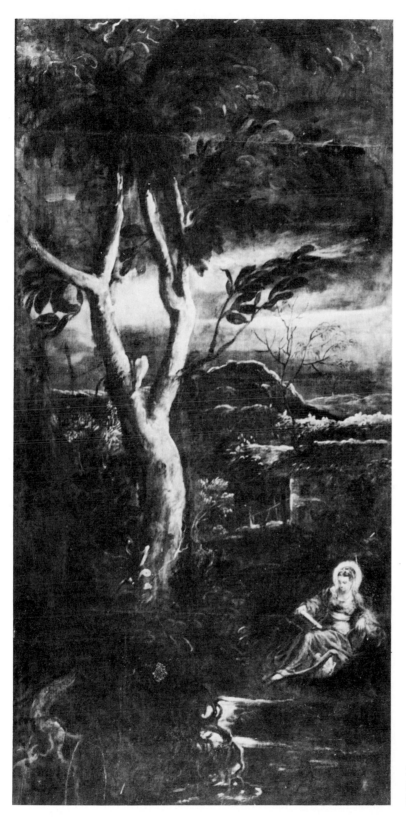

156. Jacopo Tintoretto,
St. Mary Magdalen. Venice,
Scuola Grande di San Rocco

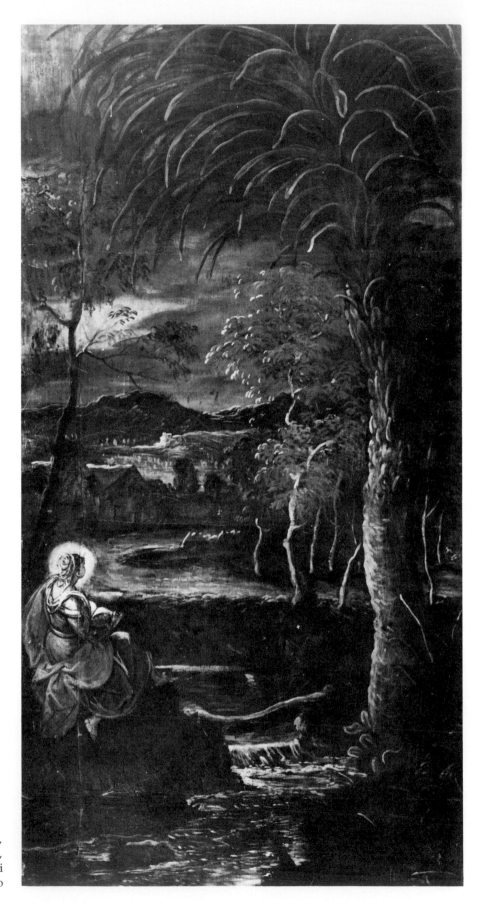

157. Jacopo Tintoretto, *St. Mary of Egypt.* Venice, Scuola Grande di San Rocco

Appendix: Documents Relating to the Scuola della Carità

The following documents, most of which have not been previously published, are all preserved in the Archivio di Stato in Venice. There does not yet exist a modern index to the 357 *registri* and *buste* in which the records of the Scuola Grande di Santa Maria della Carità are collected (cf. Andrea da Mosto, *L'Archivio di Stato di Venezia: indice generale, storico, descrittivo ed anulitico* [Rome, 1937–40], vol. 2, p. 218), but two older indices offer some guidance to this material: Registro 351 ("Sommario delle scritture della Scuola, 1260–1659") and Registro 311 ("Catastico di scritture della veneranda Scola di S. Maria della Carità, opera di Vettor Todeschini notaro veneto e confratello di detta Scola . . . principiato l'anno MDCCXX e terminato l'anno MDCCXXVII"). Although neither of these volumes constitutes a complete index to the Scuola's archives, Registro 311 in particular comprises a useful summary of the early building history of the confraternity. (Wherever I have been able to locate the original document described in the Catastico I have added the relevant reference.) For the sake of convenience, I have grouped the documents under three headings: (1) Construction of the Scuola and its *Albergo*, (2) Renovations and Restorations of the Fabric, and (3) Pictorial Decoration of the *Albergo*.

It should be noted that the Venetian calendar (*more veneto*) began on March 1; where necessary, appropriate changes have been indicated.

1344, 20 Febraro.

. . . Decreto fatto da Monsignore Aimerico Cardinal, e Legato Apostolico Prior del Priorado di S. Maria in Porto del Lido di Mar dell'Ordine di S. Agostino Diocese di Ravenna, con cui concede, et impartisce facoltà et auttorità alli Padri, e Monastero di S. Maria della Carità, la Chiesa de quali è membro di detto Priorato, e ad esso immediate soggetta di poter devenire all'infrascritta compositione et accordo con il Guardiano, e Compagni della Scola de Battudi di S. Maria della Carità, per la quale convengono, et accordano di una possessione, e Territorio sivè terreno posto nel Luoco di S. Maria della Carità, del quale questi sono li confini, cioè dal primo ladi il Campo in faccia il Ponte, dal secondo il muro ch'è oltre la riva, dal terzo il rio picciolo, e dal quarto la corte sivè cortil con un

1. CONSTRUCTION OF THE SCUOLA AND ITS *ALBERGO*
Document 1

passo di detto Cortil oltre il muro per retto trame siccome tiene la posses-
sione, e questa possessione e sopra questa devono detti Guardian, e
compagni ad libitum lavorar, et edificar sivè al piano ò al basso, sivè in
soler, et aver le finestre ferrate, e vetrate, e la porta sopra la Corte sivè
Cortile per loro uso per andar e ritornar di giorno, e di notte, e devono
aver una chiave della porta del cortile, et in oltre possono andar, e
ritornar per il Claustro vecchio, e nuovo, e nella Chiesa, e per essa, e far le
sue Processioni però secondo la consuetudine, e siccome è stato fatto.
Item che non possano tenere detta Possessione per Ospital, ne per uso ad
Ospital, ne affittarla ad alcuna persona, mà solo tenerla per detta Scola.
Item che debbano far condurre di fuori li comodi, che vi sono dentro à
loro spese. Item che tutti li patti che hanno detti Guardiano, e Compagni
nella loro Matricola, e fuori d'essa Matricola con detti Padri saranno
osservati et adempiti da dette Patti. E per la sudetta Possessione detti
Guardiano, e Compagni in via di cambio dano à detto Monastero una
Casa in soler, nella quale detti Confratelli tengono le loro cappe, et arnesi
posta nel detto Luoco di S. Maria della Carità, et in oltre dano ducati
duecento d'oro da esser impiegati nell'acquisto d'una Possessione in
Venezia ò altrove ove sara più utile à detto Monastero. Item siano tenuti
dar à detto Monastero ogn'anno per affitto soldi vinti de grossi in
moneda. Item siano obligati tener il pozzo riparato. In oltre sono con-
venuti, che se in alcun tempo accadesse, che detta Scola mancasse, e non
vi fosse, overo che di volontà di quelli di detta Scola volessero alienarsi da
detto Luoco di S. Maria della Carità, debba detta Possessione sivè detto
Casamento edificato, e lavorato come all'ora sarà detto Casamento
edificato, e lavorato come all'ora sarà rimaner liberamente à detto
Monastero, et all'incontro si obligano detti Padri che se in alcun tempo
accadesse, che per diffetto di detto Prior, ò del Preposito, overo delli
Padri sudetti ò di alcun'altra persona, che volessero espellere detti Guar-
dian, e Compagni ò non volessero osservare li patti, ricusando la loro
compagnia debbano pagare, e restituire à detta Scola tutti li dinari, che
per li edificij, e lavoriero di detto Casamento fossero stati spesi da detti
Confratelli; appar in atti di D. Giacomo di Azzoli Notaro Imperiale.

> (Registro 311 ["Catastico di
> scritture"], no. 11, fols. 2v–3v. The
> original document [Busta 3, no. 11]
> bears the notation: "1344, 20 fevrer:
> et chiama in altro instromento de
> patti de 1343, 7 zener.")

Document 2 1384, 3 Luglio.

. . . Compositione, et accordo seguito trà la Veneranda Scola di S.
Maria della Carità da una, e li Reverendi Padri Cannonici del Monastero
di S. Maria della Carità dall'altra, per occasione del bisogno che tiene
detto Monastero di riparare il muro, e fondamento del Cimitero del
Monastero sudetto da quella parte che guarda sopra il Canal grande, et
anche sopra il rio che discorre à S. Agnese, qual fondamento di detto

Monastero per l'impeto dell'acqua è talmente diroccato, che se ve-
locemente non si accorresse al riparo minaccia totale rovina al Campanile
del Monastero stesso; per la quale il Guardian e Compagni di detta Scola
offeriscono à detti Padri la somma di ducati cento d'oro per la riparatione
sudetto, et all'incontro detti Padri hanno dato, e concesso à detta Scola
licenza plenaria, et omnimoda libertà di poter far costruire, et edificare à
comodo della Scola sudetta et à di lei spese e fatiche sopra l'ospicio
maggiore per il quale s'entra in detto Monastero cioè nella Corte grande
ov'è un certo pozzo, un ospicio in soler che abbia l'ingresso per la Casa di
detta Scola, qual ospicio deve confinare da un suo capo nel muro della
Casa di detta Scola, e dall'altro capo nel muro di detto Monastero
ponendo sopra l'angolo del muro di detto Monastero un'angolo di pietra
viva sivè una colonna di pietra viva, che sia fondata à basso dal ladi di
detto angolo di muro, qual angolo sivè colonna non si estenda di fuori
cioè à basso più di piedi uno e mezo, e di sopra abbia li modioni sivè le
cime di pietra viva, che si estendano in fuori sino alla larghezza di detto
Ospicio, qual Ospicio deve esser alto nella travadura com'è la travadura
della Casa de Battudi di detta Scola e dev'esser lungo dal muro della Casa
di detta Scola de Battudi sino al muro di detto Monastero, e dev'esser
largo piedi dieci sino undeci entro esso Ospicio, ne deve detto Ospicio
aver alcuna colonna in mezo, che in alcun modo impedisca l'ingresso
della Corte di detto Monastero, ne possa avere alcun ingresso se non per
la Casa della Scola di detti Battudi com'è detto, nel qual ospicio si
possano far finestre dentro, e fuori per lume del medesimo; del qual
ospicio detta Scola starà sempre nel quieto, e pacifico possesso, e se detti
Padri, ò li loro successori inquietassero mai detta Scola promettono di
esborsarli tutto quello, e quanto che avesse speso nella fabrica del
medesimo, et in oltre restituirli li ducati cento come sopra esborsati per la
riparatione del loro Monastero; appar Instromento in atti di D. Marco di
Raffanelli Notaro Veneto.

> (Registro 311 ["Catastico di
> scritture"], no. 56, fols. 11ᵛ–12. The
> original document [Busta 2, no. 57]
> bears the notation: "Charta de far
> l'albergo in soler, et del cimiterio de
> Santa Maria de la Charitade.")

1384, 21 Decembre. **Document 3**
 . . . Laudo, et approbatione fatta dalli sudetti Reverendi Padri
dell'Ospicio fatto fabricare da detta Scola doppo aver averlo veduto, e
ben considerato, asserendo esser fabricato et costrutto nel modo, e forma
accennata, e stablita nel sudetto Instrumento, facendo quietanza alla
Scola medesima della sudetti ducati cento d'oro esborsati in ordine à
detto Instrumento, e di ducati vinti d'oro di più donati à detti Padri;
appar in atti di detto Notaro.

> (Registro 311 ["Catastico di
> scritture"], no. 58, fol. 12.)

Document 4 1411, 26 Novembre.

. . . Memoria della carta sequita trà la Scola di S. Maria della Carità da una, et il Prior, Convento, e Capitolo di S. Maria della Carità dall'altra, per la quale furono da detto Convento concessi à detta Scola quattro graneri, due alberghi, una Casa, e parte del suo orto, e libertà di poter allargar l'albergo ove si fanno le riduttioni sino al muro della Chiesa, e perciò da detta Scola furono scritti à detto Convento ducati duecento d'Imprestidi, et esborsati ducati cento d'oro, come appar Instromento in atti di D. Ettore Notaro de Signori sopra li Monasterij, et altra memoria di notar tute le spese che si faranno per detta fabrica.

<div align="right">

(Registro 311 ["Catastico di scritture"], no. 35, fol. 9.)

</div>

Document 5 1442, 10 Aprile.

. . . Compositione et accordo seguito trà li Reverendi Padri del Monastero di S. Maria della Carità da una, e la Veneranda Scola di S. Maria della Carità dall'altra, per la quale li Deputati à ciò dal Capitolo Generale di detta Scola, et il Guardian Grande, e Compagni in di lei nome hanno rinonciato, e riffiutato à detti Padri tutto il ius, e tutte le azioni ch'essi Guardian, e Compagni hanno avuto, et hanno di estendere, ingrandire, et allungare l'albergo sivè ospicio, in cui li Confratelli di detta Scola fanno le loro raggioni, e conti sino al muro antico di detto Monastero, nel quale al presente è la porta principale della Chiesa come si contiene nell'Instromento 1411, 26 Novembre al numero 85 in atti di D. Ettore di Baisini Notaro Veneto, ad effetto che detti Padri possano in conveniente, e debita forma fabricar, et allungar la loro Chiesa cessando l'ellungatione di detto albergo. Et all'incontro detti Padri volendosi render grati benevoli, et amicabili verso detti Confratelli per con[tro]cambio di dette raggioni hanno dato, e concesso à detti Guardian, e compagni per nome di detta Scola, che ad ogni loro beneplacito, e volontà possano, e vagliano detto albergo accrescere, allargare, et alzare verso la Corte, in cui è il pozzo, et estendersi per undeci piedi misuratorij entro li muri oltre la larghezza, che di presente hà esso albergo, e poner, e piantar colonne nella Corte secondo l'opportunità, e possa farsi l'ellongatione di esso albergo dal muro superior della Scala di essa Scola sino al muro del dormitorio vecchio di detto Monastero per essa larghezza di piedi undeci, nel qual muro del Monastero si possano ponere et affiggere legnami, pietre, ferramenta, et altre cose necessarie per la costruttione di detto albergo, e si possano in esso albergo far finestre così dalla parte d'avanti verso il Canal Grande quanto dalla parte di dietro verso la Corte ov'è il Pozzo, qual fabrica di albergo sudetto debba farsi à tutte spese di detta Scola, e se nel fabricare si distruggesse alcuna cosa appartenente à detti Padri debba esser ridotta nel pristino, e conveniente stato. Dichiarando che la detta Corte ov'è il pozzo debba restar perpetuamente libera e espedita fatta la fabrica di detto albergo così che in essa non possa farsi alcun'altra fabrica che occupi detta Corte; possano però detti Padri à loro beneplacito e de successori fabricar, e far fabricar sopra il muro di detto dormitorio vecchio come hanno potuto, e possono. Item

hanno promesso detti Padri, che nel muro sivè appresso il muro nuovo di detta Chiesa, che al presente si fà dalla parte d'avanti verso il Campo non faranno, ne permetteranno che sia fatto alcun portico, appendice, ò altro coperto acciò non sia occupata e deturpata l'entrata et uscita di detta Scola, acciò essi Confratelli possano con li loro penelli, e cerei far le Processioni e divotioni sue. Item hanno concesso, e sono contenti detti Padri di far, e far far à loro spese una porta in forma conveniente nel muro anteriore di detta Chiesa da fabricarsi di nuovo al coperto sotto l'albergo vecchio predetto, della qual porta essi Confratelli sempre possono valersi nelli suoi giorni ordinati, e nelli giorni delle sue processioni, e divotioni restando però sempre le chiavi appresso detti Padri. Item detti Padri sono contenti, e concedono, che detti Confratelli possano salizare di quadrelli overo di pietre cotte tutta quella parte di Campo sivè Cimiterio, ch'è trà le salizata che sono dalla parte d'avanti della Chiesa, e dalla parte d'avanti della Scola sino al Canal grande, et al rio, qual parte di cimiterio così salizato sia, et esser debba in libertà di detti Padri, e loro Monastero, e successori di dar, e conceder à chi vorranno per sepolture, quali sepolture da ponersi, e concedersi debbano farsi di pietre vive egualmente con detto cimitero salizato ò da salizarsi, dichiarando che dette salizate deputate per stradda delle persone non vengano impedite da alcune sepolture restando anch'esso cimitero in perpetuo disoccupato da altre fabriche. Item che in quanto detti Padri volessero far fabricar addesso overo per l'avvenire una ò più capelle, che si estendano sotto il portico di detta Chiesa, ch'è verso il Canal grande, sotto il qual portico sono sepolture di detti Confratelli, e distruggessero overo amovessero dette sepolture ò parte di esse, che all'ora et in quel caso siano obligati dar altro luoco sotto detto Portico, ò altrove grato à detti Confratelli, nel quale detti Padri debbano far ponere à loro spese le sepolture da distruggersi overo amoversi per la fabrica di detta una ò più capelle in detto Luoco da assegnarsi ò assegnato in debita e conveniente forma, e fabricando sivè facendo fabricare detta una ò più Capelle nel modo predetto occupanti esso portico, detti Padri siano obligati nello stesso tempo allargare tanto portico verso il Canale quanto di esso occuperanno per detta Fabrica. Con questa conditione, che se detti Padri volessero far fare una Capella nel muro vecchio di essa Chiesa che non occupasse eccessivamente detto Portico, che possano farla non occupando se non sino alla metà di detto Portico, e per detta Capella non siano obligati ad allargar detto Portico. E se per la fabrica di detta Capella si amovessero ò distruggessero alcune sepolture di detta Scola che avanti che si amovano per detti Padri sia assignato à detta Scola loro grato ad essi Confratelli sotto esso Portico, ò altrove, nel qual essi Padri facciano riponere esse sepolture à loro spese in debita, e conveniente forma. Item hanno voluto, e sono convenuti detti Padri, e detti Confratelli, che se in dette fabriche da farsi per esse Parti ora e per l'avvenire essi Padri tanto nella Chiesa quanto fuori distruggessero ò amovessero alcuno delli lavorieri, et edificij fatti per essi Confratelli overo per li suoi precessori ò da farsi per l'avvenire sempre con la volontà, e consenso di detti Padri, e similmente se detti Confratelli amovessero ò distruggessero alcuno delli edificij fatti ò da farsi per essi

Padri e suoi precessori ò successori che tutto il distrutto ò amosso sivè da distruggersi ò amoversi sia rifato, e riformato in pristina, e conveniente forma per la parte che distruggesse ò facesse distruggere, à sue spese. Item sono convenuti che tutte le altre obligationi, promissioni, et Instromenti, che alcuna di esse Parti ad invicem avessero, che non derogassero alle sopradette conventioni restino ferme, e valide in tutte le sue parti eccettuate le parti deroganti e contravenenti alla sudetta conventione; quali parti siano e s'intendano casse, nulle, revocate, et esse parti deroganti alle sopradette contenute nel presente Instromento s'intendano cassate, et anullate; appar Instromento in atti di D. Pasio q. Prosdocimo di Bettepaglia Notaro Veneto.

(Registro 311 ["Catastico di scritture"], no. 98, fols. 23–25.)

Document 6 Laus deo. adi 31 luio [1491].

Perche le scriture testamenti et altre carte de ogni condition che se atrova in questa nostra schuola son mal tegnude et governade la qual e lanima de tuta dita scuola et vita: plurimum vel etiam per molti officiali che per i tempi se atrova tolte a qualche suo propoxito a gran dano e detrimento e de dita schuola et questo e per esser quele neli banchi delo albergo nostro confuxamente mese senza algun ordene, per esser cotidie manizade per chadaun official del albergo a suo piaxer, nej qual banchi ne sono molte de guaste si per la humidita come per pioze che ano piovesto sopra e chi non provede de trovar luogo abele dalungar quele separadamente luna da laltra con armeri de breve andarano in oblivion ac etiam molte cose delo albergo nostro patise per non aver luogo capace come sono paramenti ombrele e tapezarie: Pero el spetabel miser Marco Grazian vardian grando con il suo compagni considerando questa cosa molto danosa ala schuola et vogliando proveder el remedio, examinando tuto quelo che de tal cosa si puol examinar et non trovando piuj utele seguro et abel modo a poder conservar dite scriture e dite cose necesarie salvo che sopra lo albergo nostro, et avendo avudo bon et optimo conseio da molti insicienti Maestri: I qual conclude che liziermente et con pocha spexa et faria tal lavor sopra dito albergo che faria una canzelaria over sagrestia da conservar dite cose senza alguna ocupation de dito albergo imo con piuj segurta de quelo et pero el predito miser Marco Grazian e compagni prediti mete per parte che dita fabrica se posi far posando spender oltra le uxade limitatio ducati cento e non piuj e se piui se spendese deli danari dela dita scuola se intenda queli piui sia trati dele borse de fradeli si de queli da la banca come de altri che volese dar elemosina prometando etiam dito Vardian e compagni adornar el sofita quanto piuj saldo si potra adornare ad onor de questa sancta schuola senza alguna altra sua spexa de dita schuola ma tuto de le borse di fradelli: Mese a capitolo a di ditto.

Fo de la parte si baloti n.º 38 E fo prexa
De no baloti n.º 4

(Registro 236 ["Libro detto il Bergameno", 1460–1614], fol. 20.)

Adi ditto [1534 (=1535), adi 2 fevrer].

El non bisogno molto affaticarsi in dimostrar, et decchiarir di quanta importantia sia ben governar, et tenir le scritture nostre perche quelle sono el fondamento della schuolla nostra, et ogn'uno largamente intende, che è la principal cosa si habbi à custodir. Et considerando, che sopra ciò chadauno, che de tempo in tempo si hà ritrovato à questo governo, si hà doluto del mal modo in tenir ditte scritture nostre, le qual si attrovano nella Cancelaria sopra lo Albergo tanto mal in ordine, che pezzo dir non si può, confuse, disordinate, mosse dalli suoj luochi, guaste da polvere, et dissipate, senza chiave alcuna su li Armarj. Il che procede che per la incomodità, et senestro de andar in ditta nostra Cancelaria per esser una schalla in buovolo angustissima, et senestra, de certo tuol l'animo à cadaun vardian per quella andarvj. Onde havendo con diligentia considerato el spettabel miser Nicolo dalla Torre Vardian Grando mette per parte, che la ditta schalla in buovollo, qual và nella ditta Cancellaria nostra sia slargada, et fatta abbele con bona consideration, et conseglio de' peritti, dove siano regolate tutte scritture nostre; deputando a cadauna comessaria el suo locho separato in uno Armaro, con la sua chiave, si che tutto diligentissimamente sia regolato, et prompto à ritrovar in ogni occorentia nostra, et appresso di potter reffar, et adaptar le fenestre dell'Albergo nostro per dar luce alla pittura del teller va nel ditto nostro Albergo, possendo spender quanto farà bisogno.

Della bancha	n° 13	De si	n° 23	et fo presa di tutti
Della zonta	n° 10	De no	n°	ballottj

(Registro 256 [Notatorio, 1531–1543], fol. 34.)

2. RENOVATIONS AND RESTORATIONS OF THE FABRIC
Document 7

1572 adi 10 marzo.

Ritrovandosi il luogo nostro dell'albergo moltto angusto nell'intrar per una sola portta al tempo della nostra festa et per doni per laquale se conviene intrar et uscir con gran disturbo et difficultà come e, nottorio a tutti onde e, staro necessario preveder in far in detto nostro albergo una altra portta simile dalaltra banda pero l'andera parte che mette il magnifico miser Nicolo di Franceschi guardian grando che nel haver fatta detta portta si habi speso delli danari della scuola nostra quel tanto potra importar il far di unaltra portta di piera viva simile alla vechia et accioche le ditte portte siano simili se debbia far tutte due le portte di legname con quel adornamento neccessario che se ricerca a honor della scuola nostra:

Fo letta adi primo marzo 1572 in albergo al n° di 21

Fo messa adi 10 ditto in albergo al n° di 26

De parte	17
De no	9

Fo reballottada

De parte	18	E fo presa
De no	8	

(Registro 258 [Notatorio, 1557–1581], fol. 140v.)

Document 8

Document 9 Adi 27 ditto [Avosto 1547], et sopragionse uno de Zonta.

Essendo necesario di refar la porta grande de la scuolla nostra et quella che va sopra il campo sancto de la charita per esser quelle vechissime et mal conditionate, anzi poco sicure come ad occulum si vede. . . .

Perho mete per parte el magnifico miser Sancto Barbarigo vardian grando che per far le cose preditte el pose spender fino ducati 70 et tanto meno quanto afar le ditte cosse si spendessi de liqual esso guardian sia obligato far tenir particular conto acio che si possi sempre veder come ditti ducati setanta sarano stati spesi. . . .

De si n.° 25
 Et fu presa
De non n.° 0

(Registro 257 [Notatorio, 1543–1557], fols. 45–45v.)

Document 10 MDLIII adi 9 April. In Capitolo General

Quanto sia grato al omnipotente Dio il construir et ornar il suo tabernaculo, questo si vede nel vechio testamento instrution et amaestramento de fidelissimi Christiani. Et percio non senza causa li progenitori nostri in carita et amor congregati gia tanto tempo fu [i]ndorno [?] la habitation di tanta confraternita non considerando alli futuri tempi, ne anche alla imbecillita del sexo humano contentandosi del ingrosso quantunque angusto et a nostri tempi de grandissimo incomodo, et questo perche a quelli tempi non se attrovavano tanti doni et gratie dalla sede apostolica donatti in remedio de nostri peccati, alle qual tutta la Citta et lochi a quelli vicini concorreno per non perder tanto dono et gratia concesso. Onde per tal et altre cause, et maggior commodo et ornamento di essa nostra confraternita desideroso il magnifico miser Vicenzo Quartari guardian grando di essa confraternita proveder a quello che al presente e di grandissimo bisogno qual è, de construir et fabricar due scalle alla ditta schola nostra accio piu non se incorri in tanti desordeni come fin hora se ha fatto et etiam per satisfar al desederio de nostri gentilhomeni et cittadini, quali ogni giorno pregano che tal cosa se habbi a fare.

Pero mette per parte che per auttorita di questo general capitolo in amor et carita congregatto, sia preso che se debbi far le dette due schale et etiam una porta grande in campo di essa schola juxto et secondo el modello che per cinque nostri fratelli da questo general capitolo da esser eletti insieme con esso guardian grando et vicario et la maggior parte di quelli sara preso terminato et stabilito quali habbino auttoritta in tal matteria di poter spender fabricare et ornare come alla maggior parte de loro parera le conscentie delli quali in questo aggravamo casi nella eletion del modello, come nel spendere dello danaro per tal operatione. Dechiarando che tal spesa non possi exciuder la summa de ducati mille e dusento da lire 6 soldi 4 per ducati. Dechiarando che non trovandossi li homeni 100 con li ducati 4 per uno la detta parte non se intendi presa.

Reduti al n.° de 107
Della parte n.° 48
 Non fu presa
De non n.° 59

(Registro 257 [Notatorio, 1543–1557], fol. 111v.)

adi 16 ditto [Dicembre 1565]. In Capitolo General, reduti al n.º de 50. Letta la sottoscrita parte fin adi 6, redutj al n.º de 41.

Document 11

Devendosi per commodità & honorevolezza della scola nostra accomodar le scalle ascendente in questa Salla in modo che stiano bene, & far ciò con quella minor spesa che sij possibile.

L'Anderà parte che mete il Magnifico miser Marian Vidal Vardian Grando che dette scalle sijno redute si come per il modello hora mostrato a questo capitolo appar, & per ciò sij dato facculta alli Magnifici Guardian sudetto, Viccario, & Vardian da Matin di spender quanto sara necessario per l'effetto predetto, & perche facendosi mutatione delle scale vecchie, serà etiam neccessario reaccomodar porte et balconi, pero sij etiam datto faculta alli sudetti di accomodar detti balchoni et porte in quel modo che li parerà con minor spesa sera possibile, devendo tenir conto particular di quanto spenderano juxta il solito. Dechiarando che non sij fatto mutatione d'alcun'altra porta se non di quella sopra il rio, qual sij fatta a dirimpetto di quella per la qual si entra al presente in scola, et li balconi s'intendino quelli che occorerà farsi per illuminar li patti delle scalle et sotto li patti, non devendosi a modo alcuno mover le due porte cioe quella dell'Albergo et la maestra. Et cosi servatis servandis furno

de parte —	n.º 38
de non —	n.º 12
Non sinceri —	n.º 0

(Registro 258 [Notatorio, 1557–1581], fol. 91.)

Sia lauda Dio. MDLXVI adi XV Mazo. In Albergo redutj al n.º de xxv.

Document 12

Essendo stà per il far della scalla et il balcone grande della scola nostra novamente fatti per il magnifico guardian passato ritrovato il muro della faza di essa scola in malissimo termine, et in modo tale che per le aperture di quello la travamenta e stata trovata marcita, unde essendo da provederli con quel modo piu conveniente che si diè a benefficio et conservatione della scola nostra,

L'Anderà parte che mete il Magnifico miser Francesco Arzentinj Dottor, Guardian grande che si debba far terrazar et smaltar la fazzada de detta scola, qual essendo vecchissima come è et de tanti anni, et in faza de Tramontana sottoposta a venti et pioggie è fatta in maggior parte corrosa come si vede, Dandoli etiam auttorità di far indorar il segno nostro della carità et la madona di marmo che e sopra la porta di detta scola nel compo grande. Facendo etiam terrazar et smaltar de dentro di essa porta sotto il portego che si entra nella scola nostra et farli una banca commoda et honorevole a detta intrada, spendendo delli danari della scuola nostra quanto sopra ciò sarà bisogno per adornar detta entrata come è conveniente.

La presente parte fu letta in albergo redutj al n.º de xx[v]. Et in questo giorno ballotata, et furno

della parte —	n.º 20	Et fu presa
de non —	n.º 5	

(Registro 258 [Notatorio, 1557–1581], fol. 94.)

3. PICTORIAL DECORATION OF THE *ALBERGO*
Document 13

+Christus matter Maria mcccciij [=1504] adi xx zener

Dexiderando miser Nicolo Brevio al prexente guardian grando et compagni in lalbergo de la scuola de madona santa Maria de la charita de voler far un bellisima opera in lo predeto albergo nostro laqual stia a laude et gloria de la glorioxisima Vergene Maria madre nostra de charita et ornamento bellismo del predeto albergo et scuola nostra et che si onorificha sperando da tuti esser laudada. Et za molti anj forsj dexiderada simel hopera da moltj guardianj e governj stadi in questa benedeta scuola, e la chaxon perche la non stata fata fina alora prexentj forsj per la incomodita de danaro per aver avuto la dita scuola in diversj tenpi de molti strafori e grandi angarie. Al prexente per la grazia de miser domene dio e de la glorioxa madre nostra santa Maria e medianti le fadige nostre la scuola xe obertoxa de danarj e sono stati sfati e se satisfa tute le angarie e chi deve aver da quello etc.

Onde che nuj jnsperadi piuj presto da madona santa Maria madre nostra de charita che de niuna altra ochaxion voler far depenzer uno telaro e quello meter in faza de lalbergo sopra la porta, et far la instoria a laude de nostra dona como la fo oferta al tenpio che segondo el desegnio sera nobelissima cosa etc.

Esendo conparso maistro Pasqualin da Venexia depentor davanti de nuj in lalbergo nostro oferendose de voler far simel opera e farla in superlativo grado a tutj suo spexe con largisime oferte como apar per scritura de so mano. E prima che de prexio che nuj de lalbergo li metemo prexio, et non voler danarj fina opera compida, et molte altre condizion como in quella sua scritura apar e per tanto consideratis considerandis per esser nuj inluminada da madona santa Maria madre nostra della charita perche questo abia esser per onor et laude de gloria soa. Et per tanto landera parte che mete el predito miser Nicolo Brevio vardian grando che dita opera se debia dar a far al soprascrito maistro Pasqualin da Venexia depentor [con] gli modj como per la sua scritura apar e de zonta como qui soto sera dechiarito. Et prima che luj abia per sua marzede per el far de dita opera ducati 170 a tutti sue spexe prometendo luj de meter bonj e finj colorj, et intterzetera boni zenabrij e finj azurj oltra marinj de li piuj finj se posi trovar e non vardar a prezio potese costar, et qual telaro luj abii a far per el stupendio supra scrito a tute sue spexe como e dito fina posto suxo al suo luogo e chel non posi aver dita sua marzede fina a lopera conpida laqual hopera luj a rechiesto de termeni ani doi e chusi semo contenti. Et perche del dito maistro Pasqualin non abiamo visto opera alguna de sua mano simelle a questa che nuj dexideremo de far, ma per la invenzion de el desegnio avemo avuto da luj a mostrato molto meglio de li altrij che se ano meso a questa prova, e per questo luj se oferisce che non fazando opera perfeta ita che la piaxa al chapitolo nostro el qual tonc tenporis stia ciamata segondo lordene de la scuola nostra, e non piaxendo al dito capitolo over ala mazor parte de quelli che in questo caxo el predito teller rimanga per conto del dito maistro Pasqualin et luj abia vadagnia per suo marzede solon el legniame del telaro e la tella, e non altro.

(Registro 253 [Notatorio, 1488–1528], fol. 68ᵛ.)

Laus deo. 1503 [=1504] adi 28 zener **Document 14**
 Io Pasqualin da Venetia depentor contra serito nominato son contento
e si me obligo afar el dito teler con li modi e condizion che sono notadi
alincontro.
 (Registro 253 [Notatorio, 1488–
 1528], fol. 69.)

Laus deo adi sopraditto [1504, 6 decembre]. **Document 15**
 Avendo considerato miser Lion Sanson avichario de madona sancta
Maria de la charita con li suoi compagni al prexente al governo di quella
benedetta schuola si atrova e desiderando continuo con ogni suo studio
et inzegno far cosa sia di laude e beneficio di essa schuola ed inpero
cognosando expresse che la partida fatta per miser Nicholo Brevio fo
vardian pasado in el bancho di Pisani di ducati 170 grossi 5 condicionadi
da esser queli dati al maistro e dipentor che lopera de uno teler per
lalbergo nostro tolse a far da esser dati aquelo ad opera finida e non poder
queli esser ni tratti di esso bancho ni adoperati adaltro effecto che apagar
ditto teler et opera ditta. Et essendo hora occorso el caso de la morte di
maistro Pasqualin che ditta opera havea tolto afar et al prexente non
essendo fin hora stato altramente provisto ni quelo adaltri dato afar et
chorendo el tempo. E questi tal dinari restano e stano in ditto bancho
morti senza algun utele et e amaleficio e danno de essa nostra schuola et
inpero desiderando sempre el ditto miser Lion e suo compagni far cosa
utele laudabile e abeneficio di essa nostra schuola adeliberato di zo
provederne e pertanto:
 Landera parte che mete el ditto miser Lion Sanson avichario per esser
el vardian grando al prexente amalato che questa tal partida de ducati 170
grossi 5 posti in ditto bancho di Pisani condicionati abi a esser e possi
esser tratti del ditto bancho per el ditto miser Lion e per quelo abi a esser
spexi intanto chavedal de monte novo comprando quelo anome de ditta
schuola di charita restando sempre ditto chavedal epero che di quelo
avera aseguir condicionado e obligado che quelo mai per niun guardian
ni compagni in niun tempo quelo se possa ni se debia poder spender
adaltro che de seguir e pagar de ditta opera de ditto teler et ornamento de
el ditto nostro albergo. E che per ogni tempo che achadera afar el
pagamento de tal teler edopera de ditto albergo non se atrovando tanto
pero che de esso chavedal se avesse fin qua de tratto che suplisi a esso
pagamento in tal caxo el sia in liberta de quelo guardian e compagni ho
queli che in quel tempo fosse ho se atrovasse al governo de ditta schuola
queli possi e habi liberta senza altra licencia de capitulo de vender de esso
chavedal parte ho tutto come achadesse ho bessognasse per el far e de
seguir tal pagamento de esso teler che per ornamento de ditto nostro
albergo fosse fatto non per niuna altra cosa che solum per esso
pagamento etc.
 Di 6 decembre redutti nel albergo al n⁰ 11 fo balotada ditta parte e fo de
si n⁰ 11 e de no n⁰ 0 e fo presa:–

Di 19 zener redutto el capitolo a n.º 31 fo balotada la sopra scripta parte e fo de si· n.º 29 e de no n.º 2 e fo presa:—

> (Registro 236 ["Libro detto il Bergameno," 1460–1614], fols. 28ᵛ–29; also in Registro 253 [Notatorio, 1488–1528], fol. 74ᵛ.)

Document 16 Laus deo [1504 (=1505)] adi 19 [zener]

Landera partte che mette miser Lion Sanson vicario per lexensia del guardian nostro mortte che exendo seguitta la mortte de maistro Pasqualin depenttor, che avea afar uno teler per lalbergo nostro, et exendo conpido i patti che con el detto se avea rispetto la mortte sua, e ristando per i patti el teler con la tela aluj che alttro el ditto non aguadagniaria non levendo compido; et exendo conparso suo fradelo ser Marin rechiedendo qualche premio de el desegnio e de la fattiga per el ditto chorsa solum per hopera piattoxa e per una charitta verso el ditto ase deliberatto de azettar adriedo quelo tteler de legniame con le tele nel termene se attrova e darli tanto quanto quelo za ni chosto che son ducati 3 gr. 12.

e balottada ditta partte fo de si n.º 12 e de no n.º 0, e fo prexa.

adi 26 ditto fo pagatto a ditto maistro Marin per vigor de ditta partte ducati 3 gr. 12.

> (Registro 253 [Notatorio, 1488–1528], fol. 75.)

Document 17 1504 [=1505], 14 februarij

Presentibus preconibus curiae testibus ad infrascripta vocatis habitis specialiter rogatis et alijs. Spectabiles et generosi viri domini Petrus Longo, Paulus Corario et Philippus de Molino honorandi judices curiae Petitionum juxta requisitionem egregij virj ser Leonis Sansono vicarij scholae batutorum sanctae Mariae Charitatis, petentis et requirentis quod ducati centum septuaginta qui repperiuntur in bancho de Pixanis, depositati per ser Nicolaum Brevio, tunc guardianum dictae scolae, conditionati quod darentur quondam magistro Pasqualino pictori pro manifatura sive mercede unius telleri fiendi per ipsum pro albergo dictae scolae, prout de dictis partitis in dicto bancho apparet, sub die XXVIII° martij 1504; qui magister Pasqualinus mortuus est, et non potuit perficere dictum tellere in execution partis captae in capitulo dictae scolae, die 6 dezembris proxime preteriti extrahemini ex dicto bancho per dictum dominum vicharium, sive per successores suos et ex ipsis emantur tot imprestiti ad montem novum ad cameram inprestitorum, et ibi ponantur cum ipsamet condicione et obligacione prout erant in dicto bancho de Pixanis. Cum premissa predictus dominus vicarius minime facere possit absque auctoritate presentis judicij, vissa partita preallegata, vissa partita capta in capitulo dictae scolae, et consideratis considerandis per eorum iustitiam et suam difinitivam terminationem vigore sui officij determinando, determinaverunt et declaraverunt, prefacto ser Leono Sansono vichario dictae scolae, nec non guardiano et

sociis dictae scholae, qui per tempora reperientur, licentiam et auc-
toritatem contullerunt quatenus libere valleant et possint extrahere ex
dicto bancho de Pixanis dictos ducatos centum septuaginta non obstante
dicta condicione apposita super dictis denariis, et ipsos ponere ad
cameram imprestitorum ad montem novum, cum dicta condicione et
obligacione prout sunt et erant in predicto bancho, et omnia alia et
singula facere procurare et exercere in omnibus et per omnia prout
superius est naratum et requisitum et declaratum cum modis et con-
dicionibus superius declaratis, omni contradictione et obstachulo re-
motis causis et rationibus antedictis, et hec determinationis carta semper
in sua firmitate permaneat jurata.

(S.T.) Ergo Priamus Balanzano Curiae Petitionum et Veneciarum
notarius presentem determinationem in libris Curiae insertam mandato
suprascriptorum dominorum Judicum petitionum in hanc publicam
formam transcripsi et in fidem premissorum me subscripsi signumque
meum apposui consuetum.

> (Mani Morte, Miscellanea perga-
> mene, Scuola della Carità
> [transcribed from Ludwig].)

1534, adi 29 Auosto. Sabato **Document 18**

Cum sit che fin adi 6 dizembrio 1504 per miser Lion Sanson tunc
tempori Vicario al governo della schuola nostra de madonna santa Maria
della Charità per la infirmità de miser Beneto Charlonj vardian grando
fusse preso parte che li ducati 170 gr. 5 deli qual fu fatta la partida per el
quondam miser Nicolo Brevio vardian grando precedente nel bancho di
Pisani chondizionati da esser dadi à maistro Pasqualin depentor per el
depenzer de un teler delalbergo nostro a tutta opera finida li qual non si
potesse adoperar ne spender in altro, salvo in satisfar ditta opera, et
essendo successa la morte del ditto maistro Pasqualin per la qual fo
impedito, et sopra stato al far di quellj, acciò li danari non havesseno à
star infrutuosi nel ditto bancho, fosseno tratti, et comprado tanto cavedal
de monte nuovo al nome della preffatta schuolla nostra de Charità,
restando perhò ditto cavedal, et prò, che de quello seguisse con-
ditionado, et obligado, che mai per alcun tempo povedesse, ne dovesse
esser speso in altro, che in satisfar l'opera de ditta teler, over pittura, et
ornamento dell'Albergo nostro, con espresa libertà al Vardian e Com-
pagni che pro tempora se ritroveranno, che non havendo tanto pro
seguito, che satisfacesse alla preditta opera, di poter vender esso cavedal
in tutto, over in parte, come alla satisfation di quella bisognasse, et
perche ditto chavedal, et prò è stà in bona parte scosso, e posto in monte
de ditta schuola nostra, qual racionabilmente stante la parte preditta, se
doveva tenir separato per aplicar segnanter in ogni aiunto alla preditta
opera. Però considerando el spettabel miser Nicolò dalla Tore Vardian
grando esser congrua et chondegna provision redur ad effetto tal pittura,
et ornamento, come se convien al decoro delalbergo nostro, et come si
vede nelli altri alberghi delle schuole grande de questa Illustrissima Città,

mette per parte de trazer ditti chavedali, et pro del monte, de essa
schuolla nostra, et far marcado, et restar dacordo, con sufficienti, et
famosi pittori, quelli satisfacendo de tal danarj justa la parte del pro-
nominato quondam miser Lion Sanson, et come meglio, et più es-
pediente li parerà insieme col suo Vicario, et Vardian da matin, redutti
nel nostro Albergo della Bancha n° 12 delli agionti n° 9 posta, et ballottata
la sopraditta parte.

Della parte — n° 21 et fo presa —
De no — n° —

> (Registro 255 [Mani Morte], fol. 27ᵛ;
> also in Registro 256 [Notatorio,
> 1531–1543], fol. 27ᵛ.)

Document 19 Adi 6 Marzo 1538

Quanto sia necessaria, et conveniente à mortali li adornamenti nel
tabernaculo dell'omnipotente Iddio, e della gloriosissima protetrice
madre de Charità madonna santa Maria, non si potria con parole es-
primer. Imperoche da quello non solum cressono la devotione verum
etiam accendono li Animi à molti, che più volontieri, et con bon animo
concorrino nel farsi descriver nelle confraternità, et congregation pre-
fatte, per il che considerando il spettabile miser Andrea Zio Vardian
grando della schuolla de madonna santa Maria della Charità, quanto sia
necessario de far construir, et depenser il quadro nelalbergo nostro dalla
banda dove stà la santissima Croce, cosa veramente de grandissimo
bisogno, et molto honorevole alla ditta schuola, si per il culto delabi-
taculo divino, come per honor della confraternità nostra. Però mette per
parte chel ditto quadro sia fatto depenser per lo ingeniosissimo, et
prudentissimo homo miser Zuan Antonio da Pordenon alli tempi nostri
homo di grandissimo ingegno, sopra del qual se habbia à far cosa ho-
norevole, et conveniente alla schuola nostra, nella qual se habbia à
spender fino alla suma de ducati 10 [*sic*] in dodese de grossi, attento che
fin hora se attrova da Lire 8 in circha de grossi da esser à tal causa
deputtati.

De sì — n° 19 fo presa
De no — n° 2

> (Registro 255 [Mani Morte], fol. 86;
> also in Registro 256 [Notatorio,
> 1531–1543], fol. 86. The proper sum
> is recorded in Registro 351
> ["Sommario delle scritture"], fol.
> 138ᵛ: ". . . si debba spender fin
> ducati 120 essendone ducati 80 hora
> à ciò deputadi.")

Document 20 1539, adi 6 Marzo

Essendo venuto a morte il excelente miser Zuan Antonio da Pordenon
pittor al qual per parte presa del 1538, adi 6 marzo prossimo passatto

appar in questo à carte 88 [*recte* 86] fo datto il cargo de depenzer il teller, over quadro, qual era nel nostro Albergo dalla banda dove solita sentar li signori xjj de zonta, per quel pretio, come in quella se contien; el qual miser Zuan Antonio vivendo vene nell'Albergo dicendo, chel voleva principiar tal pittura, et dimandando qual istoria era la opinion di questi signori che fosse dipinta, al qual li fo dimandato, se quando li fo datto tal cargo gli era stà impostò cosa alcuna, luj veramente rispose l'era opinion de qualche uno de quelli signori, che si attrovava à quel tempo, che fosse depenta l'assumption della Madonna. La qual cosa io doppoi partido, considerando parmi, che la non seria à proposito: si per esser il loco al quanto à tal opera, si perche tal miracolo non segue quello zà fatto per l'eccelente missier Titian, et poi etiam perche tal assumption si vede esser dipinta nella salla vostra, quì appresso alla porta. Unde che havendo considerato diligentemente, non trovo cosa qual fosse più à proposito del sposalitio della Madonna, per esser cosa che segue à quell'altro tellaro, et poi perche il luogho è capace à tal cosa. Al qual li fù datta libertà, anzi ordenation, chel principiasse, et facesse tal sponsalitio, per esser anco cosa rara; et in vero come si vede è stà per el pronominato Pordenon designato tal cosa de carbon. Havendo mò parso al sommo Mottor chiamarlo à si, e forzza far provision de uno altro pittor, qual sia sufficiente à tal effetto, et fatto le proclame. Vene li oltra scritti à darsi in notta; li quali prima chiamati nell'Albergo nostro davanti alla pre[se]ntia del spettabile Guardian, et compagni redutti—

Della Bancha — n.° 16
Della Zonta — n.° 9

Furno alditti tutti, et li loro partidi, che facevano à dipenser tal tellaro, et poi ad uno ad uno ballottadi, videlicet —

Miser Paris Bordon — 7. 18.
Miser Boniffatio da S. Alvise — 13. 12.
Miser Vettor Brunello — 5. 20.
Miser Zuan Piero Silvio — 19+ 6.

E rimase el ditto miser Zuan Piero Silvio, el qual è obligato sotto scriver una scrittura per Noi fatta, nella qual se decchiara el marchatto, et il tempo qual sarà ordinato, chel ditto teller sia compito, come in quella più diffusamente apparerà.

(Registro 256 [Notatorio, 1531–1543], fols. 103ᵛ–104ᵛ.)

Adì 19 Fevrer 1539 [=1540] **Document 21**

Cum sit che altre volte per li agenti della schuolla nostra fosse datto à ser Zuan Piero Silvio pittor de construir e depenser el quadro della schuolla nostra altre volte datto al quondam Pordenon con conditione de anno uno, et come in esso instrumento più diffusamente se contiene, e perche l'anno è quasi al fine, et l'opera imprincipiata et in tal pocco restante di tempo non si può compir, et finire, et perche el saria cosa bona di prolongar esso per haver opera perfetta però:

L'Anderà parte che mette el spettabile miser Lorenzo Negro Avicario, et vice Vardiano chel preditto ser Zuan Piero Silvio habbia finir esso quadro compido iusta la forma dell'instrumento, et nel termine che starà la Bancha prossima se farà, che serà dell'anno 1540 cosi recchiedendo esso ser Zuan Piero Silvio —
Adi ditto fo ballotta ditta parte —

Della Bancha —	n.º 14
De Zonta —	n.º 9
Della parte —	n.º 19
De no —	n.º 4

et fo presa

(Registro 256 [Notatorio, 1531–1543], fols. 127ᵛ–128.)

Document 22 1543, adì 11 Novembrio]

Fu preso in Albergo della schuolla nostra de madonna Santa Maria della Charità adi 6 Marzo 1539 che ser Zuan Piero Silvio havesse à depenzer il quadro và in Albergo à banda sinistra de ditta schuolla nostra, al qual ser Zuan Piero li è stà dà per la schuolla nostra ducati 40 à bon conto contra la forma del patto nostro per comprar azuro oltra marin per far ditto quadro, come ditto ser Zuan Piero si hà obligatto de far ditto quadro, appar per instrumento de man de ser Vicenzo Pilotto Nodaro, al qual in tutto, et per tutto se habbia relation, qual quadro lo doveva far intermene de anno uno, come per detto instrumento appar, tamen per quello si puol verder fino questa hora, non sono fatto niente. La qual cosa chi non li provede l'andarà ad infinito, et però:

L'Anderà parte che mette el spettabile miser Nicolo dalla Tore Vardian grando, che à tento questa longhezza di tempo di far il ditto quadro, et veder che le stà solicitado per molti della schuolla nostra, et par che ditto ser Zuan Piero non si cura, et acciò si habbia à fenir una volta la cosa principiata, et sia finida, con quella più solicitudine si puol, chel sia da libertà, à miser Anzolo Cadena, et miser Antonio Maria Sigollo nostri Agionti di potter comparer in ogni juditio, et magistratto per nome della schuolla nostra, et sententiar, et componer, et cadauna altra cosa neccessaria per la espedition del ditto quadro, qual si habbia à far con quella brevità di tempo sia possibile, come è ditto, et li ditti miser Anzolo Caena, et miser Antonio Maria Sigollo habbia questo cargo fino sia speditto ditto quadro.

Della parte de sì — n.º 16. De no — n.º 4. fu presa.

(Registro 256 [Notatorio, 1531–1543], fol. 181.)

Document 23 Laus deo MDLVII adi 5 auosto in albergo

Cum sit ch'el si atrova nel'albergo nostro a banda sinistra nel'intrar di quello uno quadro antiquissimo defforme dali altri che hora s'atrova nel detto albergo, in locho del qual havendossi offerto questa matina nel'albergo nostro ser Ieronimo di Tician pictor di farne uno honorevolle

che a compagnare gli altri del'invention che li sera hordinato. Rimeten-
dosj poi della mercede sua nel petto de quelli si atrovera alla Banca alhora
finitto detto quadro. Et che sia anco in liberta dela scuolla nostra dappoi
finitto di aceptarlo & non aceptarlo, in caso no fusse di quella Belleza e
honorevoleza che si ricercho al locho predetto, iusta l'offerta sua, perho:

Parendo il detto partito al magnifico miser Nadalin de Davit Vardian
Grando honesto e iusto, e parendossi anco honorevoleza del locho pre-
detto che li sia uno quadro conforme e di qualche aparenza apresso gli
altri s'atrova al presente nel detto albergo, mette per parte chel sia
aceptato il partito predetto dal detto ser Ieronimo hora per luj proposto,
con obligo et espressa dichiaration che non li sia datto al presente solun il
teller & il danar che gli potrano andar in collorj. Et finito serano piacen-
dolli aquelli si atroverano alla Banca e gionta li sia datto quello gli parera e
piacera per sua mercede, iusta la scritura e profferta per luj apresentatta,
spendendossi in detto quadro delli danari liberj della Scuolla nostra
della parte — n.° 15. de non — n.° 5. e fo presa
(Registro 257 [Notatorio, 1543–
1557], fol. 185.)

Document 24

1557: 8 Agosto

. . . Esibitione fatta da Girolamo de Tician Pittor alla Veneranda Scola
di S. Maria della Carità per pura sua amorevolezza, e divotione di far un
quadro nell'albergo cioè all'entrar della porta à banda zanca sino
all'Altare, di Rappresentatione di Maria Vergine, e di Nostro Signor
Giesù Christo senz'alcuna mercede, mà solo che la Scola li faccia far il
quadro, e gli faccia dar li colori, per il che suppliranno ducati dieci perche
quanto all'opera non riceva cosa alcuna; appar in atti di D. Antonio di
Contenti Notaro Veneto, esistente in C. 25 del numero 89.
(Registro 311 ["Catastico di scrit-
ture"], no. 116, fol. 27v.)

Document 25

1558 adi 12 marzo

Fu prexa in questo albergo sotto di 5 auosto prossimo pasatto de dar
caricho a miser Ieronimo de Tician de depenzer il teler over quadro che va
nel albergo nostro da la portta fino alaltar. Justa la sopraditta de-
liberacione sopra de la qual il prefatto miser Ieronimo si ofersse di far
ditto quadro con li modi et condicion contenutte ne la schritura volon-
taria fatta sotto di 8 auosto sopraditto de man de ser Anttonio di Con-
tenttj nodaro publicho. Il qual quadro esendo quaxi finitto et esendo
necesario anzi conveniente usar cortexia che sia equivalentte ala cortexe
ofertta fatta dal sopraditto miser Ieronimo: Pero il magnifico miser Nada-
lin de Davit guardian grando visto et maturamente consideratto il tutto
insieme con tutto lalbergo esendo tuttj andattj sopra locho aveder ditto
quadro mette per partte che in cortexia et dono siano datti ducati centto
per sua fattura de ditto quadro deli danari de la schola nostra al so-
praditto miser Ieronimo oltra li danari che luj a avutto fin ora per contto
de colorj et questo per ultimo don et cortexia de la sopra ditta opera et sia

azetado ne la nostra schuola per fratello justa la sua rechiesta, esendo pero obligatto el sopra ditto finir el ditto quadro sotto il rezimento del prefatto magnifico guardian prexente senza altra lemoxina che in tutto sarano ducati centto quindexe fra fatura et colorj. Reduttj al n.º de vinttj cazado el canzelier per eser parente.

De la partte — n.º 19, de no — et fu prexa.

(Registro 258 [Notatorio, 1557–1581], fol. 6ᵛ.)

Document 26 Adi 7 ditto [zugno 1561]

Mette parte el magnifico miser Iacomo Paralion guardian grando che sia datto scudi diece a ser Ieronimo Tuzian per conpir dafinir il quadro che sono in albergo apreso il tribunal — per la parte si se die balotar. De si n.º 16, De non n.º 4, e fo presa di balotar — per la parte — n.º 17, De non — n.º 3, fo presa.

(Registro 258 [Notatorio, 1557–1581], fol. 55ᵛ.)

Document 27 Laus Deo adi . . . 1679

Inventario delle Reliquie, et altre Suppelettili di raggione della Veneranda Scola de Santa Maria della Carità. . . .

Nell'Albergo. . . .

Un quadro in tella di mano del famosissimo Ticiano sopra il quale si vede la Presentation di Maria Vergine con molte figure, è bellissima.

Altro quadro di mano con la Santissima Annonciata, et altre figure

Altro quadro di mano del Sposalizio di Maria Vergine. Questi due quadri furno levati via da dove sono, per causa del vicino focho che fu molti anni sino nel convento delli Reverendi Padri della Carità, è si ruvinano, a segue che furno rettochati come si vede dal Tentoretto Giovene come si vede.

Altro quadro in facciata della Porta con la imagine di Maria Vergine con il Bambino in braccio, e due Santi in piede, uno per parte.

Altro quadro frà il sudetto et il

Altro quadro sopra la porta che va nel Bovollo. . . .

(Busta 2, no. 118, fols. 2ᵛ–3.)

Notes

CHAPTER 1.
INTRODUCTION: THE
CONDITIONS OF
PAINTING IN
RENAISSANCE
VENICE

1 On the myth of Venice: Federico Chabod, "Venezia nella politica italiana ed europea del Cinquecento," in *La civiltà veneziana del Rinascimento* (Florence, 1958), pp. 29–55; Gina Fasoli, "Nascita di un mito," in *Studi storici in onore di Gioacchino Volpe* (Florence, 1958), vol. 1, pp. 447–79; Franco Gaeta, "Alcune considerazioni sul mito di Venezia," *Bibliothèque d'humanisme et Renaissance* 23 (1961): 58–75; Felix Gilbert, "The Venetian Constitution in Florentine Political Thought," in *Florentine Studies: Politics and Society in Renaissance Florence*, ed. Nicolai Rubenstein (London, 1968), pp. 463–500. See also Lester J. Libby, Jr., "Venetian History and Political Thought after 1509," *Studies in the Renaissance* 20 (1973): 7–45; Myron Gilmore, "Myth and Reality in Venetian Political Theory," in *Renaissance Venice*, ed. J. R. Hale (London, 1973), pp. 431–44; William J. Bouwsma, "Venice and the Political Education of Europe," in *Renaissance Venice*, pp. 445–66, and *Venice and the Defense of Republican Liberty* (Berkeley and Los Angeles, 1968); and, of particular importance, Staale Sinding-Larsen, *Christ in the Council Hall: Studies in the Religious Iconography of the Venetian Republic (Acta ad archaeologiam et artium historiam pertinentia* [Institutum Romanum Norvegiae], vol. 5) (Rome, 1974), pp. 120–55 and passim.

 Specific cultural dimensions of the theme are discussed by Ellen Rosand, "Music in the Myth of Venice," *Renaissance Quarterly* 30 (1977): 511–37; see also Edward Muir, "Images of Power: Art and Pageantry in Renaissance Venice," *American Historical Review* 84 (1979): 16–52. More general surveys of the "mythology of Venice" are offered in Oliver Logan, *Culture and Society in Venice, 1470–1790* (London, 1972), pp. 1–19; D. S. Chambers, *The Imperial Age of Venice, 1380–1580* (London, 1970), passim; and Frederic C. Lane, *Venice, A Maritime Republic* (Baltimore, 1973), esp. pp. 253–58.

2 The basic facts of the competition are summarized from the earlier sources by Giorgio Vasari, *Le vite de' più eccellenti pittori, scultori ed architettori* (1568), ed. Gaetano Milanesi (Florence, 1878–85), vol. 2, pp. 223–27, 334–36. See further Richard Krautheimer with Trude Krautheimer-Hess, *Lorenzo Ghiberti* (1956), 2d imp. (Princeton, 1970), vol. 1, pp. 31–43; and for the competitive context in particular see E. H. Gombrich, "The Leaven of Criticism in Renaissance Art: Texts and Episodes," in his *The Heritage of Apelles: Studies in the Art of the Renaissance* (Ithaca, 1976), pp. 111–31, esp. 121–22.

3 Vasari, *Vite*, vol. 2, p. 413: ". . . essendo per miracolo quivi tenuto e da ogni intelligente lodato, si deliberò di voler tornare a Fiorenza, dicendo che, se più stato vi fosse, tutto quello che sapeva dimenticato si avrebbe, essendovi tanto lodato da ognuno; e che volentieri nella sua patria tornava per esser poi colà di continuo biasimato, il quale biasimo gli dava cagione di studio, e conseguentemente di gloria maggiore." See also Vasari's further comments in his life of Perugino (vol. 3, pp. 567–68) and the discussion by Gombrich, "The Leaven of Criticism," pp. 118–19.

4 See Johannes Wilde, "The Hall of the Great Council of Florence," *Journal of the Warburg and Courtauld Institutes*, 7 (1944): 65–81; reprinted in *Renaissance Art*, ed. Creighton Gilbert (New York and Evanston, 1970), pp. 92–132. See also F. Gilbert, "The Venetian Constitution."

5 Vasari, *Vite*, vol. 4, p. 41, vol. 7, pp. 159–60.

6 For Guariento's monumental fresco, executed during the dogato of Marco Cornaro (1365–68) and representing the Coronation of the Virgin, see Francesca Flores d'Arcais, *Guariento* (Venice, 1965), pp. 72–73, with further bibliography. By 10 June 1382 the *Procuratori di San Marco* were charged with maintenance of the paintings in the Sala del Maggior Consiglio: "Quod auctoritate huius Consilij conmittatur Procuratoribus ecclesie Sancti Marci quod faciant haberi curam et diligentiam bonam Sale nove Maioris Consilij et locorum spectantium ad dictam Salam ne tam solennissimum opus devastetur in picturis vel aliis rebus" (Giambattista Lorenzi, *Monumenti per servire alla storia del Palazzo Ducale di Venezia* [Venice, 1868], doc. 107).

 For the subsequent early narrative cycle, see Franz Wickhoff, "Der Saal des grossen Rathes zu Venedig in seinem alten Schmucke," *Repertorium für Kunstwissenschaft* 6 (1883): 1–37;

Laudedeo Testi, *La storia della pittura veneziana* (Bergamo, 1909–15), vol. 1, pp. 269–74; Wolfgang Wolters, "Der Programmentwurf zur Dekoration des Dogenpalastes nach dem Brand vom 20. Dezember 1577," *Mitteilungen des Kunsthistorischen Institutes in Florenz* 12 (1966): 271–318; also Norbert Huse, *Studien zu Giovanni Bellini* (Berlin and New York, 1972), pp. 21–55; and, most recently, Cristina Pesaro, "Un'ipotesi sulle date di participazione di tre artisti veneziani alla decorazione della Sala del Maggior Consiglio nella prima metà del Quattrocento," *Bollettino dei Musei Civici Veneziani* 23 (1978): 44–56. On the continuing significance of the subject matter of this cycle, see Gaetano Cozzi, "La venuta di Alessandro III a Venezia nel dibattito religioso e politico tra il '500 e il '600," *Ateneo Veneto* 15 (1977): 119–32.

7 On the "restoration" of official paintings in Venice, see E. Tietze-Conrat, "Decorative Paintings of the Venetian Renaissance Reconstructed from Drawings," *Art Quarterly* 3 (1940): 15–39. Cf. also Sinding-Larsen, *Christ in the Council Hall*, pp. 28–42 and passim.

8 The importance of the public display of these decorations to the state may be gauged by the decision taken on 21 September 1415 to create a new staircase, worthy of the nobility of the cycle, to allow more efficient access: "pro complemento tante pulcritudinis ac fama et honore urbis nostre . . ." (Lorenzi, *Monumenti,* doc. 145).

9 Some degree of possible intervention by the artist in the shaping of such political imagery has been argued, with regard to Veronese, by Wolters ("Der Programmentwurf," pp. 297–98) and strenuously denied by Sinding-Larsen (*Christ in the Council Hall*, p. 9, n. 5).

10 Lorenzi, *Monumenti,* docs. 137, 140. Vasari (*Vite,* vol. 1, p. 662) would have Antonio Veneziano at work in the Ducal Palace, but the chronology here and the precise identity of the artist are difficult to confirm. The early quattrocento campaigns of decoration—or redecoration—involved Gentile da Fabriano and Pisanello: see Francesco Sansovino, *Venetia città nobilissima et singolare* (1581), ed. Giustiniano Martinioni (Venice, 1663), p. 325, and Carlo Ridolfi, *Le maraviglie dell'arte* (1648), ed. Detlev von Hadeln, (Berlin, 1914–24), vol. 1, pp. 40–41. The local master in charge was Jacobello del Fiore, whose original annual salary of 100 ducats was reduced by half in January of 1412 (document published by Pietro Paoletti, *L'Architettura e la scultura del Rinascimento in Venezia* [Venice, 1893], vol. 1, p. 4, n. 6; also in Pesaro, "Un'ipotesi," p. 50).

11 Lorenzi, *Monumenti,* doc. 148.

12 Lorenzi, *Monumenti,* docs. 188 (quoted below, n. 16), 192.

13 The family tradition seems to go back to Jacopo Bellini (Pesaro, "Un'ipotesi," pp. 47–49). A document reporting the fire of 20 December 1577 in the Ducal Palace records the loss of "tutte le pitture fatte di mano delli tre Bellini . . . nella Sala del Maggior Consiglio" (Lorenzi, *Monumenti,* doc. 842).

14 Vivarini's petition of 28 July 1488 opens:

> Serenissimo Principe et Excellentissima Signoria. Essendo io Alvise Vivarin da Muran fidelissimo servitor de la Vostra Serenita et di questo Illustrissimo Stado desideroso da bon tempo in qua de mostrar qualche operation del exercitio mio de la pintura e far che la sublimita vostra per experientia vedi et cognosci chel continuo studio et diligentia per me adhibita non e reussita in vano, ma in honore et laude di questa inclita citae. Come devoto me offerisco senza algun premio ne pagamento de la fatica chio ponero cum la propria persona de far sopra de me uno teler: zoe depenzerlo in Salla de gran Conseio nel modo che lavorano al presente li do fradelli Bellini. Ne per la pintura del ditto teler al presente dimando altro salvo chel teler de tela et la spexa di colori cum la spexa di garzoni quali me attenderano segondo che hanno i ditti Bellini. Quando veramente io avero perfeto l'opera, alora remetero liberamente al judicio et beneplazio dela Vostra Serenita che per la benignita soa la se degni provedermi de quel premio justo honesto et conveniente che la cognoscera per la sapientia sua meritar lopera, la qual io andero poi continuando spero cum universal satisfactione di Vostra Serenita et de tutto questo Eccellentissimo Dominio. A la gratia di la qual humelmente me ricomando.

Vivarini was commissioned to do a canvas to replace a picture by Pisanello. See Lorenzi, *Monumenti,* doc. 221.

15 Lorenzi, *Monumenti,* doc. 239, lists the following "Depentori de la Sala de Gran Conseio": Maistro Zuan Bellin depentor, Maistro Alvixe Vivarin depentor, Christophalo da Parma depentor, Latantio da Rimano, Marco Marcian depentor, Vizenzo da Treviso, Francesco Bissuol depentor, Perin fante di depentori, Matthio dicto Mapo fante di depentori.

16 Gentile was originally appointed on 1 September 1474 without salary but with the promise of the next *sansaria* to fall vacant at the Fondaco:

> Havendo bisogno la Sala de gran Conseio per esser gran parte caduca et spegazada le figure de quella de esser reconzade et reparade per honor de la nostra Signoria: Et conzosia che maistro Zintil Bellin pentor egregio et optimo maistro se offerischa et sia contento esser

obligato in vita soa reconzar tute dicte figure et penture et si al presente chome in futurum tegnirla ben in chonzo senza algun premio, ma che per sustentation sua et premio de tal sua fatica la nostra Signoria li conzieda la prima Sansaria de Fontego che vachera. Et per proveder ala reparation de dicta Sala qual e di principal ornamenti de questa nostra Cita: Et considerate le optime condition del dicto maistro Zintil venetian nostro fedelissimo: L'andara parte, che per auctorita de questo Conseio el sia deputa a la dicta opera del reconzar et reparar le figure et penture dela predicta et refar dove bisognera, et in ogni luogo dove li sera conmesso per i Provededori nostri del Sal, e che dicta Sansaria che prima vachera le sia data et conferita. El qual officio del Sal, per aspetar cussi a quelli, li habia a far la spexa di colori et altre cose necessarie in tal opera (Lorenzi, *Monumenti*, doc. 188, confirmed 21 September, doc. 189).

Presumably the *sansaria* would have guaranteed at least the 100 ducats that had previously been the annual salary for the position (see above, n. 10, and Henry Simonsfeld, *Der Fondaco dei Tedeschi in Venedig* [Stuttgart, 1887], vol. 2, pp. 23–28). On the functions of the salaried painter to the state, see Michelangelo Muraro, "Tiziano pittore ufficiale della Serenissima," in *Tiziano, nel quarto centenario della sua morte, 1576–1976 (Lezioni tenute nell'Aula Magna dell'Ateneo Veneto)* (Venice, 1977), pp. 82–100, and Charles Hope, "Titian's Role as 'Official Painter' to the Venetian Republic," in *Tiziano e Venezia: Convegno Internazionale di Studi, Venezia, 1976* (Vicenza, 1980), pp. 301–05. For Titian's active pursuit of the *sansaria*, reviewed by Hope, see also below, n. 48.

17 Lorenzi, *Monumenti*, doc. 235 (24 December 1493):

> I Magnifici . . . Provedadori al Sal. . . . volendo proveder ali depentori lavorano ala Sala de gran Conseio, i quali si pagano per questo Offitio come salariadi di quello dumente lavorano a ditta Sala di gran Conseio, la qual si vede per ditti depentori esser per tal modo diducta in longo che tardi e per vederse il fin di quella, corendovi i suoi danari de mexe in mexe, con assai murmuration dila terra, et ogni dì andara impezo si altramente non si fa nova provixion . . . a ser Bortolomio Bon proto et sovrastante . . . habia et deba solicitar cum ogni diligentia ogni zorno ala Sala granda di Palazzo et veder si li dipentori solicitano a lavorar et non li trovando lavorar per ogni volta li debano apontar per ordene di lofficio nostro, da esser sfalcadi i ponti cum il suo salario.

18 The family workshop tradition in Venice has been most importantly explored in the work of the Tietzes; see especially the general introduction to Hans Tietze and E. Tietze-Conrat, *The Drawings of the Venetian Painters in the 15th and 16th Centuries* (New York, 1944), as well as the introductions to the individual artists; see also Hans Tietze, "Master and Workshop in the Venetian Renaissance," *Parnassus* 11 (1939): 34–35, 45, and "Meister und Werkstätte in der Renaissancemalerei Venedigs," *Alte und neue Kunst, Wiener kunstwissenschaftliche Blätter* 1 (1952): 89–98.

19 Still important on Titian and his shop is E. Tietze-Conrat, "Titian's Workshop in His Late Years," *Art Bulletin* 28 (1946): 76–88; see also M. Roy Fisher, *Titian's Assistants During the Later Years* (New York and London, 1976). For the Veronese workshop, see David Rosand, "Veronese and Company: Artistic Production in a Venetian Workshop," in *Veronese and His Studio in North American Collections*, exhibition catalogue (Birmingham, Ala., 1972), pp. 5–11.

20 As it finds expression in Lodovico Dolce's *Dialogo della pittura* of 1557, ". . . nel vero bisogna che'l pittore, così bene come il poeta, nasca e sia figliuolo della natura" (in *Trattati d'arte del Cinquecento*, ed. Paola Barocchi, vol. 1 [Bari, 1960], p. 186). *Orator fit, Poeta nascitur* is the "old proverb" quoted by Sir Philip Sidney in *The Defense of Poesy*, first published in 1595 (Sir Philip Sidney, *Selected Prose and Poetry*, ed. Robert Kimbrough [New York, 1969], p. 146).

21 The albums are reproduced in facsimile by Victor Goloubew, *Les dessins de Jacopo Bellini au Louvre at au British Museum*, 2 vols. (Brussels, 1912). See also the discussion of the Tietzes, *Drawings*, pp. 9–13, 94–114—whose conclusions, especially regarding the construction of the albums and the number of hands involved, have not found general acceptance: cf. Marcel Röthlisberger, "Notes on the Drawing Books of Jacopo Bellini," *Burlington Magazine* 98 (1956): 358–64, and "Studi su Jacopo Bellini," *Saggi e memorie di storia dell'arte* 2 (1958–59): 41–89.

22 Mi ritrovo ligata in matrimonio con Misier Sebastian Casser, . . . pitor mio de casa, e questo per l'ordine et comandamento di miei fratelli Dominico et Marcho, li quali, inanzi la sua morte, me li feze prometter che, se mi pareva che detto messer Sebastiano si portasse bene nella pittura, dovese tuorlo per maritto, aciò che, con la sua virtù, il mantenise il nome de Ca' Tentoretto. Mi sun sta parechi ani suspensa, ma ò poi visto che nella pitura il puol star al par di ogni buon pitore, et di ritrati pochi li va inanzi; mi ò risolto et l'ò tolto per marito.

The document was first published by Mario Brunetti, "La continuità della tradizione artistica nella famiglia del Tintoretto a Venezia," *Venezia: studi di arte e storia a cura della Direzione del Museo Civico Correr* (Venice, 1920), p. 269.

23 The statutes of the Venetian guild were published by G. Monticolo, "Il capitolare dell'arte dei pittori a Venezia composto nel dicembre 1271 e le sue aggiunte (1271–1311)," *Nuovo archivio veneto* 2 (1891): 321–56, and *I capitolari delle arti veneziane sottoposte alla Giustizia e poi alla Giustizia Vecchia* (Istituto Storico Italiano, Fonti per la Storia d'Italia), vol. 2¹ (Rome, 1905), pp. 363–89. Fragments of the revisions of 1436 were published by Pompeo Molmenti, *Lo statuto dei pittori veneziani nel secolo XV* (Venice, 1884). The most recent discussion of the painters' guild is by Elena Favaro, *L'Arte dei Pittori in Venezia e i suoi statuti* (Florence, 1975). Still valid, especially for the later period of the Renaissance, is the pioneering study of Agostino Sagredo, *Sulle consorterie delle arti edificative in Venezia* (Venice, 1856), esp. pp. 124–35. A. Dall'Acqua-Giusti, *L'Accademia e le gallerie di Venezia, relazioni storiche* (Venice, 1873), also remains a useful introduction.

24 As one Venetian observer commented, criticizing the excess of democracy in Florence, men "who are engaged in the mechanic arts do not know the ways of government" (quoted by Bouwsma, *Venice and the Defense of Republican Liberty,* p. 168).

25 Cf. Deno John Geanakoplos, *Byzantine East and Latin West* (New York and Evanston, 1966), p. 38: "An important distinction is the fact that, unlike the West where the authority of the state had virtually disappeared, the Byzantine [guild] system was not primarily intended to serve the interest of the producers and merchants, but mainly to further government control of economic life in the interest of the state. What the actual degree of Byzantine influence may have been on the western guilds has not yet been determined." On the relationship of the guilds to the state in Venice, see the preface to Monticolo, *I capitolari,* and Sagredo, *Sulle consorterie,* pp. 180–86.

26 On the *Giustizia Vecchia,* see Marco Ferro, *Dizionario del diritto comune e veneto* (Venice, 1778–81), vol. 6, pp. 56–62; and Monticolo, *L'Ufficio della Giustizia Vecchia a Venezia dalle origini sino al 1330* (R. Deputazione Veneta di Storia Patria, *Miscellanea,* vol. 12, [Venice, 1892]); also Sagredo, *Sulle consorterie,* pp. 51–60.

27 On the *giuramento—zurado* in Venetian—see Monticolo, *I capitolari,* pp. cxi–cxvii.

28 These taxes and obligations are reviewed in Favaro, *L'Arte dei Pittori,* pp. 79–92. The distinction between patricians and plebes is explicitly outlined by Gasparo Contarini in the fifth book of *De magistratibus et republica Venetorum libri quinque* (Venice, 1543), pp. 107–11 (Italian translation: *Della republica et magistrati di Venetia libri V* [1548] [Venice, 1591], pp. 100–04). Contarini notes how successful their government of nobles has been in keeping the loyalty of the rest of the population by according it magistracies of its own, i.e., guilds and confraternities: "che'l popolo non è stato del tutto rifiutato, ma che è stato ricevuto in quegli uffici, che a quel si poterrano commetter senza detrimento del publico" (*Della republica,* p. 100; *De magistratibus,* p. 107). The nonpatrician population is divided into two groups, "popolo" and "bassa plebe," and the higher of the categories, following Aristotle, is further divided into public servants and artisans:

> All'una, & all'altra maniera a mio giudicio è stato commodamente & giustamente havuto riguardo. Conciosia cosa che a gli huomini plebei, iquali di loro natura poco studiano all'honore, ma più tosto mettono studio alle cose famigliari, sono conceduti ancora i piccioli gradi, & autorità, & honori a loro convenienti, imperoche sono distributi in tanti ordini; quanti sono gli artifici, ne i quali si travagliano, & a ciascuno ordine sono date si certe leggi particolari, sotto lequali ciascuno essercita i suoi uffici, a questi per ballote di tutto l'ordine sono preposti molti di quel numero, i quali commodamente si possono chiamare capi di quello artificio. Per commandamento di questi si prescrivono molte cose, & molti litigi di poco ò nulla importanza si determinano per arbitrio di costoro. Onde aviene, che quasi tutti gli artifici hauendo ottenuto quello honore, si compiacciano, & appaglino di quello ufficio, & pensino d'havere conseguito non poca dignità, sendo pervenuti à quello che da gli homini del suo ordine sieno havuti degni di quel grado. Sono oltre ciò in ciascheduno ordine certi più bassi de'Capi, i quali sono però di non poca stima. In questo modo dunque si sodisfa in gran parte al desiderio dell'onore, il qual par che sia natio anchora ne gli animi de gli huomini plebei, & della bassa plebe (*Della republica,* p. 102; *De magistratibus,* p. 109).

The same reasons of state lie behind the honors and powers available to the plebes in the *scuole grandi:*

> Gli honori di questa maniera nella nostra Rep. sono ordinati a gli huomini plebei dell'uno, & dell'altro ordine, acciò che del tutto privi non fussero della potestà publica, & de i civili uffici ma in questo modo soggiacessero al desiderio dell'honore, & alla ambitione, senza sollecitar punto con disturbo veruno lo stato de nobili, con la qual temperanza di governo la nostra Rep. ha conseguito quello, che niuna delle illustri antiche non ha potuto conseguire giamai

—i.e., internal peace and stability (*Della republica,* p. 105; *De magistratibus,* p. 113). The implications of this social structuring and the *scuole grandi* will be discussed further, below, chap. 3, secs. 1 and 6.

29 Nella Congiura di Bajamonte una porzione dei ribelli essendo stata sconfitta a S. Luca, principalmente dal Guardiano della Carità sopravvenuto con molti de' suoi Fratelli di Scuola, e alcuni dell'Arte dei Pittori; in memoria di ciò scrivono, che fu stabilito alzar lo Stendardo in Campo a S. Luca, e nella banderuolla metter il segno di quella Scuola, e di quell'Arte.

This information from "un'antico cronista" is recorded by Giambattista Gallicciolli, *Delle memorie venete antiche profane ed ecclesiastiche* (Venice, 1795), vol. 1, pp. 315–16. See also Samuele Romanin, *Storia documentata di Venezia* (Venice, 1853–69), vol. 3, pp. 33–34. The pedestal—which Francesco Sansovino declared to be situated "nell'ombilico della città" (*Venetia*, p. 120)—continues to bear the emblems of Venice, of St. Luke, the patron saint of painters, and of the Scuola di Santa Maria della Carità. On the Feast of San Vio, the day of the event, and the ducal *andata*, which included the chief officers of the guild and the confraternity, see Sansovino, pp. 502–03.

30 Monticolo, *I capitolari*, pp. cxxv, 366.

31 Thus, on 31 October 1577, following the plague of the preceding years, this law was invoked and guild membership was opened: see Sagredo, *Sulle consorterie*, p. 182, and Paolo Preto, *Peste e società a Venezia nel 1576* (Vicenza, 1978), pp. 117–19. For the situation following the Black Death in the fourteenth century, see Mario Brunetti, "Venezia durante la peste del 1348," *Ateneo Veneto* 32 (1909): 17, 24–25.

32 *Capitolo* XI of the 1436 revision of the statutes declares: "Che da mo avanti alcuna persona si da Venetia come forestiero non ardischa ne prosuma vender in Venexia alcuna anchona depenta salvo i depentori i quali saranno et sono de l'arte, et haverà zurado l'arte, intendano che loro sia habitadori de Venexia: Et aloro sia licito vender in le loro botege e non in altro luogo . . ." (Archivio di Stato, Venice: Arte dei Depentori, Busta 103, Atti della Scuola dei Pittori, sec. XVI e XVII, *Mariegola*, fol. 4 [this parchment volume, initiated in 1577, records entries from 1436 and runs to 1682: see Favaro, *L'Arte dei Pittori*, pp. 31–37]).

Michelangelo Muraro has attempted to assess the influence of the guild system upon actual practice and under specific historical circumstances in "The Statutes of the Venetian 'Arti' and the Mosaics of the Mascoli Chapel," *Art Bulletin* 43 (1961): 263–74 (see also Muraro, "The Guardi Problem and the Statutes of the Venetian Guilds," *Burlington Magazine* 102 [1960]: 421–28). The objections to Muraro's reading of the above quoted regulations proferred by Frederick Hartt ("Andrea del Castagno: Three Disputed Dates," *Art Bulletin* 48 [1966]: 230–31) are not persuasive; his attempt to distinguish between production and sale of paintings in fourteenth-century Venice is simply not supported by the available documents, which confirm the continuity of the laws: "Per essecution delle leze della Matricola de Depentori, et Miniatori, che non sia descritta nella loro Arte, che ardisca ingerirsi in lavorar, ne vender alcuna cosa spettante a detta Arte, ne quella tenir per vender nelle loro Botteghe in grande, ne in minima quantità sotto le pene nella detta loro Matricola et legge in essa contenute, et come in tutto et per tutto la deliberatione dell'ecc.ᵐᵒ Collegio delle Arti. 1513, 14 del mese de Novembre, ala quale insieme con tutte le altre leggi in tal materia disponenti si habbi relatione. Adi 26 Maggio 1607" (Archivio di Stato, Venice: Arte dei Depentori, Busta 103, *Mariegola*, fol. 81ᵛ).

33 "Auch wist, daz mir dy moller fast abholt hÿ sind. Sy haben mich 3 moll vür dÿ herenn genüt, und mus 4 fl. jn jr schull geben. . . . Wan awserhalb der moler will mir all welt woll" (Hans Rupprich, *Dürer: Schriftlicher Nachlass*, vol. 1 [Berlin, 1956], p. 49; translation in William Martin Conway, *The Literary Remains of Albrecht Dürer* [Cambridge, 1889], p. 51). More generally on Dürer in Venice: Ludwig Grote, *"Hier bin ich ein Herr"· Dürer in Venedig* (Munich, 1956); also Terisio Pignatti, "The Relationship between German and Venetian Painting in the Late Quattrocento and Early Cinquecento," in *Renaissance Venice*, ed. J. R. Hale, (London, 1973), pp. 244–73. For the possibility that Dürer may have actually been approached, before Giorgione, to plan the decorations on the newly rebuilt Fondaco dei Tedeschi—for which he anticipated earning 2,000 ducats—see Seiro Mayekawa, "Giorgiones 'Tempesta' und Dürer," in *Giorgione: Atti del Convegno Internazionale di Studi per il 5° Centenario della Nascita* (Castelfranco Veneto, 1979), pp. 105–07.

34 The *miniatori* were added to the lists of the *Arte* only in 1574 (Archivio di Stato, Venice: Arte dei Depentori, Busta 103, *Mariegola*, fols. 58–58ᵛ; also Favaro, *L'Arte dei Pittori*, pp. 41, 123). For the situation in Florence, where the painters were joined with physicians and dealers in drugs and spices, see Carlo Fiorilli, "I dipintori a Firenze nell'Arte dei Medici, Speziali e Merciai," *Archivio storico italiano* 78 (1920): 5–74; for a broader discussion, see Frederick Antal, *Florentine Painting and its Social Background* (London, 1947), pp. 274–87, 374–80, and, most recently, Sergio Rossi, *Dalle botteghe alle accademie: realtà sociale e teorie artistiche a Firenze dal XIV al XVI secolo* (Milan, 1980). The basic study of the Florentine guilds is Alfred Doren, *Das florentiner Zunftwesen* (Stuttgart and Berlin, 1908) (Italian trans.: *Le arti fiorentine*, 2 vols. [Florence, 1940]). See also the summaries with rich bibliography in Eugenio Battisti, "Corporations,

Workshops, and Schools in the Middle Ages and the Renaissance," in *Encyclopedia of World Art*, vol. 8 (New York, Toronto, and London, 1963), cols. 141–50; and Ettore Camesasca, *Artisti in bottega* (Milan, 1966), pp. 188–208.

35 The names of Marco Basaiti, Paris Bordone, and Vincenzo Catena are followed by *figurer* in the only extant lists of the members of the *Arte*, preserved in a nineteenth-century copy by Gianantonio Moschini (Biblioteca Correr, Venice: MSS. Moschini, Miscellanea, XIX, A.c.30, *Nota de' pittori registrati ne' libri della Veneta Accademia*). The first of these three lists begins in 1530 but covers the sixteenth century in a random and fragmentary way. The manuscript was first published by Giuseppe Nicoletti, "Per la storia dell'arte veneziana: lista di nomi di artisti tolta dai libri di tanse o luminarie della Fraglia dei Pittori," *Ateneo Veneto* 1 (1890): 378–82, 500–06, 631–39, 701–12. It was reprinted by Terisio Pignatti, "La Fraglia dei Pittori in Venezia," *Bollettino dei Musei Civici Veneziani* 10, no. 3 (1965): 16–39, and, most recently, by Favaro, *L'Arte dei Pittori*, pp. 137–60.

36 For fuller discussion of Veronese's appearance before the Inquisition and the significance of his response, see below, chap. 4, sec. 5, with further bibliography.

37 Die XXVI de Zugno. 1511: In Collegio. Item che decetero ala bancha nostra el non se debia [elez]er alcuno per Compagno per altro modo ne via salvo che per el modo et ordene antiquo come per la Deliberation et Confermation del Collegio di nostri Signori Superiori qui de sotto appare. Cassando et anullando la parte che fu prexa per mistro Zuanbatista da Coneian come superflua et impertinente, la qual volea che se elezesse do homeni depentori de figure per compagni. . . . Aldido el gastaldo di Depentori sopradetto domandando dover esser confirmado i Capitoli soprascritti per ballote 6. Et cusi hanno ratificado quelli cum questa Dechiaration, che ala bancha sia fatto decetero uno compagno de figure, uno coffaner, uno cortiner et uno dorador, come se soleva far per election di nostri antigi. Et cusi se debi observar decetero (Archivio di Stato, Venice: Arte dei Depentori, Busta 103, *Mariegola*, fol. 32).

38 Leon Battista Alberti, *De pictura*, ed. Cecil Grayson (Rome and Bari, 1975), p. 91. For general consideration of the changing social status of the Renaissance artist, see Nikolaus Pevsner, *Academies of Art Past and Present* (Cambridge, 1940), pp. 31–42; Anthony Blunt, *Artistic Theory in Italy 1450–1600*, 2d ed. (Oxford, 1956), pp. 48–57; Rudolf and Margot Wittkower, *Born under Saturn: The Character and Conduct of Artists* (London, 1963), pp. 14–16, and Rossi, *Dalle botteghe alle accademie*. See also Creighton Gilbert, "The Archbishop on the Painters of Florence, 1450," *Art Bulletin* 41 (1959): 75–89. On painting and the liberal arts: Rudolf Wittkower, *The Artist and the Liberal Arts* (London, 1952); and for the broader intellectual significance see Paul Oskar Kristeller, "The Modern System of the Arts," in his *Renaissance Thought II: Papers on Humanism and the Arts* (New York, Evanston, and London, 1965), pp. 163–227. On the background of the relationship between Florentine art and humanism: André Chastel, *Art et humanisme à Florence au temps de Laurent le Magnifique* (Paris, 1959); also Krautheimer, *Ghiberti*, pp. 294–305.

39 1482 [*more veneto*]. Die XXVI Februarij. Ioannes Bellinus per egregium ingenium suum in arte picture, pictor nostri Dominij est appellatus, et ideo assumptus ad renovandam Salam Maioris Consilij: et a nostro Dominio publice premiatus, utque ad eam solam rem vacare possit liber ab omni alia cura: Per infrascriptos Dominos Consiliarios exemptus factus fuit ab omnibus officiis et beneficiis scollae seu fratalae pictorum: eo tamen faciente omnes angarias et factiones fratalae sue hoc est luminariae et aliarum angariarum sicuti caeteri scolae predictae faciunt: Et hoc nuntiari debet Officialibus *Justitiae veteris* ut hanc nostram deliberationem observent et facient observari (Lorenzi, *Monumenti*, doc. 197).

A century later a similar privilege was accorded the sculptor Alessandro Vittoria (see below, n. 56).

40 The document recording the election is dated 29 September 1531 and is known to me only in an eighteenth-century copy (Archivio di Stato, Venice: Arte dei Depentori, Busta 104, fasc. 1: *Copie di scritture cavate dalla nostra Mariegola de Depentori in occasione della litte de Pittori, 1715*). It has been cited, without reference, for Bonifazio in Adolfo Venturi, *Storia dell'arte italiana*, vol. 9³ (Milan, 1928), p. 1035, and for Lotto in Piero Bianconi, *All the Paintings of Lorenzo Lotto* (New York, 1963), p. 30. For the text of Vincenzo Catena's last will and testament, see Sagredo, *Sulle consorterie*, pp. 348–51, and Gustav Ludwig, "Archivalische Beiträge zur Geschichte der venezianischen Malerei," *Jahrbuch der königlich preussischen Kunstsammlungen* 26 (1905): supplement, 79–88; see also Giles Robertson, *Vincenzo Catena* (Edinburgh, 1954), pp. 5–9.

41 For a general commentary on the position of the several types of *scuole*—"particolari congregazioni, confraternite, unioni di molte persone separati in respettivi corpi sotto la protezione di un qualche Santo tutelare adorato sopra peculiar altare"—see Ferro, *Dizionario del diritto*, vol. 9, pp. 352–56. On the social function of the *scuole grandi* in particular, see below, chap. 3, sec. 6, and chap. 5, sec. 4.

42 In 1532, the year after Catena's death, the painters moved into new quarters near Santa Sofia.

The edifice no longer exists, but in the Seminary of Venice is preserved the commemorative stone with the following inscription: "PICTORES ET SOLVM EMERVNT ET HAS CON-STRVXERVNT AEDES BONIS A VINCENTIO CATENA PICTORE SVO COLLEGIO RELIC-TIS MDXXXII." See Ridolfi, *Maraviglie*, vol. 1, p. 83. On the locations of the painters' guild, see Monticolo, *I capitolari*, pp. xcv–xcvi, note, and Favaro, *L'Arte dei Pittori*, pp. 107–16. For descriptions of the building at Santa Sofia, see Cesare Augusto Levi, *Notizie storiche di alcune antiche scuole d'arte e mestieri scomparse o esistenti ancora in Venezia*, 3d ed. (Venice, 1895), pp. 38–39; Giuseppe Tassini, *Edifici di Venezia distrutti o volti ad uso diverso da quello a cui furono in origini destinati* (Venice, 1885), p. 122; and Cesare Zangirolami, *Storia delle chiese, dei monasteri, delle scuole di Venezia rapinate e distrutte da Napoleone Bonaparte* (Venice, 1962), pp. 65–66.

43 Lorenzo Lotto, *Il "Libro di spese diverse" (1538–1556) con aggiunta di lettere e d'altri documenti*, ed. Pietro Zampetti (Venice and Rome, 1969), p. 304; see my review in *Art Bulletin* 53 (1971): 408. It is unlikely that the generous conditions of this testament could have been satisfied when Lotto died ten years later, in the Santa Casa at Loreto—to which, on 8 September 1554, he had pledged himself and his worldly possessions (*Il "Libro di spese diverse"*, pp. 310–12).

44 On Lavinia Vecellio's marriage to Cornelio Sarcinelli of Serravalle, see J. A. Crowe and G. B. Cavalcaselle, *The Life and Times of Titian* (1877), 2d imp. (London, 1881), vol. 2, pp. 248, 510. Their transcription of the document of 20 March 1555—which allowed a reading of 2,400 ducats—was corrected by Giovanni Morelli, *Italian Masters in German Galleries: A Critical Essay on the Italian Pictures in the Galleries of Munich, Dresden, Berlin*, trans. Mrs. Louise M. Richter (London, 1883), p. 175, n. 1. Further on noble dowries in Venice, which could reach figures as high as 10,000 ducats: James Cushman Davis, *The Decline of the Venetian Nobility as a Ruling Class* (Baltimore, 1962), pp. 66–67; Peter Burke, *Venice and Amsterdam: A Study of Seventeenth-Century Élites* (London, 1974), pp. 51, 126–27; and Stanley Chojnacki, "La posizione della donna e Venezia nel Cinquecento," in *Tiziano e Venezia: Convegno Internazionale*, pp. 68–69, with further references.

45 For Titian's patent of nobility—which would serve as important precedent for Rubens, Velázquez, and other ambitious artists of the seventeenth century—see Ridolfi, *Maraviglie*, vol. 1, pp. 180–82, and, with a more complete transcription, Giuseppe Cadorin, *Diploma di Carlo V Imperatore a Tiziano* (Venice, 1850). See also Harold E. Wethey, *The Paintings of Titian* (London, 1969–75), vol. 3, pp. 248–49, and, on Titian's early meetings with Charles V, Charles Hope in *Art Bulletin* 59 (1977): 551–52. For further comment on Titian's social status, see David Rosand, "Titian and the Critical Tradition," in *Titian: His World and His Legacy*, ed. David Rosand (New York, 1982), pp. 1–5.

46 On this theme, see Ruth Wedgwood Kennedy, "Apelles Redivivus," in *Essays in Memory of Karl Lehmann* (*Marsyas* supplement) (New York, 1964), pp. 160–70.

47 For the documentation of the frescoes, see Antonio Sartori, *L'Arciconfraternita del Santo* (Padua, 1955), pp. 63–64; also Antonio Morassi, *Tiziano: gli affreschi della Scuola del Santo a Padova* (Milan, 1956); Wethey, *Paintings of Titian*, vol. 1, pp. 128–29; and, most recently, Creighton Gilbert, "Some Findings on Early Works of Titian," *Art Bulletin* 62 (1980): 71–73.

48 1513. Die ultimo Maij In Consilio X. *Lecta fuit supplicatio infrascripta:* Illustrissimo Consilio X. Havendo da puto in suso Principe Serenissimo et Signori Excellentissimi io Tician de serviete *(a)* de Cadore postome ad imparar larte de la pictura non tanto per cupidita del guadagno, quanto per veder de acquistar qualche poco di fama: et esser connumerato tra quelli che a i presenti tempi fanno profession de tal arte. Et anchor ch io sia sta per avanti et etiam de presenti cum instantia recercato et dala Santita del Pontefice et altri Signori andar a servirli: Tamen desiderando come fidelissimo subdito che son de la Sublimita Vostra lassar qualche memoria in questa inclyta Cita ho deliberato, parendo cussi a quella, de tuor lo assumpto de venir a depenzer nel Mazor Conseio et poner ogni mio inzegno et spirito fina havero vita, principiando, se cussi parera alla Sublimita Vostra, dal teller nel qual e quella bataglia da la banda verso de piaza ch e la piu difficile et che homo alcuno, fina questo dì non ha voluto tuore tanta impresa. Io Signori Excellentissimi seria piu contento ricever per satisfaction dela opera che faro quella mercede fusse stimata conveniente et molto mancho. Ma perche como ho sopradicto, non stimo se non lhonor mio, et haver solum el modo del viver piacendo ala Sublimita Vostra se degnera concedere in vita mia la prima *Sansaria in Fontego di Todeschi*, che quovismodo venira ad vachar, non obstante altre spectative, cum i modi condiction, obligation et exemption ha missier Zuan Belin, et do Zoveni che voglio tuor apresso de mi che me adiuta, da esser pagadi al Officio del Sal, insieme cum i colori et tute altre cose necessarie, si come li mesi passati fu concesso per el prefato Illustrissimo Conseglio al dicto missier Zuane: Che prometto ale Excelentissime Signorie Vostre far tale opera: et cum tanta presteza et excelentia che le remainirano contente: A le qual humilmente mi ricomando (Lorenzi, *Monumenti*, doc. 337).

The picture in question was one of Guariento's original frescoes, representing the Battle of Spoleto, which was in poor condition and requiring "restoration." The difficulties to which

Titian alludes probably related to the position of the picture, located between two large windows on the southern wall of the room—"el qual campo . . . da una fenestra al altra," which had originally been assigned to Perugino in 1494 (Lorenzi, *Monumenti*, doc. 237).

49 For 31 May 1513 the diarist Marino Sanuto records, "In questo Consejo di X simplice, fu preso che Tiziano pytor debbi lavorar in sala dil Gran Consejo come li altri pytori, senza però alcun salario, ma la expectativa solita darsi a quelli hanno pynto, ch'è stà Zentil et Zuan Belin et Vetor Scarpaza; hora mò sarà questo Tiziano" (Marino Sanuto, *I Diarii* [1496–1533], ed. Rinaldo Fulin et al. (Venice, 1879–1903), vol. 16, col. 316). By 20 March of the following year, however, the council had revoked the promise of the *sansaria* (Lorenzi, *Monumenti*, doc. 341). Following a succession of decisions and revocations, promises and procrastinations, culminating in the threatened demand of restitution of all payments, Titian finally, in 1538, supplied the picture he had volunteered to paint in 1513. For a rehearsal of the events and documentation, see Crowe and Cavalcaselle, *Titian*, vol. 1, pp. 153; Wethey, *Paintings of Titian*, vol. 3, pp. 225–29; and Hope, "Titian's Role as 'Official Painter.' "

50 For the record of payments for the *Pesaro Madonna*, see below, chap. 2, nn. 23 and 38.

51 On the forms of Titian's signature, see Wethey, *Paintings of Titian*, vol. 3, pp. 246–48, and especially William Hood and Charles Hope, "Titian's Vatican Altarpiece and the Pictures Underneath," *Art Bulletin* 59 (1977): 535–38. On the rhetoric of his correspondence, see E. Tietze-Conrat, "Titian as a Letter Writer," *Art Bulletin* 26 (1944): 117–23.

52 "Infatti, sono confratelli e membri cogli indoradori, miniadori, disegnadori, quoridoro, cartoleri, pignateri, dipintori di travi e bianchegini," runs the complaint. The full text of the petition is published by Elena Bassi, *La R. Accademia di Belle Arti di Venezia* (Florence, 1941), pp. 127–28; see also Dall'Acqua-Giusti, *L'Accademia di Venezia*, pp. 11–12.

53 For the text: Dall'Acqua-Ginsti, *L'Accademia di Venezia*, p. 13, n. 1; for the decree of the senate: Bassi, *La R. Accademia*, p. 129. Further on the separation of 1682, see Favaro, *L'Arte dei Pittori*, pp. 117–27. The fuller historical context of these developments was first discussed in David Rosand, "The Crisis of the Venetian Renaissance Tradition," *L'Arte* 11–12 (1970): esp. pp. 26–38.

54 See Alice Binion, "The 'Collegio dei Pittori' in Venice," *L'Arte* 11–12 (1970): 92–101. The word *collegio*, a perfectly traditional appelation for a *compagnia* or *fraglia*, had long before been applied to the *Arte dei Depentori* (cf. above, n. 42).

55 In 1596 the *Arte dei Depentori* fought off "liberal" challenges from Pietro Malombra and Giovanni Contarini, artists who were unusually well born and educated for Venetian painters. Neither came from the artisan class, and they were both accused of practicing the art of painting without being properly inscribed in the guild. Contarini's defense argued that if he did occasionally paint it was not as a professional member of the trade ("come pittor artifice") but rather for his own personal enjoyment and satisfaction ("per deletatione"), and this, he asserted, was a privilege not to be denied a man of refinement. The guild, needless to say, dismissed his argument as self-deluding and devious, a blatant attempt to contravene the law. Contarini and Malombra were naturally forced to matriculate, paying fines and litigation costs in addition to the normal entrance fee. For fuller documentation of the case, see Rosand, "Crisis of the Venetian Renaissance Tradition," p. 38 and nn. 153–60; for the similar case of Giovanni Perusini, which was heard early in 1682, just before the separation of the *pittori*, see Rosand, p. 32, and Dall'Acqua-Giusti, *L'Accademia di Venezia*, p. 12.

56 According to the late-eighteenth-century account of Pietro Edwards, the sculptors of Venice in the quattrocento were actually a part of the *Arte dei Depentori* (Venice, Biblioteca Marciana: Cod. it., cl. VII, 1791 [= no. 8978], *Antichità dell'unione dei pittori in Venezia*, fols. 4ᵛ –5ᵛ). Edwards cites this as an indication of the painters' jurisdiction "sopra l'arte del disegno," an understandable interpretation from an eighteenth-century point of view but inconceivable in the context of the historical situation we have been defining. There was, of course, an *Arte dei Tagliapietra* to which the sculptors belonged until 1723, when they too were allowed to assert themselves as artists with a *collegio* of their own. The history of this guild of stonecutters contains an interesting exception to the rule. Alessandro Vittoria, who operated as a sort of artistic dictator in Venice at the end of the sixteenth century, obtained permission from the *Giustizieri Vecchi* to leave the guild, being relieved of all financial responsibilities to it as well as of possibility of military service (R. Predelli, "Le memorie e le carte di Alessandro Vittoria," *Archivio trentino* 23 [1908]: 37). Milanesi suggests that Jacopo Sansovino—like Titian, he assumes—enjoyed a similar privilege as *proto* to the *Procuratori di San Marco* (in Vasari, *Vite*, vol. 7, p. 502, n. 1).

57 The *Riformatori dello Studio di Padova*, charged by the senate with overseeing the formation of the academy, acknowledged that the *capitoli* were based on study of the "metodi usati dalle forestiere Accademie" (*Statuto e prescrizioni della pubblica Accademia di Pittura, Scultura, ed Architettura instituta nella Città di Venezia per decreto dell'Eccellentissimo Senato* [Venice, 1782], p. x). It is significant that the *Accademia* was not under the jurisdiction of the *Giustizia*

Vecchia—unlike the *Collegio dei Pittori,* which naturally continued to exist. The *Riformatori dello Studio* was a magisterial unit created in 1516 to deal with the reform of the University of Padua; it continued to supervise not only academic matters there, however, but, with control over all publishing activities, much of the intellectual life of Venice (see Ferro, *Dizionario del diritto,* vol. 9, pp. 252–56). In his entry on the *arti,* Ferro makes the following observation: "Per perfezionare le arti medesime si è riconosciuta necessaria la cognizione del Disegno; e quindi ne fu providamente tra noi instituta una Scuola, e vengono proposti, a distribuiti premj pubblici a quei studiosi, che più si distinguono nello studio stesso" (vol. 1, p. 309). If he is in fact referring to the *Accademia,* then his comment casts a revealing light on the continuing relationship between academic study and guild production in Venice. Further on the development of the Venetian academy, in addition to the studies by Dall'Acqua-Giusti and Bassi, see Gino Fogolari, "L'Accademia veneziana di pittura e scultura del Settecento," *L'Arte* 16 (1913): 241–72, 364–94.

58 On the founding, development, and character of the Florentine academy: Pevsner, *Academies of Art,* pp. 42–53, and Rossi, *Dalle botteghe alle accademie,* pp. 146–81; also Paola Barocchi, "L'Accademia del Disegno ai suoi inizi," in *Mostra di disegni dei fondatori dell'Accademia delle Arti del Disegno* (Florence, 1964), pp. 3–12, and Carl Goldstein, "Vasari and the Florentine Accademia del Disegno," *Zeitschrift für Kunstgeschichte* 38 (1975): 145–52. For renewed discussion of the larger issues, see Charles Dempsey, "Some Observations on the Education of Artists in Florence and Bologna During the Later Sixteenth Century," *Art Bulletin* 52 (1980): 552–69.

59 Vasari, *Vite,* vol. 1, p. 168. For further comment on this famous passage, see Erwin Panofsky, *Idea, A Concept in Art History,* trans. Joseph J. S. Peake (Columbia, S.C., 1968), pp. 60–63, and Svetlana Leontief Alpers, "*Ekphrasis* and Aesthetic Attitudes in Vasari's *Lives,*" *Journal of the Warburg and Courtauld Institutes* 23 (1960): 190–215.

60 Although the academy had an educational program, it was not intended to replace the traditional procedures of workshop training but rather to supplement them, especially by sponsoring lectures on auxiliary subjects such as geometry and anatomy (Pevsner, *Academies of Art,* pp. 46–49).

61 Thus, for example, the high altar of San Sebastiano was executed by a stonecarver, Salvador Tagiapiera, "secondo il dissegno fatto per M. Paulo Veronese pittore" (Terisio Pignatti, *Veronese: L'Opera completa* [Venice, 1976], vol. 1, p. 252, doc. 16). Titian's reputation as knowledgeable in architectural matters is enthusiastically attested by Sebastiano Serlio in his *Regole generali di architettura sopra le cinque maniere de gli edifici* (Venice, 1537), p. iii: "Il Cavalier Titiano, ne le cui mani vive la idea d'una nuova natura non senza gloria de l'Architettura, la quale è ornamento de la grandezza del suo perfetto Giudicio." Titian and Serlio had served together in the expertise of 1534 on Francesco Giorgi's complex program for San Francesco della Vigna (see Rudolf Wittkower, *Architectural Principles in the Age of Humanism,* 3d ed. [New York, 1971], pp. 105–06). See now Lionello Puppi, "Tiziano e l'architettura," in *Tiziano e il manierismo europeo,* ed. Rodolfo Pallucchini (Florence, 1978), pp. 205–30, and Carlo Pedretti, "Tiziano e il Serlio," in *Tiziano e Venezia: Convegno Internazionale,* pp. 243–48.

Venetian artists of the late cinquecento hardly remained impervious to the new academic movement. On 20 October 1566, Vasari received a letter from six Venetians: Titian, Tintoretto, Palladio, Giuseppe Salviati, Battista Zelotti, and Danese Cattaneo—*pittori, scultori ed architettori.* Having heard of the fame of the Florentine *Accademia del Disegno* and of the splendor of the Michelangelo obsequies—from Vasari himself, who had just returned from his second visit to Venice—these artists desired to be inscribed (Herman Walther Frey, *Neue Briefe von Giorgio Vasari* [Burg b. M., 1940], pp. 215–16). In addition, Vasari mentions Paolo Veronese and Alessandro Vittoria as *forestieri* in the Florentine academy (*Vite,* vol. 7, p. 621).

Further on the changing situation in Venice toward 1600 and the increasingly academic interests of a new generation of Venetian painters, see Rosand, "Crisis of the Venetian Renaissance Tradition," esp. pp. 34–41.

62 The case was heard in 1457; two years later the *Giustizieri Vecchi* evidently despaired of enforcing any clear distinction between the activities. See Favaro, *L'Arte dei Pittori,* pp. 68–69. For the problem in more generally productive terms, see Creighton Gilbert, "Peintres et menuisiers au début de la Renaissance en Italie," *Revue de l'art* 37 (1977): 9–28.

63 Cf. below, n. 120.

64 See especially Alpers, "*Ekphrasis* and Aesthetic Attitudes," pp. 203–15.

65 Vasari, *Vite,* vol. 1, p. 174.

66 "Alberti had used his scientific hypothesis [re: *circoscrizione*] to support a theoretical position that provided the justification for the Florentine emphasis on *disegno,* and particularly for a style of drawing with a continuous closed outline separating the figure from the ground. Florentine *disegno* does not, however, stem from Alberti, nor is it even substantially indebted to his formulation—it was already well established in the preceding century. But Alberti's

formulation affirmed that the primacy of drawing and the concept of composition as an assembly of distinct objects were consistent with the ideal of art in the new era. The historical role of art theory is not only to invent new practices and set new goals but also to indicate which traditional practices remain valid" (James S. Ackerman, "Alberti's Light," in *Studies in Late Medieval and Renaissance Painting in Honor of Millard Meiss* [New York, 1978], p. 22).

67 "Ell'è, dunque, un piano coperto di campi di colori, in superficie o di tavola o di muro o di tela, intorno a'lineamenti detti di sopra, i quali per virtù di un buon disegno di linee girate circondano la figura" (Vasari, *Vite*, vol. 1, p. 171).

68 On the problems of fresco in Venice, see Michelangelo Muraro, *Pitture murali nel Veneto e tecnica dell'affresco* (Venice, 1960).

69 As Michelangelo Muraro has suggested, it is very likely that the *sinopie* of those early frescoes still exist beneath the surfaces of the walls of the Sala del Maggior Consiglio and that they can be recovered—as was Guariento's *Paradise*.

70 "E perchè questo modo è paruto agevole e comodo, si sono fatti non solamente quadri piccoli per portare attorno, ma ancora tavole da altari ed altre opere di storie grandissime; come si vede nelle sale del palazzo di San Marco di Vinezia, ed altrove: avvegnachè, dove non arriva la grandezza delle tavole, serve la grandezza e 'l comodo delle tele" (Vasari, *Vite*, vol. 1, p. 189).

Perhaps the earliest documentable Venetian mural cycle on canvas is that for the *sala grande* of the Scuola Grande di San Giovanni Evangelista executed (in tempera, evidently) by Jacopo Bellini and his shop by 1465. Described by Ridolfi (*Maraviglie*, vol. 1, pp. 53–54), when the cycle had already been replaced by another (by Domenico Tintoretto, Sante Peranda, and Andrea Vicentino), some of the canvases have been tentatively identified: see Roberto Longhi, *Viatico per cinque secoli di pittura veneziana* (Florence, 1952), pp. 53–54, fig. 36. In a forthcoming study, previewed in a paper delivered at the annual meeting of the College Art Association of America in 1980 ("Major Narrative Paintings by Jacopo Bellini"), Howard Collins attempts a fuller reconstruction of this pictorial cycle and its original architectural setting in the Scuola di San Giovanni Evangelista. Regarding the later cycle, see now Stefania Mason Rinaldi, "Contributi d'archivio per la decorazione pittorica della Scuola di San Giovanni Evangelista," *Arte veneta* 32 (1978): 293–301.

71 The technique of using oil as a binder for pigments was certainly available in the trecento and is discussed by Cennino Cennini (*Il libro dell'arte*, trans. Daniel V. Thompson, Jr., *The Craftsman's Handbook* [New Haven, 1933], p. 57). Improvements in the method were generally credited to Hubert and Jan van Eyck, and for this tradition Vasari (*Vite*, vol. 2, pp. 565–67) provides the *locus classicus*. He asserts that the new methods were brought to Italy by Antonello da Messina, who was said to have studied in the Netherlands; while this account of Antonello's supposed travels is untenable, the Sicilian master was certainly familiar with Netherlandish painting in Naples. For earlier bibliography on the subject of oil painting, see Erwin Panofsky, *Early Netherlandish Painting* (Cambridge, Mass., 1953), p. 418; the most recent contribution is by Joanne Wright, "Antonello da Messina: The Origins of His Style and Technique," *Art History* 3 (1980): 41–60. With regard to the Venetian situation and the Antonello-Bellini relationship, see Giles Robertson, *Giovanni Bellini* (Oxford, 1968), pp. 56–58, with further references. The larger issue of "Jan van Eyck and the Italian Renaissance" was discussed by Millard Meiss in *Venezia e l'Europa (Atti del XVIII Congresso Internazionale di Storia dell'Arte)* (Venice, 1956), pp. 58–69; reprinted in his *The Painter's Choice: Problems in the Interpretation of Renaissance Art* (New York and London, 1976), pp. 19–35.

72 Millard Meiss, *Giovanni Bellini's St. Francis in the Frick Collection* (Princeton, 1964), p. 14. In this context we must recognize the important example set by the art of Piero: see Roberto Longhi, "Piero dei Franceschi e lo sviluppo della pittura veneziana," *L'Arte* 17 (1914): 198–221 and 241–56. Piero, in turn, like the Venetians, was surely aware of Netherlandish models: see Meiss, "Jan van Eyck and the Italian Renaissance," esp. pp. 63–65 (reprint, pp. 26–28). For the theme and expressive function of light in the work of Carpaccio, see, in particular, Helen I. Roberts, "St. Augustine in 'St. Jerome's Study': Carpaccio's Painting and its Legendary Source," *Art Bulletin* 41 (1959): 283–97.

73 The example of Leonardo, as Vasari recognized (*Vite*, vol. 4, pp. 11, 92), must ultimately be considered as a factor contributing to the development of tonalism in Venice. See Luigi Coletti, "La crisi giorgionesca," *Le Tre Venezie* 21 (1947): 255–67, and, on Leonardo's own aesthetic, John Shearman, "Leonardo's Colour and Chiaroscuro," *Zeitschrift für Kunstgeschichte* 25 (1962): 13–47. Various aspects of the Leonardo-Giorgione relationship were the subject of several contributions to the international Giorgione conference held in 1978: cf. the papers of Cesare Brandi ("Il principio formale di Giorgione"), Decio Gioseffi ("Giorgione e la pittura tonale"), David Rosand ("Giorgione e il concetto della creazione artistica"), Carlo Pedretti ("Ancora sul rapporto Giorgione-Leonardo e l'origine del ritratto di spalla"), and Giles Robertson ("Giorgione and Leonardo") in *Giorgione: Atti del Convegno Internazionale di Studio per il 5° Centenario della Nascita* (Castelfranco Veneto, 1979); also James S. Ackerman,

"On Early Renaissance Color Theory and Practice," in *Studies in Italian Art History,* vol. 1 (*Memoirs of the American Academy in Rome,* vol. 35) (Rome, 1980), pp. 25–38.

74 Needless to say, the interpretation of Giorgione's art is as open as the notion of his oeuvre; each study of the artist tends, in effect, to appropriate the title of an article by Giuseppe Fiocco: "Il mio Giorgione" (*Rivista di Venezia,* n.s. 1 [1955]: 5–22). The most recent monograph on the elusive master, with a catalogue, is by Terisio Pignatti, *Giorgione,* 2d ed. (Venice, 1978).

75 Carpaccio's particular use of canvas was observed by Lionello Venturi, *Giorgione e il giorgionismo* (Milan, 1913), pp. 46–47.

76 Ma venuto poi, l'anno circa 1507, Giorgione da Castelfranco, non gli piacendo in tutto il detto modo di fare, cominciò a dare alle sue opere più morbidezza e maggiore rilievo con bella maniera; usando nondimeno di cacciarsi avanti le cose vive e naturali, e di contrafarle quanto sapeva il meglio con i colori, e macchiarle con le tinte crude e dolci, secondo che il vivo mostrava, senza far disegno; tenendo per fermo che il dipignere solo con i colori stessi, senz'altro studio di disegnare in carta, fusse il vero e miglior modo di fare ed il vero disegno (Vasari, *Vite,* vol. 7, p. 427).

Confirmation of Vasari's account has been provided by modern X-ray investigation of Giorgione's paintings: see, most recently, Ludovico Mucchi, *Caratteri radiografici della pittura di Giorgione* (catalogue of the exhibition *I tempi di Giorgione,* vol. 3) (Florence, 1978).

77 Vasari, *Vite,* vol. 4, p. 11. On Vasari's observations in the context of developments at the turn of the century, see Rosand, "Giorgione e il concetto della creazione artistica," in *Giorgione: Atti del Convegno,* pp. 135–39.

78 Vasari, *Vite,* vol. 7, pp. 127–28:

quando altri ha fatto la mano disegnando in carta, si vien poi di mano in mano con più agevolezza a mettere in opera disegnando e dipignendo: e così facendo pratica nell'arte, si fa la maniera ed il giudizio perfetto, levando via quella fatica e stento con che si conducono le pitture, di cui si è ragionato di sopra: per non dir nulla che, disegnando in carta, si viene a empiere la mente di bei concetti, e s'impara a fare a mente tutte le cose della natura, senza avere a tenerle sempre innanzi, o ad avere a nasc[ond]ere sotto la vaghezza de' colori lo stento del non sapere disegnare; nella maniera che fecero molti anni i pittori viniziani, Giorgione, il Palma, il Pordenone, ed altri che non videro Roma nè altre opere di tutta perfezione.

79 Sir Joshua Reynolds, *Discourses on Art,* ed. R. R. Wark (San Marino, Cal., 1959), pp. 34–35.

80 Vasari, *Vite,* vol. 7, p. 452:

Ma è ben vero che il modo di fare che tenne in queste ultime, è assai diferente del fare suo da giovane: con ciò sia che le prime son condotte con una certa finezza e diligenza incredibile, e da essere vedute da presso e da lontano; e queste ultime, condotte di colpi, tirate via di grosso e con macchie, di maniera che da presso non si possono vedere, e di lontano appariscono perfette. E questo modo è stato cagione che molti, volendo in ciò immitare e mostrare di fare il pratico, hanno fatto di goffe pitture: e ciò adiviene perchè, se bene a molti pare che elle siano fatte senza fatica, non è così il vero, e s'ingannano; perchè si conosce che sono rifatte, e che si è ritornato loro addosso con i colori tante volte, che la fatica vi si vede. E questo modo sì fatto è giudizioso, bello e stupendo, perchè fa parere vive le pitture e fatte con grande arte, nascondendo le fatiche.

81 The outsize brush was so described by the imperial envoy Vargas (quoted in Crowe and Cavalcaselle, *Titian,* vol. 1, p. 329). Titian's working with his fingers is part of Marco Boschini's grand description of the master's procedure in the preface to *Le ricche minere della pittura veneziana* of 1674:

Mi diceva Giacomo Palma il giovine . . . , che pure anco ebbe fortuna di godere degli eruditi precetti di Tiziano, che questo abbozzava i suoi quadri con una tal massa di Colori, che servivano (come dire) per far letto, o base alle espressioni, che sopra poi li doveva fabricare; e ne ho veduti anch'io de' colpi rissoluti, con pennellate massicce di colori, alle volte d'un striscio di terra rossa schietta, e gli serviva (come a dire) per meza tinta; altre volte con una pennellata di biacca, con lo stesso pennello, tinto di rosso, di nero e di giallo, formava il rilievo d'un chiaro, e con queste massime di Dottrina faceva comparire in quattro pennellate la promessa d'una rara figura, e in ogni modo questi simili abbozzi satollavano i più intendenti, di modo che da molti erano così desiderati, per tramontana di vedere il modo di ben incaminarsi ad entrare nel Pelago della Pittura. Dopo aver formati questi preziosi fondamenti, rivolgieva i quadri alla muraglia, e ivi gli lasciava alle volte qualche mese, senza vederli; e quando poi da nuovo vi voleva applicare i pennelli, con rigorosa osservanza li

esaminava, come se fossero stati suoi capitali nemici, per vedere se in loro poteva trovar diffetto; e scoprendo alcuna cosa, che non concordasse al delicato suo intendimento, come chirurgo benefico medicava l'infermo, se faceva di bisogno spolpargli qualche gonfiezza, o soprabondanza di carne, radrizzandogli un braccio, se nella forma l'ossatura non fosse così aggiustata, se un piede nella positura avesse presa attitudine disconcia, mettendolo a luogo senza compatir al suo dolore, e cose simili. Così, operando e riformando quelle figure, le riduceva nella più perfetta simmetria che potesse rappresentare il bello della Natura e dell'Arte; e doppo, fatto questo, ponendo le mani ad altro, sino che quello fosse asciutto, faceva lo stesso; e di quando in quando poi copriva di carne viva quegli estratti di quinta essenza, riducendoli con molte repliche, che solo il respirare loro mancava; né mai fece una figura alla prima, e soleva dire che chi canta all'improviso non può formare verso erudito, né ben aggiustato. Ma il condimento de gli ultimi ritocchi era andar di quando in quando unendo con sfregazzi delle dita negli estremi de' chiari, avicinandosi alle meze tinte, ed unendo una tinta con l'altra; altre volte, con un striscio delle dita pure poneva un colpo d'oscuro in qualche angolo, per rinforzarlo, oltre qualche striscio di rossetto, quasi gocciola di sangue, che invigoriva alcun sentimento superficiale; e così andava a riducendo a perfezione le sue animate figure. Ed il Palma mi attestava, per verità, che nei finimenti dipingeva più con le dita che co' pennelli.

E veramente (chi ben ci pensa) egli con ragione così operò; perché, volendo imitare l'operazione del Sommo Creatore, faceva di bisogno osservare che egli pure, nel formar questo corpo umano, lo formò di terra con le mani.

The text of Boschini's preface is reprinted in Anna Pallucchini's edition of *La carta del navegar pitoresco* (Venice and Rome, 1966), pp. 711–12. For further discussion of its significance as a critical comment on Titian's art, see Rosand, "Titian and the Critical Tradition," pp. 23–24.

82 For broader consideration of the *pittura di macchia*, see E. H. Gombrich, *Art and Illusion: A Study in the Psychology of Pictorial Representation* (New York, 1960), pp. 192–202.

83 There exists no systematic study of the now fairly extensive radiographic investigation of Titian's work; recent contributions to the subject include: M. Hours, "Contributions à l'étude de quelques oeuvres du Titien," *Laboratoire de Recherche des Musées de France, Annales* (1976), pp. 7–31; Mercedes Garberi, in the catalogue of the exhibition *Omaggio a Tiziano: la cultura milanese nell'età di Carlo V* (Milan, 1977), pp. 11–38; and Ludovico Mucchi, "Radiografie di opere di Tiziano," *Arte veneta* 31 (1977): 297–304.

84 On the aesthetic appreciation of the cartoon, see, e.g., Vasari, *Vite*, vol. 1, pp. 174–77, and Giovanni Battista Armenini, *De' veri precetti della pittura* (1587) (Pisa, 1823), pp. 111–12.

85 Vasari, *Vite*, vol. 6, pp. 587–88:

Un pittore chiamato Iacopo Tintoretto . . . nelle cose della pittura, stravagante, capriccioso, presto e risoluto, e il più terribile cervello che abbia avuto mai la pittura, come si può vedere in tutte le sue opere e ne' componimenti delle storie fantastiche e fatte da lui diversamente e fuori dell'uso degli altri pittori: anzi ha superata la stravaganza con le nuove e capricciose invenzioni e strani ghiribizzi del suo intelletto, che ha lavorato a caso e senza disegno, quasi mostrando che quest'arte è una baia. Ha costui alcuna volta lasciato le bozze per finite, tanto a fatica sgrossate, che si veggiono i colpi de' pennegli fatti dal caso e dalla fierezza, piuttosto che dal disegno e dal giudizio. . . . E perchè nella sua giovanezza si mostrò in molte bell'opere di gran giudizio, se egli avesse conosciuto il gran principio che aveva dalla natura, ed aiutatolo con lo studio e col giudizio, come hanno fatto coloro che hanno seguitato le belle maniere de' suoi maggiori, e non avesse, come ha fatto, tirato via di pratica, sarebbe stato uno de' maggiori pittori che avesse avuto mai Vinezia: non che per questo si toglia che non sia fiero e buon pittore, e di spirito svegliato, capriccioso, e gentile.

Tintoretto was undoubtedly in Vasari's mind when he wrote of those painters who thought Titian's late manner was easily imitated and who, working *di pratica*, "hanno fatto di goffe pitture" (quoted above, n. 80). Vasari's criticism is repeated by Armenini, *De' veri precetti*, p. 129; Federico Zuccaro held Tintoretto personally responsible for the decline of Venetian painting at the end of the cinquecento: see his "Lamento della Pittura sù l'onde Venete," published in the *Lettera a Principi, et Signori Amatori del Dissegno, Pittura, Scultura, et Architettura* (Mantua, 1605), in *Scritti d'arte di Federico Zuccaro*, ed. Detlef Heikamp (Florence, 1961), p. 127. A general survey of critical opinion on Tintoretto is offered by Rodolfo Pallucchini, "Tintoretto nella luce della critica," in *Rinascimento europeo e Rinascimento veneziano*, ed. Vittore Branca (Florence, 1967), pp. 233–60.

86 Vasari's own collection of drawings, it should be noted, included sheets attributed to both Giorgione and Tintoretto—respectively, the innovator of the new Venetian manner and, to Tuscan taste, its most offensively radical practitioner. See Licia Ragghianti Collobi, *Il Libro de' Disegni del Vasari* (Florence, 1974), vol. 1, pp. 93–94, 143.

87 See especially Bernhard Degenhart, "Zur Graphologie der Handzeichnung," *Kunstgeschichtliches Jahrbuch der Bibliotheca Hertziana* 1 (1937): 270–84; also Detlev von Hadeln, *Titian's Drawings* (London, 1927), p. 2.

88 See Tietzes, *Drawings of the Venetian Painters*, introduction and passim.

89 Again, see the comments of Degenhart, "Zur Graphologie."

90 Vasari, *Vite*, vol. 7, pp. 431, 447.

91 Vasari, *Vite*, vol. 7, pp. 447–48. More specific distinctions between copying (*ritrarre, contrafare*) and imitation (*imitare*) are to be found in Vincenzo Danti's *Il primo libro del trattato delle perfette proporzioni* of 1567 (in *Trattati d'arte*, ed. Barocchi, vol. 1, p. 241). See Eugenio Battisti, "Il concetto d'imitazione nel Cinquecento italiano," in his *Rinascimento e Barocco* (Turin, 1960), pp. 175–215; also Rossi, *Dalle botteghe alle accademie*, pp. 123–45.

92 Vasari, *Vite*, vol. 4, p. 10; Armenini, *De' veri precetti*, pp. 66–77.

93 See Giampaolo Lomazzo, *Trattato dell'arte della pittura* (1584) (Rome, 1844), vol. 1, pp. 35–36, and Armenini, *De' veri precetti*, pp. 41–46. On the attitudes of sixteenth-century writers toward drawing much information will be found in the pages of Joseph Meder, *Die Handzeichnung, ihre Technik und Entwicklung*, 2d ed. (Vienna, 1923), passim; see also Karl Birch-Hirschfeld, *Die Lehre von der Malerei im Cinquecento* (Rome, 1912), pp. 27–31.

94 In addition to Vasari, see Lomazzo, *Trattato*, vol. 2, p. 466; Armenini, *De' veri precetti*, pp. 111–12; and Raffaello Borghini, *Il Riposo* (Florence, 1584), p. 564.

95 Paolo Pino, *Dialogo di pittura*, in *Trattati d'arte*, ed. Barocchi, p. 117: "Sono infinite le cose appertinenti al colorire et impossibil è isplicarle con parole, perché ciascun colore o da sé o composito può far più effetti, e niun colore vale per sua proprietà a fare un minimo dell'effetti del naturale, però se gli conviene l'intelligenzia e practica de buon maestro." Cf. James Ackerman's observations on the relative neglect of the study of light and color in optics and its application to painting; one reason for this bias, he suggests, is "that the mathematical clarity of the perspective box appeals to the positivistic attitude of modern art history and is easily taught and discussed" ("Alberti's Light," p. 3). Most recently the issue has been discussed, in a rather theoretical way for the Venetians, by Moshe Barasch, *Light and Color in the Italian Renaissance Theory of Art* (New York, 1978)—cf. esp. pp. 90–134 ("The School of Venice").

96 *Lettere sull'arte di Pietro Aretino*, ed. Fidenzio Pertile and Ettore Camesasca (Milan, 1957–60), vol. 2, no. CLXXIX. I have discussed the language of Aretino's letter of May 1544 in "Titian and the Critical Tradition," pp. 16, 21.

97 See Creighton Gilbert, "Antique Frameworks for Renaissance Art Theory: Alberti and Pino," *Marsyas* 3 (1943): 87–106.

98 Pino further subdivides *disegno* into four categories: *giudicio, circumscrizzione, pratica,* and *retta composizione.* Elaborating on *circumscrizzione,* he defines it to include not only linear contours but shading and sketching in general (*Dialogo di pittura*, ed. Barocchi, pp. 113–14).

99 Pino, p. 116. A critical bibliography on Pino will be found in Barocchi, *Trattati d'arte*, vol. 1, pp. 342–43, to which should be added Barasch, *Light and Color* (cited above, n. 95).

100 On Dolce's relationship with Aretino, implicit in the title of his dialogue—"intitolato l'Aretino"—see Mark W. Roskill, *Dolce's "Aretino" and Venetian Art Theory of the Cinquecento* (New York, 1968), introduction, esp. pp. 25–49.

101 Lodovico Dolce, *Dialogo della pittura*, in *Trattati d'arte*, ed. Barocchi, vol. 1, p. 184: "Ora, bisogna che la mescolanza de' colori sia sfumata et unita di modo che rappresenti il naturale e non resti cosa che offenda gli occhi: come sono le linee de' contorni, le quali si debbono fuggire, ché la natura non le fa. . . ." Leonardo, of course, had already made this point, in a rather more practical, less rhetorical way: cf. *The Literary Works of Leonardo da Vinci*, ed. Jean Paul Richter (London, 1883), vol. 1, p. 29, and the *Treatise on Painting* [*Codex Urbinas Latinus 1270*], ed. A. Philip McMahon (Princeton, 1956), vol. 1, p. 75.

102 "Chè non basta il saper formar le figure in disegni eccellenti, se poi le tinte de' colori, che deono imitar la carne, hanno del porfido, o del terreno, e sono prive di quella unione, e tenerezza e vivacità che fa nei corpi la natura," Dolce writes to Alessandro Contarini about 1554/55 (Giovanni Bottari and Stefano Ticozzi, *Raccolta di lettere sulla pittura, scultura ed architettura* [Milan, 1822–25], vol. 3, pp. 379–80; also in Roskill, *Dolce's "Aretino,"* p. 214). With undisguised reference to Michelangelo, Dolce's Aretino declares, "Io stimo che un corpo delicato debba anteporsi al muscoloso. E la ragione è questa; ch'è maggior fatica nell'arte a imitar le carni, che l'ossa, perché in quelle non ci va altro che durezza, e in queste solo si contiene la tenerezza, ch'è la più difficil parte della pittura, in tanto che pochissimi pittori l'hanno mai saputo esprimere o la esprimono oggidì nelle cose loro bastevolmente" (*Dialogo della pittura*, ed. Barocchi, pp. 177–78). Cf. Pino, *Dialogo di pittura*, ed. Barocchi, p. 120, a *paragone* of fresco and oil painting in which the latter is held to be the superior medium since it allows a more faithful imitation of nature.

103 Dolce, *Dialogo della pittura*, ed. Barocchi, pp. 200, 206. A critical bibliography on Dolce will be found in Barocchi, pp. 344–46, to which should be added Roskill, *Dolce's "Aretino,"* as well as

Franco Bernabei, "Tiziano e Ludovico Dolce," in *Tiziano e il manierismo veneziano,* ed. Rodolfo Pallucchini (Florence, 1978), pp. 307-37; William Melczer, "L''Aretino' del Dolce e l'estetica veneta del secondo Cinquecento," in *Tiziano e Venezia: Convegno Internazionale,* pp. 237–42 (which may tend to overstress the Neoplatonic), and, in the same volume, Maurice Poirier, " 'Disegno' in Titian: Dolce's Critical Challenge to Michelangelo," pp. 249–53.

104 On Boschini and his work, see Anna Pallucchini's introduction to her edition of *La carta del navegar pitoresco,* and Michelangelo Muraro, "Marco Boschini," in *Dizionario biografico degli italiani,* vol. 13 (Rome, 1971), pp. 199–202, with earlier bibliography.

105 Boschini offers a concise yet thorough exposition of his aesthetic in the "Breve instruzione per intender in qualche modo le maniere de gli auttori veneziani," prefacing *Le ricche minere*—the text of which is reprinted in *La carta,* ed. Pallucchini, pp. 703–56.

106 Boschini, p. 748.

107 Pino, *Dialogo di pittura,* ed. Barocchi, p. 118: "Non però intendo vaghezza l'azzurro oltra-marino da sessanta scudi l'onzia o la bella laca, perch'i colori sono anco belli nelle scatole da sé stessi. . . . " Dolce, *Dialogo della pittura,* ed. Barocchi, pp. 184–85: "Né creda alcuno che la forza del colorito consista nella scelta de' bei colori, come belle lache, bei azzurri, bei verdi e simili; percioché questi colori sono belli parimente senza che e'si mettano in opera; ma nel sapergli maneggiare convenevolmente."

108 Pino, *Dialogo di pittura,* ed. Barocchi, pp. 117–18. Dolce, *Dialogo della pittura,* ed. Barocchi, p. 185: "Bisogna sopra tutto fuggire la troppa diligenza, che in tutte le cose nuoce."

109 Boschini, "Breve instruzione," ed. Pallucchini, in *La carta,* p. 752: "Il Colorito si dilata in varie circostanze e particolarità; poiché questo alle volte si riceve per l'impasto, ed è fondamento; per la macchia, ed è Maniera; per l'unione de' colori, e questo è tenerezza; per il tingere, o ammaccare, e questo è distinzione delle parti; per il rillevare ed abbassare delle tinte, e questo è tondeggiare; per il colpo sprezzante, e questa è franchezza di colorire; per il velare, o come dicono sfregazzare, e questi sono ritocchi per unire maggiormente. Di modo che con questi, e con altri simili particolari, si forma il Colorito alla Veneziana. . . . " Less abstract still is Boschini's description of *colorito* in action, his account of the old Titian at work (quoted above, n. 81).

110 For a critical account of the development of Florentine color in the early cinquecento, see John Shearman, *Andrea del Sarto* (Oxford, 1969), pp. 131–48.

111 Vasari, *Vite,* vol. 1, p. 179: "L'unione nella pittura è una discordanza di colori diversi accordati insieme, i quali, nella diversità di più divise mostrano differentemente distinte l'una dall'altra le parti delle figure; come le carni dai capelli, ed un panno diverso di colore dall'altro."

112 Pino, *Dialogo di pittura,* ed. Barocchi, p. 118: "La prontezza di mano è cosa de grande importanza nelle figure, e mal può operare un pittore senza una sicura e stabil mano." Pino, however, could not sympathize with the extreme style of a younger contemporary like Schiavone, whose hasty execution he dismissed as "quest'empiastrar facendo il pratico" (p. 119). See Francis L. Richardson, *Andrea Schiavone* (Oxford, 1980), p. 10.

113 Dolce, *Dialogo della pittura,* ed. Barocchi, p. 149: "La facilità è il principale argomento della eccellenza di qualunche arte e la più difficile a conseguire, et è arte a nasconder l'arte." Dolce is here coming to the defense of the apparent effortlessness, and supposed artlessness, of which Raphael, in comparison to Michelangelo, was accused.

114 Cf. Boschini's passage on Titian (above, n. 81) and his description of Tintoretto's working methods ("Breve instruzione," in *La carta,* ed. Pallucchini, pp. 730–32); also Ridolfi's anecdote concerning Tintoretto's stupefaction of some visiting Flemish draftsmen with a demonstra-tion of *disegno alla veneziana* (*Maraviglie,* vol. 2, p. 65).

115 Boschini, "Breve instruzione," in *La carta,* ed. Pallucchini, p. 751 (quoted below, chap. 5, n. 102). See above, n. 85, for criticism of Tintoretto's *fierezza.* We must recall in this context that it was Tintoretto who was credited with having most successfully followed the formula reconcil-ing the *disegno-colorito* antithesis, combining "Il disegno di Michel Angelo e'l colorito di Titiano" (Ridolfi, *Maraviglie,* vol. 2, p. 14; cf. Borghini, *Il Riposo,* p. 118). The formula itself, although implicit in earlier comments by Aretino and Dolce, was actually first suggested by Pino (*Dialogo di pittura,* ed. Barocchi, p. 127). For further discussion, see Rosand, "Titian and the Critical Tradition," pp. 5, 13–16.

116 Cf. Vasari, *Vite,* vol. 4, p. 96, on the Fondaco frescoes: ". . . messovi mano Giorgione, non pensò se non a farvi figure a sua fantasia per mostrar l'arte; chè nel vero non si ritrova storie che abbino ordine o che rappresentino i fatti di nessuna persona segnalata o antica o moderna; ed io per me non l'ho mai intese, nè anche, per dimanda che si sia fatta, ho trovato chi l'intenda. . . ." For the most recent bibliography on the frescoes, see Pignatti, *Giorgione,* 2d ed., p. 106; especially important for its approach is the essay by Michelangelo Muraro, "The Political Interpretation of Giorgione's Frescoes on the Fondaco dei Tedeschi," *Gazette des Beaux-Arts* 76 (1975): 177–84. Bibliography on the *Tempesta:* Pignatti, *Giorgione,* 2d ed., p. 105;

of particular interest, if not finally convincing, is the most recent sustained study: Salvatore Settis, *La "Tempesta" interpretata: Giorgione, i committenti, il soggetto* (Turin, 1978).

117 Cf. especially Creighton Gilbert's still provocative article, "On Subject and Not-Subject in Italian Renaissance Pictures," *Art Bulletin* 34 (1952): 202–16.

118 The affective function of the implied spatial continuum is explicit in one of Alberti's best known recommendations in *Della pittura*: "E piacemi sia nella storia chi ammonisca e insegni a noi quello che ivi si facci, o chiami con la mano a vedere, o con viso cruccioso e con gli occhi turbati minacci che niuno verso loro vada, o dimostri qualche pericolo o cosa ivi maravigliosa, o te inviti a piagnere con loro insieme o a ridere" (in *De pictura*, ed. Grayson, p. 72).

119 Alberti, pp. 26–28: "E sappiamo che <quando> con sue linee circuiscono la superficie, e quando empiono di colori e' luoghi descritti, niun'altra cosa cercarsi se non che in questa superficia representino le forme delle cose vedute, non altrimenti che se essa fusse di vetro tralucente tale che la pirramide visiva indi trapassasse, posto una certa distanza, con certi lumi e certa posizione di centro in aere e ne' suoi luoghi altrove."

120 The literature on the subject is quite extensive, but a few of the significant recent contributions in English may be offered here: Erwin Panofsky, *Renaissance and Renascences in Western Art*, 2d ed. (New York and Evanston, 1969), pp. 118–27 and passim; Krautheimer, *Ghiberti*, pp. 229–53; John White, *The Birth and Rebirth of Pictorial Space*, 2d ed. (New York, Evanston, and San Francisco, 1972), pp. 113–34 and passim; Samuel Y. Edgerton, Jr., *The Renaissance Rediscovery of Linear Perspective* (New York, 1975)—all with previous bibliography.

121 Alberti, *Della pittura* "Poi moverà l'istoria l'animo quando gli uomini ivi dipinti molto porgeranno suo proprio movimento d'animo. Interviene da natura, quale nulla più che lei si truova rapace di cose a sé simile, che piagniamo con chi piange, a ridiamo con chi ride, e doglianci con chi si duole. Ma questi movimenti d'animo si conoscono dai movimenti del corpo" (in *De pictura*, ed. Grayson, p. 70). Cf. Horace, *Ars poetica*, ll. 102–03. I have discussed further aspects of these affective dimensions in " 'Troyes Painted Woes': Shakespeare and the Pictorial Imagination," *Hebrew University Studies in Literature* 8 (1980): 77–97.

122 Like the critical literature on perspective, that on Masaccio's *Trinity* is vast and still growing. The reader may be referred to the following specific studies: Ursula Schlegel, "Observations on Masaccio's *Trinity* Fresco in Santa Maria Novella," *Art Bulletin* 45 (1963): 19–33; John Coolidge, "Further Observations on Masaccio's *Trinity*," *Art Bulletin* 48 (1966): 382–84; H. W. Janson, "Ground Plan and Elevation in Masaccio's *Trinity* Fresco," in *Essays in the History of Art Presented to Rudolf Wittkower* (London, 1967), pp. 83–88; Joseph Polzer, "The Anatomy of Masaccio's *Trinity*," *Jahrbuch der Berliner Museen* 13 (1971): 18–59; Charles Dempsey, "Masaccio's *Trinity*: Altarpiece or Tomb?" *Art Bulletin* 54 (1972): 279–81. For more general consideration of illusion and fresco painting, see especially Sven Sandström, *Levels of Unreality: Studies in Structure and Construction in Italian Mural Painting during the Renaissance* (Uppsala, 1963); also E. H. Gombrich, *Means and Ends: Reflections on the History of Fresco Painting* (Walter Neurath Memorial Lecture) (London, 1976), with further bibliography.

123 Further on the Vivarini-d'Alemagna triptych and its setting: below, chap. 3, sec. 1 and Excursus. In the context of this comparison, acknowledgment must be made of Mantegna's altarpiece in San Zeno, Verona; executed between 1456 and 1459, this classicizing *ancona* applied and extended the Florentine lessons with a precise control and sense of pictorial adventure that underscore the relative timidity of its Venetian predecessor.

124 Goloubew, *Les dessins de Jacopo Bellini*, vol. 2, pl. IV. The drawing from the Codex Vallardi is no longer generally accepted as the work of Pisanello and may in fact have originated in the circle of Jacopo Bellini: see Maria Fossi Todorow, *I disegni del Pisanello e della sua cerchia* (Florence, 1966), cat. no. 99.

125 See Giles Robertson, "The Earlier Work of Giovanni Bellini," *Journal of the Warburg and Courtauld Institutes* 23 (1960): 45–59, and *Giovanni Bellini*, pp. 65–70; Huse, *Studien zu Giovanni Bellini*, pp. 21–55. On the more traditional forms of the altarpiece in Venice, see Heinz Fechner, *Rahmen und Gliederung venezianischer Anconen aus der Schule von Murano* (Munich, 1969).

126 The most sustained analysis of the picture is by Erich Hubala, *Giovanni Bellini: Madonna mit Kind, Die Pala di San Giobbe* (Stuttgart, 1969).

127 A photomontage of the *San Giobbe Altarpiece* within its original frame is illustrated in Hubala, fig. 11, and in Robertson, *Giovanni Bellini*, pl. LXVII.

128 The date actually reads 1510—also the date of Carpaccio's altarpiece for San Giobbe, the *Presentation in the Temple*—and was so read throughout the nineteenth century, until Pietro Paoletti suggested that it was in fact altered (*La Scuola Grande di San Marco* [Venice, 1929], p. 119). Paoletti argued that Bellini's altarpiece in San Giovanni Crisostomo, finished in 1513, must take chronological precedence. Although hardly founded on solid evidence, his arguments have found general acceptance, and Basaiti's *Agony in the Garden* tends to be dated 1516

(cf. Sandra Moschini Marconi, *Gallerie dell'Accademia di Venezia*, vol. 1, *Opere d'arte dei secoli XIV e XV* [Rome, 1955], no. 46).

129 The panel has been cut on the top; it is therefore difficult to determine with confidence whether the supporting cable of this lamp originally descended from a point within the field (as in Carpaccio's *Presentation in the Temple*) or (perhaps less likely) beyond the frame—i.e., whether it belonged to the architectural space of the attending saints or, implicitly, to the space of the observer, the church of San Giobbe.

130 See Cecil Gould, "The Pala of S. Giovanni Crisostomo and the Later Giorgione," *Arte veneta* 23 (1969): 206–09; also the comments of Michael Hirst, "The Kingston Lacy 'Judgment of Solomon,'" in *Giorgione: Atti del Convegno*, p. 259.

131 For further discussion of the implications and possibilities of meaning in such pictorial relationships, see Meyer Schapiro, *Words and Pictures: On the Literal and the Symbolic in the Illustration of a Text* (The Hague, 1973), and, for more general consideration of these issues, "On Some Problems in the Semiotics of Visual Art: Field and Vehicle in Image-Signs," *Semiotica* 1 (1969): 223–42.

132 The calculated quality of Carpaccio's architectural settings and, especially, their theatrical modality have been stressed by Licisco Magagnato, "A proposito delle architetture del Carpaccio," *Comunità* 17, no. 111 (1963): 70–81, and "Il momento architettonico di tre pittori veneti del tardo Quattrocento," *Bollettino del Centro Internazionale di Studi di Architettura Andrea Palladio* 6² (1964): 228–38.

133 Michelangelo Muraro has emphasized this mimetic structuring of Carpaccio's narrative compositions: see his *Carpaccio* (Florence, 1966), p. xxx and passim, and "Vittore Carpaccio o il teatro in pittura," in *Studi sul teatro veneto fra Rinascimento ed età barocca*, ed. Maria Teresa Muraro (Florence, 1971), pp. 7–19.

134 In Renaissance art literature this term refers to absolute frontality, usually of the human face—e.g.: Luca Pacioli, *De divina proportione* (1509), ed. Constantin Winterberg (Vienna, 1889), p. 133; Dolce, *Dialogo della pittura*, ed. Barocchi, p. 179; Daniele Barbaro, *La practica della perspettiva* (Venice, 1568), p. 184.

135 On this polarity, see the discussion in Schapiro, *Words and Pictures*, pp. 37–49 ("Frontal and Profile as Symbolic Forms"). For further comment on the issue in a more specifically Renaissance context, see David Summers, "*Figure Come Fratelli:* A Transformation of Symmetry in Renaissance Painting," *Art Quarterly*, n.s. 1 (1977): 59–88.

136 Jan Lauts, *Carpaccio* (London, 1962), pp. 17–24, 227–30; Muraro, *Carpaccio*, pp. XIV–LII.

137 Cf. the observations of David Alan Brown, "A Drawing by Zanetti after a Fresco on the Fondaco dei Tedeschi," *Master Drawings* 15 (1977): 31–44; for further bibliography on the frescoes, see above, n. 116.

138 For this picture, generally attributed to Palma il Vecchio and Paris Bordone—less frequently to Giorgione, although the very *concetto* of the image bespeaks his inspiration—see Paoletti, *Scuola di San Marco*, pp. 161–63; Sandra Moschini Marconi, *Gallerie dell'Accademia di Venezia*, vol. 2, *Opere d'arte del secolo XVI* (Rome, 1962), no. 275; Pignatti, *Giorgione*, 2d ed., pp. 140–41, with previous bibliography; cf. also the more positive suggestions of Günter Tschmelitsch, *Zorzo, genannt Giorgione* (Vienna, 1975), pp. 396–99, and Michelangelo Muraro, "Giorgione e la civiltà delle ville venete," in *Giorgione: Atti del Convegno Internazionale*, p. 180, n. 27 ("forse è l'ultima pittura lasciata incompleta da Giorgione"). Most recently, Philip L. Sohm has attempted to fix the date of commission as 1513, precluding Giorgione's participation and assigning the work to Palma alone, with subsequent repainting by Paris Bordone and later restorers: "Palma Vecchio's *Sea Storm:* A Political Allegory," *Revue d'art canadienne/Canadian Art Review* 6 (1979–80): 85–96.

CHAPTER 2. TITIAN AND THE CHALLENGE OF THE ALTARPIECE

1 For further discussion of this woodcut and its context, see David Rosand and Michelangelo Muraro, *Titian and the Venetian Woodcut* (Washington, D.C., 1976), cat. no. 12.

2 On the painting of *Christ carrying the Cross*—the attribution of which has vacillated between Giorgione and Titian since Vasari—see Harold E. Wethey, *The Paintings of Titian* (London, 1969–75), vol. 1, cat. no. 22, and David Rosand, *Titian* (New York, 1978), p. 64; cf. also Terisio Pignatti, *Giorgione*, 2d ed. (Venice, 1978), cat. no. 30. On the documentation of the picture, see Jaynie Anderson, " 'Christ carrying the Cross' in San Rocco: Its Commission and Miraculous History," *Arte veneta* 31 (1977): 186–88; on the many copies of the image: Lionello Puppi, "Une ancienne copie du 'Christo e il manigoldo' de Giorgione au Musée des Beaux-Arts," *Bulletin du Musée National Hongrois des Beaux-Arts* 18 (1961): 39–49.

3 Transferred to the sacristy of Santa Maria della Salute in 1656, the altarpiece is usually related to the plague of 1510 and dated ca. 1511–12, that is, after Titian's Paduan sojourn (cf. Wethey, *Paintings of Titian*, vol. 1, cat. no. 119). For reasons of style—particularly the recollections of the art of Giovanni Bellini and, in the figure of St. Sebastian with its ungainly contrapposto, of Giorgione—I find such a dating too late and prefer to place the picture between the experience

of the Fondaco frescoes and the coming to maturity in Padua (see Rosand, *Titian*, p. 68). Although we shall return to the iconography of the altarpiece in relation to the plague, it is worth noting here that early sixteenth-century Venice experienced many such disasters—e.g., in 1503–04 and in 1506–07.

4 The now canonical sexpartite division of Titian's development was given its definitive formulation by Theodor Hetzer: *Tizian: Geschichte seiner Farbe* (Frankfurt am Main, 1935), pp. 79–83 and passim, and in Thieme-Becker, *Allgemeines Lexikon der bildenden Künstler*, vol. 34 (Leipzig, 1940), pp. 158–72. See also Erwin Panofsky, *Problems in Titian, Mostly Iconographic* (New York, 1969), pp. 18–26.

5 The inscriptions on the tall pedestals of the flanking columns read: "ASSVMPTAE IN COELVM VIRGINI AETERNI OPIFICIS MATRI" and "FRATER GERMANVS HANC ARAM ERIGI CVRAVIT MDXVI." The prior is often referred to by modern scholars as Marco Germano, but, as Giuseppe Ungaro has noted (*La basilica dei Frari, Venezia* [Padua, 1968], p. 60), the *M.* or *M.°* before his name simply stands for *Maestro*. In the document cited below n. 22, he is recorded as "Magister Germanus de Casale."

6 Marino Sanuto, *I Diarii* (1496–1533), ed. Rinaldo Fulin et al. (Venice, 1879–1903), vol. 25, col. 418: "[Dil mexe di Mazo 1518] A dì 20. Fo san Bernardin, el qual zorno per parte presa in Pregadi si varda, nè li oficii senta. Et eri fu messo la palla granda di l'altar di Santa Maria di Frati Menori suso, depenta per Ticiano, et prima li fu fato atorno una opera grande di marmo a spese di maistro Zerman, ch'è guardian adesso." Sanuto's *mazo* has often been misread as *marzo* rather than dialect for *maggio*: cf., inter alia, J. A. Crowe and G. B. Cavalcaselle, *The Life and Times of Titian* (1877), 2d imp. (London, 1881), vol. 1, p. 212, and Gino Fogolari, *I Frari e i SS. Giovanni e Paolo* (Milan, 1931), pl. 8. It is also worth noting that Sanuto's entry, dated 20 May, actually refers to the day before ("[i]eri"), a point occasionally overlooked—most recently by Creighton Gilbert, "Some Findings on Early Works of Titian," *Art Bulletin* 62 (1980): 53, n. 74.

7 Lodovico Dolce, responding to the anti-Venetian bias of the first edition of Vasari's *Vite*, declared with regard to the *Assunta*, "E certo si può attribuire a miracolo che Tiziano, senza aver veduto alora le anticaglie di Roma, che furono lume a tutti i pittori eccellenti, solamente con quella poca favilluccia ch'egli aveva scoperta nelle cose di Giorgione, vide e conobbe la idea del dipingere perfettamente" (*Dialogo della pittura, intitolato l'Aretino* [1557], in *Trattati d'arte del Cinquecento*, ed. Paola Barocchi, vol. 1 [Bari, 1960], p. 202).

8 For comparison of the *Assunta* with Raphael's work, see the brief but pertinent comments in Cecil Gould, "Correggio and Rome," *Apollo* 83 (1966): 336; see also Rodolfo Pallucchini, *Tiziano* (Florence, 1969), vol. 1, p. 46, and Wethey, *Paintings of Titian*, vol. 1, cat. no. 14, both with further references. The significance of Leonardo's example was convincingly discussed by David A. Brown in a paper delivered in April of 1976 at a Titian symposium held at Johns Hopkins University, Baltimore: "A New Look at the Frari *Assunta*." Creighton Gilbert has recently introduced the name of Fra Bartolommeo into the discussion ("Some Findings," pp. 52–56), and Giles Robertson has suggested a graphic source in Marcantonio's engraving after Raphael's *Galatea* ("A Drawing after Titian's 'Madonna di Ca' Pesaro' by Federico Zuccaro," in *Tiziano e Venezia: Convegno Internazionale di Studi, Venezia, 1976* [Vicenza, 1980], p. 560, n. 2).

9 Dolce, *Dialogo*, p. 202: "E certo in questa tavola si contiene la grandezza e terribilità di Michelagnolo, la piacevolezza e venustà di Rafaello, et il colorito proprio della natura."

10 Dolce, *Dialogo*, p. 202: "Con tutto ciò i pittori goffi e lo sciocco volgo, che insino alora non avevano veduto altro che le cose morte e fredde di Giovanni Bellino, di Gentile e del Vivarino (perché Giorgione nel lavorare a olio non aveva ancora avuto lavoro publico e per lo più non faceva altre opere che mezze figure e ritratti), le quali erano senza movimento e senza rilevo, dicevano della detta tavola un gran male. Dipoi, raffreddandosi la invidia e aprendo loro a poco a poco la verità gli occhi, cominciarono le genti a stupir della nuova maniera trovata in Vinegia da Tiziano, e tutti i pittori d'indi in poi si affaticarono d'imitarla."

11 Carlo Ridolfi, *Le maraviglie dell'arte* (1648) ed. Detlev von Hadeln (Berlin, 1914–24), vol. 1, p. 163: "Dicesi, che Titiano lavorasse quella tavola nel Convento de'Frati medesimi, si che veniva molestato dalle frequenti visite loro, e da Fra Germano curatore dell'opera era spesso ripreso, che tenesse quegli Apostoli di troppo smisurata grandezza, durando egli non poca fatica à correggere il poco loro intendimento, e dargli ad intendere, che le figure dovevano esser proportionate al luogo vastissimo, ove havevansi à vedere, e che di vantaggio si sariano diminuite. . . ." The monks were evidently slow to comprehend Titian's meaning. According to Ridolfi, not until the imperial ambassador offered to buy it for the emperor did they begin to realize the value of their new altarpiece. Another version of the story has it that Titian threatened to keep the painting for himself until he received a personal apology from Fra Germano (Crowe and Cavalcaselle, *Titian*, vol. 1, p. 212).

12 Antonio Sartori, himself a Franciscan, rejects it as a malicious fabrication, a slur on the order that had earlier patronized the young Titian in Padua (*S. M. Gloriosa dei Frari*, 2d ed. [Padua,

1956], pp. 45–46). Although such apocryphal anecdotes are notoriously difficult to control historically, Wethey's outright rejection of the whole tradition seems both uncritical and unwarranted (*Paintings of Titian*, vol. 3, p. 23, n. 128, p. 257).

13 On the history of the Frari: Flaminio Corner, *Notizie storiche delle chiese e monasteri di Venezia e di Torcello* (Padua, 1758), pp. 361–67; Giambattista Soràvia, *Le chiese di Venezia descritte ed illustrate* (Venice, 1822–24), vol. 2, pp. 3–158; Pietro Paoletti, *L'Architettura e la scultura del Rinascimento in Venezia* (Venice, 1893), pt. 1, pp. 45–48; Aldo Scolari, "La chiesa di Sta. Maria Gloriosa dei Frari ed il suo recente restauro," in *Venezia: studi di arte e storia a curia della Direzione del Museo Civico Correr* (Venice, 1920), pp. 148–71; and Sartori, *Frari*, pp. 3–10. For a discussion of the Frari in the larger context of monastic basilicas, see Herbert Dellwing, *Studien zur Baukunst der Bettelorden im Veneto: Die Gotik der monumentalen Gewölbebasiliken* (Munich and Berlin, 1970), pp. 117–37, with further bibliography on p. 146.

14 A similar situation obtains in the Cappella dei Milanesi (B in fig. 37), where the Renaissance reredos of 1503 is set into a Gothic apse. The solution there, as Fogolari recognized (*I Frari*, pl. 11), anticipates in many ways the high altar of 1516 (see below, n. 19).

15 The original stained glass may have been the work of Marco da Venezia or of that "Frater Theotonicus" cited in 1335 by the Trevisan notary Oliviero Forzetta (see Michelangelo Muraro, *Paolo da Venezia* [University Park and London, 1970], pp. 23–24, 82–83, and n. 74 on p. 75, and "Maestro Marco e Maestro Paolo da Venezia," in *Studi di storia dell'arte in onore di Antonio Morassi* [Venice, 1971], pp. 23–34). The only designs presently in these windows, dedicated to the lives of St. Francis and St. Anthony of Padua, date from 1907 (Sartori, *Frari*, p. 46). On the opening and fenestration of the apse walls in Italian mendicant Gothic, see Dellwing, *Studien*, pp. 132–37, 141.

16 Giorgio Vasari, *Le vite de' più eccellenti pittori, scultori ed architettori*, ed. Gaetano Milanesi (Florence, 1878–85), vol. 7, p. 436: ". . . ma quest'opera, per essere stata fatta in tela, e forse mal custodita, si vede poco." Vasari's identification of the support as canvas—perhaps a natural enough assumption on his part when dealing with Venetian painting—has been carelessly repeated by some modern scholars (e.g., Hans Tietze, *Titian* [London, 1950], p. 396). More recently Mark Roskill has mistranslated Dolce's accurate description of the *Assunta*, "una gran tavola," as "large canvas" (*Dolce's "Aretino" and Venetian Art Theory of the Cinquecento* [New York, 1968], p. 187).

17 Scolari, "La chiesa," p. 166. The lunettes were closed in the course of the twentieth-century restorations. With regard to conservation, in 1674 Marco Boschini lamented the neglect of the picture and the waste of funds on less important projects:

> Ma, tra le singolari, quelle di Tiziano chiamano più soccorso delle altre, come la Pala Maggiore de' Frari: essendo in tavola va facendo infinite pieghe o inarcature, e si vede tutta scrostata la figura dell'Apostolo San Pietro; cosa che rende pietà a chi possiede il buon gusto. Ma Dio buono! così, come furono spese delle migliaia de scudi a levar le tele d'Aragni dal soffitto tutto di detta Chiesa e toglier la caligine alle muraglie, col biancheggiarle, e dipinger anco il soffitto medesimo, perché ancora non si poteva soccorrere ad un bisogno di tanta importanza? (from the "Breve instruzione" introducing *Le ricche minere della pittura veneziana*, reprinted in Anna Pallucchini's edition of *La carta del navegar pitoresco* [Venice and Rome, 1966], p. 746).

On the darkening of the *Assunta*, cf. also the observations of Sir Joshua Reynolds (cited in Crowe and Cavalcaselle, *Titian*, vol. 1, p. 211) and Antonio Maria Zanetti, *Della pittura veneziana* (Venice, 1771), p. 110: "Ad onta del lume contrario e del fosco velo, con cui il tempo ingombrò questa pittura si giunge a vedere ch'essa è dipinta d'un carattere assai grande. . . ." See now Francesco Valcanover, "Il restauro dell'Assunta," in *Tiziano, nel quarto centenario della sua morte, 1576–1976 (Lezioni tenute nell'Aula Magna dell'Ateneo Veneto)* (Venice, 1977), pp. 41–51.

18 The screen, possibly initiated by the Bon workshop, was completed by Pietro Lombardo and his shop and is inscribed 1475. See Giulio Lorenzetti, *Venezia e il suo estuario*, 3d ed. (Rome, 1963), p. 589, and Fogolari, *I Frari*, pl. 5.

The above analysis of the relation of the *Assunta* to the interior spaces of the Frari was first presented in my "Titian in the Frari," *Art Bulletin* 53 (1971): 196–200; a similar approach was taken by Johannes Wilde in his lectures at the Courtauld Institute, posthumously published as *Venetian Art from Bellini to Titian* (Oxford, 1974), pp. 133–34.

19 Cf., e.g., the bucrania and the Victory figures in the spandrels of the 1503 altar in the Cappella dei Milanesi (ill. in Sartori, *Frari*, p. 37) and the sepulchral monument of Benedetto Pesaro, with its nude figures of Neptune and Mars flanking the triumphant effigy of the deceased (ill. in Fogolari, *I Frari*, pl. 23).

20 Paoletti in Thieme-Becker, *Allgemeines Lexikon der bildenden Künstler*, vol. 4 (Leipzig, 1910), p. 570. The monument of Benedetto Pesaro, cited in the preceding note, has also been attributed to Lorenzo Bregno (Soràvia, *Le chiese*, vol. 2, pp. 46–49).

21 For Titian's architectural expertise, see above, chap. 1, n. 61.

22 Archivio di Stato, Venice: S. Maria Gloriosa dei Frari, No. 5, "Cathastico incomencia 1502," fol. 5. See also Wethey, *Paintings of Titian*, vol. 3, p. 259. Sartori (*Frari*, p. 28) asserts that the tomb was completed "dai Lombardi" in 1524. The inscription on the monument was recorded by Francesco Sansovino in 1581 (*Venetia città nobilissima et singolare* ed. Giustiniano Martinioni [Venice, 1663], p. 189); see also Soràvia, *Le chiese*, vol. 2, pp. 131–32.

23 Crowe and Cavalcaselle, *Titian*, vol. 1, p. 441. The document is now in the Biblioteca Correr (see Angelo Scrinzi, "Ricevute di Tiziano per il pagamento della Pala Pesaro ai Frari," in *Venezia: studi di arte e storia*, pp. 258–59).

24 Sanuto, *Diarii*, vol. 43, col. 396: "[MDXXVI dicembre] A dì 8. Fo la Conception di la Madona, et si varda, et fassi la festa a la Misericordia, *etiam* in molte altre chiese et ai Frari menori a l'altar hanno fatto i Pexari in chiesa." Sanuto's text states merely that the feast was celebrated at the Pesaro altar; it does not, as is often inferred, declare that the altar was inaugurated on that date or that Titian's painting was then "solemnly unveiled." The altar itself was always dedicated to the Immaculate Conception and is so identified in the concession to Jacopo Pesaro. The debate over the interpretation of Titian's painting as an image of the Immaculate Conception has become by now somewhat gratuitous. E. Tietze-Conrat ("The *Pesaro Madonna*: A Footnote on Titian," *Gazette des Beaux-Arts* 42 [1953]: 177–82) no doubt overstated her case, but there is no reason to reject it totally (as does Wethey, *Paintings of Titian*, vol. 3, pp. 259–60, whose arguments contradict the very documents he quotes); as Staale Sinding-Larsen notes, the idea would "normally be inherent in any figure of the Virgin" in a Franciscan church from the late fifteenth century on ("Titian's Madonna di Ca' Pesaro and its Historical Significance," *Acta ad archaeologiam et artium historiam pertinentia* [Institutum Romanum Norvegiae] 1 [1962]: 139–40). See also Eva Tea, "La Pala Pesaro e la Immacolata," *Ecclesia* 17 (1958): 605–09, and "Iconografia della Immacolata in Italia e in Francia," in *Actes du XIX^e Congrès International d'Histoire de l'Art* (Paris, 1959), pp. 283–84. For further discussion and references, see below, n. 42.

25 See Millard Meiss, *The Painter's Choice: Problems in the Interpretation of Renaissance Art* (New York and London, 1976), pp. 103–47, and Lionello Puppi, *Il trittico di Andrea Mantegna per la basilica di S. Zeno Maggiore in Verona* (Verona, 1972).

26 Jacopo Pesaro, Bishop of Paphos, appointed commander of the papal fleet by Pope Alexander VI, was victorious over the Turks at the Battle of Santa Maura in 1502. These events dominate the personal iconography of the Pesaro Madonna—in the special patronage of St. Peter and in the group of Christian warrior leading the defeated figures of a Turk and Moor—as well as that of the earlier smaller votive picture in Antwerp (fig. 43). For the problems surrounding the dating and attribution of the Antwerp canvas, cf. the observations of Sinding-Larsen, "Titian's Madonna," pp. 159–61; Panofsky, *Problems in Titian*, pp. 178–79; and, most recently, Jürg Meyer zur Capellen, "Beobachtungen zu Jacopo Pesaros Exvoto in Antwerpen," *Pantheon* 38 (1980): 144–52. For a summary of previous opinions on the dating, see Wethey, *Paintings of Titian*, vol. 1, cat. no. 132.

27 The situation was first fully discussed by Sinding-Larsen, "Titian's Madonna," pp. 139–69.

28 Louis Hourticq was evidently so struck by the beauty of this young face—all the more brilliant since the recent cleaning—that he described it as "une toute jeune fille" (*La jeunesse de Titien* [Paris, 1919], p. 192). Although generally recognized as Giovanni, son of Antonio Pesaro, the youth has been identified by Fogolari (*I Frari*, p. xxi and pl. 17) and Sartori (*Frari*, p. 27) as Lunardo, who was born in 1508 and thus, presumably, would have been the right age for Titian's picture. However, as Francesco Valcanover points out (in a study to appear in a volume dedicated to the memory of John McAndrew), the figures in the *Pesaro Madonna* were the very last forms executed, probably close to 1525 or even 1526, which would add several years to the argument. For the identity of other members of the Pesaro family, on which there is also disagreement, cf. Francesco Zanotto, *Pinacoteca veneta, ossia raccolta dei migliori dipinti delle chiese di Venezia* (Venice, 1858–60), vol. 2, no. 81; Tietze-Conrat, "The *Pesaro Madonna*," pp. 178–80; Pallucchini, *Tiziano*, vol. 1, p. 260; and Philipp Fehl, "Saints, Donors and Columns in Titian's *Pesaro Madonna*," in *Renaissance Papers: A Selection of Papers presented at the University of North Carolina* (Chapel Hill, 1974), p. 80.

At the extreme right of the group another member of the family breaks the profile sequence. And his slight turning out from the plane, like his younger relative's near frontality, contrasts with the quattrocentesque profiles of the elders—in which, we are tempted to believe, Titian did indeed infuse archaic portrait images, of deceased, with renewed life.

29 As nearly as one can determine, the orthogonals do not in fact recede to a precise point, but rather to a focused area. This does not really affect our analysis.

30 Sinding-Larsen interprets this resolution as a kind of hesitation on Titian's part: "It must be regarded as a concession to a time-honoured convention when, in the figure of St. Peter, Titian granted the picture at least a relic of a 'frontal enthroned' at which the more conserva-

tively minded onlookers could direct their eyes. In this way the new composition appeared less provocative" ("Titian's Madonna," p. 158). Cf. also Wilde, *Venetian Art,* pp. 134–37.

31 The oil sketch first published by G. J. Hoogewerff as "Un bozzetto di Tiziano per la 'Pala dei Pesaro' " (*Bollettino d'arte* 7 [1927–28]: 529–37) has never found acceptance as anything but a later copy: see Rosand, "Titian in the Frari," p. 204.

32 August Wolf, "Tizian's Madonna der Familie Pesaro in der Kirche der Frari zu Venedig," *Zeitschrift für bildende Kunst* 12 (1877): 9–14.

33 Radiographic study of the *Pesaro Madonna* was undertaken in the summer of 1977. I am grateful to Dr. Francesco Valcanover, Soprintendente ai Beni Artistici e Storici di Venezia, for generously sharing with me the results of those investigations.

34 See above, n. 22.

35 See above, chap. 1, sec. 4.

36 Sinding-Larsen, "Titian's Madonna," p. 157. In his most recent contribution to the topic, Sinding-Larsen has again insisted on this absolute distinction between the two realms, "un netto distacco, una dissociazione dello spazio pittorico da quello reale" ("La Pala dei Pesaro e la tradizione dell'immagine liturgica," in *Tiziano e Venezia: Convegno Internazionale di Studi, Venezia, 1976* [Vicenza, 1980], pp. 201– 06). Clearly, our modes of perception and interpretation are quite different, predicated on different assumptions concerning the operations and effects of pictorial representation.

37 The related asymmetry of the Treviso *Annunciation* (fig. 47), which will be discussed below, responds, on the other hand, to obliquity not of approach but of illumination. For a similar consideration of pictures by Caravaggio apparently intended to be "eyed awry," see Leo Steinberg, "Observations in the Cerasi Chapel," *Art Bulletin* 41 (1959): 183–90.

38 Charles Hope, "Documents Concerning Titian," *Burlington Magazine* 115 (1973): 809–10, has suggested that the altarpiece was placed *in situ* only in 1522 and that Titian then discovered that the intended effect of his first composition did not work satisfactorily in practice. Based on perhaps too literal a reading of the payment document, Hope's hypothesis is difficult to reconcile with the recent revelations of Titian's further intermediate solutions. Those same radiographic discoveries render all the more implausible the elaborate "perspective exegesis," difficult enough to follow, let alone accept, offered by Warman Welliver, "The Buried Treasure of Titian's Perspective: The Architecture in the 'Pala Pesaro,' " in *Tiziano e Venezia: Convegno Internazionale,* pp. 207–11.

39 Indeed, persuaded by the intelligence and logic of Titian's earlier compositional solution, both Sinding-Larsen ("Titian's Madonna," esp. pp. 141–47) and I ("Titian in the Frari," esp. pp. 200–07)—while acknowledging the need for further technical analysis—had concluded that the columns were later, possibly seventeenth-century additions to Titian's picture (they are, in fact, recorded in a drawing attributed to Federico Zuccaro [published by Giles Robertson, "A Drawing after Titian's 'Madonna di Ca' Pesaro,' " pp. 559–61]). We were both evidently deceived by the repainted surfaces and slight perspective modifications, which have just recently been removed. In the correspondence with Ann Sutherland Harris following the publication of my article (*Art Bulletin* 54 [1972]: 116–20) one central issue involved the question of whether or not there was any overpaint on the canvas at all; such restoration was fully documented in the nineteenth century, and that issue, at least, seems to have been finally resolved by the recent cleaning. The documentary references to early repainting and restoration may be found in my "Titian in the Frari," p. 196, n. 3, and in my reply to Harris (*Art Bulletin* 54 [1972]: 118–19); see also Valcanover's forthcoming publication. On other eighteenth-century tampering with Titian's work, see Zanetti's criticism, cited below, chap. 3, n. 85.

40 Crowe and Cavalcaselle, *Titian,* vol. 1, p. 306. For the response of later copyists, who had difficulty in accepting the final composition with its vestigial wall, see Rosand, "Titian in the Frari," pp. 203–05. A fuller discussion of size and scale in the *Pesaro Madonna* is offered by Thomas Puttfarken, *Masstabsfragen: über die Unterschiede zwischen grossen und kleinen Bildern* (diss., Hamburg, 1971), pp. 9–51.

41 From a sermon formerly ascribed to St. Augustine, cited in Howard Hibbard, *Poussin: The Holy Family on the Steps* (New York, 1974), pp. 88–90 and n. 76, with further references. See also Yrjö Hirn, *The Sacred Shrine: A Study of the Poetry and Art of the Catholic Church* (London, 1912), p. 464.

42 Cf. Mirella Levi D'Ancona, *The Iconography of the Immaculate Conception in the Middle Ages and Early Renaissance* (Monographs on Archaeology and Fine Arts of the College Art Association of America, vol. 7) (New York, 1957), p. 70, n. 162, and, the most recent contribution to the discussion, Helen S. Ettlinger, "The Iconography of the Columns in Titian's Pesaro Altarpiece," *Art Bulletin* 61 (1979): 59–67—but cf. the letter to the editor from Sinding-Larsen, *Art*

Bulletin 62 (1980): 304. Erik Forssman ("Über Architekturen in der venezianischen Malerei des Cinquecento," *Wallraf-Richartz Jahrbuch* 29 [1967]: 108) suggests that they may represent the columns Jachin and Boaz of Solomon's Temple, an identification not incompatible with the gates of heaven. Less plausible, however, is Puttfarken's hypothesis (*Masstabsfragen*, n. 5), which links the columns with the apostles James, Cephas (i.e., Peter), and John—"who seemed to be pillars" (Galatians 2:9)—Jacopo Pesaro himself supposedly substituting for the pillar James.

43 Although the figures, surprisingly thin in pigment substance and revealing very little to radiography, apparently were actually painted late in the execution of the canvas, we must assume that their general position within the composition had been determined early in the planning.

44 In the subdued ambivalence of his gesture, Titian's gentle Francis recalls the example of Giovanni Bellini's in the Frick Collection (as Millard Meiss observed: *Giovanni Bellini's St. Francis in the Frick Collection* [Princeton, 1964], p. 13). The standard-bearing warrior behind Jacopo Pesaro, identified by Vasari as St. George and by Dolce as an anonymous "armato con una bandiera," has recently been tentatively recognized as St. Mauritius by Fehl ("Saints, Donors and Columns," pp. 77–80), who, with perhaps too generous optimism, notes the special compassion of this victor leading the Turk "into the presence of the Madonna, not in triumph but with a love that wants to share the gifts of Christianity with him." More convincing is Sinding-Larsen's reading of the figural action, in which Jacopo Pesaro's "offering" of his trophies is viewed in a liturgical context ("La Pala del Pesaro," p. 206).

45 It is worth noting that the older literary sources make no mention of the architecture of the *Pesaro Madonna* but are impressed mainly by the naturalism of the figures. Cf. Dolce, *Dialogo*, p. 203; Vasari, *Vite*, vol. 7, p. 436; the "Anonimo del Tizianello," *Breve compendio della vita del famoso Tiziano Vecellio* (Venice, 1622) (unpaginated); and Ridolfi, *Maraviglie*, vol. 1, pp. 163–64.

46 See especially the classic essay by Millard Meiss, "Light as Form and Symbol in Some Fifteenth-Century Paintings," *Art Bulletin* 27 (1945): 175–81; repr. in the author's collected essays, *The Painter's Choice*, pp. 3–18.

47 For this dating, see above, n. 3.

48 For further comments on the signifying function of such motifs in Titian's art, see my "*Ut Pictor Poeta*: Meaning in Titian's *Poesie*," *New Literary History* 3 (1971–72): 539. Cima's altarpiece of the *Incredulity of St. Thomas* (fig. 21) offers an interesting analogy in its use of cast shadow as a dramatic device—here paralleling and thereby accentuating the thrust of Thomas's probing gesture (see above, chap. 1, p. 35).

49 For the iconographic tradition, see Karl Lehmann, "The Dome of Heaven," *Art Bulletin* 27 (1945): 1–27 (repr. in *Modern Perspectives in Western Art History*, ed. W. Eugene Kleinbauer [New York, 1971], pp. 227–70); see also Wolfgang Schöne, *Über das Licht in der Malerei* (Berlin, 1954), pp. 55–81.

50 See esp. Erwin Panofsky, *Early Netherlandish Painting* (Cambridge, Mass., 1953), vol. 1, pp. 131–48 (chap. V, "Reality and Symbol in Early Flemish Painting: 'Spiritualia sub Metaphoris Corporalium' ").

51 This relationship may be gauged by comparing Bellini's *St. Francis* in the Frick Collection with Titian's *Madonna and Saints* in the National Gallery, London (Wethey, *Paintings of Titian*, vol. 1, cat. no. 59)—a comparison already suggested by Meiss (*Bellini's St. Francis*, p. 27). Both landscapes are symbolically charged by their particular qualities of illumination: rays of light break through the clouds—at the upper left corner of Bellini's panel and directly behind the Virgin's head in Titian's picture—manifesting the holy immanence and shedding grace upon the central figures. (A color detail of this passage serves as frontispiece to Wethey, *Paintings of Titian*, vol. 1; see also Rosand, *Titian*, pl. 22, with further comment.)

52 The best survey of this theme remains Schöne, *Über das Licht in der Malerei*. For particular aspects of the tradition, see the useful essay by John Beckwith, "Byzantium: Gold and Light," in *Light in Art*, ed. Thomas B. Hess and John Ashbery (New York and London, 1971), pp. 67–81, and especially Erwin Panofsky, "Abbot Suger of St.-Denis," in his *Meaning in the Visual Arts* (Garden City, N.Y., 1957), pp. 108–45, and Otto von Simson, *The Gothic Cathedral* (New York, 1962), pp. 50–58 and passim; also Hans Peter l'Orange, "*Lux aeterna*: l'adorazione della luce nell'arte tardo-antica ed alto-medioevale," *Atti della Pontificia Accademia Romana di Archaeologia, Rendiconti* 47 (1974–75): 191–202. For the later development of the theme, in addition to Meiss, "Light as Form and Symbol," see Jan Białostocki, "*Ars auro prior*," in *Mélanges de littérature et de philologie offerts à Mieczyslaw Brahmer* (Warsaw, 1966), pp. 55–63, and E. H. Gombrich, "Light, Form and Texture in XVth Century Painting," *Journal of the Royal Society of Arts* 112 (1964): 826–49 (repr. as "Light, Form and Texture in Fifteenth-Century Painting North and South of the Alps," in his *The Heritage of Apelles* [Ithaca, 1976], pp. 19–35).

Finally, see the recent suggestive study by John Gage, "Colour in History: Relative and Absolute," *Art History* 1 (1978): 104–30.

53 On Malchiostro and his chapel, see Giuseppe Liberali, *Lotto, Pordenone e Tiziano a Treviso* (*Memorie dell'Istituto Veneto di Scienze, Lettere ed Arti*, vol. 33, no. 3) (Venice, 1963), pp. 35–63. Wethey (*Paintings of Titian*, vol. 1, cat. no. 8) inverts the name of the donor, Broccardo Malchiostro, and hence locates the picture in the "Broccardi Chapel."

54 On the iconography of the cloud and the sun, see Hirn, *The Sacred Shrine*, pp. 346–49, 466–68, and particularly n. 97 on p. 553, quoting a strophe from the *Encomium beatae Mariae* of Gualterus Wiburnus. Hirn himself (p. 314) had already recognized the symbolic function of the light in Titian's *Annunciation*. Further references: below, chap. 3, n. 87.

55 Juergen Schulz, "Pordenone's Cupolas," in *Studies in Renaissance and Baroque Art presented to Anthony Blunt* (London, 1967), p. 46.

56 Accommodating itself to the light source in the chapel, the Treviso *Annunciation*, despite the asymmetry of its architecture, remains in effect a centralized composition. Although off-center, its vanishing point lies within the pictorial field; the orthogonals converge toward the angel, adding visual weight to his diminutive figure and thereby effectively balancing the larger form of the Virgin. With regard to this centrality of perspective focus, cf. also the comments of Alessandro Parronchi, "La prospettiva a Venezia tra Quattro e Cinquecento," *Prospettiva* 9 (1977): 15–16.

57 In the words of Giovanni Battista Armenini, who merely repeats a commonplace, the painter should see that his works are "convenienti alle qualità de' luoghi" (*De' veri precetti della pittura* [1587] [Pisa, 1823], p. 165).

58 Vasari, *Vite*, vol. 7, p. 453: ". . . ed oltre ciò ha finto un lampo che, venendo di cielo e fendendo le nuvole, vince il lume del fuoco e quello delle lumiere. . . ."

59 Jacobus de Voragine, *The Golden Legend*, trans. Granger Ryan and Helmut Ripperger (New York, London, and Toronto, 1941), p. 441.

60 Cf. Panofsky, *Problems in Titian*, pp. 53–57, with a persuasive interpretation of the statue as a Victory-bearing Vesta symbolizing and witnessing "the very act of transition from paganism to Christianity"; see also Robert W. Gaston, "Vesta and the *Martyrdom of St. Lawrence* in the Sixteenth Century," *Journal of the Warburg and Courtauld Institutes* 38 (1974): 358–62. Ruth Wedgwood Kennedy, *Novelty and Tradition in Titian's Art* (Northampton, Mass., 1963), pp. 14–15, offers further observations on the variety of Titian's sources, ancient and Renaissance. A fuller discussion of the picture in relation to earlier prototypes as well as to Titian's later versions is provided by Eugen von Rothschild, "Tizians Darstellungen der Laurentiusmarter," *Belvedere* 10[1] (1931): 202–09; 10[2] (1931): 11–17; for further references, see Wethey, *Paintings of Titian*, vol. 1, cat. no. 114, and, for a color reproduction, Rosand, *Titian*, pl. 37.

61 Meiss, "Light as Form and Symbol," n. 27. For the iconography of the burning bush, see Hirn, *The Sacred Shrine*, p. 450; Levi D'Ancona, *The Iconography of the Immaculate Conception*, pp. 67–70; and the references cited by Wethey, *Paintings of Titian*, vol. 1, cat. no. 11. On the dating of the picture, see Ruggero Maschio, "Una data per l' 'Annunciazione' di Tiziano a S. Salvador," *Arte veneta* 29 (1975): 178–82, and Wethey, *Paintings of Titian*, vol. 3, p. 257. A color reproduction is in Rosand, *Titian*, pl. 43.

 The gesture (veiling or, more likely here, unveiling) of the Virgin in Titian's *Annunciation* has been said to derive from an antique prototype in the Grimani Collection (Ruth Wedgwood Kennedy, "Tiziano a Roma," in *Il mondo antico nel Rinascimento* [*Atti del V Convegno Internazionale di Studi sul Rinascimento*] [Florence, 1958], p. 237). For all its classical poise, however, the expressive intent of the gesture seems to share more significant qualities with earlier Italian paintings like Simone Martini's *Annunciation* in the Uffizi. Both images, in which the dove descends through an opening in the heavens toward the Virgin's head, evidently represent the iconography of the conception *per aurem*—which would serve to explain the particular protective recoil of Mary. (For the conception through the ear, see Meiss, "Light as Form and Symbol," p. 48, with further references, and, for Titian's allusion to the iconography in his *Annunciation* in the Scuola di San Rocco, Panofsky, *Problems in Titian*, p. 30; for the tradition of such representations in illustrated missals printed in Venice, see Duc de Rivoli, *Les missels imprimés à Venise de 1481 à 1600* [Paris, 1896], pp. 5–13). Although Panofsky's insistence that Titian's San Salvatore altarpiece must have been influenced by Michelangelo's design of the Annunciation (*Problems in Titian*, p. 25) is unconvincing in the essentially formal context in which it occurs, the two compositions do indeed share precisely this iconography; significantly, in the Florentine's conception the word is transmitted, at least implicitly, by touch.

62 J. C. J. Bierens de Haan, *L'Oeuvre gravé de Cornelis Cort, graveur hóllandais* (The Hague, 1948), p. 47, no. 23. For a more general discussion of Titian and his printmakers, see Rosand and Muraro, *Titian and the Venetian Woodcut*, esp. pp. 22–23 and 26–27, with further bibliography.

63 The freedom of Titian's late style was evidently capable of disturbing his more conservative patrons. According to Ridolfi (*Maraviglie*, vol. 1, p. 205), the emphatic signature on the *Annunciation*, "TITIANVS FECIT FECIT," was prompted by the friars' complaint that the painting had not been "ridotta à perfettione." The biographer then observes that the canvas had indeed suffered and had been restored by some incompetent painter, presumably Philip Esengren, to the further detriment of its "purità."

64 The documents concerning Titian's death and burial on the following day were published by Giuseppe Cadorin, *Dello amore ai Veneziani di Tiziano Vecellio* (Venice, 1833), p. 95, docs. L, M.

65 Ridolfi, *Maraviglie*, vol. 1, p. 206: "Haveva anco dato principio ad una tavola col morto Salvatore in seno alla dolente Madre, à cui San Girolamo serviva di sostegno, e la Maddalena con le braccia aperte si condoleva, che disegnava por Titiano nella Cappella del Christo nella Chiesa de'Frari, ottenuta da'Padri con patto di farvi quella pittura; mà portandosi la cosa in lungo ò perche, come altri dicono, non vollero quelli perder l'antica divotione del Crocefisso, che vi si vede, non vi diede fine. . . ." That the Cappella del Christo or del Crocefisso was indeed a venerated site in the Frari is attested by Sansovino in 1581: "Vi si honora parimente il Christo miracoloso situato à mezza Chiesa, à cui piedi è sepolto quel Titiano, che fu celebre nella pittura, frà tutti gli altri del tempo nostro" (*Venetia*, ed. 1663, p. 188). In 1579 the altar was conceded to the Confraternità della Passione (Soràvia, *Le chiese*, vol. 2, p. 19).

66 "Anonimo del Tizianello," *Breve compendio:* "Morì finalmente il gran Titiano di età d'anni 99, & fù sepolto nella Chiesa de'Frari di Venetia, chiamata la Ca' Grande all'Altare del Crocefisso, benche havesse morendo ordinato di dover esser sepolto, nella Chiesa Archidiaconale della sua Patria, nella sudetta Capella della sua vera Famiglia, ma ciò non seguì perche s'interpose una mortifera pestilenza, che non lasciò essequire in questo l'ordinatione di lui. . . ." Evidently following this passage, Laurie Schneider has assumed that the painting itself was placed in the family chapel at Cadore ("A Note on the Iconography of Titian's Last Painting," *Arte veneta* 23 (1969): 219, n. 1).

67 Ridolfi, *Maraviglie*, vol. 1 p. 209: "Onde d'anni 99 terminò il viaggio della vita, ferito di peste il 1576 e benche fossero vietati ad ogn'uno i funerali, gli furono dall'autorità de'maggiori conceduti gli honori della sepultura; e nella Chiesa de' Frari à piè dell'Altare del Crocefisso, come vivendo haveva ordinato, col modo più convenevole, che permise quel tempo, con le insegne di Cavaliere fù seppelito, non potendosi all'hora accrescere maggiormente la dovuta pompa " Francesco Beltrame (*Cenni illustrativi sul monumento a Tiziano* [Venice, 1852], pp. 79 and 95, n. 107) suggested that the ceremonies may have been held in San Marco. For the question of whether Titian died of the plague or, more likely, of old age during the plague, see Beltrame, p. 79; Pallucchini, *Tiziano*, vol. 1, p. 199; and Wethey, *Paintings of Titian*, vol. 3, p. 262.

68 The program was recorded by Ridolfi, *Maraviglie*, vol. 1, pp. 211–18. For the Michelangelo obsequies, see Rudolf and Margot Wittkower, *The Divine Michelangelo: The Florentine Academy's Homage on His Death* (London, 1964).

69 Fogolari, *I Frari*, pl. 19, and Sartori, *Frari*, ill. on p. 21. The iconography of Canova's design, with its veiled mourning personification of Painting followed by Sculpture and Architecture, may have been inspired by the program for the catafalque in honor of Titian. For Canova's preparatory drawings and *bozzetti*, see Elena Bassi, *La Gipsoteca di Possagno, sculture e dipinti di Antonio Canova* (Venice, 1957), cat. nos. 69–71, and Giovanni Mariacher, "Bozzetti inediti di Antonio Canova al Museo Correr di Venezia," in *Arte neoclassica* (*Atti del Convegno . . .*, 1957) (Venice and Rome, 1964), pp. 190–94; for a fuller discussion, see Selma Krasa, "Antonio Canovas Denkmal der Erzherzogin Marie Christine," *Albertina Studien* 5–6 (1967–68): 67–134.

70 The epitaph was first recorded at the end of the eighteenth century, in a late posthumous edition of Giambattista Albrizzi's guidebook (originally published in 1740), *Forestiero illuminato intorno alle cose più rare e curiose, antiche e moderne della città di Venezia* (Venice, 1792), p. 205, and then by Gianantonio Moschini, *Guida per la città di Venezia* (Venice, 1815), vol. 2, pp. 172–73. Beneath the epitaph another inscription was added when the present monument to Titian was erected: "LAPIDE ANTICA QUI TROVATA E QUI RICOLLOCATA BENCHE SENZA TRACCIA DELLA MORTALE SPOGLIA DEL PITTORE MDCCCLII." See Beltrame, *Cenni*, p. 95, n. 108.

71 Fogolari, *I Frari*, p. xxx. For the history and program of the monument, see Beltrame, *Cenni*, and, more recently, Zigmunt Wazbinski, "Tiziano Vecellio e la 'tragedia della sepoltura,' " in *Tiziano e Venezia: Convegno Internazionale*, pp. 255–73.

72 In his transcription of the text, Ridolfi misread "perfecit" for "absolvit" (*Maraviglie*, vol. 1, p. 206). After its completion by Palma the painting evidently entered the church of Sant'Angelo, where Boschini records it (*Le minere della pittura* [Venice, 1664], p. 119); it was acquired by the Accademia in 1814. For the history of the restorations and general condition of the canvas, see Sandra Moschini Marconi, *Gallerie dell'Accademia di Venezia*, vol. 2, *Opere d'arte del secolo XVI*

(Rome, 1962), no. 453. See also Wethey, *Paintings of Titian,* vol. 1, cat. no. 86, vol. 3, pp. 261–62, and Rosand, *Titian,* pls. 47, 48.

73 On Palma's attempt to associate his name with Titian, see David Rosand, "Palma il Giovane as Draughtsman: The Early Career and Related Observations," *Master Drawings* 8 (1970): 154–55.

74 Ridolfi states that the painting was completed by Palma "con l'aggiongervi alcuni Angeletti" (*Maraviglie,* vol. 1, p. 206). The quite visible *pentimenti* on the surface revealing the outlines of a torch indicate that another position for this figure was once contemplated; whether Titian or Palma initiated the change is difficult to determine.

75 Boschini's famous description of Titian's working methods, ostensibly based on the testimony of Palma, is quoted above, chap. 1, n. 81. Boschini's account and the composite structure of the canvas lend support to Johannes Wilde's suggestion (in *Zeitschrift für Kunstgeschichte* 6 [1937]: 54) that the central group of the *Pietà* was first conceived as an independent work and that only later did Titian expand the canvas and the composition to its present form. A. H. R. Martindale, in a review of Moschini Marconi's Accademia catalogue (*Burlington Magazine* 106 [1964]: 578), revived Wilde's intriguing but neglected hypothesis, which has since been tentatively endorsed by Panofsky (*Problems in Titian,* p. 26, n. 43). More recently several other scholars have returned to discuss the physical makeup and genesis of the canvas: Jürg Meyer zur Capellen, "Überlegungen zur 'Pietà' Tizians," *Münchner Jahrbuch der bildenden Kunst* 22 (1971): 117–32; Vinzenz Oberhammer, "Gedanken zum Werdegang und Schicksal im Tizians Grabbild," in *Studi di storia dell'arte in onore di Antonio Morassi* (Venice, 1971), pp. 152–61; J. Bruyn, "Notes on Titian's Pietà," in *Album amicorum J. G. van Gelder* (The Hague, 1973), pp. 66–75—all, finally, briefly reviewed by Wethey, *Paintings of Titian,* vol. 3, pp. 261–62.

76 See E. Tietze-Conrat, "Titian's Workshop in His Late Years," *Art Bulletin* 28 (1946): 76–88.

77 This hypothesis would not contradict the observations of Boschini, who writes that "li chiaroscuri sono tutti di Tiziano, ma le altre figure sono in molti luoghi ritocche e coperte dal Palma" (*Minere,* pp. 119–20). Such "retouching" might conceivably account for certain qualitative differences between the rendering of the Magdalen (most persuasively Titian's) and of St. Jerome.

78 The loneliness of Titian's late style was recognized by Vasari: "Ora, se bene molti sono stati con Tiziano per imparare, non è però grande il numero di coloro che veramente si possano dire suoi discepoli; perciochè non ha molto insegnato, ma ha imparato ciascuno più e meno, secondo che ha saputo pigliare dall'opre fatte da Tiziano" (*Vite,* vol. 7, p. 460).

79 The derivation of the Magdalen was first noted by Fritz Saxl in 1935 (see his *Lectures* [London, 1957], vol. 1, p. 173). For a summary statement regarding the importance of Michelangelo, see Panofsky, *Problems in Titian,* pp. 25–26.

80 See Saxl, *Lectures,* vol. 1, p. 171; George Martin Richter, *Giorgio da Castelfranco* (Chicago, 1937), pp. 215–16; and, for an interpretation of the picture, Panofsky, *Problems in Titian,* pp. 168–71—but cf. André Chastel, "L'Ardita capra," *Arte veneta* 29 (1975): 146–49, for an alternative reading, and Wethey, *Paintings of Titian,* vol. 3, cat. no. 27. George Goldner, "A Source for Titian's 'Nymph and Shepherd,' " *Burlington Magazine* 116 (1974): 392–95, has recognized the similarity of Titian's shepherd to Sebastiano del Piombo's *Polyphemus* in the Farnesina.

81 Lodovico Foscari, *Iconografia di Tiziano* (Venice, 1935), p. 25; also Hourticq, *La jeunesse,* pp. 195–97, for further comment on Titian's self-identification with Joseph of Arimathea in various compositions of the Entombment, and, most recently, see Gilbert, "Some Findings on Early Works of Titian," pp. 62–71. Bruyn ("Notes," p. 75, n. 49), however, doubts any such personal significance in the figure of St. Jerome in the *Pietà.*

82 On the background for this type of image, see Erwin Panofsky, " 'Imago Pietatis,' " in *Festschrift für Max J. Friedländer* (Leipzig, 1927), pp. 261–308, and Sixten Ringbom, *Icon to Narrative: The Rise of the Dramatic Close-up in Fifteenth-Century Devotional Painting* (Åbo, 1965), pp. 52–58. Schneider ("A Note on Titian's Last Painting," p. 219, n. 14) argues the appropriateness of Joseph of Arimathea in the *Pietà* with respect to his position as a patron of undertakers and gravediggers. Meyer zur Capellen ("Überlegungen," pp. 126–27), citing Job 19:25–26, identifies this figure as that Old Testament prophet—functioning in all his roles, from type of the Christian soul to prefiguration of Christ.

A certain kind of confirmation of the figure's identity as St. Jerome is offered by Palma il Giovane. In his large canvas on the entrance wall of the Sala del Senato in the Ducal Palace Doge Girolamo Priuli is accompanied by his onomastic saint, who is a direct quotation from Titian's *Pietà*—which, we recall, Palma had acquired and completed. Palma's votive picture of Lorenzo and Girolamo Priuli is illustrated in Staale Sinding-Larsen, *Christ in the Council Hall: Studies in the Religious Iconography of the Venetian Republic* (*Acta ad archaeologiam et artium historiam pertinentia* [Institutum Romanum Norvegiae], vol. 5) (Rome, 1974), pl. XXXIV.

83 Wethey, *Paintings of Titian,* vol. 1, cat. nos. 104–07. Cf. also the woodcut of ca. 1525–30 (Rosand and Muraro, *Titian and the Venetian Woodcut,* cat. no. 22).

84 Cf. the similar panel in the woodcut of *St. Roch* (fig. 33), discussed above. For the popular tradition of small votive panels to which this image belongs, see Gino Fogolari, "Le tavolette votive della Madonna dei Miracoli di Lonigo," *Dedalo* 2 (1922): 580–98. For further observations on the presumably autobiographical content of other late paintings by Titian, see Erwin Panofsky, "Titian's *Allegory of Prudence*: A Postscript," in his *Meaning in the Visual Arts*, esp. pp. 165–68.

85 Panofsky, *Problems in Titian*, p. 26. On the terms of the *disegno-colorito* controversy, see above, chap. 1, sec. 3.

86 On Van Eyck's representational mastery of the various arts, see Meiss, "Light as Form and Symbol," pp. 67–68, and Panofsky, *Early Netherlandish Painting*, vol. 1, pp. 179–82 and passim.

87 Saxl, *Lectures*, vol. 1, p. 173.

88 The association of lions with Divine Wisdom goes back to the decorations on the throne of Solomon (discussed below, chap. 3, n. 134). In the context of the *Pietà*, however, we must also recall the function of the lion as symbol of the Resurrection—or its role in funerary ritual ("ab ora leonis libera nos Domine"), as suggested by Nicola Ivanoff, "Tiziano e la critica contenutista," in *Tiziano, nel quarto centenario della sua morte*, p. 192, n. 9.

89 The fig leaves adorning the pediment have been interpreted as symbolic of the Passion (Meyer zur Capellen, "Überlegungen," p. 128) and as references to the Fall of Man and his subsequent Redemption (Wethey, *Paintings of Titian*, vol. 3, p. 262). In either reading, however, they participate in the central theme of Death and Resurrection. The literature on the symbolic fig leaf is now rather impressive: Frederike Klauner, "Zur Symbolik von Giorgiones 'Drei Philosophen,' " *Jahrbuch der kunsthistorischen Sammlungen in Wien* 51 (1955): 145–68; Oswald Goetz, *Der Feigenbaum in der religiösen Kunst des Abendlandes* (Berlin, 1965), esp. p. 122, on the *Pietà*; André Chastel, "Sur deux rameaux de figuier," in *Studies in Late Medieval and Renaissance Painting in Honor of Millard Meiss* (New York, 1977), pp. 83–87; and Mirella Levi D'Ancona, *The Garden of the Renaissance: Botanical Symbolism in Italian Painting* (Florence, 1977), pp. 135–42.

90 A specific reference to the site is implicit in the Greek inscription on the wall behind Moses: "ΜΟΥΣΗΣΙΕΡΟΝ" ("The Temple of Moses"—translated by Wethey as "The Sacred Place of the Muse"). The inscription, difficult to read now, was transcribed by Zanotto (*Pinacoteca della Imp. Reg. Accademia Veneta delle Belle Arti*, vol. 2 [Venice, 1834]). The inscription behind the Hellespontine Sibyl reads, again according to Zanotto, "ΘΕΟΣ ΛΝΟΣ ΕΝΕΣΤΙΚΗ ("The Lord is Risen").

91 See Kate Dorment, "Tomb and Testament: Architectural Significance in Titian's *Pietà*," *Art Quarterly* 35 (1972): 399–418, where the allusiveness of the architectural background is discussed with significant reference to altar, tomb, fountain, and portal.

92 It is interesting to speculate whether Titian may have intended an actual relationship with the *Pesaro Madonna*, for the glances would have been directed diagonally across the nave toward the Pesaro altar. Cf., however, Meyer zur Capellen's attempt to relocate the Altare del Crocefisso so that the figures in the *Pietà* would have directed themselves instead to the *Assunta* ("Überlegungen," pp. 125–26).

93 Although of a somewhat different order because of the inherent nature of its subject as dramatic narrative, the *Martyrdom of St. Peter Martyr* (fig. 32) too was designed for a side altar, in the spacious basilica of SS. Giovanni e Paolo, and does indeed function in a manner analogous to the *Pietà*. The canvas was destroyed by fire in the nineteenth century (see Wethey, *Paintings of Titian*, vol. 1, cat. no. 133, for further references).

1 Walter Pater, *The Renaissance*, ed. Kenneth Clark (Cleveland and New York, 1961), p. 128.

2 The Scuola della Carità was officially suppressed on 25 April 1806 (see below, Excursus). For bibliography on the painting, see Sandra Moschini Marconi, *Gallerie dell'Accademia di Venezia*, vol. 2, *Opere d'arte del secolo XVI* (Rome, 1962), no. 451, and Harold E. Wethey, *The Paintings of Titian* (London, 1969–75), vol. 1, cat. no. 87.

3 The 1530s constitute the third phase of Titian's development according to the sexpartite scheme formulated by Theodor Hetzer (see above, chap. 2, n. 4), whose interpretation was given wider circulation by Hans Tietze, *Tizian: Leben und Werk* (Vienna, 1936), vol. 1, esp. pp. 144, 147, and *Titian* (London, 1950), pp. 28–30.

4 Erwin Panofsky, *Problems in Titian, Mostly Iconographic* (New York, 1969), p. 21. Roberto Longhi (*Viatico per cinque secoli di pittura veneziana* [Florence, 1952], p. 24) viewed Titian's *Presentation of the Virgin* as an unfortunate interruption in the master's creative development, a painting characterized by a "banalità arcaistica"—a judgment cited approvingly by Rodolfo Pallucchini, *Tiziano* (Florence, 1969), vol. 1, p. 84.

5 Carlo Ridolfi, *Le maraviglie dell'arte* (1648), ed. Detlev von Hadeln (Berlin, 1914–24), vol. 1, pp. 153–54.

CHAPTER 3. TITIAN'S *PRESENTATION OF THE VIRGIN IN THE TEMPLE* AND THE SCUOLA DELLA CARITÀ

6 Giorgio Vasari, *Le vite de' più eccellenti pittori, scultori ed architettori* (1568), ed. Gaetano Milanesi (Florence, 1878–85), vol. 7, p. 440: "con teste d'ogni sorte ritratte dal naturale." Cf. also Raffaello Borghini, *Il Riposo* (1584) (Florence, 1730), p. 430, and the so-called "Anonimo del Tizianello," *Breve compendio della vita del famoso Tiziano Vecellio di Cadore* (Venice, 1622) (unpaginated).

7 For some of these identifications, see Francesco Zanotto, *Pinacoteca della Imp. Reg. Accademia Veneta delle Belle Arti* (Venice, 1833–34), vol. 2 [p. 223ᵛ], repeated by Anna Jameson, *Legends of the Madonna as Represented in the Fine Arts,* 3d ed. (London, 1864), pp. 153–54; also Louis Hourticq, *La jeunesse de Titien* (Paris, 1919), p. 278, and, most recently, Peter Meller, "Il lessico ritrattistico di Tiziano," in *Tiziano e Venezia: Convegno Internazionale di Studi, Venezia, 1976* (Vicenza, 1980), pp. 333–34.

8 Jacob Burckhardt, *The Cicerone* (1855), trans. Mrs. A. H. Clough (London, 1909), p. 195.

9 "Anonimo del Tizianello," *Breve compendio:* "ma sopra il tutto vi si vede una Vecchia tutta ranichiatta, & crespa, che guardando quell'attione rende stupore à chiunque intendente la contempla." Ridolfi, *Maraviglie,* vol. 1, p. 154: "A fianchi alla scala siede una vecchia contadina, in vilesco drappo involta con uova e poli entro ad un cesto, che non si può esprimere, quanto sia naturale." Marco Boschini, *Le minere della pittura* (Venice, 1664), p. 361: "à piedi dello scalinato, una Vecchia Contadina, con un cesto d'ovi, & poli più naturale, che se fosse viva." Antonio Maria Zanetti, *Della pittura veneziana* (Venice, 1771), p. 114: "la famosa figura di quella vecchia villana, che stassi a sedere in un canto, presso ad un canestrello d'uova e ad alcuni polli. Non può essere più viva e più vera nello spirito e nell'atteggiamento essa villana: e quel ch'è più raro è dipinta con molta felicità."

 A lone dissenting voice was raised in the nineteenth century by John Ruskin: "Opposite you is Titian's great 'Presentation of the Virgin,' interesting to artists, and an unusually large specimen of Titian's rough work. To me, simply the most stupid and uninteresting picture ever painted by him:—if you can find anything to enjoy in it, you are very welcome: I have nothing more to say of it, except that the colour of the landscape is as false as a piece of common blue tapestry, and that the 'celebrated' old woman with her basket of eggs is as dismally ugly and vulgar a filling of spare corner as was ever daubed on a side-scene in a hurry at Drury Lane" (*Guide to the Principal Pictures in the Academy of Fine Arts at Venice* [1877], in *The Works of John Ruskin,* ed. E.T. Cook and Alexander Wedderburn, vol. 24 [London and New York, 1906], p. 158).

10 Louis Réau, *Iconographie de l'art chrétien* (Paris, 1955–59), vol. 2², p. 165.

11 Cf., most recently, S. J. Freedberg, *Painting in Italy, 1500 to 1600* (Harmondsworth and Baltimore, 1971), p. 216.

12 Panofsky, *Problems in Titian,* p. 22. Panofsky's attitude toward Titian's old women appears rather personal at times. (On the aged scholar's special relationship to the old Titian, see Michelangelo Muraro's review, *Art Bulletin* 54 [1972]: 353–55.) For further modern response to the *vecchia,* see Kurt Bauch, "Zu Tizian als Zeichner," in *Walter Friedlaender zum 90. Geburtstag* (Berlin, 1965), pp. 36–37.

13 Theodor Hetzer, *Tizian: Geschichte seiner Farbe* (Frankfurt am Main, 1935), pp. 119–21; also Tietze, *Tizian,* vol. 1, pp. 150–51, *Titian,* p. 29.

14 An inscription now above one of the landings of the double staircase in the Accademia reads: "CHARITATE AMORE / HUMANITATE IN / PAUPERES ANTECESSORES / AEDIFICARUNT MCCLX / SUCCESSORES VERO / RESTAURARUNT MDLXVI." It is recorded by Francesco Sansovino, *Venetia città nobilissima et singolare* (1581), ed. Giustiniano Martinioni (Venice, 1663), p. 282; see also Giuseppe Tassini, "Iscrizioni dell'ex chiesa, convento e confraternita di S. Maria della Carità in Venezia," *Archivio veneto* 12 (1877): 114. On the building of the Scuola della Carità, see the Excursus below.

 By the middle of the sixteenth century there were six *scuole grandi* in Venice, one in each of the *sestieri:* Santa Maria della Carità (1260) in the *sestiere* of Dorsoduro; San Marco (1261) in Castello; San Giovanni Evangelista (1261) in Santa Croce; Santa Maria della Misericordia (1308) in Cannaregio; San Rocco (1478) in San Polo; and the Scuola di San Teodoro in the *sestiere* of San Marco. This last was actually the oldest of the confraternities, founded in 1258, but it was not designated a *scuola grande* until 1552 (see Rodolfo Gallo, "La Scuola Grande di San Teodoro di Venezia," *Atti dell'Istituto Veneto di Scienze, Lettere ed Arti* 120 (1961–62): 461–95). Indeed, according to Marino Sanuto, on 31 May 1533 the Scuola di Santa Maria della Giustizia had originally been selected as the *scuola grande* in the *sestiere* of San Marco: "Fu preso, che la scuola di S. Maria di Colombini da San Fantin, va a compagnar li iusticiadi, sia nel numero de le altre 5 scuole de Veniexia . . ." (*I Diarii,* ed. Rinaldo Fulin et al. [Venice, 1879–1903], vol. 58, col. 238). That decision, evidently, was never carried out and was eventually reversed.

 For the origins, evolution, and function of the *scuole grandi,* see the fundamental study by

Brian Pullan, *Rich and Poor in Renaissance Venice* (Oxford: 1971), pp. 33–193, and the dissertation of William B. Wurthmann, "The *Scuole Grandi* and Venetian Art, 1260–c.1500" (University of Chicago, 1975), pp. 1–128; also Lia Sbriziolo, *Le confraternite veneziane di devozione, saggio bibliografico e premesse storiografiche* (Rome, 1968). For a more general background, see the still useful survey by Gennaro Maria Monti, *Le confraternite medievali dell'alta e media Italia*, 2 vols. (Venice, 1927).

15 "Questa nostra fraterna hebbe principio da grandissimo amore et infinita dillettione verso il prossimo, et intitolandosi dal glorioso et honorato nome della maggior virtu teologica, cioe la carita, nella quale proprio e la fede de Dio benedetto" (Archivio di Stato, Venice: Scuola Grande di Santa Maria della Carità, Registro 236, fol. 70). The position of the *scuole grandi* in the fabric of Venetian life is succinctly summarized by Giovanni Nicolò Doglioni, *Le cose maravigliose dell'inclita città di Venezia . . .* (Venice, 1603), p. 42:

 Noi habbiamo sei scuole ò fraterne che le diciate, delle quali io non credo, che in tutta Italia se ne trovino altre tante così ricche e superbe. Ricche d'entrate, di paramenti sacri, di argentarie e di cose appartenenti al culto divino: Superbe per edifici. . . . Tutte le sopradette scuole hanno sale reali, lequali non sarebbono se non grandi a qualunque palazzo di qualunque Signor si sia; percioche i primi ordinatori volsero, che i fratelli s'adunassero tutti in un luogo spatioso, e capace a udir l'officio divino. In queste scuole si maritano assai vergini ogni anno. Si distribuiscono case a poveri huomini per l'amor di Dio; si fanno limosine notabili; & pochi sono che morendo non lascino qualche cosa a dette scuole. Et perch'elle son sottoposte al Consi. Illustrissimo de X. per legge del 1468, però potete considerare s'elle sono di grande importanza; la pompa delle quali si vede tutto l'anno, ma molto più il dì del Corpo di Christo, & la settimana santa.

See also Marco Ferro, *Dizionario del diritto comune e veneto* (Venice, 1778–81), vol. 9, pp. 352–56; and above, chap. 1, n. 28, and below, n. 142, for Gasparo Contarini's observations, from which Doglioni's text derives. For the particular service rendered to the republic by the Scuola della Carità during the crisis of 1310, see above, chap. 1, n. 29.

16 The officially sponsored participation of the *scholae battutorum* in the Corpus Christi procession goes back at least to 1323; in 1454 their obligation to participate was reaffirmed by the state (Monti, *Le confraternite*, vol. 1, p. 276). Further on the processions: Wurthmann, "The *Scuole Grandi*," pp. 113–17.

17 See Appendix, Document 19. The formula is typical and prefaces other decisions regarding the embellishment or renovation of the Scuola (e.g., Documents 10, 13). The importance of maintaining the *scuole grandi* as public monuments was fully recognized by the Venetian government. Thus, for example, on 6 September 1492, the Council of Ten, the magistracy in charge of overseeing the confraternities (see n. 15), allowed that for a period of five years the *scuole* were not to distribute their usual charity, but that instead the sum of 200 ducats was to be deposited "da esser spesi in fabriche, o vero in altri ornamenti della scola" (Archivio di Stato, Venice: Scuola Grande di Santa Maria della Carità, Registro 351, fol. 137; the full text of the council's decree is entered as *capitolo* 87 in Registro 236, fol. 25). Cf. also below, n. 27. For the context of this ruling, see Wurthmann, "The *Scuole Grandi*," pp. 219–21.

18 This situation will be most familiar to visitors to Venice from their experience of the Scuola di San Rocco, the only one of the *scuole grandi* surviving as a confraternity. See Rodolfo Pallucchini and Mario Brunetti, *Tintoretto a San Rocco* (Venice, 1937), and, for the best illustrations of the decorations, Charles de Tolnay, "L'Interpretazione dei cicli pittorici del Tintoretto nella Scuola di San Rocco," *Critica d'arte* 7 (1960): 341–76. On the architecture of the several *scuole*, see Pietro Paoletti, *La Scuola Grande di San Marco* (Venice, 1929); Giulio Lorenzetti, *La Scuola Grande di San Giovanni Evangelista* (Venice, 1929); Giorgia Scattolin, *La Scuola Grande di San Teodoro* (Venice, 1961); Giovanna Scirè Nepi, "La Scuola Vecchia di Santa Maria della Misericordia di Venezia," *Quaderni della Soprintendenza ai Beni Artistici e Storici di Venezia* 7 (1978): 31–36; Deborah Howard, *Jacopo Sansovino: Architecture and Patronage in Renaissance Venice* (New Haven and London, 1975), pp. 96–112; Raban von der Malsburg, *Die Architektur der Scuola Grande di San Rocco in Venedig* (diss., Heidelberg, 1978). See also Ludwig H. Heydenreich and Wolfgang Lotz, *Architecture in Italy, 1400 to 1600* (Harmondsworth and Baltimore, 1974), pp. 91–92, 317.

19 Although in its earliest usage *albergo* referred to the entire fabric of the *scuola*, Panofsky's literal translation as "guest-house" (*Problems in Titian*, p. 36) is somewhat misleading; "storehouse" would probably be closer to the functional meaning of the word: cf. Giuseppe Boerio, *Dizionario del dialetto veneziano* (Venice, 1829), p. 7.

20 For the building history of the Scuola della Carità, its *albergo*, and its lost earlier decorations, see below, Excursus.

21 Sandra Moschini Marconi, *Gallerie dell'Accademia di Venezia*, vol. 1, *Opere d'arte dei secoli XIV e XV* (Rome, 1955), no. 36. Further on this painting: below, n. 168.

22 Further on the problem of the ceiling's date: below, Excursus and n. 169.

23 Guidebooks and inventories do refer to paintings of earlier date, but these are impossible to identify with any certainty. Cf. the descriptions of Marcantonio Michiel (quoted below, n. 168) and of Boschini (*Minere*, p. 360), as well as the inventory of 1679 (Appendix: Document 27).

24 See below, Appendix: Documents 13–17.

25 Further on this competition: below, Excursus, p. 141. On Pasqualino as an artist, see Lionello Puppi, "Per Pasqualino Veneto," *Critica d'arte* 8, no. 44 (1961): 36–47.

26 Appendix: Document 18.

27 Paoletti, *Scuola Grande di San Marco*, p. 164. Completing the ceiling of its original *sala grande* in the fifteenth century, the Scuola di San Marco had itself acknowledged the inspiration of the example set by the Scuola di San Giovanni Evangelista (Paoletti, p. 16). On 27 August 1506, the Scuola della Carità declared the necessity of ordering a new banner "a honorar prima Idio e poi esser egual ale altre scuole" (Archivio di Stato, Venice: Scuola Grande di Santa Maria della Carità, Registro 236, fol. 31). The commission for this "penello over confalon che possi star al paragon con quelli de le altre scuole" went to Benedetto Diana, who was a member of the confraternity (see Gustav Ludwig, "Archivalische Beiträge zur Geschichte der venezianischen Malerei," *Jahrbuch der königlich preussischen Kunstsammlungen* 26 [1905]: supplement, p. 59); it was probably intended to replace one executed by Jacopo Bellini in 1452 (Pietro Paoletti, *Raccolta di documenti inediti per servire alla storia della pittura veneziana nei secoli XV e XVI* [*I Bellini*] [Padua, 1894], pp. 8–9). Further on the competitive world of the *scuole grandi*: Philip L. Sohm, "The Staircases of the Venetian Scuole Grandi and Mauro Coducci," *Architectura* 8 (1978): 125–49; also Wurthmann, "The *Scuole Grandi*," pp. 149–50.

28 Appendix: Document 20.

29 Appendix: Document 7. For Titian's interest in the problems of site and illumination, see below, n. 56.

30 For the payment to Pasqualino's brother, see Appendix: Document 6. The Tietzes, discounting the attribution to Carpaccio of the Uffizi drawing (fig. 64) and attempting to place it instead in the circle of Gentile Bellini, suggested that it may in fact have been Pasqualino's successful entry in the competition of 1504 (Hans Tietze and E. Tietze-Conrat, *The Drawings of the Venetian Painters in the 15th and 16th Centuries* [New York, 1944], no. 284). The drawing, which was originally published as Carpaccio's *modello* for the Scuola della Carità competition (Pompeo Molmenti and Gustav Ludwig, *Vittore Carpaccio* [Milan, 1906], p. 173), is still generally accepted as autograph: see Michelangelo Muraro, *I disegni di Vittore Carpaccio* (Florence, 1977), pp. 39–40. Jan Lauts (*Carpaccio* [London, 1962], p. 270) considered it a relatively late drawing by that master, whereas Terisio Pignatti (reviewing Lauts in *Master Drawings* 1, no. 4 [1963]: 51) attributed it to Carpaccio's son, Benedetto.

31 Further on the use of canvas in Venice: above, chap. 1, pp. 16–19.

32 On central Italian fresco tradition, see Eve Borsook, *The Mural Painters of Tuscany* (London, 1960), and Millard Meiss, *The Great Age of Fresco: Discoveries, Recoveries, and Survivals* (New York, 1970); also E. H. Gombrich, *Means and Ends: Reflections on the History of Fresco Painting* (Walter Neurath Memorial Lecture) (London, 1976).

33 See above, chap. 1, sec. 3. No thorough study of Venetian mural traditions exists; however, the circumstances to which we allude have been more fully discussed with respect to the problems of ceiling decoration by Juergen Schulz, *Venetian Painted Ceilings of the Renaissance* (Berkeley and Los Angeles, 1968), introduction.

34 In the Scuola del Santo at Padua, however, Titian seems to have adapted the compositional type and, in a certain sense, even the colors of the Venetian *teleri* to the medium of fresco, especially in the *Miracle of the New-Born Infant*. See Michelangelo Muraro, *Pitture murali nel Veneto e tecnica dell'affresco* (Venice, 1960), no. 70, and David Rosand, *Titian* (New York, 1978), pls. 6, 7. On the cycle in general: Antonio Morassi, *Tiziano: gli affreschi della Scuola del Santo a Padova* (Milan, 1956); also Wethey, *Paintings of Titian*, vol. 1, cat. nos. 93–95.

35 For further observations on the tableau composition, see above, chap. 1, pp. 39–43, and for its subsequent development, see below, chap. 4, sec. 1.

36 Victor Goloubew, *Les dessins de Jacopo Bellini au Louvre et au British Museum* (Brussels, 1912), vol. 1, pl. LXVII. This drawing, like many of Jacopo's designs in these albums, seems to have originated, initially on the right-hand page and then extended to the left, as an exercise in perspective construction, the figures evidently added to a preexisting architectural setting. For further analysis, see Marcel Röthlisberger, "Studi su Jacopo Bellini," *Saggi e memorie di storia dell'arte* 2 (1958–59): 41–89, esp. pp. 51–68. Cf. also the similarly structured composition of the *Presentation of the Virgin* in the predella of the Annunciation altarpiece in Sant'Alessandro, Brescia (fig. 63).

37 See above, n. 30.

38 Lauts, *Carpaccio*, pp. 234–35; Michelangelo Muraro, *Carpaccio* (Florence, 1966), p. cxiv.

39 Cf., inter alia, Luigi Coletti, *Cima da Conegliano* (Venice, 1959), p. 79; Bauch, "Zu Tizian als Zeichner," pp. 36–37; and Panofsky, *Problems in Titian*, p. 37. Cima's picture, usually dated ca. 1500, is on panel and was probably not part of a decorative mural cycle.

40 Cf., e.g., *Il Menologio di Basilio II (Cod. Vaticano greco 1613)* (Turin, 1907), vol. 2, pl. 198, and Louis Bréhier, "Les miniatures des 'Homélies' du moine Jacques et le théâtre religieux à Byzance," *Monuments et mémoires publiés par l'Académie des Inscriptions et Belles-Lettres, Fondation Eugène Piot* 24 (1920): 101–28, fig. 7 and pl. VI. For a survey of such representations, see Jacqueline Lafontaine-Dosogne, *Iconographie de l'enfance de la Vierge dans l'empire byzantin et en occident* (Brussels, 1964–65), vol. 1, pp. 136–67; also George La Piana, "The Byzantine Iconography of the Presentation of the Virgin and a Latin Religious Pageant," in *Late Classical and Mediaeval Studies in Honor of Albert Mathias Friend, Jr.* (Princeton, 1955), pp. 261–71.

41 Ghirlandaio's fresco of ca. 1485–90, in Santa Maria Novella (fig. 82), stands as an apparent exception to this Tuscan tradition, although Vasari (*Vite*, vol. 1, p. 595) suggests that Ghirlandaio, replacing the original frescoes by Orcagna, made considerable use of the latter's inventions. On the earlier Tuscan tradition, see Millard Meiss, *Painting in Florence and Siena after the Black Death* (Princeton, 1951), pp. 27–38. The iconographic relationship of Ghirlandaio's composition to Titian's will be discussed below.

42 This panel, in the Saibene Collection, Milan, was brought to my attention by Millard Meiss, who kindly permitted me to publish it on his behalf. Meiss suggested that the artist is also the author of the panel of the *Marriage of the Virgin* in the Berenson Collection ("Mortality among Florentine Immortals," *Art News* 58 [May 1959]: 27–29 and 46–47; [September 1959]: 6, and "Contributions to Two Elusive Masters," *Burlington Magazine* 103 [1961]: 57–58; but cf. Federico Zeri, *Due dipinti, la filologia e un nome* [Turin, 1961], p. 52, n. 1). Meiss recognized in the Berenson panel a reflection of the lost fresco begun by Domenico Veneziano and finished by Baldovinetti in the church of Sant'Egidio in Florence, a composition known to us through Vasari's description. Similarly, Meiss suggested that the Saibene panel of the *Presentation* may well reflect Castagno's composition of the subject, part of the same Marian cycle in Sant'Egidio, and he cited in particular the elaborate architectural setting of Castagno's design, also described by Vasari (*Vite*, vol. 2, p. 547).

43 For a similar transposition of the Presentation, although on a minor scale, cf. the motif in the background of Carpaccio's *Reception of the English Ambassadors* (fig. 25) and its preparatory drawing (Muraro, *I disegni di Vittore Carpaccio*, pp. 68–69, fig. 10).

44 Peruzzi's fresco, generally dated ca. 1517, has been placed between 1523 and 1526 by Christoph Luitpold Frommel, *Baldassare Peruzzi als Maler und Zeichner (Beiheft zum Römischen Jahrbuch für Kunstgeschichte*, vol. 11) (Vienna and Munich, 1967–68), cat. no. 89.

45 For the iconographic significance of these forms, see below, sec. 4.

46 Cecil Gould, "Sebastiano Serlio and Venetian Painting," *Journal of the Warburg and Courtauld Institutes* 25 (1962): 56–64.

47 The nonfunctional aspect of Bordone's background space may be compared to the similarly dissociated backdrops of Carpaccio, who also attempted in his own way to adapt elaborate perspectives to the tableau composition: see above, chap. 1, pp. 41–43.

48 See above, n. 27, and Giordana Canova, *Paris Bordone* (Venice, 1964), pp. 93–94. Noting Bordone's use of a specific Serlian motif, the double staircase in the background, Gould has suggested a later date for the painting, after the publication of Serlio's *Secondo libro* in 1545 ("Serlio and Venetian Painting," p. 61, and review of Canova, *Burlington Magazine* 107 [1965]: 583). Given Serlio's evidently close contacts with painters in Venice, however—he is said to have supplied the architectural backdrop for a picture by Cariani—there seems no reason to insist that Bordone's knowledge of his designs had to await their formal publication.

49 Jacobus de Voragine, *The Golden Legend*, trans. Granger Ryan and Helmut Ripperger (New York, London, and Toronto, 1941), p. 523. The most thorough study of the subject is still the dissertation of Sister Mary Jerome Kishpaugh, *The Feast of the Presentation of the Virgin in the Temple: An Historical and Literary Study* (Washington, D.C., 1941).

50 For Titian's earlier awareness of these problems, see above, chap. 2.

51 The decision to open the second door was made on 10 March 1572 (Appendix: Document 8).

52 This insistent pictorial flatness seems to me to qualify the general notion that the architecture of the *Presentation* was particularly inspired by the perspective spaces of stage scenery: cf. Carl Nordenfalk, "Tizians Darstelung des Schauens," *Nationalmusei Årsbok* (Stockholm, 1947–48), p. 54; Gould, "Serlio and Venetian Painting," pp. 56–58; Panofsky, *Problems in Titian*, p. 37; and Götz Pochat, *Figur und Landschaft: eine historische Interpretation der Landschaftsmalerei von der Antik bis zur Renaissance* (Berlin and New York, 1973), pp. 452–54. Titian does not appear to have been interested in creating perspective-based illusion in his tableau—although one may indeed cite certain resemblances in detail to sets of Serlio (cf. the motifs catalogued in his descriptions of stage scenery, quoted by Gould, p. 57) or to designs traditionally ascribed to Bramante and also associated with the theater (see Irving Lavin, "The Campidoglio and Sixteenth-Century Stage Design," in *Essays in Honor of Walter Friedlaender* [*Marsyas,*

supplement] [New York, 1965], pp. 114–18). For a balanced and informative discussion of the subject, see now Carlo Pedretti, "Tiziano e il Serlio," in *Tiziano e Venezia: Convegno Internazionale,* pp. 243–48.

53 "Titian's *Presentation of the Virgin in the Temple,*" lecture at the Metropolitan Museum of Art, New York, 21 October 1965.

54 The aged mother of Mary, with her hands together in prayer as in the pictures by Carpaccio and Cima, has been missed by many critics, who, in a rather casual way, have identified as Anna the stately young woman at the foot of the temple stairs (fig. 85): cf., e.g., J. A. Crowe and G. B. Cavalcaselle, *The Life and Times of Titian* (1877), 2d imp. (London, 1881), vol. 2, p. 32, and Hetzer, *Tizian,* p. 119. (For further comment on this figure, see below, pp. 119–21.) Joachim has been more generally recognized, although Panofsky himself (*Problems in Titian,* p. 37) refers to him offhandedly as an apparently anonymous figure, whereas Wethey (*Paintings of Titian,* vol. 1, p. 123) calls him Joseph, clearly a slip of the pen.

55 Cf., e.g., Gould, "Serlio and Venetian Painting," p. 56: "It is perfectly clear that in general Titian had no interest in architectural forms as such and usually incorporated only the minimum architectural element which might from time to time be demanded by the subject." More recent study of Titian's architecture, as well as the technical investigation of some of his more ambitious compositions, suggests a much less casual and passive approach by the master. Cf. the altarpieces discussed in chap. 2, and, for the meaning of the architecture in the *Presentation,* see below, sec. 7.

56 In a letter of 22 April 1560, regarding a projected cycle celebrating the victories of Charles V, Titian wrote: "farmi intendere il lume, secondo la qualità e condition delle sale o camere nelle quali havra a esser riposta" (Crowe and Cavalcaselle, *Titian,* vol. 2, pp. 581–82). On 2 December 1567, Titian offered to complete a St. Lawrence cycle and asked to know "in quante parti essa la voglia et l'altezza et larghezza de i quadri con il lume loro" (Crowe and Cavalcaselle, p. 536). Earlier, in the bacchanals for Ferrara, the same attention to actual lighting conditions is observed (see Charles Hope, "The 'Camerini d'Alabastro' of Alfonso d'Este," *Burlington Magazine* 113 [1971]: 645, and Dana Goodgal, "The Camerino of Alfonso I d'Este," *Art History* 1 [1978]: 162–90, esp. pp. 172–76). For Titian's use of natural light sources in the Malchiostro Chapel in Treviso, see above, chap. 2, sec. 3.

 Similarly, when Raphael was about to begin a painting for Isabella d'Este he requested certain basic information: "la mesura del quadro et il lume" (Vincenzo Golzio, *Raffaello nei documenti, nelle testimonianze dei contemporanei e nella letteratura del suo secolo* [Vatican City, 1936], p. 37). For Raphael's attention to lighting conditions in the Sistine Chapel, see John White and John Shearman, "Raphael's Tapestries and their Cartoons," *Art Bulletin* 40 (1958): 201.

57 In the eighth chapter of *Il libro dell'arte* Cennino Cennini addressed himself to this issue (*The Craftsman's Handbook,* trans. Daniel V. Thompson, Jr. [New Haven, 1933], p. 6). See Wolfgang Schöne, *Über das Licht in der Malerei* (Berlin, 1954), pp. 88–91, for further discussion.

58 "Di potter reffar et adaptar le fenestre dell'Albergo nostro per dar luce alla pittura del teller va nel ditto nostro Albergo" (Appendix: Document 7).

59 The compositional type can be followed back through the work of the earlier Venetian masters Giorgione and Giovanni Bellini to what appears to be an Ur-statement in the drawings of Jacopo Bellini.

60 The blues of the left side are carried over and variously modified in the Virgin's dress, the high priest's vestments, and even in the grays of the old woman. The pink stones of the central palace seem to collect and dampen the stronger reds isolated in the vermilion robes of the chief officer of the Scuola, then distributed in the rug over the balcony and in the cloak of the spectator with the plumed hat, and finally muted in the garments of the second priest, as well as in the various smaller accents; the dark crimson of the young woman pointing at the foot of the stairs also participates in this distribution. One wonders if Titian signed a contract similar to that in which Pasqualino Veneto had agreed to use "boni zenabrij e fini azurj oltra marinj de li piuj finj se posi trovar" (Appendix: Document 13).

61 In the Latin text known as the *Gospel of the Pseudo-Matthew* the young Mary in the temple is described in such glowing terms: "So persevering was she in prayer, and so beautiful and glorious her appearance that her face shone as the snow so that one could scarcely look upon her countenance" (quoted by Kishpaugh, *The Feast,* p. 7). With regard to the gesture of shielding the eyes against divine radiance, see Rudolf Wittkower, "El Greco's Language of Gestures," *Art News* 56 (March 1957): 44–49, 53–54.

 In the *rapraesentatio figurata* of Philippe de Mézières's *Festum Praesentationis Beatae Mariae Virginis,* an angel invites the audience to "Look forth and see the beautiful Virgin, pleasing to God, shining in brightness, giving joy to angels, persevering in honesty, and adorning the world. . . . Behold the Ark of the Lord, the Vessel of Divine Wisdom . . ." (trans. by Robert S.

Haller, *Figurative Representation of the Presentation of the Virgin in the Temple* [Lincoln, Neb., 1971], p. 20). Further on Mézières's *Festum* and its relation to Venice: below, pp. 116–18.

In *La vita di Maria Vergine* (1539), Pietro Aretino—conceivably inspired by Titian's painting, but continuing the standard Mariographic tradition—describes the Virgin's radiance at her Presentation in the Temple: "In tanto ella, che cinta dal lume de la propria gloria; non con altro modo raggiava, che si facci il Sole pure allhora levatosi de l'Oceano" (quoted from *La vita di Maria Vergine, di Caterina Santa, & di Tomaso Aquinate Beato* [Venice, 1552], p. 14ᵛ).

62 Hetzer, in Thieme-Becker, *Allgemeines Lexikon der bildenden Künstler,* vol. 34 (Leipzig, 1940), p. 163; Ruth Wedgwood Kennedy, *Novelty and Tradition in Titian's Art* (Northampton, Mass., 1963), pp. 5–6; Johannes Wilde, *Venetian Art from Bellini to Titian* (Oxford, 1974), p. 160.

63 Which, as Zanotto observed (*Pinacoteca,* vol. 2, p. 223ᵛ), follows Mosaic prescriptions set down in Leviticus 8:7–9. Titian's visual source may have been one of the Latin Bibles published in the late fifteenth century in Venice (ill. in Prince D'Essling, *Les livres à figures vénitiens de la fin du XVᵉ siècle et du commencement du XVIᵉ* (Florence and Paris, 1907–14), vol. 1¹, pp. 123, 136). Cf. J. M. Fletcher, "Sources of Carpaccio in German Woodcuts," *Burlington Magazine* 115 (1973): 599.

64 Each of the Evangelists on the *albergo* ceiling displays an appropriate text from his Gospel. Matthew (1:1): "Liber generationis Jesu Christi filii David, filii Abraham. . . ." Luke (1:5): "Fuit in diebus Herodis, regis Judae, sacredos quidam nomine Zacharias. . . ." John (1:1–3): "In principio erat verbum, et verbum erat apud Deum, et Deus erat verbum. Hoc erat in principio apud Deum. Omnia per ipsum facta sunt: et sine ipso. . . ." The text of Mark, whose book is less open to the viewer, is unfortunately now illegible.

65 E.g., in the vault of the Cappella Martorana at Palermo (Schöne, *Über das Licht,* p. 74) and in San Marco itself (Staale Sinding-Larsen, *Christ in the Council Hall: Studies in the Religious Iconography of the Venetian Republic* [*Acta ad archaeologiam et artium historiam pertinentia* (Institutum Romanum Norvegiae), vol. 5] [Rome, 1974], pp. 207–08). For further bibliography on the later medieval response to this theme, see above, chap. 2, n. 52.

66 Cf. the admonishing comments in Alberti's *Della pittura*: "Truovasi chi adopera molto in sue storie oro, che stima porga maestà. Non lo lodo. . . . nei colori imitando i razzi dell'oro sta più ammirazione e lode all'artefice" (in *De pictura,* ed. Cecil Grayson [Rome and Bari, 1975], p. 88). Regarding the use of the gold ground as a deliberately iconographic device, see Erwin Panofsky, *Early Netherlandish Painting* (Cambridge, Mass., 1953), vol. 1, p. 167 and n. 2 on pp. 423–24.

67 See above, chap. 2, sec. 1.

68 Yrjö Hirn, *The Sacred Shrine: A Study of the Poetry and Art of the Catholic Church* (London, 1912), p. 460; also Panofsky, *Early Netherlandish Painting,* vol. 1, p. 143 and n. 2 on p. 415.

69 See André Grabar, "The Virgin in a Mandorla of Light," In *Late Classical and Mediaeval Studies in Honor of Albert Mathias Friend, Jr.* (Princeton, 1955), esp. pp. 310–11. A close pictorial and iconographic parallel is offered by Raphael's *Sistine Madonna*: see Schöne, *Über das Licht,* pp. 130–32, and, for further bibliography, Luitpold Dussler, *Raphael: A Critical Catalogue* (London and New York, 1971), pp. 36–38.

70 Millard Meiss, "Light as Form and Symbol in Some Fifteenth-Century Paintings," *Art Bulletin* 27 (1945): 175–81; repr. in his *The Painter's Choice: Problems in the Interpretation of Renaissance Art* (New York and London, 1976), pp. 3–18. For the contrast between mundane and heavenly illumination in the art of Piero della Francesca, see Marilyn Aronberg Lavin, *Piero della Francesca: The Flagellation* (New York, 1972), pp. 45–51.

71 Meiss, "Light as Form and Symbol," p. 180 (p. 12 in repr.).

72 On the role of Divine Wisdom in the development of Mariology, see Louis Boyer, *The Seat of Wisdom: An Essay on the Place of the Virgin Mary in Christian Theology,* trans. Fr. A. V. Littledale (New York, 1962), pp. 20–28, 45–48, and S. N. Bulgakov, *The Wisdom of God: A Brief Summary of Sophiology* (New York and London, 1937), pp. 173–96. See also the chapter on the symbols of the Virgin in Hirn, *The Sacred Shrine,* pp. 435–70. The iconographic development of the theme in art is most traditionally associated with the metaphor of the Virgin as *Sedes Sapientiae* (see Ilene H. Forsyth, *The Throne of Wisdom: Wood Sculptures of the Madonna in Romanesque France* [Princeton, 1972], pp. 1–7 and 22–30; also Gertrud Schiller, *Iconography of Christian Art* [London, 1971–72], vol. 1, pp. 23–25). Among the most explicit examples of this iconography in Venetian painting are the enthroned Madonnas of Giovanni Bellini: in the Pesaro triptych in the Frari sacristy the Bible held by St. Benedict is open to the beginning chapters of Ecclesiasticus, while the royal motif crowning the throne in the San Zaccaria altarpiece is surely a Solomonic reference. For the rich exposition of Marian iconography in Bellini's so-called *Sacred Allegory,* see Philippe Verdier, "L'Allegoria della Misericordia e della Giustizia di Giambellino agli Uffizi," *Atti dell'Istituto Veneto di Scienze, Lettere ed Arti* 111 (1952–53): 106–07, with particular regard to the Throne of Wisdom; but cf. also Susan J. Delaney, "The Iconog-

raphy of Giovanni Bellini's *Sacred Allegory*," *Art Bulletin* 59 (1977): 331–35. Further on the *Sedes Sapientiae:* below, nn. 133 and 134.

73 This point has been stressed consistently by Meiss in his fundamental investigations of the theme. See above, chap. 2, sec. 3.

74 In the Paris manuscript of the homilies of the Monk James, for example, the legend to the illustration of the Presentation explains: "Mary advances and purifies the earth by the touch of her feet. She is not adorned with costly apparel, but the mantle of her innocence makes her fairer than the virgins following her, even as the light of the sun darkens the stars." See Adolfo Venturi, *La Madonna: svolgimento artistico delle rappresentazioni della Vergine* (Milan, 1900), pp. 105–17, and Hirn, *The Sacred Shrine,* pp. 264–65 (whose brief observations on Titian's *Presentation* give proper stress to the extraordinary qualities of the young Mary). The source for this motif of the train of virgins, each of them carrying a burning lamp "that the child not turn backward and her heart be taken captive away from the temple of the Lord," is the Greek *Protoevangelium of James* (in Montague Rhodes James, *The Apocryphal New Testament* [Oxford, 1924], pp. 41–42). Cf. above, p. 94 and n. 40.

The fusion of iconography and devotional practice can be gauged from the stage directions in Philippe de Mézières's *Festum:* "And note that each member of the clergy marching in the procession will carry a lighted candle in his hand, and if the nobles and other people wish to carry candles also while marching, in honor of that Light which is to come from the womb later to illuminate the whole world, do not by any means discourage them from carrying this light" (Haller, *Figurative Representation,* p. 15).

75 With respect to painters as knowledgeable iconographers, an interesting case is provided by Pordenone's relations with the Scuola della Carità in 1538, following the completion of Titian's picture: see below, Excursus, pp. 141–42.

76 See above, n. 54.

77 Antonio Lorenzi, *Italia artistica: Cadore* (Bergamo, 1907), p. 30, identified the mountains as the Marmarole seen from Roccolo di Sant'Alipio, and the suggestion has been sanctioned by repetition, albeit qualified, in Tietze, *Tizian,* vol. 1, p. 150, and *Titian,* pp. 29, 394.

78 The mountain was, of course, a frequent epithet for the Virgin (Hirn, *The Sacred Shrine,* pp. 462–64; also Frederick Hartt, "Mantegna's Madonna of the Rocks," *Gazette des Beaux-Arts* 40 [1952]: 329–42), but the structure of Titian's composition and its general relation to the Wisdom texts seem to me to encourage interpretation of these forms in a comparative rather than a directly symbolic sense (cf., in contrast, the prominently placed—symbolic—mountain in Leonardo's Uffizi *Annunciation*).

Here, too, the descriptive metaphor of Mézières's *Festum,* based on traditional biblical sources, offers imagery of suggestive relevance. The first angel asks, "Who is she who ascends from the desert as a wisp of smoke, from the fragrance of myrrh and frankincense: is it not that staff which will arise from the root of Jesse, and will not a flower come forth from that root, and the spirit of the Lord rest on him, the spirit of wisdom and knowledge, the spirit of learning and counsel, the spirit of piety and courage, the spirit of the fear of the Lord?" (Haller, *Figurative Representation,* p. 18).

79 This concept of the Immaculate Conception finds still more explicit expression in other sixteenth-century images: e.g., Giulio Clovio's illumination in the Farnese Book of Hours in the Pierpont Morgan Library (fig. 77), cited by Mirella Levi D'Ancona, *The Iconography of the Immaculate Conception in the Middle Ages and Early Renaissance* (Monographs on Archaeology and Fine Arts of the College Art Association of America, vol. 7) (New York, 1957), p. 56. In this miniature the Virgin kneels on the clouds beneath the outstretched arm of the creating God the Father. The dependence of the image on the Sistine Ceiling is hardly casual, for in Michelangelo's *Creation of Adam* the enigmatic female supporting the left arm of God may well be that of the eternal Mary, as and like Divine Wisdom present at the Creation. Cf. Wolfgang S. Seiferth, *Synagogue and Church in the Middle Ages: Two Symbols in Art and Literature* (New York, 1970), pp. 123–40, who, following the same line of reasoning, identifies the figure with *Ecclesia universalis.*

80 Giuseppe Dalla Santa, "Di alcuni manifestazioni del culto all'Immacolata Concezione in Venezia dal 1480 alla metà del secolo XVI (nota storica)," in *Serto di fiori a Maria Immacolata anno L* (Venice, 1904) (offprint), pp. 10–11.

81 Its proportions seem too elongated to permit certain identification of this form with the pyramid of Caius Cestius, as suggested by Cornelius Vermeule, *European Art and the Classical Past* (Cambridge, Mass., 1964), p. 89.

82 W. S. Heckscher, "Bernini's Elephant and Obelisk," *Art Bulletin* 29 (1947): 178.

83 For the symbolic interpretation of the pyramid and obelisk in the Renaissance, see Heckscher, pp. 177–82; in Bernini's monument of the elephant and obelisk the Wisdom texts provide a similar base, reinforcing the double reference, solar and eternal, of the obelisk. For more on the meaning of these forms, see Filippo Picinelli, *Mondo simbolico* (1653) (Milan, 1680), p. 659,

where the pyramid signifies "Presenza d'Iddio," "Beato," and "Concettione di Maria Vergine."

84 Although the basic design of Tintoretto's painting may have been inspired by Daniele da Volterra's in SS. Trinità dei Monti in Rome (Simon H. Levie, "Daniele da Volterra e Tintoretto," *Arte veneta* 7 [1953]: 168–70), in the details of the Virgin's pose and her silhouetted juxtaposition with the obelisk it varies significantly from the Roman model. Further to Tintoretto's painting, see below, nn. 97 and 114. I have thus far been unable to locate a specific source for the set of hieroglyphic inscriptions on Tintoretto's obelisk.

85 Zanetti, one of the few critics to appreciate the light in Titian's picture, describes "La gran nuvola che sta quasi nel mezzo risplendente più che ogn'altro oggetto, che muovesi veramente, si cambia e scioglie sotto gli occhi di chi la mira" (*Della pittura veneziana*, p. 113). In a note he criticizes the eighteenth-century restoration of the painting, "poichè chi ha rinettato questo quadro ha creduto di dargli la vera armonia, lasciando quella nuvola in un lume quieto, come dicono, basso e accordato. La verità si è che ora tutto il giuoco del quadro è perduto; ed è secondo l'intenzione dell'autore stranamente privo del vero accordo." For the subsequent restorations of the picture, see Moschini Marconi, *Gallerie dell'Accademia*, vol. 2, p. 258.

86 The combination of the pyramid with a divine eye hovering above in the heavens was a common image of the omniscient deity: e.g., in the Paris edition of 1559 of the *Hieroglyphica* of Horapollo (see Edgar Wind, *Pagan Mysteries in the Renaissance*, rev. ed. [Baltimore, 1967], p. 232, fig. 84, for illustration and further references).

87 Cf. Picinelli, *Mondo simbolico*, pp. 69–73, where the cloud signifies, inter alia, "Misericordia divina," "Gratia divina," "Maria gravida e risplendente," and "Maria gravida simile à Dio." Under the third of these rubrics Picinelli describes the following device: "Una nube riscontro al Sole, nella quale si vede improntata un'imagine bellissima del Sole col motto LVMEN DE LVMINE. . . . quest'impresa anco riesce opportuna à gli honori di Maria Vergine, mentre piena d'Iddio, e portava il Sole eterno, incarnato entro il suo seno, e ne scopriva, come dicono alcuni, i brillanti splendori d'intorni al viso." A survey of this imagery and its sources is offered by Hirn, *The Sacred Shrine*, pp. 346–49, 466–68.

88 See above, chap. 2, sec. 3.

89 For Titian's woodcut, see David Rosand and Michelangelo Muraro, *Titian and the Venetian Woodcut* (Washington, D.C., 1976), cat. no. 4. For further consideration of the cloud *topos* in painting, see Hubert Damisch, *Théorie du nuage: pour une histoire de la peinture* (Paris, 1972).

90 The question of interpreting Titian's landscapes has still not been adequately investigated. Cf., however, E. Tietze-Conrat, "Titian as a Landscape Painter," *Gazette des Beaux-Arts* 45 (1957): 11–20; Pochat, *Figure und Landschaft*, pp. 427–76, the most sustained effort to date; and my own brief comments in "Art History and Criticism: The Past as Present," *New Literary History* 5 (1973–74): 442, and in *Titian*, pp. 27–29. For more general guidelines, see E. H. Gombrich, "The Renaissance Theory of Art and the Rise of Landscape," in his *Norm and Form* (London, 1966), pp. 107–21.

91 Further examples of Titian's precise pictorial response to text are discussed above, chap. 2, sec. 3.

92 Panofsky, *Problems in Titian*, pp. 37–39. Since Panofsky himself stressed the formal situation of these figures "outside the picture space proper," it is particularly unfortunate that the editors of his posthumously published Wrightsman lectures chose for illustration (fig. 41) an old, pre-1895 photograph showing the early nineteenth-century additions filling in the door with new canvas and totally destroying the spatial sense and complexity of Titian's design.

The style of the torso's cuirass has been identified as Hellenistic by Vermeule (*European Art and the Classical Past*, p. 88: "This exercise in observation from the antique looks like the Belvedere Torso in Greek imperial armor . . ."), who also notes its similarity to types used by Mantegna (p. 49).

93 Strange to say, Panofsky's interpretation has been greeted with skepticism; the older naturalist bias dies hard: cf. Francis Haskell's review, "Explaining Titian's Egg Seller," *New York Review of Books* 15 (2 July 1970): esp. pp. 33–34.

94 In the later sixteenth century, in large measure undoubtedly owing to Titian's example, eggs became standard fare on the temple steps—e.g., in depictions of the Purification of the Temple by Bassano and El Greco. As one reviewer of Panofsky's book pointed out, however, eggs are not entirely without place in Jewish ritual: "The one time in the year when eggs must be eaten is at the 'Seder' meal on the eve of Passover—a possible reference to the later 'Seder' which proved to be Christ's Last Supper" (Theodore K. Rabb, "The Historian and the Art Historian," *Journal of Interdisciplinary History* 4 [1973]: 111)—a less than totally convincing hypothesis in the particular context of Titian's picture.

Recently, William Hood has suggested that the eggs do indeed derive their meaning from the Passover ritual, but as signs of mourning and bitterness; he has also associated the fowl with officially discouraged but continually popular Jewish practices of atonement: see his

"The Narrative Mode in Titian's *Presentation of the Virgin,*" in *Studies in Italian Art History,* vol. 1 (*Memoirs of the American Academy in Rome,* vol. 35) (Rome, 1980), p. 140, n. 39.

95 Contrary to Wethey (*Paintings of Titian,* vol. 1, p. 123), there is only one chicken (although the older sources consistently use the plural: cf. above, n. 9) and the animal to its left is not a black pig. In Ghirlandaio's *Expulsion of Joachim from the Temple* one youth does indeed carry a black lamb as an offering. In Giotto's Arena Chapel *Nativity* one black goat appears among the sheep, facing away from the Child, a skeptic among the faithful (see Don Denny, "Some Symbols in the Arena Chapel Frescoes," *Art Bulletin* 55 [1973]: 209).

96 Panofsky, *Problems in Titian,* p. 38, n. 26. Doubts concerning the identification of Ghirlandaio's nude as representative of paganism will be raised below, p. 123.

97 An especially interesting variation occurs in the miniature of the *Purification of the Virgin* in the *Très Riches Heures,* which is derived from Gaddi's composition (Jean Longnon and Raymond Cazelles, *The* Très Riches Heures *of Jean, Duke of Berry* [New York, 1969], pl. 56): the addition of the conical cap renders absolutely explicit the negative identification of these figures as Jews (cf. our fig. 88).

 In Tintoretto's *Presentation of the Virgin* (fig. 79) the opposition, no longer so absolute, assumes a more actively pictorial form, following the overall division of the two sides of the field (originally separated as two organ shutters) into areas of light and shadow: the figures emerging from the darkness at the left turn from a world *ante gratiam* toward the new light. (On the other figures in the painting, see below, n. 114.)

 In Peruzzi's fresco (fig. 72), as one might expect, the architecture itself serves to make this fundamental distinction. The temple at the left represents the Old Testament; crowning its pediment are statues of Moses flanked by David (Frommel, *Peruzzi als Maler,* p. 127, suggests Samson) and Judith, and these figures, separated from the Virgin by the obelisk, look to the right and witness her ascent. The meditative figure at the foot of the obelisk, who has been identified as a philosopher (Frommel, p. 128), is more likely a prophet, who would serve as an appropriate link between the two eras.

98 See above, n. 42.

99 Remembering the importance of the Wisdom texts for Marian iconography in general and for Titian's painting in particular, we may adduce the opposing figure of the foolish woman ("mulier stulta et clamosa") of Proverbs 9:13–15. A "noisy" foil to Divine Wisdom, she sits "at the door of her house, upon a seat, in a high place of the city, to call those that pass by the way, and go on their journey" ("Sedit in foribus domus suae super sellam in excelso urbis loco. Ut vocaret transeuntes per viam, et pergentes itinere suo"). For a general survey of the thematic contrast between Church and Synagogue, see Seiferth, *Synagogue and Church.*

100 The text of this *Festum Praesentationis Beatae Mariae Virginis* is published in Karl Young, *The Drama of the Medieval Church* (Oxford, 1933), vol. 2, pp. 225–45, with further notes on pp. 472–79. Young's edition of the Latin text is reprinted with an English translation by Haller (see above, n. 61). See also Kishpaugh, *The Feast,* pp. 92–104.

101 Young, *The Drama,* vol. 2, p. 474; Haller, *Figurative Representation,* p. 60, trans. on p. 53. In the letter (of 1372) accompanying the script of his *rapraesentatio figurata* Mézières describes having "arranged the celebration of the said feast accompanied by a most devout and figurative representation performed out of reverence for the Most Blessed Evervirgin Mary and with her help several years ago in certain parts of Italy, more particularly in that splendid city of Venice, sometimes in communion with those of that city devoted to the Virgin, sometimes celebrating the feast with outsiders confirming its signs and visions and participating in it."

 Philippe de Mézières had been accorded Venetian citizenship in 1365 (Paolo Sambin, *Ricerche di storia monastica medioevale* [Padua, 1959], p. 54, with further references). His donation of the piece of the True Cross to the Scuola Grande di San Giovanni Evangelista is the subject of one of the paintings, by Lazzaro Bastiani, in the pictorial cycle celebrating the miracles effectuated by that relic: see Moschini Marconi, *Gallerie dell'Accademia,* vol. 1, no. 56; also G. M. Urbani de Gheltoff, *Guida storico-artistica della Scuola di S. Giovanni Evangelista* (Venice, 1895), pp. 6–9.

102 In a *capitolo* of the Scuola's *mariegola* that may be dated to 1369 the feast of the Presentation of the Virgin in the Temple appears as one at which the relic of the True Cross is to be carried in procession (see above, n. 16). And this seems to have been the custom at least until 1422, when the Scuola complained to the Consiglio dei Dieci, citing "un ordine . . . in la soa matricola, fato antigamente, per una festa de la oblation de Madona Santa Maria al Templo: per el qual la dita scuola era tegnuda spoiarse et andar a la gliexia de Santa Maria de' frari menori ogni anno, a dì vintuno novembre" (published by Lia Sbriziolo, "Per la storia delle confraternite veneziane: dalle deliberazioni miste [1310–1476] del Consiglio dei Dieci: Le scuole dei battuti," in *Miscellanea Gilles Gerard Meerseman* [Padua, 1970], pp. 755–56).

103 La Piana, "The Byzantine Iconography of the Presentation," and Bréhier, "Les miniatures des 'Homélies ' " (both cited above, n. 40).

104 Synagoga vero induetur ad modum antique vetule cum tunica talari inueterata alicuius panni simplicis coloris, et mantello nigro et rupto. Capud vero ad modum vetule ornatum de aliquo velo obscuri coloris, et coram oculus et facie habebit velum nigrum, per quod tamen possit videre. In manu vero sinistra portabit quoddam vexillum rubeum cuius hasta nigra fracta apparebit, vexillo inclinato super humeros suos. In quo quidem vexillo rubeo scribentur litere de auro: S.P.Q.R., que sunt arma Romanorum. Et in manu dextera portabit duas tabulas lapideas inclinatas versus terram, in quibus lapideis erunt scripte litere quasi litere Hebreorum significantes legem Moysi et Vetus Testamentum (Young, *The Drama,* vol. 2, p. 230; Haller, *Figurative Representation,* pp. 32–33, trans. on pp. 9–10).

 The figure in black in Giotto's *Meeting at the Golden Gate* has been interpreted as Synagogue by Laurine Mack Bongiorno, "The Theme of the Old and the New Law in the Arena Chapel," *Art Bulletin* 50 (1968): 13–14—objected to, on rather narrow iconographic grounds, by Denny, "Some Symbols," pp. 209–11.

105 Cf. also Panofsky, *Early Netherlandish Painting,* vol. 1, p. 415, n. 5 for p. 141.

106 A version of the *Quem queritis* was published in Venice as late as 1678, representing a late codification of enduring medieval traditions: see Vincenzo De Bartholomaeis, *Origini della poesia drammatica italiana,* 2d ed. (Turin, 1952), p. 121; also Maria Teresa Muraro, "Venezia," in *Enciclopedia dello spettacolo,* vol. 9 (Rome, 1962), cols. 1530–32. See, as well, below, chap. 5, sec. 2.

107 We may imagine—although not prove—that the annual processions of the Scuola di San Giovanni Evangelista to the Frari (above, n. 102) were part of larger celebrations of the feast that included the play. The feast of the Presentation is generally, but not always, recorded on 21 November in the *Diarii* of Marino Sanuto for the early years of the sixteenth century, up to 1532, usually with the observation that "li offici non sentano." (Sanuto, however, is not an entirely reliable guide in such matters, especially since on occasion he calls the feast of that day the Conception of the Virgin [1528] or the Visitation [1532].) See also Vincenzo Coronelli, *Guida de' forestieri o sia epitome diaria perpetua sagra-profana per la città di Venezia* (1667) (Venice, 1744), p. 291, and Silvio Tramontin, "Il 'kalendarium' veneziano," in *Culto dei santi a Venezia* (Venice, 1965), p. 320. At least three churches in Venice were dedicated to the Presentation of the Virgin: the Zitelle, San Sepolcro, and Santa Maria della Salute—for which see Michelangelo Muraro, "Il tempio votivo di Santa Maria della Salute in un poema del Seicento," *Ateneo Veneto* 11 (1973): esp. p. 112, and Antonio Niero, "Un progetto sconosciuto per la basilica della Salute e questioni iconografiche," *Arte veneta* 26 (1972): 246. The feast is still celebrated in Venice on 21 November as the Festa di Santa Maria della Salute, established following the plague of 1630. For the varied fate of the feast in the Roman calendar, see Kishpaugh, *The Feast,* pp. 128–32.

108 For further discussion of such temporal extension, see below, chap. 4, sec. 6, and chap. 5, sec. 1.

109 See the references cited above, n. 40.

110 The white and gold of her dress, with their implications of purity, are colors traditionally associated with *Fides,* as is her gesture: cf. Cesare Ripa, *Iconologia* (Rome, 1603), p. 149, s.v. "Fede cattolica": "Donna vestita di bianco, che si tenga la destra mano sopra il petto. . . ." Gold is the color of *Ecclesia* in Mézières's *Festum* (Young, *The Drama,* vol. 2, p. 230; Haller, *Figurative Representation,* p. 32, trans. on p. 9).

111 Regarding the bridal aspect of the costume, cf. Sansovino's description of "la sposa, vestita per antico uso di bianco" (*Venetia,* p. 401); see further Emma H. Mellencamp, "A Note on the Costume of Titian's Flora," *Art Bulletin* 51 (1969): 174–77. In the Byzantine literature Mary is received by the high priest Barochias, who is said to be the father of Zacharias (Kishpaugh, *The Feast,* pp. 24, 36–37). The marital theme of the Presentation is underscored in Mézières's *Festum,* in which the bishop greets the Virgin with words modified from the Song of Songs: "Veni amica mea, veni columba mea, quia macula non est in te. Veni de Lybano electa ab eterno, ut te accipiam sponsam dilecto filio meo" (Young, *The Drama,* vol. 2, p. 240; Haller, *Figurative Representation,* p. 45, trans. on p. 27).

112 See above, n. 64.

113 See the text quoted above, n. 15. An inscription formerly in the Scuola proclaimed: "QUID PRODEST HOMINI SI CHARITATE / HOMINEM NON ALIT CHARITAS / ENIM A DEO DESCENDIT / SI CHARITATEM IN PAUPERES / HAVEBIMUS SEDEM IN CELO / ANIMABUS NOSTRIS LUCRABIMUR / MDLXVI." It is recorded in Martinioni's additions to Sansovino (*Venetia,* p. 283); see also Tassini, "Iscrizioni," p. 115. The fuller social context in which this inscription should be read is discussed by Brian Pullan, "Poverty, Charity and the Reason of State: Some Venetian Examples," *Bollettino dell'Istituto di Storia della Società e dello Stato Veneziano* 2 (1960): 17–60; for the charitable activities of the *scuole grandi* in general, see Pullan, *Rich and Poor,* esp. pp. 157–87, and Wurthmann, "The *Scuole Grandi,*" pp. 82–96 (for

the *albergo* as a center of such activity, see the document from the Scuola della Carità cited by Pullan on p. 78).

114 See below, p. 129. The representation of charity as an act of giving *(amor proximi)* finds precedents in the trecento decorations in the Ducal Palace (below, n. 136) and in the late dugento mural in the cathedral of Bergamo depicting members of a Confraternita della Misericordia bearing food and drink (ill. in Pietro Toesca, *La pittura e la miniatura nella Lombardia* [Milan, 1912], fig. 104; see also R. Freyhan, "The Evolution of the Caritas Figure in the Thirteenth and Fourteenth Centuries," *Journal of the Warburg and Courtauld Institutes* 11 [1948]: 71). Cf. also the image of distributive charity in the fresco cycle of the Scuola di Sant'Antonio in Padua (Morassi, *Tiziano: gli affreschi*, pp. 21–23, figs. 6, 22).

In the Scuola della Carità, each of the subsequent paintings for the *albergo*, Gian Pietro Silvio's *Marriage of the Virgin* (fig. 102) and Girolamo Dente's *Annunciation* (fig. 103), incorporates a rather conspicuous beggar and a personified *Caritas* (further on these paintings: below, Excursus, p. 133).

Tintoretto's *Presentation of the Virgin* (fig. 79) seems to multiply the instances of the charity motif in the several mother-child groups filling the right side of the composition. The inspiration for this may have been the expansive dramatization of the subject by Pietro Aretino in his *Vita di Maria Vergine*, published in 1539 and reprinted in 1552 (see above, n. 61), just when Tintoretto was working on the picture. Aretino's picturesque account of the infant Mary's first presentation in the temple, at the age of forty days, describes a great multitude, including many nursing mothers, witnessing the event: "Non si vidde mai tanta folta di turbe, in alcuno spettacolo; era comparita nel tempio, & ne la piazza, che gli è dinanzi qualunche lattava, & faceva lattar figliuoli. Onde le madri, & le nutrici mescolate insieme si facevano vedere, mentre calpestavano altri, & da altri erano calpestate in diverse maniere di attitudini alcune temendo gli urti de gli urtati con un braccio si ristringevano al petto i figli, & con l'altro respingevano in dietro i risospinti." In the terrible confusion one of the infants loses her life and, upon appeal to Anna, is miraculously revived by Marian intervention. "Conosciuta, & publicata si stupenda cosa, le lingue di mille madri tutte in un tempo raccomandarono i figli a la figliuola di Dio, di Anna, & di Giovacchino . . ." (pp. 13–14). The significance of Aretino's religious writings has been emphasized by Michael Levey in a paper, "Titian, Aretino, and the Religious Picture," read at a conference on Titian, Aretino, and Sansovino held at Kings College, Cambridge, in 1973; see also Mina Gregori, "Tiziano e l'Aretino," in *Tiziano e il manierismo europeo*, ed. Rodolfo Pallucchini (Florence, 1978), pp. 271–306. Further on Aretino and painting: below, chap. 4, nn. 55, 58, and chap. 5, pp. 195–97 and accompanying notes.

115 Cf. Vasari's enthusiastic description of Castagno's lost fresco of the *Presentation* in Sant'Egidio: "la Nostra Donna che sale i gradi del tempio, sopra i quali figurò molti poveri . . ." (*Vite*, vol. 2, p. 547).

116 This is a detail from a larger plate depicting the *Coronation of the Virgin*, with seven scenes from her life, illustrated here from a modern copy of the original of ca. 1460–70. For the full print, see Arthur M. Hind, *Early Italian Engraving* (London, 1938–48), vol. 1, p. 30, no. 12, pls. 12, 13. Cf. also the engravings by Giovanni Antonio da Brescia (Hind, vol. 5, p. 44, no. 24, pl. 543) and Marcello Fogolino (vol. 5, p. 218, no. 2, pl. 801).

The charity of Joachim, although not specifically on the occasion of the Virgin's Presentation, is often found in accounts such as the *Protoevangelium of James* and the *Gospel of the Birth of Mary*, from which it passed into the *Golden Legend*: James, *Apocryphal New Testament*, pp. 40, 70.

117 Vermeule (*European Art and the Classical Past*, p. 89) has remarked of the composition that it has "the axis and grouping of a Roman imperial state relief," but he does not pursue the analogy.

118 See above, n. 6.

119 Ridolfi, *Maraviglie*, vol. 1, p. 154: "e de Confrati al naturale ritratti, tra quali è Andrea de' Franceschi in veste Ducale, che fù gran Cancellier Veneto, amorevolissimo del Pittore, e Lazzero Crasso." Boschini, *Minere*, p. 361. The tradition of Titian's friendship with the grand chancellor is documented in an interesting way by the triple portrait at Hampton Court representing the artist himself, Andrea de' Franceschi, and the so-called "friend of Titian" (Wethey, *Paintings of Titian*, vol. 2, cat. no. X-103, pl. 275).

120 Wethey, cat. no. 34, also cat. no. 35. Wethey accepts Ridolfi's identification, although he actually illustrates the visual confrontation that seems convincingly to disprove it.

121 See Emmanuele Antonio Cicogna, *Delle iscrizioni veneziane* (Venice, 1824–53), vol. 3, p. 159. Cf. also Terisio Pignatti, *Giorgione*, 2d ed. (Venice, 1978), no. A25, pl. 208. It is, of course, possible that Ridolfi had in mind another, less known and undocumented Lazzaro Crasso.

122 The grand chancellor was the highest magistrate of Venice, a nonpatrician who was accorded official honors second only to the doge. He was, like other civil servants and nobles, theoretically excluded from holding office in the *scuole* (Pullan, *Rich and Poor*, p. 109). For the position

and its privileges, see Sansovino, *Venetia*, pp. 32–22; Ferro, *Dizionario del diritto*, vol. 3, pp. 6–8; Andrea Da Mosto, *L'Archivio di Stato di Venezia: indice generale storico, descrittivo ed analitico* (Rome, 1937–40), vol. 1, p. 219; and especially Felix Gilbert, "The Last Will of a Venetian Grand Chancellor," in *Philosophy and Humanism: Renaissance Essays in Honor of Paul Oskar Kristeller* (New York, 1976), pp. 502–17 (the grand chancellor in question is Gianpietro Stella, whose testament indicates that he was a brother of the Scuola di San Marco). On the levels of Venetian citizenship and their relation to the *scuole*, see Pullan, *Rich and Poor*, pp. 99–131.

123 For the governmental structure of the *scuole*, see the contemporary description of Sansovino, *Venetia*, pp. 281–82, and the modern accounts by Pullan, *Rich and Poor*, pp. 67–83, and Wurthmann, "The *Scuole Grandi*," pp. 75–80.

124 Sansovino, *Venetia*, p. 282: "Il Guardiano Grande col Vicario vanno vestiti nella solennissima festività del Corpo di Christo, l'uno di color cremesino con le maniche alla Ducale, & l'altro di panno pavonazzo à comito, come rappresentanti in questa parte il Dominio: & per l'ordinario si come instituto procedente ab antiquo, si honora il Guardiano con titolo di Magnifico."

The chief officers of the Scuola della Carità enjoyed the special privilege of personally flanking the doge at the annual procession to the church of San Vio in celebration of the suppression of the rebellious followers of Bajamonte Tiepolo on 15 June 1310; the honor was in recognition of the role played by the brothers of the Scuola, who, along with the masters of the painters' guild, fought the key battle in Campo San Luca (see above, chap. 1, n. 29)

125 Dalla Torre's successors as *guardiano grande* were: Domenico Ziprian (1535), Zuan de Steffani (1536), Andrea Zio (1537), and Zuan Battista Arduin (1538). (A Niccolò della Torre appears with his father, the physician Giovanni Agostino, in a portrait by Lorenzo Lotto, dated 1515, in the National Gallery, London [Cecil Gould, *The Sixteenth-Century Italian Schools* (National Gallery Catalogue) (London, 1975), pp. 133–34]; although there may be a very general resemblance to the portrait in Titian's *Presentation*, an inscription identifies Lotto's sitter as a Bergamasque nobleman, and he is therefore not likely to qualify as chief officer of the Venetian confraternity.)

The third of the major officers of the Scuola, the *guardian da mattin*, was specifically responsible for organizing and marshalling the *confratelli* for processions, and in the sixteenth century he was in addition in charge of the distribution of alms during those processions (Pullan, *Rich and Poor*, p. 69). It has therefore been plausibly suggested that the bearded figure performing this act of charity in the painting may in fact be the *guardian da mattin* (see J. M. Fletcher, review of Pullan, in *Burlington Magazine* 113 [1971]: 747). On the evolution and function of the official positions within the *scuole*, see Wurthmann, "The *Scuole Grandi*," pp. 47–60.

126 Cf. above, n. 52; also Wethey, *Paintings of Titian*, vol. 1, p. 123.

127 I owe this observation to Meyer Schapiro. The tradition according to which the temple was approached by fifteen steps—"one for each of the fifteen gradual Psalms" (Voragine, *Golden Legend*, p. 523)—evidently goes back to Flavius Josephus's description in his *History of the Jewish Wars* (V, v): see Kishpaugh, *The Feast*, p. 6, n. 18. Neither the recent study by Carol Herselle Krinsky ("Representations of the Temple of Jerusalem before 1500," *Journal of the Warburg and Courtauld Institutes* 33 [1970]: 1–19) nor that by Rachel Wischnitzer ("Rembrandt, Callot, and Tobias Stimmer," *Art Bulletin* 39 [1957]: 224–30) deals with this particular aspect of the problem.

128 Vitruvius, *De architectura*, IX, *praefatio*, 6–8. This relationship was pointed out to me by the late Arnold Noach of the University of Leeds, who was preparing a study of the iconography of the temple in Renaissance and baroque art. As Noach further observed, Leonardo had earlier followed the Vitruvian recommendation in the background stairs of the *Adoration of the Magi*, in the well-known preparatory perspective drawing as well as in the unfinished painting.

With regard to Titian's double flight of eight plus five risers, it is interesting to compare Daniele Barbaro's later comments on this Vitruvian passage: "ci gioverà la figura di Vitr. il numero de i gradi, & de i riposi (perche egli si deve avvertire di non far molti gradi senza una requie di mezzo) però non usavano gli antichi di fare piu di sette, ò nove gradi senza un piano . . ." (*I dieci libri dell'architettura di M. Vitruvio tradutti et commentati da Monsignor Barbaro eletto Patriarca d'Aquileggia* [Venice, 1556], p. 203). Vermeule (*European Art and the Classical Past*, p. 89) suggests that the "colonnade and staircase are put together from a side view of the Forum of August with the staircase derived from external vistas of the curtain wall"—a suggestion that fails to convince by its very complexity.

129 I Kings in the Authorized Version. A colonnaded portico is also a prominent part of Ghirlandaio's architectural setting (fig. 82), and it becomes a common feature by the seventeenth century (e.g., in Luca Giordano's *Presentation of the Virgin* in Santa Maria della Salute, Venice). Another aspect of the Temple of Solomon, the twin columns Jachin and Boaz (I Kings 7:21), is probably represented in Cima's painting (fig. 66).

With regard to the Corinthian order of Titian's colonnade, Carlo Pedretti ("Tiziano e il Serlio," p. 247) has suggestively adduced a passage from chapter 8 of Serlio's *libro quarto*, a commentary on the Vitruvian account of the virgin of Corinth who inspired the order: "Dirò ben, che havendosi da far un tempio sacro di questo ordine; ei si debba dedicar alla vergine Maria madre di Giesù Christo redentor nostro."

130 Vermeule, *European Art and the Classical Past*, p. 89.

131 Panofsky, *Problems in Titian*, p. 38, and *The Life and Art of Albrecht Dürer* (Princeton, 1955), p. 102 ("the arch connecting the Temple with another building [in Dürer's woodcut] is adorned by 'mythological' reliefs and is surmounted by a statue apparently intended to represent Apollo the Dragon-Killer"); also Panofsky, *Early Netherlandish Painting*, vol. 1, p. 415, n. 5 for p. 141.

132 Suzanne Spain, "The Temple of Solomon, the Incarnation and the Mosaics of S. Maria Maggiore," abstract published in *Journal of the Society of Architectural Historians* 28 (1969): 214–15.

133 This interpretation would parallel the symbolic structure of Bernini's monument for Alexander VII before Santa Maria sopra Minerva, analyzed by Heckscher, "Bernini's Elephant and Obelisk," pp. 179–80: Isis, Minerva, and Mary form "a triad under the common denominator of Divine Wisdom. At first Divine Wisdom was incarnate in the Egyptian Isis, then in the Graeco-Roman Minerva, and ultimately, in its purest exponent, the Mother of the Lord Herself, in the words of St. Bernard, the 'miranda et profundissima dispentrix sapientiae.' "

For Minerva as Virgin, see, e.g., Vincenzo Cartari, *Le imagini de i dei degli antichi* (Venice, 1567), pp. 310–11: "nasce Minerva senza Giunone, ma ci vien' infusa dal supremo intelletto. Onde si legge nelle sacre lettere che tutta la sapienza viene da Dio, e quella di se parlando medesimamente cosi dice. Io sono uscita dalla bocco dell'altissimo. Fu Minerva sempre vergine perche la sapienza rimane pura sempre, ne sente macchia alcuna delle cose mortali." Cf. further Arthur Henkel and Albrecht Schöne, *Emblemata: Handbuch zur Sinnbildkunst des XVI. und XVII. Jahrhunderts* (Stuttgart, 1967), col. 1732: "Custodiendas Virgines" (with reference to Alciatus).

134 The roundel is displayed on the façade of the Ducal Palace facing the Piazzetta (for further details, see Francesco Zanotto, *Il Palazzo Ducale di Venezia* [Venice, 1853–61], vol. 1, p. 206; also Wolfgang Wolters, *La scultura veneziana gotica [1300–1460]* [Venice, 1976], no. 49). For a reading of the palace's symbolic significance, see Michelangelo Muraro, "Venezia: Interpretazione del Palazzo Ducale," *Studi urbinati di storia, filosofia e letteratura* 45 (1971): 1160–75, esp. p. 1166, regarding the identification of Justice and Venice. See also Camillo Semenzato, "Scultura come simbologia del potere," in *Il Palazzo Ducale di Venezia* (Turin, 1971), pp. 169–214, and Wolters, *Scultura veneziana*, pp. 46–47 and n. 19 on p. 136.

The Venice-Justice identification is also implicit in Jacobello del Fiore's Justice triptych of 1421, originally in the Magistrato del Proprio in the Ducal Palace (Moschini Marconi, *Gallerie dell'Accademia*, vol. 1, no. 26): see Staale Sinding-Larsen, *Christ in the Council Hall: Studies in the Religious Iconography of the Venetian Republic* (Acta ad archaeologiam et artium historiam pertinentia [Institutum Romanum Norvegiae], vol. 5) (Rome, 1974), pp. 55–56, 174–75. An interesting further transformation of this imagery is offered by a drawing in Berlin once attributed to Pordenone (Detlev von Hadeln, *Venezianische Zeichnungen der Hochrenaissance* [Berlin, 1925], pl. 35; Tietzes, *Drawings*, no. A1293): flanked by St. Sebastian and St. Roch, the Madonna and Child are depicted seated upon a throne supported by two lions—thereby reuniting, as it were, the traditional identifications of the Virgin as *Sedes Sapientiae* (above, n. 72) and of Venice as *Vergine* (below, n. 140). See also Isa Ragusa, "*Terror demonum* and *terror inimicorum*: The Two Lions on the Throne of Solomon and the Open Door of Paradise," *Zeitschrift für Kunstgeschichte* 40 (1970): 93–114.

135 See Sinding-Larsen, *Christ in the Council Hall*, pp. 170–71, and Wolters, *Scultura veneziana*, no. 245. With respect to Venetian awareness of architectural iconography and propriety, we may cite the Kingston Lacy *Judgment of Solomon*, an unfinished canvas often associated with Giorgione's "teller da esser posto a la Udienza" of the Ducal Palace but now generally ascribed to Sebastiano del Piombo (see Pignatti, *Giorgione*, p. 121, pl. 190; Wilde, *Venetian Art*, pp. 99–101; and especially Michael Hirst, "The Kingston Lacy 'Judgment of Solomon,' " in *Giorgione: Atti del Convegno Internazionale di Studio per il 5° Centenario della Nascita* [Castelfranco Veneto, 1979], pp. 257–62). In this painting the scene of judgment quite properly takes place in a conspicuously accurate reconstruction of an ancient basilica, traditionally the setting for the dispensation of justice in Roman antiquity.

Once one recognizes the associative significance of specific architectural forms and styles, the settings created by Venetian Renaissance painters appear less arbitrary or merely modish. Erik Forssman, for example, in discussing Titian's Louvre *Crowning of Thorns*, has emphasized the meaning of the rustication and the Tuscan order in that picture with respect to their

implications of heroic reference as well as to the architecture of justice ("Über Architekturen in der venezianischen Malerei des Cinquecento," *Wallraf-Richartz Jahrbuch* 29 [1967]: 109; see also Panofsky, *Problems in Titian*, p. 49, and Rosand, *Titian*, pl. 29). Tintoretto's use of the Serlian tragic scene in the background of the Prado *Washing of the Feet* (fig. 107) assumes a richer meaning when considered in the context of the subject, the impending tragedy of Christ's sacrifice (Forssman, "Über Architekturen," p. 115; and below, chap. 5, p. 150).

136 Cf. Sansovino's description of the earliest decorations in the Sala del Maggior Consiglio: "Di sopra all'una delle porte per fianco erano due Santi Romiti, che spartendo un pane fra loro, se lo porgevano l'uno all'altro, con significatione di carità: per dimostrare che i governanti di questo Stato, debbono essere insieme una cosa medesima, amandosi intensamente l'un l'altro, & communicando l'uno all'altro gli honori con carità, & con giustitia per mantenimento della libertà" (*Venetia*, p. 326). On the Porta della Carta the four Cardinal Virtues are represented; Justice, however, has been assigned the highest position, crowning the entire structure, and its place, chief among the niches flanking the portal, has been taken by Charity (Zanotto, *Palazzo Ducale*, vol. 1, p. 359; Anne Markham Schulz, *The Sculpture of Giovanni and Bartolomeo Bon and their Workshop* [Transactions of the American Philosophical Society] [Philadelphia, 1978], figs. 1, 38, 46). Similarly, in the *finestrone* on the façade facing the molo (fig. 91), crowned by a figure of Justice, the roundel below has been filled with a *Caritas* group (Zanotto, vol. 1, p. 202).

137 Vermeule, *European Art and the Classical Past*, p. 89.

138 See the commentary in Sebastiano Erizzo, *Discorso sopra le medaglie de gli antichi*, 2d ed. (Venice, 1568), p. 338. On the institution of the *Alimenta* and its representation: Mason Hammond, "A Statue of Trajan represented on the 'Anaglypha Traiani,'" *Memoirs of the American Academy in Rome* 21 (1953): 125–83, and *The Antonine Monarchy* (Rome, 1959), pp. 36, 54–55, 326.

139 The use of ancient medals as sources for a new propagandistic iconography becomes especially common in the later sixteenth century and is explicitly acknowledged in the programs for the pictorial redecoration of the Ducal Palace after the fires of 1574 and 1577: the personification of *Venetia* is based on the example of *Roma* "sicome si vede nelle medaglie antique." See Wolfgang Wolters, "Der Programmentwurf zur Dekoration des Dogenpalastes nach dem Brand von 20. Dezember 1577," *Mitteilungen des Kunsthistorischen Institutes in Florenz* 12 (1966): 271–318, cf. also Sinding-Larsen, *Christ in the Council Hall*, pp. 224–32. For further observations on Titian's use of numismatic models, see Panofsky, *Problems in Titian*, pp. 76–77, 86, and Robert W. Gaston, "Vesta and the *Martyrdom of St. Lawrence* in the Sixteenth Century," *Journal of the Warburg and Courtauld Institutes* 38 (1974): 358–62.

140 See Sinding-Larsen, *Christ in the Council Hall*, pp. 142–44. Thus, Guariento's fresco of the *Coronation of the Virgin*, the first and dominant decoration of the Sala del Maggior Consiglio, was flanked by the protagonists of the Annunciation. Perhaps the clearest pictorial statement of the theme is to be found in Bonifazio de' Pitati's three-part painting for the Camera degli Imprestidi (Moschini Marconi, *Gallerie dell'Accademia*, vol. 2, no. 73): within the two outer arches of this now dismembered field were the Archangel Gabriel and the Virgin Annunciate; the central panel depicts God the Father hovering low over a view of Piazza San Marco and the Piazzetta. In its original form, then, Bonifazio's painting made Venice itself simultaneously setting for and, as it were, participant in the Incarnation.

The inviolate nature of unconquered Venice, secure within its lagoon fortress, lent itself to iconographic elaboration based upon and paralleling the liturgy and imagery of Mary. In the *pro duce*, a prayer for the doge, Venice emerges as *Venetia aeterna*, created by God in all its perfection from eternity, civic surrogate for Divine Wisdom (cited by Sinding-Larsen, *Christ in the Council Hall*, p. 155). Cf. also Sansovino's political comments on "Venetia Vergine" (*Venetia*, pp. 323–24).

The inscription in the center of Santa Maria della Salute, "UNDE ORIGO INDE SALUS," refers to the origin of Venice under the special patronage of the Virgin and to the health, spiritual and physical, that is the benefit of that patronage: see Muraro, "Il tempio votivo," pp. 87–119, and Rudolf Wittkower, "Santa Maria della Salute," *Saggi e memorie di storia dell'arte* 3 (1963): 34. Further on the adaptation of liturgical imagery in the civic iconography of Venice: Charles de Tolnay, "Il 'Paradiso' del Tintoretto: note sull'interpretazione della tela in Palazzo Ducale," *Arte veneta* 24 (1970): 103–10, and especially Sinding-Larsen, *Christ in the Council Hall*.

The Ducal Palace itself not infrequently figures as the setting of religious subjects in painting: e.g., in Bonifazio de' Pitati's *Christ and the Adultress*, a scene of judgment that was originally in the Magistrato del Sale (Moschini Marconi, *Gallerie dell'Accademia*, vol. 2, no. 92), and in Cesare da Conegliano's *Last Supper* (dated 1583) in the presbytery of Santi Apostoli. Cf. also Jacopo Bellini's drawing of the *Presentation of the Virgin* (fig. 62), in which the architecture

seems to have been inspired, in a more general way, by the Ducal Palace (above, n. 36).

141 See chap. 1, sec. 2. On the notion of civic harmony and its literal manifestations, see Ellen Rosand, "Music in the Myth of Venice," *Renaissance Quarterly* 30 (1977): 511–37.

142 Sansovino, *Venetia*, p. 282: "rappresentano anco un certo modo di governo civile, nel quale i cittadini, quasi in propria Repub. hanno i gradi & gli honori secondo i meriti, & le qualità loro." Sansovino's description and explanation follow that of Gasparo Contarini, *De magistratibus et republica Venetorum libri quinque* (Venice, 1543), pp. 111–13 (Italian translation: *Della republica et magistrati di Venetia libri V* (1548), [Venice, 1591], pp. 104–05):

> ciascun [scuola] hanno la loro destinata stanza appartata, nella quale si ragunano i capi della Schola, il qual Magistrato si muta d'anno in anno, & è non picciola dignita tra' plebei. Questi ragunati insieme consultano delle cose, che s'hanno da fare, & danno opera, che non si manchi in parte alcuna al bene della Schola. E commessa anchora nella fede di quegli gran quantita di danari da doversi dispensare a poveri. Conciosia cosa che ne tempi antichi furono di cotanta stima queste Schole, che molti, i quali per testamento havevano lasciato, che le sue robbe si distribuissero nell'uso de' poveri, fecero questi principalmente tuttori, per arbitrio di iquali si dispensassero que' danari. Onde è fatto, che alcune di queste Schole concedano ogni anno la copia di queste facolta, lequali in questi usi si deono dispensare, a i Procuratori di San Marco, ilquale Magistrato si come è solo di gentilhuomini, cosi è di molta grandezza. A questo honore, cioè a questa presidenza di Schole, niuno de' Gentilhuomini può pervenire, quantunque sieno del numero de i confrati, ma solamente gli huomini plebei possono ottenere quella dignità, acciò che in questa parte anchora il popolo imitasse la nobilta. Impero che questi capi delle Schole riferiscono in un certo modo nel popolo la dignità de' Procuratori.

On Contarini and his book, which was written in 1524, see Felix Gilbert, "The Date of the Composition of Contarini's and Giannotti's Books on Venice," *Studies in the Renaissance* 14 (1967): 172–84; for a general comment on Contarini in the context of Venetian propaganda, see Oliver Logan, *Culture and Society in Venice, 1470–1790* (London, 1972), pp. 5–8.

143 One of the inscriptions, recording the restorations of 1566 in the Scuola della Carità and now on the landing of the double staircase, declares these basic principles: "DOMINIUM VENETUM / RELIGIONE LEGE / IUSTITIA CONSERVAT / REMPUBLICAM. CHARITATE / AMORE PIETATE / SUBDITOS MDLXVI." Sansovino, *Venetia*, p. 282; Tassini, "Iscrizioni," p. 114. See above, n. 14.

144 Pullan, *Rich and Poor*, esp. pp. 107–08.

145 Cf. Leo Steinberg's exploration of the manifold unity accessible only to an open and unprejudiced criticism, of one of the presumably best-known paintings in the history of art: "Leonardo's *Last Supper*," *Art Quarterly* 36 (1973): 297–410.

146 On the concept and implications of *colorito*: above, chap. 1, sec. 3.

147 And his demonstration stands as a link between the earlier *teleri* of the quattrocento masters and those of the artist who would found much of his own style on those venerable models, Paolo Veronese: see below, chap. 4.

148 Archivio di Stato, Venice: Scuola Grande di Santa Maria della Carità, Registro 311, fols. 1ᵛ–2. The Scuola was to pay an annual sum of 6 *soldi de piccioli* for this privilege, with the further understanding that if any of the brothers desired burial elsewhere the monastery was obligated to send two monks to officiate at the funeral.

 The assumption that the Scuola was actually located for a period at San Giacomo on the Giudecca before its transfer to the monastery of Santa Maria della Carità (Tassini, "Iscrizioni," p. 114) seems to lack any clear documentary evidence. On the church and its history, see G. Fogolari, "La chiesa di Santa Maria della Carità di Venezia," *Archivio veneto-tridentino* 5 (1924): 57–119, summarizing the documents dealing with the early relations between the Scuola and the monastery.

149 Archivio di Stato, Venice: Scuola Grande di Santa Maria della Carità, Registro 311, fol. 2.

150 References are to the Appendix of documents, below, pp. 221–38. Another document, of 7 March 1294, records one step in the Scuola's progress toward larger quarters: ". . . detti Padri hanno ritolto à detta Scola una Camera posta appresso il Dormitorio di detto Monastero, che avevano concesso alla Scola medesima per esser necessaria alli medesimi di poter à spese di detta Scola far una camera in soler sopra le mura del Portico et andio per quali si discende nella Corte grande per qual Corte si và fuori di detto Monastero" (Archivio di Stato, Venice: Scuola Grande di Santa Maria della Carità, Registro 311, fol. 2ᵛ).

151 "MCCCXLIII DIE XII DE AVRIL QUESTA POSE/SION FO CHOMENZADA AL ONOR DE L'ALTISIMO / DIO E DE LA SOA DOLCE MARE BIATISIMA MADONA / SC̄A MARIA DE LA CHARITADE E P̄. BEN E ONORE DE/STRO DE TUTI LI NOSTRI FRARI DE LA SCUOLA DE LI / BATUDI E FO C̄MPLIDA DEL MESE DE ZENER E TUTA / LA POSESION FO SCOMENZADA E C̄MPLIDA IN TEMPO / DE MĪS MAFIO BISUOL DE SĒ VIDAL VAR-

DIAN DE LA / DITA SCUOLA E TUTI LI SUO CHŌPAGNI FO CHON/PLIDA E. ROBORADA E DEL SACHO DE SĀ MARIA E DE LE / BORSE DE LI BONI OMENI DE LA SCOLA FO PAGADA." Tassini, "Iscrizioni," pp. 114–15; see also the translation and comments of Ruskin in his *Guide to the Principal Pictures in the Academy,* pp. 173–75.

According to the terms of the contract (Document 1), the monks acquired in exchange "una Casa in soler," which may be the structure alluded to in the document of 1294 (see the preceding note).

152 On 11 March 1381 the monks had agreed to rent to the Scuola "due Ospicij sivè Volte con un'altro ospicietto doppo." These rooms, however, were evidently not in the same position as the new *albergo* but rather at the opposite (southern) end of the Scuola's *casa grande:* ". . . uno di detti due ospicij confinano da un capo con una case grande delli Battudi di S. Maria della Carità verso S. Gervaso, dall'altro suo capo confinano in terra vacua ove hà l'entrata et uscita, andando verso la riva sopra il riello in faccia la detta Casa di detti Battudi, da un suo ladi confinano sopra il rio, dall'altro suo ladi confinano con detto Monastero di S. Maria della Carità" (Archivio di Stato, Venice: Scuola Grande di Santa Maria della Carità, Registro 311, fol. 8).

153 As part of another contract of the same date the Scuola also received permission to construct its hospital: ". . . con patto che sopra dette casette, graneri, e terrano vacuo, et alberghi possano detti Guardian, e compagni di detta Scola far lavorar, e fabricar le Case, ospitale, e tutto quel che ad essi piacerà; mà che non si possa far ivi Chiesa ne Capella, nelle quali si celebri il Divino Officio . . ." (Archivio di Stato, Venice: Scuola Grande di Santa Maria della Carità, Registro 311, fol. 20ᵛ).

154 Archivio di Stato, Venice: Scuola Grande di Santa Maria della Carità, Busta 277, no. 104: "Conto della fabricha de lalbergo nuovo fato in mccccxliij." See Pietro Paoletti, *L'Architettura e la scultura del Rinascimento in Venezia* (Venice, 1893), vol. 1, pp. 56–57, 91–92 (our Document 5).

155 The Scuola was officially suppressed on 25 April 1806. For the history of the subsequent transformations, see Tassini, "Iscrizioni"; also Elena Bassi, *La R. Accademia di Belle Arti di Venezia* (Florence, 1941), and *Il convento della Carità (Corpus Palladianum,* vol. 6) (Vicenza, 1971). For the church in particular, see Fogolari, "La chiesa," and, more recently, Laura de Carli and Michele Zaggia, "Chiesa, convento e Scuola di S. Maria della Carità in Venezia," *Bollettino del Centro . . . Andrea Palladio* 16 (1974): 421–44.

156 Probably a sixteenth-century copy of a quattrocento composition: see Moschini Marconi, *Gallerie dell'Accademia,* vol. 2, no. 361. Bird's-eye views of Venice, beginning with Jacopo de' Barbari's celebrated multiblock woodcut of 1500, invariably show the Carità complex from the east, with the church blocking the view of the Scuola; hence they are of limited value in any attempt at reconstruction. Cf. Bassi, *Il convento,* figs. I, II, III. On these graphic sources in general, see Juergen Schulz, *The Printed Plans and Panoramic Views of Venice (1486–1797)* (Florence, 1970) (published as volume 7 of *Saggi e memorie di storia dell'arte,* 1972).

157 Fogolari ("La chiesa," p. 62) had assumed that the portal on the *campo* was the exclusive entrance to the Scuola.

158 The relief of the Madonna above the portal is dated 1345: "MCCCXLV. ĪLO TEMPO DE MIS. MARCHO ZULIĀ FO FATO STO LAVORIER" (Tassini, "Iscrizioni," pp. 115–16; Wolters, *Scultura veneziana,* no. 52); that of St. Leonard, to the left of the door, carries the date of 1377: "MCCCLXXVII FO FATO QUESTO LAVORIER / A L'ONOR DE DIO E DE LA VERGENE MARIA E D̄L GLORIO/XO CHONFESOR MIS. SEN. LUNARDO E IN MEMUOR/IA DE TUTI CHE IN LO SO SANTO DI FO CHOMEN/ZADA E CREADA QUESTA SANTA FRATERNITA/DE E SCHUOLA" (Tassini, "Iscrizioni," p. 116), and the St. Christopher on the other side was probably executed in 1384, although the inscription is mutilated: "MC . . . XXXIIII DEL MESE DE ZENER FO FATO STO LAVORIER" (Tassini, p. 116). See also Wolters, *Scultura veneziana,* p. 155. On the tradition of placing an image of St. Christopher just outside the portal of a church, see Muraro, *Art Bulletin* 54 (1972): 354.

159 The sculpted cusp originally crowning this portal may still be preserved, now set into the exterior wall of the Accademia. For the topographical changes, see Bassi, *Il convento.*

160 The traces of such a staircase are still visible in the internal wall masonry of the Accademia; moreover, the remains of a well further suggest an entrance *cortile* complex at the southern end of the Scuola della Carità. For illustrations of such external staircases, see Edoardo Arslan, *Gothic Architecture in Venice* (London, 1971), figs. 143–45, 149, 160, 185.

161 Tassini, "Iscrizioni," pp. 114–15; the inscriptions are quoted above, n. 14, 143.

162 For these eighteenth-century transformations, see Sandra Moschini, "Il catalogo delle Gallerie dell'Accademia—nuovi accertamenti," *Ateneo Veneto* 5 (1967): 148–56; Antonio Massari, *Giorgio Massari, architetto veneziano del Settecento* (Vicenza, 1971), pp. 113–14 and fig. 262 (an early nineteenth-century lithograph showing Massari's façade before its own subsequent metamorphosis); and de Carli and Zaggia, "Chiesa, convento e Scuola."

163 Boschini's explicit reference to the two doors to the *albergo* suggests that at least until 1674, the

date of the second edition of his guide, no double staircase had yet rendered useless one of the entrances (see below, n. 175). The absence of any recorded epigraphic evidence might also argue against any such major construction before 1765.

164 The height of the quattrocento(?) frieze in the *sala grande* of the Scuola della Carità indicates that the ceiling of the room had been raised, probably in the eighteenth century. Here, too, however, such a major renovation was anticipated by many years: on 13 March 1589, the brothers debated and rejected the "Parte d'alzar il soffitto della scola" (Archivio di Stato, Venice: Scuola Grande di Santa Maria della Carità, Registro 351, fol. 142; full text in Registro 259, fol. 103). Reconstructions of this kind were not unusual among *scuole grandi*; in 1495, for example, the ceiling of the *sala grande* of the Scuola di San Giovanni Evangelista was raised by more than two meters in order to accommodate the new monumental staircase (Sohm, "The Staircases of the Venetian Scuole Grandi," p. 137).

165 Such a renovation might have been part of the same campaign that involved the cutting of a new door, designed by Scamozzi, into the *sala terrena* from the shared *cortile* (Bassi, *Il convento*, fig. LXXXVII). Mauro Coducci's grand internal staircases for the Scuola di San Marco and the Scuola di San Giovanni Evangelista had already established by the end of the fifteenth century a new standard of architectural elegance and monumentality in the competitive world of the *scuole grandi* (Paoletti, *La Scuola Grande di San Marco*, p. 40; Lorenzetti, *La Scuola Grande di San Giovanni Evangelista*, pp. 33–37). And these were followed in the sixteenth century by Scarpagnino's still more grandiose *scalone* in the newly erected Scuola di San Rocco (documents in Giambattista Soràvia, *Le chiese di Venezia* [Venice, 1822–24], vol. 3, pp. 310–13). For the fullest discussion of the issue, see now Sohm, "The Staircases of the Venetian Scuole Grandi."

166 Paoletti, *L'Architettura*, p. 57. The contract of 1384 regarding construction of the *albergo* had stipulated that the room could have windows on both sides, facing the *campo* as well as the *cortile* (Document 2), and this is repeated in the agreement of 1442 on the enlargement of the room (Document 5).

167 Originally published in David Rosand, "Titian's 'Presentation of the Virgin': The Second Door," *Burlington Magazine* 115 (1973): 603. As Charles Hope then pointed out ("Documents Concerning Titian," *Burlington Magazine* 115 [1973]: 809), Titian himself had been consulted about a similar problem in 1544 by the Scuola di San Giovanni Evangelista and had recommended that a part of Carpaccio's canvas of the *Miracle of the True Cross* be cut to allow for the construction of a new door (see Juergen Schulz, "Titian's Ceiling in the Scuola di San Giovanni Evangelista," *Art Bulletin* 48 [1966]: 93, doc. III).

168 Michiel's inventory reads as follows:

> La nostra donna in testa delalbergo, cun el puttino in brazzo, cun li altri dui santi un per lato à guazzo, in tavola [*sic*], et magior del natural, furono de man de Antonio da Muran.
>
> Nel ditto albergo a man mancha li apostoli pur in tavola a guazzo, mazior del natural, furon de man de Jacomello dal Fior l'anno 1418. 13. Febbrajo.
>
> A man dextra le pitture, ut supra furono de man de. . . .
>
> In la sala della ditta scola la nostra donna a guazzo in tavola a man mancha appresso la porta delalbergo fu dipinta lanno 1352 da. . . .
>
> La pittura in ditta sala sopra la scala fu fatta lanno 1487 da. . . .
>
> Le altre pitture da lun lato e laltro della sala, pur a guazzo, in tavole cun la istoria della nostra donna, furono de man de. . . .
>
> Nell'albergo el ritratto del cardinal Niceno vestito di zambellotto negro cun la cappa in capo, et cun lo cappello deposto giuso accosto dello, fu de mano de . . . et novamente è stato refatto da. . . .
>
> El quadretto della passion del nostro signore cun tutti li misterii in piu capitoli a figure picole alla Grecca, cun el texto delli evangelii Grecco sotto, fu opera Costantinopolitana, et par essere stata una porta dun armaro. Et fu donata dal cardinal Niceno alla scola, della qual volse esser fratello. Per il che essi lo fecero ritrar nel ditto quadro della questa passion, de sotto inzenochiato cun la croce in mano cun dui altri fratelli della scola similmente inzenochiati, et cun le cappe in dosso.
>
> Ivi, el quadretto della testa di Christo in maiestà, a guazzo, fu de mano de Andrea Bellino, come appar per la sottoscriptione (*Notizia d'opere del disegno*, ed. Theodor Frimmel [Vienna, 1888], pp. 116–18).

Jacobello's *Apostles*, which may have been replaced in the sixteenth century, evidently survived into the nineteenth: see Michele Caffi, "Giacomello del Fiore pittore veneziano del sec. XV," *Archivio storico italiano* 6 (1880): 407. A brother of the Scuola della Carità, Jacobello was clearly deeply involved with the confraternity, to which he bequeathed "omnes et singulas meas reliquas sanctorum cum suis ornamentis" (Caffi, p. 411, and Pietro Paoletti,

Raccolta di documenti inediti per servire alla storia della pittura veneziana nei secoli XV e XVI, vol. 2 [Padua, 1895], p. 8). His son Ercole was also a member and also thought of the Scuola in his final testament: "Item lasso Tuti dessegnamenti et ognj altre cosse aspeta alarte de la pentoria sono si in chaxa come in botega aj poverj de la schuola de la charita . . ." (Paoletti, p. 10). Although we do not know if Antonio Vivarini was in the confraternity, it seems likely; his son Alvise was a *confratello* from 1476 until 1488, when he was expelled "per non aver fato le fazion e nun esser vegnudo za moltj annj ala schuola essendo sta amonido è sta meso fuora" (Paoletti, p. 19). In general on the relationship of artists to the *scuole grandi*, see the documentary survey in Wurthmann, "The *Scuole Grandi*," pp. 238–85; also Jürg Meyer zur Capellen, "Bellini in der Scuola Grande di S. Marco," *Zeitschrift für Kunstgeschichte* 43 (1980): 104–08.

169 Lorenzetti, *Venezia*, p. 679; cf. Schulz, *Venetian Painted Ceilings*, p. 6 and n. 15, and Wolfgang Wolters, *Plastische Deckendekorationen des Cinquecento in Venedig und im Veneto* (Berlin, 1968), p. 7, n. 25. Paoletti (*L'Architettura*, p. 83, n. 7) plausibly suggested that the central roundel, stylistically more archaic than the rest, was taken from an earlier ceiling—possibly one for which 100 ducats had been left in 1461 by Tomaso Cavasso. In his additions to Morelli's commentary on Michiel, Gustavo Frizzoni records a date of 1443 on the *albergo* ceiling (*Notizia d'opere di disegno* [Bologna, 1884], p. 237). Three hundred ducats had been bequeathed to the Scuola in 1436 by Bartolomeo di Giacomo Bonetti, primarily for an altarpiece ("un altar con sua palla a Maria Vergine nella Casa"), the remainder to be used "per far soffitar la Casa sudetta" (Archivio di Stato, Venice: Scuola Grande di Santa Maria della Carità, Registro 311, fol. 235), that is, presumably, the ceiling of the *sala grande*. See Wurthmann, "The *Scuole Grandi*," pp. 145, 210.

170 These documents were first published by Gustav Ludwig, "Archivalische Beiträge zur Geschichte der venezianischen Malerei," *Jahrbuch der königlich preussischen Kunstsammlungen* 26 (1905): supplement, pp. 53–56. They were, however, apparently already known to Paoletti: see G. Cantalamessa, "RR. Gallerie di Venezia—pitture," *Le gallerie nazionali italiane* 2 (1896): 37–43.

171 Above, pp. 90–91.

172 For Bessarione's donation of 1463, a Byzantine reliquary of the fourteenth or fifteenth century—described by Michiel (above, n. 168)—see Moschini Marconi, *Gallerie dell'Accademia*, vol. 1, no. 216, with further bibliography.

173 The documents were published by Ludwig ("Archivalische Beiträge," pp. 145–47), but incompletely and with some serious errors. In transcribing them, he inadvertently conflated our Documents 20 and 22, publishing them as a single entry for 1539, and entirely overlooked Document 21. A rather compressed chronology of the events naturally resulted, in which the impatience of the Scuola is incomprehensible.

174 Since 1888 the painting has been on deposit in the parish church of Mason Vicentino. See Moschini Marconi, *Gallerie dell'Accademia*, vol. 2, no. 376; also Giovanna Scirè, "Appunti sul Silvio," *Arte veneta* 23 (1969): 213.

175 Boschini, *Minere*, pp. 360–61: "Alla sinistra, entrando dentro dalla porta verso il Campo, due quadri della scuola di Tiziano: ma perche sono tutti racconciati, poco vi resta dell'Autore."

176 Moschini Marconi, *Gallerie dell'Accademia*, vol. 2, no. 375, also on deposit at Mason Vicentino.

177 Most recently by Scirè, "Appunti sul Silvio," p. 213.

178 In a letter of 1564 Girolamo was described as "a relative or pupil who has been in Titian's house more than thirty years, and is considered the next best after him, though he does not come up to him" (quoted by Crowe and Cavalcaselle, *Titian*, vol. 2, p. 343). On this master, see Detlev von Hadeln, s.v. "Girolamo Dente," in Thieme-Becker, *Allgemeines Lexikon der bildenden Künstler*, vol. 9 (Leipzig, 1913), pp. 81–82, and "Girolamo di Tiziano," *Burlington Magazine* 65 (1934): 84–89; Jan Zarnowski, "L'Atelier de Titien: Girolamo di Tiziano," *Dawna Sztuka* 1 (1938): 107–30; Pallucchini, *Tiziano*, vol. 1, p. 214, vol. 2, pls. 651–53; and M. Roy Fisher, *Titian's Assistants During the Later Years* (New York and London, 1976), pp. 31–42.

179 The "quadro antiquissimo defformè dali altri" may conceivably be the panel of the apostles attributed to Jacobello del Fiore by Michiel (above, n. 168). We must assume that the inaccurate description of Girolamo's painting in Document 24 as a "representation of the Virgin Mary and Our Lord Jesus Christ" is the result of scribal carelessness—unless it may reflect in some way the subject of the old picture being replaced (below, n. 182).

180 The author of the *Marriage of the Virgin*, Silvio, seems to be more ambitious in his compositional aspirations; his figures are rather more self-consciously posed with a certain mannered quality (and here we may wonder to what extent he may have been consulting the chalk drawing left by Pordenone). The artist of the *Annunciation*, on the other hand, operates within a more limited mode and, because of this modesty, seems to display a more convincing control over his pictorial means. His figures, less prepossessing than those of Silvio, betray a closer dependence on Titianesque models. Finally, the architecture in each of the canvases is

constructed quite differently: Silvio in particular uses an elaborate scaffolding of incised guide lines, a system not at all evident in the painting of the *Annunciation*.

181 For the fire of 1630, see Bassi, *Il convento*, p. 51.

182 Cf. in particular Michiel's description, quoted above, n. 168. The anonymous portrait of Bessarione, recording a quattrocento original, "novamente è stato refatto," according to Michiel, and his observation is confirmed by a document of 8 March 1540 (cited in Moschini Marconi, *Gallerie dell'Accademia*, vol. 2, no. 347). Sansovino, like Michiel, lists in addition "un quadretto con una testa di Christo in maestà fatta à guazzo da Andrea Bellino" (*Venetia*, p. 282); Boschini describes it as "un quadretto mobile, di mano di Giovanni Bellini" (*Minere*, p. 360). The painting, although probably included, is not further specified in the inventory of 1679 (Document 27). An inventory of 19 March 1674, however, does list "Un quadro della Madonna con il Bambino del Zambellino" as in the *cancelleria* (Archivio di Stato, Venice: Scuola Grande di Santa Maria della Carità, Busta 2, no. 117, fol. 2ᵛ).

CHAPTER 4. THEATER AND STRUCTURE IN THE ART OF PAOLO VERONESE

1 Carlo Ridolfi, *Le maraviglie dell'arte* (1648), ed. Detlev von Hadeln (Berlin, 1914–24), vol. 1, p. 297.

2 Marco Boschini, *Le ricche minere della pittura veneziana* (Venice, 1674) (reprinted in Boschini, *La carta del navegar pitoresco*, ed. Anna Pallucchini [Venice and Rome, 1966], p. 732).

3 Thus, e.g., Michael Levey ("An Early Dated Veronese and Veronese's Early Work," *Burlington Magazine* 102 [1960]: 106–11) speaks of Veronese's "curious and continual failure with the person of Christ" and of a group of relatively early works as "attempts by Veronese to deal in decorative rather than dramatic terms with religious subjects." Levey concludes, "There is little doubt that religious subjects presented a problem to him as they did not either to Titian or Tintoretto."

4 On "decoration" in Veronese's art see the discussion in Theodor Hetzer, "Paolo Veronese," in his *Aufsätze und Vorträge* (Leipzig, 1957), vol. 1, pp. 113–21. Hetzer's acute essay (originally published in *Römisches Jahrbuch für Kunstgeschichte* 4 [1940]: 1–58) remains among the best sustained critical efforts in the field. See also Cecil Gould, "Observations on the Role of Decoration in the Formation of Veronese's Art," in *Essays in the History of Art presented to Rudolf Wittkower* (London, 1967), pp. 123–27.

5 Most studies of Veronese's iconography rarely go beyond the presumed a priori program to recognize the artist himself as an intellectually active participant in the creation of the "content" of a picture. Important exceptions to this are two highly suggestive articles by Philipp Fehl: "Questions of Identity in Veronese's *Christ and the Centurion*," *Art Bulletin* 39 (1957): 301–02, and "Veronese and the Inquisition: A Study of the Subject Matter of the So-called 'Feast in the House of Levi,'" *Gazette des Beaux-Arts* 58 (1961): 325–54. See also Madlyn Kahr, "The Meaning of Veronese's Paintings in the Church of San Sebastiano in Venice," *Journal of the Warburg and Courtauld Institutes* 33 (1970): 235–47.

6 Only recently has the artist received his catalogue raisonné: Terisio Pignatti, *Veronese: L'Opera completa*, 2 vols. (Venice, 1976).

7 See, e.g., Anna Maria Brizio, "La pittura di Paolo Veronese in rapporto con l'opera del Sanmicheli e del Palladio," *Bollettino del Centro Internazionale di Studi di Architettura Andrea Palladio* 2 (1960): 19–25; Erik Forssman, "Über Architekturen in der venezianischen Malerei des Cinquecento," *Wallraf-Richartz Jahrbuch* 29 (1967): 122–37; and Christian Lenz, *Veroneses Bildarchitektur* (diss., Ludwig-Maximilians-Universität, Munich, 1969). The most recent contribution to this literature, however, expands the scope of the discussion in significant ways: Sergio Marinelli, "Lo spazio ideologico di Paolo Veronese," *Comunità* 28, no. 173 (1974): 302–64.

8 One aspect of this subject was treated briefly and in a rather generalized fashion by Eva Tea, "Paolo Veronese e il teatro," in *Venezia e l'Europa (Atti del XVIII Congresso Internazionale di Storia dell'Arte)* (Venice, 1956), pp. 282–84, and somewhat less vaguely by Anna Maria Brizio, "Paolo Veronese," in *Rinascimento europeo e Rinascimento veneziano*, ed. Vittore Branca (Florence, 1967), pp. 223–31. On the dangers of forcing this particular issue, see the judicious comments of Ludovico Zorzi, "Elementi per la visualizzazione della scena veneta prima del Palladio," in *Studi sul teatro veneto fra Rinascimento ed età barocca*, ed. Maria Teresa Muraro (Florence, 1971), pp. 22–23.

9 For full particulars on the painting, see Cecil Gould, *The Sixteenth-Century Italian Schools* (National Gallery Catalogue) (London, 1975), pp. 320–22; also his *The Family of Darius before Alexander by Paolo Veronese* (London [1978])—as well as Gould's exchange with Richard Cocke in *The Burlington Magazine* 120 (1978): 325–29, 603.

10 Goethe assumed the figure in crimson ceremonial armor to be in fact not Alexander but Hephaestion (*Italian Journey* [1786–1788], trans. W. H. Auden and Elizabeth Mayer [New York, 1968], p. 78). Though with respect to the anecdote of the subject this would appear to make

sense, the very nature of this figure's stance and gesture, imperious yet benevolent, seems more likely to bespeak the true Alexander. For the literary sources, see Gould, *Sixteenth-Century Italian Schools,* p. 321, and for further comment on the figure of Alexander, see below, pp. 167, 170.

11 At an earlier stage in the execution Veronese had evidently planned a solid wall as the backdrop to these figures, which might have even further stabilized this group. For observations on the infrared investigation of the canvas, see Gould, *Sixteenth-Century Italian Schools,* p. 321. I would like to thank Mr. Gould for his kindness in making available to me the infrared photographs.

12 On the relationship of style to site and to the nature of the commission in Veronese's art, see Gould, "Observations on the Role of Decoration."

13 With regard to this dissociation of architectural backdrops in Venetian painting, Forssman ("Über Architekturen," p. 108) cites the advice of Paolo Pino to "ornar l'opera con figure, animali, paesi, prospettive." Architectural setting, then, would be just one among several decorative elements in a composition and, in this context, hardly to be considered a basic organizing factor of the design.

14 See above, chap. 1, sec. 4. A full-scale study of the origins and development of the Venetian votive picture remains a *desideratum.* See meanwhile Hetzer, "Paolo Veronese," pp. 87–96 (also with regard to Veronese as *Zeremonialmahler*); Staale Sinding-Larsen, "Titian's Madonna di Ca' Pesaro and Its Historical Significance," *Acta ad archaeologiam et artium historium pertinentia* (Institutum Romanum Norvegiae) 1 (1962): 139–69; and, on a particular class of votive pictures, Irene Kleinschmidt, *Gruppenvotivbilder venezianischer Beamter (1550–1630): Tintoretto und die Entwicklung eine Aufgabe* (Centro Tedesco di Studi Veneziani, *Quaderni,* 4) (Venice, 1977).

15 Cecil Gould, "Sebastiano Serlio and Venetian Painting," *Journal of the Warburg and Courtauld Institutes* 25 (1962): 56–64. On the general trend toward architectural backgrounds and the so-called "Mannerist crisis" in Venetian painting, see Luigi Coletti, "La crisi manieristica nella pittura veneziana," *Convivium* 13 (1941): 109–26, and Rodolfo Pallucchini, *La giovinezza del Tintoretto* (Milan, 1950), pp. 19–64. On Serlio himself, see Marco Rosci, "Sebastiano Serlio e il teatro del Cinquecento," *Bollettino del Centro . . . Andrea Palladio* 16 (1974): 235–42.

16 See Sandra Moschini Marconi, *Gallerie dell'Accademia di Venezia,* vol. 2, *Opere d'arte del secolo XVI* (Rome, 1962), no. 407, with further bibliography. See also below, chap. 5, sec. 2.

17 For surveys of these developments, see Licisco Magagnato, *Teatri italiani del Cinquecento* (Venice, 1954), and Elena Povoledo, "Origini e aspetti della scenografia in Italia," in Nino Pirrotta, *Li due Orfei da Poliziano a Monteverdi,* 2d ed (Milan, 1975), esp. pp. 372–400 ("La commedia regolare e la scena prospettica"). See also the highly suggestive studies by Richard Krautheimer, "The Tragic and Comic Scene of the Renaissance: The Baltimore and Urbino Panels," in his *Studies in Early Christian, Medieval, and Renaissance Art* (New York and London, 1969), pp. 345–60, and Eugenio Battisti, "La visualizzazione della scena classica nella commedia umanistica," in his *Rinascimento e Barocco* (Turin, 1960), pp. 96–111. More recently, see Ludovico Zorzi, *Il teatro e la città: saggi sulla scena italiana* (Turin, 1977), and the papers devoted to "l'architettura teatrale dall'epoca greca al Palladio" published in *Bollettino del Centro . . . Andrea Palladio* 16 (1974).

18 Cf. Kurt Badt's Aristotelian reading of "Raphael's 'Incendio del Borgo,' " *Journal of the Warburg and Courtauld Institutes* 22 (1959): 35–59. Further on the dramatic unities: Joel E. Spingarn, *Literary Criticism in the Renaissance* (1908) (New York and Burlingame, 1963), pp. 56–63; on Aristotle's *Poetics* and their impact, see Bernard Weinberg, *A History of Literary Criticism in the Italian Renaissance* (Chicago, 1961), vol. 1, pp. 349–634.

19 See Gould, "Serlio and Venetian Painting," pp. 58–62; also Forssman, "Über Architekturen," pp. 111–16.

20 One must refrain from over-generalizing, however, since in Tintoretto's art format likewise played a critical role in determining spatial structure. In longer canvases he frequently employed the double focus of two-point perspective (e.g., fig. 107). The resulting divergent thrusts establish a narrative tension through the striking lack of coincidence of the main perspective focus, the *scena tragica,* in the left background of the *Washing of the Feet* and the dramatic focus of Christ at the right foreground. The situation is further complicated by the juxtaposition of this foreground scene with, above and behind it, the paschal supper itself, the larger moment of the narrative.

21 On Renaissance interpretations of the Vitruvian theater, see Robert Klein and Henri Zerner, "Vitruve et le théâtre de la Renaissance italienne," in *Le lieu théâtral à la Renaissance (Colloques Internationaux du Centre National de la Recherche Scientifique),* ed. Jean Jacquet et al. (Paris, 1964), pp. 49–60. For a particularly stimulating discussion of the problems of adapting Vitruvian precepts to the professional requirements of the modern—i.e., Renaissance—stage, see

Frances Yates, *Theatre of the World* (Chicago, 1969), pp. 112–35 (chap. VII: "The English Public Theatre as an Adaptation of the Ancient Theatre").

22 Our illustration is a chiaroscuro woodcut by Andrea Andreani (B. XII, 156, 29 II), published in 1589; the drawing by Girolamo da Bolsena records the design of Bartolomeo Neroni (Riccio Senese) for the 1560 production of Alessandro Piccolomini's *Ortensio* in Siena. See Magagnato, *Teatri italiani*, pp. 43–44, and Konrad Oberhuber, *Die Kunst der Graphik, 3: Renaissance in Italien, 16. Jahrhundert (Werk aus dem Besitz der Albertina)* (Vienna, 1966), cat. no. 225.

23 Yates, *Theatre of the World*, p. 118.

24 On the theatrical dimensions of the Farnesina loggia (in Egidio Gallo's poetic commentary, "Hic et prompta est positis modo / Scena Theatris / Fabula seu soccos / seu sit sumptura Cothurnos"), see Christoph Luitpold Frommel, *Die Farnesina und Peruzzis architektonisches Frühwerk* (Berlin, 1961), esp. pp. 36–37, 114–15, and Fabrizio Cruciani, "Gli allestimenti scenici di Baldassare Peruzzi," *Bollettino del Centro . . . Andrea Palladio* 16 (1974): 155–72; on the Cornaro loggia, see Giuseppe Fiocco, "Alvise Cornaro e il teatro," in *Essays in the History of Architecture presented to Rudolf Wittkower* (London, 1967), pp. 34–39. For more general observations: André Chastel, "Cortile et théâtre," in *Le lieu théâtrale*, pp. 41–47, and Zorzi, *Il teatro e la città*, pp. 295–326.

25 *Marci Actii Plauti linguae latinae principes: comoediae vigiti* (Venice, 1518). The relationship of these illustrations, which are repeated throughout the volume, to the theatrical function of the Cornaro loggia is noted by Magagnato, *Teatri italiani*, pp. 33–34. Cf. also George R. Kernodle, *From Art to Theatre: Form and Convention in the Renaissance* (Chicago, 1944), p. 169, who fails, however, to make an adequate distinction between this sort of classicizing arcade and other types of stage structures.

26 Still the most penetrating critical study of the Teatro Olimpico is Licisco Magagnato, "The Genesis of the *Teatro Olimpico*," *Journal of the Warburg and Courtauld Institutes* 14 (1951): 209–20. See also Magagnato, *Teatri italiani*, pp. 50–75; Lionello Puppi, *Il Teatro Olimpico* (Vicenza, 1963); Giangiorgio Zorzi, *Le ville e i teatri di Andrea Palladio* (Vicenza, 1968), pp. 282–327; Renato Cevese et al., *Mostra del Palladio* (Vicenza, 1973), pp. 118–20; Lionello Puppi, *Andrea Palladio* (Milan, 1973), cat. no. 143.

27 In this I follow Magagnato, who, considering Scamozzi's designs an exaggeration of Palladio's intentions, concludes: "The important fact, however, is that Palladio himself envisaged his stage as holding space within space" ("The Genesis," p. 217). For the extreme positions in the Palladio-Scamozzi debate, cf. Giangiorgio Zorzi, "Le prospettive del Teatro Olimpico di Vicenza nei disegni degli Uffizi di Firenze e nei documenti dell'Ambrosiana di Milano," *Arte lombarda* 10² (1965): 70–97; Lionello Puppi, "Prospettive dell'Olimpico, documenti dell'Ambrosiana e altre cose: argomenti per una replica," *Arte lombarda*, 11¹ (1966): 26–32; and again Zorzi, *Le ville e i teatri*, pp. 293–98 and esp. pp. 300–03.

28 *I dieci libri dell'architettura di M. Vitruvio tradutti et commentati da Monsignor Barbaro eletto Patriarca d'Aquileggia* (Venice, 1556), pp. 150–60. Barbaro's translation of and commentary on the passages on theater are available in Ferruccio Marotti's useful anthology, *Storia documentaria del teatro italiano: lo spettacolo dall'Umanesimo al Manierismo* (Milan, 1974), pp. 145–64.

29 Daniele Barbaro, *La pratica della perspettiva* (Venice, 1568), p. 131. "Et qui bisogna avvertire, che tutte le faccie delle machine poste nelle tre apriture, o nichi, rispondevano ad uno punto, cioè le tre facciate della Scena Tragica erano regulate da uno punto & le tre della comica da uno, & le tre della Satirica da uno, & a questo modo di tre faccie si componeva un aspetto, & una Perspettiva sola." The relevant sections of Barbaro's perspective treatise are reprinted in Marotti, *Storia documentaria*, pp. 205–12. For further discussion, see below, Excursus, pp. 177–81.

30 For this very reason the question of whether they were intended to be actual spaces or only painted illusions is immaterial to our argument.

31 However, for the 1585 production of *Edipo Tiranno* the separation between audience and spectacle was evidently reinforced by the use of a valance and curtain, which supported and masked the lights and served "as a kind of rudimentary proscenium-arch" (Magagnato, "The Genesis," p. 215, n. 3).

32 The effect of the spectacle of 1585 is described by Filippo Pigafetta, *Due lettere descrittive l'una dell'ingresso a Vicenza della Imperatrice Maria d'Austria nell'anno MDLXXXI l'altra della recita nel Teatro Olimpico dell'Edippo di Sofocle nel MDLXXXV* (Padua, 1830) (English version in A. M. Nagler, *A Source Book in Theatrical History* [New York, 1959], pp. 81–86). The aesthetic behind the production is discussed by the director himself, Angelo Ingegneri, in the second part of his *Della poesia rappresentativa & del modo di rappresentare le favole sceniche* (Ferrara, 1598), pp. 53–84. The inauguration of the Teatro Olimpico has been the subject of studies by Leo Schrade, *La représentation d'Edipo Tiranno au Teatro Olimpico* (Paris, 1960); by Lionello Puppi, "La rappresentazione inaugurale del Teatro Olimpico: appunti per la restituzione di uno spettacolo rinascimentale," *Critica d'arte* 9, no. 2 (1962): 57–63; no. 3: 57–69, and "Gli spettacoli all'Olimpico di Vicenza dal 1585 all'inizio del '600," in *Studi sul teatro veneto*, pp. 73–96; and,

most recently, by Alberto Gallo, *La prima rappresentazione al Teatro Olimpico* (Milan, 1973), reprinting the relevant textual sources. See also D. J. Gordon, "Academicians Build a Theatre and Give a Play: the Accademia Olimpica, 1579–1585," in *Friendship's Garland: Essays presented to Mario Praz* (Rome, 1966), vol. 1, pp. 105–38.

33 The classic analysis of these aspects of Palladio's style is by Rudolf Wittkower, *Architectural Principles in the Age of Humanism*, 3d ed. (New York, 1971), pp. 57–100 ("Principles of Palladio's Architecture"). See also the observations of Manfredo Tafuri, "Teatro e città nell'architettura palladiana," *Bollettino del Centro . . . Andrea Palladio* 10 (1968): 65–78.

34 Describing the *Feast in the House of Simon,* now in the Louvre, Ridolfi writes: "La Mensa è situata nel seno di maestoso Teatro, nel cui circuito girano molte colonne . . ." (*Maraviglie,* vol. 1, p. 315). The special relevance of the concept *in maestà* (for further references, see above, chap. 1, n. 134) was first appreciated by Marinelli ("Lo spazio ideologico," pp. 333, 340).

35 Barbaro, *I dieci libri . . . di M. Vitruvio,* p. 167 [=158]. For such scenes, continues Barbaro's commentary, "convenivano Palaggi, Loggie, Colonnati." The expansive spectacle of Veronese's canvases would presumably have satisfied Serlio's sense of the *scena tragica:* "Li casamenti d'essa vogliono essere di grandi personaggi . . . in cotali apparati non si farà edificio che non abbia del nobile, sí come si dimostra nella seguente figura [fig. 108], dentro la quale (per esser piccola) non ho potuto dimostrare quei grandi edificii regii e signorili che in un luogo spazioso si potrebbono fare . . ." (*Il secondo libro di perspettiva* [Paris, 1545]; in Marotti, *Storia documentaria,* p. 200).

36 What Panofsky, with reference to pre-Renaissance pictorial structures, has called the "herringbone scheme" (e.g., in *Renaissance and Renascences in Western Art,* 2d ed. [New York and Evanston, 1969], p. 136). For further references, see above, chap. 1, n. 120.

37 What Armenini would call *la convenienza alla qualità del luogo* (see above, chap. 2, n. 57).

38 The relationship of the *Marriage at Cana* to the refectory of San Giorgio Maggiore, in which the break between room and painting is muted by the receding foreground colonnades at either side, has been noted by Forssman ("Über Architekturen," p. 129). We might add that the red marble columns of these wings may have been intended to pick up the warm color of the marble trim in Palladio's refectory. For a rather primitive rendering of the picture *in situ,* see the late seventeenth-century engraving illustrated in Gino Damerini, *L'Isola e il cenobio di San Giorgio Maggiore* (Venice, 1956), fig. 17.

Decio Gioseffi ("Palladio e Scamozzi: il recupero dell'illusionismo integrale del teatro vitruviano," *Bollettino del Centro . . . Andrea Palladio* 16 [1974]: 281–85) has attempted to explain Veronese's "mistaken" perspective construction as the result of a miscalculation. According to this hypothesis, the painter's original canvas, a composition based on a precise single-point perspective system, was cut when he discovered that he had neglected to take into account the high wooden *zocolo* below. Gioseffi's reconstruction of the presumed original state inserts an arcaded loggia "sansovinesca" between the two levels of figures (his fig. 152)—a not very convincing solution.

39 Forssman ("Über Architekturen," p. 130) finds it difficult to accept that the perspective inconsistencies in Veronese's festive compositions were deliberately planned by the master; the logic and satisfaction of our experience of these pictures, however, would seem to confirm intentionality.

The nineteenth-century restorer of the San Sebastiano canvas of *St. Sebastian Exhorting St. Marcus and St. Marcellianus* apparently found the dissociative quality of Veronese's perspective—technically correct in this case—rather disturbing, for he "corrected" it by substituting a flight of steps for the original pavement, thereby offering a rationale for the seeming break in spatial continuity. See Terisio Pignatti, *Le pitture di Paolo Veronese nella chiesa di S. Sebastiano in Venezia* (Milan, 1966), figs. 51 and 52, and Lionetto Tintori's technical observations on pp. 117–18.

40 Palladio himself, in discussing the various festive functions of rooms in great palaces, observed: "Servono queste loggie à molti commodi, come à spasseggiare, à mangiare, & ad altri diporti. . . . Le Sale servono à feste, è conviti, ad apparati per recitar comedie, nozze, e simili sollazzi: e però deono questi luoghi esser molto maggiori de gli altri, & haver quella forma, che capacissima sia: acciò che molta gente commodamente vi possa stare, & vedere quello che vi si faccia" (*I quattro libri dell'architettura* [Venice, 1570], I, xxi, p. 52).

41 Further commentary on the traditions and sources behind Veronese's loggia may be found in Forssman, "Über Architekturen," pp. 132–36, and Lenz, *Veroneses Bildarchitektur,* pp. 99–102 and esp. n. 97 on pp. 147–49. Both authors note the parallel with theater structures, and Lenz in particular emphasizes the significance of the Palladian theater, citing the description of the rich setting for the 1562 production of Trissino's *Sofonisba* (cf. our fig. 111). The most important immediate source for Veronese's triple arcade was probably the *Last Supper* painted by Titian precisely for the refectory of SS. Giovanni e Paolo but destroyed by fire in 1571. Its composition may be inferred from a studio copy in the Brera and a related redaction in the Escorial: see J. A. Crowe and G. B. Cavalcaselle, *The Life and Times of Titian* (1877), 2d imp. (London, 1881),

vol. 2, pp. 337–39; Hans Tietze, *Titian* (London, 1950), p. 370; and Harold E. Wethey, *The Paintings of Titian* (London, 1969–75), vol. 1, cat. no. 46 and copy 4. Tietze and Wethey, however, are skeptical of the relationship of these works to the lost SS. Giovanni e Paolo canvas. But, as Fehl has noted ("Veronese and the Inquisition," pp. 329–30), since this was the painting Veronese was commissioned to replace, it would seem quite probable that he would have retained some of the characteristics of the lost composition—as was commonly the practice with such *restauri* in Venice: see E. Tietze-Conrat, "Decorative Paintings of the Venetian Renaissance Reconstructed from Drawings," *Art Quarterly* 3 (1940): 15–39, for such traditions of compositional preservation. The problem has recently been reviewed by Brian T. D'Argaville, "Titian's 'Cenacolo' for the Refectory of SS. Giovanni e Paolo Reconsidered," in *Tiziano e Venezia: Convegno Internazionale di Studi, Venezia, 1976* (Vicenza, 1980), pp. 161–67.

42 This pictorial structure is directly analogous to that of Domenico Veneziano's *St. Lucy Altarpiece* (see above, chap. 1, p. 30).

43 The full transcript of the interrogation is available in Gino Fogolari, "Il processo dell'Inquisizione a Paolo Veronese," *Archivio veneto* 17 (1935): 352–86 (text: pp. 384–86); Giuseppe Delogu, *Veronese: La Cena in Casa di Levi* (Milan, n.d.) (unpaginated); and Fehl, "Veronese and the Inquisition," pp. 348–54, whose transcription of the document is also printed in Pignatti, *Veronese*, pp. 255–56 (doc. 41). An English translation is published in Elizabeth G. Holt, *A Documentary History of Art* (Garden City, N.Y., 1958), vol. 2, pp. 65–70.

44 The text is quoted below, n. 48.

45 On this *topos*, see Fehl, "Veronese and the Inquisition," p. 353, n. 18. For the legal context of Veronese's professional description of himself—"Io depingo et fazzo delle figure"—see above, chap. 1, pp. 10–11.

46 The phrase is Delogu's (*Veronese: La Cena*).

47 Ei dictum: In questa Cena, che havete fatto a S. Gioanni Paulo, che significa la pittura di colui che li esce il sangue dal naso? Respondit: L'ho fatto per un servo, che per qualche accidente li possa esser venuto [i] il sangue del naso. Ei dictum: Che significa quelli armati alla Thodesca vestiti con una lambarde per una in mano? Respondit: E'l fa bisogno, che dica qui vinti parole. Ei dictum che'l dica. Respondit: Nui pittori [havemo la] si pigliamo licentia, che si pigliano i poeti et i matti, et ho fatto quelli dui Alabardieri uno che beve, et l'altro che magna appresso una scala morta, i quali sono messi la, che possino far qualche officio parendomi conveniente, che'l patron della Casa che era grande e richo, secondo che mi e stato detto dovesse haver tal servitori. Ei dictum: Quel vestito da Buffon con il papagalo in pugno, a che effetto l'avete depento in quel Telaro? Respondit: Per ornamento, come si fa. . . . Ei dictum: Chi credete voi veramente che si trovasse in quella Cena? Respondit: Credo che si trovassero Christo con li suoi apostoli; ma se nel [spa] quadro li avanza spacio io l'adorno di figure si come mi vien commesso, et secondo le invenzioni. Ei dictum se da alcuna persona vi e stato commesso che voi dipengeste in quel quadro Thodeschi et buffoni et simil cose? Respondit: Signor no: Ma la commission fu di ornar il quadro secondo mi parese, il quale è grande et capace di molte figure, si come à me pareva.

48 Ei dictum: Se li ornamenti che lui pittore [sc] è solito di fare dintorno le pitture o quadri, a (?) terno le solito di fare conveniente et proportionati alla materia et figure principali, o veramente a caso beneplacito secondo che li viene in fantasia senza alcuna discrittione et giuditio? Respondit: Io fazzo le pitture con quella consideration che è conveniente, che'l mio intellecto puo capire. Interrogatus se li par conveniente, che alla cena ultima del signore si convegna depingere buffoni, imbriachi Thodeschi [arma], nani, et simili scurrilita? Respondit: Signor no. Interrogatus: Perche dunque l'havete dipinto? [Respondit:] L'ho fatto perche presuppono che questi sieno fuori [dove] del luoco dove si fa la cena.

Veronese's final defense:

Signor Ill.mo no che non lo voglio defender; ma pensava di far bene. Et che non hò considerato tante cose, pensando di non far desordine nisuno tanto piu, che quelle figure di Buffoni sono di fuora del luogo dove è il nostro Signore.

According to the basic account of the 1571 fire that consumed Titian's *Last Supper*, the conflagration was started by drunken German soldiers quartered in a room beneath the refectory (see Emmanuele Antonio Cicogna, *Delle iscrizioni veneziane* [Venice, 1824–53], vol. 6, p. 825, and Crowe and Cavalcaselle, *Titian*, vol. 2, pp. 337–38). Is it possible that Veronese's inclusion of drinking soldiers in German costume was intended to serve as a reminder of the event? This was briefly suggested by Delogu (*Veronese: La Cena*). It should be noted, however, that two similar halberdiers appear on the staircase behind Christ and St. Gregory in the *Supper of Gregory the Great*. Fehl ("Veronese and the Inquisition," p. 353, n. 15) wonders if the bleeding nose of one of the servants is not, "after a fashion, comparable to the ominous over-turning of the salt cellar (by Judas) in Leonardo's 'Last Supper.' "

49 Thus Vasari on the *Feast in the House of Simon* now in Turin (*Le vite de' più eccellenti pittori, scultori ed architettori* [1568], ed. Gaetano Milanesi [Florence, 1878–85], vol. 6, p. 370). See Pignatti, *Veronese*, cat. no. 93, fig. 188.

50 A similar structure governs the composition of the *Feast in the House of Simon* at Versailles, where, however, the gravitational descent of the backdrop silhouette accentuates the humility of the Magdalen's action (Pignatti, *Veronese*, cat. no. 176, fig. 454).

51 The text refers not to the Supper of Gregory but to the miracle of the Easter Mass in Santa Maria Maggiore: following Gregory's recitation of these words, the response, "Et cum spiritu tuo," came from the angel of God (Jacobus de Voragine, *The Golden Legend*, trans. Granger Ryan and Helmut Ripperger [New York, 1941], p. 184).

52 Fehl ("Veronese and the Inquisition," p. 353, n. 20) called attention to the relevance of the Gospel descriptions with respect specifically to Veronese's comment on the host, who was said to be very rich and therefore likely to have many servants (see above, n. 47). Referring to the steps, Forssman ("Über Architekturen," p. 132) interprets them as connecting the *piano nobile* with the "Wirtschaftsräume" below; although he observes that the orthogonals of the visible pavement design converge to a point between the hands of Christ and rightly infers an iconographic significance here, Forssman does not extend any such meaning to the architectural structure.

Fehl's reading of the painting as the moment of Christ's announcement of the betrayal is difficult to accept. But in rejecting it, Lenz (*Veroneses Bildarchitektur*, pp. 101 and 158, n. 175) questions whether the picture was even intended to represent the Last Supper and further suggests that the painter himself may have been responsible for the decision to replace Titian's *Last Supper* with a *Feast in the House of Levi*. His hypothesis, however, is contradicted by the normal practices of patronage and, more decisively, by the very nature of the Inquisitors' objections, by Veronese's own declaration that "Questo è un quadro della Cena ultima, che fece Gesù Christo con li sui apostoli," and by the internal evidence of the picture itself.

With respect to the possible meanings of Veronese's architectural splendor, see Dagobert Frey's observations on monumentality as an expression of the transcendent: "Die Darstellung des Transzendenten in der Malerei des 16. Jahrhundert," in *Umanesimo e simbolismo (Atti del IV Convegno Internazionale di Studi Umanistici)*, ed. Enrico Castelli (Padua, 1958), pp. 193–98, esp. p. 195.

53 This identification of the *Supper of Gregory the Great* with the Mass is underscored by the inscription (see above, n. 51). The relation to the *Last Supper* is reinforced by the divergence from the text of the *Golden Legend*; as Fehl pointed out ("Veronese and the Inquisition," p. 341, n. 9), whereas in the text Christ reveals himself to Gregory by showing him the silver porringer the saint had charitably given him many years earlier, Veronese depicts Christ as uncovering the dish before him which contains the lamb.

54 In this context attention should be drawn to the reinterpretation by Madlyn Kahr of one of the ceiling paintings in San Sebastiano ("The Meaning of Veronese's Paintings," p. 241). Of the oval canvas generally described as "Esther being led to Ahasuerus," she writes: "No one seems to have noticed that the female figure who is central to the action is being led down the steps, away from the king who is enthroned at the far right, not towards him. . . . The central figure is surely Vashti, being deposed and cast aside." That observers for so long had failed to note the descending movement in the newly recognized *Vashti Banished*, a movement so clearly articulated by the stairs, indicates the degree to which matters of form and content have been dissociated in traditional Veronese criticism.

55 The visual brilliance of Veronese's account of the miracle finds a close literary analogue in Pietro Aretino's narration in *I quattro libri de la humanità di Christo* ([Venice, 1539], pp. 44–45):

In quei giorni in Cana di Galilea si celebrarono le nozze: dove con pompa reale comparsero le piu gravi, le piu nobili, e le piu leggiadre persone de la citta. E per piu solennita, vi fu invitato Christo, i suoi fratelli, e Maria. . . . I servi, che in tavola ponevano, e levavano le vivande, et i vasi, stupidamente si erano smarriti, udendo çioche udivano. Et il piu pretioso cibo che i convitati mangiassero, furono i detti suoi. Ne per altro Christo accettava le cene di chi gliene proferiva, che per aprir gliocchi de le menti cieche ne lo splendore de i piaceri del mondo.

And the miracle itself inspires some of Aretino's most hedonistic prose:

Erano ivi sei vasi di pietra di non piccol prezzo, secondo il costume de gli hebrei. E comandandogli Christo, che si empiessero di acqua fino a l'orlo, fu ubidito. Onde egli disse: Attignetene, e portatene a chi guida il convito. I servi ne attinsero, e portarola a lo Scalco, al cui naso giugnendo l'odore di quel vino, che fu ricolto ne le vigne celesti, ravivò gli spiriti; quasi huomo, i cui sensi si rivocano con la vertu de lo aceto, di che egli ha bagnati i polsi. E gustandolo sentì stillarsi de la sua dolcezza mordente fino a le unghie de i piedi. Et

empiendone una coppa di Christallo, si saria giurato ch'ella, fosse stata piena di rubini stillati.

The relationship between Aretino's prose and Veronese's painting was the subject of a paper by Maurice Cope, presented at the annual meeting of the College Art Association of America, Chicago, 1976. For further comment and bibliography on Aretino's religious writings, see below, chap. 5, pp. 195–96 and n. 38.

56 The contract for this work would seem to have afforded ample room for the sort of free invention Veronese speaks of in his answers to the Holy Tribunal. It stipulated that he was to make a "quadro nel refectorio novo di la largeza ed alteza che si ritrova la fazada, facendola tutta piena, facendo la istoria di la cena del miracolo fatto da Cristo in Cana Galilea, facendo quella quantità de figure che le potra intrar acomodamente et che se richiede a tal intentione." The final phrase here, however, probably should be read as a reference to the appropriate decorum to be observed with respect to the subject. The text of the contract, dated 6 June 1562, is available in Pignatti, *Veronese,* pp. 253–54 (doc. 22). On 6 October 1563 Veronese acknowledged full payment of 300 ducats (p. 254 [doc. 24]).

57 Cf., e.g., S. J. Freedberg, *Painting in Italy, 1500 to 1600* (Harmondsworth and Baltimore, 1971), p. 381:

> A *Marriage at Cana* . . . makes a panorama of opulence out of the Christian story, paraphrasing (and surely magnifying) the luxury of dress and setting which a grand patrician feast would have in contemporary Venice, and capturing its effects of movement and of visual brilliance. The viewer is compelled to hunt for the illustration (and it is no more than that) of the religious theme, and in this sense Paolo's image may be taken as mundane reportage. But at the same time it is a *poesia*—about a quite contrary theme—celebrating sheer opulence, an orchestration in the grandest range of forms and colors, and a stage manager's masterpiece.

Frederick Hartt (*History of Italian Renaissance Art* [New York, 1969], p. 560) declares that in his biblical suppers Veronese's "concern was only with material food, and with the material splendor of the setting, and the sumptuous costumes of the actors."

58 Here, too, Aretino's dramatic anecdote affords an interesting parallel, as the writer also elaborates the protocol of seating:

> Essendo poste le mense, e sopra quelle vasi d'oro, e di argento puro, e scolpito; e ne i seggi ornati adagiatisi, i piu degni, et i maggiori contemplavano Christo: il quale raccolto ne la sua propria humilitade si era posto al lato a la Madre, nel piu basso luogo. E facendogli forza il pregare del Signore de la casa, si levò con la Vergine, e sede in parte piu honorata. Et in quello atto dimostro il pregio de la humilta, la cui modestia si alza al Cielo, mentre si china in terra (*Humanità di Christo,* p. 44).

59 The identification of the musicians goes back to Boschini, *Le ricche minere:* "Il Vecchio, che suona il Basso, è Tiziano; l'altro che suona il Flauto, è Giacomo Bassano; quello che suona il Violino, è il Tintoretto, ed il quarto vestito di bianco, che suona la Viola è lo stesso Paolo . . ." (in *La carta del navegar,* ed. Anna Pallucchini, p. 755).

60 The hourglass on the scribe's table in Tintoretto's *Christ before Pilate* (fig. 138) probably also alludes to that hour now come. See Patricia Egan, " 'Concert' Scenes in Musical Paintings of the Italian Renaissance," *Journal of the American Musicological Society* 14 (1961): 192, who discusses as well other aspects of music as measured time. For a quite different interpretation of the hourglass, cf. A. P. de Mirimonde, "Le sablier, la musique et la danse dans les 'Noces de Cana' de Paul Véronèse," *Gazette des Beaux-Arts* 88 (1976): 129–36.

61 For a nineteenth-century defense of Veronese's opulent religious compositions on the basis of their metahistorical resonance and contemporary relevance, see the poem quoted by Margaret Stokes in her additions to Alphonse N. Didron, *Christian Iconography,* vol. 2 (London, 1886), pp. 219–20:

> They err who say this long-withdrawing line
> Of palace-fronts Palladian, this brocade
> From looms of Genoa, this gold inlaid
> Resplendent plate of Milan, that combine
> To spread soft lustre through the grand design,
> Show but in fond factitious masquerade
> The actual feast by leper Simon made
> To that great Guest, of old, in Palestine.
> Christ walks amongst us still; at liberal table

Scorns not to sit: no sorrowing Magdalene
But of these dear feet kindly gets her kiss
Now, even as then; and thou, be honorable,
Who, by the might of thy majestic scene,
Bringest down that age, and minglest it with this.

Sir Samuel Ferguson's pious verse was inspired, one suspects, by his reading of Ruskin (cf. below, n. 81).

62 Goethe, *Italian Journey*, p. 78. For the continuation of this attitude in our own time, cf. the comments of Freedberg: "Paolo is most eloquent when he can transpose an assigned subject into terms that let him deal primarily with the appearance and manners of Venetian society, as when he paints the confrontation, without a trace of tragedy, between *Alexander and the Family of Darius* . . . , all sumptuousness and fine courtier's elegance, in its setting and cool artificiality of action also like a tableau on a stage" (*Painting in Italy*, p. 381). In criticizing the absence of tragedy here, Freedberg seems to miss the point of the subject, which celebrates not the tragedy of Darius or his family but one of the *gesta* of Alexander.

63 On this legislation in the sixteenth century and its relative ineffectualness, see G. Bistort, *Il Magistrato alle Pompe nella Repubblica di Venezia* (Miscellanea di Storia Veneta . . . della R. Deputazione Veneta di Storia Patria) (Venice, 1912), esp. pp. 373–414; also Pompeo Molmenti, *La storia di Venezia nella vita privata*, 7th ed. (Bergamo, 1927–29), vol. 2, pp. 309–12.

64 Leone de' Sommi, *Quattro dialoghi in materia di rappresentazioni sceniche*, ed. Feruccio Marotti (Milan, 1966), p. 48: "Parlando dunque de gl'abiti . . . dicovi principalmente ch'io mi sforzo di vestir sempre gl'istrioni piú nobilmente che mi sia possibile, ma che siano però proporzionati fra loro, atteso che l'abito sontuoso (et massimamente a questi tempi che sono le pompe nel lor sommo grado, e, sopra tutte le cose, i tempi e i lochi osservar ci bisogna) mi par, dico, che l'abito sontuoso accresca molto di riputazione et di vaghezza alle comedie, et molto piú poi alle tragedie." (An English translation of de' Sommi's dialogues is in Allardyce Nicoll, *The Development of the Theatre*, 4th rev. ed. [New York, 1957], pp. 237–62.) See also the comments of Ingegneri, *Della poesia rappresentativa*, p. 71: "Ma noi, usando in ciò maggior libertà, & pigliando le cose più in universale per meglio conformarci al moderno costume, ch'e ito molto avanzando di larghezza, & di pompa." His own particular rule of decorum regarding costume: "Et se l'Attione sia Tragica, riccamente, & superbamente."

Cf. further Giovambattista Giraldi Cintio, *Discorso intorno al comporre delle comedie et delle tragedie* (1554): "Non sara nondimeno senon bene, che nell'una, et nellaltra Scena [sc. *comedia* and *tragedia*] siano gli habiti de gli histrioni di lontano paese. Perche la novita de gli habiti genera ammiratione, et fa lo spettatore piu intento allo spettacolo, che non sarebbe, se vedesse gli histrioni vestiti de gli habiti, ch'egli ha continuamente ne gli occhi" (in *Discorsi di M. Giovambattista Giraldi Cinthio* . . . [Venice, 1554], p. 278).

65 For the debate over the decorum of staging, see Schrade, *La représentation d'Edipo Tiranno*, pp. 53–54; Puppi, "Gli spettacoli all'Olimpico," pp. 93–94; and Gallo, *La prima rappresentazione*, pp. XXXI–XXXVII and p. 31 ("Proposte di Sperone Speroni").

66 Hans Tietze and E. Tietze-Conrat, *The Drawings of the Venetian Painters in the 15th and 16th Centuries* (New York, 1944), no. 2141. For the work of Fasolo and Zelotti for the Accademia Olimpica, see Giangiorgio Zorzi, "Gio. Antonio Fasolo," *Arte lombarda* 6 (1961): 209–26. Many painters in Venice were employed by the various *compagnie della calza* to design the settings and decorations for their theatrical productions and pageants. The work of Titian, Federico Zuccaro, and Vasari is documented in Lionello Venturi, "Le compagnie delle calze," *Nuovo archivio veneto* 17, no. 1 (1909): 187–88, 193, 188, and 230–31; see also Michelangelo Muraro, "Vittore Carpaccio o il teatro in pittura," in *Studi sul teatro veneto*, pp. 7–19. For Tintoretto's work as theatrical designer, see below, chap. 5, sec. 2.

67 There is no reason at all to doubt the correctness of the attribution to Veronese nor—except perhaps for the dramatis personae—to associate this sheet with the series of drawings ascribed to Maganza and called costume designs for the Olimpico's *Edipo Tiranno*: cf. Puppi, "La rappresentazione inaugurale, 2," p. 69, n. 57. For an addition to the corpus of costume studies by Maganza, see Stefania Mason Rinaldi, *Catalogue of Drawings by Jacopo Palma il Giovane from the Collection of the Late Mr. C.R. Rudolf*, Sotheby's (London, 1977 [4 July]), no. 38.

68 An interesting parallel to Alexander's armor may be found in that late sixteenth-century compendium of costume lore, Cesare Vecellio's *Habiti antichi et moderni di tutto il mondo* (Venice, 1598), p. 7: "Habito antichissimo de' Romani che fu anco usato prima da' Troiani." The armor illustrated in the woodcut on p. 6ᵛ, as Vecellio explains, is based on that worn by the *Tetrarchs*, the famous porphyry group set into a corner of San Marco toward the Piazzetta. Although Veronese designed a much more sumptuous and stylistically more sophisticated outfit, details of Alexander's costume like the high jeweled girdle may indicate that the painter

was indeed attentive to the fourth-century sculpture. In her unpublished notes on the costumes of Veronese's figures Stella Mary Newton suggests that the color of the hero's armor in the painting may ultimately derive from the belief that ancient Roman armor was of molded leather covered "di porpora, o di giacinto," as Vecellio writes.

Vecellio's text is worth quoting in full, since, being more than just a description of the illustration, it offers an apology for the delight taken in ancient costumes, a rationalization which may also speak for the public taste that an artist like Veronese both catered to and helped create:

> È cosa molto dilettevole il considerare i capricci de gli antichi Romani, & non è dubbio, che gli habiti loro ci porgono per la lontananza del tempo maggior diletto, che non fanno i moderni, i quali del continuo habbiamo avanti à gli occhi. Per tanto quelli, che sono venuti à Venetia, se pur haveranno havuto qualche diletto di veder cose notabili, non haveranno lasciato à dietro di considerare quelle quattro figure di Porfido di rilevo pieno, armate, lequali sono dinanzi alla porta del Palazzo di S. Marco; e furono portate insieme con altre statue, scolture, & cose preciose di Grecia, et dalle parti piu lontane qua à Venetia, quando questa potentissima Rep. andava allargando i termini del suo Imperio con lieto grido del nome suo, & con felice corso delle sue imprese. Di cio si dicono molte cose; ma vere, o false che siano, io ritrovo essere quest' habito antichissimo usato da Troiani & da Romani, & anco in tempo d'Alessandro Magno.

The question of historical distance was naturally of crucial importance to the theater, and Vecellio's observations have been cited in the literature on Renaissance stage costume: see, e.g., Hal H. Smith, "Some Principles of Elizabethan Stage Costume," *Journal of the Warburg and Courtauld Institutes* 25 (1962): 240–57. On the question in general, see Stella Mary Newton, *Renaissance Theatre Costume and the Sense of the Historic Past* (New York, 1975).

69 For an example of Veronese's close study of modern armor, see the chiaroscuro drawing in the Berlin Kupferstichkabinett (Tietze, *Drawings of the Venetian Painters*, no. 2034). The Tietzes suggest that the suit of armor depicted may have belonged to the artist, since it appears in several of his compositions. See also E. Tietze-Conrat, " 'Paolo Veronese armato' (Ridolfi, II, 225)," *Arte veneta* 13–14 (1959–60): 96–99.

70 Such sartorial differentiation seems to have been a standard part of decorum in the Renaissance theater. Cf. de' Sommi, *Quattro dialoghi*, p. 49: "Io mi ingegno poi quanto piú posso di vestire i recitanti fra loro differentissimi; et questo aiuta assai, sí allo accrescere vaghezza con la varietà loro, et sí anco a facilitare l'intelligenza della favola." This sense of theatrical decorum, needless to say, violates the more rigorous Aristotelian principles standard in much Renaissance art theory—e.g., Lodovico Dolce's *Dialogo della pittura* of 1557: "Di qui terrà sempre riguardo alla qualità delle persone, né meno alle nazioni, a' costumi, a' luoghi et a' tempi; talché, se depingerà un fatto d'arme di Cesare o di Alessandro Magno, non conviene che armi i soldati nel modo che si costuma oggidì, et ad altra guisa farà le armature a Macedoni, ad altra a Romani" (in *Trattati d'arte del Cinquecento*, ed. Paola Barocchi, vol. 1 [Bari, 1960], p. 165).

71 Cf. Fehl's reading of Veronese's *Christ and the Centurion* ("Questions of Identity"). The subject of that picture involves a miracle whose cause, Christ, we witness but which itself takes place elsewhere; also witnessing the words of Christ and the faith of the centurion is at least one exotic type, a Moor, probably representing the Gentiles who "shall come from the east and west, and shall sit down with Abraham and Isaac and Jacob, in the kingdom of heaven" (Matthew 8:11). Here too, then, it would seem that Veronese's choice of costume is not simply an indulgence of a taste for the exotic. The distinction of armor types also points to an expansion of the temporal frame of reference, extending from the fancifully antique dress of the centurion and his two immediate retainers to, at the right of the composition, the more Renaissance appearance of the other witnesses; the ancient miracle in this way confirms a modern faith, symbolized by the gesture of the soldier at the right frame who places his hand to his breast.

72 On the triumphal architectural iconography of ceiling paintings like the *Triumph of Venice* in the Sala del Maggior Consiglio and the *Annunciation* from Santa Maria dell'Umiltà, now in the Cappella del Rosario of SS. Giovanni e Paolo, both of which are dominated by monumental arches, see Lenz, *Veroneses Bildarchitektur*, pp. 31–35.

73 Cf. Forssman, "Über Architekturen," p. 126.

74 This is also Lenz's conclusion (*Veroneses Bildarchitektur*, pp. 111–15); cf. further the observations in Hetzer's discussion of the great feasts ("Paolo Veronese," pp. 103–12) and the full thesis of Marinelli ("Lo spazio ideologico").

75 See Chastel, "Cortile et théâtre," and "Palladio et l'art des fêtes," *Bollettino del Centro . . . Andrea Palladio* 2 (1960): 29–33.

76 On the Arco Foscari and its ceremonial function, see Lenz, *Veroneses Bildarchitektur*, pp. 33–35;

Staale Sinding-Larsen, *Christ in the Council Hall: Studies in the Religious Iconography of the Venetian Republic* (*Acta ad archaeologiam et artium historiam pertinentia* [Institutum Romanum Norvegiae], vol. 5) (Rome, 1974), pp. 210–12; and Debra Pincus, *The Arco Foscari: The Building of a Triumphal Gateway in Fifteenth Century Venice* (New York and London, 1976). On the Loggetta, see Manfredo Tafuri, *Jacopo Sansovino e l'architettura del '500 a Venezia*, 2d ed. (Padua, 1972), pp. 72–80, and Deborah Howard, *Jacopo Sansovino: Architecture and Patronage in Renaissance Venice* (New Haven and London, 1975), pp. 28–35; cf. also the comments of Zorzi, *Il teatro e la città*, pp. 199–200: "riproduce in realtà, pietrificato, un arco per apparato stradale, di ascendenza nettamente fiorentina."

77 Achille Bocchi, *Symbolicarum quaestionum liber secundus* (Bologna, 1574), Symbolum XLVIII, ciii ("Vera Gloria"); Cesare Ripa, *Iconologia* (Rome, 1603), pp. 189–92 ("Gloria de' Principi"). For further discussion of the symbolic significance of the obelisk in the Renaissance, see William S. Heckscher, "Bernini's Elephant and Obelisk," *Art Bulletin* 29 (1947): 177–82; also above, chap. 3, pp. 109–10.

78 On Veronese's use of the structural conceit of the picture-within-a-picture, see Fehl, "Veronese and the Inquisition," pp. 326–27, and Lenz, *Veroneses Bildarchitektur*, pp. 78–80; see also Hetzer, "Paolo Veronese," pp. 87–96.

79 See Rodolfo Gallo, "Per la datazione delle opere del Veronese," *Emporium* 89 (1939): 145–52, and Forssman, "Über Architekturen," pp. 124–26; also Pignatti, *Veronese*, cat. no. 167.

80 Further on Carpaccio's *teleri*, their relationship to the narratives of Piero della Francesca and the theatrical implications of their structure: above, chap. 1, sec. 4.

81 Contrasting religious painting in Venice with the "formalities and abstractions of the so-called sacred schools" of central Italy, Ruskin, using Veronese's *Supper at Emmaus* as his reference, welcomed the legitimately worldly piety of the Venetians: "the saints no more breathe celestial air. They are on our own plain ground—nay, here in our houses with us. All kind of worldly business going on in their presence, fearlessly; our own friends and respected acquaintances, with all their mortal faults, and in their mortal flesh, looking at them face to face unalarmed: nay, our dearest children playing with their pet dogs at Christ's very feet.

"I once myself thought this irreverent. How foolishly! As if children whom He loved *could* play anywhere else" (*Modern Painters*, part IX: III, 18; 4th ed. [London, 1851–1860], vol. 5, p. 226).

82 See Fehl, "Veronese and the Inquisition," pp. 326–27, on the Borghese *Baptist*. Here too Carpaccio offers an earlier prototype, in the long canvas in the St. Ursula cycle narrating the various stages in the departure of Ursula and her *fidanzato* (fig. 26): the topography of the visually unified landscape before which the action is set is quite clearly differentiated to distinguish pagan England from Christian Brittany. See Michelangelo Muraro, *Carpaccio* (Florence, 1966), pp. XLII–XLIV, and "Vittore Carpaccio o il teatro in pittura," pp. 12–13, and above, chap. 1, p. 42.

83 For further discussion of the narrative traditions and conventions in the illustration of this subject, see David Rosand, "*Ut Pictor Poeta*: Meaning in Titian's *Poesie*," *New Literary History* 3 (1971–72): 540–46; Philipp Fehl and Paul Watson, "Ovidian Delight and Problems in Iconography: Two Essays on Titian's *Rape of Europa*," *Storia dell'arte* 26 (1976): 23–30; and Paul F. Watson, "Titian's 'Rape of Europa': A Bride Stripped Bare," *Storia dell'arte* 28 (1976): 249–58.

84 "Renewed" expectations may be more accurate, for an earlier critic like Ruskin had taken fair measure of the mind of Veronese: "capable of tragic power to the utmost, if he chooses to exert it in that direction, but, by habitual preference, exquisitely graceful and playful; religious without severity, and winningly noble; delighting in slight, sweet, every-day incident, but hiding deep meanings underneath it; rarely painting a gloomy subject, and never a base one" (*Modern Painters*, part IX: III, 27; 4th ed., vol. 5, p. 230).

85 *I dieci libri dell'architettura di M. Vitruvio tradutti et commentati da Monsignor Barbaro eletto Patriarca d'Aquileggia* (Venice, 1556). There followed many subsequent editions, including a revised text published in 1567 and a Latin edition of the same year. See Cevese, *Mostra del Palladio*, pp. 175–76, for further comment on these.

The fullest modern study of Barbaro is P. J. Laven, "Daniele Barbaro, Patriarch Elect of Aquileia, with Special Reference to His Circle of Scholars and to His Literary Achievement" (Diss., University of London, 1957). See also Giovanni Maria Mazzuchelli, *Gli scrittori d'Italia* (Brescia, 1753–63), vol. 2¹, pp. 247–53; Pio Paschini, "Daniele Barbaro letterato e prelato veneziano nel Cinquecento," *Rivista di storia della chiesa in Italia* 16 (1962): 73–107; and G. Alberigo, "Daniele Barbaro," in *Dizionario biografico degli italiani*, vol. 6 (Rome, 1964), pp. 89–95, with further references. For Veronese's portrait of Barbaro, see Pignatti, *Veronese*, cat. no. 143, and Howard Burns et al., *Andrea Palladio, 1508–1580: The Portico and the Farmyard* (London, 1975), cat. no. 176; there are also two portraits of Barbaro by Titian (Harold E. Wethey, *The Paintings of Titian* [London, 1969–75], vol. 2, cat. nos. 11, 12).

86 *I dieci libri,* V, viii, p. 167. On Palladio's relationship to Barbaro, see Wittkower, *Architectural Principles,* pp. 65–69, 135–42; also Erik Forssman, "Palladio e Daniele Barbaro," *Bollettino del Centro . . . Andrea Palladio* 8² (1966): 68–81.

87 *I dieci libri,* I, ii, p. 20; cf. the expanded discussion in the edition of 1567, pp. 30–36. Barbaro's concern with the incommensurability of *scaenographia* in the context of architectural rendering represents the culmination of a Renaissance tradition of Vitruvian commentary going back to Alberti and including Raphael; this has been amply demonstrated and elegantly analyzed by Paula Spilner of Columbia University in a paper soon to be published, "Vitruvian Studies in the Renaissance: Scaenographia." Barbaro's understanding of *sciagraphia* as "descrittione del profilo" seems a valid extension of the ancient "shadow painting." For the continuing problems surrounding the interpretation of the concept, see J. J. Pollitt, *The Ancient View of Greek Art: Criticism, History, and Terminology* (New Haven, 1974), pp. 247–54, and the discussion between Eva Keuls, "Skiagraphia Once Again," *American Journal of Archaeology* 79 (1975): 1–16, and Elizabeth G. Pemberton, "A Note on Skiagraphia," *American Journal of Archaeology* 80 (1976): 82–84.

88 *I dieci libri,* V, viii, p. 157.

89 Questa è la fatica mia circa la Prospettiva pratica, della quale, fin hora che io sappia niuno ha trattato, e dato in luce alcuna cosa, benche nelle pitture de gli antipassati molte se ne vedino fatte con mirabile arteficio, dove non sol i paesi, & le fabriche sono state poste con ragione di Prospettiva, ma con somma diligenza le figure de gli huomini, & de i brutti sono state tirate al punto, dove con ammiratione de i riguardanti, & giudiciosi ingegni sono state sommamente lodate, talche potemo ragionevolmente biasmare la età nostra, che habbia produtto eccellenti pittori, ma pochi Prospettivi. Vedo esser sprezzata la fatica, ma lodata l'opera della Prospettiva, ammirano il ben fatto, fuggono lo studio di fare. Vogliono haver le cose belle, d'altri, ma non si curano di saper farle da loro. Ma per essortare chiunque dalla fatica sbigottito non ardisce porsi alla impresa di imparare questa si bella arte.

90 A second edition appeared the following year with a slightly modified title, here describing the book as "opera molto profittevole a pittori, scultori, et architetti." Two manuscript versions of the text are preserved in the Biblioteca Marciana, Venice: Codici italiani, cl. IV, cod. 39 (= no. 5446) ("Trattato della prospettiva"), an earlier and more extensive draft that was then revised and reduced, and no. 5447 ("La pratica della prospettiva"), which corresponds closely to the printed version: see Jacopo Morelli, *I codici manoscritti volgari della Libreria Naniana* (Venice, 1776), pp. 12–14. There were evidently plans for a Latin edition of the treatise, an incomplete manuscript of which is also in the Marciana: Codici latini, cl. VIII, cod. 41 (= no. 3069) ("Danielis Barbari electi Patriarchae Aquileiensis scenographia pictoribus et sculptoribus perutilis").

91 *La pratica della perspettiva,* "Proemio," p. 3:

> Tra molte belle, & illustri parti della Perspettiva, una ven'hà, laquale da Greci è detta Scenographia. Di questa ne i miei commentari sopra Vitruvio mi ricorda d'haver promesso di trattare: Percioche si come ella ha molte, & meravigliose ragioni nell'uso, & essercitio suo molto utili a Pittori, Scultori, & Architetti, cosi molto abandonata, per non dire sprezzata, & fuggita si trova da quelli, a i quali è piu necessaria, che ricercata. Gia in Athene insegnando Eschilo, Agatarcho fece la Scena Tragica, & di questa ne lasciò scritto uno bellissimo commentario, dal quale avvertiti Democrito, & Anaxagora, vollero ancho essi scrivere sopra la istessa cosa. Noi leggemo, che appresso de Romani gli ornamenti, & gli apparati delle Scene erano in grandissima riputatione. Avanti la età nostra i Pittori, che si trovavano a quei tempi, lasciarono di questa arte molto belle memorie di opere eccellenti, nelle quali non solamente i paesi, i monti, le selve, gli edifici si vedeno egregiamente dissegnati, & adombrati, ma ancho gli istessi corpi humani, & gli altri animali con linee all'occhio come al centro tirate sono sottilissimamente poste in Perspettiva. Ma in che modo, & con quali precetti si reggessero, niuno (che io sappia) ne gli scritti suoi ne ha lasciato memoria. Se forse non vogliamo chiamare precetti, & regole, alcune pratiche leggieri poste senza ordine, & fondamento, & esplicate rozzamente: perche di queste ne sono pure alcune di Pietro dal Borgo S. Stefano [*sic*], & d'altri, che per gli idioti ci potriano servire. Poche cose ci ha lasciato Alberto Durero, benche ingeniose, & sottili. Piu grossamente si è portato il Serlio: ma l'uno, & l'altro (dirò cosi) si sono fermati sopra il limitare della porta.

(The slip of "S. Stefano" for "S. Sepolcro," an editorial decision made in the second Marciana manuscript, is corrected in the printed index: "Pietro dal borgo S. Sepolcro, se bene e scritto altrove S. Stefano nel proemio.")

Barbaro's chapters on geometric projections and solids (parts II and III especially) rely rather heavily on the work of Piero, as the patriarch elect himself somewhat grudgingly admits with a

reference to "Pietro dal borgo S. Stefano [*sic*], ilquale hà lasciato alcune cose di Perspettiva, dalqual hò preso alcune delle sopraposte discrittioni . . ." (*La pratica della perspettiva*, II, viii, p. 36). Barbaro's borrowings from Dürer, who is used and cited more frequently than any other source, are discussed below. This obvious reliance on the work of his predecessors did in fact lead to severe criticism and charges of plagiarism: see Mazzuchelli, *Gli scrittori d'Italia*, pp. 251–52, for further references.

92 "I Pittori de i nostri tempi altrimenti celebri, & di gran nome, si lasciano condurre da una semplice pratica, & nelle tavole loro non dimostrano sopra questa parte cosa degna di molta commendatione, & nelle carte in iscritto niuno precetto si vede dato da loro" (*La pratica della perspettiva*, "Proemio," p. 3).

93 "Messer Giac.º Sansouino fiorentino nõ solamente statuario, et architetto famosissimo: mà sotilissimo perspettiuo" (Biblioteca Marciana, Cod. it., cl. IV, cod. 39 [= no. 5446], fol. 7ᵛ). The comment occurs in a draft of the chapter entitled "Di qual grandezza si deono far le figure nel quadro" (corresponding to I, ix, p. 23, of the printed edition), and one wonders whether it may allude to some part of Sansovino's projected treatise on anatomy, mentioned by his son (Francesco Sansovino, *L'Edificio del corpo humano* [Venice, 1550], p. 4). Barbaro also has words of praise for the illusionistic ceilings in the Madonna dell'Orto by Cristoforo and Stefano Rosa of Brescia (*La pratica della perspettiva*, VII, ii, p. 177)—for which see Juergen Schulz, "A Forgotten Chapter in the Early History of *Quadratura* Painting: the Fratelli Rosa," *Burlington Magazine* 103 (1961): 90–102.

94 Si può ancora, ed è conceduto fermar il punto più alto, e più basso. Più alto, quando la cosa rappresentata è più bassa del piano, ove è considerata; come sarebbe dipinger l'esser sopra un'altezza, e veder un piano con molte persone, un conflitto, ovver un'armata, et altre quasi simili cose: perchè altramente fermandolo, una cosa offuscarebbe in tal maniera l'altra, che più presto una fondusione, che perspettiva parebbe. Il che prevedendo Messer Giovanni Bellino, dipintor nostro famosissimo nel conflitto marittimo dipinto per lui nel palaggio della patria nostra, fermò il punto quasi al sommo del quadro; vedendo prima aver fatto il simile nel quadro dipinto per lui de la piazza: e esserli succeduta l'opera sua quasi alla vera simile. Nè discrepante volse esser da lui in questo Vittore Carpaccio in molte sue operazioni perspettive, degne per comune giuditio d'eterna fama . . ." (Biblioteca Marciana, Cod. it., cl. IV, cod. 39 [= no. 5446], fol. 2).

The opening three folios of this manuscript were transcribed by Morelli, *I codici manoscritti*, pp. 12–14.

Daniele himself had an active interest in the decorations of the Ducal Palace. According to Francesco Sansovino (*Venetia città nobilissima et singolare* [1581], ed. Giustiniano Martinioni [Venice, 1663], p. 325), Barbaro was author of the iconographic program for the ceiling of the Sala del Consiglio dei Dieci, painted by Veronese, Ponchino, and Zelotti between 1553 and 1555 (see Juergen Schulz, *Venetian Painted Ceilings of the Renaissance* [Berkeley and Los Angeles, 1968], pp. 97–99).

95 Più basso ancora è conceduto di fermar il punto nel quadro, come si vede haver fatto l'unico imitator della natura Messere Andrea Mantegna nella Città sua di Padova nella Chiesa degli Eremitani, che dipingendo quasi al sommo d'una Capella, pose il punto non solamente più basso nel quadro, ma di sotto a quello nel pariete; e per quello, che si vede, è posto all'altezza degli occhi de'riguardanti, in modo che di molte figure, che ivi sono dipinte, alcune non sono perfettamente compiute, per esser ascose dal piano, in che fermano le piante: cosa in vero non meno lodevole, che artifiziosa. E quale fu quell'opera del Mantegna, che lodevole e artifiziosa non fosse? Certo niuna, che io mi creda. E credenza non solamente ne rendono le altre in detto luoco dipinte per lui; ma eziando il Trionfo di Cesare figurato per lui in Mantova, che per quello, che universalmente se ne ragiona, è cosa tanto al vero simile, che si tien per certo che altramente esser non doveva esso Cesare in Roma trionfante. Sì maestrevolmente pose ogni cosa al suo luoco, e talmente esprimendola con le principali linee; che chiaramente si vede che ciascuna figura dimostra far qualche naturale operazione, restando alla destinata distanza considerate (Biblioteca Marciana, Cod. it., cl. IV, cod. 39 [= no. 5446], fol. 2ᵛ).

96 Paolo Pino, *Dialogo di pittura* (1548), in *Trattati d'arte*, ed. Barocchi, vol. 1, p. 117. On the critical problems surrounding discussion of Venetian *colorito*, see above, chap. 1, sec. 3.

97 *La pratica della perspettiva*, VII, pp. 175–78 ("Laquale tratta de i lumi, delle ombre, & de i colori"):

Prima quanto al colore, il piano dove si hà da dipingere, sia di tale colore, che possi cavar fuori & scuotere tutto quello, chi vi si dipigne sopra. Onde bella, & ingeniosa pratica è quella dell'acquarella. imperoche con l'acqua si fà, che il medesimo colore sia piu chiaro, & piu

scuro, & dove hanno a battere i lumi, ivi pongono il piu chiaro, & dove hanno ad essere le ombre ivi lasciano il piu scuro, & se lavorano di chiaro, e di scuro bene spesso, anzi sempre i buoni maestri lasciano in luogo del chiaro la bianchezza della carta, overo della tavola sopra laquale dipigneno. . . . Le ombre non deveno mutare i colori. Ma servare lo istesso colore, & farlo piu scuro, perche l'ombra è mancamento di lume, & non effetto di color nero. . . .

That Barbaro was indeed a practicing amateur is attested by Lodovico Dolce in his *Dialogo della pittura* of 1557 (in *Trattati d'arte*, ed. Barocchi, vol. 1, p. 154); see also Laven, "Daniele Barbaro," pp. 180–82, and Mark W. Roskill, *Dolce's "Aretino" and Venetian Art Theory of the Cinquecento* [New York, 1968], p. 247).

Barbaro's most enthusiastic passage in the section on color is, paradoxically, an admiring description of the engraver's art:

In vero è cosa maravigliosa, che quelli intagliatori con la moderatione de i tagli imitano i panni grossi, i sottili, le pelli, la seta, il veluto, il broccato, & non usano colore alcuno. Ma che piu? & l'aurora, & il Sole oriente, & la notte, & i fuochi, le tempestà, i riflessi dell'acque, le nubi, & le forme di cose animate, & inanimate cosi bene vanno moderando con i tagli, che con grande facilità si distingue una cosa dall'altra (*La pratica della perspettiva*, VII, i, p.176)

98 *La pratica della perspettiva*, VIII, pp. 179–86 ("Nella quale si tratta delle misure del corpo humano"). Further on the position of Dürer's *Vier Bücher* in the later cinquecento and the first Italian translation (Venice, 1591): David Rosand, "The Crisis of the Venetian Renaissance Tradition," *L'Arte* 11–12 (1970): 18–19.

99 *La pratica della perspettiva*, IV ("Nella quale si tratta della scenographia, cioè descrittione delle scene"), xvi, pp. 155–56, xvii, p. 157, xviii, p. 158.

100 On this relationship, see E. H. Gombrich, "The Renaissance Theory of Art and the Rise of Landscape," in his *Norm and Form* (London, 1966), pp. 107–21.

101 See above, n. 91. On the relationship of scene painting and mural decoration in antiquity, see A. M. G. Little, "Scaenographia," *Art Bulletin* 18 (1936): 407–18, and "Perspective and Scene Painting," *Art Bulletin* 19 (1937): 487–95. See also Pollitt, *The Ancient View of Greek Art*, pp. 236–47; Gisela M. A. Richter, *Perspective in Greek and Roman Art* (London [1970?]), pp. 58–61; and John White, *The Birth and Rebirth of Pictorial Space*, 2d ed. (New York and London, 1972), pp. 249–73.

102 For the literary inspiration behind Veronese's frescoes at Maser, see Juergen Schulz, "Le fonti di Paolo Veronese come decoratore," *Bollettino del Centro . . . Andrea Palladio* 10 (1968): 241–54; also Ingvar Bergström, *Revival of Antique Illusionistic Wall-Painting in Renaissance Art* (Göteborg, 1957), p. 53–58. On the specific visual sources of some of the landscapes, prints by Hieronymus Cock and Giambattista Pittoni, see A. Richard Turner, *The Vision of Landscape in Renaissance Italy* (Princeton, 1966), pp. 205–12, and Konrad Oberhuber, "H. Cock, Battista Pittoni und Paolo Veronese in Villa Maser," in *Munuscula Discipulorum, Festschrift für Hans Kaufmann* (Berlin, 1968), pp. 207–24, and "Gli affreschi di Paolo Veronese nella villa Barbaro," *Bollettino del Centro . . . Andrea Palladio* 10 (1968): 188–202.

103 See especially Norbert Huse, "Palladio und die Villa Barbaro in Maser: Bermerkungen zum Problem der Autorschaft," *Arte veneta* 28 (1974): 106–21.

We assume, of course, that the patron himself conceived the basic iconographic program of the decorations. An interesting anticipation of the *concetto* informing the so-called Stanza dell'Olimpo, with its heavenly vault of pagan deities, may be found in Sperone Speroni's dialogue "Della dignita delle donne," first published in Venice (at Barbaro's initiative) in 1543. One of the interlocutors is Daniele Barbaro himself, who at one point declares: "Finalmente (qual che si sia la cagione) noi siamo in terra huomini, & donne, quasi in mezo di qualche theatro; e d'ogn'intorno per ogni parte del cielo siedeno li Dei, tutti intenti à guardare la tragedia dell'esser nostro. Noi adunque, il cui fine altra cosa esser non dee, che'l compiacere à gli spettatori; sotto tal forma dovemo cercar di comparer nella scena, che lodati ce ne possiamo partire: il qual officio, molte fiate meglio adempie alcun servo flagellato con le cathene, e co ceppi, che non fa Re, ò Prencipe che v'intervenga" (*Dialogi di M. S. Speroni* [Venice, 1543], p. 46ᵛ). The theatrical dimensions of the villa at Maser, then, may extend well beyond questions of *scaenographia* as the building assumes its part in this *theatrum mundi*.

104 James S. Ackerman, *Palladio's Villas* (Locust Valley, N.Y., 1967), p. 58; also Rodolfo Pallucchini, "Gli affreschi di Paolo Veronese," in *Palladio, Veronese e Vittoria a Maser* (Milan, 1960), pp. 69–83. One must recall, however, that in his description of the Palazzo Porti Palladio refers to "Messer Paolo Veronese Pittore eccellentissimo" (*I quattro libri*, II, iii, p. 8).

105 Cf. James S. Ackerman, *Palladio* (Harmondsworth and Baltimore, 1966), p. 40. On the harmonic basis of Palladio's architecture, see Wittkower, *Architectural Principles*, pp. 126–42; also Erik Forssman, *Visible Harmony: Palladio's Villa Foscari at Malcontenta* (Stockholm, 1973). For the interpretation of Veronese's frescoes, still an issue, see the two highly suggestive studies by Nicola Ivanoff, "Il sacro ed il profano negli affreschi di Maser," *Ateneo Veneto* 145, no. 1 (1961):

99–104, and "La tematica degli affreschi di Maser," *Arte veneta* 24 (1970): 210–13. On the most recent, if not entirely convincing, effort by Richard Cocke, "Veronese and Daniele Barbaro: The Decoration of Villa Maser," *Journal of the Warburg and Courtauld Institutes* 35 (1972): 226–46, cf. the critique by Ivanoff, "Genio et Laribus (postilla all'iconologia degli affreschi di Maser)," *Ateneo Veneto* 14 (1976): 27–31.

106 Cf. in particular the criticism of Wolfgang Wolters, "Andrea Palladio e la decorazione dei suoi edifici," *Bollettino del Centro . . . Andrea Palladio* 10 (1968): 262–67.

107 Erik Forssman ("Palladio e la pittura a fresco," *Arte veneta* 21 [1967]: 71–76) may argue for too strict a relationship between the mural decorations at Maser and Palladio's reconstructions of the "Sale Corinthie" and "Sale Egittie" (*I quattro libri*, II, ix, x, pp. 38–41). However, to reject this relationship merely because the decorative schemes develop certain traditions already established in cinquecento mural design (cf. Schulz, "Le fonti di Paolo Veronese," p. 254, n. 46) is to ignore a central issue at Maser, the common heritage shared by both painter and architect and Veronese's full awareness of Palladio's articulation of that heritage.

108 See Huse, "Palladio und die Villa Barbaro," who seems to me, however, to insist on too neat a distinction between the roles of the architect and the patron in the design, imputing various presumed impurities in the final product to the latter's intervention.

The villa was, of course, constructed for Daniele Barbaro and his equally distinguished brother, Marcantonio, who was also a gifted amateur artist and architectural expert—as well as a patrician active in the service of the republic (on Marcantonio, see Charles Yriarte, *La vie d'un patricien de Venise au XVIe siècle* [Paris, 1874]; F. Gaeta, "Marcantonio Barbaro," in *Dizionario biografico degli italiani*, vol. 6 [Rome, 1964], pp. 110–12; also Burns, *Andrea Palladio*, cat. no. 278). In a letter of April 1546, Aretino had publicly praised Marcantonio's varied talents: "Né solo in la pittura vi essercita la dote, ch'ella [sc. la natura] vi diede in le fasce, ma in gli stucchi, in la prospettiva e negli intagli" (*Lettere sull'arte di Pietro Aretino*, ed. Fidenzio Pertile and Ettore Camesasca [Milan, 1957–60], vol. 2, no. CCCXLI, pp. 158–59). Of the sculptural decorations of the nymphaeum at Maser itself, Ridolfi writes: "e vi sono ancora figure di stucco, che per ricreatione far soleva il Signor Marc'Antonio . . ." (*Maraviglie*, vol. 1, p. 303).

On the villa in general, see the entries, each with further bibliography, in Cevese, *Mostra del Palladio*, pp. 78–81; Puppi, *Palladio*, vol. 2, pp. 314–18; Burns, *Andrea Palladio*, cat. no. 351. The forthcoming dissertation of Inge Jackson Reist of Columbia University, "Renaissance Harmony: The Villa Barbaro at Maser," will offer a sustained interpretation of the building, its architecture and decoration, within the full range of its contexts, especially scenographic, and of the relations among patron, architect, and painter.

1 For the painting, see Sandra Moschini Marconi, *Gallerie dell'Accademia di Venezia*, vol. 2, *Opere d'arte del secolo XVI* (Rome, 1962), no. 394, with the most complete bibliography; regarding the restoration of the picture, see Francesco Valcanover's entry in *Restauri nel Veneto, 1965* (Venice, 1966), pp. 25–26. On the *scuola*, see Pietro Paoletti, *La Scuola Grande di San Marco* (Venice, 1929), esp. pp. 166–88 for Tintoretto's role in the decorations.

2 In February of 1545 Aretino had written to Tintoretto to thank him for and to praise two ceiling pictures of mythological subjects (*Lettere sull'arte di Pietro Aretino*, ed. Fidenzio Pertile and Ettore Camesasca [Milan, 1957–1960], vol. 2, no. CCXI, pp. 52–53. On the relationship of the two, see Giulio Lorenzetti, "Il Tintoretto e l'Aretino," in *La mostra del Tintoretto a Venezia*, fascicolo 1, February 1937, pp. 7–14.

3 The letter of 1548 reads:

> Da che la voce de la publica laude conferma con quella propria da me datavi nel gran quadro de l'istoria dedicata in la scola di San Marco, mi rallegro non meno con il mio giudizio, che sa tanto inanzi, ch'io mi facci con la vostra arte, che passa sì oltra. E, sì come non è naso, per infreddato che sia, che non senta in qualche parte il fumo de lo incenso, così non è uomo sì poco instrutto ne la virtù del dissegno che non si stupisca nel rilievo de la figura che, tutta ignuda, giuso in terra, è offerta a le crudeltà del martiro. I suoi colori son carne, il suo lineamento ritondo, e il suo corpo vivo, tal che vi giuro, per il bene ch'io vi voglio, che le cere, l'arie e le viste de le turbe, che la circondano, sono tanto simili agli effetti ch'esse fanno in tale opera, che lo spettacolo pare più tosto vero che finto. Ma non insuperbite, se bene è così, ché ciò sarebbe un non voler salire in maggior grado di perfezione. E beato il nome vostro, se reduceste la prestezza del fatto in la pazienzia del fare. Benché a poco a poco a ciò provederanno gli anni; conciosia ch'essi, e non altri, sono bastanti a raffrenare il corso de la trascuratezza, di che tanto si prevale la gioventù volonterosa e veloce (*Lettere sull'arte*, vol. 2, no. CDII, pp. 204–05).

In his letter of 1545 Aretino had already commented on the painter's speed of execution, a virtue he himself quite appreciated: "e perché i buoni pittori apprezzano molto un bel groppo

CHAPTER 5. ACTION AND PIETY IN TINTORETTO'S RELIGIOUS PICTURES

di figure abozzate, lascio stampare le mie cose così fatte, né mi curo punto di miniar parole," he writes of his own work in the dedication of his dialogue between Nanna and Pippa of 1536 (*Sei giornate,* ed. Giovanni Aquilecchia [Bari, 1969], p. 146).

4 Giorgio Vasari, *Le vite de' più eccellenti pittori, scultori ed architettori* (1568), ed. Gaetano Milanesi (Florence, 1878–85), vol. 6, pp. 587–88—quoted above, chap. 1, n. 85, with further references.

5 Carlo Ridolfi, *Le maraviglie dell'arte* (1648), ed. Detlev von Hadeln (Berlin, 1914–24), vol. 2, p. 22:

> Ma perche la Virtù incontrò sempre nelle difficoltà, avvenne, che nato disparere trà confrati, volendo alcuni & altri nò, che il quadro vi rimanesse, per le loro ostentationi: perloche sdegnato il Tintoretto, lo fece distaccare dal luogo posto, & à casa il riportò. Finalmente quietato il rumore, vedendosi quelli della fattione nemica scherniti, pensando à quanto di perdita si faceva con la privatione di quella Pittura, acclamata dall'universale per maravigliosa, si ridussero à ripregarlo, che la riponesse; ed egli sospendendone per qualche tempo gl'animi loro, in fine ve la remisse.

Cf. the more indignant versification of the story in Marco Boschini's *La carta del navegar pitoresco* of 1660 (ed. Anna Pallucchini [Venice and Rome, 1966], p. 516).

In 1547 the *guardian grande* of the Scuola di San Marco was Marco Episcopi, Tintoretto's future father-in-law. A similar internal friction marred the painter's initial relations with the Scuola di San Rocco, leading at least one brother to pledge funds toward the decorations on condition that the commission not go to Tintoretto: the relevant materials are conveniently surveyed by Mario Brunetti in Rodolfo Pallucchini, *Tintoretto a San Rocco* (Venice, 1937), pp. 9–21.

6 Ridolfi, *Maraviglie,* vol. 2, p. 42. See David R. Coffin, "Tintoretto and the Medici Tombs," *Art Bulletin* 33 (1951): 119–25.

7 In his *Quattro dialoghi in materia di rappresentazioni sceniche* Leone de' Sommi speaks of the "eloquenza del corpo" or "corporale eloquenza" (ed. Ferruccio Marotti [Milan, 1968], p. 47). The expression has been appropriately adapted to the painting of Tintoretto by Pierluigi De Vecchi, "Invenzioni sceniche e iconografia del miracolo nella pittura di Jacopo Tintoretto," *L'Arte* 17 (1972): 101–32, esp. p. 108.

8 We refer, of course, to the two seated figures at the base of the throne in the lower right of the composition.

9 "*Il disegno di Michel Angelo e'l colorito di Titiano.*" This, according to Ridolfi (*Maraviglie,* vol. 2, p. 14), was the motto Tintoretto inscribed on the wall of his studio, "per non deviare dal proposto tema." Although Michelangelo and Titian had long assumed their roles as personifications of *disegno* and *colorito,* respectively, the most explicit presentation of the formula was published in Venice in 1548, in Paolo Pino's *Dialogo di pittura:* "e se Tiziano e Michiel Angelo fussero un corpo solo, over al disegno di Michiel Angelo aggiontovi il colore di Tiziano, se gli potrebbe dir lo dio della pittura" (in *Trattati d'arte del Cinquecento,* ed. Paola Barocchi, vol. 1 [Bari, 1960], p. 127). For further discussion of these issues, see above, chap. 1, sec. 3.

10 Giovanni Stringa, *Vita di S. Marco Evangelista, Protettor invittissimo della Sereniss. Republica di Venetia . . .* (Venice, 1610), p. 91ᵛ: "per memoria di quello [miracolo] non solo è stato in Bronzo nel Coro di S. Marco scolpito, & nella Sagrestia ne' Banchi con bellissime intersiature rappresentato; ma ancora nel Salone della Schola maggiore di S. Marco in faccia all'Altare dall'Eccellentissimo Tintoretto depinto ad honor, & gloria di Dio, & di questo nostro Beatissimo, & Gloriosissimo Evangelista." Marco Boschini also locates the picture precisely in his enthusiastic description: "Veramente ne il Tintoretto, ne tutta l'Arte della Pittura, poteva fare di più di quello si vede in essa scuola: ma trà le maraviglie, la maraviglia maggiore, è il quadro per testa di quella Sala, che è dalla parte del Campo di San Giovanni, e Paolo, dove son vedute pur anco le meraviglie di San Marco, ivi assistente nell'Aria, che libera dal martirio un suo divoto servo, convertito al Signore" (*Le minere della pittura* [Venice, 1664], pp. 235–36).

11 Boschini (*Minere,* p. 236) reports that the spaces between those windows on the long adjacent wall were also decorated with figures by Tintoretto, but that these had fallen into disrepair and been restored badly: "Vi sono anco trà le finestre: compartite da un capo all'altro della Sala, varie figure di chiaro oscuro giallo, come sarebbero Profeti, e Sibille, che erano del Tintoretto à guazzo: ma furono ritocche per esser smarrite: temerità di chi lo fece."

12 Stringa, *Vita di S. Marco,* p. 88ᵛ: "Se ne era già sparsa la fama in molte parti del mondo de i miracoli, che Iddio si degnava operare ad intercessione di S. Marco. . . ." The basic trilogy of *passio, translatio,* and *inventio* constituted the three books of Stringa's original publication, *Della vita, traslatione, et apparitione di S. Marco Vangelista . . . libri tre* (1601); the second edition, of 1610, was revised by the addition of a fourth book devoted to the later miracles, which

represent a patriotic elaboration of the collection in the *Golden Legend*. On the hagiography of St. Mark, see Giuseppe Pavanello, "S. Marco nella leggenda e nella storia," *Rivista della città di Venezia* 7 (1928): 293–324; Silvio Tramontin, "San Marco," in *Culto dei santi a Venezia* (Venice, 1965), pp. 41–73; and, more recently, Antonio Niero, "Questioni agiografiche su San Marco," *Studi veneziani* 12 (1970): 3–27, and Silvio Tramontin, "Realtà e leggenda nei racconti marciani veneti," *Studi veneziani* 12 (1970): 35–58.

13 In the *Golden Legend* he is a slave or servant *(servus)*, but in the Venetian hagiography of Stringa, which presumably repeats local tradition, the faithful victim becomes a *castellano*.

14 Stringa's account is more circumstantial than that in the *Golden Legend* (Jacobus de Voragine, *The Golden Legend*, trans. Granger Ryan and Helmut Ripperger [New York, 1941], pp. 242–43), and the climactic scene in the church of San Marco underscores the special position of Venice, the divinely ordained repository of the relics of its patron saint, in the story.

15 Stringa cites Sansovino's relief, along with the earlier intarsie in the sacristy of San Marco and Tintoretto's canvas, at the conclusion of his account of the legend (above, n. 10). See also the comparative analytical comments of De Vecchi, "Invenzioni sceniche," p. 114.

16 Ridolfi, *Maraviglie*, vol. 2, p. 22: "Quì dunque il Tintoretto dipinse quel servo frà le rotture de' legni e de' ferri allestiti per lo tormento; & in aere si vede comparir San Marco in suo aiuto, in uno scorcio maraviglioso accomodato, mediante che quegli rimase illeso; poiche non mancano i Santi del loro patrocinio nelle tribulationi à suoi divoti."

As suggested by my student John Markowitz, the prominent display of the hammer in Tintoretto's painting may reflect a rather literal response to Jacobus de Voragine's etymological comments on the saint's name: "Mark means high in the commandment, sure, bent down and bitter. . . . Or Mark comes from *marco*, a heavy hammer: it forges the iron, strengthens the anvil, and makes the blow to ring out at one and the same time. So, with the sole teaching of his gospel, Mark struck down the evil of the heretics, strengthened the Church, and permitted the praise of God to ring out" (*Golden Legend*, p. 238). The celebration of Mark in any Venetian image becomes, of course, an acclamation of Venice itself. On the theme in general, see Hans Conrad Peyer, *Stadt und Stadtpatron im mittelalterichen Italien* (Zurich, 1955), pp. 8–24.

17 De Vecchi ("Invenzioni sceniche," p. 130, n. 22) has suggested the possibility that this may be a self-portrait.

18 On Rangone and his image, which appears in Tintoretto's subsequent canvases for the Scuola di San Marco, see Erasmus Weddigen, "Thomas Philologus Ravennas: Gelehrter, Wohltäter und Mäzen," *Saggi e memorie di storia dell'arte* 9 (1974): 7–76, and, for his attempt to place a statue of himself on Sansovino's new facade for San Geminiano in Piazza San Marco—a project rejected by the senate but subsequently realized on the façade of San Giuliano—see also Deborah Howard, *Jacopo Sansovino: Architecture and Patronage in Renaissance Venice* (New Haven and London, 1975), pp. 81–82, 84–87. See also below, n. 24, for further comment.

The search for portraits in the *Miracle of St. Mark* has led to the identification of Aretino as well as Rangone and Tintoretto in the composition: cf. Paoletti, *La Scuola Grande di San Marco*, p. 172, and Moschini Marconi, *Gallerie dell'Accademia*, vol. 2, p. 222.

19 Ridolfi, *Maraviglie*, vol. 2, p. 22: "Assistono à tanto miracolo molti personaggi vestiti con zimarre & ornamenti barbareschi; soldati e ministri in atto di ammiratione, un de' quali dimostra al suo Signore, che siede in alto, ripieno di maraviglia, i martelli e le fratture de' legni." Vasari (*Vite*, vol. 6, p. 592) had also noted the "gran copia di figure, di scorti, d'armature, casamenti, ritratti, ed altri cose simili, che rendono molto ornata quell'opera."

20 On the recurrence and possible significance of the mother-child group in Tintoretto's art, see below, p. 213.

21 Stringa, *Vita di S. Marco*, p. 91ᵛ: "Apportò senza dubbio questo miracolo stupore grandissimo à tutta la Città, à tutta Italia, à tutto il Mondo."

22 Luigi Coletti, *Il Tintoretto* (Bergamo, 1940), p. 6.

23 Cf. the representation, *coliseus sive theatrum*, of the frontispiece to Simon de Luere's edition of Terence published in Venice in 1497 (ill. in Licisco Magagnato, *Teatri italiani del Cinquecento* [Venice, 1954], fig. 7), and, as an extension of this tradition, the anatomical theater of Vesalius's *De humani corporis fabrica libri septem*, published in 1543 at Basel but totally prepared in Italy (see David Rosand and Michelangelo Muraro, *Titian and the Venetian Woodcut* [Washington, D.C., 1976], p. 220).

24 Completed by 1566, these two canvases, plus that of *St. Mark rescuing a Saracen* (Venice, Gallerie dell'Accademia), were commissioned for the Scuola di San Marco in 1562 by Tommaso Rangone, then *guardian grande*. Rangone's portrait figures prominently in the compositions (see above, n. 18), and his presence there became a cause of dissension within the confraternity, for in 1573 Tintoretto was charged to remove these effigies: "messer Jacopo si offerse . . . a finirle perfettamente levando la figura dell'Ex Ravena et in loco di essa mettendo

altra accomodata . . ." (Paoletti, *La Scuola Grande di San Marco*, p. 182). The changes were evidently never made. For further bibliography on these canvases, see Moschini Marconi, *Gallerie dell'Accademia*, vol. 2, p. 236; also Weddigen, "Thomas Philologus," pp. 51–53.

25 On the "odor soavissimo" that became an olfactory sign of the saint's corpse, see especially Stringa, *Vita di S. Marco*, p. 34, whose account elaborates upon phenomena already established in the *Golden Legend*.

26 Ridolfi, *Maraviglie*, vol. 2, p. 15:

> Esercitavasi ancora nel far piccioli modelli di cera e di creta, vestendoli di cenci, ricercandone accuratamente con le pieghe de' panni le parti delle membra, quali divisava ancora entro picciole case e prospettive composte di asse e di cartoni, accommodandovi lumicini per le fenestre, recandovi in tale guisa lumi e le ombre.
>
> Sospendeva ancora alcuni modelli co' fili alle travature, per osservare gli effetti, che facevano veduti all'insù, per formar gli scorci posti ne' soffitti, componendo in tali modi bizzarre inventioni.

See also Boschini's elaboration in the preface to *Le ricche minere* (in *La carta del navegar pitoresco*, ed. Anna Pallucchini, pp. 730–31). For further discussion of Tintoretto's procedure, see Detlev von Hadeln, *Zeichnungen des Giacomo Tintoretto* (Berlin, 1922), pp. 29–37. Such methods were common practice throughout most of Italy in the sixteenth century, especially when painters began decorating ceilings, vaults, and domes. They are recommended by Vasari (*Vite*, vol. 1, p. 176), and Lomazzo asserts that even Titian made such models (Giampaolo Lomazzo, *Idea del tempio della pittura* [Milan, 1590], p. 53), although there is no direct evidence for this. The topic is treated circumstantially by Joseph Meder, *Die Handzeichnung, ihre Technik und Entwicklung*, 2d ed. (Vienna, 1923), pp. 414–25 and 551–58, and Julius von Schlosser, "Aus der Bilderwerkstatt der Renaissance," *Jahrbuch der kunsthistorischen Sammlungen des allerhöchsten Kaiserhauses* 31 (1913): 67–135 and esp. pp. 102–11; on pp. 128–35 Schlosser includes an appendix of texts from the older literary sources on the painters' use of small models.

27 Stage lighting ("de' lumi artificiali delle scene") was, of course, a standard topic in sixteenth-century treatises—as, for example, in Serlio's *Secondo libro di perspettiva* and Leone de' Sommi's *Dialoghi in materia di rappresentazioni sceniche* (the relevant passages are conveniently anthologized in Ferruccio Marotti, *Storia documentaria del teatro italiano: lo spettacolo dall'Umanesimo al Manierismo* [Milan, 1974], pp. 203–05, 262–64).

28 Ridolfi, *Maraviglie*, vol. 2, p. 69: "Inventò ancora bizzarri capricci d'habiti & di motti faceti per le rappresentationi delle comedie, che si recitavano in Venetia per diletto dalla studiosa gioventù, inventandone dico molte curiosità, che apportavano maraviglia à gli spettatori, ond'erano celebrate per singolari, si che ogn'uno ricorreva à lui in simili occasioni."

29 See Calmo's ebullient letter, published in 1548, to the painter:

> Al cocolao da la natura e mestura d'Esculapio e fio adotivo d'Apelle, M. IACOMO TENTORETTO depentor. . . . Lassemo andar che algun tien che i bocaleri sia miracolosi, perché d'un tòco de crea a menando un pe e fagando un pozzeto con le man, subito i fa una pignata, un vaso e una scuela; vardela, la xe po de tera e revertetur in cenere; mo vu, che con un fregolin de sbiaca, e d'imbuoro incorporao, a ziogolando col penelo, fè una fegura retrata dal natural in meza hora, che quanti calegheri, sartori e mureri se trova, in vinti anni no saverare a malestente destriar i colori. Savevu che havé cusì bela idea intel presentar de i gesti, maniere, maiestae, i scurci, perfili, ombre e lontani e prospetive, quanto altro che cavalca el Pegaseo moderno, e si dirò sta veritae iustissima, che si havessé tante man, co quanto cuor e saver, che xe in vu, el non è cossa dificile che la fosse, che no le fassé" (*Le lettere di Messer Andrea Calmo*, ed. Vittorio Rossi [Turin, 1888], pp. 132–33).

30 In addition to Vasari's own descriptions (*Vite*, vol. 6, pp. 223–25, vol. 7, pp. 283–87), see Juergen Schulz, "Vasari at Venice," *Burlington Magazine* 103 (1961): 500–11; also Gino Damerini, "Un teatro per la 'Talanta' dell'Aretino," *Il Dramma* 38, no. 306 (1962): 43–50.

31 Sanuto's references to such phenomena have been collected in an eighteenth-century manuscript in the Biblioteca Correr, Venice (Cod. 1650/XV): "Articoli estratti dai Diarii di Marino Sanudo concernanti notizie storiche di commedie, mumarie, feste e compagnie della calza."

32 Cf. Sanuto's description of the Corpus Christi procession of 12 June 1533: "Il Serenissimo vene in chiesia di San Marco. . . . Fo ditto la messa solenne . . ., poi comenzò la procession qual fu bela, et *maxime* la scuola di S. Rocco, qual havea molte fantasie, 12 profeti vestiti benissimo, tre cari con cose dil testamento vechio suso, do cari con arzenti assai et uno S. Rocco, d'arzento in zima de uno di queli *noviter* fatto, bellissimo; et taze apicade a li torzì 24 dorati et tre per uno di 4 cierii; poi Batudi con assà arzenti in man . . ." (*I Diarii*, ed. Rinaldo Fulin et al. [Venice, 1879–1903], vol. 58, col. 315). Further on the *scuole* and their processions will be found in Brian

Pullan, *Rich and Poor in Renaissance Venice* (Oxford, 1971), pp. 52–54, 59–60, 68–69, 127–29, and passim; also William B. Wurthmann, "The *Scuole Grandi* and Venetian Art, 1260–c.1500" (Diss., University of Chicago, 1975), pp. 113–17. On the processional spectacle of Titian's *Triumph of Christ*, which very likely dates from 1508, as Vasari said, see Rosand and Muraro, *Titian and the Venetian Woodcut*, pp. 37–44.

33 For an anthology of these texts, see Alessandro d'Ancona, *Sacre rappresentazioni dei secoli XIV, XV e XVI*, 3 vols. (Florence, 1872), and, for a broader survey of the material, *Origini del teatro italiano*, 2d ed. (Turin, 1891), vol. 1. Sanuto's diaries record the periodic prohibition of comedies and other forms of theatrical entertainment, but the frequency of such decrees and the diarist's own records of subsequent performances make it quite clear that Venice enjoyed a continuing tradition of such spectacle, including sacred drama—cf., in this regard, the somewhat misleading generalization of Michael Baxandall that "in Florence there was a great flowering of religious drama during the fifteenth century, but in Venice such representations were forbidden" (*Painting and Experience in Fifteenth-Century Italy* [Oxford, 1972], p. 71). On the general situation in Venice, see Maria Teresa Muraro, "Venice," *Enciclopedia dello spettacolo*, vol. 9 (Rome, 1962), cols. 1530–39; see also Ludovico Zorzi, *Il teatro e la città: saggi sulla scena italiana* (Turin, 1977), pp. 237–83, 295–326.

34 [1515 Febbraio] "A dì 13. . . . la sera fo fatto nel monastero di San Salvador una representatione per li frati, di santo Alexio. Fo devota cossa" (Sanuto, *Diarii*, vol. 19, col. 434).

 [1515 Maggio] "A dì 28. . . . A Muran, in chiexia di San Donado, ozi fo principià una bella demonstration di la storia di Santo Ylarione convertido da Santo Antonio; fo fato bello aparato e ben vestido, et fo compida il zorno sequente" (Sanuto, *Diarii*, vol. 20, col. 234).

 See D'Ancona, *Origini*, vol. 1, pp. 343–45, for further comment on religious theater in Venice and the Veneto.

35 See Charles E. Cohen, "Pordenone's Cremona Passion Scenes and German Art," *Arte lombarda* 42–43 (1975): 74–95, esp. 86–93 on sacred theater.

36 The issues are discussed, albeit with regard to the highly articulated English drama, in an extremely relevant manner by V. A. Kolve, *The Play called Corpus Christi* (Stanford, 1966). See also James Marrow, "*Circumdederunt me canes multi*: Christ's Tormentors in Northern European Art of the Late Middle Ages and Early Renaissance," *Art Bulletin* 59 (1977): 167–81.

37 Citing D'Ancona (*Origini*, vol. 1, pp. 354–56), Cohen ("Pordenone's Cremona Passion," p. 87) adduces the case of the Passion cycle performed in the Colosseum in the fifteenth and sixteenth centuries in which audience response inspired, by extension, such violence against the Jews of Rome that the authorities eventually had to prohibit the spectacle.

38 Pietro Aretino, *I quattro libri de la humanità di Christo* (Venice, 1539), p. 77v:

> Ma guai a l'huomo, per cui egli sara tradito. Et era ben per lui, se egli non fosse nato. Giuda, che si mosse a cotal detto men, che non si muove un Colosso al respirar del vento, posato il gombito in su la mensa, presa la barba con la mano, in cui posava il mento, raccogliendo le ciglia con le crespe de la fronte, alzando il viso; ch'era piu smorto che la sua invidia, affisando gliocchi altrove, con sicurezza di temerario disse: Son'io Signore? Tu l'hai detto respose egli.

On Aretino's religious writings, still insufficiently evaluated, see Giorgio Petrocchi, *Pietro Aretino, tra Rinascimento e Controriforma* (Milan, 1948), pp. 264–97, and Georg Weise, "Manieristische und frühbarocke Elemente in den religiösen Schriften des Pietro Aretino," *Bibliothèque d'humanisme et Renaissance* 19 (1957): 170–207.

39 Aretino, *Humanità di Christo*, p. 96:

> E cinto da la costanza sua gli fu presa la mano, con la quale creò il Sole: & apertagli la palma; uno ci mise la punta del chiodo: & uno altro alzando il braccio, e declinando giu il colpo; percotendo il capo del chiodo con la faccia del martello; con tal suono faceva tonare il Cielo: che per cio si risentiva: e forata la carne gliene affise nel legno. Allhora la Vergine stese la mano non altrimenti, che in lei fosse rimaso il ferro. La turba data la prima ferita rinovò il grido: e racuetatasi nel prendere quella mano, con cui fece la Luna; radoppiò le voci ammonendo chi lo faceva a dargli in su la dita: & ottenuta la gratia, gridavano; come si grida nel Theatro nel cadere, e nel arrizzarsi de la fiera.

The deliberate pace of the torture and the discursive attention given to the puncture of the palms is, of course, standard in the scripts of the Passion plays, Italian as well as northern. Cf., e.g., the *Rappresentazione della Cena e Passione* of Castellano Castellani, published first in 1519, where the officiating centurion orders:

> Fate che'l chiovo sia grosso e spuntato,
> E che senza pietà drento si metta.

Allor sarà il mio cor contento e sazio,
Quanto vedrò di quel più grave strazio

(D'Ancona, *Sacre rappresentazioni*, vol. 1, p. 320).

40 Aretino's highly pictorial description of the heavenly splendor manifest at the Annunciation to the Virgin (*Humanità di Christo*, pp. 6–6ᵛ) inevitably demands comparison with Titian's lost painting, executed for the convent of Santa Maria degli Angeli on Murano and known through an engraved copy by Caraglio (Harold E. Wethey, *The Paintings of Titian* [London, 1969–75], vol. 1, cat. no. 10). Because of disagreement over the price, the altarpiece was never delivered; instead, apparently on Aretino's advice, it was sent to the Empress Isabella.

41 See above, p. 274, n. 114. A much more positive case for Aretino's influence on Tintoretto has been argued by Eduard Hüttinger, *Die Bilderzyklen Tintorettos in der Scuola di S. Rocco zu Venedig* (Zurich, 1962), pp. 75–79. See also Petrocchi, *Aretino*, pp. 279–80, and Weise, "Manieristische und frühbarocke Elemente," pp. 188–91.

42 Relatively rare in Italian painting, when these themes do appear there is reason to look to northern art for specific models (especially prints) as well as general inspiration. See the observations in Cohen, "Pordenone's Cremona Passion," p. 78. Kolve's analyses in *The Play called Corpus Christi* again offer some suggestive and useful ways of considering the significance of these developments to a Christian audience; see especially chapters 8 ("The Passion and Resurrection in Play and Game") and 9 ("Natural Man and Evil").

43 One clear indication of this revival is the publication in Venice in 1573 (with a second edition in 1585) of Francesco Sansovino's Italian translation of the fourteenth-century *Vita Christi* of Ludolph of Saxony, an important text for the earlier pictorial elaboration of the Passion drama: see Marrow, "*Circumdederunt me canes multi*," pp. 167, 172, 174. Federico Zeri (*Pittura e Controriforma: l'arte senza tempo di Scipio da Gaeta* [Turin, 1957], p. 80) has suggested the possible inspiration of an earlier Netherlandish model, Gerard David's *Nailing to the Cross*, on Italian painting of the later sixteenth century.

44 In the *Ecce Homo* over the door in the *albergo* of the Scuola di San Rocco (fig. 137), Christ's blood, especially that on his hands, glows in the shadows with a special intensity; in order to obtain this chromatic saturation here Tintoretto evidently used lacquer as his medium. Cf. also the sanguinary emphasis on the body of Christ in the *Deposition* in San Giorgio Maggiore (color ill. in Pierluigi De Vecchi, *L'Opera completa del Tintoretto* [Milan, 1970], pl. LXII). A dramatic parallel to this fascination with Christ's blood is offered by Castellani's *Rappresentazione*; as he disrobes Christ, one *carnefice* describes him:

Egli è tanto il suo corpo insanguinato
Che da ogni parte il sangue in terra getta

(D'Ancona, *Sacre rappresentazioni*, vol. 1, p. 320).

45 This aspect of Tintoretto's drama was frequently observed by John Ruskin. Of the ceiling paintings in the *sala grande* of the Scuola di San Rocco he writes: "In none of these three compositions has the painter made the slightest effort at expression in the human countenance; everything is done by gesture, and the faces of the people who are drinking from the rock, dying from the serpent-bites, and eating the manna, are all alike as calm as if nothing was happening" (*The Stones of Venice*, 2d ed. [London, 1858–67], vol. 3, p. 346). In a more analytic vein, he writes of the *Massacre of the Innocents* in the *sala terrena*: "Knowing or feeling, that the expression of the human face was, in such circumstances, not to be rendered, and that the effort could only end in an ugly falsehood, he denies himself all aid from the features, he feels that if he is to place himself or us in the midst of that maddened multitude, there can be no time allowed for watching expression" (p. 329).

Regarding the *Massacre of the Innocents*, Hüttinger (*Die Bilderzyklen*, p. 79) rightly recognized the significance of the description in Aretino's *Humanità di Christo* (pp. 24ᵛ–29). In the confusing particularity of its details, the passage does indeed appear relevant to Tintoretto's composition. Almost as though anticipating Ruskin's sensibility, Aretino avoids getting intimately involved in individual pathos; remaining at a distance from the event, he offers rather a series of gestures and responses, cumulatively affective and set in a bloodied world: "Veramente fu felice chi non nacque in quel tempo: e se pur nacque, nacque altrove. . . . Il giorno è pallido, e mostra dolersi del dolore, che hanno le madri di tanti figli" (p. 25). As a purely pictorial model of such dramatic chaos, Tintoretto may also have had in mind Raphael's *Fire in the Borgo*—a composition that may, as well, have served to form Aretino's own sense of pathetic staging.

46 Giovanni Andrea Gilio, *Due dialoghi . . . degli errori de' pittori circa l'historie . . .* (1564), in *Trattati d'arte del Cinquecento*, ed. Paola Barocchi, vol. 2 (Bari, 1961), p. 40.

47 The following observations are offered with full acknowledgment of the appropriateness of

Ruskin's brief comment upon the *Crucifixion:* "I must leave this picture to work its will on the spectator; for it is beyond all analysis, and above all praise" (*The Stones of Venice,* vol. 3, p. 353). But cf. below, nn. 50 and 52.

48 This physical counterpoint may be taken as a motivic key to Tintoretto's art: cf. the similar group of the apostles removing their leggings in the *Washing of the Feet* (fig. 107).

49 Pullan, *Rich and Poor,* pp. 41–42.

50 Karl Swoboda ("Die grosse Kreuzigung Tintorettos im Albergo der Scuola di San Rocco," *Arte veneta* 25 [1971]: 150 and n. 17), on the other hand, identified this figure as possibly Caiaphas, leader of the hostile Jews. His very positive position between Christ and the good thief, however, would seem to argue against such an essentially negative interpretation. But cf. also Ruskin's observation—the second he allowed himself on the *Crucifixion*—on the function of this figure:

> But the great painter felt he had something more to do yet. Not only that Agony of the Crucified, but the tumult of the people, that rage which invoked his blood upon them and their children. Not only the brutality of the soldier, the apathy of the Centurion, or any other merely instrumental cause of the Divine suffering, but the fury of his own people, the noise against him of those for whom he died, were to be set before the eye of the understanding, if the power of the picture was to be complete. This rage, be it remembered, was one of disappointed pride; and the disappointment dated essentially from the time when, but five days before, the King of Zion came, and was received with hosannahs, riding upon an ass, and a colt the foal of an ass. To this time, then, it was necessary to direct the thoughts, for therein are found both the cause and the character, the excitement of, and the witness against, this madness of the people. In the shadow behind the cross, a man, riding on an ass colt, looks back to the multitude, while he points with a rod to the Christ crucified. The ass is feeding on the *remnants* of *the withered palm-leaves* (*Modern Painters,* part III:II, iii, 20, 4th ed. [London, 1851–60], vol. 2, pp. 173–74).

51 The manner in which this group is framed by the door as one approaches the *albergo* from the *sala grande* (fig. 145) confirms its special status as the most immediate and accessible pathetic unit in the composition.

52 Once again, Ruskin's observations are worthy of quotation:

> But Tintoret here, as in all other cases, penetrating into the root and deep places of his subject, despising all outward and bodily appearances of pain, and seeking for some means of expressing, not the rack of nerve or sinew, but the fainting of the deserted Son of God before his Eloi cry, and yet feeling himself utterly unequal to the expression of this by the countenance, has, on the one hand, filled his picture with such various and impetuous muscular exertion, that the body of the Crucified is, by comparison, in perfect repose, and, on the other, has cast the countenance altogether into shade. But the Agony is told by this, and by this only; that, though there yet remains a chasm of light on the mountain horizon where the earthquake darkness closes upon the day, the broad and sunlike glory about the head of the Redeemer has become wan, *and of the colour of ashes* (*Modern Painters,* part III:II, iii, 20; 4th ed., vol. 2, p. 173).

The cosmological tremors manifest at Christ's death on the cross—which become frequent subjects for Venetian painters in the last quarter of the cinquecento, with renewed interest especially in the opening of the graves (Matthew 27:52–53)—were naturally expanded on by Aretino:

> Ma ecco, che trema la terra: ecco che si spezzon le pietre: ecco mugghiare i venti, ecco aprirsi il velo del Tempio: si scuoteno i monti: si oscura il Sole: suda l'aria: vanno i mari: arrestansi i fiumi: gonfiano i laghi: fan tempesta i rivi. I lauri, perdano il verde: gli uccelli il volo: i pesci il noto: le fiere il corso: gli armenti l'herbe: i greggi l'acque: e gli elementi si confusero insieme, quasi volessero ritornarsi nel primo stato, le porte del limbo si crollarono, si scossero gli abissi. E nel patir d'ogni cosa, per rompersi le leggi de la natura, risuscitando corpi de i Santi adormentati gran tempo innanzi, patì ancho la morte (*Humanità di Christo,* p. 100ᵛ).

53 Matthew 27:55; Mark 15:40; Luke 23:49 (". . . and the women that followed him from Galilee, stood afar off, beholding these things").

54 The inscription on the plaque reads: ".M.D.LXV. / TEMPORE MAGNIFICI / DOMINI HIERONYMI / ROTAE, ET COLLEGARVM / IACOBVS TINTOREC-/ TVS FACEBAT."

At the right, the figures and horses with their backs to us, although visually balancing the composition and physically if not emotionally opening the space on that side, hardly engage us with the same presence. Acknowledging the dominant illumination of the windows on the

right wall of the *albergo,* light enters the picture from this side, casting the faces of these figures into shadow.

55 Just this sort of mix is censured by Lodovico Dolce in his *Dialogo della pittura* of 1557: "colui che dipinse . . . la istoria della scomunica fatta da papa Alessandro a Federico Barbarossa imperadore, avendo nella sua invenzione rappresentata Roma, uscì al mio parere sconciamente fuori della convenevolezza a farvi dentro que' tanti senatori viniziani, che fuor di proposito stanno a vedere: conciosiacosa che non ha del verisimile che essi così tutti a un tempo vi si trovassero, né hanno punto da far con la istoria" (in *Trattati d'arte,* ed. Barocchi, vol. 1, pp. 168–69). For the possibility that this *Excommunication of Barbarossa* in the Ducal Palace was in fact by Tintoretto, see the discussion by Mark Roskill, *Dolce's "Aretino" and Venetian Art Theory of the Cinquecento* (New York, 1968), pp. 281–83.

56 Noting the fullness of Tintoretto's narrative—"facendovi cadere ogni avvenimento di consideratione narrato dagl'Evangelisti"—Ridolfi (*Maraviglie,* vol. 2, pp. 28–29) then proceeds to offer his own rather full and appreciative description of the picture. "In somma," he concludes, "il Tintoretto non mancò di farvi cosa, che esser potesse verisimile in quell'avvenimento, & che destar potesse affetti di pietà ne' riguardanti, come s'egli havesse veduto & osservato quel tragico successo. Ed in vero nel rappresentare i misteri della nostra Sacrosanta Religione dovrebbesi procurare di spiegarli in guisa, che destassero divotione, non riso, come tal hor si vede."

57 Cf. Ruskin's observations, quoted above, n. 45.

58 This group includes, at its center, the fainting Virgin as well as the three other Maries (Matthew 27:56; Mark 15:40). At the left are St. John and the Magdalen, looking up to Christ on the cross, and Joseph of Arimathea, kneeling with pious concern before the Virgin. Balancing him on the right is a rather enigmatic figure, shrouded in white, implausibly identified by Swoboda as Nicodemus ("Die grosse Kreuzigung," p. 146)—we are reminded instead of the naming of Salome in Mark's Gospel text. The woman standing at the foot of the cross observing Christ with a gesture of awe or recognition exceeds the list of names offered by the Gospels; her prominence requires a correspondingly significant identification, and Swoboda's suggestion of Ecclesia as the Bride of Christ is, despite some (chromatic) problems, a possibility.

59 The inscription on the empty stool reads: "MDXXXX / VII / ADI XXVII / AGOSTO / IN TENPO / DE. MISER. ISE/PO MORANDE/LO. ET. CONPA/GNI."

60 Epitomizing the iconic frontality of this composition is the still life set upon the table in poignant juxtaposition to Christ. Directly on the central axis, which is marked so conspicuously by the vertical fold in the tablecloth, this arrangement of sacramental objects bespeaks with a stark immediacy the betrayal and the sacrifice of the Son of Man: below the lamb are set the bread and the knife, and the group is flanked with ceremonial formality by two wine glasses—as the full scene is framed by the personifications of Faith and Charity. It should be noted that the current position of the canvas in the presbytery of the church, where it is now viewed at an angle, was not its intended location; originally the picture was probably approached directly on axis (see below, nn. 81 and 82), which renders its iconic centrality more relevant and accessible to the viewer.

61 The same gesture marks Judas in Tintoretto's mosaic cartoon for the *Last Supper* in San Marco (ill. in De Vecchi, *L'Opera completa,* p. 84). I have commented on the reading of the pronated arm as a gestural sign of death—admittedly in another context—in "Titian and the 'Bed of Polyclitus,' " *Burlington Magazine* 117 (1975): 242–45.

62 The painting is often dated ca. 1566 or shortly thereafter, following the supposed consecration of the Cappella del Santissimo Sacramento (cf. De Vecchi, *L'Opera completa,* cat. no. 169). In 1583, however, the church of San Trovaso collapsed; reconstruction began the following year (Francesco Sansovino, *Venetia città nobilissima et singolare,* ed. Giustiniano Martinioni [Venice, 1663], p. 247; Flaminio Cornelio, *Ecclesiae Venetae antiquis monumentis . . . illustratae* [Venice, 1749], vol. 5, pp. 235–42; Flaminio Corner, *Notizie storiche delle chiese e monasteri di Venezia . . .* [Padua, 1758], pp. 421–22). An elaborate altar in the style of Vittoria now dominates the Cappella del Santissimo Sacramento, but on the base of the pilaster to the left of the entrance a single date is inscribed: MDVI. And a date of ca. 1556 would seem to accord with the style of Tintoretto's painting—cf., most recently, the observations of Swoboda, "Die grosse Kreuzigung," p. 146 and n. 5. Hans Tietze, *Tintoretto* (London, 1948), p. 373, dated the painting about 1560.

63 In the background, behind and beyond Christ, two figures converse: a woman who points toward the main scene and an old man. Dressed in long robes, they would seem to be a sibyl and a prophet; thinly painted in a spectral white, they are further distanced from the palpable naturalism of the foreground. Thus along the central axis of the picture a sequence runs directly from the apostle reaching for the flask, past Christ, to the background couple—from the world of the observer to a time *ante gratiam,* personified by figures of prophetic vision who look forward to the coming and sacrifice of the Savior. Crouching on the stairs in the darkness

to the left is an old woman with a distaff—like some ancient Fate, whose distant isolation seems somehow to confirm the tragic import of the event.

64 Antonio Maria Zanetti, *Della pittura veneziana* . . . (Venice, 1771), p. 154: "Viene egli [sc. Tintoretto] incolpato in questa rappresentazione d'aver poste in attitudini troppo violenti le figure degli Apostoli senza necessità. Chi potea dar mai leggi a quel genio, e come si può chiedere regolarità intiera dove arde un vivo fuoco che vuole unicamente libertà?"

65 Ruskin, *The Stones of Venice*, vol. 3, p. 361.

66 The same motif distinguishes Judas in the *Last Supper* in the Scuola di San Rocco (fig. 150), where he is lost in the shadows to the extreme right of the composition. In the San Trovaso canvas this identification is further confirmed by the response of the two apostles at the corner of the table, who turn not to Christ but, rather, recoil from the isolated Judas with gestures of shocked recognition. That the figure in the foreground reaching for the wine is to be identified as Judas has been assumed, inter alia, by Erich von der Bercken and August L. Mayer, *Jacopo Tintoretto* (Munich, 1923), vol. 1, p. 207, Coletti, *Il Tintoretto*, p. 25, and Tietze, *Tintoretto*, p. 17.

67 Ridolfi, *Maraviglie*, vol. 2, p. 39: "Operò di più per la compagnia di Nostro Signore in S. Gervaso e Protaso un'altra Cena del Giovedì Santo, di nuova & curiosa inventione. E si vede in questa Christo in atto di benedire il pane & gli Apostoli d'intorno sopra humili sedie, in gesti divoti, alcun de' quali somministra vivande alla mensa. Vi è un fanciullo, che arreca frutti in un piatto, e nella cima d'una scala una vecchia, che fila, dipinta con molta naturalezza." For Jacob Burckhardt such humility appeared only to trivialize the subject: "In the left transept of S. Trovaso, a Last Supper, degraded to the most ordinary banquet" (*The Cicerone* [1855], trans. Mrs. A. H. Clough [London, 1909], p. 207).

68 Ridolfi, *Maraviglie*, vol. 2, p. 41: "In S. Polo ammirasi un'altra Cena, ove Nostro Signore communica gli Apostoli, diversandosi in quella dalle inventioni operate in questo proposito, non mancando al Tintoretto materia di nuovi concetti, poiche era l'ingegno suo un'Erario d'ogni più rara curiosità."

69 The gestural eloquence of this picture has not always made its point to modern critics. Kenneth Clark, for example, comparing it unfavorably to "the quietness and clarity of statement suitable to the subject," and presumably exemplified by Leonardo's classic composition, condemns Tintoretto for having turned the Last Supper "into a scene of violence and confusion in which the Apostles reel and struggle among servants and unknown onlookers" (*Leonardo da Vinci*, rev. ed. [Baltimore, 1967], p. 93). The comparison with Leonardo's *Last Supper* is surely appropriate, but only if we acknowledge the complex significance of its drama, which is indeed relevant to our reading of Tintoretto's picture: "The Eucharistic elements at Christ's fingertips, placed in extension of his own body, are points of transmission between the divine presence and our own" (Leo Steinberg, "Leonardo's Last Supper," *Art Quarterly* 36 [1973]: 330).

70 Boschini, *Minere*, p. 249: "Sopra il Banco della scuola del Santissimo, la Cena di Christo, con gli Apostoli, è opera singolare pure del Tintoretto."

71 In the central act of charity the leaning apostle extends bread to the beggar; the child at the right, however, is being offered what appears to be a piece of fruit. If this is an allusion to the apple of the Fall, the original sin that will be canceled by the sacrifice of Christ, then the action assumes a negative connotation: a perverse gift of sin to the innocent—the giver, then, may be Judas himself, although such an interpretation must remain purely speculative. In dealing with the meaning of the fruit, we must consider also the bowl of fruit in the San Trovaso *Last Supper*. On the place of the apple in Tintoretto's *Last Supper* in San Giorgio Maggiore (fig. 155), see Nicola Ivanoff, "Il ciclo eucaristico di S. Giorgio Maggiore a Venezia," *Notizia da Palazzo Albani* (*Rivista semestrale di storia dell'arte, Università degli Studi di Urbino*) 4, no. 2 (1975): 54.

72 Ridolfi, *Maraviglie*, vol. 2, p. 31: "la Cena di Christo con gli Apostoli, accomodata con bizzarra prospettiva in una Sala terrena, che tiene dell'horrido, con naturale espressione."

73 On Christ's role as priest in the iconography of the Communion of the Apostles, see Marilyn Aronberg Lavin, "The Altar of Corpus Domini in Urbino: Paolo Uccello, Joos Van Ghent, Piero della Francesca," *Art Bulletin* 49 (1967): 11–13, with further references.

74 The lines are from the sequence for the feast of Corpus Christi composed by Thomas Aquinas (*Analecta hymnica medii aevi*, ed. Clemens Blume and Guido M. Dreves, vol. 50 [Leipzig, 1907], p. 584); they were first associated with the canine presence in Tintoretto's *Last Supper* by Michael Levey, "Tintoretto and the Theme of Miraculous Intervention," *Journal of the Royal Society of Arts* 113 (1965): 721. The regularity with which the dog appears in representations of the Last Supper, often set in poignant (and expectant) juxtaposition to the lamb on the table, suggests a traditional meaning of this motif. For an alternative interpretation, however, which associates the dog with Judas, see Louis Réau, *Iconographie de l'art chrétien* (Paris, 1955–59), vol. 2², p. 415.

75 Quoted above, n. 72. Cf. Ruskin's observations on the *Last Supper* in San Giorgio Maggiore, which he declared, with characteristic enthusiasm, "remarkable for its entire homeliness in the general treatment of the subject; the entertainment being represented like any large

supper in a second-rate Italian inn" (*The Stones of Venice*, vol. 3, p. 302). In the Scuola di San Rocco Burckhardt again found Tintoretto's treatment of the subject to be trivial: "the Last Supper has hardly ever been more vulgarly conceived" (*The Cicerone*, p. 207).

If Veronese's architectural settings seemed naturally related to the concept of the *scena tragica*, then Tintoretto's would invite comparison with the *scena comica*: here, too, we find "le cose quotidiane, & le cure famigliari di bassa gente" (*I dieci libri dell'architettura di M. Vitruvio tradutti et commentati da Monsignor Barbaro* . . . [Venice, 1556], p. 167 [= 158]; also in Marotti, *Storia documentaria*, p. 161). In Tintoretto's settings, as in the comic, "ci va menor cognitione della Architettura, che nella Tragica, percioche gli edificij sono di persone private" (Daniele Barbaro, *La pratica della perspettiva* [Venice, 1568], p. 157; also in Marotti, *Storia documentaria*, p. 212).

76 Among the modern critics who have read Tintoretto's spatial structures with a certain sensitivity to their social as well as affective significance, attention should be drawn to S. Vipper, whose monograph on the artist (Moscow, 1948) is partly available in Italian translation: "Il Tintoretto e il suo tempo," *Rassegna sovietica*, no. 8 (1950): 50–57; no. 9 (1951): 63–73; no. 10 (1951): 52–77; no. 11 (1951): 53–60. See also De Vecchi, "Invenzioni sceniche," passim, and Sergio Marinelli, "La costruzione dello spazio nelle opere di Jacopo Tintoretto," in *La prospettiva rinascimentale (Atti del Convegno . . . , 1977)* (Florence, 1980), pp. 319–30.

77 Here, too, the dramatic transformation of symbolic values in the religious prose of Aretino offers a suggestive analogy. Even as it is described, the table of the Last Supper manifests its meaning in pious conceits: "E posti seco a mensa con lo affetto, che i confessi e contritti si humiliano al Sacerdote ricevendo il Sacramento, e standosi a la cena; le cui vivande fur cotte al fuoco de la charitade; condite dal sudor de la poverta, et administrate per man de la fede . . ." (*Humanità di Christo*, p. 77). One is again tempted to assume that such *ekphraseis* were perhaps as important as the Bible itself to the foundation of the painter's imagination. We might also recall here Christ's invitation at the Supper in Castellano Castellani's *Rappresentazione della Cena e Passione*: "Mangiate tutti in carità perfetta, / Chè miglior cibo ancor voi s'aspetta" (D'Ancona, *Sacre rappresentazioni*, vol. 1, p. 308).

78 An exception, of course, is the *Marriage at Cana* painted, presumably in 1561, for the refectory of the Crociferi—and which passed to the sacristy of Santa Maria della Salute at the dissolution of that order in 1657. This picture's deep perspective must be considered in the context of the large room for which it was designed; as one early observer noted, "pareva si raddoppiassero le mense e i conviti" (quoted by Nino Barbantini in *La mostra del Tintoretto* [Venice, 1937], cat. no. 33).

79 Ridolfi, *Maraviglie*, vol. 2, p. 39.

80 Boschini, *Le ricche minere* (cited above, n. 70). Evidently the first confraternity dedicated to the Santissimo Sacramento in Venice was established in 1395, exactly a century after the first celebration there of the feast of Corpus Domini (Lia Sbriziolo, "Per la storia delle confraternite veneziane: dalle deliberazioni miste [1310–1476] del Consiglio dei Dieci: *Scolae comunes*, artigiane e nazionali," *Atti dell'Istituto Veneto di Scienze, Lettere ed Arti* 126 [1967–68]: 412, 422). By 1539 there were at least nineteen such congregations in Venice (see Giuseppe Barbiero, *Le confraternite del Santissimo Sacramento prima del 1539, saggio storico* [Vedelago (Treviso), 1941], pp. 105–11, 135–41, 298). Those for which Tintoretto worked were apparently founded later in the century. Although the original trecento confraternity was also called "dei Nobili," its sixteenth-century followers were clearly more humble, their members coming from the artisan classes: cf. the roll of names in the *mariegola* of the Scuola del Santissimo Sacramento di San Tomà, reproduced in Barbiero, pl. 29 (opp. p. 139). Further on these confraternities, which multiplied in the course of the sixteenth century as officially encouraged manifestations of reaffirmed reverence for the Eucharist: see Pietro Tacchi Venturi, *Storia della Compagnia di Gesù in Italia*, 2d ed. (Rome, 1950–51), vol. 1¹, pp. 219–26, and Pio Paschini, "Note sul culto eucaristico nella vita religiosa nel primo Rinascimento," *Divinitas* 2 (1962): 340–79; and for further comment on their position in Venice, see Giambattista Gallicciolli, *Delle memorie venete antiche profane ed ecclesiastiche* (Venice, 1795), vol. 3, pp. 248–55, and the comments in Pullan, *Rich and Poor*, pp. 121, 253. The most thorough art–historical study of the subject is Maurice E. Cope's University of Chicago dissertation, *The Venetian Chapel of the Sacrament in the Sixteenth Century* (1965), now available in the Garland series of outstanding dissertations in the fine arts (New York and London, 1979).

81 Recent research by Paola Rossi has established that this *scuola* was the patron at San Marcuola; a copy of the *mariegola* of the fraternity preserved in the parish archives contains the following record: "1547 adi 27 auosto in tempo di Ser Jacomo Morandella furno fatti li Banchi, et il Quadro, et l'Anzolo" (as reported in Rodolfo Pallucchini, "Il Tintoretto di Newcastle-upon-Tyne," *Arte veneta* 30 [1976]: 86–87).

82 Rodolfo Pallucchini ("Il Tintoretto di Newcastle-upon-Tyne," pp. 81–97) has recently argued that the original painting from San Marcuola is not that in the Prado but rather the version in Newcastle-upon-Tyne—a conclusion I cannot accept without serious reservation. However, he has demonstrated that the pictures in San Marcuola were not in fact part of the same commission but were paired at a later date. Boschini's account of 1664, which attributes the main altarpiece to Leonardo Corona, makes it quite clear that the paintings in the presbytery had already been rearranged, but long after the execution of Tintoretto's canvases (*Minere*, p. 480). As early as 1642, Ridolfi (*Maraviglie*, vol. 2, pp. 17–18) had recorded the loss of the original *Washing of the Feet*: "furono due quadri di S. Ermacora della Cena di Christo, e del lavar de'piedi a gli Apostoli, con vedute di belle prospettive; ma il secondo fù levato rimettendovisi la copia."

There seems no reason, on the other hand, to doubt that the pictures in San Trovaso were explicitly commissioned to adorn the chapel of the Holy Sacrament (above, n. 62). The juxtaposition of these subjects, even in separate commissions subsequently paired, can be seen in other Venetian churches as well—e.g., in the presbytery of San Giovanni in Bragora Paris Bordone's *Last Supper* was later faced by a *Washing of the Feet* by Jacopo Palma il Giovane.

83 It is hardly surprising that Tintoretto's rendition of the theme follows the Gospel text (John 13:4–11) with explicit fidelity, particularly in the dialogue between Christ and Peter: "Then cometh he to Simon Peter: and Peter saith unto him, Lord, does thou wash my feet?"

84 See Staale Sinding-Larsen, *Christ in the Council Hall: Studies in the Religious Iconography of the Venetian Republic* (*Acta ad archaeologiam et artium historiam pertinentia* [Institutum Romanum Norvegiae], vol. 5) (Rome, 1974), pp. 200–01, with further references.

85 [1524 Marzo] Adì 24. . . . fo come le stazion di Roma a l'hospedal di mal Incurabele, et trovono de contadi ducati 130 in zerca. Et è da saper. Ozi in ditto hospedal, poi disnar, fu fatto il mandato molto devoto, però che li zentilomeni, Procuratori et altri, quali sono 12 in tutto dil ditto hospedal, con grande humilità lavorno li piedi a li poveri infermi infranzozati, et le done zentildone lavorno i piedi a le done overo femine inferme dil ditto mal; che fu assà persone a veder, et mosse molti a devution vedendo questi di primi di la terra far opera cussì pia (Sanuto, *Diarii*, XXXVI, col. 102–03).

For the historical context of this pious spectacle in a Venice inspired by the words and acts of Gaetano Thiene and Gian Pietro Caraffa, see Pullan, *Rich and Poor*, pp. 216–38; Pullan, "Le scuole grandi e la loro opera nel quadro della Controriforma," *Studi veneziani* 14 (1972): 83–109; and Silvio Tramontin, "Lo spirito, le attività, gli sviluppi dell'Oratorio del Divino Amore nella Venezia del Cinquecento," *Studi veneziani* 14 (1972): 111–36.

86 Further indication of the role of charity in Venice's self-image is afforded by Giovanni Botero's commentary:

Ma non è cosa che renda communemente piú credibile la pietà e la religione altrui che la carità e la benigna distributione delle proprie facoltà alli bisognosi. . . . Hor non è niuna altra città con cosí alta virtú che sia tanto prontamente abbracciata, largamente essercitata et sollecitamente maneggiata. . . . Le elemosine . . . si fanno quotidianamente de' particolari a questo et a quello nelle chiese, per le strade, alle porte delle case. . . . Gareggia . . . la publica beneficenza con la privata liberalità. . . . Sí che si vede che la elemosina et la cura, che altrove ai particolari si rimette, qui è publica et di grandissima riputatione. . . . Quindi nasce nella plebe una certa sicurezza che, per la grandezza de' Magistrati a' quali la tutela et cura de' poveri è raccomandata, il pane non debba mai, per alcuno accidente, mancare. Nascene anco una particolare affettione verso la republica nella quale fioriscono instituti favorevoli e pensieri cosí giovevoli a loro, perché sí come li nobili fanno capitale dell'honore et d'una certa eminenza per la quale siano stimati et reveriti, cosí la plebe fa stima principale del vitto et di quelli che, prendendosi di ciò pensiero, alle loro necessità compenso trovano (*Relatione della republica venetiana* [Venice, 1605]—as quoted in Gino Benzoni, *Venezia nell'età della Controriforma* [Milan, 1973], p. 107).

In the course of the fifteenth century, however, such practices seem to have lost their original impact: see Wurthmann, "The *Scuole Grandi*," pp. 95–96.

87 See Pullan, *Rich and Poor*, p. 63.

88 Swoboda ("Die grosse Kreuzigung," p. 146), in fact, speaks of Tintoretto's "Franciscan naturalism."

89 Although his attempt to suggest an analogy between Tintoretto's art and the philosophy of Bernardino Telesio may not be entirely convincing, Vipper's own observations on this point seem quite relevant; stressing the affirmation of social virtues, he notes (and I quote from the Italian translation) that "proprio i rapporti tra l'individuo e la collettività, il problema della

solidarietà sociale formano parte importante di molte opere del maestro veneziano" (*Rassegna sovietica*, no. 9 [1951]: 70).

90 Such as the compositions of *Christ and the Adulteress* in Milan and Amsterdam (De Vecchi, *L'Opera completa*, cat. nos. 49 and 50).

91 Cf. the images of this subject in the Contini Bonacossi collection, Florence, and in the Metropolitan Museum (De Vecchi, nos. 137 and 138), as well as the canvas in the Scuola di San Rocco.

92 Cf., e.g., Von der Bercken and Mayer, *Tintoretto*, vol. 1, p. 166; Max Dvořák, *Geschichte der italienischen Kunst* (Munich, 1927–28), vol. 2, p. 164; and, more recently, Arnold Hauser, *Mannerism* (New York, 1965), vol. 1, p. 221, and S. J. Freedberg, *Painting in Italy, 1500 to 1600* (Harmondsworth and Baltimore, 1971), p. 360. De Vecchi ("Invenzioni sceniche," p. 114) rightly stresses the degree to which an artist like Tintoretto in fact anticipates the formulations of the Council of Trent in his representations of "miracula et salutaria exempla." See also the observations of Charles de Tolnay, "L'Interpretazione dei cicli pittorici del Tintoretto nella Scuola di San Rocco," *Critica d'arte* 7 (1960): 372–74, and Anna Pallucchini, "Venezia religiosa nella pittura del Cinquecento," *Studi veneziani* 14 (1972): 179–84.

93 Earlier in the century a Venetian nobleman, Gasparo Contarini, weighing the alternatives of monastic dedication and civic responsibility, summarized both the dilemma and its peculiarly Venetian resolution by declaring: "il viver solitario non è naturale all'uomo, il quale la natura ha fatto animal sociabile." As a Venetian Christian, Contarini felt compelled to realize his religious duties within the social context of the city. See Delio Cantimori, *Umanesimo e religione nel Rinascimento* (Turin, 1975), pp. 247–58, and Hubert Jedin, "Gasparo Contarini e il contributo veneziano alla Riforma Cattolica," in *La civiltà veneziana del Rinascimento* (Florence, 1958), pp. 105–24. See also Brian Pullan, "Service to the Venetian State: Aspects of Myth and Reality in the Early Seventeenth Century," *Studi secenteschi* 5 (1964): 95–147.

94 On the iconographic relation of Tintoretto's paintings to the program of the high altar of the church, dedicated to the Trinity and the doctrine of the Transubstantiation, see Ivanoff, "Il ciclo eucaristico"; also Levey, "Miraculous Intervention," pp. 722–24. The most thorough consideration of these pictures, combining compositional and theological analysis, was offered by Maurice Cope in a paper delivered before the annual meeting of the College Art Association of America at New York in 1971: see now his *Venetian Chapel of the Sacrament*, pp. 190–213.

95 The social roots of Tintoretto's naturalism seem to me to put into question comparisons with the personal mysticism of contemporaries like St. John of the Cross or St. Theresa (cf., e.g., Tietze, *Tintoretto*, p. 49; Tolnay, "L'Interpretazione," p. 370; Anna Pallucchini, "Venezia religiosa," p. 182). Moreover, the claims of Tintoretto's art on the imagination of the observer, its rhetorical invitation to participate, seem fundamentally different from the aims of the spiritual exercises of Ignatius of Loyola or even of the popular *Prattica dell'orazione mentale* of Fra Mattia Bellintani da Salò (as suggested by Pallucchini, who otherwise quite properly stresses the relevance of the Capuchin for an understanding of certain currents of piety in northern Italy); that focused intensity of the personal vision is not the result of an art so gestural and so lacking in the pathos of physiognomic expression as is Tintoretto's.

96 R. Berliner, "Die Tatigkeit Tintorettos in der Scuola di San Rocco," *Kunstchronik und Kunstmarkt* 31 (1920): 473. The documents first published by Berliner are summarized by Mario Brunetti in Pallucchini, *Tintoretto a San Rocco*, pp. 5–21.

97 The fundamental aspects of this interpretation were first analyzed and discussed by Henry Thode, "Tintoretto: kritische Studien über des Meisters Werke, G. Die Bilder in den Scuolen," *Repertorium für Kunstwissenschaft* 28 (1904): 24–43, and more recently by Tolnay, "L'Interpretazione," pp. 341–76, and Hüttinger, *Die Bilderzyklen*. On the position of the ceiling paintings in particular within the development of the genre, see Juergen Schulz, *Venetian Painted Ceilings of the Renaissance* (Berkeley and Los Angeles, 1968), pp. 32–34, 87–91.

98 Ridolfi, *Maraviglie*, vol. 2, p. 36—but cf. Hadeln's n. 2. Further on the salaried painter to the state: above, chap. 1, p. 6.

99 Berliner, "Die Tatigkeit Tintorettos," p. 493. Although by this deal the painter acquired a guaranteed annual income (of 100 ducats), to question the sincerity of Tintoretto's motives may be unnecessarily skeptical (cf. Freedberg, *Painting in Italy*, p. 507, n. 21 for p. 360).

100 These begin with Vasari's report (*Vite*, vol. 6, pp. 593–94) of Tintoretto's capture of the commission for the *albergo* ceiling in the Scuola di San Rocco, an account repeated by Ridolfi (*Maraviglie*, vol. 2, p. 27)—and more recently dismissed by Hüttinger (*Die Bilderzyklen*, p. 13), but confirmed again by Schulz (*Venetian Painted Ceilings*, cat. no. 28). To this basic legend Ridolfi adds new chapters concerning Tintoretto's painting in the manner of other artists, such as Schiavone or Paolo Veronese, in order to steal a commission (*Maraviglie*, vol. 2, pp. 17, 38), or his willingness to accept no payment for works because "solo pretendeva di fare le opere tutte della Città. . . . essendo egli buon Cittadino della sua patria" (*Maraviglie*, vol. 2, p.

35). The most recent and most suggestive contribution to the myth of Tintoretto is the biographical essay by Jean-Paul Sartre, "Le séquestré de Venise," *Les temps modernes* 13 (1957): 761–800 (available in several English translations: see Bibliography).

101 On a still larger scale, such chiaroscuro patterns impose a new rhythm on the entire wall of the *sala grande* in the Scuola di San Rocco, dominating and appropriating the sequence of windows into a new order dictated by the paintings themselves. See Tolnay, "L'Interpretazione," figs. 2 and 8, for the fullest available illustrations of these walls. For the lower floor, see the excellent analysis by Józef Grabski, "The Group of Paintings by Tintoretto in the 'Sala Terrena' in the Scuola di San Rocco in Venice and their Relationship to the Architectural Structure," *Artibus et historiae* 1 (1980): 115–31.

102 For all its baroque extravagance, Boschini's celebration isolates just this quality of Tintoretto's art: "oh Dissegno impareggiabile e mostruoso, che dà documento a tutto l'Universo, per non esser state formate simili azioni da niuno vivente nel Mondo, solo da nostri gran Dissegnatori Veneziani! Ma a te, oh Gran Tintoretto, tocca aver il titolo di Monarca nel Dissegno" (from the preface to *Le ricche minere*, reprinted in *La carta del navegar pitoresco*, ed. Anna Pallucchini, p. 751).

Bibliography

Ackerman, James S. *Palladio.* Harmondsworth and Baltimore, 1966.

—————. *Palladio's Villas.* Locust Valley, N.Y., 1967.

—————. "Alberti's Light." In *Studies in Late Medieval and Renaissance Painting in Honor of Millard Meiss,* pp. 1–27. New York, 1978.

—————. "On Early Renaissance Color Theory and Practice." In *Studies in Italian Art History.* Vol. 1 (*Memoirs of the American Academy in Rome,* vol. 35), pp. 11–44. Rome, 1980.

Alberigo, G. "Daniele Barbaro." In *Dizionario biografico degli italiani,* vol. 6, pp. 89–95. Rome, 1964.

Alberti, Leon Battista. *De pictura.* Edited by Cecil Grayson. Rome and Bari, 1975.

Albrizzi, Giambattista. *Forestiero illuminato intorno alle cose più rare e curiose, antiche e moderne della città di Venezia* (1740). Venice, 1792.

Alpers, Svetlana Leontief. "Ekphrasis and Aesthetic Attitudes in Vasari's *Lives.*" *Journal of the Warburg and Courtauld Institutes* 23 (1960): 190–215.

Anderson, Jaynie. " 'Christ carrying the Cross' in San Rocco: Its Commission and Miraculous History." *Arte veneta* 31 (1977): 186–88.

"Anonimo del Tizianello." *Breve compendio della vita del famoso Tiziano Vecellio di Cadore.* Venice, 1622.

Antal, Frederick. *Florentine Painting and its Social Background.* London, 1947.

Aretino, Pietro. *Sei giornate* (1536). Edited by Giovanni Aquilecchia. Bari, 1969.

—————. *I quattro libri de la humanità di Christo.* Venice, 1539.

—————. *La vita di Maria Vergine, di Caterina Santa, & di Tomaso Aquinato Beato.* Venice, 1552.

—————. *Lettere sull'arte di Pietro Aretino.* Edited by Fidenzio Pertile and Ettore Camesasca. 3 vols. in 4. Milan, 1957–60.

Armenini, Giovanni Battista. *De' veri precetti della pittura* (1587). Pisa, 1823.

Arslan, Edoardo. *Gothic Architecture in Venice.* London, 1971.

Badt, Kurt. "Raphael's 'Incendio del Borgo.' " *Journal of the Warburg and Courtauld Institutes* 22 (1959): 35–59.

Barasch, Moshe. *Light and Color in the Italian Renaissance Theory of Art.* New York, 1978.

Barbantini, Nino. *La mostra del Tintoretto.* Venice, 1937.

Barbaro, Daniele. *La pratica della perspettiva.* Venice, 1568.

Barbiero, Giuseppe. *Le confraternite del Santissimo Sacramento prima del 1539, saggio storico.* Vedelago (Treviso), 1941.

Barocchi, Paola, ed. *Trattati d'arte del Cinquecento.* 3 vols. Bari, 1960–62.

—————, et al. *Mostra di disegni dei fondatori dell'Accademia delle Arti del Disegno nel IV centenario della fondazione.* Florence, 1964.

Bassi, Elena. *La R. Accademia di Belle Arti di Venezia.* Florence, 1941.

—————. *La Gipsoteca di Possagno, sculture e dipinti di Antonio Canova.* Venice, 1957.

—————. *Il convento della Carità* (*Corpus Palladianum,* vol. 6). Vicenza, 1971.

Battisti, Eugenio. *Rinascimento e Barocco.* Turin, 1960.

—————. "Corporations, Workshops, and Schools in the Middle Ages and the Renais-

sance." *Encyclopedia of World Art*, vol. 8, cols. 141–50. New York, Toronto, and London, 1963.

Bauch, Kurt. "Zu Tizian als Ziechner." In *Walter Friedlaender zum 90. Geburtstag*, pp. 36–41. Berlin, 1965.

Baxandall, Michael. *Painting and Experience in Fifteenth-Century Italy*. Oxford, 1972.

Beckwith, John. "Byzantium: Gold and Light." In *Light in Art*, edited by Thomas B. Hess and John Ashbery, pp. 67–81. New York and London, 1971.

Beltrame, Francesco. *Cenni illustrativi sul monumento a Tiziano*. Venice, 1852.

Benzoni, Gino. *Venezia nell'età della Controriforma*. Milan, 1973.

Bercken, Erich von der. *Die Gemälde des Jacopo Tintoretto*. Munich, 1942.

_____, and Mayer, August L. *Jacopo Tintoretto*. 2 vols. Munich, 1923.

Bergström, İngvar. *Revival of Antique Illusionistic Wall-Painting in Renaissance Art*. Göteborg, 1957.

Berliner, R. "Die Tatigkeit Tintorettos in der Scuola di San Rocco." *Kunstchronik und Kunstmarkt* 31 (1920): 468–97.

Bernabei, Franco. "Tiziano e Ludovico Dolce." In *Tiziano e il manierismo europeo*, edited by Rodolfo Pallucchini, pp. 307–37. Florence, 1978.

Białostocki, Jan. "Ars auro prior." In *Mélanges de littérature et de philologie offerts à Mieczyslaw Brahmer*, pp. 55–63. Warsaw, 1966.

Bianconi, Piero. *All the Paintings of Lorenzo Lotto*. New York, 1963.

Bierens de Haan, J. C. J. *L'Oeuvre gravé de Cornelis Cort, graveur hollandais*. The Hague, 1948.

Binion. Alice. "The 'Collegio dei Pittori' in Venice." *L'Arte* 11–12 (1970): 92–101.

Birch-Hirschfeld, Karl. *Die Lehre von der Malerei im Cinquecento*. Rome, 1912.

Bistort, G. *Il Magistrato alle Pompe nella Repubblica di Venezia* (Miscellanea di Storia Veneta . . . della R. Deputazione Veneta di Storia Patria). Venice, 1912.

Blume, Clemens, and Dreves, Guido M., eds. *Analecta hymnica medii aevi*. 55 vols. Leipzig, 1886–1922.

Blunt, Anthony. *Artistic Theory in Italy 1450–1600*. 2d ed. Oxford, 1956.

Bocchi, Achille. *Symbolicarum quaestionum de universo genere . . . libri quinque*. Bologna, 1574.

Boerio, Giuseppe. *Dizionario del dialetto veneziano*. Venice, 1829.

Bongiorno, Laurine Mack. "The Theme of the Old and the New Law in the Arena Chapel." *Art Bulletin* 50 (1968): 11–20.

Borghini, Raffaello. *Il Riposo*. Florence, 1584.

Borsook, Eve. *The Mural Painters of Tuscany*. London, 1960.

Boschini, Marco. *La carta del navegar pitoresco* (1660). Edited by Anna Pallucchini. Venice and Rome, 1966.

_____. *Le minere della pittura*. Venice, 1664.

_____. *Le ricche minere della pittura veneziana*. Venice, 1674.

Botero, Giovanni. *Relatione della republica venetiana*. Venice, 1605.

Bottari, Giovanni, and Ticozzi, Stefano. *Raccolta di lettere sulla pittura, scultura ed architettura*. 8 vols. Milan, 1822–25.

Bouwsma, William J. *Venice and the Defense of Republican Liberty*. Berkeley and Los Angeles, 1968.

_____. "Venice and the Political Education of Europe." In *Renaissance Venice*, edited by J. R. Hale, pp. 445–66. London, 1973.

Boyer, Louis. *The Seat of Wisdom: An Essay on the Place of the Virgin Mary in Christian Theology*. Translated by Fr. A. V. Littledale. New York, 1962.

Brandi, Cesare. "Il principio formale di Giorgione." In *Giorgione: Atti del Convegno Internazionale di Studio per il 5° Centenario della Nascita*, pp. 77–81. Castelfranco Veneto, 1979.

Bréhier, Louis. "Les miniatures des 'Homélies' du moine Jacques et le théâtre religieux à Byzance." *Monuments et mémoires publiés par l'Académie des Inscriptions et Belles-Lettres, Foundation Eugène Piot* 24 (1920): 101–28.

Brizio, Anna Maria. "La pittura di Paolo Veronese in rapporto con l'opera del Sanmicheli

e del Palladio." *Bollettino del Centro Internazionale di Studi di Architettura Andrea Palladio* 2 (1960): 19–25.

————. "Paolo Veronese." In *Rinascimento europeo e Rinascimento veneziano*, edited by Vittore Branca, pp. 223–31. Florence, 1967.

Brown, David Alan. "A Drawing by Zanetti after a Fresco on the Fondaco dei Tedeschi." *Master Drawings* 15 (1977): 31–44.

Brunetti, Mario. "Venezia durante la peste del 1348." *Ateneo Veneto* 32 (1909): i, pp. 289–311, ii, pp. 5–42.

————. "La continuità della tradizione artistica nella famiglia del Tintoretto a Venezia." In *Venezia: studi di arte e storia a cura della Direzione del Museo Civico Correr*, pp. 267–71. Venice, 1920.

————. See Pallucchini, Rodolfo.

Bruyn, J. "Notes on Titian's Pietà." In *Album amicorum J. G. van Gelder*, pp. 66–75. The Hague, 1973.

Bulgakov, S. N. *The Wisdom of God: A Brief Summary of Sophiology.* New York and London, 1937.

Burckhardt, Jacob. *The Cicerone* (1855). Translated by Mrs. A. H. Clough. London, 1909.

Burke, Peter. *Venice and Amsterdam: A Study of Seventeenth-Century Élites.* London, 1974.

Burns, Howard, et al. *Andrea Palladio, 1508–1580: The Portico and the Farmyard.* London, 1975.

Cadorin, Giuseppe. *Dello amore ai veneziani di Tiziano Vecellio.* Venice, 1833.

————. *Diploma di Carlo V Imperatore a Tiziano.* Venice, 1850.

Caffi, Michele. "Giacomello del Fiore pittore veneziano del sec. XV." *Archivio storico italiano* 6 (1880): 402–13.

Calmo, Andrea. *Le lettere di Messer Andrea Calmo.* Edited by Vittorio Rossi. Turin, 1888.

Camesasca, Ettore. *Artisti in bottega.* Milan, 1966.

Canova, Giordana. *Paris Bordone.* Venice, 1964.

————. "Riflessioni su Jacopo Bellini e sul libro dei disegni del Louvre." *Arte veneta* 26 (1972): 9–30.

Cantalamessa, G. "RR. Gallerie di Venezia—pitture." *Le gallerie nazionali italiane* 2 (1896): 27–43.

Cantimori, Delio. *Umanesimo e religione nel Rinascimento.* Turin, 1975.

Carli, Laura de, and Zaggia, Michele. "Chiesa, convento e Scuola di S. Maria della Carità in Venezia." *Bollettino del Centro Internazionale di Studi di Architettura Andrea Palladio* 16 (1974): 421–44.

Cartari, Vincenzo. *Le imagini de i dei degli antichi.* Venice, 1567.

Cavalcaselle, G. B. See Crowe, J. A.

Cazelles, Raymond. See Longnon, Jean.

Cennini, Cennino. *Il libro dell'arte.* Translated by Daniel V. Thompson, Jr., *The Craftsman's Handbook.* New Haven, 1933.

Cevese, Renato, et al. *Mostra del Palladio.* Vicenza, 1973.

Chabod, Federico. "Venezia nella politica italiana ed europea del Cinquecento." In *La civiltà veneziana del Rinascimento*, pp. 29–55. Florence, 1958.

Chambers, D. S. *The Imperial Age of Venice, 1380–1580.* London, 1970.

Chastel, André. *Art et humanisme à Florence au temps de Laurent le Magnifique.* Paris, 1959.

————. "Palladio et l'art des fêtes." *Bollettino del Centro Internazionale di Studi di Architettura Andrea Palladio* 2 (1960): 29–33.

————. "Cortile et théâtre." In *Le lieu théâtrale à la Renaissance (Colloques Internationaux du Centre National de la Recherche Scientifique)*, edited by Jean Jacquot et al., pp. 41–47. Paris, 1964.

————. "L'Ardita capra." *Arte veneta* 29 (1975): 146–49.

————. "Sur deux rameaux de figuier." In *Studies in Late Medieval and Renaissance Painting in Honor of Millard Meiss*, pp. 83–87. New York, 1977.

Chojnacki, Stanley. "La posizione della donna a Venezia nel Cinquecento." In *Tiziano e Venezia: Convegno Internazionale di Studi, Venezia, 1976*, pp. 65–70. Vicenza, 1980.

Cicogna, Emmanuele Antonio. *Delle iscrizioni veneziane.* 6 vols. Venice, 1824–53.

Clark, Kenneth. *Leonardo da Vinci.* Rev. ed. Baltimore, 1967.

Cocke, Richard. "Veronese and Daniele Barbaro: The Decoration of Villa Maser." *Journal of the Warburg and Courtauld Institutes* 35 (1972): 226–46.

————. "Veronese's 'Family of Darius' at the National Gallery." *Burlington Magazine* 120 (1978): 325–29.

Coffin, David R. "Tintoretto and the Medici Tombs." *Art Bulletin* 33 (1951): 119–25.

Cohen, Charles E. "Pordenone's Cremona Passion Scenes and German Art." *Arte lombarda* 42–43 (1975): 74–95.

Coletti, Luigi. *Il Tintoretto.* Bergamo, 1940.

————. "La crisi manieristica nella pittura veneziana." *Convivium* 13 (1941): 109–26.

————. "La crisi giorgionesca." *Le Tre Venezie* 21 (1947): 255–67.

————. *Cima da Conegliano.* Venice, 1959.

Contarini, Gasparo. *De magistratibus et republica Venetorum libri quinque.* Venice, 1543.

————. *Della republica et magistrati di Venetia libri V* (1548). Venice, 1591.

Coolidge, John. "Further Observations on Masaccio's *Trinity.*" *Art Bulletin* 48 (1966): 382–84.

Cope, Maurice E. *The Venetian Chapel of the Sacrament in the Sixteenth Century.* New York and London, 1979.

Cornelio, Flaminio. *Ecclesiae Venetae antiquis monumentis . . . illustratae.* 18 vols. Venice, 1749.

———— (Corner, Flaminio). *Notizie storiche delle chiese e monasteri di Venezia e di Torcello.* Padua, 1758.

Coronelli, Vincenzo. *Guida de' forestieri o sia epitome diaria perpetua sagra-profana per la città di Venezia* (1667). Venice, 1744.

Cozzi, Gaetano. "La venuta di Alessandro III a Venezia nel dibattito religioso e politico tra il '500 e il '600." *Ateneo Veneto* 15 (1977): 119–32.

Crowe, J. A., and Cavalcaselle, G. B. *The Life and Times of Titian* (1877). 2 vols. 2d imp., London, 1881.

Cruciani, Fabrizio. "Gli allestimenti scenici di Baldassare Peruzzi." *Bollettino del Centro Internazionale di Studi di Architettura Andrea Palladio* 16 (1974): 155–72.

Dall'Acqua-Giusti, A. *L'Accademia e le gallerie di Venezia, relazioni storiche.* Venice, 1873.

Dalla Santa, Giuseppe. "Di alcuni manifestazioni del culto all'Immacolata Concezione in Venezia dal 1480 alla metà del secolo XVI (nota storica)." In *Serto di fiori a Maria Immacolata anno L* (offprint). Venice, 1904.

Damerini, Gino. *L'Isola e il cenobio di San Giorgio Maggiore.* Venice, 1956.

————. "Un teatro per la 'Talanta' dell'Aretino." *Il Dramma* 38, ño. 306 (1962): 43–50.

Damisch, Hubert. *Théorie du nuage: pour une histoire de la peinture.* Paris, 1972.

Da Mosto, Andrea. *L'Archivio di Stato di Venezia: indice generale storico, descrittivo ed analitico.* 2 vols. Rome, 1937–40.

D'Ancona, Alessandro. *Sacre rappresentazioni dei secoli XIV, XV e XVI.* 3 vols. Florence, 1872.

————. *Origini del treatro italiano.* 2d ed. 2 vols. Turin, 1891.

Danti, Vincenzo. *Il primo libro del trattato delle perfette proporzioni* (1567). In *Trattati d'arte del Cinquecento,* edited by Paola Barocchi, vol. 1. Bari, 1960.

D'Arcais, Francesca Flores. *Guariento.* Venice, 1965.

D'Argaville, Brian T. "Titian's 'Cenacolo' for the Refectory of SS. Giovanni e Paolo Reconsidered." In *Tiziano e Venezia: Convegno Internazionale di Studi, Venezia, 1976,* pp. 161–67. Vicenza, 1980.

Davis, James Cushman. *The Decline of the Venetian Nobility as a Ruling Class.* Baltimore, 1962.

De Bartholomaeis, Vincenzo. *Origini della poesia drammatica italiana.* 2d ed. Turin, 1952.

Degenhart, Bernhard. "Zur Graphologie der Handzeichnung." *Kunstgeschichtliches Jahrbuch der Bibliotheca Hertziana* 1 (1937): 223–343.

Delaney, Susan J. "The Iconography of Giovanni Bellini's *Sacred Allegory.*" *Art Bulletin* 59 (1977): 331–35.

Dellwing, Herbert. *Studien zur Baukunst der Bettelorden im Veneto: Die Gotik der monumentalen Gewölbebasiliken.* Munich and Berlin, 1970.

Delogu, Giuseppe. *Veronese: La Cena in Casa di Levi.* Milan, n.d.

Dempsey, Charles. "Masaccio's *Trinity:* Altarpiece or Tomb?" *Art Bulletin* 54 (1973): 279–81.

————. "Some Observations on the Education of Artists in Florence and Bologna During the Later Sixteenth Century." *Art Bulletin* 52 (1980): 552–69.

Denny, Don. "Some Symbols in the Arena Chapel Frescoes." *Art Bulletin* 55 (1973): 205–12.

De Vecchi, Pierluigi. *L'Opera completa del Tintoretto.* Milan, 1970.

————. "Invenzioni sceniche e iconografia del miracolo nella pittura di Jacopo Tintoretto." *L'Arte* 17 (1972): 101–32.

Didron, Alphonse N. *Christian Iconography.* 2 vols. London, 1886.

Doglioni, Giovanni Nicolò. *Le cose maravigliose dell'inclita città di Venezia. . . .* Venice, 1603.

Dolce, Lodovico. *Dialogo della pittura, intitolato l'Aretino* (1557). In *Trattati d'arte del Cinquecento,* edited by Paola Barocchi, vol. 1. Bari, 1960.

Doren, Alfred. *Das florentiner Zunftwesen.* Stuttgart and Berlin, 1908. Italian translation: *Le arti fiorentine.* 2 vols. Florence, 1940.

Dorment, Kate. "Tomb and Testament: Architectural Significance in Titian's *Pietà.*" *Art Quarterly* 35 (1972): 399–418.

Dürer, Albrecht. *The Literary Remains of Albrecht Dürer.* Edited by William Martin Conway. Cambridge, 1889.

————. *Dürer: Schriftlicher Nachlass.* Edited by Hans Rupprich. 3 vols. Berlin, 1956–66.

Dussler, Luitpold. *Raphael: A Critical Catalogue.* London and New York, 1971.

Dvořák, Max. *Geschichte der italienischen Kunst.* 2 vols. Munich, 1927–28.

Edgerton, Samuel Y., Jr. *The Renaissance Rediscovery of Linear Perspective.* New York, 1975.

Egan, Patricia. " 'Concert' Scenes in Musical Paintings of the Italian Renaissance." *Journal of the American Musicological Society* 14 (1961): 184–95.

Erizzo, Sebastiano. *Discorso sopra le medaglie de gli antichi.* 2d ed. Venice, 1568.

Essling, Prince d'. *Les livres à figures vénitiens de la fin du XV* siècle et du commencement du XVI*.* 3 vols. Florence and Paris, 1907–14.

Ettlinger, Helen S. "The Iconography of the Columns in Titian's Pesaro Altarpiece." *Art Bulletin* 61 (1979): 59–67.

Fasoli, Gina. "Nascita di un mito." In *Studi storici in onore di Gioacchino Volpe,* vol. 1, pp. 447–79. Florence, 1958.

Favaro, Elena. *L'Arte dei Pittori in Venezia e i suoi statuti.* Florence, 1975.

Fechner, Heinz. *Rahmen und Gliederung venezianischer Anconen aus der Schule von Murano.* Munich, 1969.

Fehl, Phillip. "Questions of Identity in Veronese's *Christ and the Centurion.*" *Art Bulletin* 39 (1957): 301–02.

————. "Veronese and the Inquisition: A Study of the Subject Matter of the so-called 'Feast in the House of Levi.' " *Gazette des Beaux-Arts* 58 (1961): 325–54.

————. "Saints, Donors and Columns in Titian's *Pesaro Madonna.*" In *Renaissance Papers: A Selection of Papers presented at the University of North Carolina,* pp. 75–85. Chapel Hill, 1974.

————, and Watson, Paul F. "Ovidian Delight and Problems in Iconography: Two Essays on Titian's *Rape of Europa.*" *Storia dell'arte* 26 (1976): 23–30.

Ferro, Marco. *Dizionario del diritto comune e veneto.* 10 vols. Venice, 1778–81.

Fiocco, Giuseppe. "Il mio Giorgione." *Rivista di Venezia,* n.s. 1 (1955): 5–22.

————. "Alvise Cornaro e il teatro." In *Essays in the History of Architecture presented to Rudolf Wittkower,* pp. 34–39. London, 1967.

Fiorilli, Carlo "I dipintori a Firenze nell'Arte dei Medici, Speziali e Merciai." *Archivio storico italiano* 78 (1920): 5–74.

Fisher, M. Roy. *Titian's Assistants During the Later Years.* New York and London, 1976.

Fletcher, J. M. Review of B. Pullan, *Rich and Poor in Renaissance Venice. Burlington Magazine* 113 (1971): 747.

————. "Sources of Carpaccio in German Woodcuts." *Burlington Magazine* 115 (1973): 599.

Fogolari, Gino. "L'Accademia veneziana di pittura e scultura del Settecento." *L'Arte* 16 (1913): 241–72, 364–94.

————. "Le tavolette votive della Madonna dei Miracoli di Lonigo." *Dedalo* 2 (1922): 580–98.

————. "La chiesa di Santa Maria della Carità di Venezia." *Archivio veneto-tridentino* 5 (1924): 57–119.

————. *I Frari e i SS. Giovanni e Paolo.* Milan, 1931.

————. "Il processo dell'Inquisizione a Paolo Veronese." *Archivio veneto* 17 (1935): 352–86.

Forssman, Erik. "Palladio e Daniele Barbaro." *Bollettino del Centro Internazionale di Studi di Architettura Andrea Palladio* 8 (1966): 68–81.

————. "Palladio e la pittura a fresco." *Arte veneta* 21 (1967): 71–76.

————. "Über Architekturen in der venezianischen Malerei des Cinquecento." *Wallraf-Richartz Jahrbuch* 29 (1967): 105–39.

————. *Visible Harmony: Palladio's Villa Foscari at Malcontenta.* Stockholm, 1973.

Forsyth, Ilene H. *The Throne of Wisdom: Wood Sculptures of the Madonna in Romanesque France.* Princeton, 1972.

Foscari, Lodovico. *Iconografia di Tiziano.* Venice, 1935.

Fossi Todorow, Maria. *I disegni del Pisanello e della sua cerchia.* Florence, 1966.

Freedberg, S. J. *Painting in Italy, 1500 to 1600.* Harmondsworth and Baltimore, 1971.

Frey, Dagobert. "Die Darstellung des Transzendenten in der Malerei des 16. Jahrhundert." In *Umanesimo e simbolismo (Atti del IV Convegno Internazionale di Studi Umanistici),* edited by Enrico Castelli, pp. 193–98. Padua, 1958.

Frey, Herman-Walther. *Neue Briefe von Giorgio Vasari.* Burg b. M., 1940.

Freyhan, R. "The Evolution of the Caritas Figure in the Thirteenth and Fourteenth Centuries." *Journal of the Warburg and Courtauld Institutes* 11 (1948): 68–86.

Frommel, Christoph Luitpold. *Die Farnesina und Peruzzis architektonisches Frühwerk.* Berlin, 1961.

————. *Baldassare Peruzzi als Maler und Zeichner (Beiheft zum Römischen Jahrbuch für Kunstgeschichte,* vol. 11). Vienna and Munich, 1967–68.

Gaeta, Franco. "Alcune considerazioni sul mito di Venezia." *Bibliothèque d'humanisme et Renaissance* 23 (1961): 58–75.

————. "Marcantonio Barbaro." In *Dizionario biografico degli italiani,* vol. 6, pp. 110–12. Rome, 1964.

Gage, John. "Colour in History: Relative and Absolute." *Art History* 1 (1978): 104–30.

Gallicciolli, Giambattista. *Delle memorie venete antiche profane ed ecclesiastiche.* 8 vols. Venice, 1795.

Gallo, Alberto. *La prima rappresentazione al Teatro Olimpico.* Milan, 1973.

Gallo, Rodolfo. "Per la datazione delle opere del Veronese." *Emporium* 89 (1939): 145–52.

————. "La Scuola Grande di San Teodoro di Venezia." *Atti dell'Istituto Veneto di Scienze, Lettere ed Arti* 120 (1961–62): 461–95.

Garberi, Mercedes, et al. *Omaggio a Tiziano: la cultura milanese nell'età di Carlo V.* Milan, 1977.

Gaston, Robert W. "Vesta and the *Martyrdom of St. Lawrence* in the Sixteenth Century." *Journal of the Warburg and Courtauld Institutes* 38 (1974): 358–62.

Geanakoplos, Deno John. *Byzantine East and Latin West.* New York and Evanston, 1966.

Gilbert, Creighton. "Antique Frameworks for Renaissance Art Theory: Alberti and Pino." *Marsyas* 3 (1943): 87–106.

————. "On Subject and Not-Subject in Italian Renaissance Pictures." *Art Bulletin* 34 (1952): 202–16.

————. "The Archbishop on the Painters of Florence, 1450." *Art Bulletin* 41 (1959): 75-89.

————. "Peintres et menuisiers au début de la Renaissance en Italie." *Revue de l'art* 37 (1977): 9–28.

————. "Some Findings on Early Works of Titian." *Art Bulletin* 62 (1980): 36–75.

Gilbert, Felix. "The Date of the Composition of Contarini's and Giannotti's Books on Venice." *Studies in the Renaissance* 14 (1967): 172–84.

————. "The Venetian Constitution in Florentine Political Thought." In *Florentine Studies: Politics and Society in Renaissance Florence,* edited by Nicolai Rubenstein, pp. 463–500. London, 1968.

————. "The Last Will of a Venetian Grand Chancellor." In *Philosophy and Humanism: Renaissance Essays in Honor of Paul Oskar Kristeller,* pp. 502–17. New York, 1976.

Gilmore, Myron. "Myth and Reality in Venetian Political Theory." In *Renaissance Venice,* edited by J. R. Hale, pp. 431–44. London, 1973.

Gilio, Giovanni Andrea. *Due diologhi . . . nel secondo [de' quali] si ragiona degli errori de' pittori circa l'historie, con molte annotazioni fatte sopra il Giudizio Universale dipinto dal Buonarroti* (1564). In *Trattati d'arte del Cinquecento,* edited by Paola Barocchi, vol. 2. Bari, 1961.

Gioseffi, Decio. "Palladio e Scamozzi: il recupero dell'illusionismo integrale del teatro vitruviano." *Bollettino del Centro Internazionale di Studi di Architettura Andrea Palladio* 16 (1974): 281–85.

————. "Giorgione e la pittura tonale." In *Giorgione: Atti del Convegno Internazionale di Studio per il 5° Centenario della Nascita,* pp. 91–98. Castelfranco Veneto, 1979.

Giraldi Cintio, Giovambattista. *Discorsi di M. Giovambattista Giraldi Cinthio* Venice, 1554.

Goethe, Johann Wolfgang von. *Italian Journey (1786–1788).* Translated by W. H. Auden and Elizabeth Mayer. New York, 1968.

Goetz, Oswald. *Der Feigenbaum in der religiösen Kunst des Abendlandes.* Berlin, 1965.

Goldner, George. "A Source for Titian's 'Nymph and Shepherd.'" *Burlington Magazine* 116 (1974): 392–95.

Goldstein, Carl. "Vasari and the Florentine Accademia del Disegno." *Zeitschrift für Kunstgeschichte* 38 (1975): 145–52.

Goloubew, Victor. *Les dessins de Jacopo Bellini au Louvre et au British Museum.* 2 vols. Brussels, 1912.

Golzio, Vincenzo. *Raffaello nei documenti, nelle testimonianze dei contemporanei e nella letteratura del suo secolo.* Vatican City, 1936.

Gombrich, E. H. *Art and Illusion: A Study in the Psychology of Pictorial Representation.* New York, 1960.

————. "Light, Form and Texture in XVth Century Painting." *Journal of the Royal Society of Arts* 112 (1964): 826–49.

————. *Norm and Form: Studies in the Art of the Renaissance.* London, 1966.

————. *The Heritage of Apelles: Studies in the Art of the Renaissance.* Ithaca, 1976.

————. *Means and Ends: Reflections on the History of Fresco Painting.* Walter Neurath Memorial Lecture. London, 1976.

Goodgal, Dana. "The Camerino of Alfonso I d'Este." *Art History* 1 (1978): 162–90.

Gordon, D. J. "Academicians Build a Theatre and Give a Play: the Accademia Olimpica, 1579–1585." In *Friendship's Garland: Essays presented to Mario Praz,* vol. 1, pp. 105–38. Rome, 1966.

Gould, Cecil. "Sebastiano Serlio and Venetian Painting." *Journal of the Warburg and Courtauld Institutes* 25 (1962): 56–64.

————. Review of G. Canova, *Paris Bordone. Burlington Magazine* 107 (1965): 583–84.

————. "Correggio and Rome." *Apollo* 83 (1966): 329–37.

————. "Observations on the Role of Decoration in the Formation of Veronese's Art." In *Essays in the History of Art presented to Rudolf Wittkower,* pp. 123–27. London, 1967.

————. "The Pala of S. Giovanni Crisostomo and the Later Giorgione." *Arte veneta* 23 (1969): 206–09.

————. *The Sixteenth-Century Italian Schools.* National Gallery Catalogue. London, 1975.

————. *The Family of Darius before Alexander by Paolo Veronese.* London (1978).

————. "Veronese and 'The Family of Darius.'" *Burlington Magazine* 120 (1978): 603.

Grabar, André. "The Virgin in a Mandorla of Light." In *Late Classical and Mediaeval Studies in Honor of Albert Mathias Friend, Jr.,* pp. 305–11. Princeton, 1955.

Grabski, Józef. "The Group of Paintings by Tintoretto in the 'Sala Terrena' in the Scuola di San Rocco in Venice and their Relationship to the Architectural Structure."

Artibus et historiae 1 (1980): 115–31.

Gregori, Mina. "Tiziano e l'Aretino." In *Tiziano e il manierismo europeo,* edited by Rodolfo Pallucchini, pp. 271–306. Florence, 1978.

Grote, Ludwig. *"Hier bin ich ein Herr": Dürer in Venedig.* Munich, 1956.

Hadeln, Detlev von. "Girolamo Dente." In Thieme-Becker, *Allgemeines Lexikon der bildenden Künstler,* vol. 9, pp. 81–82. Leipzig, 1913.

————. *Zeichnungen des Giacomo Tintoretto.* Berlin, 1922.

————. *Venezianische Zeichnungen der Hochrenaissance.* Berlin, 1925.

————. *Titian's Drawings.* 2d ed. London, 1927.

————. "Girolamo di Tiziano." *Burlington Magazine* 65 (1934): 84–89.

Hammond, Mason. "A Statue of Trajan represented on the 'Anaglypha Traiani.' " *Memoirs of the American Academy in Rome* 21 (1953): 125–83.

————. *The Antonine Monarchy.* Rome, 1959.

Harris, Ann Sutherland. Letter to the Editor. *Art Bulletin* 54 (1972): 116–18.

Hartt, Frederick. "Mantegna's Madonna of the Rocks." *Gazette des Beaux-Arts* 40 (1952): 329–42.

————. "Andrea del Castagno: Three Disputed Dates." *Art Bulletin* 48 (1966): 228–34.

————. *History of Italian Renaissance Art.* New York, 1969.

Haskell, Francis. "Explaining Titian's Egg Seller." Review of E. Panofsky, *Problems in Titian, Mostly Iconographic. New York Review of Books* 15 (2 July 1970): 32–35.

Hauser, Arnold. *Mannerism: The Crisis of the Renaissance and the Origin of Modern Art.* 2 vols. New York, 1965.

Heckscher, William S. "Bernini's Elephant and Obelisk." *Art Bulletin,* 29 (1947): 155–82.

Henkel, Arthur, and Schöne, Albrecht. *Emblemata: Handbuch zur Sinnbildkunst des XVI. und XVII. Jahrhunderts.* Stuttgart, 1967.

Hetzer, Theodor. *Tizian: Geschichte seiner Farbe.* Frankfurt am Main, 1935.

————. "Tiziano Vecellio." In Thieme-Becker, *Allgemeines Lexikon der bildenden Künstler* vol. 34, pp. 158–72. Leipzig, 1940.

————. "Paolo Veronese." *Römisches Jahrbuch für Kunstgeschichte* 4 (1940): 1–58.

————. *Aufsätze und Vorträge.* 2 vols. Leipzig, 1957.

Heydenreich, Ludwig H., and Lotz, Wolfgang. *Architecture in Italy, 1400 to 1600.*

Hind, Arthur M. *Early Italian Engraving.* 7 vols. London, 1938–48.

Hibbard, Howard. *Poussin: The Holy Family on the Steps.* New York, 1974.

Hind, Arthur M. *Early Italian Engraving.* 7 vols. London, 1938–48.

Hirn, Yrjö. *The Sacred Shrine: A Study of the Poetry and Art of the Catholic Church.* London, 1912.

Hirst, Michael. "The Kingston Lacy 'Judgment of Solomon.' " In *Giorgione: Atti del Convegno Internazionale di Studio per il 5₀ Centenario della Nascita,* pp. 257–62. Castelfranco Veneto, 1979.

Holt, Elizabeth G., ed. *A Documentary History of Art.* 2 vols. Garden City, N.Y., 1957–58.

Hood, William. "The Narrative Mode in Titian's *Presentation of the Virgin.*" In *Studies in Italian Art History,* vol. 1 (*Memoirs of the American Academy in Rome,* vol. 35), pp. 125–62. Rome, 1980.

————, and Hope, Charles. "Titian's Vatican Altarpiece and the Pictures Underneath." *Art Bulletin* 59 (1977): 534–52.

Hoogewerff, G. J. "Un bozzetto di Tiziano per la 'Pala dei Pesaro.' " *Bollettino d'arte* 7 (1927–28): 529–37.

Hope, Charles. "The 'Camerini d'Alabastro' of Alfonso d'Este." *Burlington Magazine* 113 (1971): 641–50, 712–21.

————. "Documents Concerning Titian." *Burlington Magazine* 115 (1973): 809–10.

————. "Titian's Role as 'Official Painter' to the Venetian Republic." In *Tiziano e Venezia: Convegno Internazionale di Studi, Venezia, 1976,* pp. 301–05. Vicenza, 1980.

————. See Hood, William.

Hours, M. "Contributions à l'étude de quelques oeuvres du Titien." *Laboratoire de Recherche des Musées de France, Annales,* pp. 7–31. Paris, 1976.

Hourticq, Louis. *La jeunesse de Titien.* Paris, 1919.

Howard, Deborah. *Jacopo Sansovino: Architecture and Patronage in Renaissance Venice*. New Haven and London, 1975.

Hubala, Erich. *Giovanni Bellini: Madonna mit Kind, Die Pala di San Giobbe*. Stuttgart, 1969.

Huse, Norbert. *Studien zu Giovanni Bellini*. Berlin and New York, 1972.

————. "Palladio und die Villa Barbaro in Maser: Bermerkungen zum Problem der Autorschaft." *Arte veneta* 28 (1974): 106–21.

Hüttinger, Eduard. *Die Bilderzyklen Tintorettos in der Scuola di S. Rocco zu Venedig*. Zurich, 1962.

Ingegneri, Angelo. *Della poesia rappresentativa & del modo di rappresentare le favole sceniche*. Ferrara, 1598.

Ivanoff, Nicola. "Il sacro ed il profano negli affreschi di Maser." *Ateneo Veneto* 145, no. 1 (1961): 99–104.

————. "La tematica degli affreschi di Maser." *Arte veneta* 24 (1970): 210–13.

————. "Il ciclo eucaristico di S. Giorgio Maggiore a Venezia." *Notizie da Palazzo Albani (Rivista semestrale di storia dell'arte, Università degli Studi di Urbino)* 4, no. 2 (1975): 50–57.

————. "Genio et Laribus (postilla all'iconologia degli affreschi di Maser)." *Ateneo Veneto* 14 (1976): 27–31.

————. "Tiziano e la critica contenutista." In *Tiziano, nel quarto centenario della sua morte, 1576–1976 (Lezioni tenute nell'Aula Magna dell'Ateneo Veneto)*, pp. 187–93. Venice, 1977.

James, Montague Rhodes, trans. *The Apocryphal New Testament*. Oxford, 1924.

Jameson, Anna. *Legends of the Madonna as Represented in the Fine Arts*. 3d ed. London, 1864.

Janson, H. W. "Ground Plan and Elevation in Masaccio's *Trinity* Fresco." In *Essays in the History of Art presented to Rudolf Wittkower*, pp. 83–88. London, 1967.

Jedin, Hubert. "Gasparo Contarini e il contributo veneziano alla Riforma Cattolica." In *La civiltà veneziana del Rinascimento*, pp. 105–24. Florence, 1968.

Kahr, Madlyn. "The Meaning of Veronese's Paintings in the Church of San Sebastiano in Venice." *Journal of the Warburg and Courtauld Institutes* 33 (1970): 235–47.

Kennedy, Ruth Wedgwood. "Tiziano a Roma." In *Il mondo antico nel Rinascimento (Atti del V Convegno Internazionale di Studi sul Rinascimento)*, pp. 237–43. Florence, 1958.

————. *Novelty and Tradition in Titian's Art*. Northampton, Mass., 1963.

————. "Apelles Redivivus." In *Essays in Memory of Karl Lehmann (Marsyas* supplement), pp. 160–70. New York, 1964.

Kernodle, George R. *From Art to Theatre: Form and Convention in the Renaissance*. Chicago, 1944.

Keuls, Eva. "Skiagraphia Once Again." *American Journal of Archaeology* 79 (1975): 1–16.

Kishpaugh, Sister Mary Jerome. *The Feast of the Presentation of the Virgin in the Temple: An Historical and Literary Study*. Washington, D.C., 1941.

Klauner, Frederike. "Zur Symbolik von Giorgiones 'Drei Philosophen.' " *Jahrbuch der kunsthistorischen Sammlungen in Wien* 51 (1955): 145–68.

Klein, Robert, and Zerner, Henri. "Vitruve et le théâtre de la Renaissance italienne." In *Le lieu théâtral à la Renaissance (Colloques Internationaux du Centre National de la Recherche Scientifique)*, edited by Jean Jacquot et al., pp. 49–60. Paris, 1964.

Kleinschmidt, Irene. *Gruppenvotivbilder venezianischer Beamter (1550–1630): Tintoretto und die Entwicklung einer Aufgabe* (Centro Tedesco di Studi Veneziani, *Quaderni*, 4). Venice, 1977.

Kolve, V. A. *The Play Called Corpus Christi*. Stanford, 1966.

Krasa, Selma. "Antonio Canovas Denkmal der Erzherzogin Marie Christine." *Albertina Studien* 5–6 (1967–68): 67–134.

Krautheimer, Richard. *Studies in Early Christian, Medieval, and Renaissance Art*. New York and London, 1969.

————, with Krautheimer-Hess, Trude. *Lorenzo Ghiberti* (1956). 2d imp. 2 vols. Princeton, 1970.

Krinsky, Carol Herselle. "Representations of the Temple of Jerusalem before 1500."

Journal of the Warburg and Courtauld Institutes 33 (1970): 1–19.

Kristeller, Paul Oskar. *Renaissance Thought II: Papers on Humanism and the Arts.* New York, Evanston, and London, 1965.

Lafontaine-Dosogne, Jacqueline. *Iconographie de l'enfance de la Vierge dans l'empire byzantin et en occident.* 2 vols. Brussels, 1964–65.

Lane, Frederic C. *Venice, A Maritime Republic.* Baltimore, 1973.

La Piana, George. "The Byzantine Iconography of the Presentation of the Virgin and a Latin Religious Pageant." In *Late Classical and Mediaeval Studies in Honor of Albert Mathias Friend, Jr.,* pp. 261–71. Princeton, 1955.

Lauts, Jan. *Carpaccio.* London, 1962.

Laven, P. J. "Daniele Barbaro, Patriarch Elect of Aquileia, with Special Reference to His Circle of Scholars and to His Literary Achievement." Diss., University of London, 1957.

Lavin, Irving. "The Campidoglio and Sixteenth-Century Stage Design." In *Essays in Honor of Walter Friedlaender* (*Marsyas* supplement), pp. 114–18. New York, 1965.

Lavin, Marilyn Aronberg. "The Altar of Corpus Domini in Urbino: Paolo Uccello, Joos Van Ghent, Piero della Francesca." *Art Bulletin* 49 (1967): 1–24.

————. *Piero della Francesca: The Flagellation.* New York, 1972.

Lehmann, Karl. "The Dome of Heaven." *Art Bulletin* 27 (1945): 1–27. Reprinted in *Modern Perspectives in Western Art History,* edited by W. Eugene Kleinbauer, pp. 227–70. New York, 1971.

Lenz, Christian. *Veroneses Bildarchitektur.* Diss., Ludwig-Maximilians-Universität, Munich, 1969.

Leonardo da Vinci. *The Literary Works of Leonardo da Vinci.* Edited by Jean Paul Richter. 2 vols. London, 1883.

————. *Treatise on Painting* [*Codex Urbinas Latinus 1270*]. Edited by A. Philip McMahon. 2 vols. Princeton, 1956.

Levey, Michael. "An Early Dated Veronese and Veronese's Early Work." *Burlington Magazine* 102 (1960): 106–11.

————. "Tintoretto and the Theme of Miraculous Intervention." *Journal of the Royal Society of Arts* 113 (1965): 707–25.

Levi, Cesare A. *Notizie storiche di alcune antiche scuole d'arte e mestieri scomparse o esistenti ancora in Venezia.* 3d ed. Venice, 1897.

Levi D'Ancona, Mirella. *The Iconography of the Immaculate Conception in the Middle Ages and Early Renaissance* (Monographs on Archaeology and Fine Arts of the College Art Association of America, vol. 7). New York, 1957.

————. *The Garden of the Renaissance: Botanical Symbolism in Italian Painting.* Florence, 1977.

Levie, Simon H. "Daniele da Volterra e Tintoretto." *Arte veneta* 7 (1953): 168–70.

Libby, Lester J., Jr. "Venetian History and Political Thought after 1509." *Studies in the Renaissance* 20 (1973): 7–45.

Liberali, Giuseppe. *Lotto, Pordenone e Tiziano a Treviso* (*Memorie dell'Istituto Veneto di Scienze, Lettere ed Arti,* vol. 33, no. 3). Venice, 1963.

Little, A. M. G. "Scaenographia." *Art Bulletin* 18 (1936): 407–18.

————. "Perspective and Scene Painting." *Art Bulletin* 19 (1937): 487–95.

Logan, Oliver. *Culture and Society in Venice, 1470–1790.* London, 1972.

Lomazzo, Giampaolo. *Trattato dell'arte della pittura* (1584). 3 vols. Rome, 1844.

————. *Ideal del tempio della pittura.* Milan, 1590.

Longhi, Roberto. "Piero dei Franceschi e lo sviluppo della pittura veneziana." *L'Arte* 17 (1914): 198–221, 241–56.

————. *Viatico per cinque secoli di pittura veneziana.* Florence, 1952.

Longnon, Jean, and Cazelles, Raymond. *The Très Riches Heures of Jean, Duke of Berry.* New York, 1969.

L'Orange, Hans Peter. "*Lux aeterna:* l'adorazione della luce nell'arte tardo-antica ed alto-medioevale." *Atti della Pontificia Accademia Romana di Archaeologia, Rendiconti* 47 (1974–75): 191–202.

Lorenzetti, Giulio. *La Scuola Grande di San Giovanni Evangelista.* Venice, 1929.

_____. "Il Tintoretto e l'Aretino." In *La mostra del Tintoretto a Venezia*, fascicolo 1, February 1937, pp. 7–14.

_____. *Venezia e il suo estuario*. 3d ed. Rome, 1963.

Lorenzi, Antonio. *Italia artistica: Cadore*. Bergamo, 1907.

Lorenzi, Giambattista. *Monumenti per servire alla storia del Palazzo Ducale di Venezia*. Venice, 1868.

Lotto, Lorenzo. *Il "Libro di spese diverse" con aggiunta di lettere e d'altri documenti*. Edited by Pietro Zampetti. Venice and Rome, 1969.

Lotz, Wolfgang. See Heydenreich, Ludwig H.

Ludolph of Saxony. *Vita di Giesù Christo nostro Redentore . . . fatta volgare da M. Francesco Sansovino*. Venice, 1573.

Ludwig, Gustav. "Archivalische Beiträge zur Geschichte der venezianischen Malerei." *Jahrbuch der königlich preussischen Kunstsammlungen* 26 (1905): supplement.

_____. See Molmenti, Pompeo.

Magagnato, Licisco. "The Genesis of the *Teatro Olimpico*." *Journal of the Warburg and Courtauld Institutes* 14 (1951): 209–20.

_____. *Teatri italiani del Cinquecento*. Venice, 1954.

_____. "A proposito delle architetture del Carpaccio." *Comunità* 17, no. 111 (1963): 70–81.

_____. "Il momento architettonico di tre pittori veneti del tardo Quattrocento." *Bollettino del Centro Internazionale di Studi di Architettura Andrea Palladio* 6² (1964): 228–38.

Malsburg, Raban von der. *Die Architektur der Scuola Grande di San Rocco in Venedig*. Heidelberg, 1978.

Mariacher, Giovanni. "Bozzetti inediti di Antonio Canova al Museo Correr di Venezia." In *Arte neoclassica (Atti del Convegno . . ., 1957)*, pp. 185–98. Venice and Rome, 1964.

Marinelli, Sergio. "Lo spazio ideologico di Paolo Veronese." *Comunità* 28, no. 173 (1974): 302–64.

_____. "La costruzione dello spazio nelle opere di Jacopo Tintoretto." In *La prospettiva rinascimentale (Atti del Convegno . . ., 1977)*, pp. 319–30. Florence, 1980.

Marotti, Ferruccio. *Storia documentaria del teatro italiano: lo spettacolo dall'Umanesimo al Manierismo*. Milan, 1974.

Marrow, James. "*Circumdederunt me canes multi*: Christ's Tormentors in Northern European Art of the Late Middle Ages and Early Renaissance." *Art Bulletin* 59 (1977): 167–81.

Martindale, A. H. R. Review of S. Moschini Marconi, *Gallerie dell'Accademia di Venezia*, vol 2. *Burlington Magazine* 106 (1964): 578–79.

Maschio, Ruggero. "Una data per l' 'Annunciazione' di Tiziano a S. Salvador." *Arte veneta* 29 (1975): 178–82.

Mason Rinaldi, Stefania. *Catalogue of Drawings by Jacopo Palma il Giovane from the Collection of the Late Mr. C. R. Rudolf*. Sotheby's, London, 1977.

_____. "Contributi d'archivio per la decorazione pittorica della Scuola di San Giovanni Evangelista." *Arte veneta* 32 (1978): 293–301.

Massari, Antonio. *Giorgio Massari, architetto veneziano del Settecento*. Vicenza, 1971.

Mayekawa, Seiro. "Giorgiones 'Tempesta' und Dürer." In *Giorgione: Atti del Convegno Internazionale di Studi per il 5° Centenario della Nascita*, pp. 105-07. Castelfranco Veneto, 1979.

Mayer, August L. See Bercken, Erich von der.

Mazzuchelli, Giovanni Maria. *Gli scrittori d'Italia*. 2 vols. in 6. Brescia, 1753–63.

Meder, Joseph. *Die Handzeichnung, ihre Technik und Entwicklung*. 2d ed. Vienna, 1923.

Meiss, Millard. "Light as Form and Symbol in Some Fifteenth-Century Paintings." *Art Bulletin* 27 (1945): 175–81.

_____. *Painting in Florence and Siena after the Black Death*. Princeton, 1951.

_____. "Jan van Eyck and the Italian Renaissance." In *Venezia e l'Europa (Atti del XVIII Congresso Internazionale di Storia dell'Arte)*, pp. 58–69. Venice, 1956.

_____. "Mortality among Florentine Immortals." *Art News* 58 (May 1959): 27–29, 46ff.; (September 1959): 6.

————. "Contributions to Two Elusive Masters." *Burlington Magazine* 103 (1961): 57–66.

————. *Giovanni Bellini's St. Francis in the Frick Collection*. Princeton, 1964.

————. *The Great Age of Fresco: Discoveries, Recoveries, and Survivals*. New York, 1970.

————. *The Painter's Choice: Problems in the Interpretation of Renaissance Art*. New York and London, 1976.

Melczer, William. "L' 'Aretino' del Dolce e l'estetica veneta del secondo Cinquecento." In *Tiziano e Venezia: Convegno Internazionale di Studi, Venezia, 1976*, pp. 237–42. Vicenza, 1980.

Mellencamp, Emma H. "A Note on the Costume of Titian's Flora." *Art Bulletin* 51 (1969): 174–77.

Meller, Peter. "Il lessico ritrattistico di Tiziano." In *Tiziano e Venezia: Convegno Internazionale di Studi, Venezia, 1976*, pp. 325–35. Vicenza, 1980.

Il Menologio di Basilio II (Cod. Vaticano greco 1613). 2 vols. Turin, 1907.

Meyer zur Capellen, Jürg. "Überlegungen zur 'Pietà' Tizians." *Münchner Jahrbuch der bildenden Kunst* 22 (1971): 117–32.

————. "Beobachtungen zu Jacopo Pesaros Exvoto in Antwerpen." *Pantheon* 38 (1980): 144–52.

————. "Bellini in der Scuola Grande di S. Marco." *Zeitschrift für Kunstgeschichte* 43 (1980): 104–08.

Mézières, Philippe de. *Figurative Representation of the Presentation of the Virgin in the Temple*. Translated by Robert S. Haller. Lincoln, Neb., 1971.

Michiel, Marcantonio. *Notizia d'opere di disegno*. Edited by Gustavo Frizzoni. Bologna, 1884. *Notizia d'opere del disegno*. Edited by Theodor Frimmel. Vienna, 1888.

Mirimonde, A.P. de. "Le sablier, la musique et la danse dans les 'Noces de Cana' de Paul Véronèse." *Gazette des Beaux-Arts* 88 (1976): 129–36.

Molmenti, Pompeo. *Lo statuto dei pittori veneziani nel secolo XV*. Venice, 1884.

————. *La Storia di Venezia nella vita privata*. 7th ed. 3 vols. Bergamo, 1927–29.

————, and Ludwig, Gustav. *Vittore Carpaccio*. Milan, 1906.

Monti, Gennaro Maria. *Le confraternite medievali dell'alta e media Italia*. 2 vols. Venice, 1927.

Monticolo, G. "Il capitolare dell'arte dei pittori a Venezia composto nel dicembre 1271 e le sue aggiunte (1271–1311)." *Nuovo archivio veneto* 2 (1891): 321–56.

————. *L'Ufficio della Giustizia Vecchia a Venezia dalle origini sino al 1330* (R. Deputazione Veneta di Storia Patria, *Miscellanea*, vol. 12). Venice, 1892.

————. *I capitolari delle arti veneziane sottoposte alla Giustizia e poi alla Giustizia Vecchia* (Istituto Storico Italiano, Fonti per la Storia d'Italia). Vol. 2^1. Rome, 1905.

Morassi, Antonio. *Tiziano: gli affreschi della Scuola del Santo a Padova*. Milan, 1956.

Morelli, Giovanni. *Italian Masters in German Galleries: A Critical Essay on the Italian Pictures in the Galleries of Munich, Dresden, Berlin*. Translated by Mrs. Louise M. Richter. London, 1875.

Morelli, Jacopo. *I codici manoscritti volgari della Libreria Naniana*. Venice, 1776.

Moschini, Gianantonio. *Guida per la città di Venezia*. 2 vols. Venice, 1815.

Moschini Marconi, Sandra. *Gallerie dell'Accademia di Venezia*. Vol. 1. *Opere d'arte dei secoli XIV e XV*. Rome, 1955. Vol. 2. *Opere d'arte del secolo XVI*. Rome, 1962.

————. "Il catalogo delle Gallerie dell'Accademia—nuovi accertamenti." *Ateneo Veneto* 5 (1967): 143–58.

Mucchi, Ludovico. "Radiografie di opere di Tiziano." *Arte veneta* 31 (1977): 297–304.

————. *Caratteri radiografici della pittura di Giorgione*. Catalogue of the exhibition *I tempi di Giorgione*. Vol. 3. Florence, 1978.

Muir, Edward. "Images of Power: Art and Pageantry in Renaissance Venice." *American Historical Review* 84 (1979): 16–52.

Muraro, Maria Teresa. "Venice." In *Enciclopedia dello spettacolo*, vol. 9, cols. 1530–57. Rome, 1962.

Muraro, Michelangelo. *Pitture murali nel Veneto e tecnica dell'affresco*. Venice, 1960.

————. "The Guardi Problem and the Statutes of the Venetian Guilds." *Burlington Magazine* 102 (1960): 421–28.

————. "The Statutes of the Venetian 'Arti' and the Mosaics of the Mascoli Chapel." *Art Bulletin* 43 (1961): 263–74.

————. *Carpaccio.* Florence, 1966.

————. *Paolo da Venezia.* University Park and London, 1970.

————. "Marco Boschini." In *Dizionario biografico degli italiani,* vol. 13, pp. 199–202. Rome, 1971.

————. "Maestro Marco e Maestro Paolo da Venezia." In *Studi di storia dell'arte in onore di Antonio Morassi,* pp. 23–34. Venice, 1971.

————. "Venezia: Interpretazione del Palazzo Ducale." *Studi urbinati di storia, filosofia e letteratura* 45 (1971): 1160–75.

————. "Vittore Carpaccio o il teatro in pittura." In *Studi sul teatro veneto fra Rinascimento ed età barocca,* edited by Maria Teresa Muraro, pp. 7–19. Florence, 1971.

————. Review of E. Panofsky, *Problems in Titian, Mostly Iconographic. Art Bulletin* 54 (1972): 353–55.

————. "Il tempio votivo di Santa Maria della Salute in un poema del Seicento." *Ateneo Veneto* 11 (1973): 87–119.

————. "The Political Interpretation of Giorgione's Frescoes on the Fondaco dei Tedeschi." *Gazette des Beaux-Arts* 76 (1975): 177–84.

————. *I disegni di Vittore Carpaccio.* Florence, 1977.

————. "Tiziano pittore ufficiale della Serenissima." In *Tiziano, nel quarto centenario della sua morte, 1576–1976 (Lezioni tenute nell'Aula Magna dell'Ateneo Veneto),* pp. 82–100. Venice, 1977.

————. "Giorgione e la civiltà delle ville venete." In *Giorgione: Atti del Convegno Internazionale di Studio per il 5° Centenario della Nascita,* pp. 171–80. Castelfranco Veneto, 1979.

————. See Rosand, David.

Nagler, A. M. *A Source Book in Theatrical History.* New York, 1959.

Newton, Stella Mary. *Renaissance Theatre Costume and the Sense of the Historic Past.* New York, 1975.

Nicoletti, Giuseppe. "Illustrazione della Chiesa e Scuola di S. Rocco in Venezia." *R. Deputazione Veneta sopra gli Studi di Storia Patria, Miscellanea* 3 (1885): 1–69.

————. "Per la storia dell'arte veneziana: lista di nomi di artisti tolta dai libri di tanse o luminarie della Fraglia dei Pittori." *Ateneo Veneto* 1 (1890): pp. 378–82, 500–06, 631–39, 701–12.

Nicoll, Allardyce. *The Development of the Theatre.* 4th rev. ed. New York, 1957.

Niero, Antonio. "Questioni agiografiche su San Marco." *Studi veneziani* 12 (1970): 3–27.

————. "Un progretto sconosciuto per la basilica della Salute e questioni iconografiche." *Arte veneta* 26 (1972): 245–49.

Nordenfalk, Carl. "Tizians Darstellung des Schauens." *Nationalmusei Årsbok,* pp. 39–60. Stockholm, 1947–48.

Oberhammer, Vinzenz. "Gedanken zum Werdegang und Schicksal im Tizians Grabbild." In *Studi di storia dell'arte in onore di Antonio Morassi,* pp. 152–61. Venice, 1971.

Oberhuber, Konrad. *Die Kunst der Graphik, 3. Renaissance in Italien, 16. Jahrhundert (Werk aus dem Besitz der Albertina).* Vienna, 1966.

————. "Gli affreschi di Paolo Veronese nella villa Barbaro." *Bollettino del Centro Internazionale di Studi di Architettura Andrea Palladio* 10 (1968): 188–202.

————. "H. Cock, Battista Pittoni und Paolo Veronese in Villa Maser." *Munuscula Discipulorum: Festschrift für Hans Kaufmann,* pp. 207–24. Berlin, 1968.

Pacioli, Luca. *De divina porportione* (1509). Edited by Constantin Winterberg. Vienna, 1889.

Palladio, Andrea. *I quattro libri dell'architettura.* Venice, 1570.

Pallucchini, Anna. "Venezia religiosa nella pittura del Cinquecento." *Studi veneziani* 14 (1972): 159–84.

Pallucchini, Rodolfo. *La giovinezza del Tintoretto.* Milan, 1950.

————. "Gli affreschi di Paolo Veronese." In *Palladio, Veronese e Vittoria a Maser,* pp. 69–83. Milan, 1960.

————. "Tintoretto nella luce della critica." In *Rinascimento europeo e Rinascimento*

veneziano, edited by Vittore Branca, pp. 233–60. Florence, 1967.

————. *Tiziano*. 2 vols. Florence, 1969.

————. "Il Tintoretto di Newcastle-upon-Tyne." *Arte veneta* 30 (1976): 81–97.

————, and Brunetti, Mario. *Tintoretto a San Rocco*. Venice, 1937.

Panofsky, Erwin. " 'Imago Pietatis': ein Beitrag zur Typengeschichte des 'Schmerzens-manns' und der 'Maria Mediatrix.' " In *Festschrift für Max J. Friedländer*, pp. 261–308. Leipzig, 1927.

————. *Early Netherlandish Painting*. 2 vols. Cambridge, Mass., 1953.

————. *The Life and Art of Albrecht Dürer*. Princeton, 1955.

————. *Meaning in the Visual Arts: Papers in and on Art History*. Garden City, N.Y., 1957.

————. *Idea, A Concept in Art History*. Translated by Joseph J. S. Peake. Columbia, S.C., 1968.

————. *Problems in Titian, Mostly Iconographic*. New York, 1969.

————. *Renaissance and Renascences in Western Art*. 2d ed. New York and Evanston, 1969.

Paoletti, Pietro. *L'Architettura e la scultura del Rinascimento in Venezia*. 2 vols. in 3. Venice, 1893–97.

————. *Raccolta di documenti inediti per servire alla storia della pittura veneziana nei secoli XV e XVI*. 2 vols. Padua, 1894–95.

————. "Lorenzo Bregno." In Thieme-Becker, *Allgemeines Lexikon der bildenden Künstler*, vol. 4, p. 570. Leipzig, 1910.

————. *La Scuola Grande di San Marco*. Venice, 1929.

Parronchi, Alessandro. "La prospettiva a Venezia tra Quattro e Cinquecento." *Prospettiva* 9 (1977): 7–16.

Paschini, Pio. "Daniele Barbaro letterato e prelato veneziano nel Cinquecento." *Rivista di storia della chiesa in Italia* 16 (1962): 73–107.

————. "Note sul culto eucaristico nella vita religiosa nel primo Rinascimento." *Divinitas* 2 (1962): 340–79.

Pater, Walter. *The Renaissance*. Edited by Kenneth Clark. Cleveland and New York, 1961.

Pavanello, Giuseppe. "S. Marco nella leggenda e nella storia." *Rivista della città di Venezia* 7 (1928): 293–324.

Pedretti, Carlo. "Ancora sul rapporto Giorgione-Leonardo e l'origine del ritratto di spalla." In *Giorgione: Atti del Convegno Internazionale di Studio per il 5° Centenario della Nascita*, pp. 181–85. Castelfranco Veneto, 1979.

————. "Tiziano e il Serlio." In *Tiziano e Venezia: Convegno Internazionale di Studi, Venezia, 1976*, pp. 243–48. Vicenza, 1980.

Pemberton, Elizabeth G. "A Note on Skiagraphia." *American Journal of Archaeology* 80 (1976): 82–84.

Pesaro, Cristina. "Un'ipotesi sulle date di participazione di tre artisti veneziani alla decorazione della Sala del Maggior Consiglio nella prima metà del Quattrocento." *Bollettino dei Musei Civici Veneziani* 23 (1978): 44–56.

Petrocchi, Giorgio. *Pietro Aretino, tra Rinascimento e Controriforma*. Milan, 1948.

Pevsner, Nikolaus. *Academies of Art Past and Present*. Cambridge, 1940.

Peyer, Hans Conrad. *Stadt und Stadtpatron im mittelalterichen Italien*. Zurich, 1955.

Picinelli, Filippo. *Mondo simbolico* (1653). Milan, 1680.

Pigafetta, Filippo. *Due lettere descrittive, l'una dell'ingresso a Vicenza della Imperatrice Maria d'Austria nell'anno MDLXXXI, l'altra della recita nel Teatro Olimpico dell'Edippo di Sofocle nel MDLXXXV*. Padua, 1830.

Pignatti, Terisio. Review of J. Lauts, *Carpaccio*. *Master Drawings* 1, no. 4 (1963): 47–54.

————. "La Fraglia dei Pittori in Venezia." *Bollettino dei Musei Civici Veneziani* 10, no. 3 (1965): 16–39.

————. *Le pitture di Paolo Veronese nella chiesa di S. Sebastiano*. Milan, 1966.

————. "The Relationship between German and Venetian Painting in the Late Quattrocento and Early Cinquecento." In *Renaissance Venice*, edited by J. R. Hale, pp. 244–73. London, 1973.

————. *Veronese: L'Opera completa*. 2 vols. Venice, 1976.

————. *Giorgione* (1969). 2d ed. Venice, 1978.

Pincus, Debra. *The Arco Foscari: The Building of a Triumphal Gateway in Fifteenth Century Venice.* New York and London, 1976.

Pino, Paolo. *Dialogo di pittura* (1548). In *Trattati d'arte del Cinquecento,* edited by Paola Barocchi, vol. 1. Bari, 1960.

Pochat, Götz. *Figur und Landschaft: eine historische Interpretation der Landschaftsmalerei von der Antik bis zur Renaissance.* Berlin and New York, 1973.

Poirier, Maurice. " 'Disegno' in Titian: Dolce's Critical Challenge to Michelangelo." In *Tiziano e Venezia: Convegno Internazionale di Studi, Venezia, 1976,* pp. 249–53. Vicenza, 1980.

Pollitt, J. J. *The Ancient View of Greek Art: Criticism, History, and Terminology.* New Haven, 1974.

Polzer, Joseph. "The Anatomy of Masaccio's *Trinity.*" *Jahrbuch der Berliner Museen* 13 (1971): 18–59.

Povoledo, Elena. "Origini e aspetti della scenografia in Italia." In Nino Pirrotta, *Li due Orfei da Poliziano a Monteverdi,* 2d ed., pp. 335–460. Milan, 1975.

Pozzi, Mario. "Note sulla cultura artistica e sulla poetica di Pietro Aretino." *Giornale storico della letteratura italiana* 145 (1968): 293–322.

Predelli, R. "Le memorie e le carte di Alessandro Vittoria." *Archivio trentino* 23 (1908): 5–74, 129–225.

Preto, Paolo. *Peste e società a Venezia nel 1576.* Vicenza, 1978.

Pullan, Brian. "Poverty, Charity and the Reason of State: Some Venetian Examples." *Bollettino dell'Istituto di Storia della Società e dello Stato Veneziano* 2 (1960): 17–60.

————. "Service to the Venetian State: Aspects of Myth and Reality in the Early Seventeenth Century." *Studi secenteschi* 5 (1964): 95–117.

————. *Rich and Poor in Renaissance Venice: The Social Institutions of a Catholic State, to 1620.* Oxford, 1971.

————. "Le scuole grandi e la loro opera nel quadro della Controriforma." *Studi veneziani* 14 (1972): 83–109.

Puppi, Lionello. "Per Pasqualino Veneto." *Critica d'arte* 8, no. 4 (1961): 36–47.

————. "Une ancienne copie du 'Christo e il manigoldo' de Giorgione au Musée des Beaux-Arts." *Bulletin du Musée National Hongrois des Beaux-Arts* 18 (1961): 39–49.

————. "La rappresentazione inaugurale del Teatro Olimpico: appunti per la restituzione di uno spettacolo rinascimentale." *Critica d'arte* 9 (1962): no. 2, 57–63; no. 3, 57–69.

————. *Il Teatro Olimpico.* Vicenza, 1963.

————. "Prospettive dell'Olimpico, documenti dell'Ambrosiana e altre cose: argomenti per una replica." *Arte lombarda* 11¹ (1966): 26–32.

————. "Gli spettacoli all'Olimpico di Vicenza dal 1585 all'inizio del '600." In *Studi sul teatro veneto fra Rinascimento ed età barocca,* edited by Maria Teresa Muraro, pp. 73–96. Florence, 1971.

————. *Il trittico di Andrea Mantegna per la basilica di S. Zeno Maggiore in Verona.* Verona, 1972.

————. *Andrea Palladio.* 2 vols. Milan, 1973.

————. "Tiziano e l'architettura." In *Tiziano e il manierismo europeo,* edited by Rodolfo Pallucchini, pp. 205–30. Florence, 1978.

Puttfarken, Thomas. *Masstabsfragen: über die Unterschiede zwischen grossen und kleinen Bildern.* Diss., Hamburg, 1971.

Rabb, Theodore K. "The Historian and the Art Historian." *Journal of Interdisciplinary History* 4 (1973): 107–17.

Ragghianti Collobi, Licia. *Il Libro de' Disegni del Vasari.* 2 vols. Florence, 1974.

Ragusa, Isa. "*Terror demonum* and *terror inimicorum:* The Two Lions on the Throne of Solomon and the Open Door of Paradise." *Zeitschrift für Kunstgeschichte* 40 (1970): 93–114.

Réau, Louis. *Iconographie de l'art chrétien.* 3 vols. in 5. Paris, 1955–59.

Reynolds, Sir Joshua. *Discourses on Art.* Edited by R. R. Wark. San Marino, Cal., 1959.

Richardson, Francis L. *Andrea Schiavone.* Oxford, 1980.

Richter, George Martin. *Giorgio da Castelfranco.* Chicago, 1937.

Richter, Gisela M. A. *Perspective in Greek and Roman Art.* London [1970?].

Ridolfi, Carlo. *Le maraviglie dell'arte* (1648). Edited by Detlev von Hadeln. 2 vols. Berlin, 1914–24.

Ringbom, Sixten. *Icon to Narrative: The Rise of the Dramatic Close-up in Fifteenth-Century Devotional Painting.* Åbo, 1965.

Ripa, Cesare. *Iconologia.* Rome, 1603.

Rivoli, Duc de. *Les missels imprimés à Venise de 1481 à 1600.* Paris, 1896.

Roberts, Helen I. "St. Augustine in 'St. Jerome's Study': Carpaccio's Painting and its Legendary Source." *Art Bulletin* 41 (1959): 283–97.

Robertson, Giles. *Vincenzo Catena.* Edinburgh, 1954.

————. "The Earlier Works of Giovanni Bellini." *Journal of the Warburg and Courtauld Institutes* 23 (1960): 45–59.

————. *Giovanni Bellini.* Oxford, 1968.

————. "Giorgione and Leonardo." In *Giorgione: Atti del Convegno Internazionale di Studio per il 5° Centenario della Nascita,* pp. 195–99. Castelfranco Veneto, 1979.

————. "A Drawing after Titian's 'Madonna di Ca' Pesaro' by Federico Zuccaro." In *Tiziano e Venezia: Convegno Internazionale di Studi, Venezia, 1976,* pp. 559–61. Vicenza, 1980.

Romanin, Samuele. *Storia documentata di Venezia.* 10 vols. Venice, 1853–69.

Rosand, David. "The Crisis of the Venetian Renaissance Tradition." *L'Arte* 11–12 (1970): 5–53.

————. "Palma il Giovane as Draughtsman: The Early Career and Related Observations." *Master Drawings* 8 (1970): 148–61.

————. "Titian in the Frari." *Art Bulletin* 53 (1971): 196–213.

————. Review of P. Farinati, *Giornale (1573–1606),* ed. L. Puppi, and L. Lotto, *Il "Libro di spese diverse" (1538–1556),* ed. P. Zampetti. *Art Bulletin* 53 (1971): 407–09.

————. "Ut Pictor Poeta: Meaning in Titian's *Poesie.*" *New Literary History* 3 (1971–72): 527–46.

————. Reply to letter to the editor. *Art Bulletin* 54 (1972): 118–20.

————. "Veronese and Company: Artistic Production in a Venetian Workshop." In *Veronese and His Studio in North American Collections,* pp. 5–11. Birmingham, Ala., 1972.

————. "Veronese in San Sebastiano: A Forgotten Fresco." *Burlington Magazine* 114 (1972): 325–26.

————. "Theater and Structure in the Art of Paolo Veronese." *Art Bulletin* 55 (1973): 217–39.

————. "Titian's 'Presentation of the Virgin': The Second Door." *Burlington Magazine* 115 (1973): 603.

————. "Art History and Criticism: The Past as Present." *New Literary History* 5 (1973–74): 435–45.

————. "Titian and the 'Bed of Polyclitus.'" *Burlington Magazine* 117 (1975): 242–45.

————. "Titian's Light as Form and Symbol." *Art Bulletin* 57 (1975): 58–64.

————. "Titian's *Presentation of the Virgin in the Temple* and the Scuola della Carità." *Art Bulletin* 58 (1976): 55–84.

————. *Titian.* New York, 1978.

————. "Giorgione e il concetto della creazione artistica." In *Giorgione: Atti del Convegno Internazionale di Studio per il 5° Centenario della Nascita,* pp. 135–39. Castelfranco Veneto, 1979.

————. "'Troyes Painted Woes': Shakespeare and the Pictorial Imagination." *Hebrew University Studies in Literature* 8 (1980): 77–97.

————. "Titian and the Critical Tradition." In *Titian: His World and His Legacy,* edited by David Rosand, pp. 1–39. New York, 1982.

————, and Muraro, Michelangelo. *Titian and the Venetian Woodcut.* Washington, D.C., 1976.

Rosand, Ellen. "Music in the Myth of Venice." *Renaissance Quarterly* 30 (1977): 511–37.

Rosci, Marco. "Sebastiano Serlio e il teatro del Cinquecento." *Bollettino del Centro Internazionale di Studi di Architettura Andrea Palladio* 16 (1974): 235–42.

Roskill, Mark W. *Dolce's "Aretino" and Venetian Art Theory of the Cinquecento.* New York, 1968.

Rossi, Sergio. *Dalle botteghe alle accademie: realtà sociale e teorie artistiche a Firenze dal XIV al XVI secolo.* Milan, 1980.

Röthlisberger, Marcel. "Notes on the Drawing Books of Jacopo Bellini." *Burlington Magazine* 98 (1956): 358–64.

————. "Studi su Jacopo Bellini." *Saggi e memorie di storia dell'arte* 2 (1958–59): 41–89.

Rothschild, Eugen von. "Tizians Darstellungen der Laurentiusmarter," *Belvedere* 10¹ (1931): 202–09; 10² (1931): 11–17.

Ruskin, John. *Modern Painters.* 4th ed. 5 vols. London, 1851–60.

————. *The Stones of Venice.* 2d ed. 3 vols. London, 1858–67.

————. *Guide to the Principal Pictures in the Academy of Fine Arts at Venice* (1877). In *The Works of John Ruskin.* Edited by E.T. Cook and Alexander Wedderburn, vol. 24. London and New York, 1906.

Sagredo, Agostino. *Sulle consorterie delle arti edificative in Venezia.* Venice, 1856.

Sambin, Paolo. *Ricerche di storia monastica medioevale.* Padua, 1959.

Sandström, Sven. *Levels of Unreality: Studies in Structure and Construction in Italian Mural Painting during the Renaissance.* Uppsala, 1963.

Sansovino, Francesco. *L'Edificio del corpo humano.* Venice, 1550.

————. *Venetia città nobilissima et singolare* (1581). Edited by Giustiniano Martinioni. Venice, 1663.

Sanuto, Marino. *I Diarii* (1496–1533). 58 vols. Edited by Rinaldo Fulin et al. Venice, 1879–1903.

Sartori, Antonio. *L'Arciconfraternita del Santo.* Padua, 1955.

————. *S. M. Gloriosa dei Frari.* 2d ed. Padua, 1956.

Sartre, Jean-Paul. "Le séquestré de Venise." *Les temps modernes* 13 (1957): 761–800. Translated as "From a Study on Tintoretto," in *New French Writing,* edited by Georges Borchardt, pp. 9–54. New York, 1961; as "The Venetian Pariah," in Jean-Paul Sartre, *Essays in Aesthetics,* edited by Wade Baskin, pp. 1–45. New York, 1963.

Saxl, Fritz. *Lectures.* 2 vols. London, 1957.

Sbriziolo, Lia. "Per la storia delle confraternite veneziane: dalle deliberazioni miste (1310–1476) del Consiglio dei Dieci: *Scolae comunes,* artigiane e nazionali." *Atti dell'Istituto Veneto di Scienze, Lettere ed Arti* 126 (1967–68): 405–42.

————. *Le confraternite veneziane di devozione, saggio bibliografico e premesse storiografiche.* Rome, 1968.

————. "Per la storia delle confraternite veneziane: dalle deliberazioni miste (1310–1476) del Consiglio dei Dieci: Le scuole dei battuti." In *Miscellanea Gilles Gerard Meerseman,* pp. 716–63. Padua, 1970.

Scatolin, Giorgia. *La Scuola Grande di San Teodoro.* Venice, 1961.

Schapiro, Meyer. "On Some Problems in the Semiotics of Visual Art: Field and Vehicle in Image-Signs." *Semiotica* 1 (1969): 223–42.

————. *Words and Pictures: On the Literal and the Symbolic in the Illustration of a Text.* The Hague, 1973.

Schiller, Gertrud. *Iconography of Christian Art.* 2 vols. London, 1971–72.

Schlegel, Ursula. "Observations on Masaccio's *Trinity* Fresco in Santa Maria Novella." *Art Bulletin* 45 (1963): 19–33.

Schlosser, Julius von. "Aus der Bilderwerkstatt der Renaissance," *Jahrbuch der kunsthistorischen Sammlungen des allerhöchsten Kaiserhauses* 31 (1913): 67–135.

Schneider, Laurie. "A Note on the Iconography of Titian's Last Painting." *Arte veneta* 23 (1969): 218–19.

Schöne, Albrecht. See Henkel, Arthur.

Schöne, Wolfgang. *Über das Licht in der Malerei.* Berlin, 1954.

Schrade, Leo. *La représentation d'Edipo Tiranno au Teatro Olimpico.* Paris, 1960.

Schulz, Anne Markham. *The Sculpture of Giovanni and Bartolomeo Bon and their Workshop* (Transactions of the American Philosophical Society). Philadelphia, 1978.

Schulz, Juergen. "A Forgotten Chapter in the Early History of *Quadratura* Painting: the Fratelli Rosa." *Burlington Magazine* 103 (1961): 90–102.

————. "Vasari at Venice." *Burlington Magazine* 103 (1961): 500–11.

————. "Titian's Ceiling in the Scuola di San Giovanni Evangelista." *Art Bulletin* 48 (1966): 89–95.

————. "Pordenone's Cupolas." In *Studies in Renaissance and Baroque Art presented to Anthony Blunt*, pp. 44–50. London, 1967.

————. "Le fonti di Paolo Veronese come decoratore." *Bollettino del Centro Internazionale di Studi di Architettura Andrea Palladio* 10 (1968): 241–54.

————. *Venetian Painted Ceilings of the Renaissance.* Berkeley and Los Angeles, 1968.

————. *The Printed Plans and Panoramic Views of Venice (1486–1797).* Florence, 1970. Published as volume 7 of *Saggi e memorie di storia dell'arte*, 1972.

Scirè, Giovanna. "Appunti sul Silvio." *Arte veneta* 23 (1969): 210–17.

———— (Scirè Nepi, Giovanna). "La Scuola Vecchia di Santa Maria della Misericordia di Venezia." *Quaderni della Soprintendenza ai Beni Artistici e Storici di Venezia* 7 (1978): 31–38.

Scolari, Aldo. "La chiesa di Sta. Maria Gloriosa dei Frari ed il suo recente restauro." In *Venezia: studi di arte e storia a cura della Direzione del Museo Civico Correr*, pp. 148–71. Venice, 1920.

Scrinzi, Angelo. "Ricevute di Tiziano per il pagamento della Pala Pesaro ai Frari." In *Venezia: studi di arte e storia a cura della Direzione del Museo Civico Correr*, pp. 258–59. Venice, 1920.

Seiferth, Wolfgang S. *Synagogue and Church in the Middle Ages: Two Symbols in Art and Literature.* New York, 1970.

Semenzato, Camillo. "Scultura come simbologia del potere." In *Il Palazzo Ducale di Venezia*, pp. 169–214. Turin, 1971.

Serlio, Sebastiano. *Regole generali di architettura sopra le cinque maniere de gli edifici.* Venice, 1537.

————. *Il secondo libro di perspettiva.* Paris, 1545.

Settis, Salvatore. *La "Tempesta" interpretata: Giorgione, i committenti, il soggetto.* Turin, 1978.

Shearman, John. "Leonardo's Colour and Chiaroscuro." *Zeitschrift für Kunstgeschichte* 25 (1962): 13–47.

————. *Andrea del Sarto.* 2 vols. Oxford, 1969.

————. See White, John.

Sidney, Sir Philip. *Selected Prose and Poetry.* Edited by Robert Kimbrough. New York, 1969.

Simonsfeld, Henry. *Der Fondaco dei Tedeschi in Venedig und die deutsch-venetianischen Handelsbeziehung.* 2 vols. Stuttgart, 1887.

Simson, Otto von. *The Gothic Cathedral.* New York, 1962.

Sinding-Larsen, Staale. "Titian's Madonna di Ca' Pesaro and its Historical Significance." *Acta ad archaeologiam et artium historiam pertinentia* (Institutum Romanum Norvegiae) 1 (1962): 139–69.

————. *Christ in the Council Hall: Studies in the Religious Iconography of the Venetian Republic (Acta ad archaeologiam et artium historiam pertinentia* [Institutum Romanum Norvegiae] Vol. 5). Rome, 1974.

————. "La Pala dei Pesaro e la tradizione dell'immagine liturgica." In *Tiziano e Venezia: Convegno Internazionale di Studi, Venezia, 1976*, pp. 201–06. Vicenza, 1980.

————. Letter to the Editor. *Art Bulletin* 62 (1980): 304.

Smith, Hal H. "Some Principles of Elizabethan Stage Costume." *Journal of the Warburg and Courtauld Institutes* 25 (1962): 240–57.

Sohm, Philip L. "The Staircases of the Venetian Scuole Grandi and Mauro Coducci." *Architectura* 8 (1978): 125–49.

————. "Palma Vecchio's *Sea Storm*: A Political Allegory." *Revue d'art canadienne/Canadian Art Review* 6 (1979–80): 85–96.

Sommi, Leone de'. *Quattro dialoghi in materia di rappresentazioni sceniche.* Edited by Feruccio Marotti. Milan, 1966.

Soràvia, Giambattista. *Le chiese di Venezia descritte ed illustrate.* 3 vols. Venice, 1822–24.

Spain, Suzanne. "The Temple of Solomon, the Incarnation and the Mosaics of S. Maria Maggiore" (abstract). *Journal of the Society of Architectural Historians* 28 (1969): 214–15.

Speroni, Sperone. *Dialogi di M. S. Speroni.* Venice, 1543.

Spingarn, Joel E. *Literary Criticism in the Renaissance* (1908). New York and Burlingame, 1963.

Steinberg, Leo. "Observations in the Cerasi Chapel." *Art Bulletin* 41 (1959): 183–90.

————. "Leonardo's *Last Supper.*" *Art Quarterly* 36 (1973): 297–410.

Stringa, Giovanni. *Della vita, traslatione, et apparitione di S. Marco Vangelista . . . libri tre.* Venice, 1601.

————. *Vita di S. Marco Evangelista, Protettor invittissimo della Sereniss. Republica di Venetia* Venice, 1610.

Summers, David. "*Figure Come Fratelli:* A Transformation of Symmetry in Renaissance Painting." *Art Quarterly,* n.s. 1 (1977): 59–88.

Swoboda, Karl. "Die grosse Kreuzigung Tintorettos im Albergo der Scuola di San Rocco." *Arte veneta* 25 (1971): 145–52.

Tacchi Venturi, Pietro. *Storia della Compagnia di Gesù in Italia.* 2d ed. 2 vols. in 4. Rome, 1950–51.

Tafuri, Manfredo. "Teatro e città nell'architettura palladiana." *Bollettino del Centro Internazionale di Studi di Architettura Andrea Palladio* 10 (1968): 65–78.

————. *Jacopo Sansovino e l'architettura del '500 a Venezia.* 2d ed. Padua, 1972.

Tassini, Giuseppe. "Iscrizioni dell'ex chiesa, convento e confraternita di S. Maria della Carità in Venezia." *Archivio veneto* 11 (1877): 357–92; 12 (1877): 112–29, 311–34.

————. *Edifici di Venezia distrutti o volti ad uso diverso da quello a cui furono in origini destinati.* Venice, 1885.

Tea, Eva. "Paolo Veronese e il teatro." In *Venezia e l'Europa (Atti del XVIII Congresso Internazionale di Storia dell'Arte),* pp. 282 84. Venice, 1956.

————. "La Pala Pesaro e la Immacolata." *Ecclesia* 17 (1958): 605–09.

————. "Iconografia della Immacolata in Italia e in Francia." In *Actes du XXI^e Congrès International d'Histoire de l'Art,* pp. 274–84. Paris, 1959.

Testi, Laudedeo. *La storia della pittura veneziana.* 2 vols. Bergamo, 1909–15.

Thode, Henry. "Tintoretto: kritische Studien über des Meisters Werk," *Repertorium für Kunstwissenschaft* 23 (1900): 427–42; 24 (1901): 7–35, 426–47; 28 (1904): 24–45.

Ticozzi, Stefano. See Bottari, Giovanni.

Tietze, Hans. *Tizian: Leben und Werk.* 2 vols. Vienna, 1936.

————. "Master and Workshop in the Venetian Renaissance." *Parnassus* 11 (1939): 34–35, 45.

————. *Tintoretto.* London, 1948.

————. *Titian.* London, 1950.

————. "Meister and Werkstätte in der Renaissancemalerei Venedigs." *Alte und neue Kunst, Wiener kunstwissenschaftliche Blätter* 1 (1952): 89–98.

————, and Tietze-Conrat, E. *The Drawings of the Venetian Painters in the 15th and 16th Centuries.* New York, 1944.

Tietze-Conrat, E. "Decorative Paintings of the Venetian Renaissance Reconstructed from Drawings." *Art Quarterly* 3 (1940): 15–39.

————. "Titian as a Letter Writer." *Art Bulletin* 26 (1944): 117–23.

————. "Titian's Workshop in His Late Years." *Art Bulletin* 28 (1946): 76–88.

————. "The *Pesaro Madonna:* A Footnote on Titian." *Gazette des Beaux-Arts* 42 (1953): 177–82.

————. "Titian as a Landscape Painter." *Gazette des Beaux-Arts* 45 (1957): 11–20.

————. " 'Paolo Veronese armato' (Ridolfi, II, 225)." *Arte veneta* 13–14 (1959–60): 96–99.

Toesca, Pietro. *La pittura e la miniatura nella Lombardia.* Milan, 1912.

Tolnay, Charles de. "L'Interpretazione dei cicli pittorici del Tintoretto nella Scuola di San Rocco." *Critica d'arte* 7 (1960): 341–76.

————. "Il 'Paradiso' del Tintoretto: note sull'interpretazione della tela in Palazzo Ducale." *Arte veneta* 24 (1970): 103–10.

Tramontin, Silvio. "Realtà e leggenda nei racconti marciani veneti." *Studi veneziani* 12 (1970): 35–58.

————. "Lo spirito, le attività, gli sviluppi dell'Oratorio del Divino Amore nella Venezia del Cinquecento." *Studi veneziani* 14 (1972): 111–36.

————, et al. *Culto dei santi a Venezia.* Venice, 1965.

Tschmelitsch, Günter. *Zorzo, genannt Giorgione.* Vienna, 1975.

Turner, A. Richard. *The Vision of Landscape in Renaissance Italy.* Princeton, 1966.

Urbani de Gheltoff, G. M. *Guida storico-artistica della Scuola di S. Giovanni Evangelista.* Venice, 1895.

Ungaro, Giuseppe. *La basilica dei Frari, Venezia.* Padua, 1968.

Valcanover, Francesco. "Il restauro dell'Assunta." In *Tiziano, nel quarto centenario della sua morte, 1576–1976 (Lezioni tenute nell'Aula Magna dell'Ateneo Veneto),* pp 41–51. Venice, 1977.

————, et al. *Restauri nel Veneto, 1965.* Venice, 1966.

Vasari, Giorgio. *Le vite de' più eccellenti pittori, scultori ed architettori* (1568). 9 vols. Edited by Gaetano Milanesi. Florence, 1878–85.

Vecellio, Cesare. *Habiti antichi et moderni di tutto il mondo.* Venice, 1598.

Venice, Assessorato alla Cultura e Belle Arti. *Venezia e la peste, 1348/1797* (exhibition catalogue). Venice, 1979.

Venturi, Adolfo. *La Madonna: svolgimento artistico delle rappresentazioni della Vergine.* Milan, 1900.

————. *Storia dell'arte italiana.* 11 vols. in 25. Milan, 1901–67.

Venturi, Lionello. "Le compagnie delle calze." *Nuovo archivio veneto* 16 (1908): 161–221; 17 (1909): 140–233.

————. *Giorgione e il giorgionismo.* Milan, 1913.

Verdier, Philippe. "L'Allegoria della Misericordia e della Giustizia di Giambellino agli Uffizi." *Atti dell'Istituto Veneto di Scienze, Lettere ed Arti* 111 (1952–53): 97–116.

Vermeule, Cornelius. *European Art and the Classical Past.* Cambridge, Mass., 1964.

Vipper, S. "Il Tintoretto e il suo tempo." *Rassegna sovietica,* no. 8 (1950): 50–57; no. 9 (1951): 63–73; no. 10 (1951): 52–77; no. 11 (1951): 53–60.

Vitruvius. *I dieci libri dell'architettura di M. Vitruvio tradutti et commentati da Monsignor Barbaro eletto Patriarca d'Aquileggia.* Venice, 1556.

Voragine, Jacobus de. *The Golden Legend.* Translated by Granger Ryan and Helmut Ripperger. New York, London, and Toronto, 1941.

Watson, Paul F. "Titian's 'Rape of Europa': A Bride Stripped Bare." *Storia dell'arte* 28 (1976): 249–58.

————. See Fehl, Phillip.

Wazbinski, Zygmunt. "Tiziano Vecellio e la 'tragedia della sepoltura.'" In *Tiziano e Venezia: Convegno Internazionale di Studi, Venezia, 1976,* pp. 255–73. Vicenza, 1980.

Weddigen, Erasmus. "Thomas Philologus Ravennas: Gelehrter, Wohltäter und Mäzen." *Saggi e memorie di storia dell'arte* 9 (1974): 7–76.

Weinberg, Bernard. *A History of Literary Criticism in the Italian Renaissance.* 2 vols. Chicago, 1961.

Weise, Georg. "Manieristische und frühbarocke Elemente in den religiösen Schriften des Pietro Aretino." *Bibliothèque d'humanisme et Renaissance* 19 (1957): 170–207.

Welliver, Warman. "The Buried Treasure of Titian's Perspective: The Architecture in the 'Pala Pesaro.'" In *Tiziano e Venezia: Convegno Internazionale di Studi, Venezia, 1976,* pp. 207–11. Vicenza, 1980.

Wethey, Harold E. *The Paintings of Titian.* 3 vols. London, 1969–75.

White, John. *The Birth and Rebirth of Pictorial Space.* 2d ed. New York and London, 1972.

————, and Shearman, John. "Raphael's Tapestries and their Cartoons." *Art Bulletin* 45 (1958): 193–221, 299–323.

Wickhoff, Franz. "Der Saal des grossen Rathes zu Venedig in seinem alten Schmucke." *Repertorium für Kunstwissenschaft* 6 (1883): 1–37.

Wilde, Johannes. Review of Th. Hetzer, *Tizian: Geschichte seiner Farbe. Zeitschrift für Kunstgeschichte* 6 (1937): 52–55.

————. "The Hall of the Great Council of Florence." *Journal of the Warburg and Courtauld Institutes* 7 (1944): 65–81. Reprinted in *Renaissance Art,* edited by Creighton Gilbert, pp. 92–132. New York and Evanston, 1970.

————. *Venetian Art from Bellini to Titian.* Oxford, 1974.

Wind, Edgar. *Pagan Mysteries in the Renaissance.* Rev. ed. Baltimore, 1967.

Wischnitzer, Rachel. "Rembrandt, Callot, and Tobias Stimmer." *Art Bulletin* 39 (1957): 224–30.

Wittkower, Rudolf. *The Artist and the Liberal Arts.* London, 1952.

————. "El Greco's Language of Gestures." *Art News* 56 (March 1957): 44–49, 53–54.

————. "Santa Maria della Salute." *Saggi e memorie di storia dell'arte* 3 (1963): 33–54.

————. *Architectural Principles in the Age of Humanism.* 3d ed. New York, 1971.

————, and Wittkower, Margot. *Born under Saturn: The Character and Conduct of Artists.* London, 1963.

————. *The Divine Michelangelo: The Florentine Academy's Homage on His Death.* London, 1964.

Wolf, August. "Tizian's Madonna der Familie Pesaro in der Kirche der Frari zu Venedig." *Zeitschrift für bildende Kunst* 12 (1877): 9–14.

Wolters, Wolfgang. "Der Progammentwurf zur Dekoration des Dogenpalastes nach dem Brand vom 20. Dezember 1577." *Mitteilungen des Kunsthistorischen Institutes in Florenz* 12 (1966): 271–318.

————. "Andrea Palladio e la decorazione dei suoi edifici." *Bollettino del Centro Internazionale di Studi di Architettura Andrea Palladio* 10 (1968): 255–67.

————. *Plastische Deckendekorationen des Cinquecento in Venedig und im Veneto.* Berlin, 1968.

————. *La scultura veneziana gotica (1300–1460).* 2 vols. Venice, 1976.

Wright, Joanne. "Antonello da Messina: The Origins of His Style and Technique." *Art History* 3 (1980): 41–60.

Wurthmann, William B. "The *Scuole Grandi* and Venetian Art, 1260–c.1500." Diss., University of Chicago, 1975.

Yates, Frances. *Theatre of the World.* Chicago, 1969.

Young, Karl. *The Drama of the Medieval Church.* 2 vols. Oxford, 1933.

Yriarte, Charles. *La vie d'un patricien de Venise au XVIe siècle.* Paris, 1874.

Zaggia, Michele. See Carli, Laura de.

Zanetti, Antonio Maria. *Della pittura veneziana e delle opere pubbliche de' veneziani maestri libri V.* Venice, 1771.

Zangirolami, Cesare. *Storia delle chiese, dei monasteri, delle scuole di Venezia rapinate e distrutte da Napoleone Bonaparte.* Venice, 1962.

Zanotto, Francesco. *Pinacoteca della Imp. Reg. Accademia Veneta delle Belle Arti.* 2 vols. Venice, 1833–34.

————. *Il Palazzo Ducale di Venezia.* 4 vols. Venice, 1853–61.

————. *Pinacoteca veneta, ossia raccolta dei migliori dipinti delle chiese di Venezia.* 2 vols. Venice, 1858–60.

Zarnowski, Jan. "L'Atelier de Titien: Girolamo di Tiziano." *Dawna Sztuka* 1 (1938): 107–30.

Zeri, Federico. *Pittura e Controriforma: l'arte senza tempo di Scipio da Gaeta.* Turin, 1957.

————. *Due dipinti, la filologia e un nome.* Turin, 1961.

Zerner, Henri. See Klein, Robert.

Zorzi, Giangiorgio. "Gio. Antonio Fasolo." *Arte lombarda* 6 (1961): 209–26.

————. "Le prospettive del Teatro Olimpico di Vicenza nei disegni degli Uffizi di Firenze e nei documenti dell'Ambrosiana di Milano." *Arte lombarda,* 10² (1965): 70–97.

————. *Le ville e i teatri di Andrea Palladio.* Vicenza, 1968.

Zorzi, Ludovico. "Elementi per la visualizzazione della scena veneta prima del Palladio." In *Studi sul teatro veneto fra Rinascimento ed età barocca,* edited by Maria Teresa Muraro, pp. 21–51. Florence, 1971.

————. *Il teatro e la città: saggi sulla scena italiana.* Turin, 1977.

Zuccaro, Federico. *Scritti d'arte di Federico Zuccaro.* Edited by Detlef Heikamp. Florence, 1961.

Index